Italian Art in the 20th Century

This is the third volume to appear in conjunction with the series of exhibitions of twentieth-century art organized by the Royal Academy of Arts, London

Series editor: Norman Rosenthal

Already published:

German Art in the 20th Century: Painting and Sculpture 1905-1985
Edited by Christos M. Joachimides, Norman Rosenthal and Wieland Schmied, 1985

British Art in the 20th Century: The Modern Movement
Edited by Susan Compton, 1987

The exhibition was made possible by **Alitalia** and **FIAT**

Italian Art

in the 20th Century

Painting and Sculpture
1900-1988

Edited by
Emily Braun

With contributions by

Alberto Asor Rosa, Paolo Baldacci, Carlo Bertelli, Emily Braun,
Giuliano Briganti, Maurizio Calvesi, Philip V. Cannistraro,
Luciano Caramel, Germano Celant, Ester Coen, Enrico Crispolti,
Anna Maria Damigella, Mario De Micheli, Jole De Sanna,
Joan M. Lukach, Adrian Lyttelton, Norman Rosenthal,
Wieland Schmied, Caroline Tisdall, Pia Vivarelli and Stuart Woolf

Prestel

First published on the occasion of the exhibition
'Italian Art in the 20th Century: Painting and Sculpture 1900-1988'
Royal Academy of Arts, London, 14 January - 9 April 1989

Exhibition organized by Norman Rosenthal and Germano Celant

Executive Committee

PIERS RODGERS, *Secretary of the Royal Academy*, Chairman
ROGER DE GREY, *President of the Royal Academy*
BRUNO DORIA
FREDERICK GORE, RA
Sir LAWRENCE GOWING, ARA
JOHN PIGOTT, FCA, *Financial Comptroller*
RICHARD ROGERS, RA
NORMAN ROSENTHAL
PAOLO SANI

Secretary to the Committee: ANNETTE BRADSHAW

Exhibition Coordinator: SIMONETTA FRAQUELLI
Exhibition Assistants: MIRANDA BENNION, MARGHERITA GIACOMETTI BRAIS
Exhibition Designers: MARIO BELLINI with GIOVANNA BONFANTI
Design Coordinator: IVOR HEAL
Graphic Designer: PHILIP MILES
Copy Editor: ANN WILSON

Contents

Foreword

'Italian Art in the 20th Century' is the third in the series of exhibitions in which we survey the tumultuous history of our century and present the achievements of painters and sculptors from the pioneers of the early years to the leading figures of today. The parameters of the series, which started with German art in 1985, followed by British art in 1987, are national but their ambition is international. The original concept arose in discussions between the Royal Academy's Exhibitions Secretary, Norman Rosenthal, and his colleagues Christos M. Joachimides and Wieland Schmied, and was readily endorsed by the Academy's Exhibitions Committee.

Italian artists have been among the most influential of the century, yet there is little opportunity to see their works in this country: we are convinced that this exhibition will come as a revelation to the British public.

We are most honoured that His Royal Highness The Prince of Wales and the president of the Italian Senate, Senatore Prof. Giovanni Spadolini, should have agreed to be patrons of the exhibition.

An enterprise of this scope is always difficult, and cannot be realized without the goodwill and the practical assistance of many – artists, lenders and others. It is right that I should acknowledge first a particular debt of gratitude to the Italian authorities, whose support has been essential to us, and who have once more demonstrated their attachment to the ideals of cultural exchange. The Italian Ministries of Foreign Affairs and of Cultural and National Heritage – in particular the Director-General of the latter, Prof. Francesco Sisinni – have been unfailingly supportive. Successive Italian ambassadors in London – Their Excellencies Mr Bruno Bottai and Mr Boris Biancheri – have given us their advice and encouragement, and the help of the Embassy Staff, in particular the Cultural Attaché, Prof. Alessandro Vaciago, has been invaluable. Others who have given us the benefit of their advice include Senatore Susanna Agnelli, Ministro Umberto Vattani and the British Ambassador in Rome, H. E. Sir Derek Thomas.

This exhibition of Italian art has been selected by Norman Rosenthal, with Germano Celant, the well-known Italian art critic and historian. They have been able to call upon a most distinguished Advisory Committee.

Museums and private collectors in Italy and elsewhere have responded with great generosity to our requests for the loan of works of art of the first importance, and we have enjoyed the ready and enthusiastic support of the artists and their families. We thank the scholars of distinction who have contributed to this catalogue. The exhibition design is the work of the celebrated architect and designer, Mario Bellini.

Our sponsors, Fiat and Alitalia, have been outstanding in their generosity and their understanding. Without their support, the exhibition would not have been possible. The personal commitment of Avv. Giovanni Agnelli, Dr Cesare Romiti, Dr Cesare Annibaldi, Dr Furio Colombo and Dr Bruno Doria of Fiat, and of Dr Carlo Verri, Dr Sergio Pietrobelli and Dr Paolo Sani of Alitalia, has been much appreciated.

Many individuals have contributed to the making of this exhibition. Among our colleagues in the great institutions, particular mention must be made of Dr Augusta Monferini, Dr Mercedes Garberi, Dr Rosalba Tardito and Prof. Nicola Spinosa in Italy and of William S. Lieberman, Kirk Varnedoe and Thomas Krens in New York. At an early stage in the preparation of the exhibition we benefited from discussions with Prof. Pontus Hulten and our cooperation with him and with

Dr Giuseppe Donegà and Dr Emilio Melli, successively Directors of Palazzo Grassi, Venice, has been close and cordial. Eric Estorick and Volker Feierabend have been outstanding in their generosity. Philippe Daverio and Prof. Paolo Baldacci were always ready to share with us their wide knowledge of the field, as were Claudia Gian Ferrari and Massimo di Carlo. Two distinguished Milanese publishers, Leonardo Mondadori and Massimo Zelman, have afforded help at difficult moments, and the advice of Gaia Servadio, London correspondent of *La Stampa*, has proved invaluable. The high standard of production of this catalogue is due to the dedication and competence of Prestel-Verlag in Munich.

Finally, particular thanks go to two specialists in the field: Emily Braun, who has edited the catalogue with great skill, and Simonetta Fraquelli, who has coordinated the arrangements for the exhibition and the catalogue. In these tasks they have been ably assisted by Margherita Giacometti Brais and Miranda Bennion.

ROGER DE GREY
President of the Royal Academy

Acknowledgments

In addition to those mentioned above, the Royal Academy of Arts and the organizers of the exhibition extend their warm thanks to:

Rosetta Agresti Mosco
Salvatore Ala
Luisa Arrigoni
Roberto Barravalle
Heiner Bastian
GianFranco Benedetti
Maria Bertagnin Martini
Carlo Bertelli
Peter Beye
Giovanna Bonfanti
Giuliano Briganti
Claudio Bruni Sakraischik
Alberto Burri
Luciano Caramel
Massimo Carrà
Norberto Cappello
Clarenza Catullo
Ester Coen
Luigi Corbani
Michelle Coudray
Plinio De Martiis
Danielle Dutry

Anthony D'Offay
Giancarlo Elia
Valeria Ernesti
Maurizio Fagiolo dell'Arco
Konrad Fischer
Teresita Fontana
Giorgio Franchetti
Ida Gianelli
Hugues Joffre
Elisabetta Kelescian
Jan Krugier
Guido Lenzi
Rosa Maria Letts
Corrado Levi
Joan M. Lukach
Adrian Lyttelton
Salvatore Magliano
Miriam Mafai
Giorgio Marconi
Gabriele Mazzotta
Daniel Moynihan
Andrew Murray

Carla Panicali
Antonio Paulucci
Alessandra Bianca Pinto
Massimo Prampolini
Flaminio Qualdoni
Cora Rosevear
Lia Rumma
Angelica Savinio
Rosanna Maggio Serra
Massimo Simonetti
Joanna Skipwith
Franco Solmi
Gian Enzo Sperone
Paolo Sprovieri
Anne L. Strauss
Stephanie Struyvenberg
Domenico Valentino
Emilio Vedova
Lamberto Vitali
Pia Vivarelli
Giorgio Verzotti
Angela Westwater

Introduction

For the people of other nations, Italy is still a land of the dead, an immense Pompeii still whitening with sepulchres. But Italy is being reborn, and in the wake of her political resurgence an intellectual resurgence is taking place. In the land of the illiterates schools are opening; in the land of *dolce far niente* innumerable factories are now roaring full tilt; in the land of traditional aesthetics one is struck today by a new élan, by lightning-bright inspirations of something utterly new.

(*Manifesto of Futurist Painters*, 11 February 1910)

The presence of the past is surely more visible in Italy than in any other country in Europe. In spite of countless wars and invasions over the centuries, every episode of history has left a seemingly inexhaustible quantity of cultural remains. No foreign visitor to Italy can fail to notice the plethora of Etruscan, Roman, medieval, Renaissance and Baroque architecture, painting, sculpture and artifacts, and he can almost be forgiven for overlooking the existence of a rich visual culture created in our own century. Italy has few prominent museums devoted solely to the art of the twentieth century, and those that do exist, most notably in Rome and Milan, do not have fully representative collections of contemporary art comparable to those found in France, West Germany, the United States or even Great Britain. There are many reasons for this, not least, the enormous burden which the preservation of the past has placed on Italy's human and financial resources.

It is therefore not surprising that the Futurist painters should have begun the first of their many manifestos (February 1910) with an outburst against museums and the oppressive culture of the past: 'We are rebelling against the sluggishly supine admiration for old canvases, old statues, old objects, and against the enthusiasm for everything worm-eaten, rotting with filth, eaten away by time . . . we are nauseated by the despicable sloth that, ever since the sixteenth century, has let our artists survive only through an incessant reworking of the glories of the past'.[1]

With unceasing self-promotion and artificially provoked scandals, the Futurists Giacomo Balla, Umberto Boccioni, Carlo Carrà, Luigi Russolo and Gino Severini, encouraged and supported by that extraordinary art propagandist Filippo Marinetti, sent their art to exhibitions in Paris and London, Germany and America. Although the number of major works they produced was small in comparison to the Cubists, each canvas was conceived with the ambition of being a political and aesthetic manifesto. As the exhibition 'Futurismo & Futurismi', organized at the Palazzo Grassi in Venice in 1985, demonstrated, the group's images and words were not without effect. Futurist groups sprang up everywhere, in England (with the Vorticist movement), France, Germany, Russia and even in Mexico and Japan. It was indeed a dynamic impulse for art on the eve of the First World War. If the inventions of Georges Braque and Pablo Picasso provided a more revolutionary and, consequently, more esoteric means of expression, it was the deliberately loud and attention-seeking works of Futurism that shocked and shook the world.

Although the Futurists aimed at sweeping Italy clean of history to make way for the young, the violent and the headstrong, the culture of the past was not so easily disposed of. Indeed, the strength of Italian art of this century is to be found in the dialogue between innovation and tradition. The tension between desire for the new and self-consciousness towards the past has coloured the most diverse art movements

1 G. Balla, U. Boccioni, C. Carrà, L. Russolo and G. Severini, *Manifesto dei Pittori Futurista*, 11 February 1910; translated by R. E. Wolf, in E. Coen, *Boccioni*, New York, 1988, pp. 229-30 (p. 229).

in Italy throughout the century. If modern German art (in its most characteristic style, Expressionism) has been concerned, above all, with the self, Italian art has addressed problems of place and cultural dislocation. Italy's culture is characterized by breaks and contradictions between north and south, neighbouring provinces, city and country, and the experience of these regional cultures and historical fractures has had a profound influence on the country's visual arts.

Despite the insularity of its visual culture during the late nineteenth century, Italy gave birth to two of the most influential movements of the early twentieth century: Futurism and Metaphysical painting. The latter was invented by a single artist, Giorgio de Chirico, one of the most complex and contradictory artistic figures of our century, in response, among other things, to a sense of historical rupture. Whereas the Futurists preached revolution, de Chirico longed for the past, and the anxiety inherent in both these attitudes reflected the chaos that was soon to engulf Europe.

The contradictions of the Futurists' modern vision are made plain in the art and aspirations of Boccioni. The series of paintings entitled *Stati d'animo* (*States of Mind*; Cat. 19-21) depict the modern subject of the railway station: while the image captures the sensation of dynamic movement, the figures in the train seem to be in a trance, and those leaving the station are like Dantesque shades passing through purgatory. Although the Futurists extolled the machine, Boccioni's favourite subject was, in fact, his mother (Cat. 22, 25), around whose features circulate all the explosions of modern life. Yet her static, immutable presence is surely a symbol of continuity and stability. She is the Italian matriarch, a symbol of Italy itself, facing the future but inextricably linked to the past.

Both Boccioni and de Chirico in their different ways reflected on the concept of time, influenced by the philosophy of Henri Bergson and by the idea of the continuum as the only true reality. Unlike Boccioni, de Chirico felt quite consciously bound to tradition. His city squares, empty of life, are perceived as if in a dream: a gloved hand disturbs the peace of an Italian *piazza* (Cat. 45), a factory chimney rises amidst buildings whose classical features have been obscured by time. De Chirico's schematic classicism has had a profound impact on twentieth-century non-modernist architecture from the inter-war period onwards. The first impression produced by his paintings is one of calm and serenity; but then the weight of civilization that bears down on de Chirico's images gives rise to an underlying sense of turmoil. These pictures pose a series of questions, but they give few answers.

The flat pictorial surface of de Chirico's canvases comes closer to the naive manner of Henri Rousseau than to the luscious *'bonne peinture'* of contemporary French painting. For Boccioni, too, technique was not a central issue; he borrowed from the Pointillism of the Italian Divisionists, from Cubism and Expressionism, as they suited his purpose. In this respect, Futurism and Metaphysical painting had something in common, despite their obvious differences. Pictorial technique was not an end in itself but only the means with which to express a dramatic or paradoxical point. This set a precedent which, with the possible exceptions of Filippo de Pisis (Cat. 83-6) and Giorgio Morandi (Cat. 55-7, 87-94), Italian artists were to follow. The values of a Roger Fry are hardly applicable to Italian art in this century, which, in the words of de Chirico's brother, Alberto Savinio, 'halted the plague of Cézannism that ravaged Europe in the first quarter of the century and, in part, continues to ravage it'.[2]

The First World War seemed to change everything, and nowhere more so than in Italy. Boccioni was killed after falling from a horse. His Futurist period had already come to an end, and in his last works – for example, *Ritratto del maestro Ferruccio Busoni* (*Portrait of Maestro Ferruccio Busoni*, 1916) – there were strong intimations of a *rappel à l'ordre*. The anarchic spirit was replaced by a more traditional approach to painting, a tendency which was to be found all over Europe but which was particularly marked in Italy. Carrà, too, abandoned Futurism and, after his *antigrazioso* (*anti-graceful*) paintings of 1916, turned briefly to a personal interpretation of Metaphysical painting. After 1918, he expounded his ideas on a new spiritualism in

painting in the periodical *Valori Plastici* and, a few years later, became a painter of the Italian landscape in a style that seemed deliberately to avoid anything radical.

De Chirico abandoned his early Metaphysical style for a method of painting inspired by Titian and Raphael. At the same time, he praised Masaccio and Uccello, whose stillness and calm he, like other Italian artists, sought to make relevant to the twentieth century. Writing in *Valori Plastici* in 1921, he proposed:

> If an Italian spirit exists in painting, I can see it only in the fifteenth century. In that century, the toil and labour of the Middle Ages, the midnight dreams and nightmares of Masaccio and Uccello, were resolved in the immobile clarity and adamantine transparency of a happy and tranquil art that nevertheless contained an element of unease, like a ship that reaches the calm port of a sunny land after battling through dark seas and hostile winds.[3]

The element of unease in the years following the First World War was reflected in art as well as politics. Futurism, of course, had been very much a part of that radical 'will to power' which seemed to justify both artistic and political violence. Yet Mussolini's March on Rome in 1922 was symptomatic of new cultural developments which also lay behind the return to order in art; they constituted an apparent abandonment of radical philosophical traditions in favour of a more conservative approach.

There are clear differences between Italian Fascism in the early twenties and National Socialism in Germany, which came to power a decade later. Fascism was embraced by many Italian intellectuals in good faith, especially those who shared part of its roots in Futurism, such as Carrà, Mario Sironi and Marinetti. Their work was sympathetic to the new regime, which seemed to offer not only a more dynamic and efficient state but also opportunities for patronage and public art. It appeared that Italy was again destined for great cultural achievements, and artists looked back to a glorious past in an attempt to recreate it on a grand scale.

The art of the twenties and thirties, while often shown in exhibitions in Italy, has rarely been presented abroad, although art historians on both sides of the Atlantic are beginning to look more closely at the very remarkable artistic production of this period. Some have argued that there was no Fascist style as such, and in any case, modern art, as noted, was already retreating from its avant-garde positions all over Europe. In Italy, Second Futurism continued the spirit of the first, worshipping dynamism and the machine, and counting dozens of artists from all over Italy among its ranks. But Marinetti, like his counterpart in Berlin, Herwarth Walden, now found himself involved in a far less significant movement. The most authentic artistic expression of this period in Italy, the *Novecento*, was rooted once again in history and a dialogue between past and present.

This is best seen in the work of Sironi, whose sombre paintings closely identified with the claims of Fascist ideology to continue the great culture of the past. Sironi had begun as a Futurist in the years before the war, but soon developed his own Metaphysical style in a series of urban landscapes (Cat. 100-2). Unlike de Chirico, Sironi portrayed a bleak industrial environment, often devoid of people. When human beings do appear, as in *Il cavallo bianco e il molo* (*The White Horse and the Pier*; Cat. 103), they seem like actors in a contemporary political drama.

In 1920, two years before Mussolini's seizure of power, Sironi wrote the manifesto *Contro tutti i ritorni in pittura – Manifesto futurista* (*Against all Returns in Painting – Futurist Manifesto*), which proclaimed: 'One needs to progress at whatever cost, carrying forward all previous pictorial achievements, and reinterpreting them anew with an all-embracing synthetic vision. Futurism, having left behind the period of the formidably vital, vast and profound modern sensibility, now faces the problem of how to define style, to make it concrete form and create a final, ideal synthesis.'[4] In retrospect, this synthesis represented, perhaps, a naive belief in the renewal of cultural values through political activism, a belief that allowed Sironi, an artist of exceptional talent, to associate himself publicly and whole-heartedly with the Fascist regime. He remained, however, a highly modern artist, both conceptually and pictorially, whose work, as we see it today, provides a further demonstration of the

2 A. Savinio, *The Childhood of Nivasio Dolcemare*, translated by R. Pevear, New York, 1987, p. 27.

3 G. de Chirico, 'La mania del seicento', *Valori Plastici*, no. 3, 1921; quoted in M. Carrà, *Metaphysical Art*, translated by C. Tisdall, London, 1971, p. 148.

4 L. Dudreville, A. Funi, L. Russolo and M. Sironi, *Contro tutti i ritorni in pittura – Manifesto futurista*, 11 January 1920; reprinted in M. Sironi, *Scritti editi e inediti*, ed. E. Camesasca, Milan, 1980, pp. 14-17 (p. 17).

sad dilemma of the Italian artist in this century, caught between an irretrievable past and the inescapable reality of the present.

In 1935, Sironi, Carrà and Massimo Campigli (who, together with Sironi, was involved in a revival of the Etruscan style) proposed public murals as a means of reuniting the artist with the community. Sironi received numerous commissions in the thirties to decorate public buildings, including a mural for Rome university, *L'italia fra le Arti e le Scienze* (*Italy between the Arts and the Sciences*, 1935; see Cat. 108). The design was clearly based on classical imperial models and, at first glance, seems to embody an epic vision of a new Italy. On reflection, however, this is not the crude propaganda of false heroes encountered in the official art of Nazi Germany or Stalinist Russia. Metaphysical melancholy still pervades Sironi's image: the figure of Victory descends over the scene like an omen of destruction, and the mythical image seems none too stable. The sculpture of Arturo Martini (another artist virtually unknown outside Italy, though greatly admired by Henry Moore) is also pervaded by melancholy, by an artistic disposition which looks to classical models in a highly emotional manner that is far from simple revivalism (Cat. 110-13).

Contemporary with these large-scale public works there existed manifestations of 'internal' opposition to the classical tendencies favoured by the regime. In Como and Milan artists such as Osvaldo Licini sought inspiration elsewhere in Europe and evolved a highly personal, lyrical interpretation of geometric abstraction (Cat. 131). Lucio Fontana, long before the period of his famous 'holes' and 'slashes', experimented with abstract notions of mass and space that carried further the ideas of Medardo Rosso and the Futurists (Cat. 124-30). Yet at the same time, Fontana was eclectic enough to create such works as *Signorina seduta* (*Seated Girl*; Cat. 120), a gilded sculpture of a young girl that hovers between a figurative and an abstract conception of form, deliberately ambiguous in a way that, like the sculpture of Martini, was derived from Metaphysical painting.

De Chirico's work in the 1920s was both classical and surrealistic; his images circumvented the concept of stylistic originality, creating their particular effect by referring to all histories and cultures (Cat. 70-76). At the same time, Scipione, the dominant figure of the so-called *Scuola Romana*, painted small expressionist works that evoked a decadent Baroque Rome (Cat. 143), while Fausto Pirandello produced unglamorous pictures of the working class (Cat. 141) – both far from the classical grandeur celebrated by the regime. None of these artists, however, whether abstractionist or expressionist, was ever prevented from working, and they all found ways of exhibiting in public. Opposition in the form of artistic expression was never totally suppressed, even as the inherent cruelty of Fascism in Italy became more extreme later in the decade. Paintings of protest, such as *Fucilazione in campagna* (*Execution in the Countryside*; Cat. 146) and *Crocifissione* (*Crucifixion*; Cat. 148) by Renato Guttuso, a Communist partisan, indicted the regime in public exhibitions – a freedom that was never permitted in the Germany of the Third Reich. Until the Racial Laws of 1938, 'degenerate art' was of no concern to Italian Fascism, which had preferred a strategy of stylistic pluralism. And anti-semitism, even though it was to lead to terrible atrocities after the pact that Mussolini made with Hitler in 1936, never took hold among the mass of the Italian people as it did in Germany and in most occupied countries north of the Alps.

The twenties, thirties and early forties in Italy were fundamentally conservative in their attitude to art; the avant-garde experiments that characterized Second Futurism were never more than tentative. In the years following the Second World War, however, Italian design, architecture and film began to have a profound impact on international culture. The infrastructure of the visual arts changed little; Italy remained, and remains, a country with very few institutions for the exhibition of contemporary art (with the notable exception of the Venice Biennale). Artists, critics and those concerned with the promotion of culture continued, as they continue today, to align themselves with the ideologies of political parties. There were many arguments about how best to respond to the task of restructuring the moral fabric of

Italy. Once again, it was a question of how to combine a radical position with tradition. Painters such as Guttuso, whose Realist style was largely supported by the Communist party, and sculptors such as Marino Marini and Giacomo Manzù enjoyed prominence owing to their cultivation of a strong sense of continuity with past Italian models.

Other artists, in contrast, considered abstract art to be the style of both political and creative freedom. Fontana in Milan, Alberto Burri in Rome and Emilio Vedova in Venice were the leading figures in the post-war creative explosion. Unlike their *Informel* contemporaries in Europe, the Italians were particularly concerned with material qualities, which they used to express a spiritual aestheticism. Fontana's punctured canvases, with their idea of *'spazialismo'* (spatialism; Cat. 153-9), edged towards a rediscovery of universal values that had seemed to have been destroyed by the catastrophic events of 1943 to 1945. They suggested limitless expanses, while referring back to the dynamic possibilities of Futurism as evoked by the precocious abstractions of Balla.

Burri's work was a statement of extreme radicality when it first appeared in the fifties; his canvases made of rough burlap (and, subsequently, wood, iron and plastic) initially seemed to negate the whole tradition of painting (Cat. 165-70). Yet they represented a continuation of the work of Kurt Schwitters and were to influence such American artists as Robert Rauschenberg. Though icons of industrial culture, in the course of time they have taken on a beauty that enables us to appreciate their metaphysical quality. Here again, Italy and its landscape are restructured and presented as images with a very specific sense of time and place.

Piero Manzoni and Pino Pascali built on both the spatialism of Fontana and the materiality of Burri to achieve an even more radical position in the combination of matter and metaphysics. Theirs was a particularly optimistic or ironic vision of art which was nevertheless infused with a sense of fatality, a mood that led to suicide in the cases of Manzoni and Francesco Lo Savio. The contemplation of the infinite proved too much for them to bear.

Such positions led increasingly towards an art that broke away from traditional notions of painting and sculpture. Metaphysical speculation went so far that art became simply the object itself. Artists like Giovanni Anselmo, Luciano Fabro, Giulio Paolini, Jannis Kounellis, Mario Merz, Giuseppe Penone and Gilberto Zorio were amongst those who expanded the concept of art, challenging the conventions of the gallery space and museum system as the Futurists had over half a century earlier.

Germano Celant gave this new artistic climate in Italy a name that stuck: *Arte Povera* (Poor Art), an art that used simple materials to trigger off memories and associations. Like de Chirico, these artists isolated the object, but in the space of the gallery or in the open air instead of on the canvas, endowing it with mythological, almost archaic, poetic significance. The work of art was heightened in a personal, autobiographical sense, as real objects replaced illusionistic images as vehicles of poetic ideas and ambiguities.

Similar movements existed in other European countries, particularly Germany, where Joseph Beuys (who has been extremely influential on recent Italian art) was one of a number of artists who perceived art as an agent of social reform and revelation. Objects and materials of everyday life were brought forward by the artist in an attempt to heighten the consciousness of the viewer and make him aware of both the spiritual and the plainly practical nature of the world around him. As Pino Pascali observed, 'Europe is a different condition from America. Rather than being a place of action, it is a place for reflection on action.'[5]

Kounellis, like de Chirico, was born in Greece; he moved to Rome in 1946. His work examines the tensions and paradoxes that exist within Mediterranean culture. From his early *Alfabeti* (Alphabets; Cat. 213), his work has reflected the observations of a restless wanderer moving through time and space. As he stated, 'I believe that the artist, whether of today or yesterday, never engages in a dialogue with the present, the present in a pejorative sense. But he is engaged in a permanent dialogue with the culture of the past. Certainly, this has always been the case in Europe.'[6]

5 P. Pascali, Interview with C. Lonzi, *Marcatre*, July 1967.
6 J. Beuys, J. Kounellis, A. Kiefer and E. Cucchi, *Ein Gespräch/Una Discussione*, Zurich, 1986, p. 96 ff.

One of his most notorious pieces, *Cavalli* (*Horses*; Cat. 215), consisted of eleven live horses in the white room of a gallery. At the time, it seemed to be an extreme, almost anarchic statement, yet it is also remembered as a particular moment of contemplation – like a painting by de Chirico (Cat. 72) – a moment to reflect on the horse as a symbol of history and of art.

Merz, like Kounellis, is one of the leading figures of *Arte Povera*. He is both a Futurist, in the sense that his art is the art of a prophet, and a metaphysician who continually reflects on the universal condition. The *Igloo* (Cat. 221) is the central image of his sculpture, and represents, in the artists' words, 'the globe and its balance'.[7] The spherical form provides a framework that is endlessly rich in meanings. His structures suggest a post-apocalyptic vision of a world which has nonetheless not been totally destroyed; they offer protection and are penetrated by dynamic energy. Merz's *Igloos* are also a reflection of time and movement and of the engulfing jungle of civilization from which man, the nomad, needs protection. His work seems to point even further back in time than that of the other artists discussed here, evoking those tribes who moved eastwards across Europe and effected a fusion of barbarian culture with that of Rome.

Merz is also a painter of primeval animals which seem far in spirit from the Futurist optimism that opened the century. Like Beuys, to whom he is often compared, Merz presents himself to the world as a witch doctor, offering remedies for the materialistic and barren culture that surrounds us. He belongs to that tradition of Italian art which is almost exclusively concerned with metaphysical problems, and his work can be seen as an extension of the ideas invented by de Chirico.

Italian art of this century has resembled the head of Janus, facing two ways. Movements which at first seemed to contradict each other have emerged as two aspects of the same fundamental problem. There can be little doubt that, some ten years after the radical optimism of 1968 and *Arte Povera*, there was a forceful reaction among younger artists against the international style of Conceptual Art. At the beginning of the eighties, there was much talk about a return to painting and sculpture in a traditional sense, although the practice of these genres had never died out, in Italy or elsewhere. Italy was very much at the forefront of these developments, and it was an Italian art critic, Achille Bonito Oliva, who christened the renewal '*transavanguardia*'. Like most such terms, it is ambiguous, but has nonetheless proved useful in denoting an art which broke with the international conceptual style in an attempt to replace it by one based more on local traditions.

Perhaps it is precisely because of its rich cultural heritage that Italy has led the revival in contemporary painting. The exhibition 'A New Spirit in Painting', held at the Royal Academy in 1981, was just one symptom of a changed perception of the possibilities of art that was emerging most notably in Germany and the United States, as well as Italy. Artists such as Sandro Chia, Mimmo Paladino, Enzo Cucchi and Francesco Clemente suddenly took the centre of the stage, and modern Italian art received probably more international attention than at any time since Futurism. The primarily figurative art of the *transavanguardia* never entirely abandoned conceptual possibilities; full of ambiguities and personal mythologies, it drew quite strongly in its initial stages on the example of *Arte Povera*. It soon became apparent, however, that these artists also looked to earlier Italian art, especially that of the twenties and thirties. It was this deliberate eclecticism and almost mannerist opulence that contrasted with the purity and economy of the previous generation (Cat. 225-34). The art of the *transavanguardia* seemed so dangerously all-embracing in its references that some saw it as signalling the end of the concept of the avant-garde.

Nothing could be further from the truth, however. Now, at a distance of ten years, we can place the *transavanguardia*, like *Arte Povera* before it, in a continuum of responses to cultural traditions that was initiated at the beginning of the century. The *transavanguardia* represents more than just another *rappel à l'ordre*, though it is that too, and it is also more than a return to private mythologies, even though this is an important element in the work of a new generation of Italian artists. In the final

7 M. Merz, 'Did I say it or didn't I?', *Parkett*, no. 15, 1988, p. 82.

analysis, it is a question of employing new approaches to express, once again, psychological and subjective truths within the tradition of figurative painting. The *transavanguardia* thus constitutes a vital stage in, not the end of, the avant-garde, and has already become a part of history. Like all movements, perhaps, it is an assessment of the past, and it is highly appropriate that the way in which it is developing has enabled it to draw together all the threads of Italian art in this century. We have arrived at a moment when Italian art would seem to possess a remarkable unity of purpose, and it is especially the art of today which allows us to view that of the past with a more precise and acute sensibility.

Norman Rosenthal

Art from Italy

An exhibition of Italian art in the twentieth century rests upon contrasting premises: on the one hand, the conviction that history can provide a substantive record, taking account of fundamental changes as well as of particular events; on the other, the awareness that any attempt at critical interpretation, at analysing changing strategies of style during a century of art-making in Italy, depends on the individual experience of the selectors. In the end, 'Italian Art in the 20th Century' recollects parts of a historical adventure, including the most recent art. We have tried to see which artists, from Futurism to *Informel*, from Medardo Rosso to Lucio Fontana, first set in motion the waves which still roll on today. Plunging into the depths of a collective memory, we have set off on a new voyage, starting from the 'already seen' in a search for meanings and effects which have had a formative influence on the multiplicity of contemporary art.

We attempted to make our way, as clearly and decisively as we could, to the centre of a web which contains every point representative of Italian art; it soon became apparent that the undertaking was as fascinating as it was impossible to accomplish completely. Nevertheless, from the names of the artists, no less than from the works of art, a certain order and a system of reference emerge; they constitute a history, but one arrived at through the sacrifice of others who are absent. Those present help to define this Italian century, a century whose outlines are still unclear and which is still partially unexplored. One might say that, for all their shared journey and their theoretical complicity, the organizers offer two views, one from within and one from without, one from Italy and one from Great Britain; they have constructed an image and a history, drawing on fundamentals which are common to a reductive, if primary, vision. Thus the exhibition ends up 'discovering' the well-known movements and figures which best represent the tension between modern and anti-modern throughout the period. It does not leave the mainstream to venture into the by-ways of the anomalous and the atypical, but is a celebration of the major routes from Umberto Boccioni to Giorgio de Chirico, Giorgio Morandi to Alberto Burri, Piero Manzoni to Jannis Kounellis.

In expressing certainties rather than opening up possibilities or probabilities, this voyage through Italian art in the twentieth century is not exhaustive. It might be called an exhibition of art *from* Italy, where the 'from' carries a range of meanings. It is a preposition indicating origin and provenance, as well as a certain distance.

The exhibition covers a historical period, from the beginning of the twentieth century to the present, in which Italy moved from being a disunited country, with a predominantly peasant society and craft economy, to a nation which has made the breakthrough to industrialization and wealth. Art has been subjected to a comparably rapid process of development. It has evolved at a speed which links the energy of Futurism and the arcane metaphor of *Arte Povera*, accommodating in between the lyricism and concern for materials which ran from abstraction to *Informel*.

'From' also indicates the roots and the connections which have enabled art to arise from ruins and wreckage, an art that both turns to tradition and seeks out the unknown. This art was found in the magical-hermetic creations of de Chirico, in the Neoplatonism of Morandi and the enigmas of Alberto Savinio, passed through the *Valori Plastici* and *Novecento* movements and arrived at the ideas depicted and sculpted in the neoclassical, post-modernist transfiguration practised by contemporary artists. Such an art celebrates the metaphysical circumstances that flow from strange and disturbing affinities between the past and the present, between the outgoing and

the repressed. Forms and colours spring 'from' an Italy in darkness, whose hankering after night and gloom in the inter-war years brought forth the urban nightmares of Mario Sironi and the airy refinement of Fausto Melotti.

In theory, a discourse on the separate and contrasted worlds of the 'real' and the 'imaginary', as developed by the opposing sides of this art, might seem to sanction a historical interpretation which speaks of an antithesis between Futurism and metaphysics, between abstraction and icon, between Conceptualism and Neo-Expressionism. Yet the exhibition re-establishes their complementary nature. It puts all on the same plane, bringing out their common roots and secret tensions, and presents the many connotations of a contemporaneity which excludes traditional distinctions. Room by room, the exhibition interweaves all the possible meanings and the constant shifts suggested by the constituent works and images. The web of relationships thus produces a synchronic fabric, in which archaism and experiment, painting and sculpture, Pop and Minimal or post-modern, each take their place and convey a meaning which transcends definitions and groups.

The art from Italy shown here gives the outlines and the points of reference by which Italian art is, and will be, known in the world. Artistic research and innovation do not settle in previously conquered territory, but push out to the frontiers to confront other developments; thriving on the concept of a visual mode of doing and thinking, they leave behind the provincialism of the *genius loci* and take on the import of a prophecy among the nations. We thus turned away from the endless enumeration of names so typical of such exhibitions, which would merely have led us into a maze, and have preferred to adopt a rigorously selective approach, in which the protagonists' works can breathe and unfold before the public, rather than falling into the trap of token representation of too many.

The aim is to present those artists and works whose quality of renewal and cultural roots enable them to express an 'Italian identity'. Furthermore, in an exhibition held outside Italy, the 'from' implies a certain distance from, if not a subversion of, the process of lionization from which these artists suffer on the international scene. For they are not mythical persons; they are the objective protagonists of an irreversible historical situation. Their work has shaped, and will shape, the historical memory of Italian civilization. Indeed, if the essence of the nineteenth century is French, the sensory impermanence, the rapid linguistic mutations in art and design, in cinema and architecture, so characteristic of the end of the twentieth century, owe a great deal to Italian innovations.

The rapid transformation of the metropolitan landscape, taking place at the hurried pace of modern life, is clearly present in the elusive and dynamic images of Futurism, which were later cultivated for their secular linearity and explosive potential by Fontana and Manzoni. The Futurists' speed of vision and action 'killed' time and led to an anti-monumentality which was able to endow the ephemeral with a strong sense of permanence. It is the strength of the unrepeatable moment – magnified by Boccioni and Giacomo Balla, reawakened by Osvaldo Licini and Emilio Vedova and frozen by Luciano Fabro and Enzo Cucchi – that unites the artists, even though they may have 'registered' it in different ways. This capacity to 'register' the intersection of the past and the present, of tradition and experiment – seen in subjective and collective practices, in individuals and groups – is unique to the nomadic path of Italian art.

Germano Celant

1900-1919

Adrian Lyttelton

Society and Culture in the Italy of Giolitti

In the later nineteenth century, Italy was haunted by the spectre of backwardness. Industrial development was fitful and, rather than catching up with the leading industrial nations, the Italian economy fell further behind. The contrast with the dynamism of the other new nation in Europe, Germany, was particularly depressing. In the 1880s, there was a brief period of capitalist euphoria accompanied by industrial expansion, but this was cut short by a disastrous slump at the end of the decade. The major Italian banks had preferred to direct their investments towards property speculation rather than industry, and when the market collapsed it brought on a general banking crisis. It was then revealed that the Banca Romana had used its right to issue notes to print illegal excess currency, and that many leading politicians were in its pay. As Luigi Pirandello later wrote in his novel *I vecchi e i giovani*, a tide of mud seemed to have engulfed the whole Roman political scene. For lovers of beauty, the infamy of the new Rome of speculators and politicians had been symbolized by the destruction of the famous park of the Villa Ludovisi. And what had been achieved in exchange? Rather than progress, the new capitalism appeared to have brought nothing but bankruptcy, corruption and social crisis.

The 1890s were a dark decade in Italian history, punctuated by desperate protest movements of peasants and workers, culminating in the nationwide disorders of 1898. In Milan in that year, over one hundred rioters were killed by the brutal military repression of General Bava Beccaris. The aging ex-revolutionary Francesco Crispi had tried to divert attention from the crisis at home by colonial conquest, but his efforts ended in the disaster of Adua in 1896, when an Italian army of 15,000 was cut to pieces by the Abyssinians under their emperor, Menelek. In the last years of the nineteenth century, however, Italian industry finally 'took off'. Italian industrialists proved ready and able to take advantage of the period of world-wide economic expansion which began in 1896. During the next ten years, Italian industrial growth was the fastest in Europe. Italy's future as an industrial nation was finally assured.

Yet Italy's industrial development was particularly uneven. Sixty per cent of all joint stock capital was concentrated in the industrial triangle, Milan-Turin-Genoa. In central and southern Italy, modern industry only took root in isolated enclaves within a largely agricultural economy. This accounted for the continuing feeling that the growth of a new, vigorous and modern Italy was being held back by the dead weight of traditional attitudes and social structures. All industrializing countries experienced the dramatic contrast between the new industrial city and old rural traditions. More peculiar to Italy, however, was the importance of traditional urban life. The prestige of Italy's ancient cities and the existence of an influential pre-industrial middle class maintained a humanist culture which refused to acknowledge the inroads of modern industry and capitalism. One aspect of the modern world in particular did touch these cities deeply: the development of tourism. Filippo Marinetti's declamations against 'past-loving' Venice must be seen against this background: 'We renounce the Venice of foreigners, market for counterfeiting antiquarians, magnet for snobbery and universal imbecility, bed unsprung by caravans of lovers, jewelled bathtub for cosmopolitan courtesans, *cloaca maxima* of passéism.'[1] Italian Nationalists frequently attacked the demeaning influence of the tourist trade, which encouraged servility towards foreigners. Luigi Federzoni and the Nationalist Association waged a press campaign against the 'Germanization' of the Lake of Garda; bed and breakfast signs in German were held to be a menace to national integrity.

Italy had been a laggard in the first, 'palaeotechnic' industrial revolution, that of coal, iron, steam power and cheap textiles, but by the 1900s a handful of successful Italian firms were capable of competing with the technologically advanced leaders of the 'second industrial revolution' of electricity and the internal combustion engine. The development of hydroelectric power was particularly important for Italy, given its lack of coal. The electricity industry became the motor of Italian industrial development, attracting more capital than any other sector. The huge new dams and power stations built to take advantage of the Alpine torrents became the symbol of Italy's industrial achievement (Fig. 1).

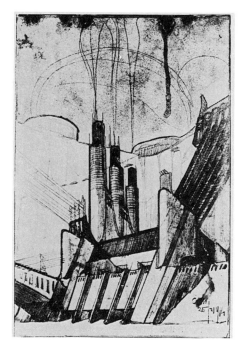

Fig. 1 Antonio Sant'Elia, *Power Station*, 1914. Paride Accettti Collection, Milan

The founders of Italy's most famous industrial families made their fortunes in the new industries, the Milanese Giambattista Pirelli in rubber and Giovanni Agnelli of Turin in cars. The success of Agnelli and the Turin firm of Fiat was particularly remarkable. Cars were still a luxury item, and the market in Italy was very restricted. But Agnelli was able to export a sizeable proportion of his output, and though he could not hope to compete with Ford, he was quick to copy the American company's mass production methods. Unlike most industrial products, the early motor car had glamorous associations with adventure and sport. The car industry was *chic;* young members of the Turin nobility helped to found Fiat, and Agnelli himself had been a cavalry officer, hardly a typical occupation for a future entrepreneur. Success was crucially dependent on victory in races and rallies, and Agnelli took care to secure the services of the best racing drivers. The press did a lot to promote the new mechanized sports and methods of travel. The *Corriere della Sera* actually organized the first important bicycle races in the 1890s, and its coverage of motor racing was exhaustive. It even sent one of its own correspondents, Luigi Barzini Sr, on a famous journey from Paris to Peking. The car could evoke in one potent image pre-industrial myths of courage, daring and individual genius, along with modern myths of triumphant mechanical force and energy. It was ideally suited to be the symbol of Marinetti's Futurist vision of a romanticized technology (Fig. 2).

The second industrial revolution transformed daily life far more than the first. It is arguable that even the organization of perception in the basic categories of space and time was affected.[2] Italy was in effect living two industrial revolutions at once. The drama of the process was correspondingly intensified.[3] The natural and prevalent response was to seek reassurance from the continuities of culture. But the juxtaposition of old symbols and new realities, of an ancient urban culture with the new, dynamic industrial environment could create a troubling sense of incongruity for the more perceptive. So, too, could the discord between the heroic values of the recent Risorgimento past and the prosaic realities of the industrial age. It was this

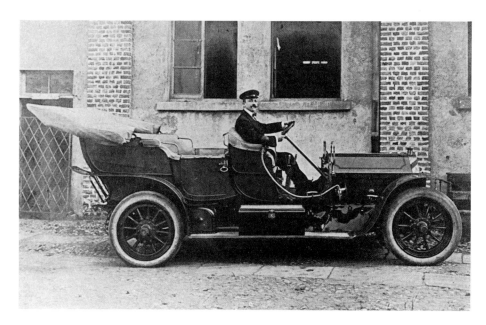

Fig. 2 Filippo Marinetti in a motor-car, c. 1908

Fig. 3 Giorgio de Chirico, *The Red Tower*, 1913.
Peggy Guggenheim Collection, Venice

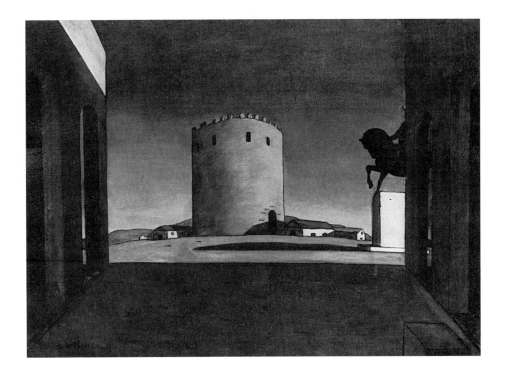

sense of incongruity which Giorgio de Chirico embraced (Fig. 3) and which the Futurists, by a radical leap of the imagination, sought to abolish.[4]

The Futurist exaltation of the machine is only explicable in an industrializing nation which still felt keenly its inferiority compared with the leading industrial powers.[5] The cult of the machine can take many different forms. The Futurist cult concentrated on speed and power. It was 'up-to-date' in that its icons were the characteristic products of the second industrial revolution of the end of the nineteenth century: the automobile, the city tram, electricity, the telephone. For the Futurists, the machine was a symbol not of rational design but of uncontrollable vitality. Marinetti was reluctant to acknowledge the more prosaic features of the industrial age; this is less true of the artists of the movement, but to some degree they fell under the spell of his interpretation.

The victory of 'prose' over 'poetry' was exemplified by the political hegemony of Giovanni Giolitti. He was 'all technique, rationality and good sense'.[6] He believed in the primacy of domestic policy over foreign policy. He was also the first Italian prime minister not to have taken an active role in Risorgimento politics. He came from the Piedmontese bureaucracy and it was often assumed, quite unfairly, that he had the limited horizons of the official mind. In fact, as a politician Giolitti was far from cautious or short-sighted. His long-term strategy was extremely ambitious; he aimed to broaden the base of the monarchic liberal state by co-opting the leadership of the two mass movements which threatened it – the Socialist and the Catholic. By playing the two movements off against each other, he hoped to prevent the political balance shifting too far in the direction of either revolution or reaction.

Giolitti's practical temperament led him to underrate the importance of intellectuals and their capacity to form opinion. He once commented that he never believed that his rival, Sidney Sonnino, would be much good as a politician, because he had too many books. There was no Giolittian rhetoric, unless precisely in the declared renunciation of the art of persuasion for an honest politics of 'fact'. Even at the time of Italy's conquest of Libya (1911) he refused to supply the expected patriotic uplift. His skill in making broad political alliances had no counterpart in the cultural field. Although he devoted a lot of time and money to managing the press, he was consistently opposed by the most important newspaper in Italy, the *Corriere della Sera*, under its formidably independent editor, Luigi Albertini. The new intellectual and literary reviews were almost unanimously hostile.[7]

1 F. T. Marinetti, *Selected Writings*, ed. R. W. Flint, London, 1972, p. 55.

2 See S. Kern, *The Culture of Time and Space, 1880-1918*, London, 1983, passim.

3 Can one draw a parallel between Trotsky's 'law of uneven development' and Boccioni's complaint that he had to subsume in his own art a hundred years of artistic development?

4 See A. Zander Rudenstine, *Peggy Guggenheim Collection, Venice*, New York, 1985, p. 158, for de Chirico's ironic evocation of the 'imagery of the Risorgimento and a heroic historical past'.

5 See R. Cork, 'The Vorticist Circle, Bomberg and the First World War', in *British Art in the 20th Century*, ed. S. Compton, Munich, 1986, p. 138, for Wyndham Lewis's perception of the different situation in Britain and Italy: 'Industrialization had come to Italy long after Britain, and Lewis believed that Vorticism should view the mechanized age with a greater understanding of its complexity.'

6 A. Asor Rosa, *La cultura*, in *Storia d'Italia*, ed. R. Romano and C. Vivanti, Turin, 1975, vol. 4, pt 2, p. 1111. Giolitti was Minister of the Interior 1901-3, and Prime Minister 1903-5, 1906-9 and 1911-14. But even when he was not in office, he remained by far the most important leader in parliament.

7 The most influential intellectual of them all, Benedetto Croce, served in Giolitti's post-war government as Minister of Education, and came to have great admiration for him. But before the war his attitude was on the whole unfavourable.

Giolitti interpreted liberalism as a practice of mediation, and this angered true believers of all descriptions. Conservatives accused him of failing to defend the interests of the state against the Socialists, while revolutionaries accused him of corrupting Socialism and rendering it innocuous. The image of Giolitti as the cynical manipulator and arch-corrupter did not do him justice, but in one respect it did have some basis in fact. He used extremely unscrupulous methods to secure the election of a solid bloc of government supporters from the south. Even here, it is possible to argue that he was no worse than his predecessors; but perhaps the point is that he was no better either. Giolitti's personal dominance was undoubtedly an obstacle to the development of strong parties, and in this way he may have contributed to the discrediting of the parliamentary system.

The revulsion against Giolitti's prosaic style of government was incarnated by Italy's most famous poet, Gabriele D'Annunzio (Fig. 4). D'Annunzio had voiced his opposition to parliamentary government at the time of the bank scandals. It was D'Annunzio who introduced the potent image of Nietzsche's superman to the Italian imagination. 'Let us with a firm faith prepare through art for the advent of the superman.'[8] He aspired to play a role in Italian culture similar to that of Wagner in German culture. To the German's command of music he opposed his command of the 'word'. But D'Annunzio's ambitions did not stop here. With breathtaking complacency, D'Annunzio let it be known that Nietzsche merely served to confirm what he already knew, as a healthy Mediterranean sensualist, imbued with an intuitive grasp of the beautiful as revealed through the glories of Italian culture. He would not only produce works of art; his whole life would be a work of art. He became a 'star'; he dazzled a mass public even more by his glamorous style of life than by his command of language. Fact and fiction blended to create the image of the D'Annunzian hero as Renaissance man: at one and the same time, an irresistible seducer of women, a daring sportsman, a refined aesthete and a virtuoso of conspicuous consumption. To a provincial bourgeoisie, he offered the vicarious experience of international high society. Significantly, one issue on which D'Annunzio differed from Nietzsche was in his rejection of the latter's criticism of Wagner for having surrendered to the taste of his epoch: 'It is not possible to resist the pressure of the public spirit. The general state of manners always determines the nature of the work of art.'[9] The lonely glories of the avant-garde innovator were not for D'Annunzio; he would take care never to be more than one step ahead of public taste. He was extremely conscious of the new mass public and of the ways of reaching it; he became the hero of a cultural journalism which took on new importance during the Giolittian period.[10] He made *fin de siècle* aestheticism palatable to a large audience.

D'Annunzio had an important role in relation to the visual arts, as critic and arbiter of taste. He was a friend of some of the most successful salon artists of the day, and he contributed a great deal towards establishing their reputation. One of the painters closest to D'Annunzio was Giulio Aristide Sartorio, who combined a 'decadent' sexual imagery, drawn from mythology, with a traditional technique, based on the idea of a 'return to the Renaissance'. Ironically, in view of D'Annunzio's anti-parliamentarianism, Sartorio was chosen to paint the frieze for the Chamber of Deputies in 1908 (Fig. 5). In his preference for mythological imagery and for the high finish or 'licked surface', D'Annunzio set himself clearly against modernist trends in art. Envied and imitated, admired for his violation of the bourgeois code in morals and literature, but despised for his compromises with prevailing standards of taste, D'Annunzio was a figure whom the avant-garde could neither ignore nor accept.[11]

In Italy, the great poet was expected to sing of the nation and its glories. D'Annunzio unhesitatingly embraced the cause of the new imperialism and of naval expansion, and married it to the older, irredentist tradition by calling for the conquest of Trieste and dominion over the Adriatic as the first priority. The cult of the Venetian imperial past served both purposes.[12] In 1908, his speech at a banquet given to celebrate the performance of *La Nave*, his drama on the origins of Venice, drew a strong protest (and excellent publicity) from the Austrian government.

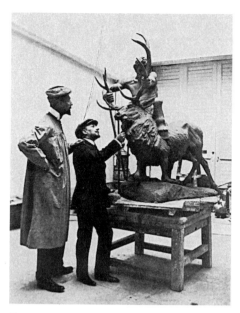

Fig. 4 Gabriele D'Annunzio examining Clemente Origo's *Centaur and Stag* with the artist in his studio, Florence, 1907. Photograph by Mario Nunes Vais

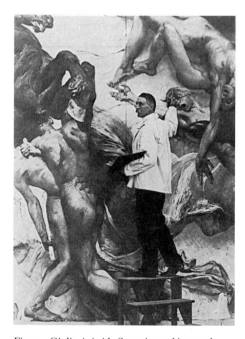

Fig. 5 Giulio Aristide Sartorio working on the murals for the Chamber of Deputies, Rome, 1908. Photograph by Mario Nunes Vais

8 G. Michelini, *Nietzsche nell'Italia di D'Annunzio*, Palermo, 1978, p. 98.

9 Ibid., p. 112.

10 The cultural 'third page' of Italian newspapers was an innovation of the period after 1900. Its invention dates from the full-page coverage of D'Annunzio's tragedy *Francesca da Rimini* in 1901 by the *Giornale d'Italia*. (G. Licata, *Storia del Corriere della Sera*, Milan, 1976, p. 133, n. 160.)

11 See Boccioni's very revealing note on seeing D'Annunzio at the Brescia motor races (1907): 'I saw D'Annunzio with motor cars, ladies and gentlemen. Everyone watched him and followed him in admiration. He passed smiling amid the looks of the crowd. And I, alone, unknown, an imbecile' Quoted in G. Lopez, 'La città attorno a lui', in *Boccioni a Milano*, Milan, 1982, p. 94.

12 In 1888, D'Annunzio dedicated the first of his *Odi Navali* to 'a Torpedo-boat in the Adriatic': *Naviglio d'acciaio,/ diritto veloce guizzante/ bello come un'arme nuda.* In his celebration of the beauty of the new war machines, D'Annunzio anticipated the Futurists (see P. Alatri, *Gabriele D'Annunzio*, Turin, 1983, p. 70). Lunaciarski referred to this when he called Marinetti 'an industrialized D'Annunzio', but this ignores the question of style (F. Roche-Pezard, *L'aventure futuriste 1909-1916*, Rome, 1983, p. 178). The writings of Mario Morasso, from which Marinetti borrowed directly, represent a kind of transition between the D'Annunzian and the Futurist celebration of the machine: see P. Bergman, *'Modernolatria' et 'Simultaneità'*, Stockholm, 1962, pp. 229-34.

13 The most important intellectual reviews were published in Florence: *Leonardo* (1903), *Il Regno* (1904), *La Voce* (1908) and *Lacerba* (1913). Naples was the centre of Croce's many intellectual enterprises, although *La Critica* (1903) was published in Bari.

14 Asor Rosa, *La cultura*, p. 1158.

D'Annunzio prepared a climate of opinion which became increasingly impatient with Giolitti's cautious and rational pursuit of limited gains. The new Nationalist movement was much influenced by D'Annunzio; its founder, Enrico Corradini, took from him the idea that the cult of beauty and the patriotic ideal had alike been sacrificed to sordid materialism. But the Nationalists differed from D'Annunzio in one important respect. The leaders of their movement were admirers of German economic power and militarist determination, and wanted Italy to remain loyal to the Triple Alliance with Germany and Austria-Hungary, whereas D'Annunzio (like Marinetti) never wavered in his support for France.

In the early years of the century, it seemed as if the Italy of culture had turned its back on the Italy of industry. The centres of cultural innovation were Florence and Naples rather than Milan.[13] The whole tenor of Italian high culture changed with the Idealist revolt against Positivism. The values of art were reasserted against the mere facts of science, and the recovery of the past was taken to be a more urgent priority than the prediction of the future. The success of the Idealist revolt was helped by the blatant weaknesses and contradictions of Positivism. The leading Italian Positivists were not always paragons of the spirit of critical enquiry. Belief in 'science' tended to become a new secular faith, and the collection of facts was too often divorced from an adequate theory to make sense of them. If they rejected old superstitions, the Positivists sometimes proved peculiarly vulnerable to new forms of credulity. One of the most representative figures of Italian Positivist culture during the 1890s, the criminologist Cesare Lombroso, took up spiritualism and became a devotee of the famous Neapolitan medium, Eusapia Paladino. The old Positivism was also undermined by new developments in the philosophy of science itself. Science was no longer viewed as a repository of fixed and universally valid laws, but as a constantly changing ensemble of instrumental hypotheses, which did not represent reality but deliberately abstracted from it. This internal crisis in the idea of science lent some plausibility to its depreciation by Benedetto Croce and the Idealists, for whom scientific concepts were only 'pseudo-concepts', incapable of apprehending the higher level of reality as revealed through the development of the spirit in history.

One should not assume, however, that scientific interpretations of history and society ceased to be important, or that all forms of Positivism declined equally. The right-wing interpretation of Darwinism, dominated by the concept of 'the survival of the fittest', gained new potency in an age of heightened international conflict. The new Nationalist critics of democracy and Socialism made effective use of the scientific sociology of Vilfredo Pareto, with its emphasis on the irrational roots of human behaviour. What particularly came under attack was the optimistic synthesis between a Positivist belief in 'evolution' and faith in the inevitable advance of democracy and Socialism. The culture of Filippo Turati and the other founders of Italian Socialism was grounded in Positivism. Marxism was absorbed into an 'evolutionary Socialism'. In the 1890s, Socialism could command a wide area of sympathy among intellectuals who shared the Positivist outlook; however, the scientific claims of Marxism were already being subjected to severe criticism by both economists and philosophers. Croce was even willing to call himself a Marxist before he evolved his own Idealist philosophy of history. But he accepted Marxism only as 'an empirical canon of interpretation', not as a scientific system. The turning-away of intellectuals from Socialism after 1900 can be explained in large part by the rejection of its cultural premises, although it is also true that Socialism was more attractive to them when it was fighting for survival against government repression than when it was visibly gaining in power and influence. The Socialists lost prestige by remaining for a long time deaf to the cultural debate. In 1906, Turati's review, *Critica Sociale*, announced defiantly that 'we are today Marxists, as we are Darwinians, evolutionists, positivists'.[14] But by 1910 the review was on the intellectual defensive, aware of the criticism that the party lacked a philosophy.

Thus among intellectuals the rejection of the evolutionary Positivist synthesis went together with the rejection of evolutionary, gradualist social democracy. At the

mass level, however, the Socialist identification with 'science' was still effective in a period of rapid urbanization, accompanied by the growth of literacy and secularization. The workers were discovered to be eager neophytes of bourgeois Positivist culture. For the young Florentine intellectual Giovanni Papini, 'an average bourgeois and a worker are alike even in this: that they do not understand either a symphony of Wagner's or a paradox of Nietzsche's.[15] This cultural gap, one might note, was created by the acceptance of the cultural models of the European *fin de siècle*. The rejection of Realism in art and literature ran parallel to the rejection of Positivism in philosophy. Tolstoy and Verdi were compatible with popular Socialist culture; Nietzsche and Wagner were not. For most intellectuals, moderate democratic Socialism, encouraged by Giolitti, posed a more insidious and graver threat than violent revolution. This was, in a sense, a kind of unwilling tribute to Turati's strategy of working towards Socialism through gradual reform. Left and right joined hands in deploring the equivocal nature of the compromise between Socialism and bourgeois democracy. In spite of their very different intellectual standpoints, both Croce and Pareto shared an admiration for the originality and moral rigour of the theoretician of revolutionary syndicalism, Georges Sorel. Croce was responsible for the Italian translation of his famous *Réflexions sur la violence* in 1908.

At first there was a tactical alliance between Croce and the younger intellectuals of the Florentine journals, led by Papini and Giuseppe Prezzolini. In the battle against Positivism these brilliant, but superficial, polemicists played the role of light cavalry assisting the heavy philosophical phalanxes of Croce and Giovanni Gentile by a kind of intellectual skirmishing tactics. The most important of the Florentine reviews, *La Voce*, succeeded between 1908 and 1911 in giving a voice to all the most vital elements in contemporary Italian culture. It made a conscious attempt to break down the barriers between art, politics and literature. In its pages the painter Ardengo Soffici publicized the Cubism of Picasso and Braque. The appeal of the intellectual journals was increased by the stagnation of much academic culture. The culture of the journals had an anti-institutional bias which was favourable to innovation. But it also favoured a rather facile improvisation; intellectual fashions were rapidly absorbed and as rapidly dropped. Croce became increasingly concerned with the irrationalism and lack of intellectual discipline of the younger generation. Papini interpreted the pragmatism of William James in an individual fashion to support a belief in the magic potency of the will. Nietzsche, too, was pressed into service. He provided a heroic self-justification for the isolated intellectual in a secularized and industrializing world. This was particularly appropriate for the artist, at odds with the public and convinced that concessions to prevailing taste would destroy his originality. Nietzsche's insistence on philosophy as a personal interpretation of the world was genuinely liberating. But the rejection of system could easily degenerate into the rejection of all intellectual discipline. Without Nietzsche's passionate rigour, it could become the excuse for a series of 'stunts'.

The revolt against Giolittian mediation, against reformist Socialism and against 'parliamentarianism' was led by the revolutionary syndicalists on the left and the Nationalists on the right. Both claimed to represent the interests of the 'producers', contrasted with a 'parasitic' governing class. Both preached the virtues of an honest confrontation, in which the strongest would win. Both profited from the changing context of politics in the period 1908-14, at home and abroad. The slowing of economic growth after 1907 sharpened class antagonisms. Still more important, the Bosnian crisis of 1908 opened a period of heightened international tension in Europe, in which the Nationalists' attack on the primacy given by Giolitti to domestic reform over foreign policy acquired a new relevance. This made it difficult for Giolitti to ignore the pressure to exploit a favourable opportunity for asserting the Italian claim to Libya, still part of the Ottoman Empire. But the Libyan War undermined the basis of Giolitti's policies. On the right, it raised Nationalist excitement to a new pitch. On the left, the war aroused violent opposition, and secured the defeat of the reformist leadership of the Socialist party by its revolutionary wing. Benito Mussolini rose to prominence in these years as the leader of revolutionary Socialism.

It is in this context that Marinetti gave birth to the Futurist movement. As a political force, Futurism was wholly negligible until 1914. But as a political symptom it was highly significant. The new political and intellectual trends of the years before the war, whether of left or right, had in common a reaffirmation of the moment of decision and action. The Futurist movement was the most extreme expression of a broader current of opinion which can be termed 'the activist revolt'.[16] It was characterized by a belief in the primacy of action, life and inspired creativity over reason and 'dead' systems of thought. It emphasized the role of 'dynamic minorities' and individual leaders in galvanizing the inert masses by means of 'myths' which made their impact through striking images rather than argument.[17] Mussolini participated in this movement, using the ideas of Sorel and Nietzsche to attack the determinist interpretation of Marx hitherto dominant in Socialist culture. Futurism and Fascism both have their origins in this same cultural matrix. Marinetti made plain his political philosophy, if it can be called that, in the original manifesto, and in a supplementary political statement issued for the 1909 general elections he gave a more concise definition: 'We want to combine nationalism with the destructive action of the lovers of freedom.' Indeed, in an extraordinary way Marinetti anticipated the fusion of motifs from the revolutionary left and the Nationalist right from which Fascist ideology was eventually created.[18]

There is a danger in viewing Futurism too exclusively from the standpoint of contemporary 'high culture'. For Marinetti, Severini and Soffici perhaps the crucial reference is to the international avant-garde: but Umberto Boccioni and Giacomo Balla came from a more provincial and limited world where the heritage of late nineteenth-century Socialism, Positivism and scientific popularization was still of primary importance. They even shared the characteristic interest in spiritualism.[19] Balla, Boccioni and Carlo Carrà all took part in left-wing politics, and believed in the social mission of art. Balla participated in an exhibition designed to dramatize the terrible living conditions of peasants in the Agro Romano, and in 1911 Boccioni, already a Futurist, organized an exhibition of Free Art for workers in an abandoned factory in Milan.[20] In 1907, Boccioni recorded a remarkable expression of his artistic aspirations and frustrations: 'I must confess that I seek, seek and seek and do not find I feel that I wish to paint the new, the fruits of our industrial age. I am nauseated by old walls and old palaces, and by old motifs, by reminiscences. I wish to have the life of today in front of my eyes It seems to me that today art and artists are in conflict with science Our feverish epoch makes that which was produced yesterday obsolete and useless '[21]

Boccioni's paintings of the industrial periphery of Milan, such as *Officine a Porta Romana* (*Workshops at the Porta Romana*; Cat. 14) and *Sobborgo di Milano* (*Suburb of Milan*; Cat. 15), might seem to be an adequate response to his problems, but it was not one which satisfied him for long. We can see how his fascination with 'the feverish epoch' in which he was living predisposed him to accept Marinetti's Futurist message with enthusiasm. This did not mean, however, immediate acceptance of Marinetti's political ideas. What really moved Boccioni closer to Marinetti was his dissatisfaction with the cultural and artistic values of the Socialist left. By 1913, his disillusionment is very evident, and instead of his early faith in a democratic art for the people, we now hear a very different note, of the artist as natural aristocrat or even solitary superman, condemned to be understood only by a few privileged spirits. But this was not just a response to lack of success. What lay behind it was an artistic conversion, Boccioni's refusal to remain satisfied with a modernity of content, and his determination to embrace instead a radical modernity of form. It is this new definition of modernity as a break with naturalistic representation (influenced by the lessons of Cubism) which made Socialism seem no longer modern but 'obsolete', since it was inextricably identified with nineteenth-century realism or naturalism and indifferent if not actually hostile to formal experimentation.[22] The repudiation of the old type of realistic social art was connected with the general phenomenon of the revolt against Positivism and social democracy. The violent rejection of Socialist and humanitarian culture by the artists, especially Boccioni, amounted to a

15 Ibid., p. 1151.
16 It was a philosophy of direct action in both sex and politics, which rejected 'love and parliamentarianism' as unnecessary forms of verbal mediation. A new technological primitivism was to banish psychological introspection: see R. Tessari, *Il mito della macchina. Letteratura e industria nel primo novecento italiano*, Milan, 1973, pp. 222-3.
17 Sorel's concept of the myth as 'a body of images', which could be grasped by intuition alone, was deeply indebted to the philosophy of Henri Bergson, as was Futurist artistic theory: see A. Lyttelton, *The Seizure of Power*, 2nd ed., London and Princeton, 1987, p. 366.
18 Ibid., p. 368; conservatism and nationalism were 'linked ideas which must be brutally separated'.
19 M. M. Lamberti, 'I mutamenti del mercato e le ricerche degli artisti', in *Storia dell'arte italiana*, pt 2, vol. 3, *Il Novecento*, Turin, 1982, p. 143n.
20 Ibid., p. 147.
21 M. W. Martin, *Futurist Art and Theory, 1909-1915*, Oxford, 1968, p. 63.
22 See 'Pubblico moderno nella vita, passatista in arte', in U. Boccioni, *Pittura Scultura Futuriste (dinamismo plastico)*, Milan, 1914, pp. 53-64.

deliberate repudiation of their own earlier beliefs. It was not voiced until they had absorbed the messages of both Marinetti and the French avant-garde about the meaning of modernism. At the same time, the artists' interest in science remained much more active than Marinetti's. The scientific revolution contributed to the sense that art, too, required a radical revolution. Both Boccioni and Balla tried to resolve the conflict between art and science in a new view of the world which incorporated such concepts as the equivalence of mass and energy and the relativity of space and time (see Boccioni, *Materia* [*Matter;* Cat. 25], and Balla, *Velocità astratta* [*Abstract Speed;* Cat. 12]).[23] Yet in a culture where the values of scientific enquiry were weak or, if anything, in retreat, the 'scientific' strain in Futurism was likely to have less resonance than the irrationalist call to action, destruction, and war.

The outbreak of the Great War in August 1914 created a situation in which cultural revolt could become militant politics (Fig. 6). Italy had been a partner of Germany and Austria-Hungary in the Triple Alliance, but public opinion sided strongly with France against German aggression. The government's initial decision to remain neutral was therefore generally welcomed, except by the small Nationalist movement; however, between September 1914 and May 1915, the nation became bitterly divided between 'neutralists' and 'interventionists', who agitated for Italy's entry into the war on the side of the Entente. The majority of the Socialist party remained faithful to its internationalist principles, and took a neutralist line, as did Giolitti. But after some hesitation Mussolini took a pro-interventionist stance, which led to his breach with the Socialist party. With money provided by Italian industrialists, he founded his own newspaper, *Il Popolo d'Italia*, which served as the rallying point for a motley but vigorous political grouping known as the *Fasci d'azione rivoluzionaria*. It included revolutionary syndicalists, 'heretics' of Socialism like Mussolini himself, and, last but not least, the Futurists. They could claim with justice to have been the precursors of the movement of 'revolutionary interventionism'. Marinetti and Boccioni were arrested in early September 1914 after a demonstration in which the Futurists burned five Austrian flags and wrecked the smart Café Biffi in the centre of Milan.[24] They were pioneers in the rhetoric and practice of violence. The interventionist demonstrations carried on where the Futurist 'evenings' left off.[25] They succeeded in creating a kind of carnival atmosphere, in which war was presented as the ultimate festival. This is very well suggested by Carrà's extraordinary collage, *Parole-in-libertà: Demostrazione interventista* (*Words-in-Freedom: Interventionist Demonstration;* Fig. 7).[26] This composition perhaps reveals even more than it

23 Not enough is known about the artists' scientific culture, but see Lamberti, 'I mutamenti', pp. 143, 156, and G. Ballo, 'Boccioni a Milano', in *Boccioni a Milano*, pp. 12-13, 23, 37. The concept of 'lines of force' may have been derived from Faraday's magnetic field theory. Evidently, the Futurists' use of scientific ideas was eclectic and imaginative rather than consistent or theoretical.

24 Lopez, 'La città attorno a lui', pp. 96-7.

25 G. L. Mosse, 'Futurismo e cultura politica in Europa: una prospettiva globale', in *Futurismo, cultura e politica*, ed. R. De Felice, Turin, 1988, p. 19.

26 The collage was actually created before the outbreak of war, under a slightly different title. For a careful analysis of this problem, see Roche-Pezard, *L'aventure futuriste*, pp. 440-43.

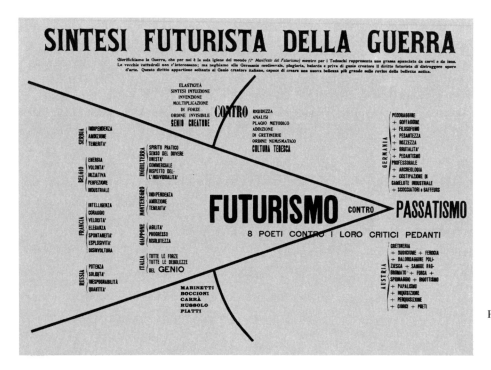

Fig. 6 *Futurist Synthesis of the War.* Leaflet signed by Filippo Marinetti, Umberto Boccioni, Carlo Carrà, Luigi Russolo and Ugo Piatti, September 1914

Fig. 7 Carlo Carrà, *Words-in-Freedom:*
 Interventionist Demonstration, 1914.
 Mattioli Collection, Milan

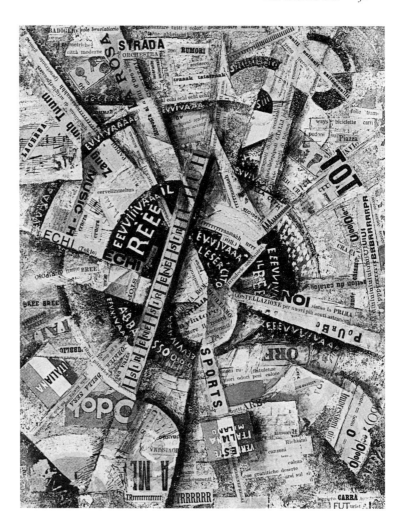

Fig. 7 Carlo Carrà, *Words-in-Freedom:*
 Interventionist Demonstration, 1914.
 Mattioli Collection, Milan

intends in the way in which a variety of slogans and motifs, representative of the confused and rebellious aspirations of Futurism and 'revolutionary interventionism', find unity only in the traditional patriotic slogans, *'Evviva il Re'* ('Long Live the King') and *'Evviva l'esercito'* ('Long Live the Army'). The revolutionary currents are sucked into the whirlpool of nationalism; the word 'Italy' has overruled the word 'freedom', as Marinetti had said it must.

The true Fascist movement (*Fasci di combattimento*) was not founded until 1919, but it always acknowledged its roots in the interventionist agitation of 1914-15. The conquest of the *piazza* by the 'dynamic minorities' against the opposition of the neutralist 'masses', both Socialist and Catholic, was a fateful precedent, as was the overriding of the will of parliament. In May 1915, D'Annunzio returned from France, where he had retired to escape his debts, to lead the demonstrations against a possible return of Giolitti to power on a neutralist platform. His oratory mobilized vast crowds in an orgy of patriotic enthusiasm and hatred for the 'internal enemies' who were standing in the way of Italy's destiny. Against the pseudo-religious rhetoric of 'communion' and 'sacrifice', reason had no defence. The politics of 'poetry' defeated the politics of 'prose', and not, unfortunately, for the last time. The novelty and the vitality of Italy's modernist cultural revolt ran into the sands of patriotic unity. The inspiration of the original Futurist group foundered on the contrast between the reality and the rhetoric of war, even if Marinetti's optimism remained extraordinarily unscathed. For artists and intellectuals, the war imposed a revaluation and rethinking of tradition.

Anna Maria Damigella

Divisionism and Symbolism in Italy at the Turn of the Century

In their manifestos, and critical and autobiographical writings the Futurists declared their intention to break away from the mainstream of Italian art with its cult of 'doddering classicism' and superficial genre painting. Exempt from their criticism were Gaetano Previati, Giovanni Segantini and Giuseppe Pellizza da Volpedo, the protagonists of Divisionism, whom they recognized as truly individual and creative and as being among the few Italian artists to have developed an expressive, modern language of colour and light.

These artists, so unjustly neglected by official culture, influenced Futurist painting during the early stages of the movement. In addition to their appropriation of the Divisionists' poetic use of colour, the Futurists owed a moral debt to this small group from Piedmont and Lombardy which had rebelled against academic conventions, provincialism and the pictorial limits of empirical reality. The Divisionists had asserted the right to express their individuality, the need for contemporaneity and the possibility of making art a total experience, congruent with life itself. Above all, they provided a means of symbolic expression which became an important feature of early Futurist painting, with its excessive sensibility and idealizing angst. The Futurists' faith in modernity and progress accompanied the belief that emotions and psychological states could be expressed through the purely pictorial means of line and colour. These concepts can be traced to the art and theories of Previati and. to an earlier movement, the *Scapigliatura* (The Dishevelled).

The Futurists, however, adapted the Divisionist method in an instinctive rather than a scientific manner, freely applying the laws of divided and complementary colours to obtain strident and dissonant tones. Their interpretation was also influenced by a knowledge of French Impressionism, which had previously been largely extraneous to the development of modern Italian art.[1] Individualized brushstrokes and vibrating colours now provided the means of conveying a whole new reality – a continuum of energy and life. Umberto Boccioni later referred to the style of early Futurism as 'a violated and synthesized Impressionism, the only Neo- and Post-Impressionism possible for those of us who were in a hurry' – in other words, the means of overcoming the static vision of the Divisionists, whose aim of embodying stable and universal values was no longer relevant.[2]

When Divisionism came to the fore in the 1890s it marked a decisive break with the various manifestations of Realism, which had never been a cohesive movement in Italy owing to an artistic culture that was scattered among various regional centres. The new interest in painting as an optical science was only the most apparent feature in a complex transformation of the meaning and purpose of art. Modern theories of colour and vision, involving the mechanics of retinal perception and psychic response, granted the artist greater freedom in expressing an ever wider range of emotions and ideas. The theory of Divisionism – the application of pure hues and the juxtaposition of complementary colours in separate brushstrokes which combine to produce colour mixtures in the eye of the viewer – had already been advanced throughout Europe. The moral climate of Italian Divisionism was different, however, as was its technique. Previati, Segantini, Pellizza, Vittore Grubicy de Dragon and Angelo Morbelli were motivated by a basic dissatisfaction with modern civilization and felt the dual need to endow art with a scientific approach and to make it an instrument of 'social illumination' (*espansività sociale*). Art became the vehicle for authentic and eternal values that were to be made intelligible to the general public through harmonious visions of a more just society.

1 The principle source of the Futurists' knowledge of Impressionism was a series of articles by Ardengo Soffici, an informed critic of contemporary French art: 'Impressionismo e l'arte italiana', *La Voce*, nos. 16, 18, 20 and 21, 1909.
2 U. Boccioni, *Pittura Scultura Futuriste (dinamismo plastico)*, Milan, 1914, p. 170.

The Brera Triennale in Milan and the Turin Triennale (instituted in 1891 and 1896 respectively), as well as such publications as *Cronaca dell'Esposizione di Brera, 1891*, *La Battaglia per l'Arte*, *Vita Moderna* and *La Triennale*, provided a forum for contact and exchange between artists, including those who lived outside the urban centres. The common point of reference for many artists was the critic, art dealer and, later, painter Grubicy who, together with his brother Alberto, promoted the Divisionists and organized exhibitions abroad. Grubicy was a friend of Segantini and influenced the younger artist's evolution from Naturalism to Divisionism between 1885 and 1891. Grubicy and Previati knew each other from their connection with the *Scapigliatura* movement and they frequented the Famiglia Artistica in Milan, the scene of regular exhibitions of contemporary art. A close friendship, documented by an extensive correspondence beginning around 1894, linked the Piedmontese Morbelli, who lived in Milan, with his fellow countryman Pellizza. At the same time, Pellizza, in the tiny village of Volpedo in Monferrato, exchanged letters with Segantini, who resided in the Swiss Alps. Within this loose association of highly individual temperaments, style and technique varied considerably. Yet the artists were united by a faith in what they recognized as the most advanced means of rendering light in paint on canvas and by a need to protect the truth and sincerity of their art through isolation, through constant contact with the self, nature and the world of ideas.

For various historical, economic and cultural reasons, the change in outlook represented by Divisionism began in Milan, where the impact of the Realist movement was relatively slight in comparison with its success in Naples and in Tuscany with the *Macchiaioli*. In Milan industrialization had altered economic structures and the rapport between the classes, modernizing the urban fabric. While this resulted in a lively art market, encouraged by regular exhibitions and a flourishing press, it also signalled the demise of the enlightened bourgeoisie as cultural leaders and threw into relief the crude utilitarianism of middle-class taste. It was in these circumstances that *Scapigliatura* was born in the 1870s. A decidedly anti-bourgeois movement composed of writers, artists and musicians, it was united in its satirical view of Lombard provincialism and Italian politics and in a desire to create an art that was relevant to contemporary life. Its members emulated the bohemian, rebellious attitudes of late Romanticism and expressed their individualism in fantastic and imaginary subjects. Their ideal of the unity of the arts was influenced, in particular, by the music and aesthetics of Richard Wagner. The *Scapigliatura* style of painting was distinguished by loosely rendered areas of strong chiaroscuro contrasts, beginning in the work of Federico Faruffini and continued with increasing effect and luminosity by Tranquillo Cremona, Daniele Ranzoni and Luigi Conconi. In sculpture Giuseppe Grandi introduced roughly modelled surfaces that accentuated the play of light and shadow. Although carried to new expressive ends, the characteristic atmosphere of these artists' work derived from an eighteenth-century, specifically Lombard tradition which, in turn, derived its inspiration from the 'sfumatura' of Leonardo da Vinci. All this was to have an important influence on the innovations of the Lombard Divisionists, especially through Previati and Grubicy, who had been nurtured in the *Scapigliatura* milieu.

The Milan of the 1880s, marked by increasing industrialization and the rise of Socialism, also formed the particularly modern vision of the sculptor Medardo Rosso. Influenced by the *Scapigliatura* and *Verismo* movements, Rosso took his themes from the working-class world and rejected the Positivist concept of an immobile, objective reality in favour of the representation of subjective experience (Cat. 1-3). His fundamental approach – the abolition of clearly delineated surfaces and the use of ambient shadow to indicate the form of figures – was derived from Cremona, Conconi and Grandi. 'Nature has no limits', Rosso stated, 'and the work of art must make one forget the material used.' After his move to Paris in 1884, this premise formed the basis of his interpretation of Impressionism. If reality was continuous and homogeneous, a sculpture could not be enclosed within unbroken contours. 'When I make a portrait', Rosso observed, 'I cannot limit it to the lines of

Fig. 1 Gaetano Previati, *Motherhood*, 1890-1.
Banca Popolare, Novara

Fig. 1 Gaetano Previati, *Motherhood*, 1890-1.
Banca Popolare, Novara

the head, because this head belongs to the body and is influenced by the surrounding environment.... The impression of you I receive differs depending on whether I see you alone in a garden or in the midst of a group of people, in a drawing room or on the street.'[3] The Futurists referred specifically to Rosso when they formulated the principle of the interpenetration of figure and space, and Boccioni paid homage to the older master in his 1912 *Technical Manifesto of Futurist Sculpture*.

Previati had been schooled in Romantic history painting and the luminous chiaroscuro style of Cremona. Solitary and introspective by nature, he had the temperament of a mystic. He devoted considerable thought to questions of painting technique and was receptive to modes of expression that allowed him to express his Idealism and to free himself from the routine practices of the craft. Like Grubicy and Conconi, Previati studied Japanese prints, but it was in the medium of charcoal drawing, especially in his illustrations for the fantastic stories of Edgar Allan Poe, that he developed his distinctive style of undulating lines and waves of chiaroscuro.[4] The translation of this graphic language into painting by means of attenuated brush-strokes of pure, divided colour comprised the real novelty of *Maternità* (*Motherhood*; Fig. 1) which, when exhibited at the first Triennale di Brera in 1891, immediately provoked a debate on its Symbolist content. Instead of composing the picture with patches of light and dark in the *Scapigliatura* manner, Previati had created a web of luminous, azure-coloured filaments which twisted and turned to evoke discarnate, elliptical forms. The traditional religious iconography of mother and child was transformed in a surging continuum of indefinite forms which conveyed the emotional essence of filial love. Previati's desire for an elevated, spiritual art provided common ground with the French Rosicrucians; he exhibited *Motherhood* in Sar Peledan's 'Salon de la Rose + Croix' in 1892.[5]

Grubicy's defence of *Motherhood*, which the critics had accused of lack of composition and form, provided the occasion for expounding the principles of 'Ideistic art', defined by the French critic Albert Aurier as the highest expression of modern Symbolism.[6] It was of the utmost importance, Grubicy argued, that painting be endowed with a totally expressive value that engaged all the senses of the beholder and transmitted the heightened psychic state experienced by the artist during the act of creation. Gifted with an inner eye, the artist went beyond mere visual appearances to the essential truth, conveying in symbolic and visionary terms a moral message about a new world of human relationships. This new aesthetic guaranteed the work of art efficacy as an instrument of 'social illumination', without falling into the banality of the Realists' social subject-matter.

Grubicy's ideas were supported by books, just then published, by Jean Marie Guyau and Paul Souriau on psychological and psychophysical science and the functioning of the nervous system.[7] Identifying aesthetic enjoyment as the most refined of sensory experiences, these authors established a correlation between pleasurable sensations and specific directions of line and dispositions of form, and maintained that luminosity provided the maximum gratification since light was the equivalent of

3 A. Soffici, 'Il caso Medardo Rosso', *La Voce*, no. 32, 1909.

4 This is particularly evident in *La disesa nel malstrom* (*The Descent into the Maelstrom*) and *La Mano* (*The Hand*). Though never published in book form, the illustrations were exhibited at the Famiglia Artistica in 1890-1.

5 *Catalogue du Salon de la Rose + Croix*, Paris, Galeries Durand Ruel, 1892, p. 28, no. 110.

6 Grubicy derived his ideas for 'Tendenze evolutive delle arti plastiche alla prima Esposizione Triennale di Brera', *Pensiero Italiano*, September 1891, pp. 60-89, from Aurier's 'Gauguin et le symbolisme en peinture', *Mercure de France*, March 1891, which he knew either directly or through articles in the Belgian review *L'Art Moderne*, to which he subscribed.

7 J. M. Guyau, *Les problèmes de l'esthétique contemporaine*, Paris, 1884, and *L'Art au point de vue sociologique*, Paris, 1887; P. Souriau, *La suggestion dans l'art*, Paris, 1893.

life itself. Grubicy publicized these ideas in a number of articles and was largely responsible for widening the cultural horizons of the Divisionists, especially after 1891, when he himself attempted to put the theories into practice by applying a meticulously Pointillist technique to naturalist landscape painting. He also sought to embody synaesthetic experiences, creating the equivalent of a symphony or short poem through the 'mystery of execution' and the filter of memory.

Meanwhile, Previati was working on a grander scale that embodied his visionary Idealism and his yearning for the intangible and the infinite. He modified the principle of complementary colours to create strident dissonances and subjected his forms to distorting arabesques in audacious compositions that pointed beyond the limits of the canvas. In this way he subjected a whole repertory of religious and allegorical subjects to a novel formal interpretation, as in *Paolo e Francesca* (*Paolo and Francesca*, 1901), *Via Crucis* (*Way of the Cross*, 1901-2) and his later Symbolist triptychs. Boccioni, moved by a great interest in Previati's paintings and in his treatise *I principi scientifici del divisionismo* (1905), visited the older artist's studio in 1908 and noted that his paintings were animated by a visionary sensibility that sprang from a 'wholly modern pictorial consciousness'.[8]

In 1896, Pellizza, at that time working on the first version of *Il Quarto Stato* (*The Fourth Estate*, 1902), identified the conflict between real and ideal truth as the key problem for modern artists.[9] This was indeed the heart of the issue connecting Divisionism and Symbolism. It was recognized and resolved in a personal manner by those who had been schooled in Realism and the literal transcription of sensations gathered from the objective world of appearances. For these artists, 'reality' retained an indisputable value; they adhered to Divisionism and the painting of ideas to overcome such restricting directness.

The need for detachment was also felt by those who were less concerned with 'Ideism'. The new technique of optical mixture allowed artists to depict burning social issues with additional psychological and emotive overtones. One painter who took this course was Morbelli, who shared an interest in humanitarian themes with his friend Pellizza. Morbelli was converted to Divisionism from a Realist style after reading treatises on optics by Ogden Rood, Hermann von Helmholtz, Michel-Eugène Chevreul and others.[10] He practised a particularly rigorous technique based on the aggregation of minute strokes of pure colour, enveloping forms and figures in a diffused atmosphere with subtle luminous accents. The underlying structure and strong orthogonals of his compositions evoked the psychological aspects of the marginalization and exploitation of human beings and the annihilation of the vital energy of the individual, as in the depiction of the elderly in the Pio Albergo Trivulzio old people's home (Fig. 2) or of women labourers in *In risaia* (*In the Rice Fields*, 1901).

8 U. Boccioni, 'L'opera di Previati alla Permanente', *Gli Avvenimenti*, 1916; reprinted in T. Fiori, ed., *Archivi del Divisionismo*, vol. 1, Rome, 1968, pp. 54-8. For the relationship between Boccioni and Previati, see M. Calvesi, 'Boccioni e Previati', *Commentari*, 1961; reprinted in M. Calvesi, *Le due avanguardie*, Milan, 1966, pp. 73-82.

9 Pellizza wrote: 'The truth that appears before us always comes into conflict with the truth contained in the harmony of our mind – which one should choose to represent. It is not the *real* truth that I must portray in a picture but rather the ideal truth. The conflict between these two truths in the mind of the artist will remain unresolved in the work of art. The artist who, in searching for the truth, stays too close to the real loses sight of his objective, does not attain it. It is by sacrificing the truly real that one achieves the ideal truth.' A. Scotti, ed., *Catalogo dei manoscritti di G. Pellizza da Volpedo*, Tortona, 1974, Folio 37, p. 44.

10 O. Rood, *Modern Chromatics*, 1879; M.-E. Chevreul, *De la loi du contraste simultané des couleurs et de l'assortiment des objets colorés*, 1839; Hermann von Helmholtz, *L'optique de la peinture*, 1867; Charles Henry, *Cercle chromatique*, 1888; and the treatises on physics and optics by L. Guaita, *La Scienza dei colori*, 1893, and G. Bellotti, *Luce e Colori*, 1896.

Fig. 2 Angelo Morbelli, *The Christmas of Those Left Behind*, 1903. Galleria d'Arte Moderna, Ca' Pesaro, Venice

For Segantini, endowed with a keen eye for empirical description, there existed a perfect correlation between clarity of form and the affirmation of moral truths. Guided by Grubicy, his early Naturalist style in the manner of Jean-François Millet became infused with an ever more evocative use of light. *Le due madri* (*The Two Mothers*, 1889), exhibited at the Brera Triennale in 1891, incorporated bold effects of artificial illumination in an otherwise traditional pastoral subject, signalling a break with the direct depiction of reality and recreating it through abstract structural equivalents. His evocations of Alpine grandeur and luminosity through an intricate weave of shimmering, attenuated brushstrokes with a strong decorative effect aligned him with the panaestheticism of *Jugendstil* and the Secessions. The best known internationally of the Italian Divisionists, Segantini was the subject of a special issue of the Berlin magazine *Pan* in 1895, and he exhibited with the Munich and Vienna Secessions. He moved towards literary Symbolism in such works as *Il castigo delle lussuriose* (*The Punishment of the Lustful*; Fig. 3) and finally arrived at the cosmic pantheism of *Trittico della Natura* (*Triptych of Nature*, 1896-9), in which the inner idea was expressed by the most objectively descriptive means. Allegorical and imaginary figures were placed in a Naturalist landscape, creating an illusory reality that engaged and heightened the senses of the viewer and increased the communicative power of the picture.[11]

The ability to hold the natural and the ideal in perfect balance and to paint a picture that was both image and decoration attracted Pellizza to the example of Segantini, despite his different views on social issues. Pellizza was deeply committed to humanitarian Socialism, maintaining that it was 'time, not for art for art's sake, but for art for humanity'.[12] In 1893-4, he attended the classes of the Positivist historian Pasquale Villari and the Idealist philosopher Augusto Conti at the Istituto di Studi Superiori in Florence. He and Morbelli read the texts on social issues published by *La Critica Sociale*, and Pellizza exchanged letters with writers and critics who were open to the most recent philosophical and artistic ideas, including Neera (Anna Radius Zuccari), Domenico Tumiati and Vittorio Pica.

Pellizza was aware that these theories needed a specifically modern form of pictorial expression. He had begun in a Realist style, training under the *Macchiaioli* master Giovanni Fattori in Florence and with Cesare Tallone in Bergamo. His developing intellectual and social conscience, however, awakened in him the desire to reconcile the conflict between nature and the ideal through a greater presence of the artist's subjective self and through a more exacting pictorial method. From a *plein-air* manner influenced by Jules Bastien-Lepage, Pellizza evolved towards a more sophisticated understanding of luminous effects following contact with Plinio Nomellini and

Morbelli, who encouraged him to delve into treatises on optics, notably that by Rood.[13] In his mature Divisionist style Pellizza applied dots of pure colour to the canvas, creating an impalpable structure that exuded luminous energy and endowed his subjects with a spiritual aura. At the same time, he composed his works geometrically in accordance with the notion of correspondence between the direction of line and psychological states.[14] Familiar aspects of the natural world, observed, selected and purged of any accidental or mutable elements, were recomposed in the manner of the Renaissance masters, especially Raphael, whom Pellizza particularly admired. They assumed the character of basic, easily intelligible symbols, giving rise to an art of eternal and universal values: love of life, the inexorable progress of the working classes and, above all, nature glorified in its greatest vitality and warmth, a 'splendid nature who absorbs and annihilates man in the radiance of her immortal beauty' (*Sole Nascente* [*The Rising Sun*]; Fig. 4).[15] The need to derive his inspiration from nature eventually led Pellizza away from a scientific Divisionism, from the literary Symbolism of such works as *Autoritratto* (*Self-Portrait*, 1898) and the *Idilli* (*Idylls*) and from working-class subjects towards a concentration on pure, Idealist landscape.

Fig. 4 Giuseppe Pellizza da Volpedo, *Rising Sun*, 1904. Galleria Nazionale d'Arte Moderna, Rome

From the mid-1890s, Turin was the liveliest cultural centre in Italy. The city's leading intellectuals gathered around the Positivist Cesare Lombroso, and Pellizza was in frequent contact with many of them, including the historian Guglielmo Ferrero, author of a book on the psychological laws of Symbolism, and Paola Lombroso. He formed close friendships with the Socialist writer and poet Giovanni Cena and with Pio Viazzi, a lawyer, scholar and sensitive interpreter of his paintings. It was in this milieu that the call was first heard for a democratic art (including architecture and the decorative arts) that would respond to the ethos of modern society. Artists, critics, psychologists and sociologists were engaged in research and debates on the universal efficacy of symbols and the social, communicative function of art. The symbol was viewed as the most concise and fundamental means of conveying the profundity of the life of the mind, and for this generation it became a refuge and a fixed point of reference in the face of the uncertainty and doubt that had arisen from the crises in Positivism and traditional religious values.

Leonardo Bistolfi also moved in these circles, and was one of the first to appreciate the need to develop the sensory and emotive potential of sculpture.[16] Initially influenced by Grandi and the *Scapigliatura* group, he introduced pictorial effects and movement into his basically Realist works. Around 1890, his interest in Symbolism was encouraged by commissions for funerary monuments. The growing emphasis on individuality and a general interest in spiritualism accounted for changing tastes in tomb sculpture, which became the perfect medium for communicating new conceptions of the afterlife. Bistolfi modelled his works in a vivacious and nervous manner that endowed them with a heightened naturalism. One of his first 'Ideist' pieces, *La Sfinge* (*The Sphinx*, 1890-2), represented the world beyond as an unfathomable enigma, while in *La Bellezza della Morte* (*The Beauty of Death*; Fig. 5) a tribute to a man's genius found its most appropriate symbol in the beauty of women and flowers and in the perennially renewed life of nature.

Divisionism never acquired a pre-eminent position in the panorama of late nineteenth-century Italian art, nor did it reflect the dominant artistic culture. It is a merit of recent historiography to have understood its originality and its position as the most lively manifestation of Italian Symbolism.[17] The Futurists were the first to recognize the innovations of Divisionism, that is, its break with historicism and its affirmation of the artist's creative freedom. Yet precisely these innovative modes of expression led to the movement's relative failure. It was challenged by other conceptions of Symbolism, whose more literary basis found favour with the majority of artists and with official cultural circles. A significant role was also played by the social and political tenor of the 1890s, a particularly turbulent decade marked by the fall of Francesco Crispi's government, the defeat of the Italian army at Adua and the consequent disintegration of imperial ambitions, by an economic crisis and the harsh measures taken to repress workers' movements. If these factors account for an undercurrent of pessimism and calm resignation in much of the Divisionists' work, it never

13 Pellizza became acquainted with Nomellini during a stay in Florence in 1888 and met him again in Genoa in 1892. Florence had closer contacts with Paris and French Impressionism than other cities in Italy through artists, critics and collectors associated with the *Macchiaioli* movement. Nomellini (1866-1943) was a pupil of Giovanni Fattori and his style was an intuitive response to Impressionism rather than a scientific Divisionism. See G. Bruno, ed., *Plinio Nomellini*, Milan, 1985.

14 Pellizza mentions that he used geometric schemes in *Sul Fienile* (*In the Hayloft*, 1893), *Speranze deluse* (*Disappointed Hopes*, 1894), *Lo Specchio della Vita* (*The Mirror of Life*, 1895-8), *Idillio primaverile* (*Spring Idyll*, 1896-1901) and *Il Ponte* (*The Bridge*, 1904). The schemes were probably derived from the books of Guyau and Henry (see note 10), which Pellizza presumably knew through Morbelli.

15 Letter to Occhini, April 1903, in A. Scotti, *Pellizza da Volpedo: Catalogo Generale*, Milan, 1986, p. 446.

16 R. Bossaglia and S. Berresford, *Bistolfi (1859-1933)*, Casale Monferrato, 1984.

17 T. Fiori, ed., *Archivi del Divisionismo*; A. P. Quinsac, *La peinture divisionniste italienne: Origines et premiers développements, 1880-1895*, Paris, 1972; *Aspetti dell'arte a Roma, 1870-1914*, Rome, 1972; A. M. Damigella, *La pittura simbolista in Italia, 1885-1900*, Turin, 1981.

Fig. 5 Leonardo Bistolfi, *The Beauty of Death*,
1895. Tomb of Sebastiano Grandis,
Borgo San Dalmazzo cemetery, Cuneo

threatened their populist sentiments or their belief in the perfectibility of mankind. In other artistic quarters, however, the same events provoked conservative and escapist reactions.

The unification of Italy had promised a revival of national artistic greatness based on classical and Renaissance ideals and inspired by the heroism of the Risorgimento. Yet intellectuals soon became frustrated and disillusioned with the squalid compromises and narrow provincialism of subsequent political and intellectual life, withdrawing into a cult of the Old Masters and of beauty. As Gabriele D'Annunzio wrote in the preamble to the magazine *Il Convito* in 1895, the revival of national pride was sublimated in a dedication to art, the only form of action possible in such difficult times.

Giulio Aristide Sartorio was the most representative artist of this nationalist, aristocratic and aesthetic culture, one wholly divorced from the popular line of the Divisionists. Sartorio emulated those European artists and currents which had remained impervious to Impressionist Naturalism and had preserved an unwavering faith in classical form and myth: Puvis de Chavannes, the Pre-Raphaelites, Idealists and German Romantics. Following these examplars, who had observed the laws of that 'true art' – draughtsmanship, clarity of form and proportion – which recalled Italy's own Renaissance, Sartorio achieved a style worthy of D'Annunzian concepts in such works as *La Gorgone e gli eroi* (*The Gorgon and the Heroes*, 1895-9). Style was the sign of the Idea, impressing character on form, superimposing itself on external reality and thereby purifying and elevating it. Style, according to D'Annunzio, became a perfect symbol, an indelible hallmark of genius on the compliant outside world.[18]

18 C. Salinari, *Miti e coscienza del decadentismo italiano*, Milan, 1969, p. 91.

Fig. 6 Giulio Aristide Sartorio, *The Siren*, 1894.
Private collection, Rome

The most telling aspect of this artificial manipulation of reality, of the escape into the world of myth and ideal beauty, was its vein of inquietude: the brooding pessimism of defeated or frustrated heroes, decadent *femmes fatales* or dark evocations of distant worlds permeates the works of Sartorio (Fig. 6) and Nomellini, as in the latter's *I tesori del mare* (*The Treasures of the Sea*, 1901). This symbolic charge was weakened, however, when these artists painted large-scale civic decorations, such as Sartorio's frieze for the parliament hall at Montecitorio or Galileo Chini's allegorical frescos for the cupola of the entrance hall at the 1909 Venice Biennale. These epic works catered to the grandiose tastes of the political and industrial bourgeoisie and were welcomed by cultural conservatives as examples of reborn national art. This compromising historicism was institutionalized on a national level at the Venice Biennale, at the exhibition held in Milan in 1906 to mark the opening of the Simplon Pass and at that celebrating the fiftieth anniversary of unification in Rome in 1911. This was the official taste to which the Futurists objected, not only on account of its 'passéism', but also because it offered no opportunities to younger artists.

It was in Rome in the first decade of the century that a stalwart minority of artists proclaimed the need for a more socially relevant art, rejecting the prevalent Neo-Renaissance and Pre-Raphaelite styles and the facile Neo-Impressionism that had come to dominate the annual exhibitions of the local salon, the Amatori e Cultori. The new situation was largely brought about by the influx of artists and scholars with Socialist and Divisionist backgrounds from Turin and other centres in the north. They formed an embryonic avant-garde of artists, poets and musicians, many of whom remained unaligned, while others gathered together in the Futurist movement.[19] Giacomo Balla came to Rome from Turin in 1895 and imparted his Positivist interpretation of Divisionism to Boccioni, Gino Severini and Mario Sironi. Cena arrived in 1901, spreading his ideas on pantheistic spiritualism and humanitarian Socialism. Pellizza visited the capital in 1896 and again in 1906; his *The Fourth Estate* was exhibited there in 1907, the year of his suicide. Various young artists had previously worked in Florence, among them the sculptor Domenico Baccarini from Faenza and Raul Ferenzona.[20] The other leading figures were the Genoese-born Giovanni Prini (a sculptor in the Symbolist manner of Bistolfi), whose salons were the gathering place of artists, composers and poets, and the illustrator and designer Duilio Cambellotti.

In his autobiography Severini describes these difficult early years, with their lack of public recognition, his friendship with Boccioni and the artists' sensitivity to new developments in science, philosophy and social thought. They read Karl Marx, Friedrich Nietzsche, Arthur Schopenhauer, Alexej Tolstoy and Maxim Gorky, sharing a general interest in the philosophical foundations of these authors' works and a humanitarian sympathy for the oppressed, rather than a specific political ideology.[21] Boccioni particularly admired Cambellotti, an artist of strong moral fibre and revolutionary syndicalist sympathies. He was a member of a small group of craftsmen who followed the ideas of William Morris and Henry Van de Velde, and he headed the magazine *La Casa*, devoted to the aesthetic improvement of workers' lives and housing. In graphic works such as *La falsa civiltà* (*The False Civilization*; Fig. 7) and *Il divenire sociale* (*The Social Future*, 1905) Cambellotti attempted to reach the masses with a style that both engaged and enlightened through abbreviated, suggestive forms.

There was a common dedication to the ideas of art as inseparable from contemporary life, as capable of communicating psychological states and humanitarian content. The radical break with the art of obscure allegories, empty rhetoric and triumphant monumentality was achieved above all in sculpture and printmaking. In sculpture, portraits and 'slices of life' were rendered with vibrant modelling to convey nuances of mood. Prini, Cambellotti, Baccarini, Ferenzona, Boccioni and Severini preferred pastel, charcoal and other graphic media as a means of freeing themselves from the language and customs of Realism and late Symbolism. They drew regularly for magazines notable for a new editorial slant and modern layout: *Novissima* (modelled on *Ver Sacrum*), *Fantasio*, *L'Avanti della Domenica* and *La Casa*.

19 On the artistic circles of early twentieth-century Rome, see A. M. Damigella, 'Idealismo e Socialismo nella cultura figurativa romana del primo novecento: Duilio Cambellotti', *Cronache di archeologia e storia dell'arte*, no. 8, 1969; idem, 'Modernismo, simbolismo, divisionismo, arte sociale a Roma dal 1900 al 1911', in *Aspetti dell'arte a Roma*, pp. XLIII-LXIII; and idem, 'Il Liberty a Roma', in R. Bossaglia, ed., *Archivi del Liberty Italiano*, Milan, 1987, p. 359ff.
20 *Domenico Baccarini (1882-1907)*, Faenza, 1983.
21 Severini noted that their bohemia 'had no Murger to describe it, although it would have been worthwhile to do so'. G. Severini, *Tutta la vita di un pittore*, Milan, 1946, p. 26.

Fig. 7 Duilio Cambellotti, *The False Civilization*, c. 1905. Private collection, Rome

22 The fundamental work on early Futurism is M. Calvesi, 'Il manifesto del Futurismo e i pittori futuristi: Boccioni e il Futurismo milanese', *L'Arte Moderna*, 5, nos. 37, 38, 1967. See also M. Calvesi, 'Boccioni prima del Futurismo', in *Boccioni prefuturista*, Milan, 1983, pp. 11-32.

Art Nouveau and graphic design played an important role in this renewal. Many Italians travelled to Paris in 1900 for the Exposition Universelle, and the Liberty style (as Art Nouveau is called in Italy) dominated the 'Prima esposizione internazionale d'arte decorativa moderna' (First International Exhibition of Modern Decorative Art) in Turin in 1902 and the international exhibition 'Bianco e Nero' held in Rome that year, and achieved wide dissemination through the large circulations of such magazines as *The Studio*, *Emporium* (which published Pica's important articles on international trends) and Turin's *L'Arte Decorativa Moderna*. The vast range of European currents was now made freely accessible by modern travel, exhibitions and reviews, and young Italian artists thus became acquainted with the work of Auguste Rodin, Constantin Meunier, and the Scandinavian and Belgian Symbolists – in other words, with an Idealism that explored subjective states and celebrated the labour of the common worker.

The idea of the psychic realm as an intermediary state between matter and spirit, as the domain of energy and movement, lay at the core of early Futurism and was initially expressed through means derived from Divisionism and Symbolism.[22] From these movements the Futurists inherited strident chromatic dissonances, synaesthetic correspondences between music, line and colour that reverberate in the soul of the viewer and the concept of the picture as an intermediary in the recreation of an emotive sensation or state of mind (Cat. 00,00). The value assigned to intuition and to the flow of consciousness, in which everything exists in a state of continual flux and is preserved as memory, can be traced to Benedetto Croce's Idealism and the *élan vital* of Henri Bergson. And the elements of anarchism, Wagner and nationalism which combined in Futurism's espousal of progress and modernity derived from an Italian experience, specifically Lombard in origin and *Scapigliatura* in matrix.

Jole De Sanna

Conceptual Gesture and Enclosed Form:
Italian Sculpture of the Early Twentieth Century

By the end of the nineteenth century, the ideal of the unity of the arts had led to a deliberate obscuring of the boundary between painting and sculpture. The two artists who went furthest in this respect were Edgar Degas and Medardo Rosso, and they followed each other's work with interest for that very reason.[1] In 1896, in *Mercure de France*, Rosso stated clearly that the sculptor who wished to capture atmosphere in his work must renounce the traditional primacy of contoured form:

> Painting? Sculpture? There is only one art, identical and indivisible at all times. The sculptor who is not a painter, that is, one who is a fanatic of contour and sacrifices to it all concern for atmosphere and perspective, remains unrealistic and mediocre; and, on the other hand, within every great painter there lies a great sculptor. Does the unity of the arts not consist of just this: the merging and translation of values? Did Velazquez and Rembrandt not approach their canvases as if they were made of clay?[2]

This disavowal of the traditional concept of sculpture ultimately led to Pablo Picasso's *Tête de femme* (*Head of a Woman*, 1909) which, like the formal analysis contained in his Cubist paintings, arrived at a conflation of space and material.

Concurrently, other artists – among them, Auguste Rodin, Constantin Meunier and Antoine Bourdelle – were pursuing notions of classicism and romantic Idealism that preserved the integrity of the individual artistic disciplines. Above all, the Secession movements in northern Europe were practising a historicism and eclecticism, nostalgic and replete with ancient statues, which was completely at odds with the interests of the avant-garde. Notwithstanding his admiration for Arnold Böcklin and Max Klinger, Giorgio de Chirico would later accuse German art of this period of the worst aesthetic compromises:

> It was in Germany that 'Secessionism' was born, that foolish and barbaric school of painting which later spread to Italy. One can easily understand why it came into being and why it found such wide acceptance. French Impressionism, a superficial art, but nonetheless full of good taste and balance, could never satisfy the artistic requirements of a larger and less cultivated public. This wanted the grand portrait, the sensual nude, the panoramic landscape and mural decoration that would fit into the world of the rich bourgeoisie, the academies and officialdom. Thus was born 'Secessionism'.[3]

In fact, the milieu of the Secessions was a breeding ground for both historicist and modernist tendencies, for an eclectic as well as an increasingly novel approach to form. These two lines of development were by no means mutually exclusive. They could be – and were – integrated into a constant dialectic which permitted the creation of new styles without breaking totally with the past. The new century thus presented two possibilities to artists: an art that denied any kind of model, continually seeking the new with rigorous non-conformity and one that followed a dialectical model, impelled by a new purity of form but restrained by the weight of tradition. While the latter approach was always marked by tension between the old and the new, the art it gave rise to increasingly transcended its role as a representation of phenomenal reality and as an embodiment of bourgeois values.

The dialectical model – historicist and avant-garde, oscillating between Munich and Paris – was the cultural reality in which Italian artists existed at the beginning of the century. Looked at from this point of view, the birth of Futurism art in Italy, far from being accidental, was a natural outcome of the Janus-faced character of modern Italian culture, and the *Valori Plastici* movement after the First World War was less a return to order than the crystallization of an underlying tendency.

Umberto Boccioni and Arturo Martini both paid the obligatory visits to the French and Bavarian capitals, and both were in direct contact with Secessionists. For Boccioni, Paris held the greater attraction: he lived there for several months in

1 An anecdote records a meeting between Degas and Rosso, although the exact date is unknown. When Rosso showed Degas a photograph of his sculpture *Impression d'Omnibus*, the latter asked 'Is this a photograph of a painting?', pleasing the Italian artist no end. Many years later, Rosso returned the compliment during an interview with Julius Meier-Graefe, when he stated that Degas 'painted ballerinas the way that the Egyptians had once sculpted their Gods'. See J. De Sanna, *Medardo Rosso o la creazione dello spazio moderno*, Milan, 1985.

2 Quoted in C. de Sainte-Croix, 'Medardo Rosso', *Mercure de France*, March 1896, p. 379.

3 G. de Chirico, 'Considerazioni sulla pittura moderna' (pt I), *Primato*, no. 5, 1920; reprinted in *Il meccanismo del pensiero*, ed. M. Fagiolo dell'Arco, Turin, 1985, p. 136.

1906, and his art was to remain in constant dialogue with this city and its modernism. In 1909, Martini studied in Munich, the home of Adolf von Hildebrand, whose theories of 'pure visibility' propagated the ideal of a modern, non-academic classicism. Rosso and de Chirico, although they too travelled to Munich, Vienna and Paris, were the only Italian artists not to tread the historicist-modernist path. Each in his own way attempted to undermine one half of the equation, Rosso by repudiating the past, de Chirico by rejecting the present. This led some critics to hail them, respectively, as the greatest living sculptor and painter.[4]

Rosso's command of historical styles was so complete that he succeeded in passing off his copies of Egyptian, antique and Renaissance statues as genuine in his dealings with museum curators. He achieved notoriety as early as 1883, when he led a group of students who occupied the Accademia di Brera in protest against the system of copying plaster casts of antique statues and was subsequently expelled.[5] In his writings he never missed an opportunity of expressing his disdain for 'the works of the "second" Greece, of its branch office, Rome, and its sub-branch office, the Renaissance (not to mention the sub-sub-branch office of the latter, justly designated "Empire" – those paperweights of Signor Antonio Canova)'.[6] Rosso was the first to conceive of form as the action of space on mass, moving beyond traditional definitions of painting and sculpture. He refuted the idea of sculpture as 'statuary' and opened the contours of matter to the natural and immediate effects of light and atmosphere. Works such as *Femme à la voilette* (*The Veiled Lady*, 1893; Cat. 1) and *Bookmaker* (1894; Cat. 3) created the impression of a synthetic and succinct 'impulse', fulfilling Rosso's desire to make an image that was an 'instantaneous optical and internal emotion'.

Even more modern than his break with historicism was Rosso's decision to stop sculpting in 1906, after the completion of *Ecce Puer* (Fig. 1), and to turn to a new type of 'modelling', shaping the presentation of his person and oeuvre for posterity. After the publication of his treatise *L'Impressionisme en Sculpture* (*Impressionism in Sculpture*) in 1902,[7] he promoted his ideas in numerous interviews and letters to the editors of magazines, making effective use of the mass media in a way that anticipated the strategy of the Futurists. He was a precocious practitioner of 'performance', turning his demonstrations of bronze fusions into public spectacles, or using provocation and scandal both to defend and to promote his work.[8] In 1913, with the assistance of Etha Fles, his patron and critical champion, he organized the sale or donation of selected works – those of which he 'approved', such as *Madame X* (1896) and *Ecce Puer*, which he considered to be his finest creation – to museums of modern art. He oversaw the photography of his own sculpture and insisted on controlling that of works by others. In this way he continued his activity as a sculptor, circumventing the modernist credos of originality and novelty in art with a new ploy, the 'conceptual gesture'.

The Futurists acknowledged their admiration for Rosso in the *Manifesto dei Pittori Futuristi* (*Manifesto of Futurist Painters*), and the arguments on simultaneity and the persistence of images on the retina, expounded in *Pittura Futurista Manifesto Tecnico* (*Futurist Painting, Technical Manifesto*), were clearly indebted to his *Impressionism in Sculpture*.[9] On the perception of movement, Rosso stated: 'If the tones appear first to recede, then advance, then recede again, the viewer has a precise sensation of a living movement.... Thus I maintain that it is impossible to see the four legs of a horse at the same time or a man isolated in space like a doll. I also see that this horse and this man belong to a whole from which they cannot be separated, and that the artist has to take account of the surroundings.'[10]

The clearest evidence of Rosso's influence is to be found in Boccioni's *Manifesto Tecnico della Scultura Futurista* (*Technical Manifesto of Futurist Sculpture*) of 11 April 1912, which openly proclaimed the older master to be 'the only great modern sculptor who has sought to open up a vaster field to sculpture by rendering in three-dimensional art the influences of the surroundings and the atmospheric links that bind them to the subject'.[11] Boccioni's development as a sculptor can be seen as a progressive dialogue with the ideas first set out by Rosso. Even the signature on the

Fig. 1 Medardo Rosso, *Ecce Puer*, 1906.
Galleria Civica d'Arte Moderna, Verona

4 Such was the opinion Guillaume Apollinaire gave of Rosso in *L'Europe Nouvelle*, 13 July 1918. In a letter to Francesco Messina, Paris, 25 May 1927, Martini wrote: 'With de Chirico we are on good terms. Just think, he's been proclaimed the greatest Western painter of our epoch.'

5 De Sanna, *Medardo Rosso*, p. 99.

6 M. Rosso, letter to the editor of *Il Veneto*, Padua, 22 October 1921; reprinted in De Sanna, *Medardo Rosso*, pp. 154-63.

7 M. Rosso, reply to the inquiry by E. Claris, 'Impressionisme en sculpture: Auguste Rodin et Medardo Rosso', *La Nouvelle Revue*, Paris, 1902.

8 De Sanna, *Medardo Rosso*, p. 99.

9 *Manifesto dei Pittori Futuristi*, 11 February 1910, published in *Poesia*, February 1910; *Pittura Futurista Manifesto Tecnico*, 11 April 1910, *Poesia*, April 1910. The Futurists had earlier publicly declared their support for Rosso, on the occasion of the exhibition of Impressionism and Medardo Rosso at the Lyceum Club in Florence in April 1909; their telegram was sent to Ardengo Soffici, and published in *La Voce*, 11, no. 23, 19 May 1910.

10 M. Rosso, in Claris, '*Impressionisme en sculpture*'. On the similar description by the Futurists, see *Futurist Painting, Technical Manifesto*, 11 April 1910; translated by R. E. Wolf, in E. Coen, *Boccioni*, New York, 1988, pp. 230-1.

11 Ibid., pp. 240-3.

12 See the diary of 1907-8, notebooks and letters in U. Boccioni, *Gli scritti editi e inediti*, ed. Z. Birolli, Milan, 1971.

13 U. Boccioni to Vico Baer, Paris, 15 March 1912, and U. Boccioni to G. Severini, Milan, August 1912; printed in Boccioni, *Gli scritti*.

14 U. Boccioni, *Pittura, Scultura, Futuriste*, Milan, 1914; printed in translation in Coen, *Boccioni*, p. 243.

Fig. 2 Umberto Boccioni with his sculpture
Head + House + Light, 1912. Destroyed

Fig. 3 Pablo Picasso, *Head of a Woman*, 1909.
Musée Picasso, Paris

manifesto, 'U. Boccioni, painter and sculptor', acknowledges the standpoint of the older artist with regard to the indivisibility of the two disciplines (Fig. 2).

Like the other Futurist manifestos, the sculpture treatise challenged the old and advocated the new, taking as its point of departure the theories that had already been exemplified by Futurist painting. As the image on canvas had 'deepened and broadened itself by letting the landscape and surroundings act simultaneously on the human figure or objects, thus arriving at our Futurist *interpenetration of planes*', sculpture was now to achieve the 'translation of the atmospheric planes that link and intersect things' by incorporating such diverse materials as plaster, bronze, glass and wood.

Boccioni was tormented by doubts and indecision concerning technique, composition and all formal decisions.[12] The sculpture manifesto, intended as a theoretical support for his three-dimensional work, led to artistic problems which its author had not foreseen, as his personal correspondence reveals. Just before publication of the manifesto, he had written confidently to Vico Baer, 'I think I have seen the way to completely reform this mummified art'; but some months later, he confided to Gino Severini: 'And then I am struggling with sculpture: I work and work and don't know what I am producing. Is it interior? Is it exterior? Is it sensation? Is it delirium? Is it mere brain? Analysis? Synthesis? What the hell it is I simply do not know! Forms on forms . . . confusion'[13]

Boccioni's *Antigrazioso* (*Anti-graceful*, 1913; Cat. 22) reveals that he was also looking closely at the modelling of Picasso's *Head of a Woman* (Fig. 3) in an attempt to find a solution to his problems. Both works share the deformation of mass by space, but Boccioni's retained a greater figurative realism, while also exhibiting an increased abstraction of form. Moreover, his subject also included the physical presence of 'atmospheric planes' in the shape of a rectangular form (the abstraction of a house facade) jutting out from the head. This accords with the text of the sculpture manifesto, which had proclaimed: 'Thus the wheel of some piece of machinery might project from a mechanic's armpit; thus the line of a table could cut right through the head of a man reading; thus the book with its fan of pages could slice the reader's stomach into cross-sections.' The environment was forced to become a piece of sculpture itself, as in *Fusione di una testa e di una finestra* (*Fusion of a Head and a Window*, c. 1912; Fig. 4), in which elements of a window pane and the facade of a house are interjected visually, maintaining their individual characteristics as in a collage. Although the manifesto had called for the abstract reconstruction of planes and volumes that determine forms, at this point, Boccioni's incorporation of the surroundings in the form of fragments of actual objects interrupted the perception of a time-space continuum, defeating the ideal of 'dynamic synthesis'.

Boccioni's most significant departure from Analytical Cubism, as represented by Picasso's *Head of a Woman*, was his reliance on geometry to describe the motion of objects. It was on this point that Boccioni disagreed with Picasso, arguing that the Cubist perception of an object from different points of view 'makes the artist an analyser of fixity, an intellectual Impressionist of pure form'.[14] As a sculptor, Boccioni was far more sympathetic to the work of Alexander Archipenko, who devised a system of intersecting volumes and rotating planes that could suggest the evolution of a form in space. The dilemma of the relationship between the object in motion and its surrounding space came to the fore in Boccioni's *Sviluppo di una bottiglia nello spazio* (*Development of a Bottle in Space*, 1913; Cat. 26). Here the geometric shape of a cylinder and the profile of a bottle coincide; rising from a vortex of spinning volumes, the shapes minimize the disjuncture between the subject represented and pure form, while at the same time bringing into relief the very problem of the subject in sculpture: is it a bottle or is it volumes? Divisions were further dissolved in *Forme uniche della continuità nello spazio* (*Unique Forms of Continuity in Space*, 1913; Cat. 27), but the conflicts perceived by Boccioni were never to be satisfactorily resolved. Even his most abstract sculpture, *Cavallo + case* (*Horse and Houses*, c. 1914), was still governed by his characteristic principle of addition: form + force, dynamism + environment, object + environment. The desire to synthesize sculpture and sur-

roundings would find its solution only in the shaping of a total environment, as advocated by Giacomo Balla in the manifesto *Ricostruzione Futurista dell'Universo* (*Futurist Reconstruction of the Universe*).

It was during the period of crisis in 1912 that Boccioni wrote to Rosso.[15] Rosso did not reply, and ignored the Futurists' solicitations and their exhibition in Paris at the Galerie Bernheim-Jeune in 1912. Although Futurism effectively carried Rosso's experiments further, he was utterly hostile to the group and to what he felt they represented. He had long since rejected both the idea of describing movement and the mechanistic concept of form, notions so dear to the Futurists; indeed, his denial that it was possible to 'see the four legs of a horse at the same time' was an explicit attack on the contemporary chronophotography of Etienne Jules Marey, which broke down movement into successive stages (Fig. 5).[16] Instead, Rosso conceived of movement as the displacement of mass in space, a space that divests itself of the fixed perspective of photography, opening up and reacting against things like a substance. It was not to be realized as intervals of time, but as a fragment or an instant impression. These differences were recognized by Boccioni who, while praising Rosso in the sculpture manifesto, declared the limitations of his 'Impressionistic approach' to lie in 'an outwardly pictorial concept and a neglect of the problem of a new construction of planes'.

Boccioni identified with the ideology of the avant-garde, with its exaltation of progress and the modern. In these surroundings he felt a sense of both camaraderie and rivalry with the French Cubists. He openly favoured Picasso and disparaged his followers, although he himself was closer in style to the *Section d'Or* Cubists (Albert Gleizes, Henri Le Fauconnier, Jean Metzinger). Like them, he synthesized figurative elements within an overall architecture of form. In 1913, he observed, 'All of Cubism seems to have come to a halt. . . . The sculpture of Archipenko has been plunged into archaism and barbarism'; yet the following year, his own compositions began to 'slow down' and the formal coherence of the object to re-emerge.

The avant-garde was indeed turning towards the historicist-modernist line, as Archipenko, Severini and Picasso looked to classicizing models. A young artist named Ernesto De Fiori, having arrived in Paris via London in 1911, began to absorb these influences and became the first Italian to pursue an archaic style. In 1914, he moved to Berlin, where he soon earned a reputation as 'the best German sculptor'.[17] It was probably through Martini that his influence began to spread throughout Italy, reaching the young Lucio Fontana, who studied his work along with that of other sculptors of the period, such as Adolfo Wildt.

After Boccioni's death in 1916, the artistic culture of Italy consisted more or less of what had emerged a decade earlier. The opposition between avant-garde and tradition was only an apparent one and, in the immediate post-war years, the dialectic model finally achieved a synthesis in the ideas propagated in the journal *Valori Plastici* (1918-21). De Chirico alone remained intransigent, using the journal as a vehicle for admonishing both modernism and the revivalism of the younger artists: 'Those painters who want to return to the past cannot possibly put themselves in the

Fig. 4 Umberto Boccioni, *Fusion of a Head and a Window*, c. 1912. Destroyed

15 U. Boccioni to M. Rosso, Paris, 2 October 1912; Archivio Rosso, Barzio.
16 E. J. Marey's *Le Mouvement* was published in Paris in 1894.
17 A. Martini to Natale Mazzola, Anticoli, 21 October 1925: 'I hear that they are preparing a large exhibition ['Il Novecento Italiano'] with important organizers and I don't know what I am to do about it; they have even invited the most celebrated sculptor in Germany, a certain bewildered Italian, De Fiori, whom I knew many years ago in Paris and who I don't deny has certain essential qualities. Sarfatti is firing all her cartridges at me, but I think in vain. They'll get what they want with De Fiori.' *Arturo Martini: Le lettere 1909-1947*, ed. G. Commisso, Florence, 1967.

Fig. 5 Etienne Jules Marey, Successive views of a man running, 1886. Musée E. J. Marey et des Beaux-Arts, Beaune

18 G. de Chirico, 'Il ritorno al mestiere', *Valori Plastici*, nos. 11-12, 1919; reprinted in de Chirico, *Il meccanismo*, pp. 93-9.

19 A. Martini to G. Commisso, Genoa, 1916; *Arturo Martini: Le lettere*.

20 These ideas were recounted by Martini to G. Scarpa, *Colloqui con Arturo Martini*, Milan, 1968.

21 G. Perocco, *Arturo Martini*, Rome, 1962.

22 Martini's monumental works include the *Victory of the Air* for the Palazzo delle Poste in Naples (1935), the bas-relief *Corporative Justice* for the Palazzo di Giustizia in Milan (1937), *The Sforzas* for the Fondazione dell'Ospedale del Perdono, Milan (1938-9), and bas-reliefs for the Arengario, Milan (1940-2). See G. Perocco, ed., *A. Martini: Catalogo delle sculture e delle ceramiche*, Treviso, 1966.

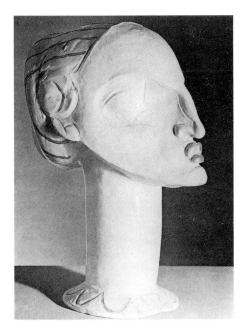

Fig. 6 Arturo Martini, *Girl Full of Love*, 1913. Museo d'Arte Moderna, Ca' Pesaro, Venice

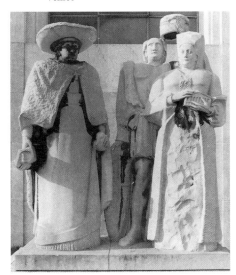

Fig. 7 Arturo Martini, *The Sforzas*, 1938-9. Ospedale Maggiore, Milan

position of the primitive craftsman The situation of today's penitents is rather tragic, but their puerile confusion displays just a touch of the comic, which prompts an ironic smile from under the moustache of the spectator.'[18]

It was during the war years, in the wake of this 'return to order', that Martini, too, turned to the past for inspiration: 'In certain epochs, and especially in ours, which has been modern to a nauseating degree, it happens that many artists find themselves attracted by the unspoilt, primitive arts'.[19] He had begun his career in 1908, participating in the exhibitions held at the Ca' Pesaro, Venice, which, under Nino Barbentini's direction, became the north Italian centre of the Secession movement. In Munich the following year, he came into contact with the Secession there, and studied the casts of works by Michelangelo, Donatello and della Robbia in the Glyptothek. The influence of the Renaissance masters revealed itself after the war. In the period between 1909 and 1913, he produced small works in gilded majolica (*Fanciulla piena d'amore* [*Girl Full of Love*], 1931; Fig. 6) and coloured terracotta (*Prostituta* [*The Prostitute*], c. 1913).

Martini's first mature works, profoundly marked both by his experience of antique statuary and a contemporary sensibility, emerged with his support of the *Valori Plastici* movement. Sculptures such as *Monaca* (*The Nun*, 1919; destroyed) and *Fanciulla verso sera* (*Girl before Evening*, 1919; Fig. 7, p. 60) announced this new direction, which might be termed a 'clothed style'. In accordance with the dictums expounded in the treatise *Après le Cubisme* (1918) by the 'reformist' Cubists Amédée Ozenfant and Le Corbusier, Martini's forms now possessed compactness, immobility and distinct, inviolable contours. Held fast by their drapery, his figures are frozen, their gestures immobile, their gazes locked in a state of expectation (see Cat. 111). In 1920, the Futurists entrusted Martini with writing their new manifesto on sculpture – a paradigmatic example of the forces of order meeting the avant-garde.

Martini's success was assured after his exhibition at the Ipogei di Via Dante gallery, Milan, in 1920, which was presented by Carlo Carrà. During the course of the exhibition, he gave a now famous lecture in which he introduced the 'unitary concept of sculpture', advocating not only the principle of closed form and its inviolability, but also the self-sufficiency of the discipline – the exact antithesis of Rosso's art. Martini's ideal sculpture was the 'maternal womb', consisting of forms that emerge by a sort of natural and spontaneous force from a 'dark and obscure channel'.[20] To illustrate this concept he had executed *Grembo materno* (*Maternal Womb*, 1920), but it did not meet his expectations and he destroyed it after the exhibition.[21]

The concept of inviolable form also contained the potential for monumentality. Martini began to receive commissions for public sculpture in 1923, when he created the war memorial at Vado Ligure, and his energies were increasingly devoted to large-scale monuments throughout the following decade (Fig. 7).[22] These obligations to produce 'statuary' provoked an artistic crisis, and Martini decided to abandon his *métier*. His career ended in 1945, with the publication of his book *La scultura lingua morta* (*Sculpture: The Dead Language*), which proclaimed the demise of traditional sculpture.

The same conclusion had already been reached by Roberto Melli, himself a sculptor in the manner of Boccioni, in his essay 'Prima rinnegazione della scultura' (The First Negation of Sculpture), published in *Valori Plastici* in 1919. In this discussion of the invalidity of sculpture, Melli anticipated the conditions that gave rise to post-war *Informel*. Addressing the example of Michelangelo, he wrote: 'All that seemed to be definite became tormented, all that was form became *without form* . . . your creation is without form, it is the *unformed*. The *unformed* is your concreteness and your purity: pure because it is *without form* . . . this chattel called sculpture ends with you, and a new reality begins.' This new reality was embodied in the post-war period, although it was anticipated in certain sculptures (*I cavalli* [*The Horses*], 1938; Cat. 130) by Lucio Fontana in the 1930s. The idea of form as matter penetrated by space – the premise of the *Informel* – can be traced back to the modernity of Medardo Rosso.

Ester Coen

The Violent Urge Towards Modernity:
Futurism and the International Avant-garde

Fig. 1 Filippo T. Marinetti, 'Le Futurisme',
 Le Figaro, 20 February 1909

When Filippo T. Marinetti published the *Manifesto del Futurismo* (*Futurist Manifesto*) in the French daily *Le Figaro* on 20 February 1909 (Fig. 1), he had little notion that his fame would spread with such rapidity to the realm of painting, since his interests were predominantly literary. He had hitherto been known in French intellectual circles as a champion of Symbolist literature, a friend of Gustav Kahn, Jean Moréas and Félix Fénéon. Not surprisingly, when Marinetti hurled his subversive ideas against the wall of the oppressive past, he did so in an onomatopoeic language still infused with a late-nineteenth-century style. He published the manifesto in French, proclaiming: 'It is from Italy that we now establish Futurism with this manifesto of overwhelming and burning violence, because we want to free this country from its fetid gangrene of professors, archaeologists, antiquarians and rhetoricians.' His words were heeded only by a few admirers; the critical voices were more numerous. The composer Camille Saint-Saëns, who received the manifesto on a leaflet published in *Poesia*, sent it back accompanied by a chiding remark: 'I fear the punches that you throw. I'm over seventy years old and I want to die in peace.'[1]

Driven by the urge to divulge his ideas on 'aggressive motion, feverish insomnia, the swift pace, the fatal leap, the slap and the punch', Marinetti enthusiastically welcomed the three artists Umberto Boccioni, Luigi Russolo and Carlo Carrà, who suggested the publication of another manifesto, this time on painting, early the following year. It was this new collaboration, along with the unruly methods of the protagonists, that attracted international attention to the ideas of Futurism which had first been expressed in Marinetti's literary manifesto.

Carrà recalled the ironic tone that pervaded the *Manifesto dei Pittori Futuristi* (*Manifesto of Futurist Painters*) of 11 February 1910, and its ridicule of the state of contemporary painting: 'Come, come! Let's make an end once and for all to the Portraitists, the Genreists, the Lake Painters, the Mountain Painters! – We have put up with them quite enough, with all those impotent painters of rustic weekends.'[2] In the *Pittura Futurista Manifesto Tecnico* (*Futurist Painting, Technical Manifesto*) of 11 April 1910, the artists' unqualified disdain for academicism, classicism and anything old still lingering in the art of the period acquired a more moderate tone. 'With this second manifesto', they proclaimed, 'we resolutely break away from any and every merely relative consideration and soar to the highest expressions of the pictorial absolute.'[3] Their emphatic declarations were accompanied by a more closely defined artistic consciousness:

> Gesture, for us, will no longer be a *single moment* within the universal dynamism brought to a sudden stop: it will be outright *dynamic sensation* given permanent form. Everything is in movement, everything rushes forward, everything is in constant swift change. A figure is never stable in front of us but is incessantly appearing and disappearing. Because images persist on the retina, things in movement multiply, change form, follow one upon the other like vibrations within the space they traverse. Thus a horse in swift course does not have four legs: it has twenty, and their movements are triangular.

The Futurists declared that the traditional conception of space had been surpassed, that modern sensibility had made the faculty of perception more acute and that colours had to 'shout' their iridescence and splendour in a luminous vision. Bodies were to be dematerialized in space, and matter liberated from the confines of form. The Futurists also affirmed their desire to paint the figure along with its surrounding atmosphere, to catapult the viewer into the centre of the painting. Several months and much experimentation were needed, however, before these brilliant colour harmonies and the much exalted concept of speed were realized on canvas.

1 Marinetti Archive, 111-17-35, Saint-Saëns, Beinecke Library, Yale University, New Haven.
2 *Manifesto of Futurist Painters*, 11 February 1910. This and other Italian passages from the Futurist texts are given in the translations by R. E. Wolf published in E. Coen, *Boccioni*, New York, The Metropolitan Museum of Art, 1988 (see page 229). Carrà's recollections are found in *La mia vita*, Milan, 1981, p. 72.
3 *Futurist Painting, Technical Manifesto*, 11 April 1910; reprinted in Coen, *Boccioni*, pp. 230-1.

Indeed, it was only at the beginning of the following year that the paintings of Boccioni, Carrà, Russolo, Gino Severini and Giacomo Balla – the artists who signed the two painting manifestos – began to reflect their verbal proclamations. A long process of liberation was needed to set Boccioni free from a style that still oscillated between Expressionism and Divisionism, to rescue Carrà from his academic manner and to enable Russolo to modernize his suggestive Symbolism. Severini eventually modified his Neo-Impressionist technique in a rhythm of luminous fragments, while Balla transformed his veristic tendencies into analytic sequences of motion (see Cat. 5, 21, 29, 34).

Throughout 1910 and much of 1911, the five artists attempted to sever their ties with the past in a search for a pictorial means that would match their verbal audacity. Each one of them in his own way proceeded to push Divisionism to its expressive limits. There was new impetus after their public debut as a group in the 'Mostra d'Arte Libera: 1ª manifestazione collettiva dei Futuristi' in Milan in the spring of 1911. On that occasion, Ardengo Soffici strongly criticized their work, calling it outmoded in comparison to the achievements of the French Cubists. The Futurists were spurred on to confront the French challenge. They familiarized themselves with Soffici's essays in the Florentine journal *La Voce* and kept up to date with articles by other critics.

Furthermore, Severini had been living in the French capital since 1906 and had been very well received in cultural circles: he knew the most prominent poets, artists and dealers. After signing the *Manifesto dei Pittori Futuristi* at the invitation of Marinetti and his own close friend Boccioni, he informed his comrades in arms of all the cultural events and artistic developments which he was observing first hand. He wrote letters to Boccioni relating his impressions and explaining the different tendencies which were then forming within Cubism:

> Those who, strictly speaking, are Cubists do not even know why they are called thus. Perhaps it is because of the geometric forms that predominate in their pictures. Their endeavour is certainly heroic, but infantile. I allude to the goal that they have set themselves: to paint an object from several sides or dissected. The engineers have resolved that question in a more complete fashion, and there is no need to go back to it. Some Cubists become decorators and caricaturists, but then their sincerity is open to doubt . . . the most interesting are the followers of Picasso and, naturally, Picasso himself.[4]

Severini's long, thoughtful letters enable one to discern which pictorial concepts had already been formulated by the Futurists before they came into direct contact with the Cubists. Indeed, as Severini observed:

> Some of their theories come fairly close to our truths. For example: If you look at a man, you can't see him circumscribed within a definite plastic form because now you have to see him in connection with all the movements he can make and in all the deformations resulting from the movements. Yet they do not accept that one can give the impression of movement by giving a man in motion more arms or more legs, because by that means one would arrive, at most, at an impressionistic physical truth, to the detriment of the plastic and pictorial point of departure which, for them, is the same as that adopted by the masters, from Rembrandt right up to Corot.[5]

Severini's letters also reveal which aspects distinguished the Futurists from the Cubists. The former represented the effects of speed on a object, dissolving it into a vortex of linear trajectories and brilliant hues. The Cubists, on the other hand, conceived of a solid construction of reality, basing their vision on a new sense of equilibrium and proportion, rendered with subtle gradations of cold tones. A point of agreement did exist, however: they were united in their battle against outmoded artistic conventions. 'One must be grateful to the Cubists', Severini wrote,

> for the formidable slap in the face they have given the Academy and the public, which enjoys commonplace expressions that call for no effort. They aspire to lead the public towards a new aesthetic, and in that respect they are admirable. They want no more landscapes with dazzling colour. Nature is too materially beautiful and kind to the eye. To our tormented souls all that healthy delight in colour and line is as irksome as the laughter of children amusing themselves while we are gnawed by doubt.[6]

It was only towards the end of 1911 that the Futurists finally decided to enter the international arena and meet the artists they had heard and read so much about. The first direct contact was made at the Salon d'Automne, where a small room was

4 E. Pontiggia, ed., 'Una lettera futurista', *Quest-arte*, no. 49, March 1986; reprinted in Coen, *Boccioni*, p. XXXVIII.

5 Ibid.

6 Ibid.

7 Letter from Boccioni, Paris, 15 October 1911, to the Baer family, The Museum of Modern Art, New York; reprinted in Coen, *Boccioni*, pp. XLI-XLII.

8 U. Boccioni, 'La Pittura Futurista', lecture delivered at the Circolo Artistico, Rome, 29 May 1911; reprinted in Coen, *Boccioni*, pp. 231-9, especially 236.

Fig. 2 Luigi Russolo, *The Revolt*, 1911. Haags
Gemeentemuseum, The Hague

devoted to the works of the Cubists Jean Metzinger, Albert Gleizes, Fernand Léger,
Roger de la Fresnaye and others. Immediately following his visit to the Salon,
Boccioni remarked:

> I have already seen the modern painters who interested me. I will continue to study them, but I see that
> I had already known virtually everything about them intuitively and it is merely a certain outward
> appearance they have (as a result of the enormous, *incredible* influence of Cézanne, Gauguin and others)
> that makes the ideas of some of them seem more daring than they really are.... It is strange how
> nothing, *absolutely nothing* has escaped me of what goes to make up the complex of aspirations of the
> finest modern painting![7]

It is clear from the manifestos of 1910, and from a lecture given by Boccioni at the
Circolo Artistico in Rome in the spring of 1911, just how complex and well de-
veloped were the Futurists' ideas for a new painting – one that captured the image of
modern life. As Boccioni exclaimed in his lecture:

Fig. 3 Gino Severini, *The Dynamic Hieroglyph of
the Bal Tabarin*, 1912. The Museum of
Modern Art, New York

Fig. 4 Umberto Boccioni, *Those Who Go II*, 1911.
The Museum of Modern Art, New York
(Gift of Nelson A. Rockefeller, 1979)

> Night life, with its women and men marvellously bent on forgetting their daytime life; the panting
> factories that incessantly produce wealth for the powerful; the geometrical city landscapes enamelled
> with gemstones, mirrors, lights; all of this creates around us an unexplored atmosphere that fascinates
> us, and into it we fling ourselves to conquer the future! All in all, in our art we give importance to
> everything that forgets the past and the present to aspire towards the future. Only becoming – moving
> forward – has value for us![8]

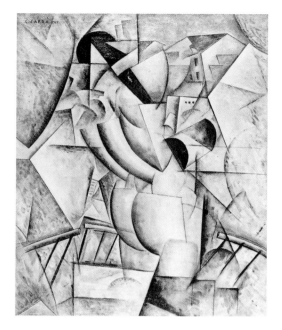

Fig. 5 Carlo Carrà, *Woman on the Balcony*, 1912.
 Magda and Riccardo Jucker Collection,
 Milan

Fig. 6 Luigi Russolo, *Solidity in the Fog*, 1912.
 Mattioli Collection, Milan

The realization of this 'future' in painted form required a long period of germina-
tion, as if the urge to express it was so uncontrollable that it had to be manifested
first in the verbal violence of written manifestos or the 'happenings' of Futurist
soirées. The confrontation with the Cubists was especially enlightening for Boccioni
and Carrà (Severini had lived with these artists and their ideas for some years). The
new conception of form expressed in the manifestos finally found pictorial solutions.
Boccioni's *Stati d'animo II* (*States of Mind II*; Fig. 4), Carrà's *Ciò che mi ha detto il tram*
(*What the Tram Told Me*; Cat. 30), Severini's *Geroglifico dinamico del Bal Tabarin* (*The
Dynamic Hieroglyph of the Bal Tabarin*; Fig. 3) and Russolo's *La rivolta* (*The Revolt*;
Fig. 2) were the first Futurist works to break with traditional narrative continuity,
replacing it with a continuum that denied all boundaries of time and space. The
sensation of dynamism, created by an emotive use of colour and the interpenetration
of planes, achieved a new visual synthesis. Although this synthesis was based on the
Cubist language, it differed in its ultimate aim. The Futurists sought to represent the
essence of speed, weaving a fabric of colours in whirling compositions, while the
Cubists analysed pictorial relationships to capture the essence of the object itself.
They constructed simple forms in accentuated relief on the surface of the canvas; the
Futurists distorted them in a complex activity of movement, amalgamating the
object with its surroundings.

Cubism was interpreted by artists in a variety of ways – some stressed the paint-
erly aspects, others the sculptural, and still others depicted only a superficial decom-
position of form. Individual styles also emerged among the Futurists. Carrà created a
play of coloured particles synchronized in a larger rhythmic pattern (*Donna sul
balcone* [*Woman on the Balcony*]; Fig. 5), while Boccioni combined the perception of
movement with a profound luminosity, giving rise to linear tension and sensations of
force within the space of the canvas (*Materia* [*Matter*]; Cat. 25). Severini's series of
dancers evoked a climax of frenetic movement by fracturing the surface with bril-
liant, luminous colours (Cat. 36). Russolo continued his individual research into
tonal harmonies, composing *Solidità nella nebbia* (*Solidity in the Fog*; Fig. 6) with waves
of colour like sonorous musical vibration, and Balla studied the sequence of forms in
rhythmic intervals over the surface of the canvas *La mano del violinista* (*The Hand of the
Violinist*; Cat. 6).

The appearance of the Futurist group on the French scene on the occasion of their
exhibition at the Galerie Bernheim-Jeune in 1912 (Fig. 7) created a certain discontent
and confusion in Parisian artistic circles, not so much because of the artists' paint-
ings, as because of their means of self-promotion.[9] With a volatile tone of calculated
provocation, the Futurists still claimed to admire the way in which their French

9 See G. Lista, 'L'exposition de 1912', *Cahiers du
 Musée National d'Art Moderne*, no. 5, 1980,
 pp. 466-75.
10 U. Boccioni, C. Carrà, L. Russolo, G. Balla
 and G. Severini, 'Les exposants au public', in
 Les peintres futuristes italiens, Paris, Galerie Bern-
 heim-Jeune, 5-24 February 1912; reprinted in
 Coen, *Boccioni*, p. XLVI.
11 U. Boccioni, *Pittura, Scultura Futuriste*, Milan,
 1914.

colleagues had battled against academicism, but, at the same time, they distanced themselves decisively from the Cubists' art: 'They obstinately continue to paint objects motionless, frozen, and all the static aspects of nature; they worship the traditionalism of Poussin, of Ingres, of Corot, ageing and petrifying their art with an obstinate attachment to the past, which to our eyes remains totally incomprehensible We, on the contrary, with points of view pertaining essentially to the future, seek a style of motion, a thing which has never been attempted before us.'[10]

It was obvious, and indeed the 'friends of chaos' – as the Futurists were dubbed by the French critic André Warnod – were well aware of it, that the reactions would be immediate and no less heated. Of course, the Futurists largely relied on unorthodox methods to obtain publicity and assert their ideas. They knew that sheer belligerence would make a stronger impression than their attempt to shock with a revolutionary aesthetic or style.

The polemics that followed from this moment on aided the Futurists in extending their battle to the international field, but, at the same time, they prompted defensive reactions and a certain diffidence that ultimately limited their effectiveness. Picasso and Braque may not have reacted to the provocations, given their voluntary isolation from the fray and even from the other Cubists. Very different was the ambiguous conduct of Guillaume Apollinaire. With his own brand of instinctive self-promotion, he attempted to create a new artistic movement, first around the Cubists, and later around Robert Delaunay, in order to halt the increasingly impetuous Italians. This impetuousness was part of the Futurists' 'religion of expressed desire' – to use Marinetti's own definition – which aimed at the reduction of all possible forms of existence and action to a single and absolute praxis. It was this 'religion' that prompted the Futurists to proselytize with extraordinary single-mindedness through speeches, gestures and manifestos, disseminating their desire to modernize all artistic media, from literature to music, poetry to theatre and, in the years to follow, even dance and cuisine.

Their publicity campaign, however, was accompanied by a kind of modern mysticism that later forced them to confront dramatic contradictions. As Boccioni wrote in his book *Pittura, Scultura Futuriste* (*Futurist Painting and Sculpture*) of 1914: 'We experience the ecstasy of modernity and the delirious innovations of our epoch. With this ecstasy and delirium, we Futurists have a divinely inspired psychic force that endows our senses with the power to perceive what has never been perceived before. We think that everything tends towards a unity, and that that which man has until today yearned to see as unity is but a small, blind and childish subdivision of matter.'[11]

Fig. 7 The Futurists in Paris on the occasion of their exhibition at the Galerie Bernheim-Jeune, February 1912. From left to right: Luigi Russolo, Carlo Carrà, Filippo T. Marinetti, Umberto Boccioni and Gino Severini

The 'ecstasy of modernity', which coloured the initial literary phase of the movement with a Symbolist sensibility, was increasingly emphasized in the artists' canvases. Impelled by their obsession with the future, with what they saw as an unfathomable absolute, the Futurists began to lose the sense of the objects and external reality. Their theories on the motion of an object, its relationship with the surrounding space and the interpenetration of iridescent forms were also informed by Henri Bergson's philosophy of temporal abstraction, creative energy and progress.

Echoing the ideas of Bergson, Carrà took another polemical stab at Cubism in an article written in 1913:

> We Futurists seek to identify with the core of things through the power of intuition, so that our Ego will merge with their uniqueness in a complex whole. Thus, we depict the planes of a picture like a spheric expansion in space, obtaining the sense of perpetual motion which is innate in every living thing. Only in this way can we express the soul and atmosphere of things, rather than a mere explanation of material reality. Surpassing the Cubists' concept of the immobility of that which is seemingly inert, we Futurists amalgamate everything in a cacophony of planes, tones and colours, achieving a complex unity which is like life itself.[12]

In 1912-13, the idea of simultaneity was expressed in the works of Carrà through an architecture of volume and mass in equilibrium. Severini, on the other hand, explored abstract correspondences between colours and lines, while Balla and Russolo simplified their compositions virtually to the point of abstraction. The compositions of Boccioni, in contrast, tended to radiate from the canvas in luminous bands (as in the series *Dinamismi* [*Dynamisms*]), propelled by lines of force within the synchronic space of the canvas. The sensation of the object's three-dimensionality emerged from this unity of place, time, form and colour.

Delaunay was also conceiving of painting as a means of expressing movement through the rhythm of forms and colours in series of 'simultaneous contrasts', begun around 1912. Delaunay, like many artists of his generation, recognized the need to distance himself from nature, from any mimetic concept of representation. In his paintings, form acquired a significance that was independent from objective reality and derived instead from pure pictorial values. Tonal gradations, contrasts of hue and the structure of the composition created an increasingly abstract 'architecture of colour' of purely visual and self-contained sensations. Delaunay found in Apollinaire a spiritual brother, who promoted the painter under the new movement of 'Orphism', which was soon in open competition with the theories of the Futurists. From the identical terminology of 'simultaneity' and the recognition of pure pictorial values sprang two entirely different conceptions. The Futurists proposed to resolve the convergence of time and space in an 'emotional unity' which consisted of a synthesis of 'what is remembered and what is seen'. Delaunay exalted the universe of pure colours in a temporal unity which would be perceived simultaneously, at a glance.

Wassily Kandinsky was concerning himself with comparable ideas on the perception of form in these years. Like Delaunay and the Futurists, Kandinsky considered the Cubist syntax to be 'too constructive' and responded by increasingly distancing his art from objective reality. He immersed himself in the spiritual substance of the universe, creating coloured impressions that echoed the profound, mysterious nature of things. All these artists, whose ideologies led them to elaborate similar artistic styles, experienced the same generational anxiety, stemming from their awareness of changes in cultural values. The presumptuous irreverence and extroversion of the Futurists thus created a sense of disapproval in Kandinsky. When the Futurists exhibited in Berlin at Herwarth Walden's Galerie Der Sturm in March 1912, he wrote: 'Art is a sacred thing that should not be treated with such flippancy. The Futurists merely play around with the more important ideas that they come up with now and again; everything is so little thought through, so little felt.'[13]

More ready and willing to welcome the Futurists' iconoclasm were the Russian artists, who were extremely conscious of the crisis in traditional culture wrought by the profound transformations of modern industrial society. United by a common desire to create an autonomous art, liberated from bourgeois traditions, the Russian

12 C. Carrà, 'Piani plastici, come espansione sferica dello spazio', *Lacerba*, 1, no. 6, 15 March 1913.

13 Letter from Kandinsky to H. Walden, director of the Galerie Der Sturm, where the Futurists exhibited in 1912 and 1913 on the occasion of the Herbstsalon; Walden Archive, Staatsbibliothek Preussischer Kulturbesitz, Berlin.

14 K. Malevich, *Ot Kubisma i futurizma k suprematismu: Novij jivopisnij realizm*, Moscow, 1915.

Fig. 8 Kasimir Malevich, *The Knife-Grinder*,
1912-13. Yale University Art Gallery,
New Haven (Gift of Société Anonyme
Collection)

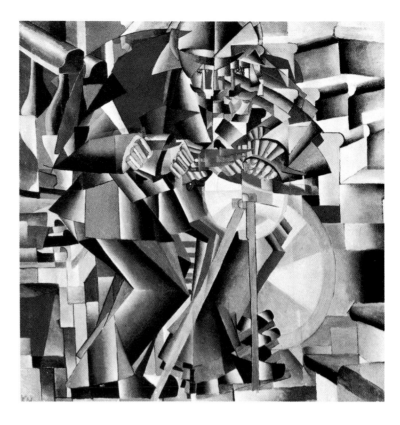

avant-garde followed the development of Cubism and Futurism, assimilating them with elements of Russian popular art. Familiarity with Futurism can be discerned in canvases of 1912-13 by Olga Rozanova, Mikhail Larionov, Natalia Goncharova and Kasimir Malevich (Fig. 8). But by the time Marinetti arrived in Russia in 1914, these artists had evolved their own distinctive idiom, and his words had a greater impact on poets and writers. Although the Russian avant-garde would continue to acknowledge the critical role played by Futurism in the development of their revolutionary artistic consciousness, by 1915 their conceptions had diverged towards a mystical vein of 'absolute creation' and completely non-objective art. As Malevich wrote in 1915: 'Futurism discovered the "novelty" of modern life: the beauty of speed. Thanks to speed, we move more rapidly. And thanks to speed, we, who were still Futurists yesterday, have now arrived at new forms and new relationships with nature and objects. We have arrived at Suprematism, leaving Futurism lagging behind in the tunnel.'[14]

In 1914, Marinetti also widened his influence in Great Britain. The Futurists had already exhibited at the Sackville Gallery in London in March 1912, and, upon his return, Marinetti wrote the manifesto *Vital English Art*, with Christopher Nevinson, against the 'passéism' of British art. Futurism had been embraced by the avant-garde above all for its ideology of speed and use of mechanistic forms. In their rebellion against Naturalism, Nevinson and David Bomberg, Frederick Etchells, Edward Wadsworth, Wyndham Lewis, William Roberts and Lawrence Atkinson looked to Futurism to create energetic compositions with 'lines of force' (Fig. 9) that recalled specific images of the Italians. Here again, with the birth of their own movement, Vorticism, the British, even while retaining the same negative attitude towards tradition, consciously distanced themselves from Futurism and developed a greater symbolic allusiveness in the direction of total abstraction.

What Boccioni once termed the Futurists' 'inexhaustible Italian genius' was not deterred by resistance abroad. Indeed, Marinetti's proselytizing never ceased and the group responded by issuing new manifestos: Boccioni's *Manifesto Tecnico della Scultura Futurista* (*Technical Manifesto of Futurist Sculpture*, 1912), Carrà's *La Pittura dei suoni, rumori, odori* (*Painting of Sounds, Noises and Smells*, 1913) and Severini's *Le analogie plastiche* (*Plastic Analogies*, 1913), to name but a few. Meanwhile, new

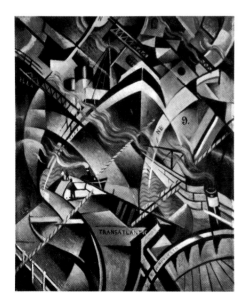

Fig. 9 Christopher Nevinson, *The Arrival*,
1913-14. Tate Gallery, London

disciples swelled the ranks of the movement: after the accession of Soffici and Gio-vanni Papini, who turned the Florentine journal *Lacerba* into a Futurist press organ, there followed Francesco Cangiullo, Fortunato Depero, Mario Sironi, Enrico Pram-polini, Ottone Rosai, Giorgio Morandi and Arturo Martini.

Towards the end of 1914, with the Futurists' active involvement in interventionist demonstrations, the artistic aspect of the movement lost its initial momentum. All forces were suddenly gathered together, as the aspiration towards modernity, the projection into the future, found its outlet in the war. Youthful idealism was soon replaced by the acceptance of an overwhelmingly cruel fate. The 'heroic' phase of Futurism ended with the deaths of Boccioni and the architect Antonio Sant'Elia, and the withdrawal of Severini, Carrà, Soffici and Papini from the movement. Marinetti attempted to revive the once glorious mood in a new phase of post-war Futurism, but the 'aggressive movement, the feverish insomnia, the swift pace, the fatal jump, the slap and the punch' had exhausted its violent charge in a last, impassioned, bloody fight.

Carlo Bertelli

Modigliani, The Cosmopolitan Italian

A comparison between Carlo Carrà's *Il gentiluomo ubriaco* (*The Drunken Gentleman*, 1916; Fig. 1), the few nudes created by Giorgio Morandi in 1915 (Fig. 2) and the religious drawings produced by Amedeo Modigliani in 1916 (Fig. 3) reveals profound similarities. It is as if the painters knew each other and were united by common goals. In fact, this was not the case, yet the similarities remain and are incontrovertible. In brief, they consist of an abstracted, post-Cubist space, the conscious use of Trecento models in an attempt to enhance the objective existence of things by accentuating their 'tactile values', and a desire for classical rhythmic balance. Since Modigliani had been out of touch with his native country from the outbreak of the First World War in 1914, and since it is not known whether Carrà or Morandi were familiar with his work at this time, the question arises as to how the artists came to share these concerns. To explain this by a common interest in Italian artistic tradition is insufficient, because no generally accepted view of that tradition existed around 1916 and, indeed, it meant something different to each of the three painters.

Although bound by affection to Italy, Modigliani was a true cosmopolitan. In post-Dreyfus Paris, he liked to introduce himself as a Jew, and he wrote to his mother in French. In fact, he became so fully acclimatized to the French capital that, during a stay on the Riviera in 1919, he complained about the strong light there and longed for the subdued tones of Paris. On this occasion he painted the only four landscapes of his mature years in an attempt to come to terms with the 'foreign' atmosphere of the south (*Paysage à Cagnes* [*Landscape at Cagnes*], 1919).

Modigliani's reading was also cosmopolitan: Dante, whom he recited by heart, Gabriele D'Annunzio, Friedrich Nietzsche in Italian translation, Paul Verlaine, Jules Laforgue, Stéphane Mallarmé and Charles Baudelaire; and he was seldom without his copy of Lautréamont's *Les Chants de Maldoror*. The influence of these authors can be sensed in Modigliani's three, unduly neglected poems, which were conceived in a mixture of French and Italian.[1]

Fig. 1 Carlo Carrà, *The Drunken Gentleman*, 1916. Private collection

Fig. 2 Giorgio Morandi, *Bathers*, 1915. Riccardo and Magda Jucker Collection, Milan

Fig. 3 Amedeo Modigliani, *Christ on the Cross*, 1915-16. Private collection

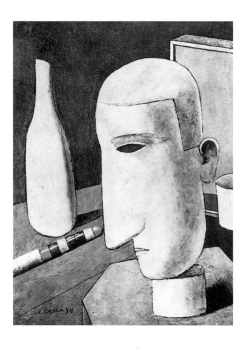

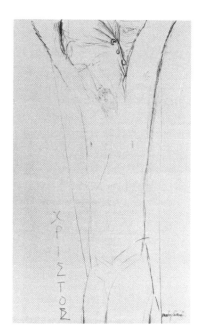

In addition to being an Italian living and painting in Paris, that is, in the nerve-centre of the Western avant-garde, Modigliani was also a Jewish maker of images. Given the absence of Jewish visual models, he looked to the canonical ideals of beauty found in Christian imagery of saints and madonnas. It would be incorrect to interpret the ease with which Modigliani switched from one culture to another as a sign of inner equilibrium. On the contrary, the sheer diversity of his experience led him to the conviction that he was living on the border between two epochs with an obligation to respond to the totality of the past. Although deeply impressed by the exhibition of Paul Cézanne's watercolours which he saw at the Salon d'Automne of 1906, he could not share the optimism inherent in the Frenchman's declared objective 'faire le Poussin d'après nature'. With Modigliani, historical consciousness in the midst of contemporary life gave rise more to a longing for the past than to a programme for the present. And the past presented itself to him as a highly complex unity, as his portrait drawing of the Jewish sculptor Chana Orloff (1916) reveals. 'Raphael's daughter' is inscribed on the sheet in Hebrew, as if the painter were paying homage to the 'divine' master of the Renaissance while living among the Jewish artists of Montparnasse.[2]

Modigliani came from a country where reverence for tradition had degenerated into facile virtuosity in the work of such established artists of the first decade of the century as Giulio Aristide Sartorio, Ettore Tito and Galileo Chini. He had been trained in the austere style of the *Macchiaoili* and felt the need to shun technical virtuosity in order to arrive at the truth. He was aided, not by a return to Italian traditions, but by his contact with the Parisian avant-garde and its interest in primitive art. Picasso, originating from the country which had produced both the Romanesque frescos of San Clemente in Tahull and the late-nineteenth-century canvases of Ignacio Zuloaga, was addressing the same problem of the artist's relationship to tradition with unprecedented skill and resourcefulness.

When Modigliani arrived in Paris in the winter of 1906, both the French capital and modernism were in full flower. Henri Matisse had just exhibited (and sold) *La joie de vivre* at the Salon des Indépendants, and was the first artist of the Parisian avant-garde to concern himself with primitive art, having bought an African mask that same year. Modigliani's own interest in primitive art took a new turn when he saw sculptures by his neighbour Constantin Brancusi in 1909.[3]

In March 1907 – one year after Matisse's purchase of the African mask – Picasso acquired two Iberian sculpted heads, which turned out to have been stolen from the Louvre by Gery Pierot, Guillaume Apollinaire's secretary. The Iberian colony in Paris was deeply affected by Picasso's acquisition. This group of artists, especially the Portuguese Jew Amadeo Souza Cardoso, was on excellent terms with Modigliani, who felt equally at home with other foreign artists as with the French avant-garde. A sculpture by Manolo Hugué, *Maternité* (*Motherhood*, 1914; Fig. 4), reveals the combined influences of Tino di Camaino, the unfinished works of Michelangelo, and Brancusi in a piece which comes surprisingly close to Modigliani's ideals.[4]

Modigliani's career as a sculptor and painter is of such coherence that it is difficult to find those moments of crisis which tell the art historian so much. Nevertheless, one period of doubt is represented by the Pointillist paintings of 1914 – for example, *Portrait of Frank Burty-Haviland* (Cat. 59). The technique of using raw, unpainted canvas to provide highlights was borrowed from Matisse, while the Divisionist brushwork had been employed earlier by the Futurists, among them Gino Severini, later a close friend of Modigliani's in Paris. The rendering of the window, with its frame and glass pane, shows that Modigliani still conceived the image in largely naturalistic terms, and the contrast between the detailed depiction of Haviland's cravat and the gestural shorthand in other areas of the canvas reinforces the impression that he was experimenting with a variety of methods with which he was not entirely familiar.

Modigliani's Divisionism, which came a decade later than that of his peers, nonetheless helped him to transform what was still a sculptor's approach to painting. The lines traced on the canvases consist of dots or dashes, as if he were trying to

1 The poems are published in *Modigliani, 1884-1920*, Barcelona, 1983.
2 See K. Silver, *The Circle of Montparnasse: Jewish Artists in Paris 1905-1945*, New York, 1985, for a discussion of Modigliani's relationships with the Parisian Jews.
3 On Modigliani and primitivism, see A. G. Wilkinson, 'Paris and London: Modigliani, Lipchitz, Epstein and Gaudier-Brzeska', in W. Rubin, ed., *'Primitivism' in 20th Century Art*, New York, 1984, pp. 417-50.
4 On Modigliani's rapport with the community of Spanish artists in Paris, see R. S. Torroella, 'Modigliani y nosaltres', in *Modigliani 1884-1920*, pp. 13-21.

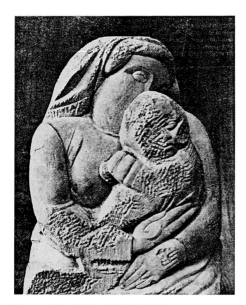

Fig. 4 Manolo Hugué, *Motherhood*, 1914. Whereabouts unknown

overcome the incisive profiles of his studies for the sculpture *Cariatide* (*Caryatid*, c. 1913). Broken outlines also dominate the drawings and paintings of Diego Rivera (1914), and continue to appear in some works of 1915, including *Portrait of Pablo Picasso*.

For Modigliani, 1915 was a turning point. The photograph showing him together with Picasso and André Salmon in front of La Café Rotonde in Montparnasse is generally thought to have been taken that year. Modigliani's affair with the English writer Beatrice Hastings, with whom he had been living since 1914, was coming to an end. It was also a difficult year for Picasso. He had shared his first bohemian years in Paris with Eva Gouel; she died in December after a long illness. The friendship between the two painters ceased in 1915 after a violent disagreement, the causes of which are still unknown. Certainly, the approaches of the two artists differed markedly, and many aspects of Modigliani's artistic personality must have irritated Picasso. Whereas the Spaniard experimented with diverse styles and demonstrated a consummate ease in turning from one to the next, Modigliani pursued his objectives with calm deliberation.

Modigliani was nevertheless indebted to Picasso, as demonstrated by his drawings for *Caryatid*, which were undoubtedly inspired by Picasso's *Coiffures*, studies of women combing their hair which date from the summer and autumn of 1906 (Figs. 5, 6). In addition to the motifs of the upraised arms and bent knees, both artists focused on the expression of precise volumes – so much so in Picasso's case that he actually made a small bronze in 1906. Whereas the women in Picasso's studies retain a physical and sensual presence, the form of Modigliani's *Caryatids* acquires an inner sensuality through the rhythm of the lines alone, which often border on the purely decorative.

It was after his break with Picasso that Modigliani painted his marvellous sequence of nudes (Cat. 63). Quite apart from their value as paintings, they were extraordinarily bold social statements at the time. The moral (or amoral) content and 'narrative' character of the nudes – their lack of ambiguity, guilt or voyeuristic qualities – were without precedent. *Nu couché sur le côté gauche* (*Nude Reclining on her Left Side*, 1917) was modelled on an engraving of about 1510 by Giulio Campagnola, as is indicated by the position of the legs and the depiction of the feet with both the upper part and the sole exposed to view. In a significant departure from his source, Modigliani twisted the torso of the model (resulting in the folds of flesh at the waist) and turned her head, with its questioning gaze, towards the beholder. Campagnola's engraving represents a sleeping nymph, but Modigliani's changes divest the figure of its mythological aloofness and render it wholly modern.[5] Complete with make-up and chignon, Modigliani's nude is a living, breathing, alert woman, who knowingly lifts her right leg to expose the inside of her thigh.

Direct, provocative gazes were no novelty in female nudes of the late nineteenth or early twentieth centuries. Countless girls and women had looked at the viewer in this way in more or less explicitly erotic or pornographic pictures. The languid pose of *La Belle Romaine* (*The Beautiful Roman Woman*, 1917) derives as much from these 'low' images as from the more respectable eroticism of Dominique Ingres's *Odalisques*. A comparably frank acceptance of female sexuality in contemporary life does not reappear until about a decade later, in the photographs of Cyula Halasz Brassai. Despite their unabashedly raw presence and the indiscreet gestures of their hands, Modigliani's women are by no means prostitutes.

The one Italian painter who learned much from Modigliani's nudes was Felice Casorati, who was attracted, not by the aesthetic sophistication of the paintings, but by their chromatic vibrations, delineated volumes and tangible sense of breathing bodies. Modigliani outlined the parts of the body with broad brushstrokes; these were then partly covered by the colours of the adjacent areas, leaving a dark line circumscribing the image. This contour creates a relief-like effect which probably reflects the artist's visits to the Egyptian collection in the Louvre. In works such as *Nu étendu aux bras levés* (*Reclining Nude with Raised Arms*, 1917) the incisive outline imparts a controlled tension to the modelling and a sensation of firm, breathing

Fig. 5 Amedeo Modigliani, *Red Caryatid with Blue Border*, 1913. Perls Galleries, New York

Fig. 6 Pablo Picasso, *La Coiffure*, 1906. City Art Museum of Saint-Louis

5 On Picasso's double-edged treatment of the sleeping female nude, see L. Steinberg, 'Picasso's Sleepwatchers', *Life*, 27 December 1968; reprinted in idem, *Other Criteria*, Oxford, 1972, pp. 93-114.

flesh. Radiographs taken in 1981 on the occasion of the Modigliani retrospective in Paris help to explain the quality of the nudes, revealing a turbulent pictorial surface characterized by powerful, nervous brushwork comparable to the chisel marks in some of the artist's sculptures.

By 1915, Modigliani was beginning to influence painters of his own age or slightly younger, including Moise Kisling, Chaim Soutine and more minor figures, such as Adolphe Feder. In the latter's *Baigneuse dans l'atelier* (*Bather in the Studio*, c. 1915), a photograph of Pisannello's portrait of a princess (in the Louvre) is displayed prominently on the wall.[6] It was probably Modigliani who brought Feder's attention to this little masterpiece, since its influence is also felt strongly in a number of his own portraits, such as *Portrait of Madame Hanka Zborowska* of 1917.

The last two years of Modigliani's life, marked by rapidly declining health, brought supreme pictorial achievements. He discovered the serene authority of Henri Rousseau's canvases, in which each object, plant and figure was described in isolation, carefully, lovingly. Modigliani, too, now began to conjure up the magical presence of his sitters without recourse to realism – indeed, with ever-increasing stylization. The individuality of his formal distortions – for example, the hands in *Hanka Zborowska aux mains jointes* (*Hanka Zborowska with Clasped Hands*, 1919) – were to inspire Gio Ponti and other, less important Italian industrial designers in the late thirties.[7]

Modigliani himself seemed little interested in the dissemination or trivialization of his artistic ideas, yet it was nevertheless a quirk of fate that he became known rather late in his native country. Despite the exhibition of a few of his works at the 1922 Venice Biennale, his name is seldom found among the pages of *Valori Plastici*. His real discovery began with a small, pioneering book of 1927 by the publisher Giovanni Scheiwiller, which was followed two years later by a small volume by Lamberto Vitali (also printed by Scheiwiller). It was through his retrospective in the Biennale of 1930, organized by Lionello Venturi, that the Italian public at large became acquainted with Modigliani's work. Venturi was the only Italian university professor of art history who was later forced to emigrate (to the United States) because he refused to swear allegiance to the Fascist government; and the 'decadent' Modigliani remained an artist beloved of anti-Fascist intellectuals, who resented the empty rhetoric characteristic of cultural life under the regime. Yet even among artists of anti-Fascist persuasion, it is difficult to pinpoint the influence of Modigliani.

Several works by Arturo Martini – for example, *Il centauro* (*The Centaur*, 1921), *Fanciulla verso sera* (*Girl before Evening*, 1919; Fig. 7) and *La madre folle* (*The Mad Mother*, 1926) – approach Modigliani's style in their nascent archaism, despite the presence of a metaphysical yearning and a mythical dimension which are completely alien to the here-and-now world, the less grandiose and more incisive message of Modigliani. The latter had been the first to integrate earlier styles – the art of ancient Egypt, of antiquity and the Trecento – with contemporary artistic expression, and it was this espousal of the archaic that Martini seized upon as a corrective to the monumental aspirations of the *Novecento* movement. Modigliani taught him to look to the past as a source of stylistic types rather than of monumental form.

Although he was admired by many Italian intellectuals, for whom he had even become something of a mythical figure, Modigliani had little real influence on the development of art in his native country after 1930. Indeed, another Italian living in Paris, Alberto Magnelli, painted a group of images with elongated necks and perfectly oval heads which deliberately parodied Modigliani's most striking stylistic mannerisms. Perhaps this represented an attempt to force Modigliani into the Italian modernist – that is, Futurist – tradition, to which, however, he had never belonged.

Fig. 7 Arturo Martini, *Girl before Evening*, 1919. Museo d'Arte Moderna, Ca' Pesaro, Venice

6 The painting by Feder, preserved in the Tiroche Gallery, Tel Aviv, is reproduced in Silver, *The Circle of Montparnasse*, colour plate VII.

7 Many examples of trivial renderings of Modigliani are illustrated in C. A. Felice, *Quadriennale della Triennale: Arte Industriale d'Oggi*, Milan, 1937, where the influence of Modigliani is oddly combined with references to Alberto Martini. See also the exhibition catalogue, *Gio Ponti: L'Arte si inamora d'industria*, Milan, 1988.

Bibliographical Note

The literature on Modigliani is enormous. The most complete bibliography is to be found in the catalogue of the exhibition *Amedeo Modigliani, 1884-1920*, Paris, Musée d'Art Moderne de la Ville de Paris, 26 March-28 June 1981. André Salmon published the first biography of the artist, *Modigliani, sa vie, son œuvre*, Paris, 1926, which was later revised and published under the more dramatic title *La vie passionnée de Modigliani*, Paris, 1957 (translated as *Modigliani: A memoir*, New York, 1961). Salmon's biography should be read against the more accurate reconstruction by the artist's daughter, Jeanne Modigliani, *Modigliani senza leggenda*, Florence, 1958 (further editions in 1961 and 1968). Numerous anecdotes about Modigliani are found in books on the artistic life of Paris. Particularly telling are those by poets of the period, such as Anna Achmatova, Ilja Ehrenburg and Blaise Cendrars. In his *Le lotissement du ciel*, Paris, 1949, Cendrars stated that every promising artist in pre-war Paris had his poet, and that his artists were Fernand Léger, Marc Chagall, Roger de la Fresnaye and Modigliani. The most recent publication on Modigliani in Italian is the exhibition catalogue *Modigliani e Montparnasse*, Verona, 1988.

Paolo Baldacci

De Chirico and Savinio: The Theory and Iconography of Metaphysical Painting

At the close of the first decade of this century, Italy's most progressive artists felt a strong need to free themselves from the influence of the clashing Positivist and Idealist currents of late nineteenth-century art. In its early phase, Futurism, influenced by Henri Bergson's ideas on *élan vital* and intuition, attempted to resolve the antinomy by representing the physical object as well as its spiritual and psychic aura. At the same time, though originating from different cultural roots, Giorgio de Chirico concluded that the only way to solve the problem was to elude the formal aspect of things and to address issues that lay elsewhere.[1] The elaboration of his theories led him to create a coherent body of painting, which, *pace* the critical literature on the artist, demonstrates a continuity between so-called 'early' and 'late' de Chirico.

The invention of Metaphysical iconography began in Munich between 1908 and 1909, even if some time passed before de Chirico achieved his mature pictorial solution.[2] During this period, and later in Paris, he worked in close contact with his brother Alberto Savinio.[3] The latter's drawing *L'oracolo* (*The Oracle*; Fig. 1) clearly dates from this time, and is the only evidence of the brothers' shared interest in the work of Arnold Böcklin and epic Greek poetry, which would appear later in paintings by de Chirico.[4] The personal interpretation of myth and the presence of the leitmotiv of the oracle demonstrate that the concerns of the 'Dioscuri' were already orientated towards the culture of pre-classical – more accurately, pre-Socratic – Greece, which had been the great discovery of German philology, beginning with Friedrich Nietzsche and Jacob Burckhardt.

While in Munich, de Chirico had been deeply impressed by the images of Max Klinger and Böcklin. He wanted to retain the particular *Stimmung* that emanated from these works, while freeing himself from their literary iconography and narrative. His return to Böcklin and his choice of mythological subjects in the Milan pictures of 1909 reveal his inclination towards classical sources, not as an external body of 'motifs' but as a germinative core of feeling and culture. From this point onwards, de Chirico interwove the origins of this culture with personal and family

Fig. 1 Alberto Savinio, *The Oracle*, c. 1909. Private collection

Fig. 2 Giorgio de Chirico, *The Enigma of the Oracle*, 1910. Private collection

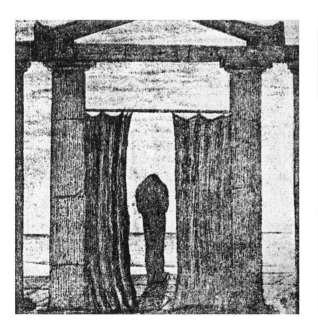

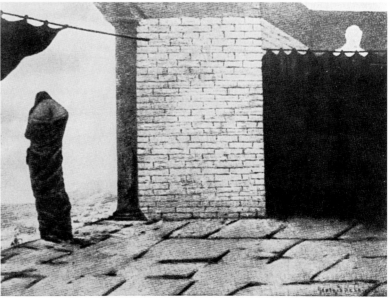

history, establishing a fertile link between the internal, psychical dimension and the external development of the narrated subject.[5]

It was in Florence, between the summers of 1910 and 1911, that de Chirico moved away from direct imitation of the German Symbolists and succeeded in painting the first images of metaphysical evocation, which created a novel sense of detachment from the objects represented. He retained two motifs derived directly from Böcklin: the draped figure seen from behind in *L'enigma dell'oracolo* (*The Enigma of the Oracle*, 1910; Fig. 2) and the combination of arcades and loggias in *L'enigma dell'ora* (*The Enigma of the Hour*, 1911). As already established in his last painting of the Milan period, architecture is used as an isolating, framing element within a simple perspective. While classical in style, the buildings are unembellished, without any descriptive, archaeological detail. Similarly, the ancient statues lack specific references to known types; some are partially hidden by buildings or appear through windows, generating a sense of surprise and mystery. The black curtains depicted in several of the images are those belonging to the inner sanctum of a temple, where they hide the simulacrum of the god from the profane or shield an oracle, sometimes ruffled by its breath of prophecy.[6] The obsession with the oracle returns in *Meditazione autunnale* (*Autumnal Meditation*, painted in Florence, but dated '1912' in Paris; Fig. 3) where the curved stick resting on the building is the sacred *lituus* of the augurs and Etruscan soothsayers. The sea is almost always present (or implied by the sails of ships), giving rise to a sense of destiny. Pregnant with impending annunciation, this atmosphere represented what de Chirico called the 'primordial feeling of prehistory'.[7] Two other elements derive from Nietzsche (in addition to the term 'enigma' used in the titles): the sails of the ships, half-hidden by low brick walls, and the choice of time – midday.[8] The Florentine period concluded with a self-portrait (1911) in which the artist assumes a well known pose of the German philosopher. He gazes pensively within a window frame which is inscribed below: 'et quid amabo, nisi quod aenigma est?' ('What shall I love if not the enigma?').

The manuscripts written by de Chirico in Paris between 1911 and 1913 provide the key to an interpretation of his early development and confirm that the fundamental characteristic of Metaphysical painting had already been present in the Florentine works, namely, the idea of art as prophecy and the artist as poet-seer.[9] De Chirico was not interested in revolutionizing the representation of the visible through the selection and reorganization of perceived facts, as were Paul Cézanne and the Cubists. Instead, he sought a new sensation, evocative but unrelated to the traditional symbol, by selecting psychological facts deposited in the consciousness in reaction to external images. What was the subject of this strange and modern sensation? De Chirico answered: the 'non-subject'. This did not entail paintings without recognizable objects and forms, but images whose true subject would be nothing – the representation of non-sense. This nihilistic conviction, gleaned from a close reading of Nietzsche and Arthur Schopenhauer, led his work towards a rigorous explanation of the universal order of the real, from which he launched a radical attack on the concept of reality as visible phenomena.

De Chirico used the term 'revelation' to denote the actual moment of selection, the moment when, as Schopenhauer put it, the artist became the 'pure subject of cognition', receiving an impulse which he translated into pictorial form by means of lines and volumes.[10] In his Florentine period, de Chirico had already understood that in the process of representation everything must be transformed and reduced to essentials in a drastic denial of naturalism. There could be no direct similarity between the thing that provoked the 'revelation' and its painted form. The faculty of reason intervened to abolish this similarity and guided the artist in defining new forms that excluded all transitory, superficial elements. The result was an effect unknown to the art of the previous century: a new relationship between the unconscious and reason, between sense and non-sense, which were no longer defined as opposites, but as counterpoints, as two faces of the same coin.

According to Nietzsche, Heraclitus was the first to recognize a lack of logic and order in the world, and gave it frightening expression by likening it to the games of

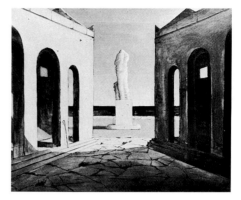

Fig. 3 Giorgio de Chirico, *Autumnal Meditation*, 1912. Private collection

1 The first Metaphysical paintings were painted in Florence during the autumn of 1910 (M. Fagiolo dell'Arco, *L'opera completa di de Chirico 1908-1924*, Milan, 1984, nos. 14, 15) and are contemporaneous with the early Futurist paintings of Umberto Boccioni. See P. Baldacci, 'Giorgio de Chirico: L'estetica del classicismo e la tradizione antica', in M. Fagiolo dell'Arco and P. Baldacci, eds, *Giorgio de Chirico: Parigi 1924-1929*, Milan, 1982, pp. 17-21.

2 De Chirico's Munich period has still not been sufficiently examined, partially owing to lack of documentation. See G. Dalla Chiesa, *Giorgio de Chirico*, Ferrara, 1985, and W. Schmied, 'Die Geburt der Metaphysik: Giorgio de Chirico und die Münchener Kunstakademie', in *Mythos Italien – Wintermärchen Deutschland*, Munich, 1988, pp. 47-52.

3 De Chirico and Savinio arrived in Munich on 27 October 1906. In 1908, de Chirico spent the months of July to October in Italy. In 1909, Savinio spent a long period in Milan and, in February 1910, left for Paris. De Chirico left Munich in February 1910, moved to Milan and then, in the summer, to Florence, where he remained, except for a trip to Rome, until July 1911, when he travelled via Turin to join his brother in Paris.

4 M. Martin, 'On de Chirico's Theater', in W. Rubin, ed., *De Chirico*, New York, 1982, p. 87, and p. 94 for the date of Savinio's drawing. The only possible dates are Munich, 1908-9, or Paris, after July 1911; the most probable is 1909. De Chirico (*Il meccanismo del pensiero*, ed. M. Fagiolo dell'Arco, Turin, 1985, p. 17) stated in 1913 that he drew his ideas for a painting (certainly *L'enigma dell'oracolo* [Fig. 2], in which the silhouette of Böcklin's Ulysses first appeared) from the Homeric passage about Ulysses and Calypso. Savinio's 1909 drawing also refers to Böcklin's *Ulysses*, demonstrating not only the collaboration of the two brothers, but above all the long gestation period (from Munich to Florence) involved in the birth of Metaphysical iconography.

5 De Chirico had a predilection for mythological themes connected with Thessaly, his birthplace: centaurs, Argonauts, etc. (Fagiolo, *L'opera*, nos. 4, 5, 8). Given modern culture's lack of an objective, unifying mythical fabric, which had constituted an outline for the ancients upon

which they could articulate an 'indirect' image of truth, de Chirico and Savinio constructed their own complex symbology, where the dimension of personal anamnesis was merged with the collective reminiscence of a historical culture, all in the tone of a language for initiates. Arturo Martini reported: 'I asked Savinio: "What is this metaphysics?" "It's nothing. It's in the family: a family language."' (G. Scarpa, *Colloqui con Arturo Martini*, Milan, 1968, p. 109). For de Chirico's identification with Ulysses, Heraclitus, Mercury, etc., see Baldacci, 'L'estetica', pp. 26-7, 53.

6 De Chirico, *Il meccanismo*, p. 22 (1913). The curtain appears in other paintings until 1924 (Fagiolo, *L'opera*, nos. 14, 15, 80, 158, 218, 232, 239, 240).

7 De Chirico, *Il meccanismo*, p. 22 (1913).

8 The atmosphere of the Florentine paintings is derived from a careful interpretation of Nietzsche's *Zarathustra* and *Ecce Homo*. See *Also Sprach Zarathustra*, in F. Nietzsche, *Sämtliche Werke: Kritische Studienausgabe*, Berlin and New York, 1967-77, vol. 4, pt 1, ch. 22, pt 2, ch. 42, pt 4, ch. 8, and *Ecce Homo*, ibid., vol. 6, ch. on Zarathustra.

9 De Chirico's manuscripts, edited in part in English translation by J. T. Soby, *Giorgio de Chirico*, New York, 1955, have been published in their entirety in the original French, along with all the other critical and autobiographical writings from 1911 to 1943, in de Chirico, *Il meccanismo*, pp. 427-37. Contrary to Fagiolo's view, it is unlikely that any of the manuscripts were written after 1913 (the earliest is dated 1911, written in Florence), since they contain no detailed articulation of the theory of signs or the theory of poetic memory, which were already embodied fully in the paintings of 1914.

10 De Chirico, *Il meccanismo*, pp. 10, 12, 18, 20, 31, (1913). For the idea of revelation, see also Nietzsche, *Ecce Homo*, pp. 339-40. For a discussion of Schopenhauer, see Baldacci, 'L'estetica', pp. 22-3. The state of suspension of the senses in which revelation occurs, a middle course between waking and sleeping, between death and life, is defined by Savinio as half-death in *Chants de la mi-mort*, published in *Les Soirées de Paris*, July 1914.

11 See F. Nietzsche, *Die Philosophie im tragischen Zeitalter der Griechen*, in *Sämtliche Werke*, vol. 1, pp. 824, 828, 830, 834, and *Die Geburt der Tragödie*, ibid., vol. 1, p. 153. For de Chirico's links with the philosophy of Heraclitus as interpreted by Nietzsche, see Baldacci, 'L'estetica', pp. 25-32.

12 Nietzsche, *Also Sprach Zarathustra*, pp. 248-9.

13 De Chirico, *Il meccanismo*, p. 68 (1919).

14 G. de Chirico, *Memorie della mia vita*, Milan, 1968, p. 71.

15 Heraclitus, in M. Diels and W. Krantz, *Die Fragmente der Vorsokratiker*, 7th ed., Berlin, 1954, n. 92 (see also n. 93).

16 Indeed, a painting of 1914, *Turin 1888*, even suggests a metempsychosis of the soul of Nietzsche into that of de Chirico, who was born in 1888, the year of Nietzsche's incipient madness. See Baldacci, 'L'estetica', pp. 16-17, n. 1. Savinio, too, claimed to be a reincarnation of Nietzsche (A. Savinio, *Maupassant e l'altro*, Milan, 1975 [1st ed., 1944], p. 13 ff.).

17 The first of de Chirico's manuscripts, written in Florence in 1911, is dedicated to Andrea del Castagno. For the artist's views on the Quattrocento, see also de Chirico, *Il meccanismo*, p. 108 (1921).

Zeus, who, as a baby, innocently accumulated and destroyed buildings of sand along the sea-shore.[11] (This metaphor of the absurdity of life as a reckless game was later taken up by Savinio in his series *Giocattoli* [*Playthings*; see Cat. 79].) Man needed to reacquire this form of creative irrationality through the *amor fati* or the virtue of poetry – or, as Zarathustra put it: 'To reunite and arrange in a single thing that which is in man a fragment, enigma, terrifying chance, and, like a poet, the solver of enigmas and liberator from chance . . . to prepare the future and, through creation, liberate everything that was'.[12] Referring directly to Heraclitus, de Chirico stated that it was not reason that would succeed in dominating fate, but the ultra-logical faculty of a soul without limits, one possessing an intuition that could perceive in things the phonemes of a language otherwise hidden by natural phenomena, that is, a plurality of meaning produced by signs. This quality of things and their hidden 'demon' (the term used by Heraclitus) constituted the enigma, whose existence was manifested in the ability to bring to light (through revelation) the non-logical face of the coin of nature: 'the discovery of the terrible void is nothing other than the truly senseless and tranquil beauty of matter'.[13]

De Chirico stated in his memoirs that the paintings of the Florentine period already contained the Greek sense of 'prehistory'.[14] To hear voices in things, to sense the presence of the demon, indicated their 'other' existence in an order beyond the comprehension of human logic. This capacity paralleled that of the primitive artist, who heard the voice of the oracle in every sign of nature, believing, for example, that the stone he was about to carve contained a god. To translate this consciousness into art constituted the act of mystical revelation, which was subject to precise procedures and rituals. Procedures that were pre-logical for the primitive were ultra-logical for the metaphysician, because the mystery that they revealed was of a different nature: the former was transcendent, the latter immanent. Although the Florentine paintings contained the element of prophecy, it was during his Paris period that de Chirico clarified the 'mediated' nature of the creative act that characterized the feeling of prehistory, initiating a complex symbology in his work. Heraclitus said, 'The god of the Oracle does not speak and does not hide, but indicates through signs'.[15] De Chirico followed precisely this line of thought, seeking to decipher this language of signs and to perceive the ability of things to emit a disconcerting multitude of meanings which formed the basis of a new system of perception and representation.

On his way to Paris to join his brother in mid-summer 1911, de Chirico stopped for an unknown number of days in Turin, a visit of seminal importance. The expansive city squares of the Piedmont capital; the long rows of porticos; the monuments to bourgeois political figures and conquering kings (the mythic heroes of the Risorgimento); trains hidden by walls, emitting white smoke like a cloud or cannon explosion; and railway stations comprised the iconography of the Turin images, which de Chirico painted subsequently in Paris, for the most part between the winters of 1912 and 1913. These works were particularly rich in references, both direct and oblique, to Nietzsche, who had shown the first signs of his madness in Turin at the end of 1888. The dark silhouette of the equestrian monument to King Carlo Alberto depicted in *La torre rossa* (*The Red Tower*; Fig. 3, p. 25) stood at the end of the Via Carlo Alberto, the street where Nietzsche had lived while writing *Ecce Homo*. The statues of the sleeping Ariadne that populate the city's squares in these pictures are particularly pregnant with meaning: they not only allude to the Greek myth, beloved of Nietzsche and symbolizing the sleeping soul in expectation of the revelatory and liberating breath of art (Dionysus), but also to the soul of the philosopher himself, who was irretrievably 'lulled to sleep' in Turin.[16] Stylistically, the influence of Quattrocento Tuscan painting (which he had studied in Florence) endowed de Chirico's work with a new sense of immobility and melancholy, a pictorial metaphor of the Nietzschean concept of time standing still.[17]

As the theory contained in the manuscripts attests, de Chirico conceived the means of representing the inversion of values through images of architecture. He recalled that had he first experienced 'metaphysical illumination' while meditating

on the architecture of the Piazza Santa Croce in Florence, during the period of his intense study of Nietzsche. By virtue of its essentially geometric volumes, architecture became a marvellous repository of significance: house, box, toy, pure abstraction, at once everything and nothing, interior and exterior, empty and full, the habitation of dream and memory. In the course of observing a building or group of buildings, different suggestions, sensations and memories entered the mental process of the artist and were recomposed to form new images.[18] The reduction of the architectural object to its geometric essence, to a spectre of reality, gave de Chirico the idea of creating what he termed *'solitudine plastica'* ('plastic solitude').

Once he had achieved this method of representation, he proceeded to the more complex *'solitudine dei segni'* ('solitude of signs'), which created extraordinary possibilities for the transmigration of meanings.[19] 'Plastic solitude' conferred a second life upon the object, one that was purified, absolute and spectral. 'Solitude of signs' went further, invoking other images, and hence other signs and meanings, in the reading of a painting. A multitude of spectres of things, stripped of their conventional references, were associated with each other in an order that had nothing to do with common logic.[20] According to the now classic categories established by Charles Peirce, certain signs indicate the thing through similarity or analogy (houses, statues, trains, artichokes, gloves), some allude to the thing through correspondence (shadows for people, maps for landscape), and others, the most truly symbolic, signify ideas through association (sail = voyage).[21] Naturally, all signs of the first two categories also had a symbolic value, and their functions were often interchangeable. The signs were distributed in a new spatial syntax – an unresolved perspective of conflicting vanishing points – which embodied an order of illogicality. What emerged was a curious counterpoint, where reason ordered the multivalence of signs in a continual colloquy with folly.[22]

With this discovery de Chirico accomplished in pictorial and visual terms a revolution comparable to that which had overturned concepts of word, sign and language in philosophy and linguistics at the turn of the century. Here too, Nietzsche was a forerunner; considering the word a convention, he deduced that elements of language received their particular significance from the contexts in which they were presented. He thus anticipated a key principle of semiology, namely, that the word has value, not through what it denotes, but through its potential to evoke associations. A sign does not have a fixed meaning, but a field of significants, and its concrete value depends on the context of the phrase. Nietzsche realized that the common usage of a word was not suitable for expressing certain types of thought, and he therefore took apart traditional language to construct a new order based on the metaphor.[23] Similarly, de Chirico became aware that he had to capture the 'demoniacal' order of things by means of association rather than representation.

Belonging to a culture which conceived of spirit and matter as opposites, painting of the early twentieth century moved increasingly towards abstraction in an attempt to liberate the former from the latter. De Chirico, on the other hand, shifted the focus of pictorial discourse, grasping the fact that the spirit lay, not beyond, but within matter. The quality of the thing itself, divested of fixed, pre-ordained significance, could be perceived only by disrupting linguistic systems. To accomplish this, de Chirico did not substantially modify the technical vocabulary of pictorial representation. Instead, he established a new syntax, playing with the stable structures of our consciousness which regulate the elements of language and expanding the boundaries of reason to encompass an unconditional freedom that held the possibility of disrupting any order.

Having mastered this system, de Chirico experienced a sort of creative euphoria between the end of 1913 and 1915. He produced many 'idea' paintings, which seem like rebuses. At the same time, he refined his skills as a 'veteran of metaphysical surprise', choosing shop signs, gloves, cannons and the strangest of objects along with exotic fruits and French artichokes (Fig. 4). His most significant discovery, however, consisted in the application of aesthetic 'filters'. Obsessed with the necessity to reduce the represented thing to its essence, to free it from connotations of

18 P. Baldacci, 'Le classicisme chez Giorgio de Chirico: Théorie et méthode', *Cahiers du Musée d'Art Moderne*, 11, 1983, pp. 18-31, especially p. 22.

19 De Chirico elucidated the theory of the metaphysics of signs in 1919 in the paragraph 'I segni eterni' of his article 'Sull'arte metafisica' (De Chirico, *Il meccanismo*, p. 86).

20 A detailed explanation of the *'solitudine dei segni'* theory is given by M. Calvesi, *La Metafisica schiarità: Da de Chirico a Morandi a Savinio*, Milan, 1982, pp. 224-6. See also Baldacci, 'Le classicisme', pp. 21-3.

21 G. P. Caprettini, *Aspetti della semiotica*, Turin, 1980, p. 55.

22 De Chirico, *Il meccanismo*, pp. 84-5 (1919). For a discussion of modern aspects of this concept of the relationship between madness and reason, see U. Galimberti, *Gli equivoci dell'anima*, Milan, 1987, pp. 62-8, 252.

23 F. Nietzsche, *Über Wahrheit und Lüge im ausser-moralischen Sinne*, in *Sämtliche Werke*, vol. 1, pp. 888-9. See also J. P. Stern, *Friedrich Nietzsche*, Harmondsworth, 1978, pp. 144-54.

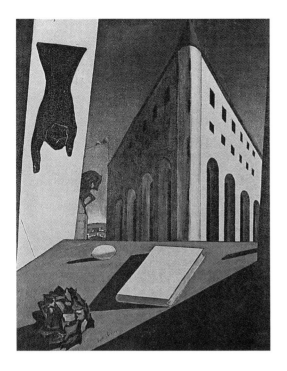

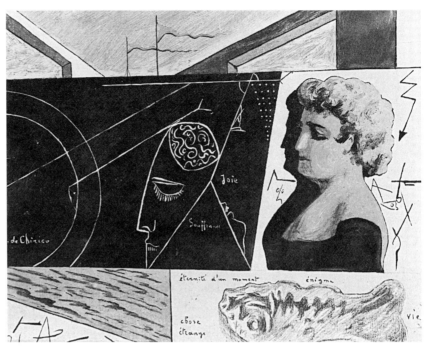

Fig. 4 Giorgio de Chirico, *Still-Life: Turin in Spring*, 1914. Private collection

Fig. 5 Giorgio de Chirico, *The Fatal Temple*, 1914. Philadelphia Museum of Art (A. E. Gallatin Collection)

24 For de Chirico's use of Reinach, see Baldacci, 'Le classicisme', p. 29.

25 De Chirico's most literal borrowing from Nietzsche is found in the painting *Il tempio fatale* (*The Fatal Temple*, 1914); see Baldacci, 'L'estetica', pp. 65-6, and for other paintings, idem, 'Le classicisme', pp. 24-9.

26 M. Fagiolo dell'Arco, 'De Chirico in Paris', in Rubin, ed., *De Chirico*, pp. 24-7, and G. Apollinaire, 'Die Moderne Malerei', *Der Sturm*, February 1913 (repr. in *Apollinaire on Art: Essays and Reviews 1902-1918*, ed. L. C. Breunig, New York, 1972, pp. 268-70).

27 For an analysis of the concept '*originario*', see R. Barilli, 'De Chirico e il recupero del museo', in *Tra presenza e assenza*, Milan, 1974, 2nd ed. 1981, pp. 268-303.

28 Heraclitus, in Diels and Krantz, *Die Fragmente*, n. 123. See also A. Savinio, 'Anadiomenon', *Valori Plastici*, 1, nos. 4-5, 1919, pp. 6-14; de Chirico, *Il meccanismo*, pp. 149-50 (1920); and Baldacci, 'L'estetica', pp. 40, 52-3.

29 For the Orphic religion, see J. P. Vernant, 'Aspects mythiques de la mémoire', *Journal de Psychologie*, 1959, pp. 1-29; M. Detienne, *Les maîtres de vérité dans la Grèce archaïque*, Paris, 1967; U. Galimberti, *Gli equivoci*, pp. 20-32; and for de Chirico's and Savinio's utilization of its tenets, Baldacci, 'L'estetica', pp. 40-51.

time and nature, he incorporated plaster casts rather than copies of actual statues (even his monuments seem to be made of plaster), referred to elementary drawing manuals with anatomical parts rendered in cross-sections or used schematic outlines of classical Greek statues taken from the archaeology manual of Salomon Reinach.[24] Cryptic allusions to philosophical truths became frequent, in many cases constituting a literal interpretation of Nietzsche's doctrine: hieroglyphs, arrows, black hands with the index finger pointing downwards, large 'X's traced on walls and the juxtaposition of words and symbols (Fig. 5).[25]

De Chirico was encouraged in his mystical fervour by discussions with Guillaume Apollinaire and his circle on the ancient Orphic religion, its doctrines of the soul and the function of poetry.[26] These ideas led the French poet to coin the term 'Orphism' for one type of lyrical Cubism, but for de Chirico and Savinio the complex Orphic themes were merged with the idea of art as mystical revelation. Both came together in the concept of '*originario*' ('ur'-language), as opposed to '*originale*' (original in the sense of 'novel'), which constituted a cardinal point of their artistic theory.[27] Art that revealed the magical contents of the sign hidden within all things was *originario* and, like the sacred character of the art of 'primitive' peoples, was subject to rules and rites of mediation. Nature was contemplated as an immobile monument of signs, recognizing neither past nor future and having its eternity in the present. This was a nature that hid its true essence from common man and that the artist had to grasp through a process of intellectual translation, the process of irony, modifying and deforming natural appearances.[28] The genesis of art, in de Chirico's definition, therefore lay in the expression of concepts through forms mediated by intelligence. In a manner similar to the ritual of initiation in the Greek mysteries, the artist found in the riddle or in the recreation of a myth the only possibility of alluding to the enigma of things, bringing him closer to the possession of truth.

The de Chirico brothers' vision of art as a form of redemption, purged of all connotations of time, is linked directly to Orphic doctrines and the Greek concept of Mnemosyne, the persona of Memory. In Orphic religion, Memory redeemed man from his individual destiny through an anamnesis that reunited the soul with its divine principle and removed it from the temporal cycle of life.[29] In Greek mythology Memory-Mnemosyne was the mother of the Muses and art and also the inspiration of the poet who, by means of poetic creation, wrested from chaos a stability greater than that possessed by temporal phenomena. Memory in this sense was not the reconstruction of the past in a time sequence, but a faculty of divine character

that permitted the poet to decipher the invisible, to lend his images a magical religious power and give the autonomous symbolic world the effect of the real. As Savinio later stated, art created an absolute value for objects, separating the lyrical from the dramatic, that is, the transitory and temporal from the static and eternal. In this way, art became a process of initiation; it derived from memory and not from the dream, escaping the dominion of the future and the past.[30] Like Picasso, de Chirico assumed the artistic right to travel in time and space, becoming the interpreter of a new humanistic culture – one no longer based on a diachronic concept of history, but on atemporal and synchronic structures of perception and psychology.

The theory of memory contained the idea of contracting time past and time future into time present. De Chirico achieved this pictorially through the spectral representation of the object, removing it from the temporal and logical sequence of cause and effect, and through the use of reversed perspective as 'a symbolic form of memory'. Unresolved vanishing points evoked memory as an illogical faculty which, like the vision of Mnemosyne, proceeded through flashes of inspiration towards both the past and the future. Metaphysical art became the representation of the immobility of the present, or the domain of metahistory, dissolving the traditional concept of time into a series of completely equal moments.

The integration of these theories and concepts into the Metaphysical system of thought owed a great deal to Savinio. Yet de Chirico had already translated these ideas into two paintings in his Paris period: *Ritratto di Apollinaire* (*Portrait of Apollinaire*) and *Il sogno del poeta* (*The Dream of the Poet*; Fig. 6), both of 1914. In the former, the father of literary and pictorial Orphism is depicted in silhouette, like a black target. In the foreground of both pictures a statue wears the sun-glasses of a blind person, the attribute of poetry as a far-seeing art. The form of a fish-mould, the Orphic symbol *par excellence* (which later became part of early Christian imagery), is drawn and modelled in pencil against a white rectangle of raw canvas.[31]

The same concepts gave birth to the mannequin figure in de Chirico's work, during a period of fertile collaboration with Apollinaire and Savinio. The faceless man appeared initially in a piece by Apollinaire published in *Les soirées de Paris* in February 1914, where it was an Orphic-Dionysian personification of the poet himself and his sexuality, modelled on the mythic figure of Pan. In July of that year, Savinio adapted it for the Metaphysical poet in his *Chants de la mi-mort*. Basing his image on Savinio's characterization, de Chirico first used the mannequin in *The Dream of the Poet*, paired with the statue wearing sun-glasses. A tailor's dummy in

Fig. 6 Giorgio de Chirico, *The Dream of the Poet*, 1914. Peggy Guggenheim Collection, Venice

Fig. 7 Giorgio de Chirico, *The Seer*, 1915. The Museum of Modern Art, New York (James Thrall Soby Bequest)

Fig. 8 Giorgio de Chirico, *The Great Metaphysician*, 1917. The Museum of Modern Art, New York (Philip L. Goodwin Collection)

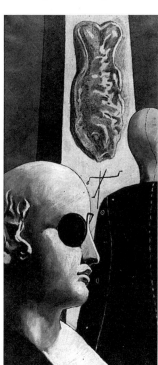

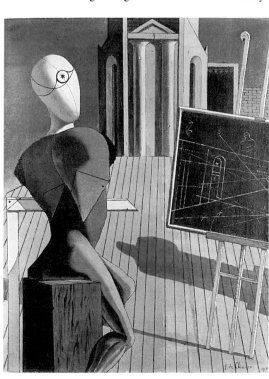

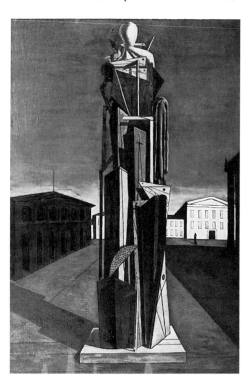

30 A. Savinio, 'Anadiomenon (principi di valu-
 tazione dell'arte contemporanea', *Valori Plastici*,
 1, nos. 4-5, 1919, pp. 6-14; idem, 'Fini
 dell'Arte', *Valori Plastici*, 1, nos. 6-10, 1919,
 pp. 17-21; idem, 'Primi Saggi di Filosofia delle
 Arti', *Valori Plastici*, 3, no. 2, 1921, pp. 25-9,
 no. 3, 1921, pp. 49-53, no. 5, 1921, pp. 103-5.
 For Savinio's theoretical contributions between
 1919 and 1924, see Baldacci, 'L'estetica',
 pp. 37-55.

31 R. Eisler, *Orphische-Dionysische Mysterien-Gedan-
 ken*, Leipzig and Berlin, 1925, p. 116.

32 W. Bohn, 'Apollinaire and de Chirico: The
 Making of the Mannequins', *Comparative Liter-
 ature*, 27, no. 2, 1975, pp. 153-65.

33 The increasingly hermetic tone was directly
 related to de Chirico's sense of isolation and
 dejection, as Savinio noted in a letter of 7 July
 1917 to Ardengo Soffici (A. Savinio, 'Cinquan-
 tanove lettere ad Ardengo Soffici, edite da
 M. C. Papini,' *Paradigma*, 4, February 1982).
 This is confirmed by de Chirico's few extant
 writings from the Ferrara period.

34 M. Fagiolo dell'Arco, *Giorgio de Chirico: Il tempo
 di 'Valori Plastici'*, Rome, 1980.

35 Baldacci, 'Le classicisme', p. 19, n. 1. For a dis-
 cussion of the 'plagiarism' of de Chirico's ideas
 on the part of Soffici and Carrà, see J. Lukach,
 'De Chirico and Italian Art Theory', in Rubin,
 ed., *De Chirico*, pp. 35-54.

this painting, it became a composite figure made of nailed sheet metal before assuming its definitive form in *Il vaticinatore* (*The Seer*, 1915; Fig. 7). A study of the genesis of this typology has shown that the black lines on the mannequins' heads (initially placed at the level of the mouth, then at that of the eyes) are metaphysical symbols indicating non-human speech and sight.[32] They refer to the transcendent, prophetic voice and the superior vision (*epopteia*) of the poet, bestowed on him by the muse Mnemosyne in exchange for relinquishing the faculty of perceiving natural phenomena. Apollinaire, Savinio and de Chirico, each in his own way, came to identify with this symbol of poetic creation.

The First World War brought de Chirico and Savinio back to Italy in 1915, where they were sent to Ferrara on military service. Here de Chirico refined his linguistic play in increasingly elaborate and at times almost abstract images. The so-called 'Ferrara interiors' (Cat. 49, 51) are claustrophobic, hermetic compositions, evocative assemblages of biscuits, bread rolls, boxes of matches, maps and fishing equipment, richly painted in a hallucinatory realism.[33] This hermeticism is exemplified in one of the most important paintings of the epoch, *Le rêve de Tobie* (*The Dream of Tobias*, 1917; Cat. 50).[34] In the biblical tale the young Tobias, guided by the Archangel Raphael, cured his father's blindness with the gall of a fish. In the painting the word 'AIDEL' (from the Greek *a-idel*[*on*], 'invisible') appears on a truncated pyramid divided into sections, next to a slender mercury thermometer. The box to the right of the pyramid contains a composition with arcades, the one on the left an interior with a metal fish-mould leaning against two trestles on the floor. The thermometer alludes to Mercury, messenger of the gods, conveyer of dreams and guide of souls to Hades (*A-ides*), the invisible realm. The mould refers to the fish of Tobias, which restored sight. Both Tobias and Mercury are symbols of the artist as poet, as metaphysician who reveals the mysteries of dreams, the significance – better, the non-significance – of the phenomenal world (or the true realm of the invisible, according to Orphic theory).

A constant personification of the poet-seer, the mannequin in the Ferrara paintings becomes charged with a new element of pathos and melancholy, encapsulated in the elegance of its mannered poses. In *Il grande metafisico* (*The Great Metaphysician*; 1917; Fig. 8) a tower or totem-man stands in a deserted square. His strange form, a kind of human Tower of Babel, denotes the composite knowledge of the new artist, who 'knows all games and speaks all languages' (as Savinio put it in *Chants de la mi-mort*), and presages the figures of the 1920s, whose stomachs are replete with archaeological ruins and symbols of cultural history. During the Ferrara period, de Chirico also invented his peculiar iconography of a painting within a painting, as in *Interno Metafisico con grande officina* (*Metaphysical Interior with Large Factory*, 1917; Cat. 48). The interior image is rendered in a richly painted realism and surrounded by 'cabalistic' signs – canvas stretchers, draughtsmen's triangles and the spectres of paintings – hence exposing the paradox of illusion and reality and questioning the very meaning of truth.

At the end of 1918, de Chirico left Ferrara for Rome, where he was joined by Savinio, recently returned from military service as an interpreter in Greece. The Rome period (1919-24) was marked by intense collaboration on the magazines *Valori Plastici*, *Il Convegno*, *Il Primato* and *La Ronda* and by a new symbiosis of ideas between the two brothers. The strong spirit of rivalry and the lively debate on artistic ideas at the end of the war prompted them to clarify and publish their theories. De Chirico redefined the canons of Metaphysical aesthetics, locating them within the broader and more specific denomination of 'Classicism'. Although this became a loaded term in the climate of restoration prevalent during the Fascist period, he did not intend it as a return to order or tradition. He chose it in contradistinction to the word 'metaphysical', which had been usurped and interpreted incorrectly by others, particularly Carlo Carrà, and as a defence against what he considered to be plagiarism of his ideas and images.[35]

The literature on de Chirico has failed to examine the close rapport between the poetic theory of the Parisian manuscripts and the concepts inherent in Classicism,

which govern his painting of the twenties.[36] The reduction of the object to a linear skeleton or sign, the representation of the eternal present and the use of perspective as a symbolic form were principles that de Chirico continued to adhere to in the post-war period.[37] In the articles 'Zeusi l'esploratore' and 'Sull'Arte Metafisica', published in *Valori Plastici* in 1918 and 1919, he set out the fundamental concepts of *'solitudine plastica'* and *'solitudine dei segni'* in a systematic elaboration of the earlier theory which allowed a radical critique of dreams and an exercise of control over madness. This included a precise distinction between biological memory (which established a habitual relationship between things) and the poetics of Mnemosyne, between the dream as a state of romantic fermentation and the higher, classical state of control over intelligence.

In contrast to the theoretical coherence of his essays, de Chirico's paintings of this time are marked by experimentation, as he abandoned earlier typologies and symbols and sought to weld the same ideas of eternity, solitude and mystery into a more intelligible, clear figuration. Investigating the archetypal quality of the past, he studied the Old Masters and Dominique Ingres in an attempt to endow his work with a sense of 'what always is'. His search was now orientated more towards the refinement of *'solitudine plastica'* than of *'solitudine dei segni'*, which had been the premise of the Ferrara period.

Fig. 9 Giorgio de Chirico, *Self-Portrait with Bust of Euripides*, 1923. Private collection

Among the some 120 paintings produced between 1919 and the end of 1924, over twenty-five are self-portraits, in a variety of historical styles and each the vehicle of a specific message. De Chirico identifies himself with Mercury, Euripides (the first poet-philosopher; Fig. 9), Heraclitus and Ulysses. He is portrayed with his mother, muse and protector, or with his brother, coupled with him like a shadow to emphasize their close affinity and collaboration. He depicts himself in duplicate, with a statue of himself in a complex allegory of time (Cat. 68) or with his soul in the form of a white silhouette.

Another important group of paintings came closer to the iconography of the early Metaphysical works, again merging allegory with personal artistic credo. In *La sala di Apollo* (*The Hall of Apollo* or *The Broken String*) the violin in front of the bust of Apollo resting on a table in an 'oracular' interior alludes to the myth of Apollo and Marsyas, that is, to the victory of the stringed instrument (art governed by intelligence) over the wind instrument (art governed by emotion). The choice of the violin rather than the lyre was influenced by Raphael's fresco *Parnassus*, in which Apollo plays an

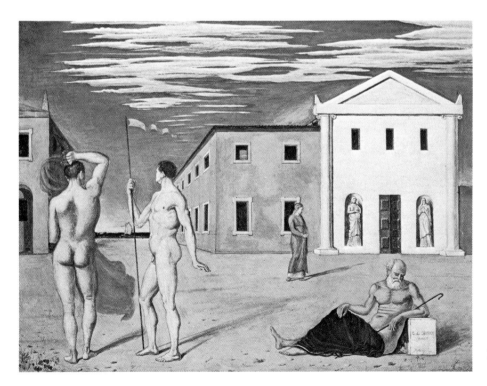

Fig. 10 Giorgio de Chirico, *The Departure of the Argonauts*, 1922. Private collection

36 The catalogue of the 1982 exhibition at The Museum of Modern Art in New York (Rubin, ed., *De Chirico*) betrays the limits of current critical comprehension of Metaphysics. Rubin's essay, 'De Chirico and Modernism', pp. 55-99, offers a formalist interpretation and assesses the artist's work solely on the basis of its connections with various modernist currents. In the preface, p. 7, a distinction is made between early and late de Chirico (the latter seen as less relevant to modern painting as a whole) which has impeded a full understanding of de Chirico's aesthetics. Even the valuable essay by J. Lukach, 'De Chirico', considers de Chirico's Classicism to be substantially opposed to Metaphysics. In substance, critics of de Chirico are still divided into those who have always rejected the intellectual and conceptual premises, reproaching them for a lack of stylistic and 'moral' unity (R. Longhi, 'Al dio ortopedico', *Il Tempo*, 22 February, 1919, and C. L. Ragghianti, *Il caso de Chirico: Saggi e studi di C. L. Ragghianti, 1934-1978*, Florence, 1979) and those who, precisely because they are drawn to the more immediately striking aspects of the Metaphysical revolution, have failed to recognize the elements of continuity in the later work, regarding the year 1919 as a point of rupture (Soby, *De Chirico*). This latter view revives that of the Surrealists, adhered to by Rubin and to some degree by M. Calvesi, *La metafisica*. The ideological unity of de Chirico's work was already grasped by J. Cocteau, *Le Mystère laic*, Paris, 1929, while Italian post-war criticism initiated a general reassessment of the artist (C. Maltese, *Storia dell'arte in Italia, 1785-1943*, Turin, 1970; R. Barilli, 'De Chirico'). In recent years, research has turned its attention to the philosophical and literary sources (Pre-Socratic Greek philosophy, Schopenhauer, Nietzsche, Otto Weininger), examining the manuscripts, deciphering the iconography and comparing the work of de Chirico with the literary and pictorial output of Savinio.

37 G. de Chirico, 'Classicismo Pittorico' (1920), in *Il meccanismo*, pp. 101-2, 142.

38 De Chirico, *Il meccanismo*, pp. 18, 20. To achieve the atmosphere of the *Ville Romane*, de Chirico looked deeply into the work of Claude Lorrain and Nicolas Poussin, echoes of which can be found in his writings from the period. He also probed the conviction that aspects of history or culture can be objectified in complexes of signs. See his article on Gustave Courbet in *Il meccanismo*, p. 247 (1924).

39 P. Baldacci, 'De Chirico: Le date, il tempo, la storia', in *Giorgio de Chirico: I temi della Metafisica*, Milan, 1985, pp. 5-11.

40 Barilli, 'De Chirico', p. 270.

41 'Vale Lutetia' was published in *La Rivista di Firenze*, 1, nos. 8-12, 1925, and reprinted in *Il meccanismo*, pp. 267-71. G. de Chirico, *Hebdomeros*, New York, 1988, p. 70.

instrument that is a precursor of the violin. The series of so-called *Ville Romane* (*Roman Villas*; Fig. 10) readdressed the theme of the metaphysics of place with a more acute sense of history. A direct precedent for these paintings can be found in de Chirico's observations in the Paris manuscripts on the meaning of architecture and its ties with the character and history of human beings.[38]

Finally, the figure of the mannequin reappears in six paintings created in 1922-3, including *Ettore e Andromaca* (*Hector and Andromache*, 1923). Although painted in a completely new style, this was deliberately backdated 1918: an affirmation of the 'free will to go backwards' and a conscious attack on the romantic concept of the uniqueness of the work of art.[39] The etymological significance of 'to repeat' is 'to return', to direct oneself towards the path already taken. Beginning in 1917, the theme of 'return' and 'those returning' recurs throughout de Chirico's writings and work in the theory of reincarnation, in the repetition of one's double and in the parable of the prodigal son as an allegory of a reunion of past and future. Nietzsche's aphorism of the eternal present and eternal return, which so influenced de Chirico's ideas on memory and the poetics of space, was thus applied as a strategy to his own career as an argument for the conviction that authenticity and uniqueness reside in ideas more than in execution of the work itself.[40]

Disillusioned by the incomprehension and hostility that surrounded him in Italian art circles, de Chirico returned to Paris at the end of 1924 and was joined there by Savinio in 1926. He had been acclaimed the father of the Surrealists (who even made pilgrimages to Rome to meet him); now he insisted with particular vehemence that his aesthetics gave art the revolutionary faculty of reabsorbing non-sense, even madness, into a higher, all-encompassing order that expanded the limitations hitherto assigned to reason and linked the work of the artist to that of such 'liberators' as Schopenhauer, Nietzsche and Arthur Rimbaud. In this way, de Chirico clearly distinguished himself from the Freudian standpoint of the Surrealists, who viewed madness in the illuministic tradition, as a principle antagonistic to reason. The rupture that occurred in mid-decade between de Chirico and the group led by André Breton was the result, not of any conceptual change in Metaphysical art, but rather of the profound difference between the concepts of Greek philosophy used by de Chirico and Savinio to interpret the unconscious and the Freudian basis of Surrealist aesthetics.

Nonetheless, renewed contact with France did bring about a critical change in de Chirico's painting, as he accorded the multivalence of signs a new unity. In the essay 'Vale Lutetia', written at the end of 1924, he described the strange sensations of the large modern city and suggested ways of creating a new iconography by unexpected superimpositions of the popular and the classical. Memories of the past and predictions of the future intermingle: 'So this is Paris. Every wall carpeted with *réclames* is a metaphysical surprise; the giant putto of Cadum soap and the red colt of Poulain chocolate rise forth with the disquieting solemnity of ancient mythical divinities.' In a similar image from his 1929 novel *Hebdomeros*, he remarked: 'A magic word shone in space like Constantine's cross and was repeated down to the far horizon, like an advertisement for toothpaste: Delphi! Delphi!'[41]

Struck by these visions, de Chirico found his first homogeneous style since the Ferrara years. In his Metaphysical paintings he had thought of painting as a syntactical fabric of multivalent signs. During his second period in Paris, this proven system was simplified and, in a certain sense, deepened: from polyphonic representation he progressed to monologues. The bewildering association of apparently incongruous elements no longer took the form of opposing different objects with one another, nor was there recourse to strange and incoherent perspectives. The multifarious and hitherto discordant elements were condensed into a single subject and coherent narrative. The signs were united in one form – a woman, horse, mannequin, gladiator or trophy (see Cat. 70, 72) – and immersed in a unified colour and atmosphere. Colour, which had previously served merely to emphasize the *Stimmung* of de Chirico's paintings, now emerged in all its lyrical and evocative power, itself becoming a sign.

The linear form of the figure, simplified to the greatest degree and transferred to the realm of archetypes, is both an icon and a symbol: a woman or a horse represent a woman or a horse because they resemble these things, but in their generality and atemporal quality (many of the forms derive from the diagrams in Reinach's manual) they refer to everything that these images can bring to mind, everything related to our personal imagination and psychology or to our collective cultural memory. Colour acquires the value of an indicative sign, which refers to something else through correspondence and which actualizes the mythical recollection. The colours are those of advertisements, neon signs and rubber toys. The unique figure is transformed into an absolute hybrid, released from any specifics of style, time and space. Glorification in the absence of style is also the amalgam of all styles: it is the triumph of kitsch, in the sublimation of which the artist sees the fulfilment of his metahistorical vision.

De Chirico thus dissolved the barriers of time and space by drawing on all forms and all styles, by referring to, and paraphrasing, other worlds, other epochs, other civilizations. The metaphysical *Stimmung* ceased to derive from the association of incongruous objects, but came instead from the conflation of incongruous cultures. Art was removed from the vagaries of time, and the past made present through its transformation into an everyday, absurd piece of bric-a-brac. As Savinio remarked, the soul of ancient Greece is no longer to be found in books, but in a boot-jack in the form of a lyre.

Hebdomeros, the protagonist of de Chirico's 1929 novel of that name, experiences such a visionary voyage through languages, rhetorical formulae and styles, at times praised or parodied. A man without a country, accustomed to viewing Italy from the perspective of *fin de siècle* colonial Greece, to seeing Greece through the buildings of Bavarian architects or the casts in the Munich Glyptothek, and Germany through the pseudo-Mediterranean filter of Nietzsche and Böcklin, de Chirico himself possessed the cultural agility embodied in Hebdomeros. In the novel de Chirico frequently referred to the 'fashion of 1880', to those decorative interiors of gambling casinos where myth entered bourgeois life, where all styles, from Greek to Egyptian, coexisted in an accumulation that gave concrete form to what Nietzsche had called 'the age of comparison'.

An analogous use of aesthetic filters (Reinach's manual, Old Master prints, family photographs) was employed by Savinio when he turned to painting in 1926.[42] Yet compared to the contemporary work of de Chirico, Savinio's painting had a more conspicuous autobiographical and ironic flavour, a more acerbic delight in desecration. The narrative of Memory, at this point blurred or entirely abandoned in his brother's painting, gave rise to an Olympus of bourgeois divinities (see Cat. 77) which was also present in his literary works. One theme peculiar to Savinio was that of animal-men, inspired by mythology, the psychology of the Viennese philosopher Otto Weininger and the Orphic beliefs underlying metempsychosis (see Cat. 81).[43]

The vast body of themes and theories found in the art and writing of the de Chirico brothers did not find immediate acceptance, neither has it been comprehended in all its subtle implications. One of the most telling aspects of Metaphysical art is the paradox of its widespread influence, which was felt both by Dada and Surrealism, on the one hand, and *Neue Sachlichkeit* and the *Novecento*, on the other. For only by penetrating the philosophic 'substratum' of metaphysics, can one understand how it can be one thing and at the same time its opposite, how the basis of de Chirico's ideology lies in precisely this *coincidentia oppositorum*, in the uniting of revolution and reaction, modernity and tradition, past and future, high culture and kitsch.

42 P. Vivarelli, *Alberto Savinio: Disegni immaginati*, Milan, 1984, esp. p. 133.

43 Otto Weininger, *Geschlecht und Charakter*, Vienna, 1903, and *Über die Letzten Dinge*, Vienna, 1907.

Wieland Schmied

De Chirico, Metaphysical Painting and the International Avant-garde: Twelve Theses

Giorgio de Chirico remains among the most controversial of all twentieth-century artists. There is no other figure of such seminal importance on whom the experts' opinions are so divided or their interpretations so widely divergent. De Chirico himself – through repeated abrupt stylistic changes, deliberate inconsistencies in dating and, indeed, through outright repudiations of works by his own hand – went some way to compound the confusion. Furthermore, the very nature of his Metaphysical painting of the period 1910-19 and the later mythological works of the 1920s positively invites subjective interpretation and varying reactions. It is true that recent research, especially that of Maurizio Fagiolo dell'Arco, has done much to set future scholarship on a sure footing; but so many open questions, unsettled issues of fact and unresolved paradoxes remain that any attempt to confront de Chirico must necessarily be a personal one. An introduction to de Chirico's complex imagery and its influence on the international avant-garde should make plain this degree of subjectivity. This is why I have chosen the word 'theses' to describe the remarks that follow: my purpose is to focus on a number of salient issues in the controversial case of de Chirico, and to open them up to debate.

First Thesis: Metaphysical painting and Futurism are the Italian contribution to modern art There is nothing controversial about the statement that Metaphysical painting and Futurism, which evolved simultaneously in the autumn of 1910, constitute Italy's central contribution to modern art.[1] The question arises however, as to whether both can be considered equally revolutionary, or if the epithet 'truly modern' does not properly belong to Futurism alone. No less distinguished an authority than William Rubin recently argued forcefully for the claims of de Chirico as against Boccioni.[2] I accept as a basic principle the contemporary relevance of both movements: Futurism and Metaphysical painting embody two diametrically opposed aspects of modernism. One represents the celebration of progress, a fascination with speed and aggression, the desire to capture the fleeting instant; the other a scepticism towards technology and progress, a preoccupation with the immobility of objects, an obsession with timelessness and immutability.

Second Thesis: De Chirico is the great outsider in Italian modernism In the context of Italian art, de Chirico was an outsider from the day he was born. Born in Greece to Italian parents, he was trained in Germany, and it was there that he gained his earliest experience as an artist. He spent a short time in Italy, more or less as a foreigner, before leaving, this time for Paris, where he developed his own style in isolation outside the mainstream of modernism. His early career was thus entirely peripheral to twentieth-century Italian art.

De Chirico was born on the periphery of the modern world, in the Thessalian port of Volos, which had only recently been transferred to Greece from the Ottoman Empire. He never regarded this as an accident of birth, but as something pre-ordained by fate. His parents gave him a decidedly strict, not to say old-fashioned upbringing. Up to his seventeenth year, his whole education, first in Volos and then in Athens – where his father died in 1905 – was centred on the study of the ancient world, lessons in drawing from the antique, languages (French and German) and ancient and modern literature. All his life, he seemed to those who met him like a man from another world and another age, deeply rooted in the archaic social patterns of the nineteenth century. He himself saw matters differently: he had been born in

1 De Chirico's first Metaphysical work and Boccioni's first Futurist painting both date from October 1910. See M. Calvesi, *Der Futurismus*, Cologne, 1987, and P. Baldacci, in J. Harten and J. Poetter, eds, *Mario Sironi*, Cologne, 1988.
2 W. Rubin, 'De Chirico and Modernism', in idem, ed., *De Chirico*, New York, 1982.

the very centre of the civilized, 'Homeric' world and was much more at home in antiquity than in modern times. Until he reached middle age, he viewed the world through the archetypes of classical mythology. He saw himself as one of the legendary Argonauts, who sailed from Volos in their quest for the Golden Fleece. He and his younger brother, Alberto Savinio (who had an artistic career of his own, as a painter, stage designer, composer and writer), identified with the Heavenly Twins, the Dioscuri, and believed themselves invincible (Fig. 1).

From the perspective of turn-of-the-century Athens, Munich was the epitome of the modern metropolis; yet for de Chirico, there was also an intimate link between the two cities. Many artists from Greece had studied in Munich, and one – Nikolaus Gysis – had taught there earlier, at the Akademie der Bildenden Künste. And so de Chirico's knowledge of Phidias was supplemented by that of the mythological figures of Arnold Böcklin, and his grounding in Greek mythology by a growing fascination with Friedrich Nietzsche, who had derived a whole new philosophy from the spirit of the pre-Socratic philosophers.

De Chirico entered the context of Italian art only in 1915, when he moved from Paris to Ferrara, and even there his life at the Villa del Seminario did little to lessen his isolation. It was not until he left Ferrara for Rome in 1918 that Italy really became his home. His work after the First World War belongs unequivocally to the Roman milieu, and this applies to more than just its iconographic content.

Fig. 1 Giorgio de Chirico, *Self-Portrait with Savinio*, 1924. Private collection

Third Thesis: De Chirico's Piazze d'Italia could be called Piazze di Monaco What did Giorgio de Chirico owe to Munich? He studied there, at the Akademie der Bildenden Künste, from early October 1906 until the end of March 1910; he visited the museums – the Pinakothek, the Schack-Galerie – where he discovered the art of Böcklin, Hans Thoma, Max Klinger and Moritz von Schwind; he fell under the spell of German philosophy, and Nietzsche, Arthur Schopenhauer and Otto Weininger became his intellectual heroes. In Munich he attended performances of Wagner's operas and painted his early mythological pictures in the manner of Böcklin. We might adapt the words of his favourite philosopher, Nietzsche (*The Birth of Tragedy from the Spirit of Music*), and speak of the 'Birth of Metaphysical Painting from the Spirit of Munich'. And even though this birth did not take place until several months after he left Munich – in Florence, in fact – the 'instant of conception' can be assigned to Munich.

We might even go one step further: the Metaphysical paintings that de Chirico referred to from a very early date as *piazze d'Italia* might well be entitled the *piazze di Monaco*. De Chirico's city squares were based not only on those which he saw in Florence and Turin but, specifically, on Odeonsplatz with the Feldherrnhalle; Max-

Fig. 2 Giorgio de Chirico, *The Sailor's Barracks*, 1914. The Norton Gallery of Art, West Palm Beach, Florida

Fig. 3 Arcades of the Hofgarten, Munich

Joseph-Platz with the Residenz, Nationaltheater and Hauptpostamt; Königsplatz with the Glyptothek, Propyläen and Antikensammlung; and, above all, the Hofgarten enclosed by arcades (Figs. 2,3).

The silent images of de Chirico's cityscapes are Italianate rather than Italian; the Munich squares themselves were *piazze d'Italia* at one remove. Hence the paintings inspired by de Chirico's Munich experience reflect the age-old German yearning for Italy (something that also fascinated him about Böcklin and Klinger). This same nostalgia for Italy was what led northern architects and city planners to Mediterranean models, recreating the spatial experiences they remembered from their visits to the South.

What Munich meant to the young de Chirico on his arrival from Greece was nothing less than a successful marriage of Northern emotion and Mediterranean intellect, of vague yearning and brilliant clarity, of the Renaissance and the present day (although he himself associates Munich with much more sombre matters in his *Memorie della mia vita*, written after the Second World War). What Munich offered him through its architecture and sculpture was the living synthesis of irreconcilable opposites which he was to pursue in his painting for the rest of his life.[3]

Fourth Thesis: De Chirico depicts the isolation of modern man in an alienated world The contemporary world, as it revealed itself to de Chirico in the first decade of the century, seemed inextricably linked to antiquity. This perspective was disrupted – and such a break with history is the very definition of modernism – when he travelled to Florence in the autumn of 1910. He described the experience in a passage that resembles Edgar Allan Poe in its tone, and captured the sensation in the now lost *Enigma di un pomeriggio d'autunno* (*Enigma of an Autumn Afternoon*, 1910).[4]

In Paris, this sense of a break was further emphasized by his encounter with the avant-garde, in particular, with the Cubism of Pablo Picasso. It was a painful experience that de Chirico never succeeded in fully comprehending, but it also led to the invention of Metaphysical painting in Paris between 1911 and 1915. In paintings such as *Canto d'amore* (*The Song of Love*; Fig. 4), *Mistero e malinconia di una strada* (*The Mystery and Melancholy of a Street*) and *L'enigma di una giornata* (*The Enigma of a Day*), all painted in 1914, de Chirico gave formal expression to that schism which runs through the consciousness of modern humanity, giving rise to its paradoxes and contradictions. He renders visible what cannot be reasoned: the coexistence of disparate worlds within us which can no longer be reconciled. The consoling motifs of antiquity and the Renaissance have retreated into an inaccessible, sloping space. The fear of modern life is emphasized by the trapping of humanity in the rigid, airless forms of statues, dressmakers' dummies or scaffold-like constructions. He shows us a past which is no longer attainable and a present from which there is no escape.

De Chirico shows the solitude of modern man in an environment that has become strange. He presents a second 'nature' in a philosophical sense: a nature created by man, and comprised of his artefacts. Human history, human endeavour, is reduced to an impenetrable world of objects. That is the irresolvable paradox of existence: it is entirely made by man, but not for his habitation. No one lives behind the arcades of de Chirico's *palazzi* and the factory chimneys stand inactive. The world is nothing but an empty, ominous backdrop.

Fifth Thesis: The means by which de Chirico succeeds in unsettling the viewer are primarily formal ones The pictorial means that de Chirico employs are all directed towards a single end: to disconcert, to delude, to unsettle the viewer. He begins with a space that apparently cannot exist, achieved by reversing such classical organizational principles as linear perspective in a disruption of the narrative and spatial continuum of Renaissance painting. He uses several vanishing points within one image and shifts them away from the spectator's viewpoint. Objects are rendered without shadows, or those that are cast are over-sized and ominous. He mixes his light sources and often uses them like spotlights. Buildings are transformed like stage flats; they become a set for a theatre of the absurd.[5]

Fig. 4 Giorgio de Chirico, *The Song of Love*, 1914. The Museum of Modern Art, New York (Nelson A. Rockefeller Bequest)

3 W. Schmied, 'Die Geburt der Metaphysik', in C. Schulz-Hoffmann, ed., *Mythos Italien – Wintermärchen Deutschland*, Munich, 1988, and idem, 'Der Maler, der sich selbst ein Rätsel blieb', *Art*, no. 7, July 1988.

4 De Chirico describes his revelation on Piazza Santa Croce in Florence in 'Meditations d'un peintre' (Manoscritti Paulhan), in *Il meccanismo del pensiero*, ed. M. Fagiolo dell'Arco, Turin, 1985, p. 32. It bears a strong resemblance to Poe's 'The Man of the Crowd' from *Tales of Mystery and Imagination* (1845).

5 W. Schmied, 'Die neue Wirklichkeit: Surrealismus und Sachlichkeit', in *Tendenzen der zwanziger Jahre*, Berlin, 1977, and W. Rubin, *Dada, Surrealism and their Heritage*, New York, 1968.

Such devices give rise to discontinuity and disequilibrium, incongruity and incoherence. In paintings such as *Natura morta: Torino a primavera* (*Still-Life: Turin in Spring*, 1914; Fig. 4, p. 65) a still-life hovers on undetermined ground, in front of a remote background. Often (particularly in the series of Ferrara interiors) one perceives a sequence of planes in depth, but they are arbitrarily stacked with no connecting space between them. This disjunction is accentuated by objects rendered with only the most rudimentary signs of three-dimensional modelling (Cat. 47).

Spatial conflicts have their counterpart in the different time-frames which collide or converge. Renaissance buildings are transformed into railway stations or co-exist with modern factories. Then there is his disruption of the times of day. Sometimes the clock on the facade shows noon or early afternoon, while long cast shadows indicate a low, late-afternoon sun and the colour of the sky suggests dusk. This same inconsistency within a single picture also applies to the atmosphere. In *Gare Montparnasse* (1914) smoke from a locomotive hangs heavily in the air in vertical plumes, while pennants on the tower flutter lightly in the breeze.[6]

Sixth Thesis: De Chirico does not evoke the solidity of objects but the enigmas that they present It is widely held that Metaphysical painting conforms to an inherently Italian tradition by representing the world of objects with a 'solidity' that is diametrically opposed to the formal 'dissolution' of abstract art. This does not hold true for de Chirico, who deprives, rather than provides, us with a secure world of objects. More precisely, he strips objects of all that was previously clear in their function, context and meaning.

When Picasso painted a guitar, he knew exactly what it was, and represented it as he wanted. De Chirico, on the other hand, does not know the things he paints, and even the most familiar seem estranged. He renders them in order to fathom them, but he only comes to understand that they are untrustworthy and indecipherable.

It is de Chirico's objective to learn to read the world and its eternal enigmas and, if not to decipher, at least to divine its secret message. As he acknowledged early on:

> Every object has two modes of representation: one, the ordinary one, which we see almost all the time, and which is seen by people generally; the other, a spectral or metaphysical manifestation which is perceived only by rare and isolated individuals in moments of clairvoyance and metaphysical abstraction, as in the case of certain bodies concealed in substances which are impenetrable to sunlight but not to X-rays or to other powerful, artificial techniques.[7]

By discovering this secret language of objects, he evolved a methaphorical system of signs and ciphers which has nothing in common with the function of traditional symbols, imposed by the human mind upon reality since time immemorial. Influenced by Weininger, de Chirico believed that the objects of phenomenal reality mirrored specific features of the human psyche, and that, conversely, the state of the psyche is reflected by constellations of objects and events in the external world. De Chirico looked for constellations of this kind, which show themselves in moments of revelation:

> A revelation can come suddenly, when it is least expected, and it can also be provoked by the sight of something – a building, a street, a garden, a square, etc. . . . When a revelation is produced by the sight of a composition of objects, then the work which manifests itself in our thoughts is closely linked to the circumstances of its creation. . . . The revelation which comes to us through a work of art, the emotional response to a picture, must represent something that has a meaning in itself, without an object, without any significance connected with human logic. Such a revelation (or emotion, if you like) must be experienced so intensely, must produce such joy or such pain, that we are driven to paint under the influence of a power greater than ourselves.[8]

Seventh Thesis: De Chirico and Carrà represent diametrically opposed positions within Metaphysical painting Outside Italian scholarship, de Chirico and Carlo Carrà are often combined into a single Metaphysical 'school', or the theories of the one are used to interpret the images of the other. Despite all superficial signs of affinity in the years 1917-18 (that is to say, despite the overwhelming evidence of Carrà's dependence on de Chirico), fundamental differences exist between them (Figs. 5, 6). These differences are apparent in the writings that reflect the different courses of

6 W. Schmied, 'Die metaphysische Kunst des Giorgio de Chirico vor dem Hintergrund der deutschen Philosophie', in W. Rubin, W. Schmied and J. Clair, eds, *Giorgio de Chirico: Der Metaphysiker*, Munich, 1982.

7 G. de Chirico, 'Sull'arte metafisica', *Valori Plastici*, nos. 4-5, 1919.

8 G. de Chirico, early manuscript from the collection of Paul Eluard, in *Il meccanismo*, pp. 13, 19.

Fig. 5 Carlo Carrà, *Solitude*, 1917. Giedion Collection, Zurich

Fig. 6 Giorgio de Chirico, *The Philosopher and the Poet*, 1914. Modern Gallery S. A., Geneva

their careers. Although both took a conservative turn after the First World War, de Chirico's interpretation of Metaphysical painting in 1913 was far more revolutionary than that put forward by Carrà three years later in his 'Talk about Giotto', in reaction to his avant-garde period as a Futurist.[9]

De Chirico first met Carrà in April 1917 at Poggio Renatico and then, after they had both been posted to the army medical corps, outside Ferrara at the Villa del Seminario, a military hospital for nervous diseases. Their past careers were very different.[10] De Chirico had developed Metaphysical painting in Paris between 1911 and 1915, and the visionary (if not revolutionary) quality was still predominant in 1917, perhaps his most fruitful year in Ferrara (Cat. 50). Carrà, who was older by seven years, had instead been nurtured by the avant-garde and was now looking for a new orientation. He had begun as a Symbolist, and joined the Futurists in 1910; after a last burst of enthusiasm at the outbreak of the war,[11] he found the obsession with speed and technology suspect. With his so-called *Antigrazioso* (*anti-graceful*) paintings he attempted to work through his crisis and make a new start. His thoughts on Giotto and Uccello, published in *La Voce* in 1916, reflected the profound changes occurring in his art.

Carrà reacted against the Futurist concept of dynamism by proclaiming the 'solidity of things' and he countered their claim to internationalism by exalting anew the quality of *Italianità*.[12] He adapted de Chirico's complex iconography to a simplified and more naturalistic pictorial space and made the evasive *Stimmung* of de Chirico's enigma into a palpable and undeniable sensation (Cat. 52).

Carrà saw Metaphysical painting as a means of returning to the masters of the Quattrocento, whereas for de Chirico it had always represented a 'new land on the horizon'.[13] A year later, de Chirico announced his own reversion to tradition, to the Old Masters and to the rules of the craft, with the proud words *'Pictor classicus sum'* ('I am a classical painter'); but when he did so he saw it as a rejection of the ideals of Metaphysical painting.[14]

Eighth Thesis: There are radical breaks in de Chirico's work but there is also continuity De Chirico's career is marked by a succession of styles, most of which appear as decisive changes in direction. The series of moves from Volos to Athens, from Athens to Florence, and from Florence to Munich, already constituted a pattern of discontinuity. He broke with his early Böcklin-inspired manner after his vision on Piazza Santa Croce in Florence, in the autumn of 1910 (Fig. 3, p. 62). These sudden shifts were repeated after his disquieting encounter with the Paris avant-garde and the experiences of his subsequent military service in Ferrara. Undoubtedly the most momentous and the most puzzling rupture, however, took place in 1919, when he abruptly turned his back on the vision of his own Metaphysical painting and proclaimed: *'Pictor classicus sum'* (Fig. 10, p. 68).[15]

This conscious decision (or compulsive response to an inner voice that even he himself could not explain) profoundly altered the images of his painting, the tone of his writing and the world view it expressed. The year 1919 divides his life and his work into two parts: what came before was the adventure of Metaphysical painting and the youthful works of genius; what followed were his mature works and an increasing, and later absolute, withdrawal from the contemporary world.

Nevertheless, the evidence of de Chirico's later evolution makes it necessary to qualify that break to some extent. For it was followed by further conversions which changed the face of his work once more. The 'first conversion', of 1919, looked to Titian and the antique tradition. The second, in 1925 (coinciding with his return to Paris), looked to the formal model of Picasso (and modern neo-classicism) as well as to the content of his own earlier motifs, now made more overtly mythological. His 'third conversion' became apparent in the early 1930s and was marked by a thoroughly banal conception of realism. His 'fourth and last conversion', in the mid-1930s, was dominated by Rubens and the Baroque (the style which de Chirico had dismissed in 1921 as a 'mania').[16] It also marked the end of a sequence of formal and thematic inventions which culminated in the *Bagni misteriosi* (*Mysterious Baths*) of

9 C. Carrà, 'Parlata su Giotto', *La Voce*, 31 March 1916.

10 C. Carrà, 'Il rinnovamento della pittura in Italia', *Valori Plastici*, nos. 11-12, 1919; nos. 1-2, 3-4, 5-6, 1920. M. Fagiolo dell'Arco, 'Carlo Carrà 1915-1919: "The Wonder of the Primeval"', in *Carlo Carrà: The Primitive Period*, Milan, 1987.

11 C. Carrà, *Guerrapittura*, Milan, 1915.

12 In Carrà's book *Pittura metafisica*, Florence, 1919, there are many passages that look like veiled attacks on de Chirico.

13 G. de Chirico, 'Zeusi l'esploratore', *Valori Plastici*, no. 1, 1918.

14 G. de Chirico, 'Il ritorno al mestiere', *Valori Plastici*, nos. 11-12, 1919.

15 Ibid. See also G. de Chirico, *Memorie della mia vita*, Rome, 1945; expanded ed., Milan, 1962; translated as *The Memoirs of Giorgio de Chirico*, trans. M. Crosland, London, 1971.

16 G. de Chirico, 'La mania del Seicento', *Valori Plastici*, no. 3, 1921.

1934-5. (Curiously enough, while he was working on these, his last truly inventive creations, he also painted a series of highly *un*mysterious beach scenes which resemble nothing so much as kitsch postcards, and in which his work descended to a first and all-time low. Despite their common iconography these two groups of paintings are utterly irreconcilable [Figs. 7, 8].) It was only from now on that de Chirico contented himself with endless recapitulations of his earlier pictorial ideas.

In view of all these breaks and transgressions, can any continuity be discerned? The answer is yes, if one looks to content and iconography rather than to the formal aspects of the works. The continuity lies in de Chirico's classical roots and in his predilection for certain subjects; in a tendency towards nostalgia and yearning; and in a certain weakness for earnest solemnity. The most consistent element throughout is the artist's susceptibility to melancholy. '*Stimmung*' always remained one of his favourite words, even when the sense of melancholy faded in his later work, and the attendant sense of angst and oppression was lost. However much the inner reality of de Chirico changed, he always reproduced it as faithfully as he could, regardless of his contemporaries' reactions.[17]

Ninth Thesis: The break that came in 1919 marked the loss of de Chirico's original vision, but not his power as a painter De Chirico owes his fame to an oeuvre of approximately 120 paintings which he produced in a span of less than a decade, between 1911 and 1919. His subsequent production, however interesting it may be, retains the stigma of the work that came *afterwards*.

As noted, de Chirico's break with Metaphysical painting in 1919 was the most profound in his career.[18] In his memoirs, written a quarter of a century later, he stated, 'I realized that something immense was happening in me',[19] attempting to add a mythical and religious dimension to the experience which overcame him that day in front of a painting by Titian in the Galleria Borghese in Rome.

This precipitated a protracted identity crisis, accompanied by extensive experimentation with pictorial techniques. In no phase of his life did he think or write so much about art, or spend so much time in museums studying – and copying – the works of the Masters. Never, before or after, did de Chirico portray himself so often, and with such a piercing air of self-interrogation, as in the years between 1919 and 1924 (Fig. 9, p. 68). It was as if he had been a sleepwalker for all those years and suddenly awoke to find his own past as strange to him as a fading dream. He had to learn the craft all over again, and changed from being a visionary artist to a professional – and highly prolific – painter. After 1919, he worked harder than he ever had

17 W. Schmied, *Giorgio de Chirico*, Hanover, 1970.

18 In his writings and in a number of isolated works, he remained its advocate for a little longer. See the articles that de Chirico published in *Valori Plastici*, *Il Primato Artistico Italiano*, *La Ronda* and *Il Convegno* in 1920-1. Under a self-portrait painted as late as 1920, there appear the words '*Et quid amabo nisi quod rerum metaphysica est?*' ('And what shall I love but what is metaphysical?').

19 De Chirico, *Memorie*.

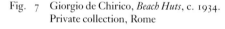

Fig. 7 Giorgio de Chirico, *Beach Huts*, c. 1934.
 Private collection, Rome

Fig. 8 Giorgio de Chirico, *Bather*, 1934.
 Isa de Chirico Collection, Rome

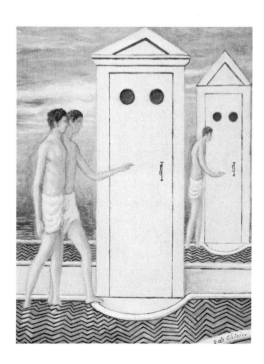

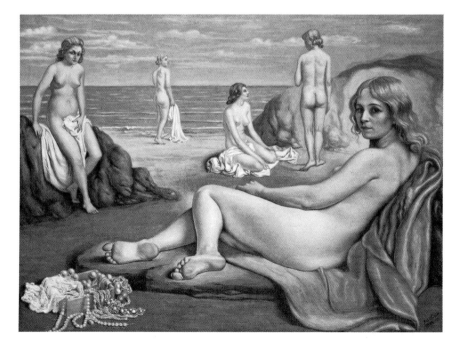

20 W. Schmied, 'Pictor classicus sum: Il ritorno alla tradizione dei Maestri', in *Conoscere de Chirico*, Milan, 1979; reprinted as 'Pictor classicus sum: Giorgio de Chiricos Rückkehr zur Tradition der Meister', in *De Chirico: Leben und Werk*, Munich, 1980.
21 W. Schmied, 'Die neue Wirklichkeit'.
22 W. Schmied, 'Points of Departure and Transformations in German Art 1905-1985', in C. M. Joachimides, N. Rosenthal and W. Schmied, eds, *German Art in the 20th Century*, Munich, 1985, and idem, *200 Jahre phantastische Malerei*, Berlin 1973 (2nd ed., Munich 1980).

in his Metaphysical years; his annual output of paintings was double what it had been previously.

There is a widely held and fundamentally flawed opinion that de Chirico's about-face of 1919 resulted in a loss of originality and decline in quality. The situation is much more complicated. When examined closely, the paintings executed between 1919 and 1924 (while he was in Rome and Florence) are characterized by an extreme variety of quality, imagery and style: neo-classical and neo-Romantic paintings which again echo Böcklin, Klinger and his own early work; homages to Eugène Delacroix and Gustave Courbet; and pictures which resemble the contemporary style of Magic Realism.[20]

From 1925, the 'erstwhile somnambulist' was back in Paris, where, encouraged by the admiration of the Surrealists, he made a supreme effort of will to recover the inspiration of his early Metaphysical period and reinterpret it in the spirit of the avant-garde. (An effort which, ironically, lost him the Surrealists' goodwill.) Synthesizing his early work with the neo-classicism of Picasso, he produced a new set of images marked by painterly vitality. The mannequins of old became the 'archaeologists', figures comprised of architectural ruins and shattered columns (Cat. 70). They also emerged as the series of 'gladiators' who battle indoors (Cat. 76), intended as a satire on art-world types (these also feature in his novel *Hebdomeros*, published in 1929). The equestrian statues of the *piazze d'Italia* now galloped as wild, long-maned horses on the shores of Thessaly (Cat. 72). From the evocation of the antique and of timeless city squares, de Chirico journeyed into the archaeology of the imagination. Freed from the modernist credo of novelty and originality, he produced a set of remarkable images that went back and forth in time.

Tenth Thesis: Without de Chirico there would never have been any Surrealist art (or else it would have looked quite different) Surrealism evolved in post-First World War Paris, directly out of the spirit of Dada and under the decisive leadership of André Breton.[21] The *époque floue* (vague period) in which Surrealism took shape and crystallized began in May 1919 with the founding of the periodical *Littérature* by Breton, Louis Aragon and Philippe Soupault and lasted until 1924. In October of that year, Breton published the *First Surrealist Manifesto*. A distinction must be made between the formation of Surrealist theory, which took place between 1920 and 1924, and the birth of Surrealist painting at a slightly later date. Apart from the pioneering work of Max Ernst, no Surrealist painting as such appeared until the exhibition held at the Galerie Pierre in Paris in 1925.

The paintings of de Chirico were the most important influence during the formative *époque floue*, providing both a conceptual point of departure and a pictorial model for individual artists (with the exception of André Masson and Joan Miró) as well as for poets such as Paul Eluard and Breton himself. His images represented an initiatory experience for Ernst, Pierre Roy, René Magritte, Yves Tanguy, Salvador Dalí and – of course – Savinio, not to mention the later Surrealists and their successors, such as Paul Delvaux.

Many examples of de Chirico's Metaphysical painting had remained in Paris after he left for Ferrara in 1915. These had influenced Breton and his group as they sought a means of overcoming the limiting nihilism of Dada and opening up 'other terrain', convinced that the spirit of revolt, far from working itself out only in actions (as Dada believed), might take objective form in works of art. De Chirico's paintings proved that it was possible to create images that preserved the purity of dreams without having to compromise with reality or rationality. The Surrealists' unconditional acceptance of Metaphysical painting (along with the work of a number of 'dark' writers, such as Lautréamont, Gérard de Nerval, Arthur Rimbaud and Guillaume Apollinaire) represented a positive belief that art was both possible and meaningful.

Breton's 'dialectical transformation' of Dada into Surrealism paralleled the artistic transformation that occurred in the work of Ernst.[22] He began by combining Dada collage with pictorial elements taken from de Chirico, transposing his own idiosyncratic figurations onto a spatial set derived from Metaphysical painting.

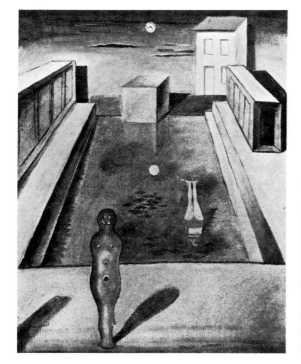
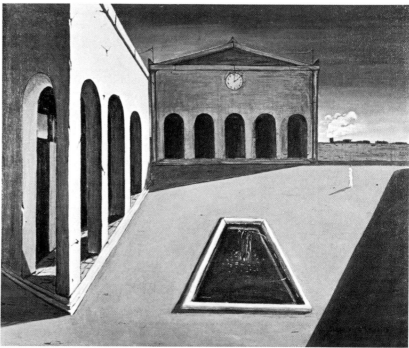

Ernst first encountered de Chirico's work in 1919, at the Galerie Goltz in Munich, where he came across twelve reproductions in a portfolio published by the periodical *Valori Plastici*, as well as the first issues of the magazine containing drawings by de Chirico and paintings by Carrà. The impact of this new pictorial world on Ernst began with the disruptive effect of contradictory systems of perspective, as in *Dada in Usum Delphini* (1920). De Chirico's and Carrà's mannequins were the direct forerunners of the dressmaker's dummy in Ernst's *Fiat Modes, Pereat Ars* (1919); and Ernst's *Aquis Submersus* (1919) is an underwater vision of a *piazza d'Italia* (Figs. 9, 10). Magritte, Tanguy and Dalí all subsequently derived inspiration from the pictorial world of de Chirico, peopling his spatial 'stage' with creatures of their own (cf. Figs. 4, 11).[23]

Eleventh Thesis: Metaphysical painting was a necessary precondition for the emergence of Neue Sachlichkeit The new German painting that sprang from the trauma of the First World War – *Neue Sachlichkeit* (New Objectivity) and Magic Realism – was inspired by Picasso's neo-classicism, Henri Rousseau, Fernand Léger's 'conceptual realism', the 'Gothic period' of André Derain and, above all, Metaphysical painting. Whereas de Chirico had personal contact with the French avant-garde and the Surrealists, his influence in post-war Germany, among the painters of *Neue Sachlichkeit*, was often felt indirectly, by way of Carrà's more conservative interpretation of Metaphysical painting (Figs. 12, 13).

Like Ernst, George Grosz, Anton Räderscheidt and Heinrich Maria Davringhausen were made aware of de Chirico and Carrà through the reproductions of their works in *Valori Plastici*. Begun in Rome in 1918, the magazine had quickly gained a wide circulation in Germany, was passed from hand to hand, and was discussed in the leading art magazine, Paul Westheim's *Das Kunstblatt*. In 1921, *Valori Plastici* sent north a touring exhibition, 'Das junge Italien' (Young Italy), which was dominated by the paintings of de Chirico, Carrà and Giorgio Morandi.

While the Surrealists took from de Chirico a paradoxical world of irreconcilable contradictions, the painters of *Neue Sachlichkeit* transposed the timelessness of de Chirico's *piazze* into the real world of modern urban life, endowing it with a sense of rigidity and stasis. The perspectival recessions of Renaissance buildings appeared as the facades of office blocks, and the Metaphysical mannequins were transformed into emotionless robots, faceless members of a servile bourgeoisie or war cripples with artificial limbs.

Fig. 9 Max Ernst, *Aquis Submersus*, 1919. Private collection, London

Fig. 10 Giorgio de Chirico, *The Delights of the Poet*, 1913. Mr and Mrs Leonard C. Yaseen Collection

Fig. 11 René Magritte, *Memory*, 1938. Menil Collection, Houston

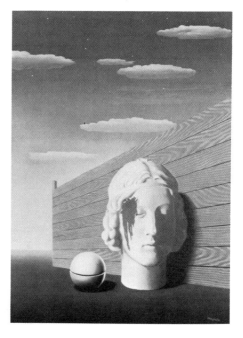

23 The first account of de Chirico's influence, a very full and convincing one, was given by J. T. Soby, *The Early Chirico*, New York, 1941; the most recent is by L. Rosenstock, 'De Chirico's Influence on the Surrealists', in Rubin, ed., *De Chirico*.

24 W. Schmied, 'De Chirico and the Realism of the Twenties', in Rubin. ed., *De Chirico*.

In de Chirico and Carrà the German painters found a convincing expression of their own existential plight in the post-war years: the loss of continuity, reification, the paralysis and isolation of the individual. They combined the contradictions of Metaphysical painting into a fearful unity with contemporary life. Despite the chill that emanates from these images, something familiar in them stirs the emotions long before the intellect. In this way, *Neue Sachlichkeit* both drew from and modified the alien world constructed by de Chirico and Carrà. As Grosz explained in 1921, in a contribution to *Das Kunstblatt* entitled 'On My New Paintings': 'I am trying to give an absolutely realistic image of the world once more.... In this endeavour to create a clear and simple style, one involuntarily finds oneself coming close to Carrà. Nevertheless, everything combines to separate me from him, because he seeks to be appreciated in a highly metaphysical way.'[24]

Twelfth Thesis: Paradoxical works have paradoxical effects In his personality and in his work de Chirico embodied the most radical contradictions. He was both seemingly naive and vastly sophisticated, infuriatingly ignorant and highly educated, utterly transparent and shrewd at covering his own tracks, endowed with a sure instinct and capable of appalling lapses of taste. These contrasting elements, especially after 1919, were directly juxtaposed in one and the same image or in concurrent works. His career is fragmented to a barely imaginable degree, and yet it remains unified by a small number of endlessly recurring motifs. De Chirico painted some of the most startling and forcefully revolutionary paintings of the twentieth century; and he also painted some of the worst. His underlying strategy was to disconcert, baffle and perturb the viewer. Many of the self-portraits painted between 1919 and 1924 present these conditions as the innermost essence of the artist himself. The discordant, torn, contradictory psyche of the artist is reflected and multiplied, within one work or in his oeuvre as a whole, by formal and thematic incongruities and by the irreconcilability of style and content.

Hence it follows that this paradoxical oeuvre has had paradoxical consequences. The two new artistic tendencies which came into being in the early 1920s, Surrealism and *Neue Sachlichkeit*, were both, in their different ways, strongly influenced by de Chirico; and in relation to each other form a contradiction *par excellence*.

Neue Sachlichkeit bears the marks of an existential appraisal of total isolation and alienation, which leads to a state of remoteness and immobility – a condition in which the reality of objects appears to be the last refuge within an unknowable, inexplicable world. Surrealism represents an absolutely contrary position. With a considerable debt to Freud, it aimed at transcending the alienation of our conscious

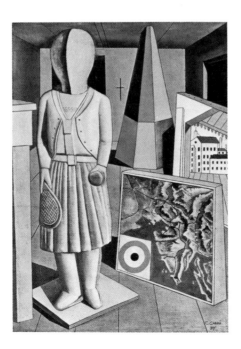

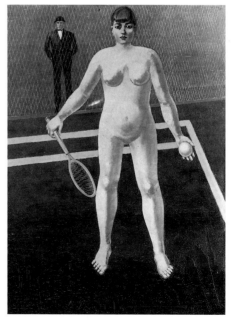

Fig. 12 Carlo Carrà, *Metaphysical Muse*, 1917. Pinacoteca di Brera, Milan (Jesi Donation)

Fig. 13 Anton Räderscheidt, *Tennis Player*, 1926 or 1928. Bayerische Staatsgemälde-sammlungen, Munich

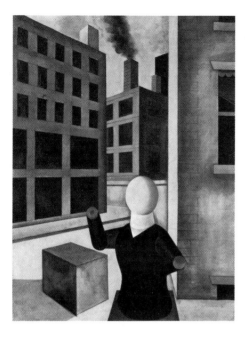
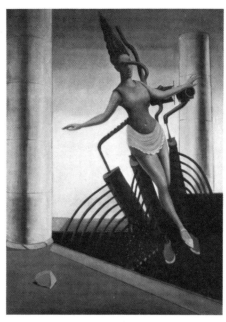

Fig. 14 George Grosz, *Untitled*, Kunstsammlung
 Nordrhein-Westfalen, Düsseldorf

Fig. 15 Max Ernst, *The Wavering Woman*, 1923.
 Kunstsammlung Nordrhein-Westfalen,
 Düsseldorf

lives by mobilizing the powers of the dream. The hegemony of reason was under-
mined to attain a new identification of the unconscious with the conscious. The
Surrealist is set free, whereas the artist of *Neue Sachlichkeit* is paralysed by self-
imposed taboos. Surrealism unmasks and spurns the world of objects to which *Neue
Sachlichkeit* clings. When Walter Benjamin defined the Surrealists' unique achieve-
ment as an altered, clairvoyant relationship to objects, in which all traces of helpless
submission to them have been overcome, he also revealed the converse situation of
Neue Sachlichkeit, which was obsessed with the object in all its limitations and nar-
rowness.[25]

The fact remains that both attitudes have their origin in the paintings of de
Chirico, underlining the inherent ambivalence and polyvalence of Metaphysical
painting. A comparison of Grosz's *Ohne Titel* (*Untitled*, 1920) and Ernst's *La femme
chancelante* (*The Wavering Woman*, 1923) serves to illustrate this point (Figs. 14, 15).
Both use synthesized, collaged space with unsettling perspectives and displaced
horizons, adopting de Chirico's compositional 'stage'; the marionette-like figures
clearly derived from his mannequins. Yet in every other respect, the two works are
poles apart. Grosz directly refers to contemporary life, using the faceless robot as a
vehicle of caustic social criticism. In Grosz's work the robot soon evolved into the
figure of the bourgeois, the factory boss, the state official, the accountant. Ernst's
Wavering Woman, in contrast, teeters on the brink of dreamland. With her eyes
closed (or masked by some tubular object), she advances nonetheless. With Grosz,
reality is made indurate and immobile; with Ernst, all is in constant metamorphosis.
Grosz's figure is doomed to live forever in the world of work, divested of his
humanity like a robot; the shopfront dummy in Ernst's painting escapes from obliga-
tion and function and awakes to a dreamlike life of her own. With Grosz, all is
emphatically present; with Ernst, all is an unfathomable enigma – the dual states
first embodied in the work of de Chirico.

25 W. Benjamin, 'Der Sürrealismus', *Literarische
 Welt*, 1, 8 and 15 February 1929.

1　Medardo Rosso, The Veiled Lady (*Femme à la voilette*)　1893

2
Medardo Rosso,
Sick Child (*Bambino malato*)
1895

3
Medardo Rosso
Bookmaker
1894

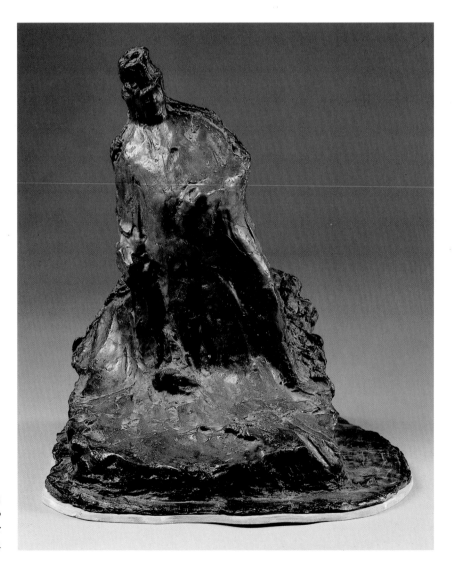

4　Giacomo Balla, Bankruptcy (*Fallimento*)　1902

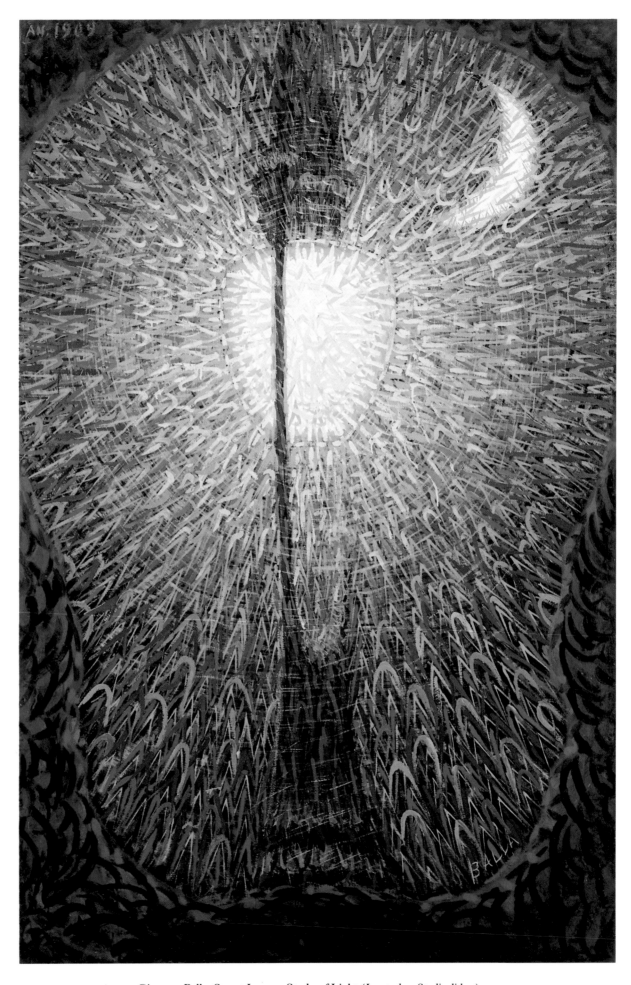

5 Giacomo Balla, Street-Lamp – Study of Light (*Lampada – Studio di luce*) 1909

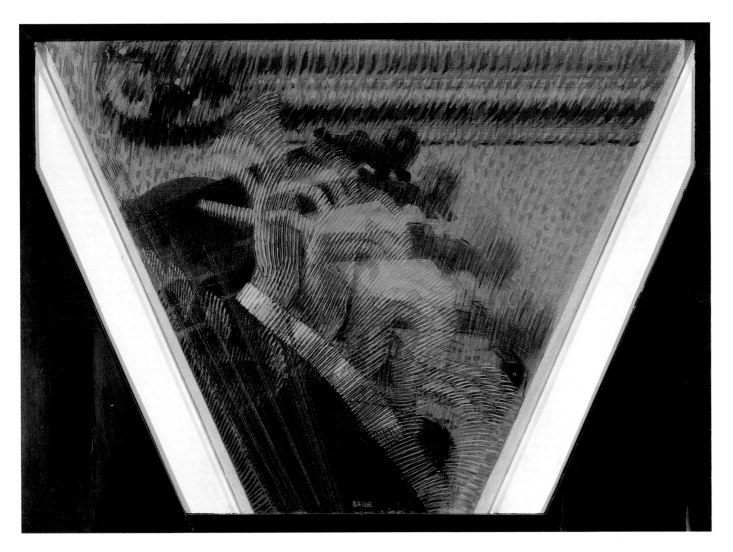

6 Giacomo Balla, The Hand of the Violinist (*La mano del violinista*) 1912

7 Giacomo Balla, Girl Running on a Balcony (*Bambina che corre sul balcone*) 1912

8 Giacomo Balla, Iridescent Compenetration No. 5 – Eucalyptus
(*Compenetrazione iridescente n. 5 – Eucaliptus*) 1914

9 Giacomo Balla, Iridescent Compenetration No. 4 – Study of Light
(*Compenetrazione iridescente n. 4 – Studio di luce*) c. 1913

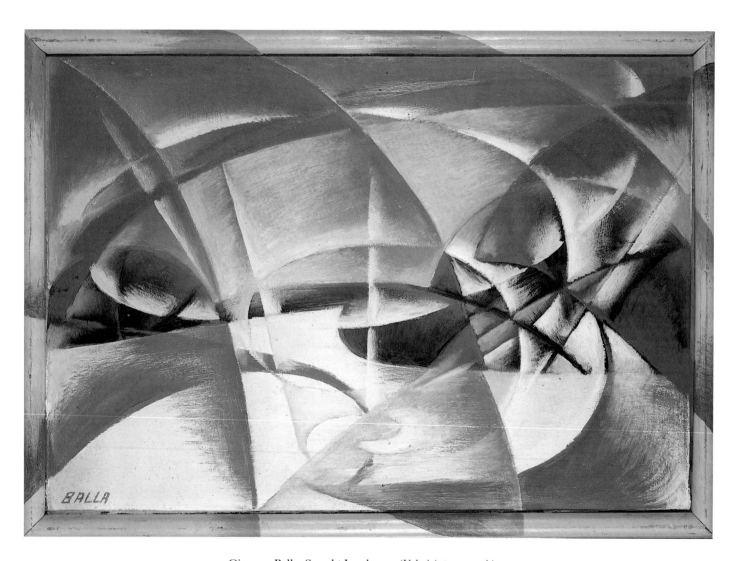

10 Giacomo Balla, Speed+Landscape (*Velocità + paesaggio*) 1913

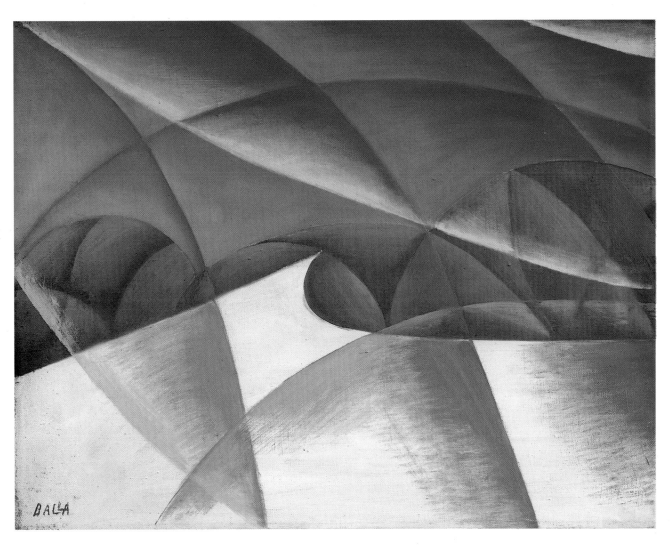

11 Giacomo Balla, Abstract Speed – The Car Has Passed (*Velocità astratta – l'auto è passata*) 1913

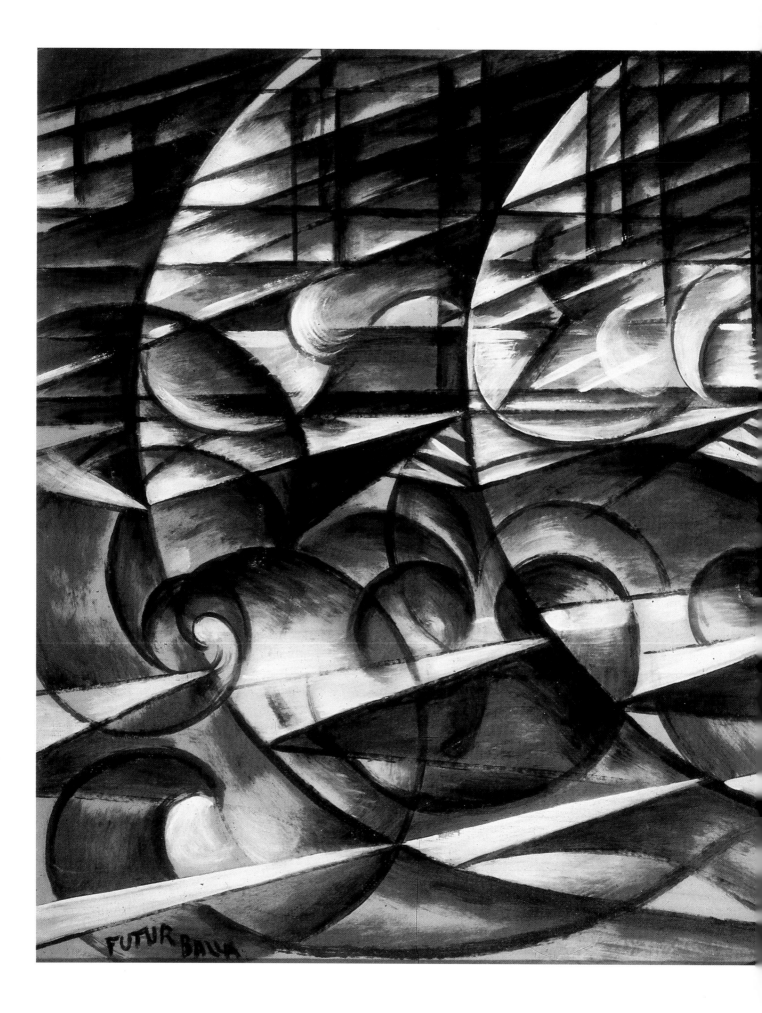

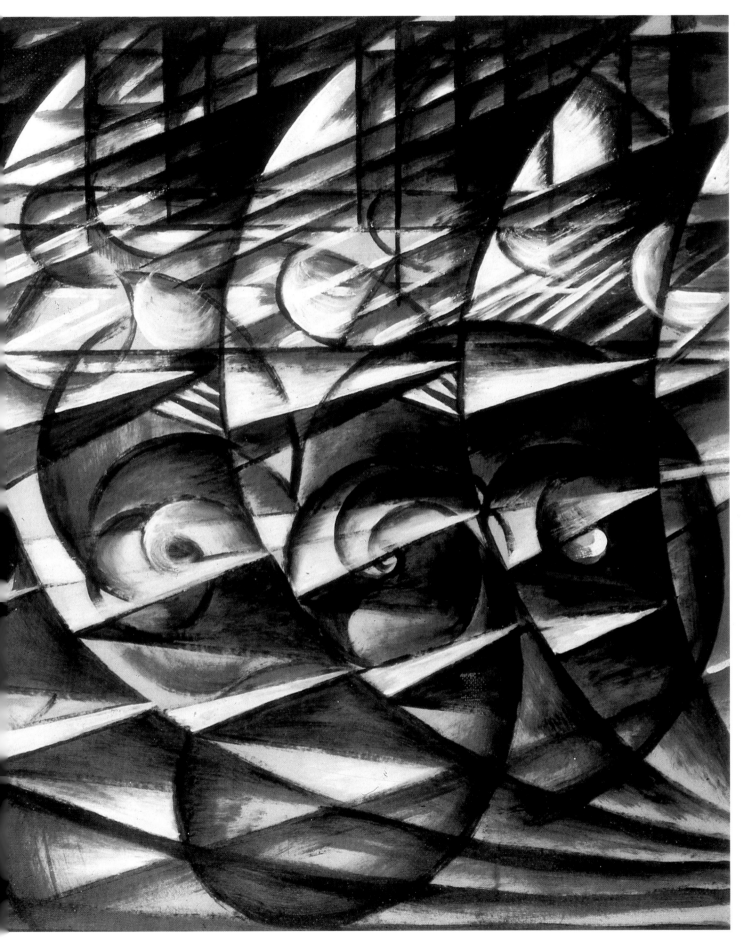

12 Giacomo Balla, Abstract Speed (*Velocità astratta*) 1913

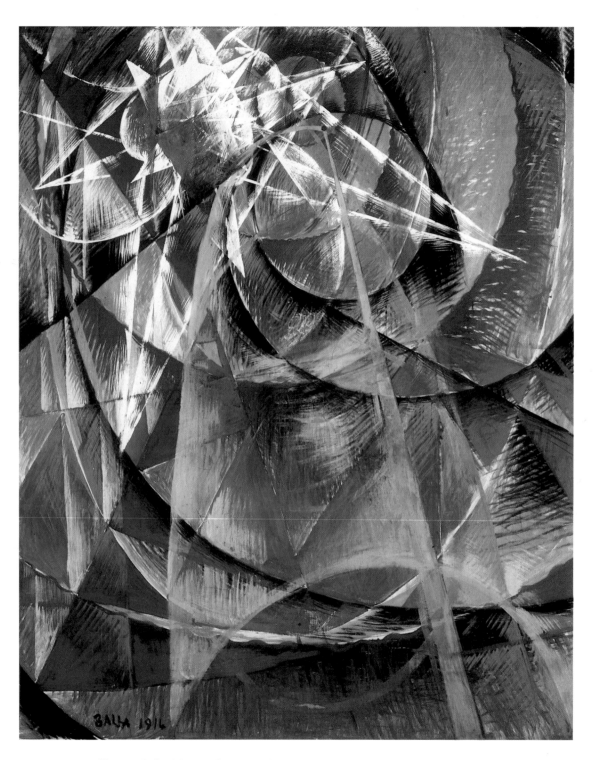

13 Giacomo Balla, Mercury Passing in front of the Sun (*Mercurio passa davanti al sole*) 1914

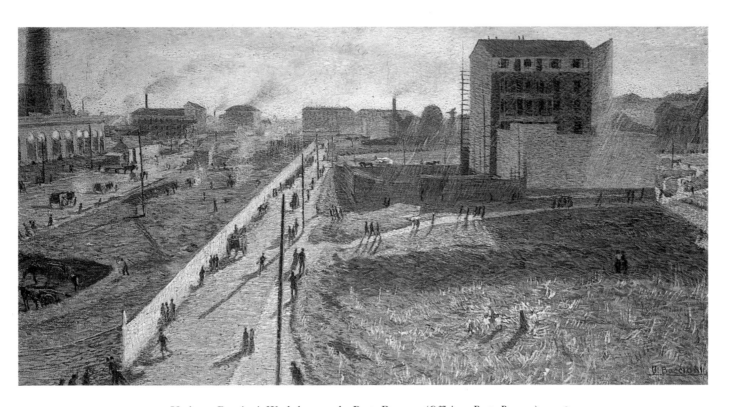

14 Umberto Boccioni, Workshops at the Porta Romana (*Officine a Porta Romana*) 1908

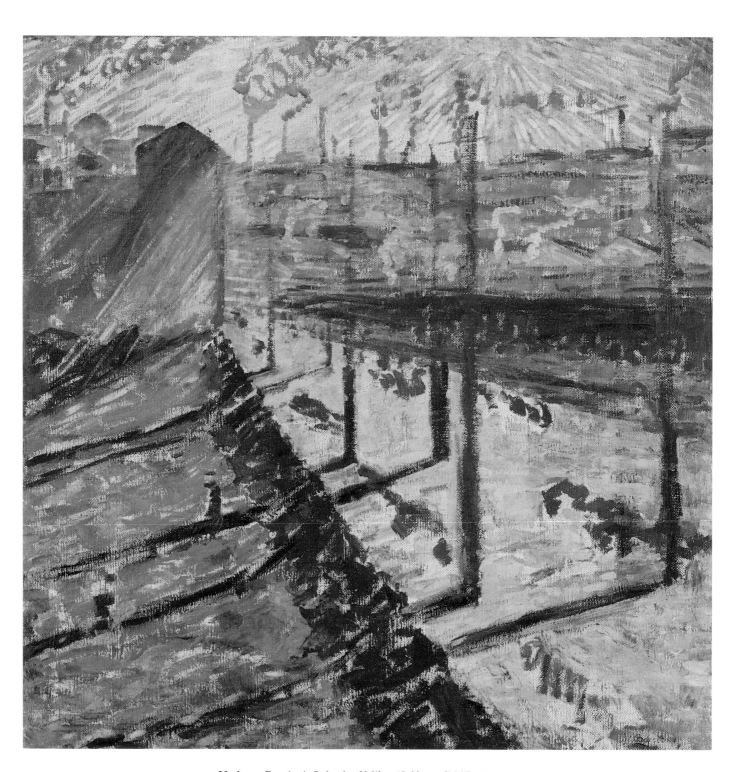

15 Umberto Boccioni, Suburb of Milan (*Sobborgo di Milano*) 1910-11

16 Umberto Boccioni, Riot in the Galleria (*Rissa in Galleria*) 1910

17 Umberto Boccioni, Modern Idol (*Idolo moderno*) 1911

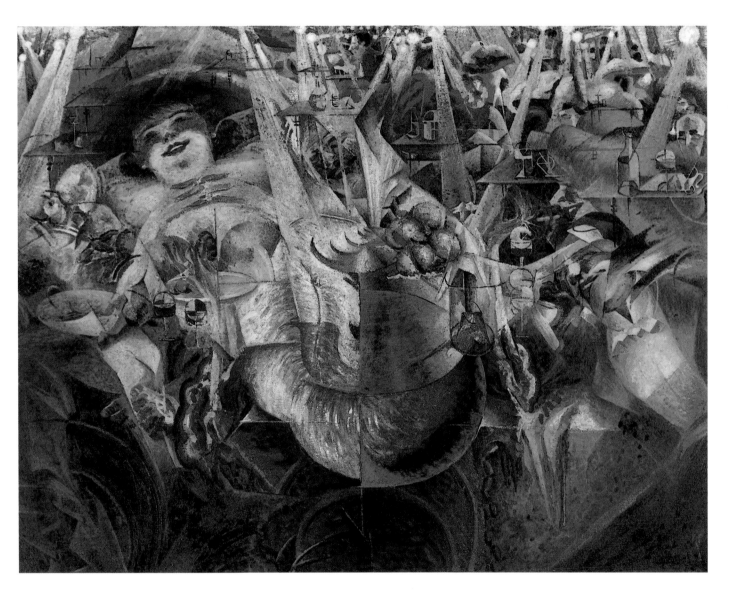

18 Umberto Boccioni, The Laugh (*La risata*) 1911

19 Umberto Boccioni, The Farewells – States of Mind I (*Gli addii – Stati d'animo I*) 1911

20 Umberto Boccioni, Those Who Go – States of Mind I (*Quelli che vanno – Stati d'animo I*) 1911

21　Umberto Boccioni, Those Who Stay – States of Mind I (*Quelli che restano – Stati d'animo I*)　1911

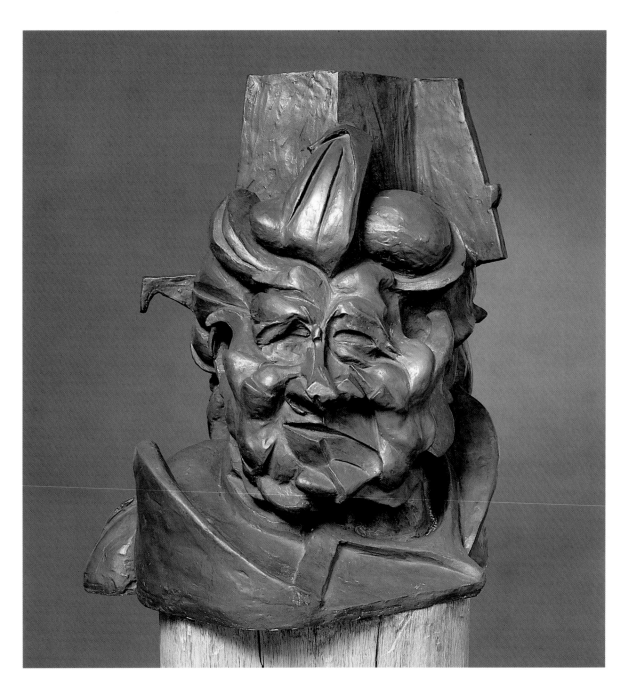

22 Umberto Boccioni, Anti-graceful (*Antigrazioso*) 1913

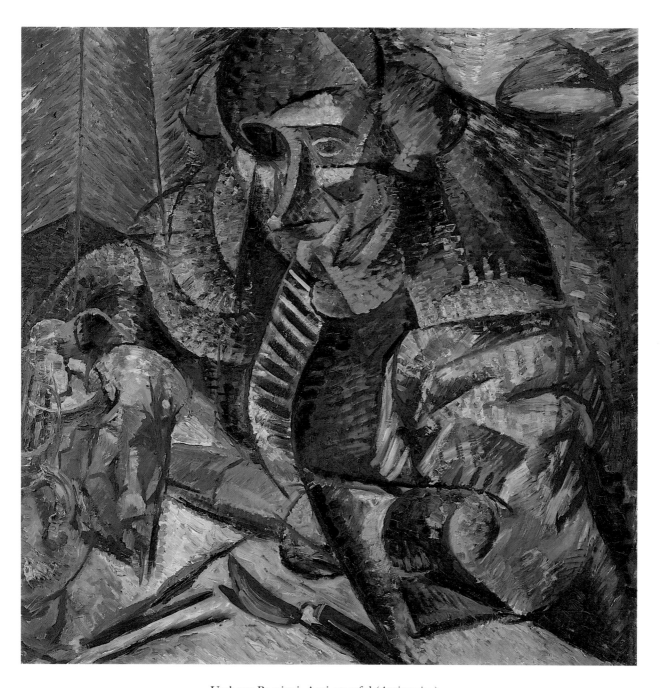

23 Umberto Boccioni, Anti-graceful (*Antigrazioso*) 1912

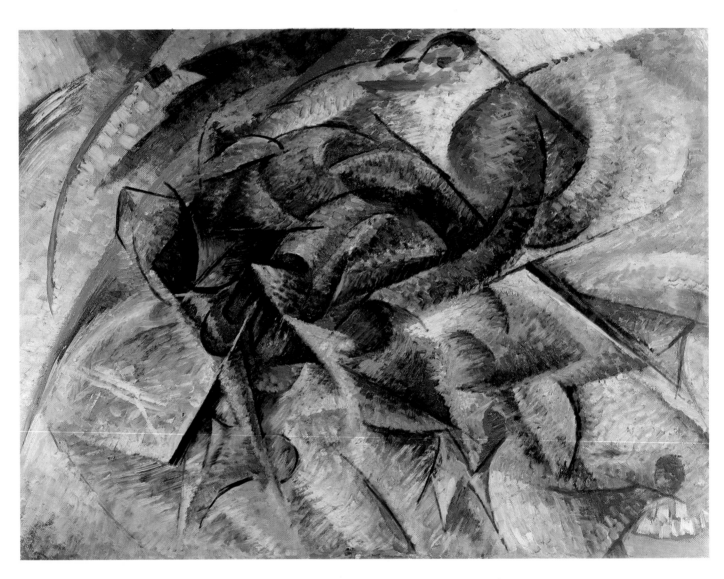

24 Umberto Boccioni, Dynamism of a Cyclist (*Dinamismo di un ciclista*) 1913

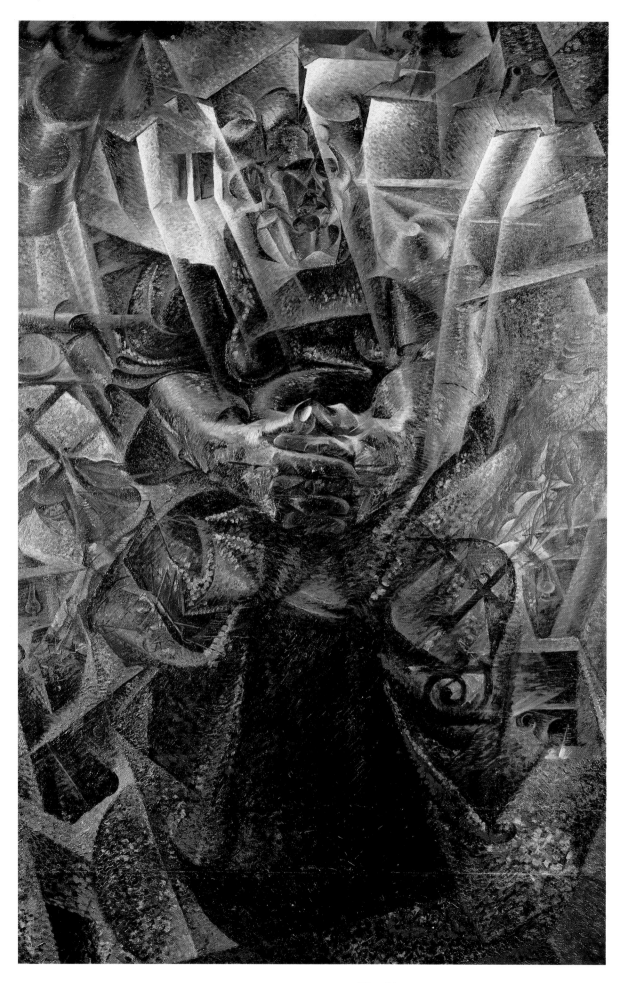

25　Umberto Boccioni, Matter (*Materia*)　1912

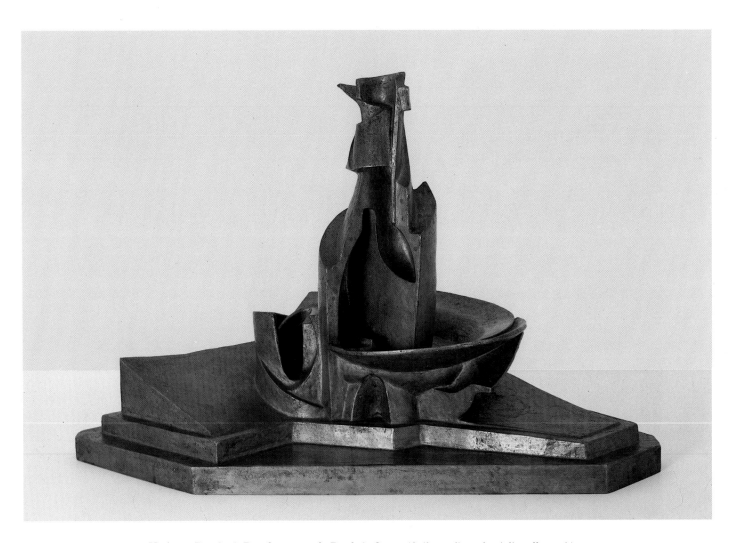

26 Umberto Boccioni, Development of a Bottle in Space (*Sviluppo di una bottiglia nello spazio*) 1912

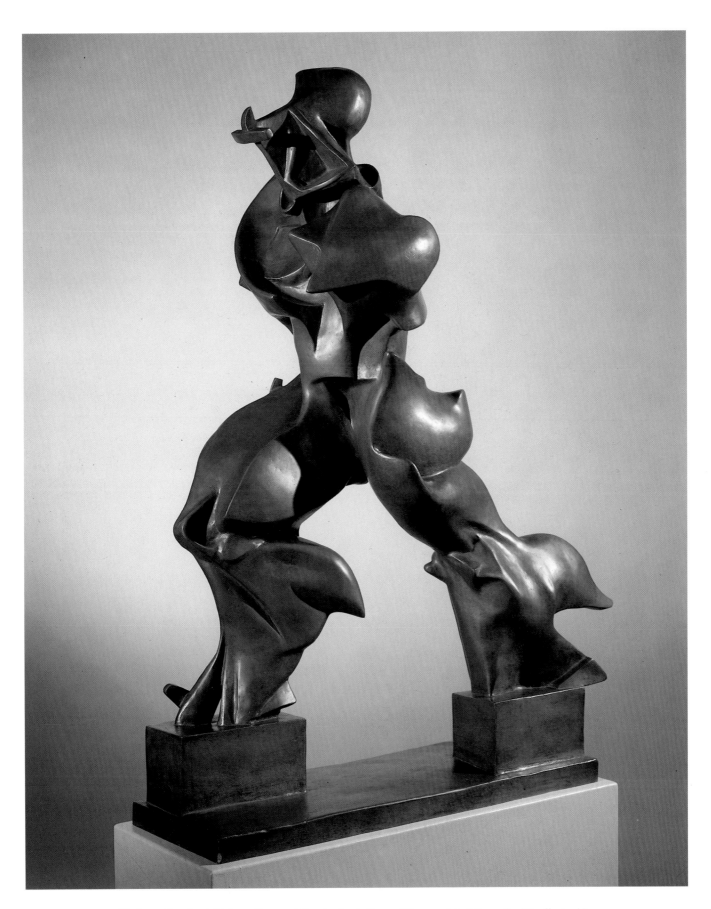

27　Umberto Boccioni, Unique Forms of Continuity in Space (*Forme uniche della continuità nello spazio*)　1913

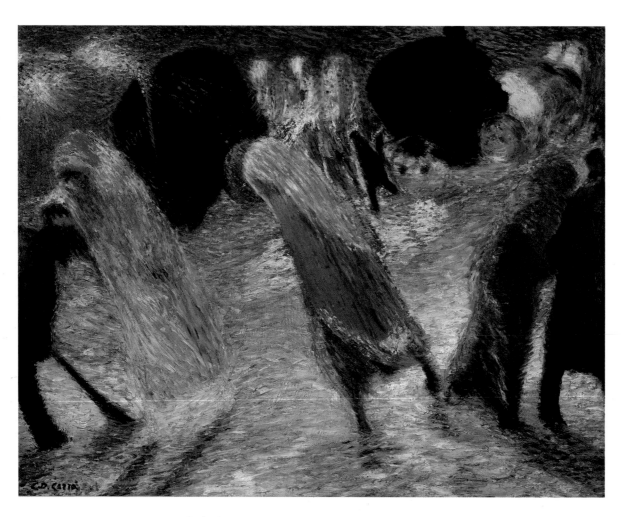

28 Carlo Carrà, Leaving the Theatre (*Uscita dal teatro*) 1909

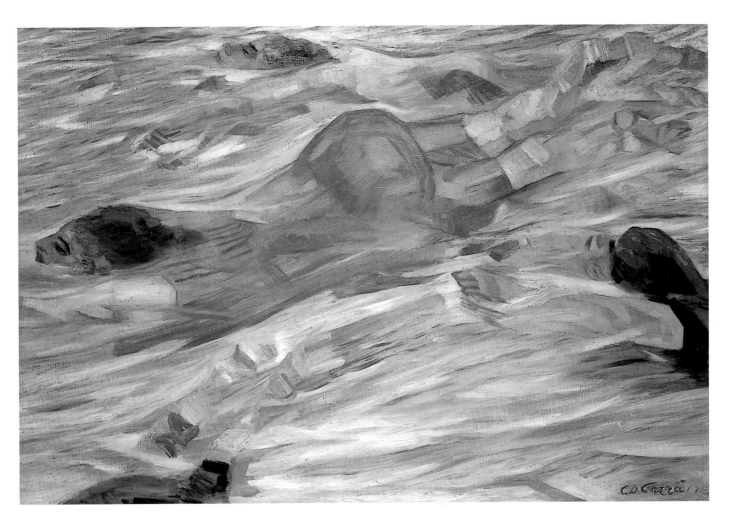

29　Carlo Carrà, Swimmers (*Nuotatrici*)　1910-12

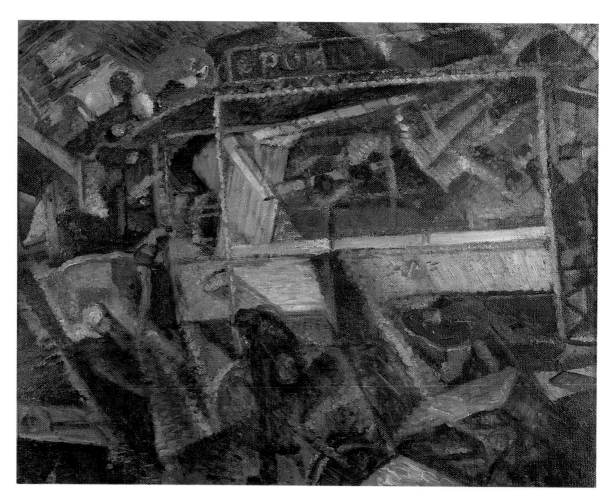

30 Carlo Carrà, What the Tram Told Me (*Ciò che mi ha detto il tram*) 1910-11

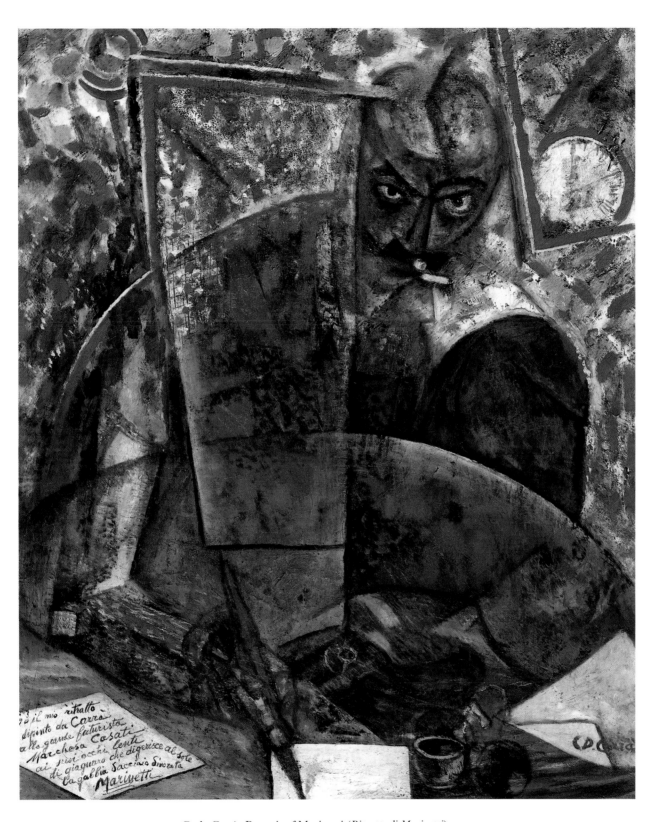

31 Carlo Carrà, Portrait of Marinetti (*Ritratto di Marinetti*) 1910–11

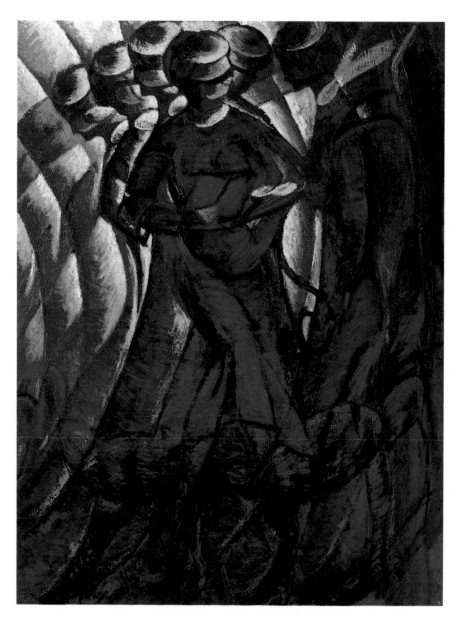

32 Luigi Russolo, Plastic Synthesis of a Woman's Movements
(*Sintesi plastica dei movimenti di una donna*) 1912

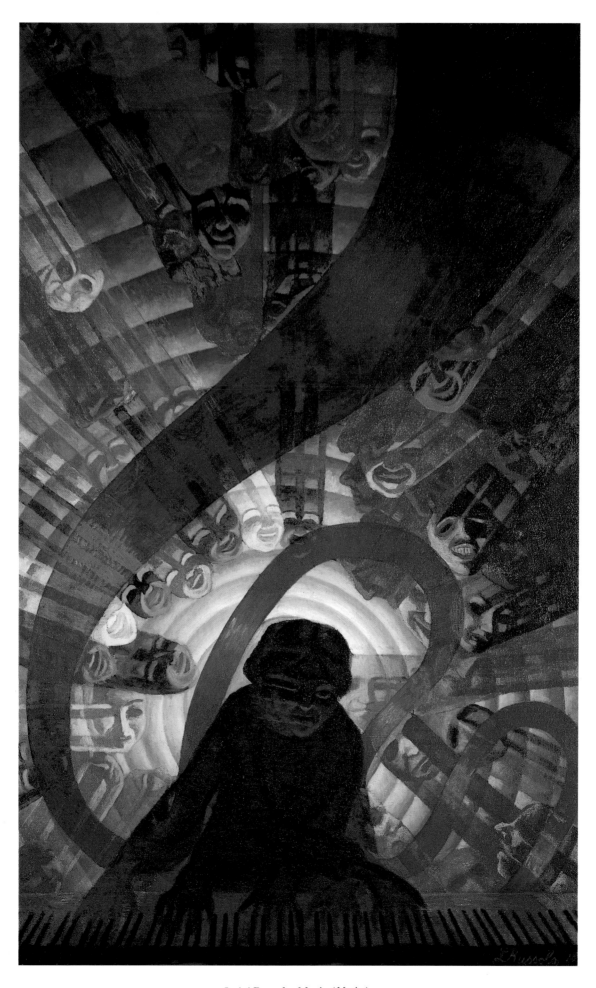

33 Luigi Russolo, Music (*Musica*) 1911

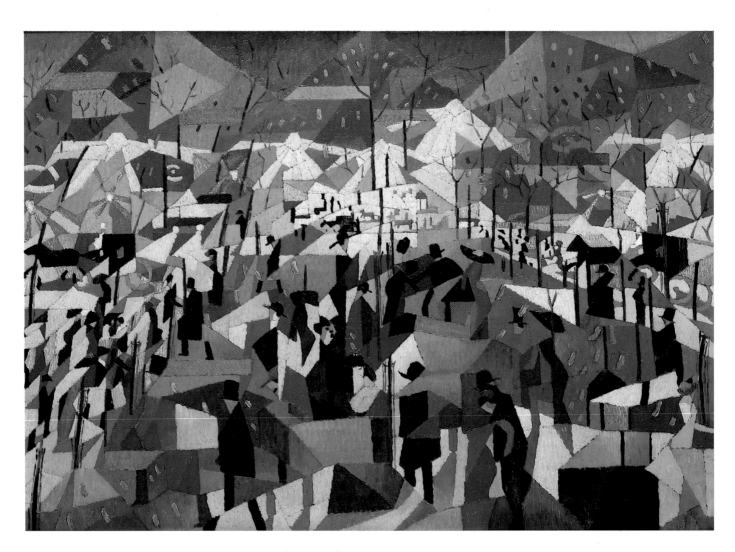

34 Gino Severini, The Boulevard (*Le boulevard*) 1911

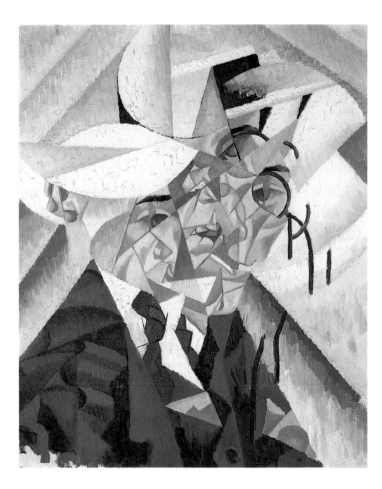

35
Gino Severini,
Self-Portrait (*Autoritratto*)
1912-13

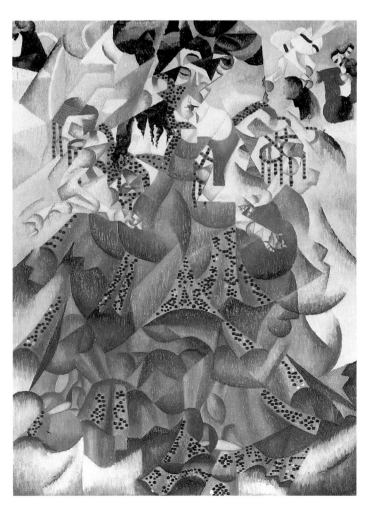

36
Gino Severini
The Blue Dancer (*La danseuse en bleu*)
1912

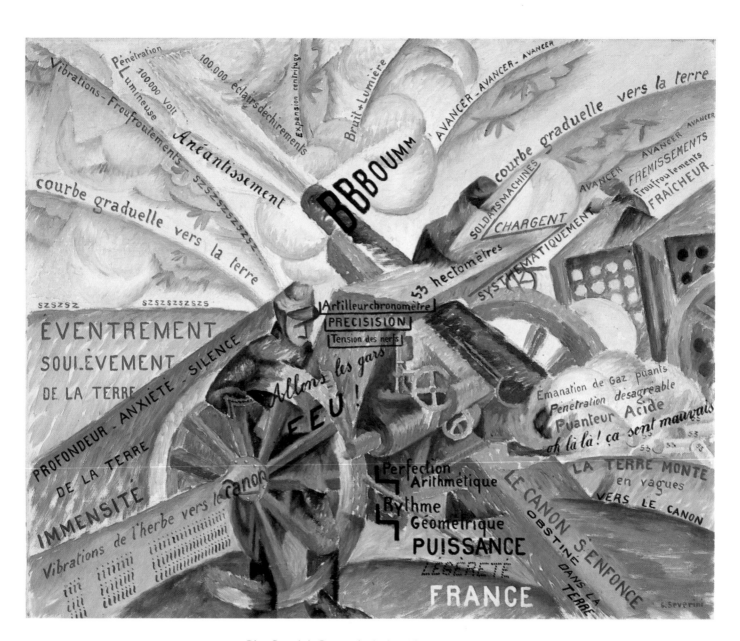

37 Gino Severini, Cannon in Action (*Canon en action*) 1915

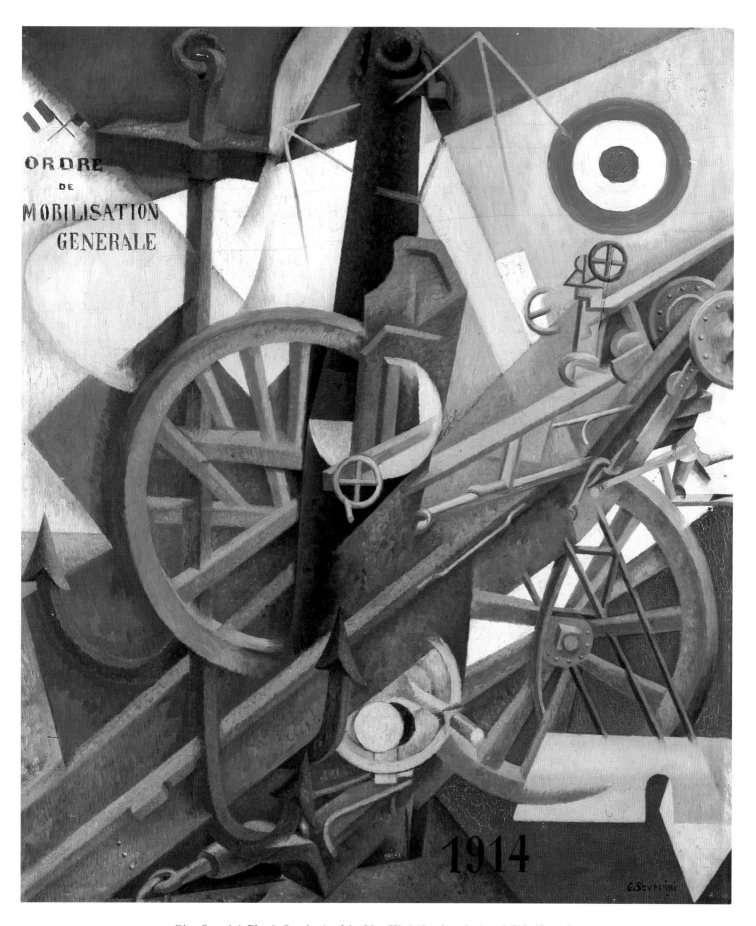

38 Gino Severini, Plastic Synthesis of the Idea 'War' (*Synthèse plastique de l'idée 'Guerre'*) 1915

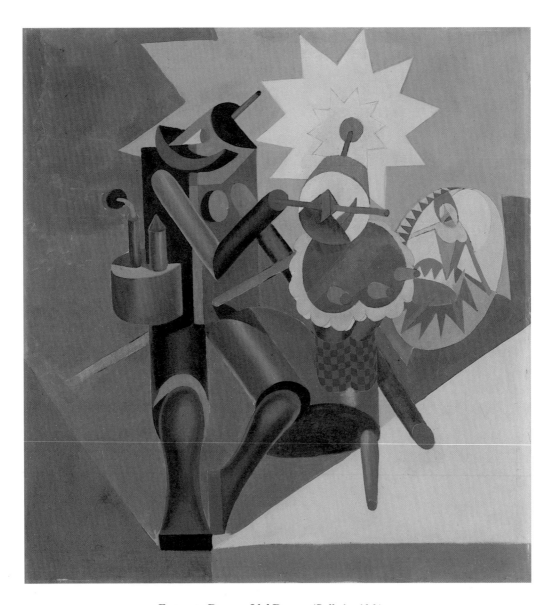

39 Fortunato Depero, Idol Dancer (*Ballerina idolo*) 1917

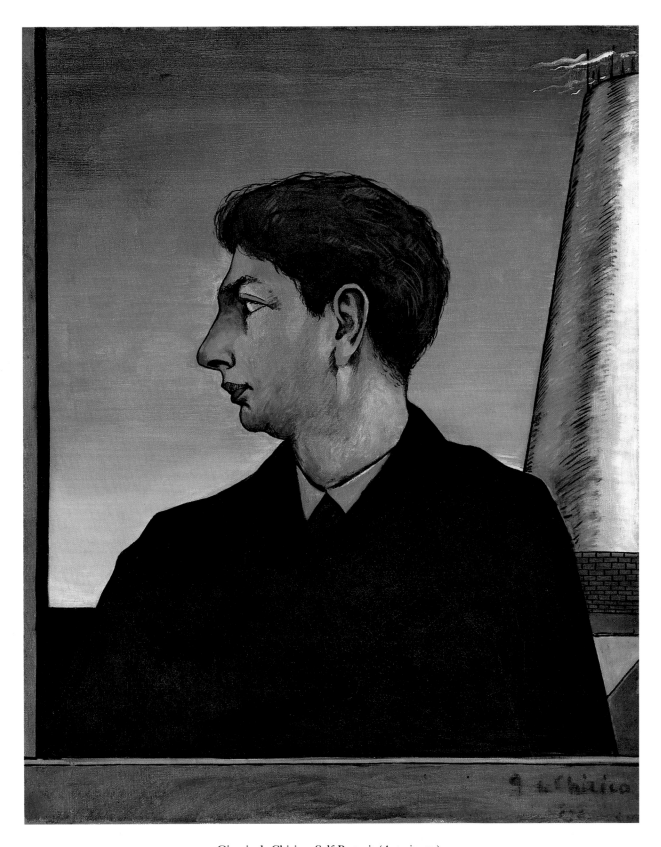

40 Giorgio de Chirico, Self-Portrait (*Autoritratto*) 1913

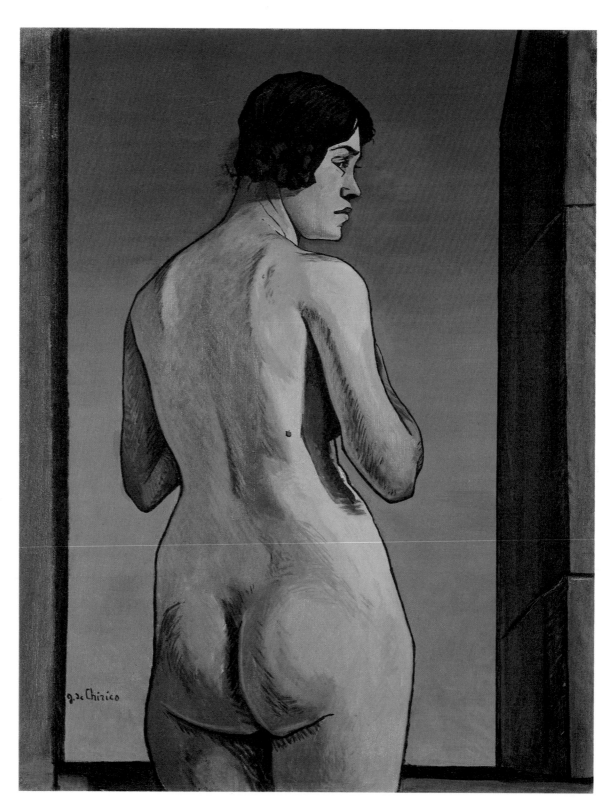

41　Giorgio de Chirico, Study (*Etude*)　1912

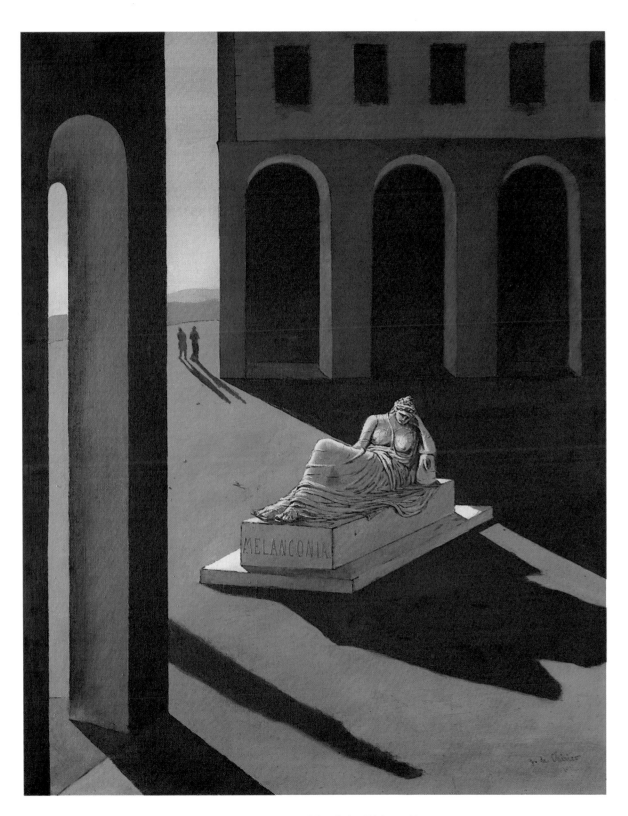

42 Giorgio de Chirico, Melancholy (*Melanconia*) 1912

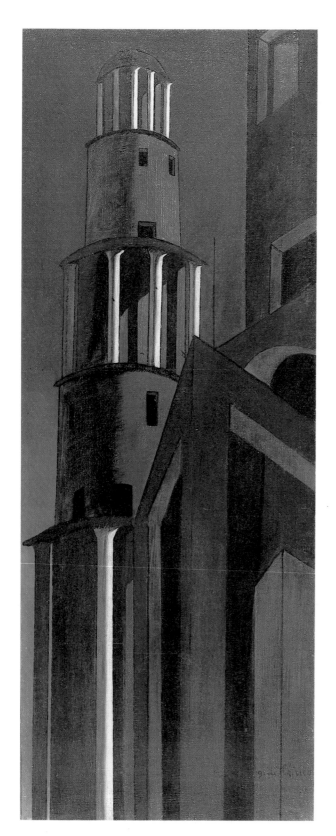

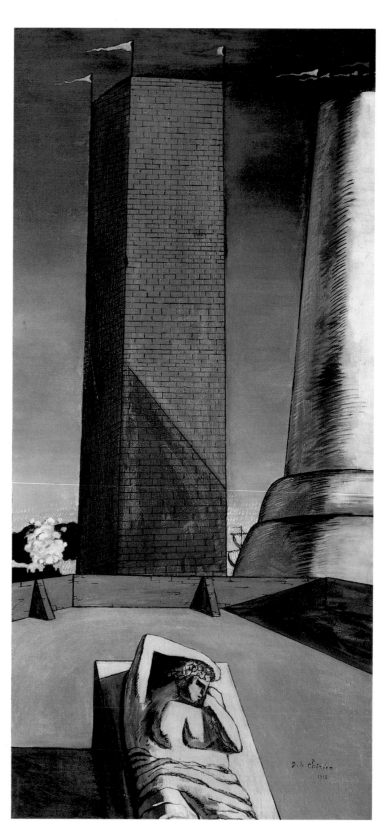

43
Giorgio de Chirico,
The Tower (*La tour*)
1912

44
Giorgio de Chirico
Ariadne's Afternoon
(*L'après-midi d'Ariane*)
1913

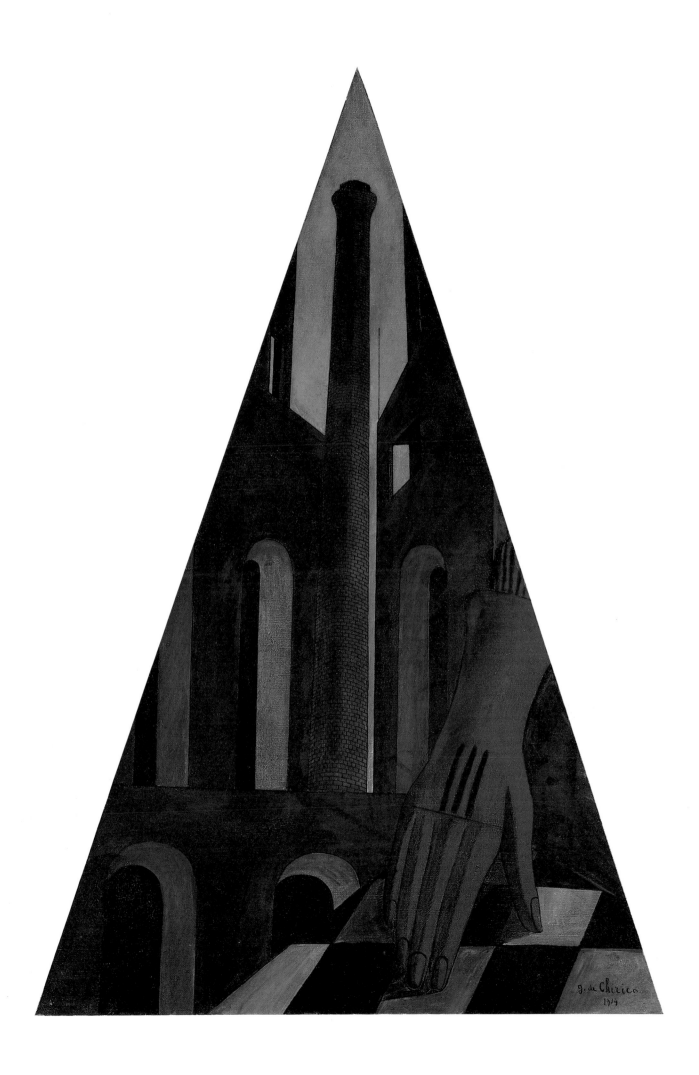

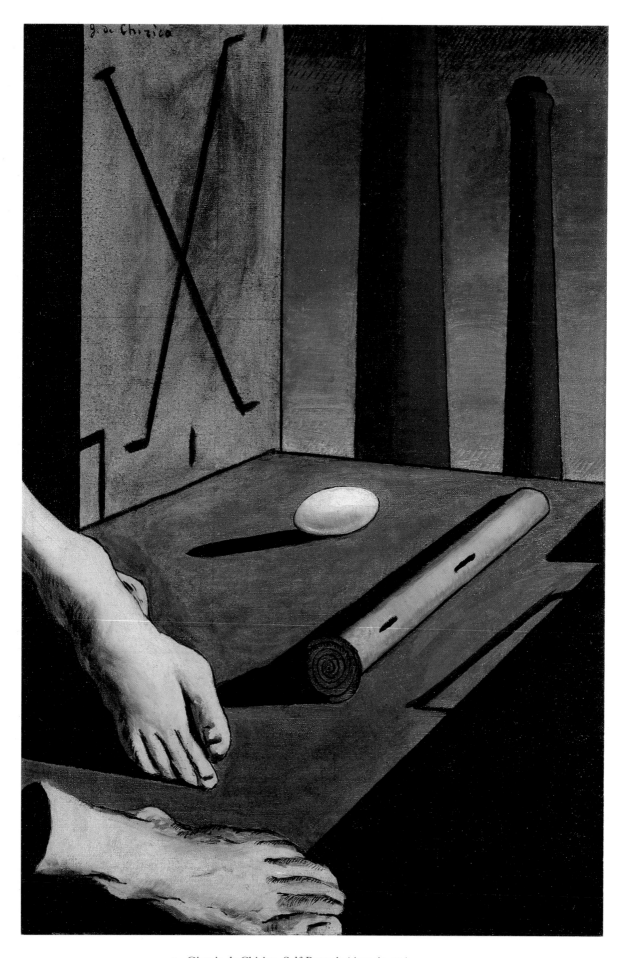

46 Giorgio de Chirico, Self-Portrait (*Autoritratto*) 1913

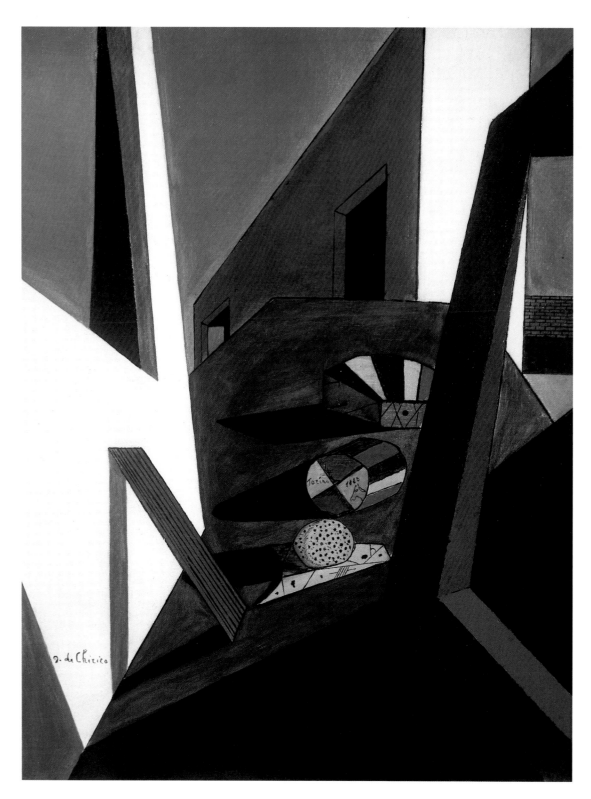

47 Giorgio de Chirico, Turin 1888 (*Torino 1888*) 1914-15

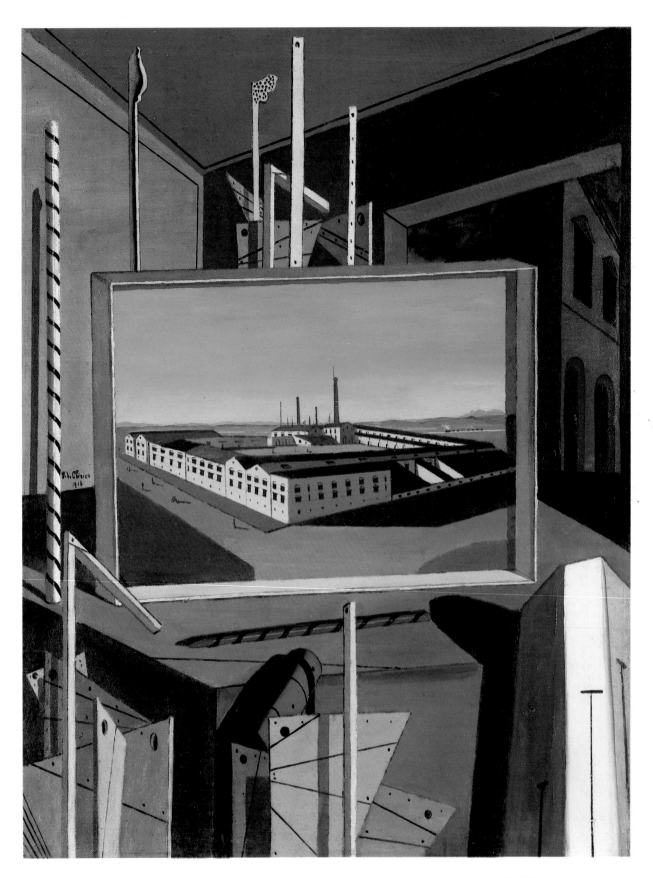

48 Giorgio de Chirico, Metaphysical Interior with Large Factory (*Interno metafisico con grande officina*) 1916-17

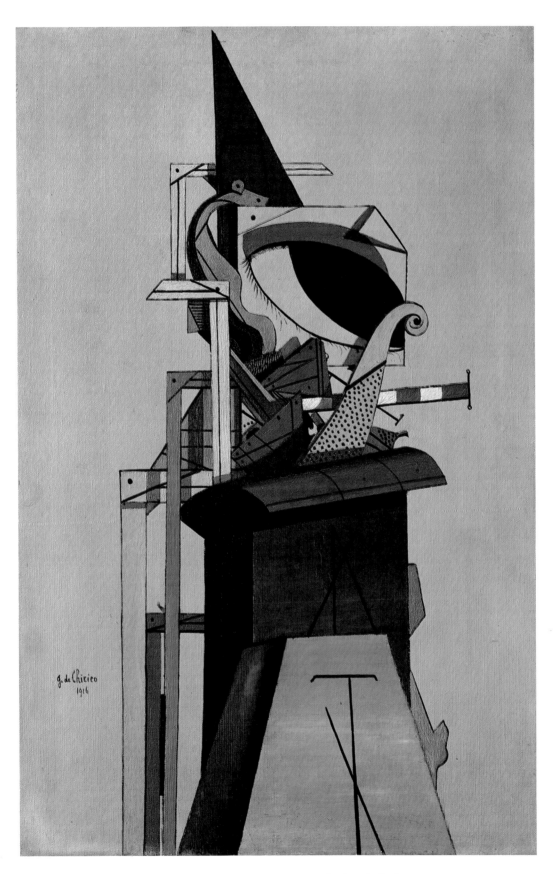

49 Giorgio de Chirico, The Jewish Angel (*L'angelo ebreo*) 1916

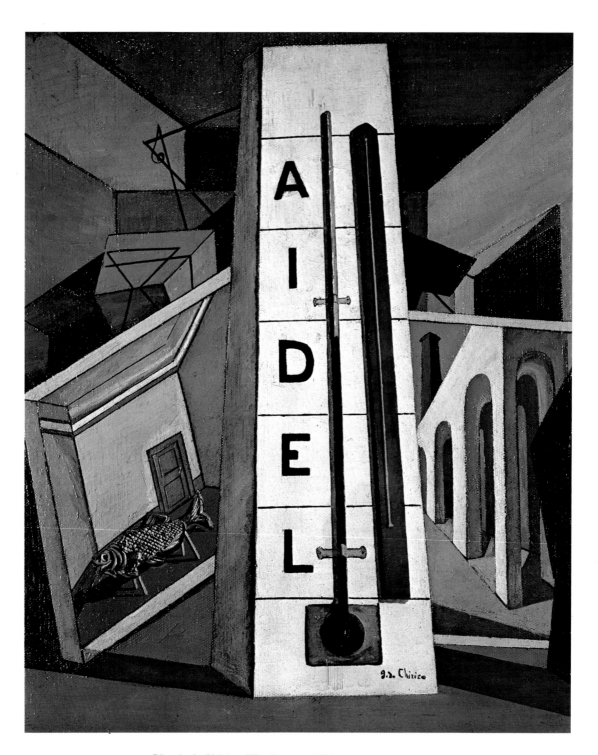

50 Giorgio de Chirico, The Dream of Tobias (*Le rêve de Tobie*) 1917

51 Giorgio de Chirico, The Revolt of the Sage (*La révolte du sage*) 1916

52 Carlo Carrà, Penelope 1917

53 Carlo Carrà, The Enchanted Room (*La camera incantata*) 1917

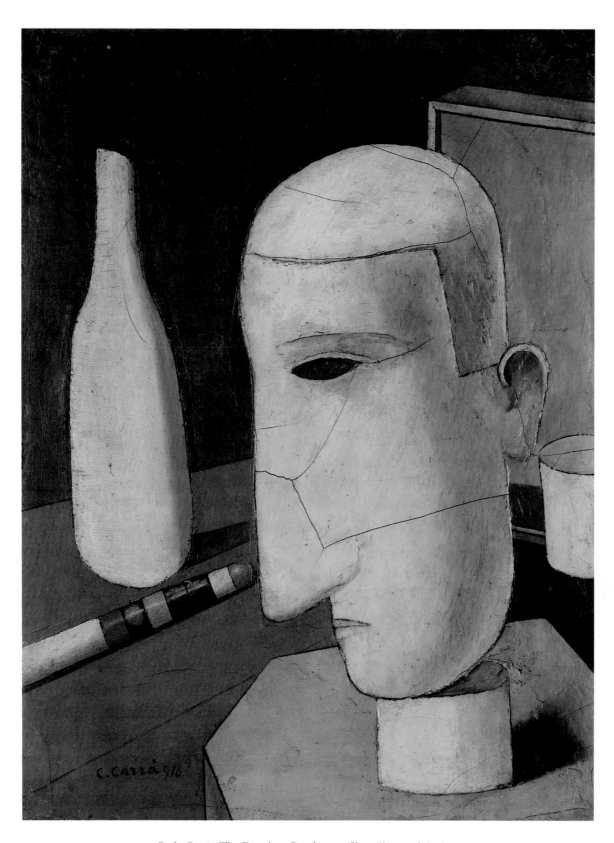

54 Carlo Carrà, The Drunken Gentleman (*Il gentiluomo ubriaco*) 1916

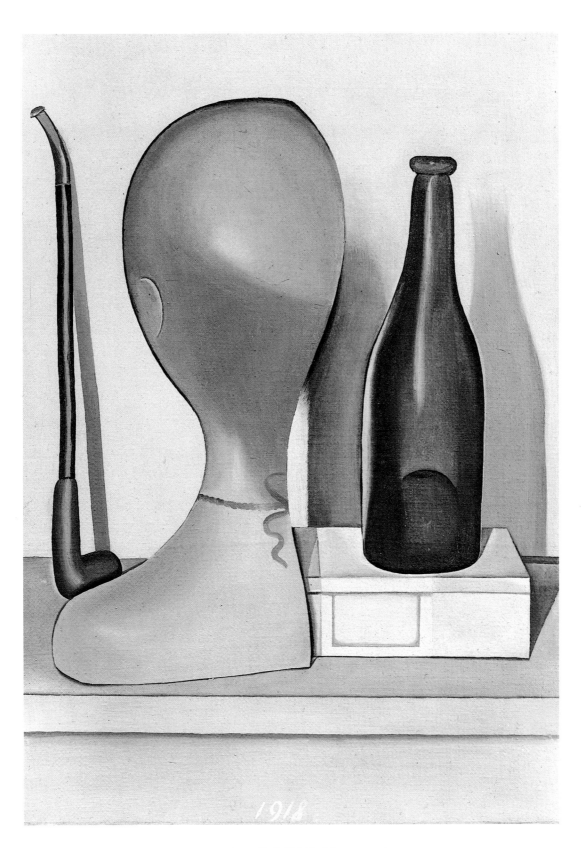

55 Giorgio Morandi, Still-Life (*Natura morta*) 1918

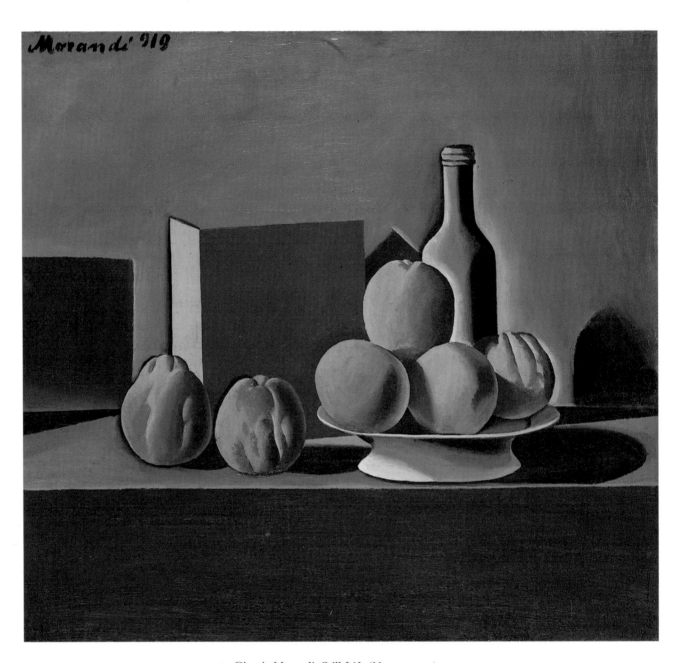

56 Giorgio Morandi, Still-Life (*Natura morta*) 1919

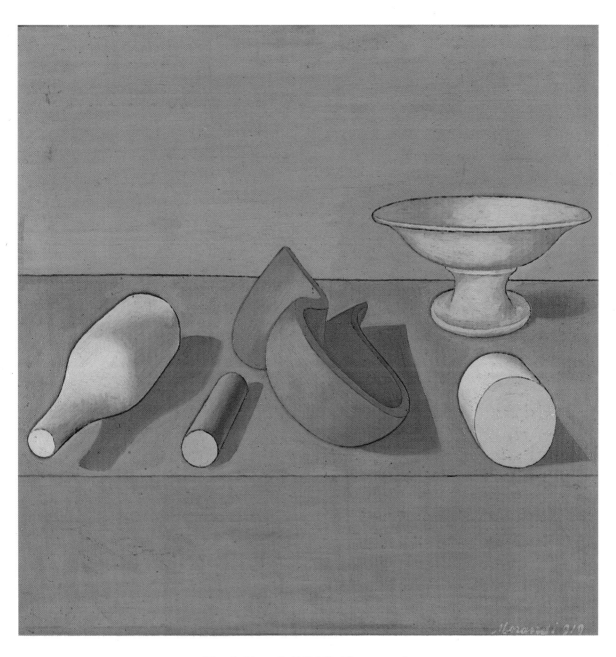

57 Giorgio Morandi, Still-Life (*Natura morta*) 1919

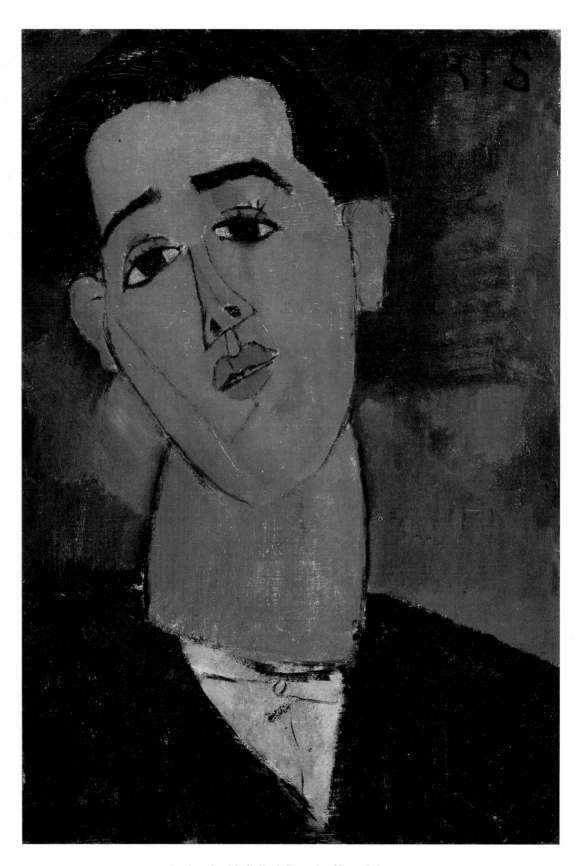

58 Amedeo Modigliani, Portrait of Juan Gris 1915

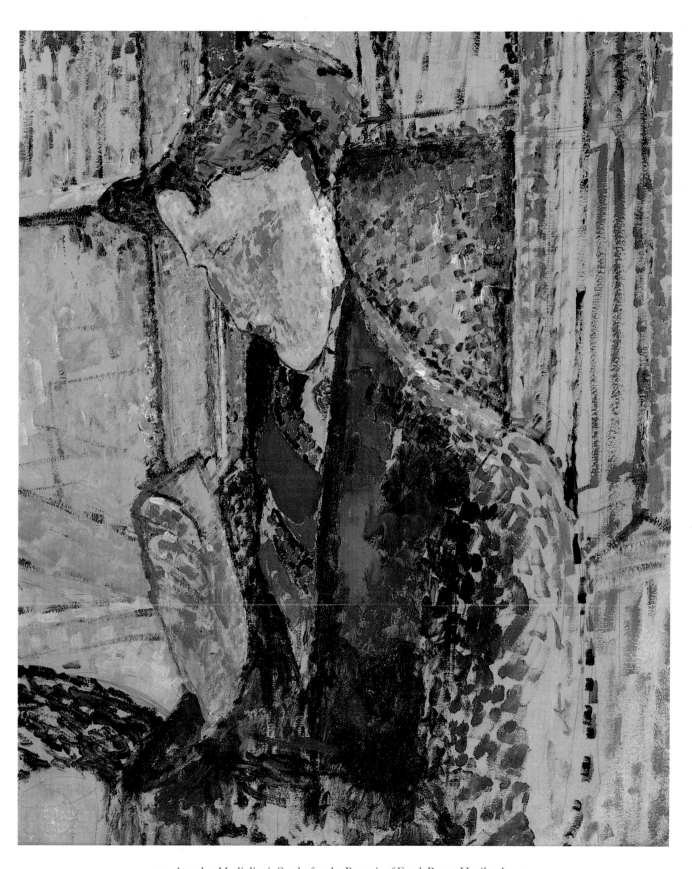

59 Amedeo Modigliani, Study for the Portrait of Frank Burty-Haviland 1914

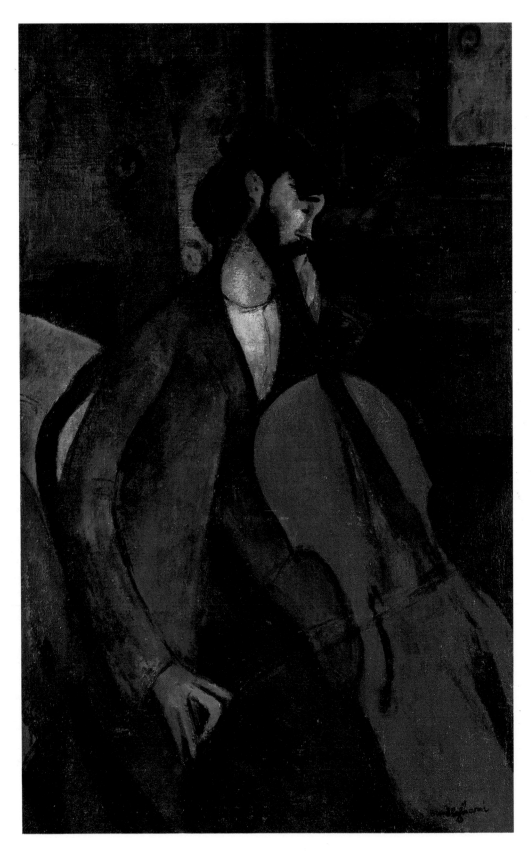

60 Amedeo Modigliani, The Cellist (*Le violoncelliste*) 1909

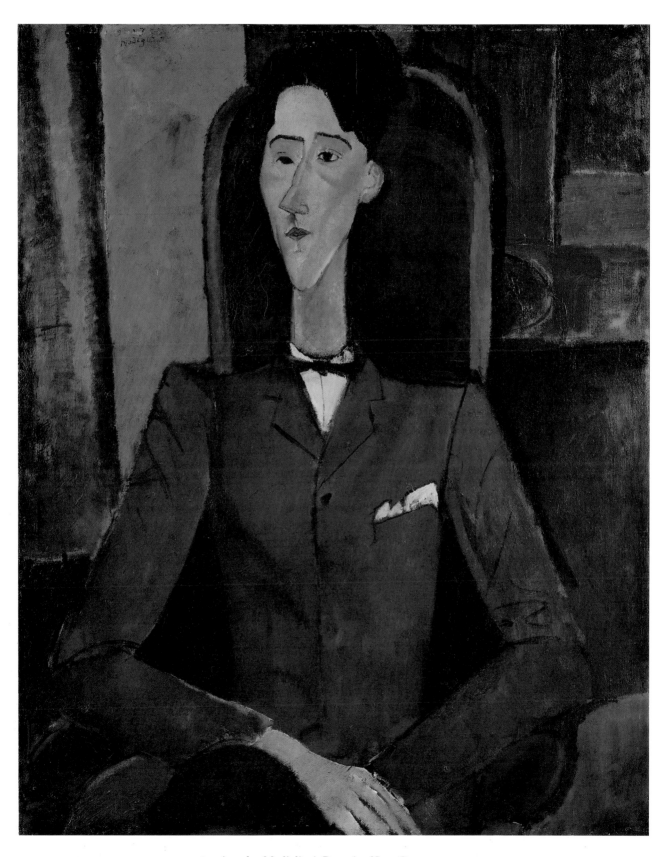

61　Amedeo Modigliani, Portrait of Jean Cocteau　1916

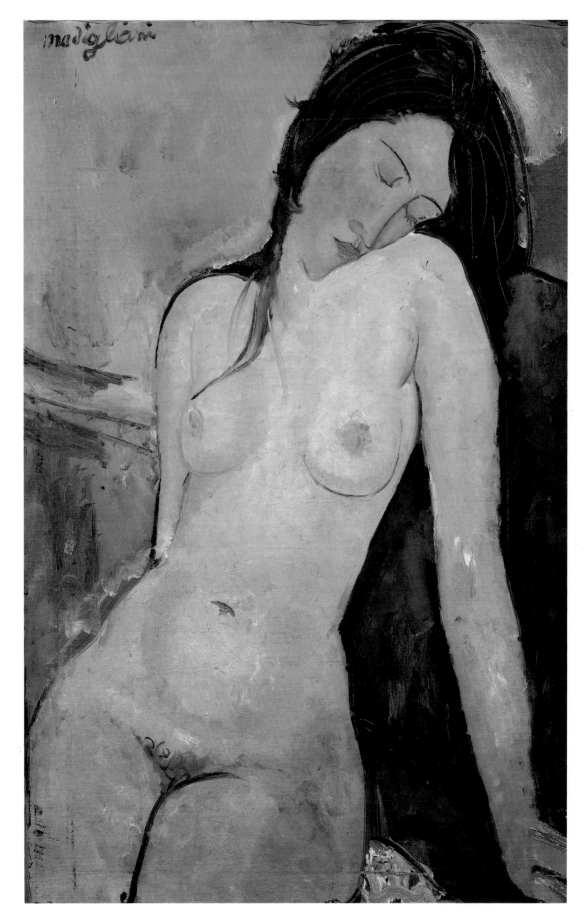

62 Amedeo Modigliani, Seated Nude (*Nu assis*) 1916

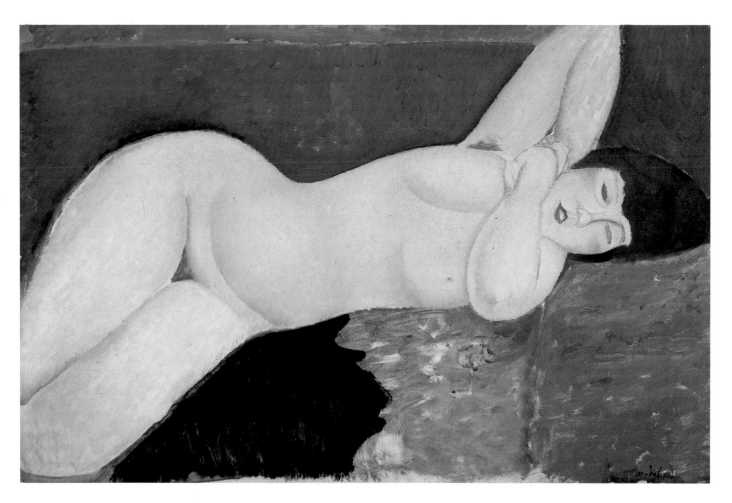

63 Amedeo Modigliani, Nude with Clasped Hands (*Nu aux mains jointes*) 1917

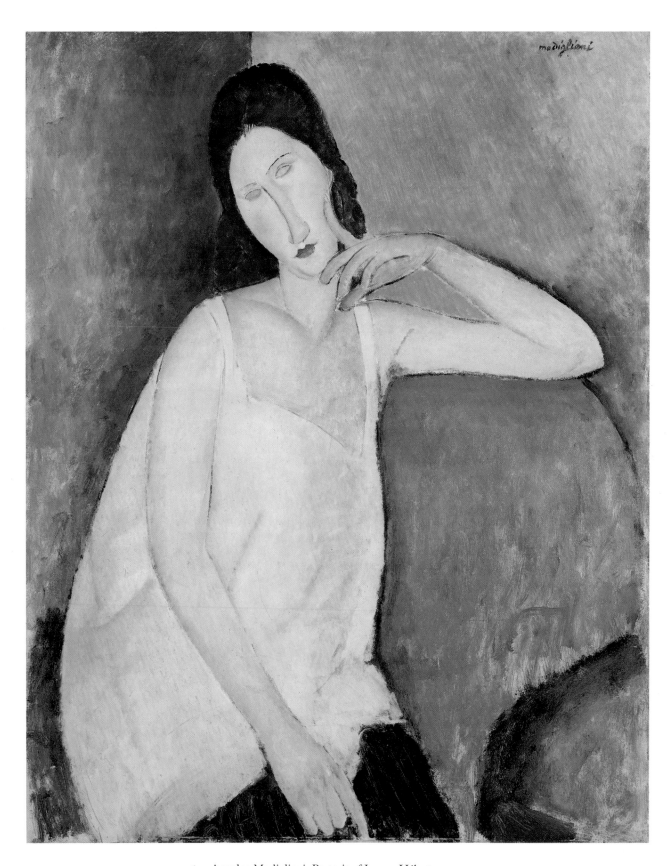

64 Amedeo Modigliani, Portrait of Jeanne Hébuterne 1919

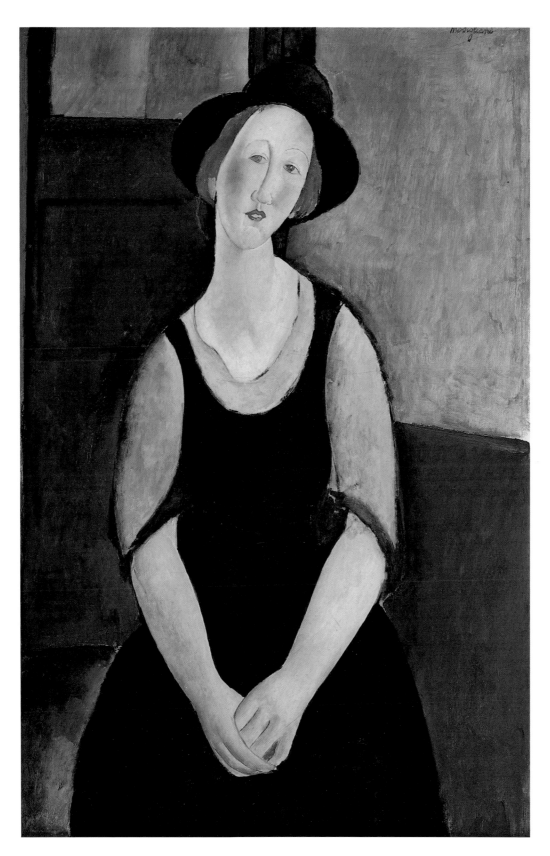

65 Amedeo Modigliani, Portrait of Thora Klinckowstrom 1919

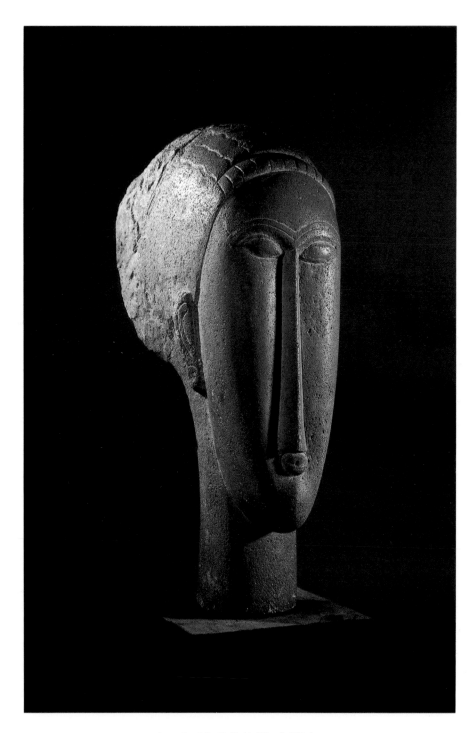

66 Amedeo Modigliani, Head (*Tête*) 1912

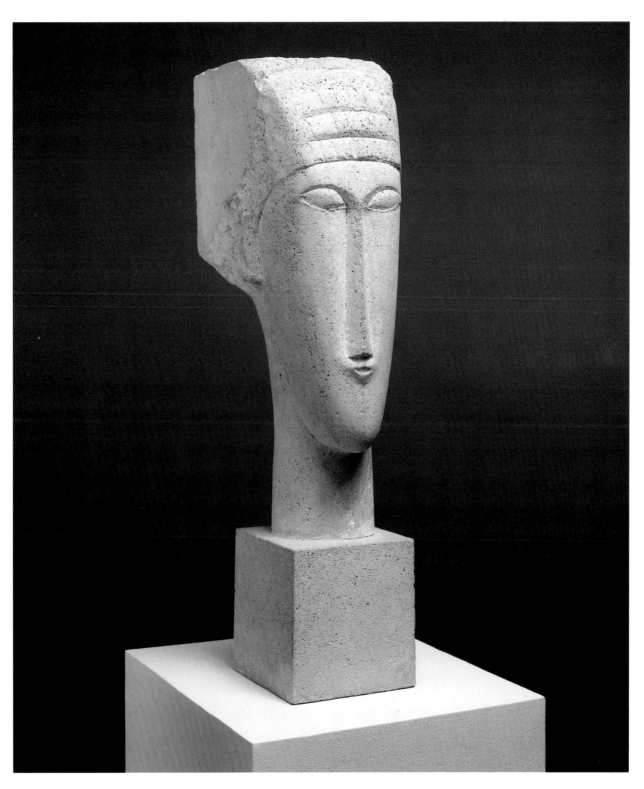

67 Amedeo Modigliani, Head (*Tête*) 1911-13

1919-1945

Philip V. Cannistraro

Fascism and Culture in Italy, 1919-1945

Fig. 1 Margherita Sarfatti (1880-1961) in 1931

Fascism had many of its immediate roots in the transformation and modernization of Italian cultural life that took place in the two decades before the First World War. During and immediately after the war, some of the most prominent artists and intellectuals gravitated towards Benito Mussolini and the early *fasci* – one thinks, for example, not only of Gabriele D'Annunzio and Arturo Toscanini, of Filippo Marinetti and the Futurists, and of Giuseppe Prezzolini and the *La Voce* circle, but of younger artists such as Carlo Carrà, Achille Funi, Mario Sironi, Primo Conti and Ottone Rosai.[1] It would be logical to assume, therefore, that in the three and a half years from the foundation of the Fascist movement in the spring of 1919 to the March on Rome in October 1922, Mussolini would have conceived long-range plans for the place of culture in a future Fascist state. Yet, by the time Mussolini became prime minister, he and the Fascist leadership had paid little attention either to the role of culture or to an official strategy towards intellectuals, a fact that the Tuscan painter Ardengo Soffici had pointed out even before the March on Rome.[2]

This general failure to integrate cultural policy into the Fascist programme seems all the more remarkable in view of the fact that since 1913 Mussolini had enjoyed the constant advice and influence of Margherita Sarfatti, his Jewish mistress and confidante, and a woman of superior intellect with a life-long involvement in the world of art and culture (Fig. 1). She was undoubtedly the behind-the-scenes inspiration for Mussolini's cultural journal, *Ardita*, launched in March 1919. Through *Ardita*, Sarfatti drew to Fascism many of the talented writers and artists to whom she was close, such as Ada Negri, Massimo Bontempelli, Mario Sironi, Achille Funi and Anselmo Bucci. In its first issue, Mussolini had proclaimed the end of the ivory-towered intellectual isolated from the fray of politics. That same year, Sarfatti herself began to write an art column entitled 'Cronaca d'Arte' in Mussolini's newspaper, *Il Popolo d'Italia*, and to form her as yet vague plans for the creation of an art movement that she hoped would parallel the rise of Fascism.[3]

On the other hand, the initial lack of a cultural policy seems less than remarkable considering that as a political movement Fascism fundamentally represented 'anti-culture'. Mussolini was, after all, a crude man, an autodidact whose intellectual development centred almost exclusively on politics. Moreover, many – if not most – of the rank and file Fascist militants were themselves uneducated thugs and, in some cases, conscious anti-intellectuals who had little use for artists or their work. In their concentration on the planning and execution of a seizure of power, neither Mussolini nor his political associates gave the issue much thought.[4]

In the years immediately following his appointment as prime minister by King Vittorio Emanuele III, Mussolini still had little time or inclination to deal with cultural matters as he made his way haltingly through his first experiences of government. In the summer of 1924, a major political crisis erupted when Fascist agents murdered Socialist deputy Giacomo Matteotti. Mussolini weathered the storm, manoeuvring skilfully through the conflicting pressures of a mounting anti-Fascist opposition, the old Liberal leadership which put its trust in the wavering king, and his own radical *squadristi*, who agitated for a complete seizure of power. Mussolini proclaimed a dictatorship in January 1925, unleashing a second wave of Blackshirt violence (as distinguished from the violence that accompanied the rise to power from 1919 to 1922). Over the next four years, he consolidated his authority over his own Fascist movement as well as over the Italian state, and laid the institutional foundations for his regime.[5]

1 G. A. Chiurco, *Storia della rivoluzione fascista*, vol. I, Florence, 1929, pp. 100, 238; G. Pini and D. Susmel, *Mussolini, L'uomo e l'opera*, vol. I, Florence, 1953, p. 391; C. Carrà, *La mia vita*, Milan, 1981, pp. 149-50.
2 A. Soffici, 'Il Fascismo e l'Arte', *Gerarchia*, September 1922, pp. 2-4.
3 Mussolini, 'Preludio', *Ardita*, 15 March 1919, in E. and D. Susmel, eds, *Opera omnia di Benito Mussolini*, vol. 12, Florence, 1953, pp. 299-300.
4 N. Bobbio, 'La cultura e il fascismo', in G. Quazza, ed., *Fascismo e società italiana*, Turin, 1973, pp. 239-40; E. R. Papa, *Fascismo e cultura*, Padua, 1974, p. 173.
5 On the period from the March on Rome to the dictatorship, see A. Lyttelton, *The Seizure of Power: Fascism in Italy, 1919-1929*, London, 1973, and R. De Felice, *Mussolini il fascista*, vol. I, Turin, 1966.

The Matteotti crisis had carried many intellectuals – mostly academics – into the anti-Fascist opposition, who naturally brought the 'anti-culture' issue to the list of their charges against the new dictatorship. Mussolini responded with a series of initiatives designed to co-opt intellectuals into the Partito Nazionale Fascista (Fascist National Party, or PNF) and to use them in legitimizing the regime. Mussolini himself felt it necessary to deny publicly, in a telegram of 27 September 1925 to a gathering of intellectuals, that Fascism was only 'action without thought'.[6] In March 1925, even while the 'second wave' of Fascist brutality was erupting in the streets, Giovanni Gentile, an eminent philosopher and Mussolini's first Minister of Public Instruction, presided in Bologna over the Congress of Fascist Intellectuals (attended by some two hundred and fifty men and women), which issued a manifesto in the following month. Within days, Benedetto Croce and Giovanni Amendola responded with their own document, signed with forty-one names. Croce's manifesto signalled the end of overt opposition, for most of the outspoken anti-Fascist intellectuals would soon be forced into exile.[7]

The Fascist view of the intellectual and the artist remained constant from these early days. The Fascists railed against the Liberal position as symbolized by Croce, who perceived the intellectual as the autonomous, ivory-tower scholar removed, for reasons of critical distance, from the political and social life of the nation. The regime, on the other hand, sought to inspire intellectuals and artists with the ideals of Fascism, making them active and committed servants of the state.[8]

Two months later, in June 1925, the regime took the first of many institutional steps towards the creation of what eventually became an unwieldy cultural bureaucracy. On a proposal by Gentile, the PNF established the Istituto Nazionale Fascista di Cultura (Fascist National Institute of Culture), charged with operating a vast network of branches to disseminate propaganda. Fascist intellectuals would lecture for the Istituto across the nation with the aim of bringing high culture to the masses.[9]

The *Enciclopedia Italiana*, also begun in 1925, was a more respectable attempt to integrate intellectuals into the regime. Intended to be a complete compendium of human knowledge, with special emphasis on the Italian contribution, Mussolini saw the project as a way of raising Italy's international prestige while simultaneously attracting intellectuals into state service. Gentile, who directed the project, actually hired scholars of widely divergent political views, including some anti-Fascists who had signed Croce's manifesto and some professors who had refused to take the Fascist oath of allegiance. Gentile was determined to maintain a high level of scientific accuracy, and certainly provided incomes for many scholars who would ordinarily have been unemployed in the regime. The success of the *Enciclopedia* suggested how some intellectuals had at least appeared to reach an accommodation with Fascism.[10]

The creation of the Reale Accademia d'Italia in January 1926 represented a more direct assault on the autonomy of intellectuals. Modelled on the French Academy, the Italian counterpart numbered sixty members, chosen for their scientific, literary and artistic achievements (Fig. 2). Academicians not only held a privileged position, but also received a handsome monthly income. In return, they swore loyalty to Italy and Fascism, and brought the prestige of their endeavours to the regime. In addition to Gentile, D'Annunzio and Marinetti, among those chosen for membership were Luigi Pirandello, Guglielmo Marconi, Ottorino Respighi, Armando Brasini, Adolfo Wildt, Felice Carena and Marcello Piacentini.[11]

While creating new cultural institutions designed to demonstrate the close relationship between Fascism and intellectuals, the regime also moved to bring pre-Fascist institutions under its control. In the 1920s, Milan's La Scala theatre, Rome's Accademia di Santa Cecilia and musical or theatrical companies throughout Italy were brought under state authority, as were the Società Dante Alighieri and dozens of other agencies. Scientific research was sponsored and controlled through the Consiglio Nazionale delle Ricerche (National Research Council), under the presidency of Marconi.[12]

6 P. V. Cannistraro, *La fabbrica del consenso: Fascismo e mass media*, Rome and Bari, 1975, pp. 31-2, 44, 46; Bobbio, 'La cultura e il fascismo', p. 240.

7 Papa, *Fascismo e cultura*, pp. 159-73. Some 400 people had actually accepted Gentile's invitation. On the anti-Fascist emigration, see C. F. Delzell, 'The Italian Anti-Fascist Emigration, 1922-1943', *Journal of Central European Affairs*, 12, April 1952, pp. 20-55.

8 On the question of intellectuals and Fascism, see A. Leone de Castris, *Egemonia e fascismo: Il problema degli intellettuali negli anni trenta*, Bologna, 1981; M. Isnenghi, *Intellettuali militanti e intellettuali funzionari. Appunti sulla cultura fascista*, Turin, 1979; G. C. Marino, *L'Autarchia della cultura: Intellettuali e fascismo negli anni trenta*, Rome, 1983; L. Mangoni, *L'interventismo della cultura: Intellettuali e riviste del fascismo*, Bari, 1974; and R. De Felice, *Intellettuali di fronte al fascismo*, Rome, 1985.

9 Cannistraro, *La fabbrica del consenso*, pp. 22-3; A. Vittoria, 'Totalitarismo e intellettuali: l'Istituto Nazionale Fascista di Cultura dal 1925 al 1937', *Studi Storici*, October-December 1982, pp. 897-918. In 1937, the Istituto's name was changed to Istituto Nazionale di Cultura Fascista.

10 G. Turi, 'Il progetto dell'Enciclopedia Italiana: l'organizzazione del consenso fra gli intellettuali', *Studi Storici*, January-March 1972, pp. 93-152; idem, *Il fascismo e il consenso degli intellettuali*, Bologna, 1980; S. Romano, *Giovanni Gentile*, Milan, 1984, pp. 211-22.

11 Cannistraro, *La fabbrica del consenso*, pp. 23-7; *Annuario della Reale Accademia d'Italia*, Rome, 1938, pp. 254, 640-1; M. Ferrarotto, *L'Accademia d'Italia: Intellettuali e potere durante il fascismo*, Naples, 1978. The Accademia was officially inaugurated in October 1929.

12 Cannistraro, *La fabbrica del consenso*, pp. 27-9; H. Sachs, *Music in Fascist Italy*, New York, 1988, pp. 57-60.

Fig. 2 Members of the Reale Accademia d'Italia, early 1930s

The *Enciclopedia* and the Accademia bound some of Italy's most prestigious cultural names to the regime, but their direct impact was limited, and neither involved coercion. Instead, the cultural *sindacati*, or unions, developed in Mussolini's corporate state encompassed virtually all of Italy's creative artists and intellectuals, and did have the ability to force many into submission.

The organization of intellectuals began with two disparate initiatives which fed into an elaborate bureaucratic maze. At the PNF national congress in January 1922, Edmondo Rossoni, the principal Fascist syndical theorist, announced the establishment of the Confederazione Nazionale delle Corporazione Sindacali (National Confederation of Syndical Corporations), which included a Corporation of Intellectuals. That same year, Giacomo Di Giacomo, an early Fascist syndicalist, organized a Sindacato Nazionale del Lavoro Intellettuale (National Union of Intellectual Labour) in Rome. On 30 December 1924, Mussolini combined these two organizations into a single Corporazione delle Professioni Intellettuali (Corporation of Intellectual Professions), housed within Rossoni's National Confederation. The new corporation included thirteen *sindacati* for such categories as architects, writers and inventors.

In April 1926, Mussolini stripped Rossoni's movement of any real power by replacing his syndical corporations with a Confederazione Nazionale dei Sindacati Fascisti (National Confederation of Fascist Unions), divided into seven federations. The Federazione dei Sindacati Intellettuali (Federation of Intellectual Unions) included for the first time separate organizations for painters and sculptors. The final change came in the period 1928-31, when Mussolini abolished the Federation in favour of six independent confederations; the Confederazione dei Professionisti e degli Artisti (Confederation of Professionals and Artists) eventually contained more than 425,000 members.

Under Giuseppe Bottai, a 'liberal' Fascist appointed Minister of Corporations from 1929 until 1932, the Confederazione wielded considerable power. It set specific policies aimed at destroying the perceived anachronism of 'free' professions by making intellectuals and artists dependent on the state for work and inspiration. Most important, each *sindacato* exercised direct control over its members through an official roster, or *albo*. Inclusion in the roster was legally necessary for practising a particular profession, and roster-listing required a PNF membership card and proof that the individual in question had maintained 'good moral and political conduct'. Artists or writers could be removed from the roster if they were judged to have done something 'against the national interest' by the union president, a prefect or a state prosecutor. In order for a painter to exhibit or sell his work he would, technically, have to be enrolled in the union. Many did so simply to practise their chosen profession and earn a living, thereby compromising their political views.

Like most Fascist institutions, the *sindacati* functioned imperfectly as a means of control, and much depended on the personalities in positions of authority. A union president such as the sculptor Antonio Maraini was a staunch Fascist who ran his union with appropriate Fascist discipline. When a renegade member, such as the sculptor Nino Cloza, tried to organize artists against Maraini, he was stripped of his union membership. On the other hand, Cornelio Di Marzio, president of the Confederation of Professionals and Artists, was a sensitive man of liberal views who tempered the effects of official regulation.[13]

Italian painters, sculptors and architects were, of course, included in the Accademia d'Italia and in the *Enciclopedia* project, but besides the *sindacati* Mussolini created little in the way of bureaucratic controls for the fine arts, and nothing at all resembling the Reich Chamber of Visual Arts in Nazi Germany. The regime's policy towards painting and sculpture remained, therefore, informal and unco-ordinated, operating principally through patronage and exhibitions. Government purchases for museums and commissions for official buildings accounted for an increasingly large portion of artist employment and income. The Direzione Generale delle Antichità e Belle Arti (Office for Antiquities and Fine Arts), under the Ministry of National Education, oversaw the operations of the national museums and the protection of artistic and archaeological patrimony.

Officially sponsored exhibitions not only gave artists opportunities to show their work but also to sell it. The Sindacato di Belle Arti, headed by the artist Cipriano Efisio Oppo, launched a vast network of annual and biennial exhibitions in the principal Italian cities, and sponsored a number of commercial galleries. Between 1927 and 1939, the Sindacato held more than three hundred regional exhibitions.[14]

Until the early 1930s, the most important regular exhibition in Italy was the Venice Biennale, which had been founded in 1895. The regime began to exercise control in 1926 when it replaced the esteemed Vittorio Pica with Antonio Maraini as Secretary General. In 1928, it was transformed from an independent regional entity to a semi-state agency funded by Rome. That same year, Giuseppe Volpi di Misurata became its president and Sarfatti a member of its executive committee. The Biennale had a powerful influence on Italian artists, for its choices for the Central Pavilion reflected those styles and painters in official favour. Moreover, both the PNF and government agencies instituted prizes for specific subjects in order to influence the content of exhibited works.[15]

In the late 1920s and early 1930s, the regime initiated two other important exhibitions, the Triennale of Milan and the Quadriennale of Rome. Conceived in 1919 for the promotion of modern architecture, decorative and industrial arts, the Triennale first opened in May 1923, with a visit from Mussolini. After 1927, when Sarfatti, Sironi and Carrà were appointed to the executive committee, the Triennale became an important showcase for a range of interpretations of the modern aesthetic, from the *Novecento* to the international style of the Rationalists.[16] The 'Quadriennale d'Arte Nazionale', created by law in December 1928 as Italy's first national art exhibition, opened in 1931 under the direction of Oppo. The composition of the selection juries – including Felice Carena, Ferruccio Ferrazzi, Giorgio Morandi, Adolfo Wildt and Aldo Carpi – revealed how eclectic its attitude was to be. Indeed, at the inaugural ceremonies Mussolini explicitly declared that the Quadriennale would be open to art of all tendencies. The extraordinarily high sum of 300,000 lire was earmarked for purchases by the Galleria d'Arte Moderna.[17]

The regime's failure to develop a coherent policy and a bureaucratic apparatus to control the fine arts stemmed in part from Mussolini's determination to tolerate – indeed, to deliberately encourage – an on-going and surprisingly open cultural debate within the regime, one that was never permitted by Hitler in Nazi Germany. The public discussion of 'Fascist Art' opened in 1926 with an inquiry launched by Giuseppe Bottai in his journal, *Critica Fascista*. Bottai asked artists to consider whether Fascism could create a new form of visual expression and to describe its characteristics and the general relationship between art and the state. There was broad consensus that Fascism both could and should create a culture that reflected

Fig. 3 Mussolini speaking at the opening of the 'Prima Mostra del Novecento Italiano', Rome, 1926. Margherita Sarfatti is seated on the left

13 Cannistraro, *La fabbrica del consenso*, pp. 30-8; G. Di Giacomo, *Intellettuali e fascismo*, Rome, 1932; F. Coscera, *Le professioni e le arti nello stato fascista*, Rome, 1941.

14 Cannistraro, *La fabbrica del consenso*, p. 125; Coscera, *Le professioni*, pp. 179-81; C. S. Lazagna, 'La concezione delle arti figurative nella politica culturale del fascismo', *Il Movimento di Liberazione in Italia*, October-December 1967, p. 19.

15 L. Alloway, *The Venice Biennale, 1895-1968*, New York, 1968; A. Lancellotti, *Le Biennale veneziane del dopoguerra*, Venice, 1926; P. Budillon-Puma, 'Les Biennales de Venise pendant l'époque fasciste', in *Aspects de la culture italienne sous le fascisme*, Grenoble, 1982, pp. 29-43.

16 F. Tempesti, *Arte dell'Italia fascista*, Milan, 1976, pp. 85-96; M. G. Sarfatti, 'Triennale e pittura murale a Milano', *Rivista illustrata del Popolo d'Italia*, June 1933, pp. 31-9. The original exhibition was the 'Biennale internazionale delle arti decorative', held at Monza. In 1930, it was changed to the 'Triennale internazionale delle arti decorative e industriali moderne'; in 1933, when it was moved to Milan, it became the 'Triennale internazionale delle arti decorative e industriali moderne e dell'architettura moderna'. See also A. Pierpaoli, 'Le Triennali', in *Gli Anni Trenta: Arte e cultura in Italia*, Milan, 1982, pp. 311-24, and A. Pica, *Storia della Triennale 1918-1957*, Milan, 1957.

17 Tempesti, *Arte dell'Italia fascista*, pp. 154-60; R. Bossaglia, *Il 'Novecento Italiano': Storia, Documenti, Iconografia*, Milan, 1979, p. 42.

Fig. 4 Mussolini at the inauguration of the
Galleria di Roma, Rome, 1930

18 See, for example, A. Soffici, 'Arte Fascista',
 Critica Fascista, 15 October 1926, pp. 383-5;
 F. T. Marinetti, 'L'arte fascista futurista',
 ibid., 1 January 1927, p. 8; G. Severini,
 'Idolatria dell'arte' e decadenza del quadro',
 ibid., 15 January 1927, pp. 24-5.
19 Bottai, 'Resultanze dell'inchiesta sull'arte
 fascista', *Critica Fascista*, 15 February 1927,
 pp. 61-4; Soffici, 'Ufficio e fini della Corpora-
 zione delle Arti', ibid., 1 March 1927, pp. 87-9.
 In 1929, Ugo Ojetti, the *Corriere della Sera*'s
 conservative critic, lamented that after more
 than six years the regime was no closer to the
 goal of creating a Fascist art. See his open letter
 to Mussolini in January 1929, republished in
 his *Venti Lettere*, Milan, 1931, pp. 3-13.
20 M. G. Sarfatti, 'Arte, fascismo e antiretorica',
 Critica Fascista, 1 March 1927, pp. 82-4; Bottai,
 'Resultanze', p. 61.
21 Bossaglia, *Il 'Novecento Italiano'*, and *Mostra del
 Novecento Italiano (1923-1933)*, Milan, 1983.
22 D. Alfieri and L. Freddi, *Mostra della
 Rivoluzione Fascista*, Rome, 1933; M. Palla,
 Firenze nel regime fascista, Florence, 1978,
 pp. 361-2; G. K. Koenig, *Architettura in Tos-
 cana, 1931-1968*, Turin, 1968, p. 35; Bossaglia,
 Il 'Novecento Italiano', p. 42.

its political and spiritual values, but most agreed that the regime needed to proceed with caution so as not to institute what Soffici called an 'official' state art. Marinetti insisted that only Futurism could be the art of Fascism. Gino Severini, writing from Switzerland, ventured into the fray with the thinly veiled argument that all the great art of the past had a higher purpose beyond art for art's sake, thereby implying that Fascism would now take the place once occupied by religion in providing art with patronage and inspiration.[18]

In his summary of the debate, Bottai argued that two institutions should have primacy over Italian cultural life: the *sindacati*, which would protect and advance the interests of artists and writers, as Soffici had suggested, and the Accademia d'Italia, which he saw as a kind of ministry of culture that would set broad policy and look after the cultural patrimony of the country. Always the 'liberal' Fascist, Bottai stressed the state's role as a stimulant to artistic labour rather than as an infringement on 'free creativity'.[19]

Sarfatti, whose article appeared in a subsequent issue of *Critica Fascista*, recommended a 'cleansing' of the artistic scene through methods which she likened to the *squadristi* punitive expeditions and the Manganello, the Blackshirt club. In her more temperate remarks, she agreed with Bottai that the regime had permitted too much 'Fascist bad taste' to clutter Italian public life, and advocated instead a controlled, severe, 'anti-rhetorical' style in art. Indeed, Bottai noted that such a style, marked by 'constructions that are increasingly solid, ample, and strong, in the manner of the great tradition of native Italian art', had already begun to appear. He stressed, however, that while attached to tradition, the new art should incorporate modern taste and sensibility.[20]

The style that Bottai described in such vague terms could only have been the *Novecento* movement that Sarfatti had forged in Milan after the war. The artists of the *Novecento*, such as Sironi and Funi, sought to revitalize the classical traditions of Western art with modernist pictorial inventions. Throughout the 1920s and early 1930s, Sarfatti worked to co-opt Italian artists of diverse schools into her movement and to secure Mussolini's recognition of the *Novecento* as the official art of the regime. Her strategy came close to success, for, by combining tradition and modernism, the *Novecento* appealed to Mussolini's overall political desire to forge a new Italy based on the cultural forms of the past and the technological advance of the present. Until Sarfatti's fall from grace in the early 1930s, she used all her considerable skill and influence to advance the cause of the *Novecento*.[21]

That the debate over the *Novecento* raged on for almost a decade, and that Fascists argued ceaselessly over the merits of traditional versus modern styles in art and architecture, points to the persistence of a constant tension within Fascism that was never fully resolved. Mussolini, no doubt under the influence of the Futurists and Sarfatti, often championed modernism, as his personal approval of both the 'Mostra della Rivoluzione Fascista' (Exhibition of the Fascist Revolution) in 1932 and the architect Giovanni Michelucci's design for Florence railway station attest. At first he gave the *Novecento* his personal prestige by inaugurating its initial exhibitions in 1923 and in 1926 (Fig. 3), but he steadfastly refused to give Sarfatti's movement official recognition. Throughout the entire period, currents and styles as diverse as *Pittura Metafisica*, *Novecento*, the *Scuola Romana*, the *Aeropittura* of the second generation of Futurism, and abstraction existed side by side and often competed for Mussolini's favour (Fig. 4).[22]

In cultural policy, as in politics, Mussolini much preferred to play conflicting interests and theories against each other. In June 1933, Antonio Maraini discreetly pressed Mussolini to make a clear statement of his own ideas about art. Mussolini's response was deliberately evasive: 'Me? Nothing doing. It's your job to worry about the artists. I know what I'm talking about. To supervise textile workers, construction crews and metal workers is easier than supervising painters'. The resulting degree of flexibility allowed many artists and intellectuals to remain in Italy and work largely undisturbed by Fascism. The expression and the conflict of opinion permitted were sometimes deliberately encouraged, as in the case of student news-

papers and the annual *Littoriali* competitions sponsored by the PNF, so as to foster a semblance of openness.[23]

Sarfatti operated against this climate of diversity wanted by Mussolini. In the period from 1922 to 1934, during which she earned her reputation as the 'dictator of the visual arts', she used her access to the *Duce* to induce artists to join the *Novecento* circle and to project herself as the cultural power-broker of the regime. She succeeded to a degree in using Mussolini and the government as patrons of her favourite artists, and organized a special room for the *Novecento* in the 1924 Biennale. She also persuaded Oppo to open the *sindacati* exhibitions and the Quadriennale to special presentations of her group, as she did the directors of the Triennale.[24]

Despite these successes, the fortunes of the *Novecento* waned along with Sarfatti's personal relationship with Mussolini. The movement became the target of increasingly harsh attack from reactionaries such as Roberto Farinacci, the brutal and intransigent Blackshirt who admired Nazi policy and wanted a 'Fascist realism' with direct propaganda value. Beginning in 1929, Farinacci accused the *Novecento* of being too modern and too influenced by international styles. Farinacci's attacks on the movement grew more insistent and vicious, and when the replies of Sarfatti and her friends brought the polemic to the front pages of the press, Mussolini finally ended the public argument. In 1934, the issue surfaced once more in the form of a free-wheeling, acrimonious debate in the Chamber of Deputies over the design for the Palazzo Littorio (the PNF national headquarters). Modernism was simultaneously attacked as 'Bolshevik' and 'German', again underscoring Mussolini's refusal to choose among styles, as several of those contributing to the debate in *Critica Fascista* had suggested he must do.[25]

By then Sarfatti had fallen out of favour and the regime itself had begun to move in the direction of a militaristic dictatorship characterized by a mania for rigid conformity and imperial rhetoric. Mussolini was increasingly a captive of his own myth as the infallible *Duce*. The original *Novecento* movement had virtually disintegrated, and Sironi now led the way with mural painting that more easily accommodated the regime's growing emphasis on direct propaganda.[26]

In the mid-1930s, the regime turned its attention increasingly to the mass media and entertainment, and eventually imposed tight state control over these areas through its Ministero della Cultura Popolare (Ministry of Popular Culture). The ministry evolved out of Mussolini's Press Office, which had initially concerned itself only with the dissemination of official information and the censorship of news. Until Count Galeazzo Ciano, Mussolini's son-in-law, took over the Press Office in 1933, a succession of directors limited its work largely to newspaper propaganda. Giovanni Capasso Torre and Lando Ferretti did establish basic propaganda themes – such as national greatness, Mussolini as *Duce*, the Roman tradition, efficiency and modernization – but it was Ciano who greatly broadened the scope of the Press Office by including radio and motion pictures under its jurisdiction. In September 1934, the Press Office was elevated into a Sottosegretariato per la stampa e la propaganda (Undersecretariat for Press and Propaganda), and took control of music, tourism, theatre and literature. This action had been taken after consultation with Nazi propaganda minister Joseph Goebbels, whose policies were much more totalitarian. The following June, Mussolini made the Undersecretariat a full ministry.

When Ciano was transferred to the Foreign Ministry in 1936, Dino Alfieri – formerly head of the Corporation of Professionals and Artists – became Minister of Press and Propaganda. Alfieri's tenure of office saw the imposition of rigid conformity and administrative control over cultural life, and the expansion of the mass media in a programme to integrate all social classes into a Fascist national experience. In May 1937, Mussolini officially renamed Alfieri's office the Ministry of Popular Culture, which Italians irreverently dubbed 'Minculpop'.

In spite of the regime's goals of producing a new and revolutionary Fascist culture, the Ministry of Popular Culture realized few of its programmes and failed to achieve the same degree of control that Goebbels had imposed on German life. It paid many artists and intellectuals secret subsidies, but they were relatively modest sums which

23 Mussolini is quoted in U. Ojetti, *I Taccuini*, Florence, 1954, p. 414. E. R. Tannenbaum, *The Fascist Experience: Italian Society and Culture, 1922-1945*, New York, 1972; D. Morosini, *L'arte degli anni difficili (1928-1944)*, Rome, 1985; M. Sechi, *Il mito della nuova cultura: Giovani, realismo e politica negli anni trenta*, Manduria, 1984; R. Zangrandi, *Il lungo viaggio attraverso il fascismo*, Milan, 1962; A. Vittoria, *Le riviste del Duce*, Milan, 1983; A. Folin and M. Quaranta, eds, *Le riviste giovanili del periodo fascista*, Treviso, 1977.

24 Bossaglia, *Il 'Novecento Italiano'*, p. 42; Tempesti, *Arte dell'Italia Fascista*, p. 155.

25 Camera dei Deputati, *Atti del Parlamento italiano*, 29th Leg., vol. I, Discussioni, Rome, 1935, pp. 330-9. On the *Novecento* polemic, see Bossaglia, *Il 'Novecento Italiano'*, pp. 42-8.

26 Bossaglia, *Il 'Novecento Italiano'*, pp. 48-55. On Sironi, see E. Braun, 'Die Gestaltung eines kollektiven Willens', in Jürgen Harten and Jochen Poetter, eds, *Sironi*, Cologne, 1988, pp. 40-9.

27 P. V. Cannistraro, 'Burocrazia e politica culturale nello stato fascista: Il Ministero della Cultura Popolare', *Storia Contemporanea*, June 1970, pp. 273-98; R. Cantore, 'Sul borderò del duce', *Panorama*, 22 February 1987, pp. 106-21; T. M. Mazzatosta, *Il regime fascista tra educazione e propaganda, 1935-1943*, Bologna, 1978, pp. 27-39.

28 Cannistraro, *La fabbrica del consenso*, pp. 150-56; Tempesti, *Arte dell'Italia fascista*, pp. 227-49. On Bottai, see A. J. De Grand, *Bottai e la cultura fascista*, Rome and Bari, 1978; G. B. Guerri, *Giuseppe Bottai, un fascista critico*, Milan, 1976.

in most cases could have had little influence on attitudes or behaviour. Newspapers and motion pictures, on the other hand, remained in private hands, and were thus subject to market demands and the escapist tendencies of the public. Only radio was nominally run by a semi-public agency but its censorship techniques were unsophisticated and often inefficient. Finally, jurisdictional disputes, particularly with the PNF and the Ministry of National Education, prevented a fully totalitarian control of Italian cultural life.[27]

The Ministry of Popular Culture never developed bureaucratic offices for the control of the visual arts, which always remained beyond its jurisdiction except in matters of international cultural exchange. Towards the end of the 1930s, Bottai, now Minister of National Education, attempted to resolve this glaring lack of a central authority in the regime's artistic policies by moving control of the fine arts into the hands of the Office for Antiquities and Fine Arts, a division of his ministry. The Office claimed a direct and independent influence over exhibitions, museums and galleries, authority which Bottai succeeded in putting into law in 1937. Throughout 1938, he made public speeches and exerted private pressure designed to promote systematic legislation covering the visual arts. In the midst of his efforts, Mussolini introduced a racial campaign in Italy and passed anti-Semitic legislation, much to the pleasure of Farinacci and other admirers of Nazism, who now pressed their attacks against modernism. Bottai's efforts therefore expanded into a defence of modern art against the growing influence of the intransigents within the regime. In 1939, Farinacci established the Premio Cremona (Cremona Prize) to encourage the kind of explicitly didactic art he favoured. Artists entering the exhibition had to conform to a given subject, for example, 'Listening to the discourse of the Duce on the radio' (Fig. 5) or 'The Battle for Grain'. In 1939, Bottai created the Premio Bergamo (Bergamo Prize) in deliberate opposition, with a jury consisting of such figures as Cornelio Di Marzio, Funi, Felice Casorati and Giulio Carlo Argan. In 1940, the Bergamo Prize was awarded to Renato Guttuso for his *Fuga dall'Etna* (*Flight from Etna*; Cat. 147).[28]

Bottai's attempt to bring the visual arts under his control in 1937-40 must be seen as part of his long-standing effort to keep an open cultural life in Fascist Italy. At the 1938 Venice Biennale he spoke out against government manipulation of the arts, and in July of that year he reiterated that 'The state does not manufacture aesthetics and does not accept any predetermined aesthetic'. Bottai's campaign proved partially successful, for in 1939 he secured the passage of a law that widened the powers of his ministry's superintendents. More importantly, in 1940 he presided over the creation of an Ufficio per l'Arte Contemporanea (Office for Contemporary Art) under the jurisdiction of the Office for Antiquities and Fine Arts. Had the Second World War

Fig. 5 Alessandro Pomi, *Listening to the Discourse of the Duce on the Radio*, 1939. Whereabouts unknown

not intervened, the new agency might well have seen an end to the unsystematic policy followed by the Fascist government since its inception.[29]

Three years of repeated military setbacks in an increasingly unpopular war – capped by the invasion of Sicily in June 1943 – eventually brought about the collapse of the Fascist regime and Mussolini's dictatorship. The crisis climaxed in the *coup d'état* against Mussolini within the Fascist Grand Council on the night of 25 June 1943, which resulted in his arrest by the king. The new government of Marshal Pietro Badoglio signed a separate armistice with the Allies that September, taking Italy out of the Axis and making her a 'co-belligerent' of the Allies. Hitler quickly ordered the occupation of Italy, but the king and the Badoglio cabinet fled south to the safety of the Allied armies.[30]

In the north, Mussolini, who had been rescued by Hitler, established a new Fascist state, the Italian Social Republic, with its headquarters at Salò. There, under *de facto* German control, he re-established the Ministry of Popular Culture. The Accademia d'Italia, with the word 'Royal' dropped from its name, was reinstituted at the Villa Carlotta at Tremezzo, but it had ceased to have any real meaning. Few intellectuals of any stature joined the Salò Republic; Marinetti and Gentile, along with Ugo Ojetti, Soffici, Oppo and Sironi, were the major exceptions. To all intents and purposes, propaganda and censorship now took the place of cultural policy.[31]

Two more years of protracted battle and a bloody civil war between anti-Fascist partisans and Republican Fascists were necessary before all of Italy was liberated. Mussolini lived to see the death of the Fascist 'cultural revolution' that his ideologues had proclaimed twenty years earlier. Gentile, who had been made president of the Accademia in 1943, was shot dead by partisans on 15 April 1944. Marinetti, the tempestuous founder of the Futurist movement, died quietly in his bed on 2 December. Mussolini himself, captured by partisans as he tried to make his way to Switzerland, was summarily executed on 28 April 1945.

29 G. Bottai, 'Direttive per la tutela dell'arte antica e moderna', 4 July 1938, in his *Politica fascista delle arti*, Rome, 1940, p. 148; Cannistraro, *La fabbrica del consenso*, pp. 150-56.

30 On the *coup d'état*, see F. W. Deakin, *The Brutal Friendship: Mussolini, Hitler and the Fall of Italian Fascism*, New York and Evanston, 1968; and D. Grandi, *25 luglio: Quarant'anni dopo*, ed. R. De Felice, Bologna, 1983.

31 On the Salò republic, see G. Bocca, *La Repubblica di Mussolini*, Rome and Bari, 1977; E. Amicucci, *I 600 giorni di Mussolini*, Rome, 1948, pp. 195-204.

Joan M. Lukach

Giorgio Morandi and Modernism in Italy between the Wars

This essay is dedicated to the memory of Joshua C. Taylor. It is an abridged version of 'Giorgio Morandi: 20th Century Modern', published in the catalogue of the exhibition of the same name held at the Des Moines Art Center in 1982. All translations from the Italian are the author's.

Giorgio Morandi, universally admired for his masterly compositions and for the poetic resonance of his small, harmonious and seemingly timeless paintings, has generally been too neatly classified as the painter of bottles, a descendant of Chardin. He has been seen as isolated from the mainstream of twentieth-century painting, a provincial Italian painter who sought to revive indigenous Old Master traditions, and whose art did not develop to any appreciable extent over the half-century of his career.

It is true that this native of Bologna rarely left his birthplace and never went to Paris. Yet he was not a solitary and reclusive painter, as many have claimed. Nor did he derive his inspiration solely from earlier French masters, as others have intimated. Like many young artists, he profited from the study of certain pre-decessors, but these were near-contemporaries as well as painters of previous centuries, Frenchmen as well as Italians. Morandi was certainly an academic artist, by training and then vocation; he was a classicist both in his compositional methods and in his efforts to revive Renaissance traditions. Yet even in the 1930s, sympathetic critics saw that he was not merely a sublime reincarnation of earlier centuries, and they found that on formal grounds he could be compared to a non-figurative artist such as Wassily Kandinsky. For Morandi consciously chose to limit his pictorial vocabulary to still-life and landscape, in order to master composition better, and he selected, discarded and disposed his objects with a sensibility that could be called modernist as well as poetic. The elements in his compositions do vary over the years and, more importantly, there are distinct changes in the method with which they are painted. These changes reflect his response to the way his paintings were seen and interpreted by others, and to the social and political events in the world around him. In short, Morandi shared in the upheavals that took place in avant-garde art in Europe between 1912 and 1940, although in his own, restrained way. If he was not entirely understood by his Italian colleagues in those years, it was mainly because he was ahead of them.

The quality of Morandi's work was recognized from the beginning of his career, when he was selected to represent Bologna in the 1914 Secession exhibition in Rome. By 1919, he had been acknowledged as one of the three Metaphysical artists and as part of the *Valori Plastici* group. In 1926, he was chosen to be one of those representing twentieth-century Italian painting in the first *Novecento* exhibition, even though he never attempted to follow the canons prescribed for the *Novecento* when it became the art approved by Mussolini's government. Then, in the late 1920s, Morandi was taken up by a circle of younger writers who, calling themselves *strapaese* (of the town or country), opposed the heroics of *Novecento* art and wished to create a mood of reverence for small towns and the countryside. By the later 1930s, Morandi's paintings were being included in international exhibitions, and the artist's achievement was perceptively assessed by several Italian critics. Nevertheless, he has remained poorly comprehended on the whole by international audiences, and is best known for the paintings of two quite separate stages of his career: the Metaphysical years of 1918 and 1919 and his late style from 1944 to 1964.

It is impossible to discuss Metaphysical art here, except as it relates to Morandi, but it is important to remember, firstly, that Giorgio de Chirico, Carlo Carrà and Morandi never referred to themselves as the *Scuola Metafisica* and, secondly, that the Metaphysical environment was very much a literary one, created by Filippo de Pisis, Giuseppe Raimondi, Alberto Savinio and de Chirico. However, it changed the face

of Italian painting just at the end of the First World War, and Morandi did play a part in it, even if only a brief one.

Initially, Carrà's paintings made a greater impact in Italy than those of de Chirico, for Carrà was better known. In 1917, in Ferrara, he began to make pictures with hermetic subject-matter mostly borrowed from de Chirico, especially dressmakers' dummies, balls, Indian clubs, measuring devices, paintings within paintings and small, mysterious rooms. When he first exhibited his new paintings, from December 1917 to January 1918, Carrà, still calling himself a Futurist in his exhibition catalogue, briefly referred to 'metaphysical' art, then emphasized that he was an 'engineer... son of a great race of constructors', and that architectural composition in the Italian tradition was his aim. He did not discourage others from calling him a Metaphysical artist and from linking him with de Chirico, and then Morandi.

Morandi produced about eight still-life paintings in 1918 and 1919 (see Cat. 55), with enigmatic, mysterious objects very similar to those used by Carrà and de Chirico, including the inescapable mannequin. The magical atmosphere of Morandi's painting was not there by chance. He had met Carrà and knew his work, and through de Pisis he was made aware of de Chirico, possibly as early as 1917.

Although Morandi occasionally protested that he had possessed a bust-length milliner's dummy since 1914 and that it was only another object, not a symbol of humans or myths, he was not moved to paint it until 1918.[1] Morandi studied the photographs of Carrà's paintings that had been collected for Raimondi's monograph on the artist and for the magazine *La Raccolta* (Bologna), and was intrigued by Carrà's employment of figurative elements, such as the stuffed, pink cloth dummy in *L'idolo ermafrodito* (*Hermaphrodite God*, 1917) and the dressmaker forms in other pictures, because these forms, though 'endowed with human sentiment', acted as still-life objects and aided the artist in the 'creation of something eternal, passionless and unalterable'. Morandi was especially impressed by Carrà's 'disposition and measurement of space', the placement of his masses, and the system and construction of his works, which 'proclaimed a quiet melodious harmony'.[2] Certainly, for two years Morandi had been preoccupied by the 'measurement of space', the disposition of it and of the objects in it, and, except for a sense of the magical created by the extraordinary objects and Morandi's handling of them, there remains a close kinship between a painting like the 1918 *Still-Life* in the Jucker Collection, Milan, and that of 1916 in the Museum of Modern Art, New York (Figs. 1,2). All of Morandi's 1918-19 paintings reflect his fascination with Renaissance composition and would yield to mathematical scrutiny. But no matter how neatly these paintings can be explained as conforming to Morandi's personal sense of construction and balance, there remains something intentionally mysterious about them. The Jucker and the 1919 Brera still-lifes (Cat. 57) are like stage sets for a magic show, magician's props redolent of mystery.

When the war ended in November 1918, the isolation of Morandi and the young people he associated with was over. Raimondi joined the staff of *La Ronda* and moved to Rome, followed by de Chirico and then de Pisis. Morandi too, though he remained in Bologna, briefly became a part of the Roman art world. A major source of animation there was the newly founded journal *Valori Plastici*. The magazine was far more substantial than *La Raccolta*, and its first issue impressed readers with both its format and contents. The editor-publisher was Mario Broglio, whose voice was an influential – and reactionary – one in Rome in the post-war period. Broglio set out with the intention of looking at all sides of art, international as well as national. His second issue was devoted to French Cubism (the Synthetic Cubists of Léonce Rosenberg's gallery), and regular contributors were Dutch and German as well as Italian. Nevertheless, Filippo Marinetti, Giacomo Balla, Enrico Prampolini, Fortunato Depero and other Futurists who had returned after the war were conspicuously absent from his roster. Broglio supported de Chirico and Carrà from the start, publishing their articles and purchasing paintings, and offered to do the same for Morandi after Raimondi introduced them. Morandi did not write articles for *Valori Plastici*, but he was grateful for the attention and agreed to send paintings to an exhibition Broglio

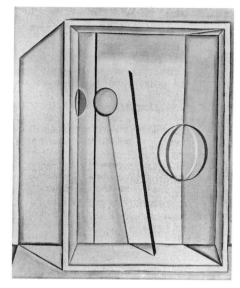

Fig. 1 Giorgio Morandi, *Still-Life*, 1918. Riccardo and Magda Jucker Collection, Milan

1 F. Arcangeli, *Morandi*, Milan, 1964, p. 104; E. Roditi, *Dialogues in Art*, London, 1960, p. 52.
2 G. Raimondi, *Anni con Giorgio Morandi*, Verona, 1970, p. 172.

3 Ibid., p. 205.
4 C. Carrà, 'L'italianismo artistico', *Valori Plastici*, nos. 4-5, 1919, p. 1.
5 G. de Chirico, 'Sull'arte metafisica', *Valori Plastici*, nos. 4-5, 1919, p. 15.
6 A. Savinio, 'Anadiomenon: Principi di valutazione dell'arte contemporanea', *Valori Plastici*, nos. 4-5, 1919, pp. 6-7.

sponsored for him at the Galleria Giosi in Rome. Held late in 1919, this was Morandi's first one-man exhibition. On 17 November 1919, he wrote to Raimondi to tell him he had sold seventeen paintings, five drawings and some watercolours to Broglio, including those on show at the Galleria Giosi and those which appeared in *Valori Plastici*.[3] Broglio regularly reproduced Morandi's paintings in *Valori Plastici*, and he deserves to be recognized as the first major collector of Morandi's work.

Broglio must also be credited with the decisive role in the identification of a Metaphysical 'school', for he was the first to bring together paintings by de Chirico, Carrà and Morandi, together with writings by them, de Pisis and Savinio. The April-May 1919 issue of his magazine may be considered the 'Metaphysical' issue. In it were articles by Carrà, 'Italianismo artistico' (Artistic Italianism), excerpted from his book *Pittura Metafisica* which was published later that year; by de Chirico, 'Sull'arte metafisica' (On Metaphysical Art); by Savinio, 'Anadiomenon: Principi di valutazione dell'arte contemporanea' (Anadiomenon: Principles of Valuation of Contemporary Art); and by Raffaello Franchi on Morandi, Carrà and others. Reproduced were Carrà's *La figlia dell'ovest* (*Daughter of the West*, 1919) and *Il figlio del costruttore* (*The Constructor's Son*, 1916), a still-life by Morandi and two drawings by de Chirico, *Natura morta* (*Still-Life*) and *Il figliol prodigo* (*The Prodigal Son*). The articles make it plain that there were a great many differences of opinion as to what constituted Metaphysical art. Carrà's chief concern in 1919 was to restore to prominence the 'Italian principle' of painting. He asserted that this principle was a recurring phenomenon in the history of Western art, which was rediscovered every time painters wished to affirm the 'constructive necessity' of their creations. 'Originality' was not a part of it, but 'an orientation towards tradition' was. The study of great artists of the past was a necessary requirement, and Italian artists in particular should make use of their heritage because it had been so glorious for so many centuries and had inspired artists of other nationalities. Carrà considered his work and de Chirico's to be 'first buds of a new thaw' in painting.[4] Curiously, he overlooked Morandi, whose painting, like de Chirico's, preceded Carrà's definition.

In his famous article, de Chirico advocated the portrayal of the mysterious aspect of objects; this was best done by 'individuals gifted with creative talent and clairvoyance'. De Chirico's well-written piece illuminated his own Metaphysical painting, but did not truly represent Morandi's, except in such passages as that entitled 'The Eternal Signs'. There de Chirico spoke of paintings he had once seen which represented the earth before the arrival of man; it was this absence of human beings upon which he meditated. Every profound work contained a 'plastic solitude', that 'contemplative beatitude offered to us by genius in construction and combination of forms', the 'spectral aspect' of the subject.[5]

Savinio, de Chirico's brother, provided an interesting and provocative definition of the adjective 'metaphysical'. It 'no longer alludes to a hypothetical after-the-natural; it signifies...all that which continues the being of reality beyond the crudely obvious aspects of reality itself'. He also called art 'the new spirituality' and, like Mario Bacchelli, objected to Positivism, adding 'why, in art, should naturalism prevail over the spiritual form?' Savinio defended his term 'spectrality': it was 'the true, substantial and spiritual essence of every appearance. To reproduce this essence in its complete genuineness is the greatest aim of art.' Savinio recognized a revived 'classicism'. The link between old classicism, 'dried up in the academies', and a new art, leading to a new classicism, was Paul Cézanne. Next, Paul Gauguin led art back to 'its most primal beginnings'. Following him were Henri Matisse, André Derain and even Henri Rousseau, until art finally arrived at 'the smoothing out of a new classicism – which appears for the first time in the paintings of Giorgio de Chirico and Carlo Carrà'.[6] This brief summary touches upon those points Savinio made which best relate to Morandi. In its entirety, Savinio's article was the fullest explanation of Metaphysical art. If he left out Morandi, who had, perhaps, followed the path he described most closely of all, it was no doubt out of relative ignorance, since Savinio had spent most of the war years in Macedonia, out of touch with current Italian art.

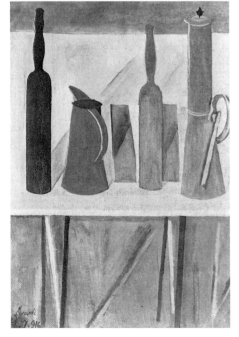

Fig. 2 Giorgio Morandi, *Still-Life*, 1916. The Museum of Modern Art, New York

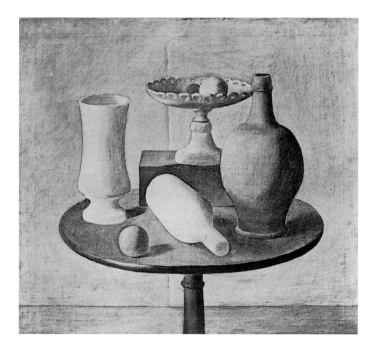 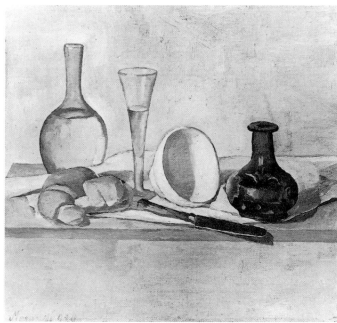

The fate of Metaphysical art was curious, for, by the end of 1919, its three creators had turned to other forms of painting. Meanwhile, however, awareness of their Metaphysical paintings began to spread to an international audience, at first by means of publications, and then in the form of an exhibition organized by Broglio and sent to Germany as 'Das Junge Italien' (Young Italy). Shown in Berlin and Hanover in 1921, it included a highly representative selection of paintings by de Chirico, Carrà and Morandi, together with works by Riccardo Francalancia, Arturo Martini, Roberto Melli, Ossip Zadkine and Edita von Zur Mühlen.[7]

By 1919, Carrà and de Chirico had committed themselves to a return to the 'Italian tradition' and to a 'return to craftsmanship', another aspect of the reaction against earlier modernism that was promulgated by Broglio and his group. When Morandi met de Chirico in Rome in the autumn of 1919, the latter had begun to copy Cinquecento Venetian paintings. Carrà gradually ceased to paint enigmatic objects grouped in curious spaces, turning first to re-stating Giotto or Masaccio (*Le figlie di Loth* [*Lot's Daughters*], 1919; Cat. 97), and then to landscape and conventional still-lifes.[8]

Morandi did not need to 'return to his heritage' or to craftsmanship, for he had never abandoned them; indeed, he had mastered his craft long since. When he went to Rome in 1919 he took the opportunity of looking at certain works by Raphael and Caravaggio, admiring the way light in Caravaggio fell on objects such as a towel. Returning home by way of Florence, he even copied Raphael's *Portrait of Cardinal Bibiena*. This he did strictly for his own edification and, in a series of letters to Raimondi in 1919, he commented on such aspects of the portrait as the oval face with sharp, clear profile, the rhythms of folds in a sleeve and the particular red of the Cardinal's robe. He collected a varied assortment of photographs: of Giotto's *Saint Joachim*, Poussin's *Self-Portrait* of 1650, painted in Rome, and works by Giovanni Fattori, Orazio Gentileschi, Francesco Hayez, Ingres and Uccello. In the Poussin he noticed the way certain elements were framed within the painting and made use of this himself.[9]

As soon as Morandi's work was seen to fit in with various critical theories then current – metaphysical or spiritual, algebraic or spectral – the mystery seemed to vanish from his painting. It was as if he had lost interest in these qualities once they were identified and labelled. Around 1920, he turned to the conventional still-life elements obsessively studied by Cézanne: fruit in a stemmed dish, rolls and bread, and crumpled napkins displayed carelessly on an old sideboard (Cat. 88). At first he

Fig. 3 Giorgio Morandi, *Still-Life*, 1920. Private collection, Milan

Fig. 4 Giorgio Morandi, *Still-Life*, 1920. Kunstsammlung Nordrhein-Westfalen, Düsseldorf

7 The anonymous author of the catalogue that accompanied the exhibition was not satisfied with Morandi's customary undescriptive titles and went to some trouble to identify the still-lifes and landscapes listed in the exhibition. For this reason it is possible to identify most of the paintings that were sent by *Valori Plastici* to Germany. Among those by Morandi were: *Landscape*, 1916; *Still-Life*, 1918; *Still-Life*, 1919; and *Still-Life*, 1920.

8 A more detailed discussion of Metaphysical art and of the *Valori Plastici* circle can be found in J. M. Lukach, '*Plastic Values:* Painting in Italy 1915-1919', Ph. D. diss., Harvard University, Cambridge, Mass., 1976.

9 The letters are published in Raimondi, *Anni*, pp. 65-6, 71, 78, 88, 186-7, 207.

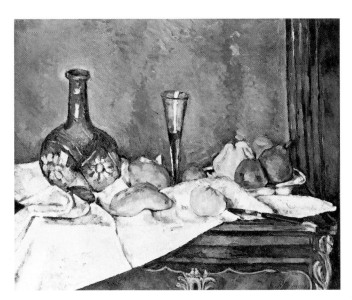

retained the carefully outlined, almost incised effect of his earlier paintings, with light flowing in from the side in a manner recalling the dramatic chiaroscuro he had noted in Caravaggio. By contrast, in a 1920 *Still-Life* in Milan, the beautiful daylight radiance suffusing the painting, which consists of a lemon in a white fruit dish and a large ochre jug, must reflect his observation of the cool light and pale palette of Piero della Francesca (Fig. 3).

The magnificent still-life now in Düsseldorf (Fig. 4) shows how Morandi broke away from the strict geometry of the previous four years by studying Cézanne. He had purchased Ambroise Vollard's book on the French master in 1919 and, in 1920, he went to Venice for the Biennale, where he saw twenty-eight works by Cézanne and others by Matisse in the French pavilion. In the Düsseldorf painting, which was exhibited in Germany in 1921 and Florence in 1922, the centre is marked by the hollow created by the tipped-up bowl. To the left are three objects, while there is only one to the right of centre. Morandi restored visual equilibrium by purely painterly means, the intense blue of the glass providing a perfect balance for the neutral brown rolls and transparent glass and carafe. In this painting, Piero's colours, especially the whites, are joined with those of Cézanne. In fact, the Prussian-blue vase itself came directly from Cézanne (Fig. 5).

Other still-lifes from this group of the 1920s are greatly simplified in composition and in the number and placement of objects. Several contain only three or four of the most ordinary domestic utensils lined up along the picture plane on a plain wooden table (Cat. 89). These paintings must surely have satisfied those compatriots of Morandi's who were calling for a return to tradition and craftsmanship. Carrà could have recognized an 'orientation towards tradition' in unified paintings in which visible reality was coordinated by the artist and not 'left in a fragmentary state', while de Chirico could not have failed to see genius in Morandi's construction and combination of forms. In short, by 1920 Morandi had become the quintessential classical painter of the Italian tradition, which was basically that of genius in architectural construction.

Morandi was rewarded for his classicism by being included in the *Valori Plastici* section of the 1922 'Primaverile' (spring exhibition) in Florence. He was introduced in the catalogue by de Chirico, who had become quite literally a classicizing painter, painting scenes of mythological Greek or Roman figures in what he believed was the Cinquecento and Seicento Venetian method. De Chirico's very personal reaction to Morandi was both poetic and just. Objects appeared to Morandi in their 'most

consoling aspect, the eternal', de Chirico asserted. He 'shared in that great lyricism, the metaphysics of the most ordinary objects' with which most of us are so familiar that we scarcely see them. De Chirico continued:

> In his old city of Bologna, Giorgio Morandi sings thus, in the Italian way, the song of the good artisans of Europe. He is poor, for the generosity of art lovers up to now has forgotten him. So in order to continue his work with purity, at night, in the dreary classrooms of a government school, he teaches children the eternal laws of geometrical design, the basis of all great beauty and all profound melancholy.

Morandi shared de Chirico's admiration for certain Old Masters but, as others of his acquaintance became more drily academic, Morandi, ignoring the encomiums of his commentators, set aside his perfectly constructed paintings of solid forms to brush in faint and wispy flowers trembling upon a barely defined surface (Fig. 6). If they were not quite in the Impressionist mode which others found so objectionable, they were uncomposed, in contrast to his flower pieces of 1916.

Part of this rejection of his perfect, classical compositions of 1920 came from Morandi's resistance to being stereotyped and predictable, and part of it from his natural inclination to experiment within his chosen limits. One of the most sympathetic of his biographers, Francesco Arcangeli, has reasoned that there was yet more to it, and that Morandi's change of approach was not based upon purely aesthetic considerations. Morandi was keenly aware of social and political activities in his country. The Futurist movement in which he had once decided to participate was as much a social and political group as an artistic one; and when Italy entered the First World War on the side of France, Morandi again willingly took part. But whatever hopes liberal young Italians had for their country following the war were gradually dimmed as the Fascist party grew in power and became, at the same time, reactionary, restrictive and ultra-nationalistic. Morandi's acquaintances claim that he was an anti-Fascist and there seems little reason to doubt it. His way was to express his life through his art and, during the early 1920s, his response to the political situation, according to Arcangeli, was rebellion, albeit obscure, implicit and even involuntary. Arcangeli saw the insubstantial bouquets as cries of despair, and compared the artist's mental state to that described in T. S. Eliot's *The Wasteland*, which Morandi knew through his poet friends, just as he knew works by John Millington Synge, James Joyce and other foreign poets.[10] Other contemporary Italian artists, such as Scipione and Mario Mafai, reflected a similar desolation in their work or, like de Pisis, simply left Italy to paint in Paris; but many made every attempt to become more and more classical.

The revival of interest in Old Master painting, in Renaissance art and in traditional techniques of composition and paint handling had initially occurred before the First World War, and was not confined to Italy. For the most part, the classicism of the early 1920s in Italy meant a concentration upon the human figure, even the nude, which Marinetti had rejected before the war as a trite convention. Morandi was unusual in that he had employed both very traditional and very modernist methods from the start of his career. Those who matured during or after the war had begun with an abstracting, a Divisionist or an Expressionist art so that figure painting in traditional techniques represented something novel to them. However, because of government or, at least, official intervention, experimentation became politicized, as the 'Italian classical tradition' became the official art of the new government and, in the process, frozen and mediocre. The human figure, over-life-size and dominating the landscape, came to symbolize the new Roman republic.

These tendencies emerged in the *Novecento* movement, which began in Milan when a number of artists, inspired by *Valori Plastici*, started to create archaizing or classicizing paintings. Margherita Sarfatti was their spokeswoman. In 1926, Morandi, who had not exhibited since the 'Primaverile' of 1922, was invited to take part in the 'Prima Mostra del Novecento Italiano' (First Exhibition of Twentieth-Century Italian Art) in Milan. He sent in three paintings: a 1925 landscape, in which the flat, blank, windowless side of a three-storey stone farm building is the most prominent feature; a still-life; and a self-portrait of 1924, showing the artist at his

10 Arcangeli, *Morandi*, pp. 181–3.
11 The still-life cannot be identified; the landscape is no. 108 in L. Vitali, *Morandi: Catalogo Generale*, 2 vols, Milan, 1977.
12 L. Vitali, *Giorgio Morandi Pittore*, 3rd ed., Milan , 1970, p. 34.
13 Vitali, *Morandi: Catalogo Generale*, nos. 128, 138, 141.
14 M. Maccari, in the newspaper *Il Resto del Carlino*, 28 June 1928.
15 Idem, in *Il Resto del Carlino*, 31 December 1928.

Fig. 7 Giorgio Morandi, *Self-Portrait*, 1924.
Private collection, Milan

easel and wearing a hat which obscures his features (Fig. 7).[11] As Lamberto Vitali has observed, these paintings had little in common with the rhetorical celebrations of political events which were the most acclaimed works in the exhibition.[12] Nevertheless, Morandi was invited to show in the second *Novecento* exhibition in 1929, and again sent in three paintings.

During the later 1920s, Morandi refined and reorganized his still-lifes. He abandoned the mannequin, the balls and pieces of wood, but continued to rearrange and observe the familiar domestic objects which he kept in the room in his home that served as his studio. In 1928 and 1929, there appeared a series of still-lifes that were remarkable for the extreme ordinariness, even dowdiness, of their components (Cat. 91).[13] Starkly rendered in a subdued light, the familiar utensils have lost all individuality. To some, this group represented a falling off of imagination on Morandi's part, but to others, this was the peak of his identification with the past, the furthest point in his turning away from avant-garde painting to the nineteenth-century atmosphere of his parents' household.

A calculated revival of the supposedly purer and simpler nineteenth-century provincial life was then under way in Bologna. Fleeing *Novecento* rhetoric, Morandi was attracted to the aggressive provincialism of the *strapaese* group, which intended to oppose the twentieth century with the nineteenth, city with country, the machine with nature, filth with hygiene and so forth. The critics and writers who advanced this position were younger than Morandi but had found inspiration in his paintings. And with his constant interest in recent developments in art – which he inevitably put to his own use – he adopted the tenets of *strapaese*, painting no-nonsense, dry-as-a-bone paintings of the calculatedly ordinary.

The founders of this grass-roots movement were enchanted by these paintings and were quick to praise Morandi in their articles. Among them, Mino Maccari and Leo Longanesi were seeking the truly Italian, not in the Imperial Roman past, but in the countryside and in small, quiet provincial cities. Both Bologna, which still retained a nineteenth-century atmosphere, and Morandi seemed to them ideal. Praising the quotidian qualities he found in Morandi's pictures, Maccari said they 'reveal the beauty and poetry of those things which, being humble and modest, need to be understood, interpreted or described by an artist for the world to take notice of them'. Morandi's still-lifes and landscapes were 'not picturesque', but 'common, simple, without excess of colour or contrast'. The miracle of Morandi lay in his ability to discover the hidden poetry in the poorest objects or the simplest aspects of a landscape. This painter-poet allowed us to see these elements more clearly and more profoundly. More than most, Morandi personified the truly classical in the understanding and practice of art. His art was 'Italianissima', with deep roots in the Italian tradition. 'If the Italian characteristics are balance and synthesis . . . purified to simplicity of expression, all are present in Morandi, especially in his latest works.'[14]

In his magazine *L'Italiano*, Longanesi wrote in a similar vein, linking Morandi firmly with his home town. Born and raised in that 'old Bologna of the red houses, where the daylight still plays under large, low porticos', Morandi produced paintings as 'genuine and home-made as bread and oil To see one of his paintings means to know his character, his family, his home, his street, his city.' One of his still-lifes, one of his compositions of dusty and translucent bottles, one of his landscapes or a bunch of his dried flowers 'tells us his entire life, his tastes, his sorrows and his loves, of this gentle and sensitive Italian'. Few painters 'have succeeded as he has in imbuing the canvas with such a serene and gentle sense of his own home and his own land'.[15]

Following this wonderfully romantic vision of his art, Morandi began to be viewed as a reclusive poet, a dusty dreamer out of tune with his century, simple and pure and, perhaps, too untranslatably *casalinga*, too Italian to be of more than regional interest. Sarfatti, by then one of the most powerful voices in Italian art, included Morandi in her 1930 book on the history of modern painting. Her aesthetics, centering on the idea of the Italian tradition as the source of much of what

she found superior in art, were narrowly distilled from certain criteria that had been in the air even before Carrà began to espouse them around 1917. She considered the 'long tradition' of representing relief, tone and chiaroscuro, a sense of composition and placement in space, to be 'Mediterranean, Latin and especially Italian'.[16] The time-honoured principles of composition were the keystone of her aesthetics, and almost equally important to her was the human figure, which 'is sacred to Latins'. To Catholics, 'Human equals spiritual', she averred.

It was probably this emphasis on the human figure that prevented Sarfatti from including Morandi in the first rank of great modern Italian painters. She gave him four lines in her book of 1930, saying that he represented the 'avant-garde of Bologna' and was a 'solitary and thoughtful artist' whose paintings 'breathed an aura of enclosed and sweet domestic melancholy'. Ignoring his genius for composition, she chose to see him as alone, provincial, gifted but outside the mainstream of the 'real' Italian tradition.

But even as his reputation as a 'homespun' Italian grew, and Morandi was invited to take part in the second *Novecento* exhibition in 1929 and in the Venice Biennale of 1930, he did something which was typical of him. Throwing out everything evocative of the nineteenth century, he changed course once more. Again, the well-meant accolades may have been too much for him, together with the idea of being cast as a provincial, no matter how singular. In the summer or autumn of 1929, Morandi systematically began to destroy both the sweet and intimate domestic objects of his paintings and the harmonious 'Mediterranean, Latin and especially Italian' compositions in which they were situated. Arcangeli's skilful summary was that objects which had been presented as 'so concrete and poetically exact' seemed to lose their names, to be lost in twilight, even to 'begin to be re-absorbed in the prime matrix of matter', the paint itself. In the Brera *Still-Life* (Fig. 8), for example, the objects are pushed together to form one fairly shapeless mass, losing their individual identity.

In seven paintings of 1931 which Arcangeli referred to as 'hallucinations' Morandi 'turned on his objects', those fragments of his life, and attacked them, as if to shake off the dust and batter them into the twentieth century or, possibly, to destroy them.[17] Pushing his objects to the point of abstraction, but never beyond, he thoroughly shook off traces of nineteenth-century nostalgia, not to mention classical composition. As already noted, Arcangeli saw this as a reaction to the increasingly hopeless political situation, as 'the most desperate freedom' of an Italian artist around 1930. In paintings as late as 1936 Morandi continued this obliteration of the clarity of form (Fig. 9). It would not be wrong to call these abstractions, for only the merest sensation of landscape remains, as Morandi, refuting the ponderous theories of Sarfatti, Carrà and the rest, created paintings that are little else than basic architectural structures, purely formal compositions with nothing specifically Italian about them.

In the process of eroding the obvious identity of his dishes and vases Morandi, curiously enough, restored his objects to life. After a lapse of ten years, ambiguity reappeared in his work, but different in form from the geometry of his Metaphysical paintings. He deliberately selected things to paint which resembled something else, such as a dish that suggested a shell or rocks that appeared to be animals.

He had now acquired something of a dual nature, for he retained a reputation as the epitome of the Italian artist, suiting both the more academic Sarfatti and the regionalist *strapaese* group while painting works which were basically abstract. In 1931, he took part in the first 'Quadriennale d'Arte Nazionale' in Rome, organized under government auspices. This amounted to official recognition, though he did not exhibit his most recent paintings. An issue of *L'Italiano* was dedicated to him in 1932, with a long article by Ardengo Soffici and reproductions of works spanning most of his career. The long-established critic, once known for his contemporaneity, now seemed out of date. He was staunchly opposed to any form of abstraction, calling it Romanticism turned to novelty and a subversion of traditional order which made art into a 'pleasant game'. Soffici preferred art to be 'spiritual and classic' and to refer to ancient values of 'grandeur and humanity', but with a 'spirit of modernity

16 M. Sarfatti, *Storia della pittura moderna*, Rome, 1930, pp. 51, 144.
17 Arcangeli, *Morandi*, pp. 233-4.
18 A. Soffici, in *L'Italiano*, 1932, pp. 38-43, 46.
19 Roditi, *Dialogues*, p. 61.

Fig. 8 Giorgio Morandi, *Still-Life*, 1929.
Pinacoteca di Brera, Milan

Fig. 9 Giorgio Morandi, *Landscape*, 1936.
Pinacoteca di Brera, Milan
(Jesi Donation)

presiding over it'. Soffici saw Morandi in 1930 as the ideal painter. Morandi 'purified his art of every artifice or aestheticism'; his art was not simply representational or anecdotal but more purely formal. The result was a harmony of forms, colours and volumes. In the 'inappropriately named Metaphysical paintings' Morandi had been too schematic, but the 'exquisite poetry of his soul', his great mental integrity and technical expertise saved them. Soffici spoke of Morandi's paintings of the 1920s with evident satisfaction. They were 'classic in the Italian mode – real and ideal and traditional all at once', with no 'artifice or dilettantism', the 'defect of most modern art'. Morandi was like an ancient artisan; his art, like 'most Old Master works', mirrored 'his soul and the world'. Soffici found 'something religious presiding at the creation of this art'. This was an aspiration of many twentieth-century artists, even the most abstract, yet to Soffici it was found only in such Old Masters as Corot, Chardin and Vermeer but in 'no other moderns'. 'Where it failed', Morandi's art was one with our times, which lack 'clear and great ideals, common beliefs, and moral, aesthetic and spiritual unity'. More than any other modern artist, Morandi had solved the problems of what Soffici believed was a legitimate, Italian modern style.[18]

Soffici, no longer young, might be excused for failing to notice that Morandi, as an artist of integrity, had evolved in accordance with his own interests and needs, which were then quite different from the interests of any of his critics. Soffici represented a prevailing view of art in Italy. Few critics there were sympathetic to abstract or Constructivist approaches to art, finding various ways to condemn them, even though, as in Soffici's case, what the critic said constituted art could generally be applied to abstract painting as well. As for Morandi, his motivations and even his paintings of the 1930s remained unrecognized, uninterpreted, practically invisible until 1939.

When Morandi again took part in the Rome Quadriennale in 1935, he exhibited some of his almost formless paintings, far from the nostalgic poetry of the 1928-9 still-lifes. This change in his painting did not go completely unnoticed, but Morandi later speculated: 'When most Italian artists of my generation were afraid to be too "modern" or "international" and not "national" or "imperial" enough, I was left in peace, perhaps because I demanded so little recognition. In the eyes of the Grand Inquisitors of Italian art, I remained but a provincial professor of etching at the Fine Arts Academy of Bologna.'[19] But if the 'Grand Inquisitors' and even his friends managed to overlook him, Morandi was attentively observed by a few, and in 1935 Roberto Longhi, whose distinguished discussions of Caravaggio and other Renaissance artists had inspired Morandi in 1916, gave a lecture on aspects of Bolognese

painting and caught his audience off guard by bringing in the name of Morandi at the end.

Longhi described Morandi as 'one of the best living Italian painters' who, 'navigating among the perilous shoals of modern painting, always knew how to direct his travels with a meditated slowness, with loving studiousness, so that they appear to be those of a new direction'.[20] Perhaps for the first time, Morandi's modernism was now recognized, and by an eminent scholar at that. During the rest of the period before the Second World War, Longhi's appraisal of Morandi as a pioneering modern artist continued to be developed in opposition to the tendency to see him as a vestigial representative of seventeenth-century still-life painting.

In 1939, a small book on Morandi appeared, written by Arnaldo Beccaria, who emphasized the poetic qualities of Morandi's art. Perceiving the dust on the objects in the paintings of the 1920s, Beccaria sensed the presence of time 'filtered by these objects', which were seen through 'the light of memory'. He wished to overlook geometry and respond to a human quality in Morandi's paintings which he located in the objects themselves. 'Consumed by time', some were there to 'comfort and support each other', while others remained anonymous, 'like lonely figures in a crowd'. Beccaria, however, was not so completely lost in poetic reverie that he overlooked the purely formal aspects. He defined Morandi's objects as a 'personal alphabet'.[21] Not merely household objects, they were nearly as abstract and non-literary as the geometric forms used by Kandinsky in the same years.

The paintings themselves are proof of Morandi's early and remarkable mastery of his craft, and also contain the evidence that an interpretation of him as the revivifier of seventeeth- and eighteenth-century painting is too limited for an artist who ingeniously combined the formal innovations of Cézanne, Rousseau, Picasso and Braque with those of Giotto, Uccello and Caravaggio. Morandi's painting, as Franchi so eloquently expressed it, is 'the painting of inert objects, on the beauty of which an entire eternity of placid contemplation has elapsed'.[22]

20 R. Longhi, in *L'Archiginnasio*, 30, nos. 1-3, 1935, p. 135.
21 A. Beccaria, *Morandi*, Milan, 1939, pp. 6-8, 13.
22 R. Franchi, 'Avvertimento critico', *Valori Plastici*, 1, nos. 4-5, 1919.

Enrico Crispolti

Second Futurism

Until recently, it was generally accepted that the creative period of Futurism ended with Italy's entry into the First World War in 1915. This idea derived from a critical interpretation of the post-war *Novecento* movement as a 'return to order'. The Futurist experience was seen as a moment of youthful impatience and rebellion that burned itself out after a few years and was succeeded by a more mature and informed dialogue with tradition. Former Futurists such as Carlo Carrà, Mario Sironi and Ardengo Soffici turned to a modern art that did not deny the past but sought, instead, to renew the solidity of form ('*valori plastici*') found in Quattrocento Italian painting. Meanwhile, Umberto Boccioni's return to the figure via a study of Paul Cézanne and his untimely death in 1916, along with that of the architect Antonio Sant'Elia, seemed to provide incontrovertible evidence of the end of the movement. However, this represents a very narrow view of Italian Futurism, focusing exclusively on the medium of painting and the person of Boccioni.[1]

An appraisal of the career of Giacomo Balla opens up a completely different perspective for the study of Futurist painting and sculpture.[2] With the death of Boccioni, Balla became the inspirational force behind the movement, uniting with Fortunato Depero and Enrico Prampolini as its new protagonists. No definite break between the 1910s and the 1920s can be discerned in the work of Balla, whose continued inventiveness took the form of a highly personal, dynamic abstract style. Depero developed his characteristic fantasy worlds, based first on his own interpretation of Metaphysical painting and then on the mechanized forms and spatial effects of his work for the theatre. During and after the war, Prampolini followed the most advanced developments in Europe, from Dada to Purism, from the aesthetics of the machine to biomorphism. One can therefore trace a line of both innovation and continuity which links so-called 'heroic' with Second Futurism, at least until Balla abandoned Futurism altogether at the beginning of the 1930s. At that point, Prampolini, with his extensive and close contacts with the international avant-garde, effectively became the leader of Futurism, maintaining the movement's modernist stance in the second decade of Fascism.

Arbitrary chronological divisions are also untenable in view of the unbroken development of Futurist literature, with its narrative poetry and 'words-in-freedom', not to mention the wide spectrum of extra-pictorial interests which were an essential part of Futurist activity: visionary concepts in architecture (Fig. 1) and town planning, interior design (Fig. 2), furnishing, fashion, scenography, graphics and mass media. This totality of interdisciplinary efforts – which the Futurists considered a 'global attempt' to revolutionize the human environment – united the movement from its origins in 1910 to the early 1940s and distinguished it from other currents of the European avant-garde. Indeed, it is the manifesto entitled *Ricostruzione Futurista dell'Universo* (*Futurist Reconstruction of the Universe*), written by Balla and Depero and published in Milan on 11 March 1915, that provided the key to interpreting both these individual creative activities and the continued Futurist experience as a whole.[3] Together with Prampolini, Balla and Depero expanded the interests of a movement which had previously revolved around painting and sculpture, as witness their success at the 'Exposition Internationale des Arts Décoratifs et Industriels Modernes' in Paris in 1925. In an article of 1958 I designated these developments 'Second Futurism', a term that is now widely accepted.[4]

The pictorial work of 'heroic' Futurism constituted only the first, if fundamental, phase of a complex movement which enjoyed a succession of distinct styles. The

1 For a historiography of Futurism, see E. Crispolti, *Storia e critica del Futurismo*, Bari, 1986, pp. V-XXI, 225-57.

2 M. Drudi Gambillo, in *Il Futurismo*, Rome, 1959 (introduction by A. Palazzeschi, texts by G. Castelfranco and J. Recupero); M. D. Gambillo and T. Fiori, *Archivi del Futurismo*, vol. 2, Rome, 1962.

3 These various endeavours and their importance for a revaluation of the continuity between first and second Futurism are discussed in E. Crispolti, *Ricostruzione futurista dell'universo*, Turin, 1980, and Crispolti, *Storia*, pp. 46-103.

4 E. Crispolti, 'Appunti sul problema del secondo futurismo nella cultura italiana fra le due guerre', *Notizie*, 2, no. 8, April 1958, pp. 34-51; repr. in E. Crispolti, *Il mito della macchina e altri temi del Futurismo*, Trapani, 1969, pp. 245-67, and *Storia*, pp. 225-46.

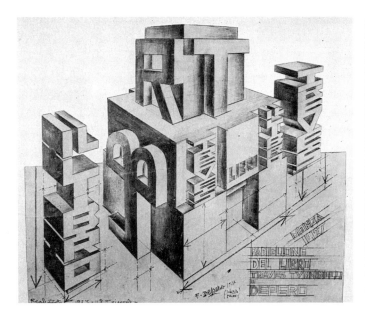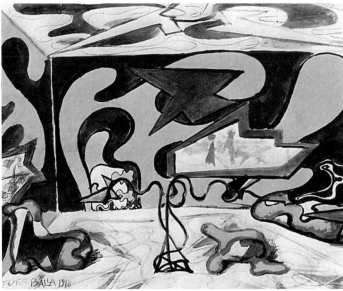

first, or analytical, phase was centred in Milan from 1910/11 until 1914. Using the language of Divisionism, the Futurists began to break down the solidity of form through the juxtaposition of complementary colours and compositions of sinuous lines. These soon evolved into a more complex structural analysis of the object and the interpenetration of its surroundings, using the visual model of French Cubism. The analytical phase reached a moment of crisis when Boccioni's emphatically volumetric canvases of 1913/14 neared total abstraction, leading to his retrenchment in a figurative style marked by the influence of Cézanne. The urge towards greater clarity through synthesis rather than fragmentation was paralleled in the neo-primitivism of Carrà and in the work of Gino Severini, Soffici, Ottone Rossi and Sironi. It also accounted for the eclectic stance of the Futurist splinter group, *Nuove tendenze* (New Tendencies), which exhibited works by Leonardo Dudreville, Carlo Erba, Achille Funi, Marcello Nizzoli and others in May-June 1914.[5]

The true synthetic, or second, phase of Futurist painting was based in Rome and ushered in by Balla's *Dimostrazioni interventiste* (*Interventionist Demonstrations*), dating from 1915, a cycle of paintings which celebrated the euphoric *stato d'animo* occasioned by Italy's entry into the war.[6] These canvases consisted of centrifugal compositions of stereometric forms built up in high relief with large areas of brilliant, unmodulated hues. In the same year, he and Depero illustrated their manifesto *Futurist Reconstruction of the Universe* with 'plastic complexes', a series of three-dimensional constructions made of wire, cardboard, silk and other unconventional materials (Fig. 3). The notion of 'plastic complexes', that is, formal analogies of emotions and sensations, formed the basis of the new abstract Futurist style. Boccioni, visiting Rome at the end of 1915, noticed the change in the recent work of Balla and Depero. It was a radically new departure, comparable to the non-figurative developments of Russian Suprematism and Dutch Neo-Plasticism. Yet Futurist abstraction differed in intent from these movements, since it evolved in a dialectic with Positivism and drew its formal analogies from phenomenal reality, from the emotive and physiological sensations of the real world. This explains Prampolini's rejection, in 1914, of Kandinsky's concept of creating abstraction solely out of spiritual 'inner necessity' and the Futurists' mistrust of non-figurative 'concrete' art in the following decades.[7]

The synthetic style of Balla, Depero and Prampolini gave way to mechanistic themes and forms around 1918/19, encouraged by the artists' work for the stage. For Igor Stravinsky's *Firebird*, produced by Sergej Diaghilev's Ballets Russes in the spring of 1917, Balla designed a play of coloured lights and shadow over a remarkable set which realized the abstract motifs of his paintings in three-dimensions. In the same period, Depero created stylized flora and fauna for the costumes and sets for Diaghilev's production of Stravinsky's *The Song of the Nightingale* (Fig. 4) and for

Fig. 1 Fortunato Depero, Design for the Book Pavilion of Treves and Tumminelli Publishers at the 'Terza Mostra Internazionale delle Arti Decorative', Monza, 1927. Museo Depero, Rovereto

Fig. 2 Giacomo Balla, *Project for an Interior and Furnishings*, 1918. Private collection, Rome

5 The exhibition also included the work of the architects Sant'Elia and Mario Chiattone. For the *Nuove tendenze* group and other derivations of Futurism, see Crispolti, *Storia*, pp. 130-62.

6 E. Crispolti, 'Il "nodo" romano 1914/15: Balla, Depero, Prampolini e Boccioni', in *Futurismo Futurismi*, supplement to *Alfabeta*, 8, no. 84, May 1986, pp. 44-55; idem, 'Appunti su Depero astrattista futurista romano', in *Depero*, Milan, 1988, pp. 183-203. On Balla's painting of the period, see his *Manifesto del colore*, published in the catalogue *Le più recenti opere del pittore futurista Giacomo Balla*, Rome, Casa d'Arte Bragaglia, October 1918.

7 E. Prampolini, 'Pittura pura', *Rassegna contemporanea*, 18, October 1914. See also note 19 below.

8 On Futurist theatre, see *Sipario*, 22, no. 260, 1967 (issue devoted to the Futurist stage); M. Kirby, *Futurist Performance*, New York, 1971; G. Lista, *Théâtre futuriste italien: Anthologie critique*, La Cité, 1976; L. Lapini, *Il teatro futurista italiano*, Milan, 1977; P. Fossati, *La realtà attrezzata: Scena e spettacolo dei futuristi*, Turin, 1977; A. C. Alberti, S. Bevere and P. Di-Giulio, *Il Teatro Sperimentale degli Indipendenti (1923-1936)*, Rome, 1984.

9 For the mechanical phase of Futurist painting and sculpture, see Crispolti, *Il mito*, pp. 436-89. The distinction between the first and second phases of Prampolini's work is analysed by Federico Pfister (De Pistoris) in *Enrico Prampolini*, Milan, 1940, pp. 14-15.

10 *Noi*, Florence, 1974 (reprint with a critical note by B. Sani). Prampolini's contacts in Zurich Dada were Tristan Tzara and Hans Arp: see E. Crispolti, 'Dada a Roma: Contributo alla partecipazione italiana al Dadaismo', *Palatino*, 10, nos. 3-4, 1966; 11, nos. 1-4, 1967; 12, nos. 1-3, 1968.

BALLA

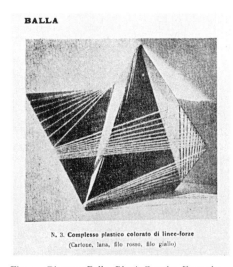

N. 3. **Complesso plastico colorato di linee-forze**
(Cartone, lana, filo rosso, filo giallo)

Fig. 3 Giacomo Balla, *Plastic Complex*. From the manifesto *Futurist Reconstruction of the Universe*, Milan, March 1915

11 The manifesto of 1923 (*Noi*, 2nd series, 1, no. 2) was a conflation of two published a year earlier: 'L'Arte meccanica futurista' by Paladini and Pannaggi (*La Nuova Lacerba*, no. 1, 20 June 1922) and 'L'estetica della macchina e l'introspezione meccanica nell'arte' by Prampolini (*De Stijl*, 5, no. 7, July 1922; reissued in *L'Impero*, 16 March 1923).

12 Fillia, 'L'Idolo meccanico', *L'Impero*, 19-20 July 1925; S. Evangelisti, *Fillia e l'avanguardia futurista negli anni del fascismo*, Milan, 1986; E. Crispolti, *Fillia fra immaginario meccanico e primario cosmico*, Milan, 1988. For the Russian-born Paladini, see G. Lista, *Dal Futurismo all' Immaginismo: Vinicio Paladini*, Salerno, 1988, pp. 14-27. The political ideology of the machine style is discussed in G. Lista, *Arte e politica: Il futurismo di sinistra in Italia*, Milan, 1980; U. Carpi, *Bolscevico immaginista: Comunismo e avanguardie nell'Italia degli anni venti*, Naples, 1981; and idem, *L'Estrema avanguardia del Novecento*, Rome, 1985.

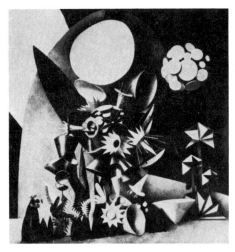

Fig. 4 Fortunato Depero, Set for Stravinsky's *The Song of the Nightingale*, 1916-17. Museo Depero, Rovereto

Francesco Canguillo's *The Zoological Garden*, which was to have music by Ravel. Although neither production came about, the influence of dance was immediately recognizable in Depero's canvases of the period (for example, *Ballerina idolo* [*Idol Dancer*], 1917; Cat. 39). In collaboration with Gilbert Clavel, Depero worked with puppets in the creation of the *Balli Plastici* of 1917-18, which led to the use of fantastic automata in his Teatro Magico of the 1920s and to the mechanized fairy-tale world of the 1924 production *Anihiccam del 3000*. Prampolini, for his part, wrote the manifestos *Scenografia e coreografia futurista* (*Futurist Scenography and Choreography*, 1915) and *L'atmosfera scenica futurista* (*Futurist Scenic Atmosphere*, 1924), which proposed that theatre should be a 'mechanical rite of the eternal transcendence of matter'. In his Teatro Magnetico of 1924 the play of light replaced the function of actors, as he had already envisioned in 1915, while in 1927 in the Teatro della Pantomima Futurista in Paris he used contraptions such as a lift and a ventilator as protagonists.[8]

The mechanistic phase signals the beginning of Second Futurism proper. Beginning in the late 1910s, Prampolini composed his paintings with large areas of unbroken colour arranged in flat geometric designs, as in *La palestra dei sensi* (*The Palaestra of the Senses*, 1924-5). From the mid-twenties onwards, the idea of mechanization became more pronounced, as individual objects and the human figure were broken down into standardized, emphatically volumetric parts.[9] These successive styles paralleled the development in the international avant-garde from late Synthetic Cubism to Purism. Prampolini maintained direct contacts with other European movements. He edited the Roman based periodical *Noi*, which in its first series (1917-20) provided a platform for Dada and, in the second (1923-5), was co-ordinated with *De Stijl* and supported the machine aesthetic of the Purist movement, propagated in Paris by Amédée Ozenfant and Le Corbusier in the journal *L'Esprit Nouveau*.[10] Balla pursued his individual path, coming closest to a mechanistic style in works such as *Numeri innamorati* (*Numbers in Love*, 1925-6; Cat. 116).

The machine offered a visual model of formal purity and exactitude, but the Second Futurists also maintained that the spirit of the machine should be rendered in accordance with 'an original lyricism and not a pre-existing scientific law' in order to capture its 'forces, rhythms and infinite analogies'. This was expressed in the *Manifesto dell'arte meccanica* (*Manifesto of Mechanical Art*), written by Prampolini, Vinicio Paladini and Ivo Pannaggi in October 1922 and published in *Noi* in May 1923. They declared: 'Everything is incisive, aristocratic, distinct. We are irresistibly attracted to the MECHANICAL SENSE, CLEAN, RESOLUTE. WE FEEL MECHANICALLY. WE FEEL MADE OF STEEL; WE TOO ARE MACHINES; WE TOO ARE MECHANIZED.'[11] At the same time, the 21-year-old Fillia (Luigi Colombo) started a Futurist group in Turin, which was joined by Ugo Pozzo, Nicolay Diulgheroff and the sculptor Mino Rosso. Machine art assumed the form of a proletarian ideology in Turin, a city in the Italian industrial triangle where working-class organizations were particularly strong, and in the 'proletcult' interests of Paladini, one of the first to embrace Russian Constructivism.[12]

By the end of the 1920s, interest in the machine had given way to *Aeropittura* (aeropainting) and its themes of flight and extraterrestrial fantasy. This aero-pictorial, or 'cosmic', phase constitutes the second creative chapter of Second Futurism, in sculpture, architecture and literature as well as painting. The tenets of the new movement were declared in the *Manifesto dell'aeropittura futurista* (*Manifesto of Futurist Aeropainting*) of 22 September 1929, which was signed by Mino Somenzi, Filippo Marinetti, Benedetta Marinetti, Balla, Depero, Prampolini, Fillia, Gerardo Dottori and Tato (Guglielmo Sansoni). *Aeropittura* was interpreted in many individual ways, as could be seen in the 'Mostra futurista di aeropittura e di scenografia', an exhibition of forty-one *aeropittori* held at the Gallerie Pesaro in Milan in October-November 1931. Nonetheless, the overriding theme of flight was represented by two distinct means – poetic analogy and literal description.

The first, and most original, of these means was exemplified by the work of Prampolini, who lived mainly in Paris between 1925 and 1937 and had become the

leading exponent of Futurist painting. *Aeropittura* served as a visual metaphor for the transcendence of the spirit into a higher state of consciousness. Of this 'cosmic idealism' Prampolini wrote: 'I maintain that to reach the highest realm of a new extraterrestrial spirituality we need to transcend the transcription of visible reality, even in its formal properties, and launch ourselves towards the total equilibrium of the infinite, thereby giving life to images latent in a new world of cosmic reality.'[13] Metaphysical inflections had already been apparent in the mechanistic painting of the early 1920s but the Second Futurists now depicted flight with highly fantastic, often 'parasurreal' results: a reverie of heavenly bodies floating in extraterrestrial spaces, what Prampolini termed his 'bioplastic aesthetic'. Brightly coloured biomorphic shapes emerge and dissipate within neutral backgrounds, evoking the sensations of weightlessness and formlessness, as in *L'automa quotidiano* (*The Everyday Automaton*, 1930; Cat. 118). The pictorial language of this branch of *Aeropittura*, with its free use of both biomorphic and non-objective forms, had points in common with that of the *Cercle et Carré* and *Abstraction-Création* artists in Paris (Fig. 5).[14]

The second kind of *Aeropittura* is represented in the work of Tato, Renato Di Bosso, Alfredo Ambrosi, Tullio Crali and Sante Monachesi. They painted literal renditions of planes in flight, aerial views of landscape and the vertiginous effects of soaring heights. The glorification of flying machines in this genre of *Aeropittura* first took on an explicitly aggressive and military tone in support of the Italian invasion of Ethiopia in 1936 (Fig. 6). The work of Dottori, on the other hand, combined the language of the avant-garde and the Realists, depicting aerial views in a vivid scenography of stylized geometric and crystalline forms which focused on lyrical rather than dramatic aspects (Fig. 7). Dottori had anticipated *Aeropittura*, having developed the artistic idea of flight independently as early as 1919 in his *Forze ascensionali* (*Rising Forces*). Balla adhered to the *Aeropittura* movement, painting soaring spaces as metaphors of psychological states and philosophical positions (for instance, *Vortice della vita* [*The Whirlwind of Life*], 1929), although he completely abandoned abstraction shortly thereafter.

In 1934, Marinetti could claim 'five hundred Italian *aeropittori*' in his presentation of the Futurist room at the Venice Biennale. By this time, Futurism had extended all over Italy with various regional factions; there were significant exponents in Liguria (the ceramist Tullio D'Albisola, who trained Lucio Fontana among others), Milan (Bruno Munari), Florence (Ernesto Thayaht and Antonio Marasco), Umbria (Dottori), Emilia (Tato and Oswaldo Bot) and elsewhere.[15] This phenomenon of 'local avant-gardes' played an important part in the dissemination of modernism; one thinks, for example, of the influence of the Sicilian Futurist Pippo Rizzo on the

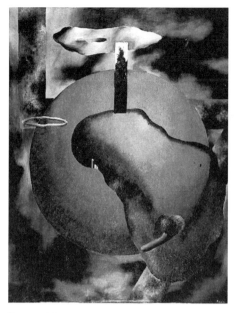

Fig. 5 Fillia, *Earthly Transcendence*, 1930-1. Private collection, Milan

13 Catalogue statement by E. Prampolini, in *Mostra futurista di aeropittura e di scenografia*, Milan, 1931. E. Crispolti, *Aeropittura futurista aeropittori*, Modena, 1985.
14 In 1930, Prampolini and Fillia participated in the exhibition of *Cercle et Carré*, while Prampolini was an adherent of *Abstraction-Création* (1932-4).

Fig. 6 Tullio Crali, *Air Chase II*, 1936. Private collection, Rome

Fig. 7 Gerardo Dottori, *Dawn over the Gulf*, 1935. Regione Umbria, Perugia

15 *I luoghi del Futurismo*, introduction by Franco Barbieri, Rome, 1986; E. Crispolti, *Il Secondo Futurismo: 5 pittori + 1 scultore, Torino, 1923-1938*, Turin, 1962; C. Benedetti, *Il futurismo in Liguria*, Savona, 1976; B. Passamani and Umberto Carpi, eds, *Frontiere d'avanguardia: Gli anni del Futurismo nella Venezia Giulia*, Gorizia, 1985; G. Manghetti, ed., *Futurismo a Firenze 1911-1920*, Verona, 1984; A. Carlo Ponti and M. Duranti, eds, *Futurismo in Umbria*, Corciano, 1986; A. C. Toni, *Futuristi nelle Marche*, Rome, 1982; U. Piscopo, *Futuristi a Napoli: Una mappa da reconoscere*, Naples, 1983.

16 C. Salaris, *Bibliografia del Futurismo 1909-1944*, Rome, 1988. For a history of the movement, see C. Salaris, *Storia del Futurismo*, Rome, 1985.

17 For architecture, see E. Godoli, *Guida all' architettura moderna: Il Futurismo*, Bari, 1983; for furniture, A. M. Ruta, *Arredi Futuristi*, Palermo, 1985; for ceramics, E. Crispolti, ed., *La ceramica futurista da Balla a Tullio d'Albisola*, Florence, 1982; for fashion, E. Crispolti, *Il Futurismo e la moda: Balla e gli altri*, Venice, 1986; for advertising and graphics, G. Lista, *Le livre futuriste: De la libération du mot au poème tactile*, Modena, 1984; C. Salaris, *Il futurismo e la pubblicità*, Milan, 1986; M. Scudiero, *Futurismi postali: Balla, Depero e la comunicazione postale futurista*, Rovereto, 1986; G. Fanelli and E. Godoli, *Il Futurismo e la grafica*, Milan, 1988; M. Scudiero, *Depero per Campari*, Florence, 1988; for photography, G. Lista, *Futurismo e Fotografia*, Milan, 1980.

18 *I° Mostra di Plastica Murale per l'Edilizia Fascista*, Genoa, Palazzo Ducale, November 1934 – January 1935, and the second exhibition at the Mercati Traianei, Rome, October-November 1936. The use of diverse materials was propagated by Prampolini in the manifesto 'Al di là della pittura verso i polimaterici', *Stile Futurista*, 1, no. 2, August 1934, pp. 8-10. On Second Futurism and the 'Mostra della Rivoluzione Fascista', see Susanne von Falkenhausen, *Der Zweite Futurismus und die Kunstpolitik des Faschismus in Italien von 1922-1943*, Frankfurt, 1979.

young Renato Guttuso. After gaining in momentum throughout the thirties, Second Futurism lost impetus with the outbreak of the Second World War and finally disintegrated upon the death of Marinetti in 1944.[16]

As noted, the Futurist movement was anything but homogeneous between the wars, but it did have a distinct profile, both in its relationship to earlier Futurism and in its rapport with other contemporary art movements. The acceleration in technical and social change in Italy and other European countries during the 1920s, and even more so in the following decade, altered the context of Futurism's modernistic vision from one of a distant utopia to a present-day reality. Technological development had caught up with Futurist fantasy, and this undoubtedly resulted in a slackening of polemic tension within the movement. In fact, Futurism no longer regarded the present with disdain, but, in competition with other artistic groups, faced contemporary needs in a concrete and practical way. It ceased to compare a progressive future with a retrograde present, and focused instead on improving a society that had already been substantially modernized. An attitude of confrontation was replaced by the desire to integrate with current tastes, social mores and modes of commercial consumption. This was encouraged by the fact that political activity on the part of Futurists had long been stifled by the Fascist regime, confining them to the artistic sphere. The clearest indication of the new context was the energy with which the Futurists devoted themselves to design, in architecture, interiors and the decorative arts – in short, to the construction of the 'Futurist universe'.

It is not possible here to give an exhaustive list of examples in fashion, furniture graphics and publicity, theatre, radio and photography.[17] Economic growth in the private and public sectors, new consumer patterns and state intervention in the arts created more opportunities for commercial design and large-scale commissions. The Futurists were particularly successful in the field of exhibition design, where they incorporated unconventional materials, photographic montage and typography and disrupted spatial syntax to achieve the force and immediacy of mass communication. These techniques of persuasion were used for blatantly propagandistic ends, as in the 'Mostra della Rivoluzione Fascista', Rome, 1932, which Marinetti considered a triumph of the Futurist style, and in more prosaic advertising for industry and trade (Fig. 8). In place of the traditional fresco or mosaic, they introduced the concept of *'plastica murale'* (mural plastics) which involved three-dimensional design and the use of mixed media.[18]

Second Futurism was not merely a revival of the first, but it did identify closely with the ideals of the original Futurist group, continuing to promote free experimentation and open dialogue with the international avant-garde and defending its cul-

Fig. 8 Enrico Prampolini, Installation in the Electronics Pavilion at the 'Mostra d'Oltremare', Naples, 1940

tural heritage, which was increasingly being ignored and marginalized by the Italian critics of the day. One challenge came from the neo-classical and naturalist painters of the *Novecento*. While competing for recognition as the official art of Fascism, they engaged in an ongoing polemic over tradition and *Italianità*; the Futurists responded to accusations of internationalism by denouncing the *Novecento* as corrupted by French influence. Although they shared many formal features with the abstract painters associated with the Galleria del Milione, Milan, the Futurists disagreed with the semantics of 'non-objective' art. For them, such purely pictorial research was 'northern' and based on 'technical speculation' to the detriment of emotional values. The attitude of the Second Futurists towards the Surrealists and André Breton was decidedly critical. They disassociated their painting from dependence on Freudian psychology and reasserted the importance of deliberate, purposeful research over the Surrealists' primacy of the subconscious. With the Rationalist architects, on the other hand, Second Futurism maintained both a critical and collaborative dialogue. While staunchly supporting the modernist designs in the public debates surrounding such important commissions as those for Florence railway station, the Via Roma in Turin and the Palazzo del Littorio in the Via Impero in Rome, they preferred a style of plastic lyricism, along the lines of Sant'Elia, to what they perceived as the sterility of functionalist aesthetics.[19]

It remains to investigate Second Futurism's relationship with Fascism. Futurism maintained a radical political stance from the very beginning, but one must examine the changing context of this position from the years immediately following the First World War, when Futurism provided a left-wing ideology for nascent Fascism, to the period of government by the Fascists, when actual political participation was impossible.[20] The platform of the Futurist political party, as stated in the *Manifesto del partito politico futurista* of September 1918, was left-wing, even anarchic, and in many ways inimical to bureaucratic implementation. It advocated the use of violence, the primacy of action over thought, universal suffrage, the eight-hour day, the right to strike, nationalization of water and mineral resources, the expropriation of uncultivated land, direct taxation and restrictions on the power of the clergy. Exalting interventionism and the war experience, the Futurists attracted the *arditi*, or assault troops, to their ranks. Together, they formed the essential component of the *Fasci di combattimento*. Mussolini employed the Futurists' left-wing programme and activist model as a tactic in his rise to power. Yet the basic incompatibility of Futurist intransigence and Mussolini's opportunism became apparent at the second Fascist Congress in Milan in May 1920: Marinetti broke with Mussolini when the latter revoked his anti-socialist, anti-monarchical stance in an effort to achieve a broader power base.

Marinetti's support for Mussolini was rekindled in 1924 with the publication of his *Futurismo e Fascismo*, and made official with his nomination to the Accademia d'Italia in 1929. While certain cases of anti-Fascist activity among Futurists can be confirmed, the movement in general adhered to, and solicited recognition from, the regime. In 1933, Mino Somenzi could even proclaim: 'Fascism has found in Futurism the art which best corresponds to it, and Futurism will go down in history as the art of the Fascist period.'[21] However, in no sense did Second Futurism become the art of the regime, even if it sometimes lent its style to the depiction of Fascist themes.[22] Although it claimed a particular identity as the art of the state, the relationship between Second Futurism and Fascism was neither exclusive nor preeminent. Neither individually nor as a group did the Futurists compromise more or less than other artists or movements: their record can stand comparison with that of the *Novecento* and the Rationalist architects. Collusion was perhaps inevitable with a ruling party that was ambiguous and opportunistic in its cultural politics.[23]

Nonetheless, in *Futurismo e Fascismo* Marinetti had already sought to establish a certain cultural autonomy for Futurism rather than a mere relationship of convenience with the regime. Although they remained loyal to the constituted authority, Marinetti and the other Futurists who were 'Fascists of the first hour' constantly revealed in their public pronouncements a nostalgia for the revolutionary days of

19 These debates are discussed in Crispolti, *Storia*, pp. 288-94. The remarks on abstract art are by Prampolini: in contrast to the view of Kandinsky he expressed in the 1910s, he accused European abstractionists of the 1930s of being 'Positivist' and promoted the 'new spiritualism' of his cosmic idealism. 'Conquiste della plastica futurista', *L'Impero*, 8 July 1932.

20 The issue of Futurism and Fascism is examined in further detail in Crispolti, *Storia*, pp. 183-224, and Falkenhausen, *Der Zweite Futurismus*.

21 M. Somenzi, 'Parole semplice e chiare sul Futurismo dedicate ai giovani', *Futurismo*, 2, no. 27, 12 March 1933 (signed 'futur').

22 On Futurist-Fascist iconography, see U. Silva, *Ideologia e arte del fascismo*, 2nd ed., Milan, 1975; F. Tempesti, *Arte dell'Italia fascista*, Milan, 1976; and G. Armellini, *Le immagini del fascismo nella arti figurative*, Milan, 1980.

23 E. Crispolti, 'La politica culturale del fascismo: Le avanguardie e il problema de futurismo', in R. De Felice, ed., *Futurismo: Cultura e politica*, Turin, 1988, pp. 247-83.

24 Marinetti's continued revolutionary position was expressed in 'I diritti artistici propugnati dai futuristi italiani: Manifesto al governo fascista', *Il Futurismo*, 1 March 1923, and in the reference to the 'marvellous spirit of 1919' which he directed at Mussolini during the Milanese Futurist Congress in November 1924 (see M. Somenzi, 'Difendo il futurismo', *A.R.T.E.*, 1937, pp. 117-24, and F. Marinetti, *Futurismo e Fascismo*, Foligno, 1924). For an example of Marinetti's open criticism of the Fascist party, see G. Manacorda, 'Marinetti, l'E.I.A.R e Th. Wilder', *Rapporti*, no. 1, 1974.

25 G. Prezzolini, 'Fascismo e futurismo', *Il Secolo*, 3 July 1923.

26 Crispolti, *Il mito*, pp. 580-843.

'*diciannovismo*' and a hostility towards the restrictive bureaucracy of the regime.[24] Despite formal obsequiousness, the profound contradictions between Fascism and Futurism, discerned by Giuseppe Prezzolini as early as 1923, remained fundamental:

> One cannot perceive how Futurist art can be in accord with Italian Fascism. This is a misunderstanding born of a proximity of persons, accidental encounters and a fermentation of forces that carried Marinetti to Mussolini's side. What was in agreement in a period of revolution will clash in a period of rule. Italian Fascism cannot accept the destructive programme of Futurism; rather, with its *Italian* logic, it should restore the values which are opposed to Futurism. Discipline and hierarchy in politics are discipline and hierarchy in literature as well. Words are overturned when political hierarchies are overturned. Fascism, if it really wants to win its battle, must realize that it has already absorbed all the stimulating qualities of Futurism and must repress whatever is still revolutionary, anti-classical and undisciplined in its art.[25]

Indeed, the instances of collaboration in the 1920s and early 1930s fade into insignificance in view of the Futurists' constant defence of modern cultural values on their own behalf and on that of the entire Italian avant-garde. In the thirties, they not only supported the new Rationalist architecture, but openly opposed a proposal by certain Fascists, among them party minister Roberto Farinacci, to emulate the Nazis and launch a 'degenerate art' campaign.[26] In 1934, on the occasion of the Futurist *Aeropittura* exhibition in Hamburg and Berlin, Marinetti and Ruggero Vasari had courted the disapproval of the Third Reich by making contact with the younger generation of German non-figurative artists and defending the avant-garde that the Nazis were attempting to eliminate. At the same time, Prampolini, in the columns of his journal *Stile Futurista*, was taking a decisive stand against the reactionary cultural policy advanced by Hitler at the Nuremberg party congress.

The crucial moment occurred between October and December 1938, when Telesio Interlandi's racist Roman weekly, *Quadrivio*, attacked all modern art as 'Jewish' and 'bolshevik'. This was followed by an article by Interlandi in the daily *Il Tevere*, another notoriously anti-semitic publication which he edited, in which he named Marinetti, along with Carrà, Giorgio de Chirico, Corrado Cagli, Renato Birolli, Mauro Reggiani, Lucio Fontana, Gino Ghiringhelli, Atanasio Soldati, Pietro Lingeri and Giuseppe Terragni, in a list of 'degenerate' Italian artists. In response, Marinetti and Somenzi organized a large demonstration at the Teatro delle Arti in Rome, and a polemic against the 'degenerate art' campaign was launched in the December 1938 and January 1939 issues of Somenzi's periodical *Artecrazia*. The journal was suppressed, but not before Somenzi had published the results of a public referendum he had organized, which came out in favour of modern art. If the Futurists were barred from concrete political action, they nonetheless performed the function of maintaining critical vigilance in the face of the regime's increasingly rigid cultural policies. With this ferocious and ultimately successful battle, Second Futurism continued the 'heroism' of the first by defending modernism and the avant-garde.

Emily Braun

Mario Sironi and a Fascist Art

Parts of this essay were included in E. Braun, 'Die Gestaltung eines kollektiven Willens', in *Mario Sironi 1855-1961*, ed. J. Harten and J. Poetter, Cologne, 1988, pp. 40-9. All translations are the author's.

1 For Fascist culture, see N. Bobbio, 'La cultura e il fascismo', in G. Quazza, ed., *Fascismo e società italiana*, Turin, 1973, and, for the historiography of Fascism, R. De Felice, *Interpretations of Fascism*, trans. B. H. Everett, Cambridge, 1977.

2 R. De Felice's multi-volume biography of Mussolini was a milestone in the revised interpretation of Italian Fascism: *Mussolini il Rivoluzionario 1883-1920*, Turin, 1965; *La conquista del potere 1921-1925*, Turin, 1966; *L'organizzazione dello Stato fascista 1925-1929*, Turin, 1968. The characterization of Fascism as 'imperfect totalitarianism' is found in A. Asor Rosa, 'La Cultura', in *Storia d'Italia Dall'Unità ad oggi*, ed. R. Romano and C. Vivanti, Turin, 1975. For a reassessment of Fascist ideology, see E. Gentile, *Le origini dell'ideologia fascista 1918-1925*, Bari, 1975.

3 'Les réalismes', Paris, Centre Georges Pompidou, 1981; 'Il Novecento italiano 1923/1933', Milan, Palazzo Reale, 1983; 'Gli Anni Trenta', Milan, Comune di Milano, 1982.

4 Morandi's autobiographical sketch is found in *20 Giovani Leoni: Autobiografie pubblicate su 'L'Assalto' negli anni 1927-28*, ed. C. Barilli and M. Bonetti, Volpi, 1984, pp. 73-6. I thank Maurizio Fagiolo dell'Arco for bringing this information to my attention.

5 The conclusion that the significant art and artists of the period were fundamentally antagonistic to the regime is reached, for example, by C. De Seta, *La cultura architettonica in Italia fra le due guerre*, Bari, 1983, pp. VII-XVIII (see pp. 147-54 for Sironi). One of the few scholars who have attempted to revise this view is D. Ghirardo; see her 'Politics of a Masterpiece: The *Vicenda* of the Decoration of the Facade of the Casa del Fascio, Como, 1936-39', *Art Bulletin*, 62, no. 3, September 1980, pp. 466-78, and 'Italian Architects and Fascist Politics: An Evaluation of the Rationalists' Role in Regime Building', *Journal of the Society of Architectural Historians*, 39, no. 2, May 1980, pp. 109-27.

Until recently, studies on the Fascist period in Italy have resisted the idea of a Fascist culture, seeing it as an invention of the rhetorical propaganda on which the regime based its popular consensus.[1] Particularly damning was the perception that Fascism lacked an ideology; devoid of a central doctrine or consistent guiding principles, it could only have produced a culture that was equally insubstantial and opportunistic. As a totalitarian system, Fascism aimed at leaving no element of the social fabric untouched; therefore, it must have corrupted any artistic manifestation that was not openly anti-Fascist. The art of the period was thus discussed largely in negative terms as evasive or inert, as a hiatus in the course of Italian cultural history. It could imitate the forms of others, but never generate its own authentic expression, whereas true, liberal culture was seen to have survived underground, emerging unscathed at the end of the Second World War.

Subsequent historical examinations of the period have attempted to qualify this simplistic interpretation, demonstrating that Italian Fascism was never absolute in its control, but rather an 'imperfect totalitarianism', and that it at least possessed a series of legitimate doctrines, if not an overriding ideology.[2] In the visual arts, a series of large-scale exhibitions over the past decade – notably 'Les réalismes' in Paris, and 'Il Novecento italiano' and 'Gli Anni Trenta' in Milan – have corrected a myopic view of the epoch as one of insularity or provincialism.[3] In fact, the period was marked by pluralism and eclecticism in the arts, the result of a relatively unrestrictive cultural policy (in comparison to that of Nazi Germany) and of Mussolini's reluctance to support any one style or group exclusively, despite the considerable efforts of many artists and critics to have their work sanctioned as the official art of the state. The avant-garde and the retrograde co-existed, one might even venture to say thrived, in dialogue with an opportunistic regime.

There is nonetheless still a general reluctance to recognize the existence of a Fascist art, a reluctance based on Benedetto Croce's Idealist assumption that art and politics are inimical to one another: genuine artistic expression could have co-existed (and compromised) with the regime but not derived its inspiration from such a discredited political ideology. The term 'Fascist art' is used only pejoratively, in reference to the paintings shown at the Premio Cremona, an annual exhibition instituted in 1939 by Party Minister Roberto Farinacci to promote an illustrative realism similar to that favoured in the Third Reich. Yet the perplexing fact remains that many, if not most, of the artistic and literary talents of the period – Luigi Pirandello, Massimo Bontempelli, Filippo T. Marinetti, Giuseppe Pagano, Giuseppe Terragni, Carlo Carrà, Mario Sironi, to name but a few – openly supported Fascism, at least until the Ethiopian invasion (1936) and the repressive measures of the Racial Laws (1938), if not right through to the Republic of Salò (1943-5). Even Giorgio Morandi, the most ideologically and stylistically 'pure' of artists, could still declare his faith in Fascism two years after the Matteotti crisis of 1925 (the turning point for many who had previously supported the movement), a faith that, in his words, 'has never decreased, even in the most grey and tempestuous moments'.[4] Yet the art of the Italian avant-garde has rarely been interpreted as an expression of conviction, with stylistic characteristics that reflected Fascist ideology or elements thereof.[5]

The art of Mario Sironi is a case in point. Generally considered to be among the most important Italian artists of the century, he has continually provoked a guarded response as a result of his affiliations with the regime and the blatant political content

of much of his imagery.[6] Critical interpretations have revolved around the duality of his artistic production, giving rise to the problem of the two Sironis: the artist of the tenebrous urban landscapes dating from the early twenties (Cat. 100) and the painter of monumental murals of a decade later (Cat. 108).[7] On the one hand, his depiction of the working-class milieu is cited as expressing genuine regret at man's alienation in the modern world, a pessimistic view which was fundamentally antagonistic to the optimistic rhetoric of the regime. On the other hand, this same mood of disquiet is read as the *ne plus ultra* of Fascist morbidity, a disdain for mankind that only resolved itself in the visual demagogy and celebratory myth-making of the murals.[8] The seemingly irreconcilable differences between left-wing and reactionary politics, between sincerity and rhetoric, have either led to the conclusion that the artist's position was ambiguous or equivocal or been seen to vindicate those who view Sironi as the very embodiment of Fascist manipulation of reality. Either way, he has emerged as the central yet atypical figure of his generation, with a dramatic and convincing style which, as his contemporaries recognized, distinguished him from his peers. The paradox was best, though unwittingly, expressed by the critic Vincenzo Costantini who, as early as 1934, proclaimed Sironi to be the true interpreter of Fascism in the visual arts and 'perhaps the only one who possesses a human "content"'. Some forty years later, Rossana Bossaglia could affirm that, as a propagandist, 'Sironi invented an image of Fascism which, precisely because of its energy and originality, appears now, at a reasonable distance in time, the most intolerable and repellent of all'.[9]

The relationship between art and political ideology is particularly relevant to the study of the avant-garde in Italy, where the idea of 'cultural interventionism' was the central issue of debate during the first decade of the century and beyond.[10] Although most intellectuals belonged to the middle and upper classes, they viewed themselves as a class apart, one disdainful of bourgeois values and in favour of the emancipation of the working class. In journals such as *La Voce*, they discussed the choice between active participation or critical distance, caught between the desire for radical social change and the preservation of class interests, between sympathy for the masses and fear of the demise of culture in modern industrial society. Fascism catered to this equivocal stance, attracting the active support of Italy's leading writers and artists by spreading the belief that they possessed both the right and the means to effect national regeneration. Such expectations were encouraged by a generation's sacrifice in the trenches of the First World War and by the Futurists' critical role in the politics of the immediate post-war period.

Mussolini's call to intellectuals to abandon their ivory tower fell on willing ears, and found its theoretical elaboration in the concept of the ethical state, as defined by the philosopher and Mussolini's first Minister of Education, Giovanni Gentile, who had broken away from Croce's notion of the autonomy of art to espouse what he termed 'militant Idealism'. Gentile called for the submission of the individual to the higher good of the nation. To the intellectual elite fell the role of educating and indoctrinating the masses. Like the politician – and this was Mussolini's own comparison – the artist moulds the mass of human clay, shaping the collective will through myth and image.[11] Though the role of intellectuals was never defined in concrete terms or implemented bureaucratically, Gentile's concept of the ethical state served as the official ideology during the first decade of Fascism and attracted many artists to its cause, long after the promise of a harmonious community had given way to the reality of a reactionary regime.[12]

The vicissitudes of Sironi's career illuminate both the strengths and the inconsistencies of Mussolini's cultural policy over a twenty-year period. A Futurist, and later the leading member of the *Novecento* group, Sironi rebelled against the cultural heritage of Liberalism in favour of an art that was intentionally anti-bourgeois in its espousal of the new political reality of the masses. Whether agitating for popular revolution during the rise of Fascism, or expounding dogma after its accession to power, he consciously devoted his creative energy to the goal of cultural interventionism to a greater degree than any other artist of the period. A master of many

6 E. Camesasca, 'Spazio di Sironi', in M. Sironi, *Scritti editi e inediti*, Milan, 1980, p. VII.

7 L. Anceschi's monograph on the artist, *Mario Sironi*, Milan, 1944, was the first to propose a dichotomy between the landscapes and the murals; this interpretation has continued throughout the literature.

8 Typical of this highly negative view of Sironi are R. Tassi, 'Dolore e mito in Sironi', *L'Approdo letterario*, October 1962, and P. Fossati, 'Con orbace e senza orbace', *Il bimestre*, nos. 26-9, 1973. One of the few studies to avoid excusing or condemning the artist is M. De Micheli, 'Un wagneriano in camicia nera', *Bolaffiarte*, January 1973, pp. 42-7, which, for the first time, analysed Sironi's espousal of Fascism in the context of his generation and intellectual roots.

9 V. Costantini, *Pittura italiana contemporanea*, Milan, 1934, pp. 262-7. Bossaglia's comment (in *Il 'Novecento Italiano'*, Milan, 1979, p. 48) refers to Sironi's room designs for the 'Mostra della Rivoluzione Fascista'. For the characterization of Sironi as 'both the central and atypical figure' of the *Novecento*, see F. Tempesta, *Arte dell'Italia fascista*, Milan, 1976, p. 64.

10 See L. Mangoni, *L'interventismo della cultura*, Bari, 1974, and G. Luti, *Cronache letteraria tra le due guerre 1920-1940*, Bari, 1966. The intellectuals of *La Voce* are placed in a larger context by R. Wohl, *The Generation of 1914*, Cambridge, Mass., 1979, especially pp. 160-202.

Fig. 1 Mario Sironi, *Cyclist*, 1916.
Private collection, Rome

Fig. 2 Mario Sironi, *Mannequins*, c. 1919.
Private collection, Bologna

11 'Alla Mostra del Novecento: Parole di Musso-
lini sull'arte e sul governo', *Il Popolo d'Italia*,
27 March 1923; reprinted in Bossaglia, *Il
'Novecento Italiano'*, pp. 83-4. In his introduc-
tory speech at the first exhibition of the 'Sette
Pittori del Novecento' Mussolini claimed, 'I am
also an artist who works a certain material and
follows certain determined ideals.' On the oc-
casion of the first exhibition of the *Novecento*, he
extended the parallel: 'The "political" creation,
like the artistic, is a slow elaboration and a sud-
den divination. At a certain moment, the artist
creates with inspiration and the politician with
decision. Both work matter and the spirit
To give wise laws to the people, one also needs
to be something of an artist' ('Discorso di Mus-
solini per l'inaugurazione della prima mostra
del Novecento Italiano', *Il Popolo d'Italia*, 16
February 1926; reprinted in Bossaglia, *Il 'Nove-
cento Italiano'*, pp. 96-8).
12 Gentile, *Le origini*, especially ch. 7: 'Il mito
dello stato'; A. James Gregor, *The Ideology of
Fascism*, New York, 1969; E. Papa, *Storia di due
manifesti*, Milan, 1958.
13 The statements by Sironi are from his 'Mani-
festo della pittura murale', *La Colonna*, De-
cember 1933; reprinted in Sironi, *Scritti*,
pp. 155-7. The manifesto was also signed by
Massimo Campigli, Carlo Carrà and Achille
Funi.
14 F. Marinetti, U. Boccioni, L. Russolo, A.
Sant'Elia, M. Sironi and U. Piatti, *L'Orgoglio
Italiano*, drafted in October 1915 and published
in January 1916 by the Direzione del Movi-
mento Futurista; reprinted in Sironi, *Scritti*,
pp. 9-11.
15 Marinetti mentions Sironi's presence at a meet-
ing of the central committee of the *Fasci di Com-
battimento* on 5 October 1919; F. T. Marinetti,
Taccuini 1915-1921, Bologna, 1987, p. 446. I
thank Philip Cannistraro for bringing this to
my attention. Throughout his career, Sironi
was known (like several other Futurists) as a
'Fascist of the first hour'; see, for example,
U. Nebbia, 'Artisti d'oggi: Mario Sironi', *Em-
porium*, 79, January 1934, pp. 2-18. He was
one of a handful of artists included in the
'Mostra degli squadristi' commemorating the
'years of passion', as Renato Guttuso called
them in his review of the exhibition in *Primato*,
15 April 1940, p. XVIII.

different arts, from caricature to architecture, he was equally at home with crude didacticism and with poetic evocation, adept at fashioning an image and a message according to the audience and the medium. He dedicated his creativity to the ends of political hegemony, openly declaring the fine arts to be the 'perfect instrument of spiritual government'.

There is no contradiction between Sironi's urban landscapes and his murals insofar as both pragmatically accommodated the needs of Fascism as it evolved from a many-faceted movement into an established order. His early images of the indus-trial milieu reflect the left-wing, anarchic-syndicalist roots that formed the basis of Futurism and of much of Mussolini's early revolutionary programme. Following the consolidation of Fascist power, Sironi turned from easel painting, which he con-sidered an anachronism of bourgeois taste, and devoted himself to propaganda work. With his mural painting and public art works of the 1930s, he aimed at eradicating the distinction between high and low culture, impelled both by pragmatic accept-ance of the Fascists' mandate to forge mass assent through cultural conformity and by the personal ambition to create a national, popular style – a Fascist style. In both theory and practice, Sironi corresponded to the Gentilian ideal of the artist as an educator and a member of the cultural elite, one who used the media and style of his artistic practice to become 'a militant artist, that is to say, an artist who serves a moral ideal and subordinates his own individuality to the collective cause'.[13]

Sironi's urban landscapes (*paesaggi urbani*) dominated his art from about 1916 to the mid-twenties, although he was to return to the theme throughout his life. They also serve to define his relationship with the Futurist movement, which he joined in 1915 for ideological rather than artistic reasons. Although he closely followed the progress of his mentor and close friend, Umberto Boccioni, and experimented with the syntax of 'plastic dynamism' in the early 1910s, he was never comfortable with Cubist fragmentation or abstraction. Indeed, his preference for solid, emphatically tactile form modelled with dense areas of chiaroscuro was already apparent in *Ciclista* (*Cyclist*, 1916; Fig. 1), one of his first urban landscapes. What did attract him to Futurism was its activist, avant-garde spirit, its call for a new artistic language for the working class and its campaign for Italy's intervention in the First World War. It is therefore significant that he officially became a member of the movement by signing the manifesto *Orgoglio Italiano* (*Italian Pride*), which called for 'slaps, kicks and gunshots in the back of the Italian artist or intellectual who hides beneath his talent like an ostrich behind its luxuriant plumes, and who fails to align his own pride with the military pride of his race'.[14]

Together with the other signatories of the manifesto – Boccioni, Marinetti, Luigi Russolo, Antonio Sant'Elia and Ugo Piatti – Sironi served at the Front in the Battaglione Lombardo Volontari Ciclisti e Automobilisti. The experience of war bound Sironi and the Futurists to the *arditi* (stormtroopers) and the other veterans who founded the *Fasci di Combattimento* in March 1919. By virtue of their daring and sacrifice during the war years, the *fasci* viewed themselves as the aristocracy of the new national state. As the central component of the *Fasci di Combattimento*, the Futurists, Sironi included, actively agitated for the demise of Liberal parliamentary government and provided Mussolini with much, if not most, of his initial, largely left-wing support.[15]

On his return to Milan after the war, Sironi produced hundreds of drawings of empty city streets, disturbed only rarely by the presence of an aeroplane, a lorry or a mannequin. The latter is no longer the muse of Giorgio de Chirico's paintings but an ironic conflation of wooden artists' figure, war invalid and machine, similar to the humanoids depicted by George Grosz during these years (Fig. 2). De Chirico's classical squares have been transformed into contemporary street corners, while retaining the unsettling perspective and still atmosphere. Motifs drawn from modern industry and transportation – cranes, pylons, lorries and trams – appear strangely unfamiliar in these landscapes of urban desolation (Cat. 100, 101). Gone is the escapist nostalgia of the Metaphysical painters: one is faced with an unrelieved sense of alienation. By the early twenties, the mannequins in Sironi's paintings had been

replaced by vagabonds and beggars. The disenfranchised and dispossessed were to continue as a sub-theme throughout his oeuvre, even when the proletariat and the agricultural labourer were ennobled on a monumental scale in his mural paintings.

Sironi's urban landscapes have inspired the representations of the working-class milieu in neo-realist cinema and even the post-modernist architecture of Aldo Rossi, yet they pointedly referred to the topical issues of zoning and workers' housing. The area of Milan depicted by Sironi – the quarter from the Porta Romana to the Via Ripamonti – was one of the most rapidly developed since the turn of the century.[16] While under construction, the buildings of the Porta Romana had been painted by Boccioni in a vital, Divisionist style. In Sironi's images, the scaffolding has given way to urban sprawl, and the optimistic vision of a Socialist utopia to a pessimistic negation of progress.

In subject and style, these are images of the working classes. They evince nothing of the bohemian *ennui* characteristic of the Impressionists' images of urban life, nor do they revel in the bourgeois decadence treated by Ernst Ludwig Kirchner in his pre-war city scenes. The canvases are coloured with the tones of industrial soot and with the ochres and greys of the stuccoed facades typical of popular housing in Milan. Factories and tenement blocks are rendered stark and powerful, as Sironi returns to the modelling and massing of Quattrocento Tuscan painting, endowing anonymous modern structures with an imposing monumentality (Cat. 102).

The attention paid by Sironi to the 'other' side of the city attests to his awareness of the shifts in social structures. The urban landscapes reflect the profound transformations brought about by the war and the tension of the immediate post-war situation, marked in particular by the industrial unrest that culminated in the '*Settimana Rossa*' (Red Week) and the occupation of the factories, when the possibility of revolution seemed very real.[17] The streets are ominously still, empty of human life but filled with a mood of brooding discontent. The implicit social message is explicitly stated in Sironi's political cartoons of the time, especially those he produced in 1920-1 for the periodical *Le Industrie Italiane Illustrate*. These are boldly rendered and highly critical commentaries on the social and political chaos engendered by the incompetence of the bureaucracy, the ineffectiveness of the Liberal parliamentary system, the Bolshevik threat and the poor conditions of the unemployed and lower classes.[18] During this post-war period, Sironi painted an image that is unique among his urban landscapes. It is one of the few with a human protagonist, significantly, a figure posed imperiously on a white horse (Cat. 103). This image of a *condottiero* may refer either to Gabriele D'Annunzio and his Fiume expedition or to Mussolini. Perhaps no other artist of the period so captured the 'ideology of crisis' which permeated post-war Italy, and which found its supposed solution in the authoritative figure of the Nietzschean superman.[19]

Immediately after the March on Rome in October 1922, when Mussolini came to power in a welter of parliamentary crises, Sironi, Carlo Carrà, Achille Funi, Marinetti and other Futurists who had belonged to the *fasci* publicly proclaimed:

> The assumption of governmental responsibility by the young Italian Benito Mussolini has finally shattered the mediocre mentality that has for so many years suffocated the chief quality of the race: the excellence of its artistic spirit. Fascism, charged with Idealistic values, is applauded by all of those who are legitimately able to call themselves Italian poets, novelists and painters. We are sure that in Mussolini we have the Man who will know how to value correctly the force of our Art dominating the world.[20]

Although it was some time before Mussolini turned his attention to the implementation of a cultural policy, artists and critics were quick to advocate an art that would reflect the new Italy of Fascism.[21] The first such movement was the *Novecento*, the brain-child of Margherita Sarfatti, a brilliant writer and critic and an intimate of Mussolini. It was the force of Sarfatti's ambitions that led to Mussolini's appearance at the opening of the exhibition 'Sette Pittori del Novecento' (Seven Painters of the Twentieth Century) in March 1922 at the Galleria Pesaro in Milan. The group, consisting of Sironi, Funi, Piero Marussig, Leonardo Dudreville, Anselmo Bucci, Ubaldo Oppi and Gian Emilio Malerba, was united by the aim of creating a new art

16 Milan's industrial growth, turn-of-the-century economy and urban expansion are reviewed in *Boccioni a Milano*, ed. G. Ballo, Milan, 1982. On the expansion of the suburbs and the concern over workers' housing, see M. Cerasi and G. Ferraresi, *La residenza operaia a Milano*, Rome, 1974.

17 The strikes took place between April 1919 and September 1920: De Felice, *Mussolini il Rivoluzinario*, pp. 423-5, and P. Spriano, *L'Occupazione delle fabbriche*, Turin, 1964. The possibility of a connection between Sironi's images and the occupation of the factories was suggested by C. Gian Ferrari, 'Cronologia', in Sironi, *Scritti*, pp. 429-30.

18 Sironi's illustrations – political caricatures, sports vignettes, literary illustrations – run into thousands. They have recently been catalogued by A. Sironi and F. Benzi, *Sironi Illustratore: Catalogo Ragionato*, Rome, 1988.

19 Gentile, *Le origini*, p. 57.

20 The statement was first published in *Il Principe*, 3 November 1922, and subsequently reprinted in *Il Popolo d'Italia*. See Sironi, *Scritti*, p. 20. Fourteen signatures were attached to the text, many of them of Futurists from the original *Fasci di Combattimento*, such as Mario Carli, Bruno Corra, Settimelli and Mino Somenzi. Carrà was not a member of the *fasci*.

21 See the essay by Philip Cannistraro in this catalogue and, for a more detailed discussion of Fascist cultural policy, his *La fabbrica del consenso*, Bari, 1975.

Fig. 3 Mario Sironi, *The Pupil*, 1924.
Private collection

22 M. Sarfatti, preface to the exhibition 'I Sei Pittori del Novecento' (Oppi was not included), in the catalogue of the Venice Biennale, 1924; reprinted in Bossaglia, *Il 'Novecento Italiano'*, pp. 84-5.

23 Gentile, *Le origini*, discusses Mussolini's relativism in politics, pp. 141-55, and its relationship to the contemporary philosophy of A. Tilgher, pp. 23-36. On Fascism as an 'anti-party', see A. Lyttelton, *The Seizure of Power*, 2nd ed., London and Princeton, 1987.

24 Bossaglia, *Il 'Novecento Italiano'*, pp. 16-19.

25 F. Roh, *Nach-Expressionismus, Magischer Realismus: Probleme der neuesten europäischen Malerei*, Leipzig, 1925. For a discussion of Roh's book, see E. Braun, 'Franz Roh: Tra postespressionismo e realismo magico', in *Realismo Magico*, ed. M. Fagiolo dell'Arco, Milan, 1988, pp. 57-64.

26 W. Haftmann, *Painting in the Twentieth Century*, vol. I, London, 1960, p. 208.

27 Costantini, *Pittura italiana contemporanea*, p. 359.

that neither broke with tradition nor merely recapitulated the past, but reflected the historical circumstances and the spirit of the twentieth century. Initially, Sarfatti gave equal attention to ideological and formal issues in her promotion of the group; it was only later, with the first national exhibition of the movement – now called *Novecento Italiano* – in 1926 (which included over one hundred painters), that the imperialistic and nationalistic rhetoric of Fascism began to permeate her critical prose. In the early stages of the group's formation she had viewed the autonomous laws of painting, what she termed the 'claims of pure visibility', rather than the dictates of order and discipline, as constituting the core of the Italian tradition.[22] One reason for this was that, until Mussolini assumed dictatorial powers in 1925, the nature of Fascism itself was not clearly defined. In its early stages, the movement was consciously anti-doctrinaire; its ideology was that of 'absolute activism', a sceptical, relativist philosophy which accepted the demise of stable values, even the linear progress of history, in favour of the power of intuition and will.[23]

The aesthetics of 'pure visibility' – clearly delineated form, with an over-accentuated 'plastic' or tactile quality – comprised the chief characteristic of Magic Realism, or what Rossana Bossaglia has called the first *Novecento* style.[24] It was the dominant form of visual expression in Italy in the early twenties – even among artists who did not properly belong to the *Novecento*, such as Carlo Carrà (Cat. 97) – and reached its height at the Venice Biennale of 1924, where Sironi exhibited his sombre neo-classical portrait *L'Allieva* (*The Pupil*, 1924; Fig. 3) and Felice Casorati his arresting image *Meriggio* (*Midday*, 1922; Cat. 114). Magic Realism has been interpreted as part of the larger European phenomenon of a return to figurative painting, or to the 'object', in reaction against the excesses of the pre-war avant-garde. Yet as the word 'magic' suggests, and as it was intended by the German critic Franz Roh, who coined the term in 1925, this realism was anything but neutral or passive.[25] Writing on both the new art in Italy and *Neue Sachlichkeit* in Germany, Roh noted that the unresolved perspectives and unnatural stillness of Metaphysical painting had been transferred to contemporary settings, endowing everyday objects with a heightened and disquieting presence. While demonstrating a longing for faith in the solid and unshakeable, the obsessive attention to the materiality of things in these images draws attention to the fact that reality has been irrevocably altered. Paintings of the period by Antonio Donghi, Virgilio Guidi or Ubaldo Oppi (Fig. 4), with their airless atmosphere and enamel-like surfaces, are anything but a reflection of normality. Compositions with multiple, non-converging perspectives in a shallow space focus attention on the individual formation of each object, or what Roh termed the 'moment of connection'. This is painting about the assertion of control or, as Werner Haftmann describes it, 'the object was no longer looked upon as a vehicle of visual effect but rather as a thing to be dominated by the activity of the mind'.[26]

Magic Realism was thus not the style of a return to order, but a visual metaphor of relativism. As such, it paralleled the shifting political programme of early Fascism: both the politician and the artist considered reality to be a creation of his own will. This symmetry of political and artistic styles continued in the mid-twenties, when upheaval and change gave way to the implementation of doctrine, and Magic Realism to a pervasive naturalism. The 'return to order', then, began with the eclecticism of the first *Novecento* exhibition in 1926 and triumphed with the first national showing of Fascist art, the Rome Quadriennale of 1931. Indeed, in 1934, the critic Vincenzo Costantini observed that the 'surrealistic' elements and formal distortions of Metaphysical painting and the early *Novecento* could not be tolerated in the new cultural climate, which stressed the 'healthy' tradition of the past and nationalistic sentiments.[27]

The *Novecento* was neither a coherent movement nor the official art of the state. Internal rivalries and competition from the regime's cultural bureaucracy, especially the regional syndicates instituted in the late twenties, led to its dissolution in 1932-3. By that time, the art of the regime had evolved into four distinct currents. Those artists working under the banner of Futurism continued to use the formal inventions of modernism, adapting Cubist or biomorphic forms to the depiction of the *Duce* or

Fig. 4 Ubaldo Oppi, *Portrait of the Painter and His Wife*, 1920. Private collection

Fig. 5 Ottone Rosai, *The Pine Tree*, 1938.
Private collection

the Fascist cult of technology. The abstractionists of Como and Milan, on the other hand, claimed that their canvases of pure, geometric forms reflected the inherently Fascist qualities of order and discipline. At the other extreme was an explicitly propagandistic, academic realism. Although this stylistic tendency increased in the late 1930s, when it was promoted by Farinacci in emulation of the art of the Third Reich (see Fig. 5, p. 153), it remained relatively unimportant. The prevalent trend, however, was a return to Naturalism, either veering towards Impressionism or combined with classicizing forms, as in the work of Carrà (Cat. 99). Even the grassroots regionalism of the *strapaese* group, which preached resistance to political conformity, found artistic expression in landscapes and images of peasants that were infused with an Impressionistic brushwork, as can be seen in the work of Ardengo Soffici or Ottone Rosai (Fig. 5).

The term 'art of the regime' is generally used to denote the work of those artists who declared themselves loyal to, or representative of, Fascism, irrespective of whether their images reflected political dogma. In the present context the term excludes those artists who were consciously 'apolitical', who did not openly extol Fascist principles or share the belief in specifically Italian qualities, maintaining an open dialogue with other European art. Such stylistic independence itself constituted a 'political' statement. Nonetheless, these artists worked and survived within the cultural bureaucracy. Such was the case with the members of the *Scuola Romana* or the *Gruppo di Sei* who, seemingly independent, nevertheless exhibited regularly on a regional and national level, had their work purchased by government institutions and received their share of public commissions. Even in the late thirties, as the regime became more repressive, these intellectuals still enjoyed the protection and support of Giuseppe Bottai, Minister of Education.[28] In the final analysis, they are less representative of an anti-Fascist current than of the ability of Fascist cultural policy to absorb even the most idiosyncratic and independent artistic expressions.

An exception to all these developments was Sironi. As the political role of the fine arts seemed to decrease in effectiveness, Sironi categorically rejected easel painting and the art market, together with the syndicate exhibitions which promoted it, as vestiges of an anachronistic nineteenth-century culture. He blamed the demise of a national culture on excessive individualism and eclecticism, rather as the self-interest of the parliamentary party system had led to political disarray. Undoubtedly with the organization of the ethical state in mind, Sironi advocated the 'submission' of individual styles to an 'absolute artistic severity' put at the service of the higher interest of a collective, innately Fascist mode of expression.[29]

Sironi maintained that a Fascist art could only be developed in large-scale art works conceived in conjunction with the imposing spaces of public architecture, restoring to the fine arts the pre-eminence they had enjoyed in epochs past. During the 1930s, he devoted his energies to mosaics, bas-reliefs and especially mural paint-

28 Bottai's role in creating an 'open' culture and a forum for debate is discussed in L. Mangoni, *La Cultura*, and G. B. Guerri, *Giuseppe Bottai: Un fascista critico*, Milan, 1976.

29 Sironi's ideas on a Fascist art were expressed in various articles for *Il Popolo d'Italia* (Mussolini's official newspaper) and *La Rivista Illustrata del Popolo d'Italia* (its monthly cultural review). His strongest criticisms of easel painting are found in 'Arte Ignorata', in Sironi, *Scritti*, pp. 158, 161, originally published in *La Rivista*, March 1934. For his theory of a collective style, see 'Templi', *La Rivista*, December 1935, and 'Antellami', *La Rivista*, February 1936; reprinted in Sironi, *Scritti*, pp. 206-9, 210-13.

Fig. 6 Mario Sironi, Room S: *Galleria dei fasci*, 'Mostra della Rivoluzione Fascista', Rome, 1932

30 Sironi's most eloquent defence of formalism is found in 'Racemi d'oro', *La Rivista*, March 1935, reprinted in Sironi, *Scritti*, pp. 191-4, where he compares the beauty and power of Byzantine mosaics to the 'linear arabesques' of Wassily Kandinsky.

31 M. Campigli, C. Carrà, A. Funi and M. Sironi, 'Manifesto della pittura murale', *La Colonna*, December 1933; reprinted in Sironi, *Scritti*, pp. 155-7. The text was written by Sironi.

32 Sironi saw El Lissitzky's pavilion at the 1928 Cologne International Press Exhibition, for which he designed, with Giovanni Muzio, the Italian Press Pavilion. Sironi later acknowledged the influence of El Lissitzky in 'L'architettura della Rivoluzione', *Il Popolo d'Italia*, 18 November 1932; reprinted in Sironi, *Scritti*, pp. 132-5. The criticism of the 1934 exhibition is found in 'Pittura in mostra', *La Rivista*, July 1934; reprinted in Sironi, *Scritti*, p. 168.

33 M. Sironi, 'Arte e tecnica della mostra "Schaffendes Volk" a Dusseldorf', *La Rivista*, November 1937; reprinted in Sironi, *Scritti*, pp. 222-6. See Braun, 'Die Gestaltung'.

34 M. Sironi, 'Gusti borghese'; first published in Sironi, *Scritti*, p. 291.

35 See, for example, the following essays:'Racemi d'oro', *La Rivista*, March 1935; 'Antellami', ibid., February 1936; 'Secolo undecimo', ibid., September 1936. Reprinted in Sironi, *Scritti*, pp. 191-4, 210-13, 214-16.

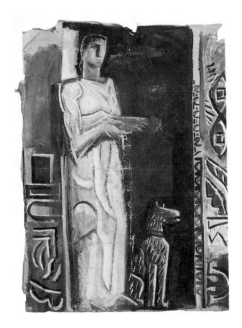

Fig. 7 Mario Sironi, Study for *Corporate Italy*, 1936. Private collection, Bologna

ings which glorified the dogma of the 'corporate state' with allegories of labour and national greatness.

Sironi sought to restore to art its social function, but his concept of style was anything but traditional. A staunch advocate of modernist principles, he defended the autonomous qualities of line, form and colour in the creation of a higher, more compelling reality.[30] Indeed, for Sironi, it was through style that art acquired the ability to go beyond the merely 'seen' or demonstrated and to inspire and persuade; in short, style, or manipulated reality, was the medium of political efficacy. As he stated in the *Manifesto della pittura murale* (*Manifesto of Mural Painting*) of 1933: 'The new civilization will identify with the "Fascist Style", which will emerge from mural painting. The educational function of painting is above all a question of style. Rather than through subject-matter (the Communist approach), it is through style that art will succeed in making a new mark on the popular consciousness.'[31]

For this reason, he was highly critical of both German National Socialist and Russian Social Realist art. He had earlier championed Russian Constructivism, having been directly influenced by El Lissitzky's Cologne Press Pavilion when designing his rooms at the 'Mostra della Rivoluzione Fascista' (Exhibition of the Fascist Revolution; Fig. 6). He was thus dismayed, when reviewing the Soviet Pavilion at the 1934 Biennale, to find that bold abstractions had been replaced by the work of mundane 'calendar painters'.[32] Similarly, when he had occasion to observe the culture of Italy's northern ally at first hand, he criticized German exhibition designers for their failure to excite and agitate the masses, for a sterile approach to propaganda.[33] Throughout his writings, he implicitly denounces Nazi cultural policy for its attempt to reduce public taste to the lowest common denominator of an illustrative 'meticulous, nordic realism'. He censured those critics who sought to turn public opinion against modern art and towards images of 'women with red lips and plump blond babies with rosy cheeks'. Significantly, he attributed this aesthetic preference for kitsch and the vulgar to the social aspirations of the petty-bourgeoisie and not to the natural inclinations of the proletariat.[34]

Sironi's concept of popular art was based neither on a style of bland realism nor on cerebral abstraction, but on an archaic monumentalism of rough-hewn forms and hierarchical compositions (Cat. 108). He attempted to eradicate regional and class differences by culling models from the art of the nation's collective history. In particular, he praised those artistic epochs which employed arbitrary stylistic conventions and expressive distortions. Thus he preferred the Etruscan to the Roman and the Romanesque to the Renaissance, seeing them as vernacular and hence more genuinely 'popular' styles. His series of articles on Byzantine mosaics and twelfth-century cathedral sculpture reveal that he perceived their formal means as metaphors of political domination and the willing submission of the populace.[35]

The actual style of Sironi's public art, be it the stained-glass *Carta del Lavoro* (*Charter of Labour*, 1931), the mosaic *L'Italia Corporativa* (*Corporate Italy*, 1936; Fig. 7) or the fresco *Le Opere e i giorni* (*Days and Labours*, 1933), was neither outright expressionism nor classical restoration, but an amalgamation of the sources he so admired: the intense gazes of the figures in Byzantine mosaics, the floating spaces of Pompeian wall painting and the block-like, rigid sculptures of Romanesque portals. Sironi's allegorical depictions of Italy or Justice, his heroic peasants or factory workers, hover in an undefined space, removed from time and place. Their surfaces are densely worked, abraded and worn, like archaeological finds, as if to endow the Fascist myths with the weight of history and the authority of time.

For Sironi, the expression of the Fascist *stato d'animo* was nothing less than the visual embodiment of the Nietzschean will to power – the struggle for self-realization transferred to a national and collective level. And how better to express this will to power than by an analogical will to form – an art of constant tension between being and becoming, chaos and order? The repressed energy of his earlier Magic Realist manner resolved itself in monumental forms and loose gestural brushwork, the contrast between dense plasticity and dissolving atmosphere creating a new tension between the figure and ground (Cat. 109).

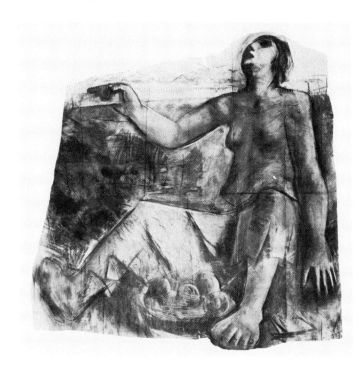

Fig. 8 Mario Sironi, *Ceres*, 1934.
Private collection, Rome

Sironi contributed to the prestige of mural painting and to the polemic that surrounded it during the Fascist period. In 1933, he served as the artistic director of the fifth Triennale in Milan, and commissioned some thirty artists (including de Chirico, Carrà, Severini and Campigli) to decorate the walls of Giovanni Muzio's recently completed Palazzo d'Arte. The event stimulated one of the most bitter debates on Fascist art in the history of the regime and, in the course of the controversy, the murals were destroyed. For the younger generation, coming of age in the second decade of Fascism, Sironi's over-sized, mythic figures represented all that was stale and obtuse in the revival of past styles. Supporters of the modern movement in architecture decried the entire enterprise as an anachronism. Far more vicious criticisms came from Farinacci, who had earlier led an attack on Sironi and the *Novecento* in the pages of his newspaper, *Il Regime Fascista*.[36] Sironi's bulky, distorted figures were the object of sarcastic commentary – his detractors dubbed him 'the painter of big feet' – and he was accused of creating 'Jewish art' during the anti-modernist, anti-semitic campaign which began in 1938.[37]

The failure of Sironi's attempt to forge a widely accepted 'Fascist style' was due less to a lack of consensus on aesthetic matters than to changes in Fascist cultural policy as a whole. Mussolini continued to tolerate a variety of styles, even those that were implicitly critical of an increasingly repressive regime, yet painting and sculpture had revealed their limited effectiveness, and their stature diminished within the party's list of propaganda priorities. By 1934, the general idea of the intellectuals' cultural interventionism had been replaced by the pragmatic reality of the Ministry of Popular Culture. The ability of the fine arts to promote consensus and sway the public paled in comparison to the efficacy of the mass media. 'Minculpop' extended its propaganda through print, radio and cinema, while evolving a kind of mass, lowbrow culture based on standardized forms of leisure and diversion rather than intellectual involvement.[38]

In the end, Sironi's public art failed as a means of indoctrination or cultural persuasion. Neither pointedly didactic nor poetically evocative, and lacking the expressive spontaneity found in his informal studies (Fig. 8), the large-scale murals and mosaics are marked by a sense of dislocation and lack of immediacy. They demand a meditative reading and a cultural preparation which are incompatible with the aggressiveness needed for the manipulation of crowd psychology. Sironi's erudite concept of a national, popular style was self-contradictory: his murals are enveloped in an aesthetic aura which is rooted in that very taste for the rare, the highly individualistic and the cultivated which he wished to supersede.

36 On the polemic between Sironi and Farinacci, see Bossaglia, *Il 'Novecento Italiano'*, pp. 42-53.

37 See G. Bottai, *Diario 1935-44*, ed. G. B. Guerri, Milan, 1982, p. 140.

38 V. De Grazia, *The Culture of Consent*, New York, 1981.

Pia Vivarelli

Personalities and Styles in Figurative Art of the Thirties

Despite the policies of centralization and nationalism pursued by the Fascist state, the social and cultural importance of the 'local', so intrinsic to Italian history, continued to manifest itself throughout the thirties. *Sei di Torino* (The Turin Six), *Italiani di Parigi* (The Italians of Paris) and *Scuola di via Cavour* (School of Via Cavour) were the most prominent developments in Italian figurative painting around 1930. Consciously avoiding the use of 'isms', the new artistic groups were defined by their geographical or regional identity. These definitions also illustrated a general refusal, on the part of critics as well as the artists themselves, to refer to any overriding aesthetic, which might have been interpreted as a uniform, ideological programme.

Even if 'high' culture had its official channels of information and was diffused on a national and international scale, it is also true that day-to-day artistic production, the activity of critics and the press, and the exhibitions and acquisitions of civic collections, maintained a regional orientation, either reflecting the stylistic heritage of local nineteenth-century schools or simply diverse economic and intellectual realities. It was only in 1932, in the second decade of Fascism, that the Venice Biennale finally eliminated regional divisions as the organizing principle of the Italian installations. Nonetheless, ingrained habits persisted, and throughout the following decade magazine and newspaper reviews of the most important national exhibitions proceeded with an analysis of stylistically homogeneous local groups.

The underlying cultural bureaucracy of the regime – beginning with the Sindicati Fascisti Professionisti e Artisti (Fascist Syndicates of Professionals and Artists) – also favoured local interests and inclinations. The regime was less concerned with the formation of a national Fascist art as a means of overcoming the provincialism and backwardness of regional modes of expression, than with the elaboration of a centralized administration that would guarantee the consensus of artists. While proclaiming the ideal of national unity, Fascism was really interested in instigating a vast and omnipresent network of state-supervised syndicates which would promote and control art exhibitions and appropriate or even eliminate previous organizations or free association among artists.

The intervention of the state and the considerable propaganda efforts and financial support devoted to the syndicates left other autonomous groups, such as the *Novecento* or Second Futurism, little room to manoeuvre or promote their own programmes.[1] On the other hand, these movements met with increasingly less success from their own ranks, as intellectuals tended to distrust or explicitly refute aesthetic manifestations bearing any ideological connotations. Despite variations in style, developments from the *Valori Plastici* movement throughout the 1920s demonstrated the progressive affirmation of the ideal of art as a separate and specialized field, and one that deserved recognition of its particular *métier*. On the whole, Fascism seemed to offer such a professional status, through both the establishment of the syndicates and, on the level of economic assistance, a broad programme of official awards, acquisitions and public commissions.

In return, artists were expected to illustrate the Fascist party line, or interpret the rhetoric of spiritual pre-eminence or the regime's historical legitimacy. Towards these ends, the Biennale instituted subject competitions as early as 1930, well before the notorious 'Premio Cremona', which was the ultimate and most vulgar example of a celebratory style of painting that developed throughout the decade. At the same time, however, the regime recognized a degree of 'technical competence', allowing

Fig. 1 Gigi Chessa, *Figure*, c. 1930. Galleria d'Arte Moderna, Palazzo Pitti, Florence

artists to follow their independent stylistic choices; needless to say, the presence of such visual diversity within official exhibitions and commissions created an often extremely confused situation on the level of critical response and evaluation.

If a specific Fascist style never existed, there was, nonetheless, a common attitude – more political and ideological than truly aesthetic in nature – related to the broad concept of *Italianità* in art. This more or less explicit emphasis on indigenous traditions or intrinsic Italian qualities prevailed in official circles, from the ever-accommodating secretary of the artists' syndicates, Cipriano Efisio Oppo, to the intransigent and coarse party minister, Roberto Farinacci.[2] It became the dominant criterion for the validity of works of art, often forcing them to fit into one historical line or another of national derivation. Any expression of modernity untempered by due reference to tradition (be it a revival of technique, style or iconography), any deformations or conceptual reworkings of objective reality, were interpreted, respectively, as grotesque or cerebral and attributed to negative foreign influences, such as Expressionism and Surrealism, those 'isms . . . that recall Berlin or Paris, also by way of Israel'.[3] Even here, however, the accusations of xenophilia or, conversely, impassioned defences of new developments belonged to the tactics and specialized field of the critics. The cultural agenda of the state even managed to absorb those tendencies which today seem somewhat dissonant, and which were certainly based on expressions of dissent, but were never organized into a coherent 'opposition'.

The meaning and import of new developments in Turin, Paris and Rome must be considered within this general context of figurative art during the thirties and should be analysed, not as examples of concrete 'movements', but as the result of regional affinities and linguistic correspondences, in the sense of local dialects of visual expression. The association of the Turin artists, for example, was based on discernible geographical characteristics and a cultural heritage distinct from other areas. During the twenties, the intellectual life of this city was dominated by the political activism of Antonio Gramsci and Piero Gobetti (whose *Rivoluzione Liberale* was one of the first anti-Fascist journals) and, in cultural activities, by the critic and art historian Lionello Venturi and the enlightened patronage of the industrialist and collector Riccardo Gualino. It was within this markedly liberal climate that Carlo Levi, Francesco Menzio, Gigi Chessa, Enrico Paulucci, Nicola Galante and Jessie Boswell began to exhibit together as the *Sei di Torino*. They addressed the problem of modernity in art through a deliberate reflection on European modernism, in particular the twentieth-century variants of Post-Impressionism from André Derain, Albert Marquet, Henri Matisse and Raoul Dufy to Jules Pascin, Marie Laurencin and Amedeo Modigliani, who was previously little recognized in his native country.

In their only collective declaration, the Turin Six stated: 'If there is a harmful tendency today, it is precisely an excessive "contemporaneity", an excess of the contingent and the practical, which are detrimental to art. . . . Events are too alive and current to be illustrated or made into poetry, since poetry is serenity and liberation. They are still too close to us; that is why we cannot recreate them as myths.'[4] The lesson of 'taste' and of 'culture', which they gleaned from the School of Paris, allowed for a poetic interpretation of reality and, in the tradition of Crocean Idealism, eliminated all ideological considerations from art to ensure a free and calming spirituality. Their painting developed a rather programmatic devotion to everyday themes – portraits of friends, landscapes and still-lifes – rendered with a refined palette and cultivated style (Fig. 1). Indeed, the *Sei di Torino* rejected any form of painting that illustrated or offered allegorical interpretations of contemporary historical events (what they termed 'exercises of oratory not poetry'); in short, any painting so loaded with reality that it could not be transformed into a lyrical fantasy.[5]

Edoardo Persico, critical champion of the *Sei di Torino*, interpreted their 'concentrated and severe Europeanism' as an inherent moralistic stance.[6] Similarly, Venturi had focused on the 'cosmopolitan' quality of Levi, Menzio and Paulucci in his catalogue essay for their 1930 group exhibition in London.[7] The style of the Turin Six was, in fact, opposed to the 'national prejudice', as Venturi called it, which was

1 The general politico-cultural design set in motion through the syndicates met with competition from groups with national aspirations, such as Filippo Marinetti's Second Futurism and Margherita Sarfatti's *Novecento* group: around 1930, Sarfatti organized a series of exhibitions of Italian art, with nationalistic overtones, in other parts of Europe, including Scandinavia, and in South America.

2 Cipriano Efisio Oppo, painter and critic, was national secretary of the artists' syndicates until 1932. He was also secretary general of the 'Quadriennale Nazionale di Roma' for the entire decade and, beginning in 1936, was vice-commissioner of 'EUR '42' ('Esposizione Universale Roma'). Roberto Farinacci, secretary general of the Partito Nazionale Fascista 1925-6 and member of the Gran Consiglio del Fascismo (Fascist Grand Council) from 1934, supported the most reactionary currents in art in the pages of his newspaper, *Il Regime Fascista* (1926-33), and later in the 'Premio Cremona' exhibition instituted in 1939.

3 C. E. Oppo, 'Mafai e Scipione alla Galleria di Roma', *La Tribuna*, 13 November 1930.

4 I Sei Pittori di Torino (Levi, Menzio, Chessa, Paulucci, Galante, Boswell), 'Il quadro storico', *Le Arti Plastiche*, 15 December 1929. For information on the Turin Six, see A. Bovero, *Archivi dei Sei Pittori di Torino*, Rome, 1965; a lucid analysis of the significance of the experience of this group can be found in G. C. Argan, 'I Sei di Torino', in *I Sei di Torino 1929-1932*, Turin, 1965.

5 I Sei Pittori di Torino, 'Il quadro storico'.

6 E. Persico, 'I Sei Pittori di Torino', *L'Ambrosiano*, 1931, reprinted in A. Bovero, *Archivi*, pp. 216-17.

7 L. Venturi, *Exhibition of New Italian Painting by Carlo Levi, Francesco Menzio, Enrico Paulucci*, London, 1930.

Fig. 2 Gino Severini, *Still-Life with Pumpkin and Mask*, c. 1930. Galleria d'Arte Moderna, Palazzo Pitti, Florence

Fig. 3 Antonietta Raphaël, *Portrait of a Young Woman*, 1928. Galleria Nazionale d'Arte Moderna, Rome

then dominant in Italian culture. Yet it was just this poetic lyricism which caused many critics, even the most perceptive, to misunderstand or simply pass over the group's subtle protest against cultural autarchy, implicit in the strategy of 'elective affinities' with European traditions.[8]

In contrast to the internationalism of Venturi and Persico, the French critic Waldemar George encouraged a specific revival of the 'Latin' roots of Italian art, in opposition to the 'Nordic' spirit that had contaminated French culture from the nineteenth century to Surrealism – a perspective that coincided with the myth of *romanità* promulgated by the Fascist regime. On the occasion of the 1930 Venice Biennale, George presented the work of a group of Italian painters residing in Paris, among them Massimo Campigli, Filippo de Pisis, Alberto Savinio, Gino Severini and Mario Tozzi, under the heading *Appels d'Italie*.[9] On close examination, however, their works did not always correspond with the programmatic declarations made by George. In general, the *Italiani di Parigi* demonstrated an overriding interest in the antique and the culture of the museum, marked by the influence of the evocative qualities and compositional devices of Metaphysical painting. Although the recourse to classicism was not used in a historicizing or celebratory way, the pervasive Idealism of works by Severini, Tozzi and Campigli exalted the Mediterranean spirit as a deep repository of pure formal values and technical mastery (Fig. 2). In the case of de Pisis, historical citation and paraphrase were mediated by personal memory and translated into objects of affection. An image by Goya or El Greco, for example, appears like a 'painting within a painting' among the intimate objects of his still-lifes. De Pisis sought mysterious aspects hidden in the folds of the past and lyrical moments concealed amidst the banalities of everyday existence, representing them like a fragmentary *mise-en-scène* of an unstable and fleeting reality, captured by the unifying texture of his brushwork and his deliberate cultivation of '*la bonne peinture*' (Cat. 84, 86).

It was above all Giorgio de Chirico and Savinio who interpreted the relationship between history and modernity as an interrogative tension or critical confrontation. Around 1930, de Chirico reaffirmed his unbridled freedom of art historical reference, alternating pastiches of the female nude in the style of Auguste Renoir with a new inventory of images related to his graphic work and stage design that ultimately evolved into the series *Bagni misteriosi* (*Mysterious Baths*; Fig. 7, p. 76). For the first time, de Chirico brought a candid amusement to his previously anguished commentary on the absolute irrationality of the world, delighting in the artificiality of existence and in fantastic games of free association. He conducted this play on two levels: an 'elevated' discourse on traditional motifs, such as the nude, and a refinement of the 'sign' through a new stylization of colour (Cat. 73).

Savinio, in turn, enriched the function of collective and individual myths through deliberate contradiction, revealing both their unfeasibility for the contemporary artist and their continued worth as repositories of stable values and certain meaning (Cat. 82). History became the realm of the random and the marvellous, a foil for liberating conventional perceptions of reality, in an approach significantly different from the Surrealists' primacy of the dream. The non-sense of recollection, the disparate connections of memory, became an ironic mirror reflecting the vacuity of contemporary bourgeois values: revered archetypes were irreverently transformed by Savinio into gross personages with the heads of birds and other animals (Cat. 80). The citation of historical models entailed their deliberate inversion, reflecting Savinio's belief that the only forms of intervention left to the modern artist were those of mental reflection, conceptual manipulation and the estrangement of given traditions.

Clearly, the various uses of antiquity, including those which harboured a corrosive contemporary humour, could not be explained by Waldemar George's comprehensive theory of the 'Italianization' of European art. Yet currents in Italian art throughout the decade were continually misunderstood or distorted in critical interpretations that attempted to encompass even the most eccentric positions within the normalizing framework of the regime's propaganda. Antonio Maraini, Secretary

8 For example, Carlo Carrà, the regular critic for the Milanese paper *L'Ambrosiano*, interpreted the invocation of French Post-Impressionism by the Turin Six as a generic summons to a modern renewal of painting ('Sei Pittori di Torino', *L'Ambrosiano*, 22 November 1929). Mario Sironi, writing for the official Fascist daily, *Il Popolo d'Italia*, 1 December 1929, emphasized the specifically pictorial qualities of their proposals, devoid of 'aesthetic fence-sitting and polemical intellectualizing', and viewed their references to French painting as 'a love, made more out of a vocation for the discipline, for the method, than for the suggestions of the results; indeed, it is easy for them, so enamoured of the propriety of pictorial language, to enter upon a scheme that is more our own, more Italian in flavour'.

9 In addition to the artists cited, *Appels d'Italie* included the Italians Renato Paresce and Onofrio Martinelli, as well as Christian Berard, Eugène Berman, Léonid Berman, Philippe Hosiasson, Amédée Ozenfant, Roger de la Fresnaye, Pierre Roy, Léopold Survage and Pavel Tchelitchew. The composition of the group *Italiani di Parigi*, which received critical attention from 1928 to 1933, was heterogeneous and varied according to the exhibitions. The most stylistically cohesive manifestations of the group were those at the Galleria Milano, Milan, January 1930, and the Venice Biennale, 1930 and 1932. They also exhibited on several occasions in Paris. The painter Tozzi was the organizational force behind the association of Italian ex-patriots. For information on the activities of the group, refer to the most recent monographs on the individual artists.

General of the Venice Biennale, readily used George's interpretation as the crux of his own general introduction to the 1930 exhibition:

> In a word, we have returned to the example of our glorious tradition, as a repository of the ideals of Mediterranean classicism, after decades of progressive estrangement in the babel-like confusion of all exoticisms, from the most refined to the most barbaric, and of all primitivisms, from the most authentic to the most artificial. Will tomorrow finally bring a resurgence of Latinity, an aspiration towards sanctity and beauty, to clear, expressive, harmonious meaning, and an immediate correspondence between form and substance . . . ?[10]

Fig. 4 Mario Mafai, *Women Undressing*, 1935. Galleria Communale d'Arte Moderna, Rome (on loan to the Galleria Nazionale d'Arte Moderna, Rome)

The case of Scipione offers perhaps the paradigmatic example of the quandary of official response to styles outside the mainstream. Scipione failed to receive the Premio della Gioventù (Youth Prize) at the 1930 Biennale, despite the fact that one of his most characteristically disquieting images, *Il Cardinale Decano* (*The Cardinal Decano*, 1930; Cat. 144), was one of four canvases that attracted the attention of the jury. While they noted the 'singularity of vision and novelty of his research', they concluded that Scipione could not be 'chosen as an example for young artists to follow until they had matured within a more Italian climate'.[11] Oppo, the cautious mediator of consensus, went even further in a series of critical acrobatics around the art of Scipione, distinguishing between his moments of 'simplicity and sincerity' and others of the 'worst symbolist-caricatural forms'. Playing down the sense of 'deformation, inconclusiveness and inexpressiveness' that could be traced in the artist's work, he managed to interpret it overall as a 'marriage between the real world and the poetic world that marriage that characterizes Italian art in its most successful instances in line with the tradition of good painting, which is to say, with Italian painting'.[12]

From 1928 to 1931, the work of Scipione, Mario Mafai and Antonietta Raphaël developed along a common line of poetic lyricism, based on a broad and original assimilation of international styles, from Expressionism and Metaphysical painting to Surrealism and the Italian Baroque, which was currently undergoing a revaluation by art historians. These artists were influenced by the nihilism of nineteenth-century German philosophers and by numerous literary interests, from the French Symbolists, Italian hermetic poetry and de Chirico's novel *Hebdomeros* to Ariosto, seventeenth-century Spanish literature and the Apocalypse of St John. In addition, Raphaël supplied Mafai and Scipione with a store of fabulous images derived from her knowledge of the School of Paris and from her Jewish-Slavonic heritage.

These three Roman artists shared a variety of stylistic mannerisms: an overall simplification of forms (while accentuating those charged with symbolic allusions), fragmentary compositions and a rapid application of paint with either sombre tones or bright accents of colour (as in the decoratively exuberant canvases of Raphaël; Fig. 3). They gave particular attention to the emblematic value of an image, which was never schematized or immobilized like a traditional symbol, but inserted in a dynamic dialogue with painterly materiality. The critic Roberto Longhi defined it as 'eccentric and anarchic art' in a review of 1929, where he also dubbed them the School of Via Cavour, after the address of Mafai's studio. Longhi emphasized that they were an anomaly within the contemporary Roman scene, noting the Expressionist elements, the 'explosive' character of colour and the effects of 'hallucination, intrigue, and magic'.[13] The sort of formal and psychic agitation remarked upon in their work was lucidly defended by Mafai as a necessity of contemporary art to communicate 'strongly', so strongly that it would, on the one hand, overcome public indifference in an age dominated by a materialism which threatened to eliminate the real function of culture and, on the other, ameliorate the fate of the artist, destined to be isolated from the world but also a proud custodian of unappreciated genius.[14] This dialectic between existential solitude and the need for communication was resolved by Mafai through essentially lyrical means, whereby the abandonment to fantasy was seen as a liberating force after a period in which the avant-garde had concerned itself with logic and reason (Fig. 4).

The dramatic images of Scipione were explicitly spiritualistic in content, but even his most hallucinatory scenes preserved a quality of physical presence (Cat. 143). By

10 Antonio Maraini, 'Sala 3 – (Salone Centrale)', in *XVII Esposizione Internazionale d'Arte di Venezia*, Venice, 1930, p. 30.

11 Ibid., p. 21.

12 C. E. Oppo, 'Mafai e Scipione'.

13 Roberto Longhi, 'Clima e opere degli irrealisti', *L'Italia Letteraria*, 14 April 1929. In this review Longhi specifically defined the confraternity of Scipione, Mafai and Raphaël as the '*Scuola di via Cavour*'. Venturi confirmed the estrangement of Scipione from the general artistic climate of the time, saying that he had a 'temperament recalcitrant to any accommodation of bourgeois taste; certain of his thrusts and recourses to the fantastic demonstrate the nausea he felt for the torpor of the usual painting' (in 'Venezia XVII', *Belvedere*, May-June 1930). For the relationship between the *Scuola Romana* and the Italian figurative tradition of the time, see E. Braun, 'Sul Novecento e sulla Scuola Romana', in *Scuola romana: Artisti tra le due guerre*, Milan, 1988, pp. 209-14.

14 See Mafai's diary entries dated 5 and 6 October 1928, in Mario Mafai, *Diario 1926-1965*, introduction by G. Appella, Rome, 1984, pp. 40-2.

15 Scipione, 'Il Greco', *Primato*, 1 December 1941 (posthumously published manuscript).

16 Renato Birolli, 'Città come riferimento a un'esperienza', *Corrente*, 15 May 1940.

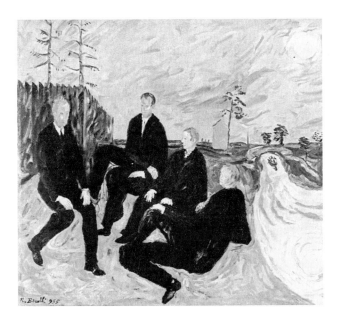

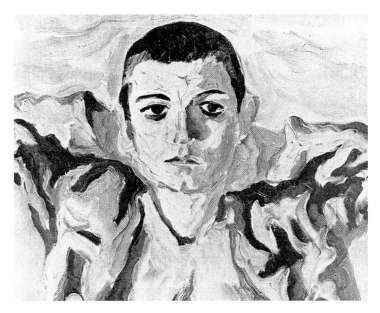

Fig. 5 Renato Birolli, *The Poets*, 1935. Birolli
Collection, Milan

Fig. 6 Carlo Levi, *Boy from Lucania*, 1935.
Fondazione Carlo Levi, Rome

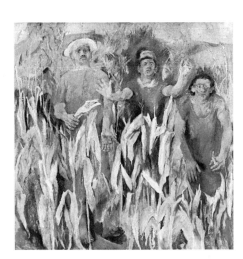

Fig. 7 Fausto Pirandello, *Drought*, 1938. Galleria
Nazionale d'Arte Moderna, Rome

and large he rejected other avenues then being pursued by the Surrealists or, earlier, by the Expressionists; his work had a relationship with phenomenal reality that was never negated to make room for a purely oneiric vision or for an overwhelming subjectivity. The distortion of forms was not intended as a mirror of the creator's psychic malaise, but stemmed from a vitalism inherent in the subjects themselves, be it the charged sexuality of prostitutes or the intimate sensuality of still-life objects. More often, such vitality was revealed in a kind of moral commentary, whether in the depiction of decadent human flesh and urban landscapes dissipating into forms of emblazened magma or in a euphoric murmur that imbued everyday reality with a prophetic message. Scipione intended his art as a process of spiritual revelation, through the rendering of base matter in constant physical tension between dissolution and becoming, contemplation and salvation. To this end he looked to the example of El Greco, whose phantasmic figures and nightmarish visions specifically evoked that 'terrible, tactile reality'.[15]

In addition to Mafai and Scipione, other individual artists expressed a disquieting existential condition, either through feverish accumulation of brushstrokes, as in the surfaces of Renato Birolli (Fig. 5), Aligi Sassu or Levi (earlier of the Turin Six; Fig. 6), or, conversely, by a slow sedimentation of colours in multiple dense layers of paint, which seemed to absorb forms to the point of decomposition, as seen in the work of Fausto Pirandello (Fig. 7).

Only at the end of the decade, however, did these elements of discontent and pictorial tension evolve into a more defined aesthetic, one connected with a new perception of the ethical commitment of intellectual activity. 'Expression must always coincide with reasons for being, must always be subject to the cadence of the present time, be transformed into moral conscience', Birolli stated in 1940.[16] The novelty both of the debate that was conducted between 1938 and 1943 in the editorials of the Milanese journal *Corrente* and of the exhibitions of the artists associated with the group surrounding it, lay not so much in the cultural alliance with European figurative painting (which now included the Picasso of the 1930s as well as Munch and Van Gogh), but in the need to express the artist's more deeply felt immanence of the real world. The artists of *Corrente* rejected the evasiveness of both pure formalism and mere naturalistic representation. In their place they demanded Realism, a term that applied to both abstract and figurative art in the immediate post-war period. In the years around 1940, however, and as it appeared frequently in the pages of *Corrente*, Realism was intended as a free and unmediated examination of reality and its 'dramatic' substance. This impassioned and direct relationship between the artist and the world was translated into an incisive and, at times, violent Expressionism. Painting was increasingly expected to fulfil a public, communicative

function, to prompt and stimulate, like a 'wrenching scream, a manifestation of rage, of love, or of justice on the corners of the street and in the angles of the city squares, rather than in the sad atmosphere of the museum, where a few specialists go once in a while to find it', as Renato Guttuso wrote in 1943.[17] Furthermore, the idea of Realism went beyond a subjective and vitalistically charged appropriation of the represented object; the artist could also be disposed towards a more detached commentary on the external world, expressed through a 'new grand narrative discourse'.[18] This tendency was articulated most clearly after the war, but it was already manifested in the reinterpretation of Picasso's visual manifestos and in the epic tension of Guttuso's *Fuga dall'Etna* (*Flight from Etna*, 1940; Cat. 147), and *Crocifissione* (*Crucifixion*, 1941; Cat. 148).

The novelty of *Corrente* as a cultural phenomenon also derived from its breadth, its ability to unify previously disparate elements; for the first time, artists consciously refuted regional attitudes in favour of a continual exchange of experience between painters, critics, philosophers and scholars from various backgrounds. Individuals of anti-Fascist leanings matured within the *Corrente* environment and their discontent later intensified during the war years, with many of them participating in the Resistance.

Yet the increasingly defined ideology of *Corrente* ran parallel to, and often intersected, the cultural initiatives of the regime developed under the auspices of Giuseppe Bottai in his capacity as Minister of National Education. Bottai understood the limitations of the syndicate system, above all the lowering of standards owing to the excessive number of participants in official exhibitions. Continuing to favour state directives, he wanted to modernize the bureaucratic structures and increase the specialization of cultural agencies.[19] But above all, Bottai's political design was based on the extensive involvement of the Italian intellectual class. He founded the cultural review *Primato* (1940-3) as an open forum for discussion of previously unaddressed issues or new artistic phenomena.[20] In its pages an often violently divisive debate unfolded over the desirable degree of cultural autonomy or cultural intervention; with the outbreak of the war, this central problem of the intellectual's social commitment acquired critical urgency.

After publication of *Corrente* was suppressed by the censor in July 1940, many of the writers and artists affiliated with the journal continued to contribute to *Primato*. Indeed, the complex and often contradictory relationship between official culture and the most advanced tendencies of artistic research was exemplified by the participation of many of the *Corrente* artists in the 'Premio Bergamo', the open exhibition which Bottai supported in opposition to Farinacci's 'Premio Cremona'. It was this institution that explicitly refuted the celebratory rhetoric of the Cremona pictures, not only by its open disregard for stipulated subject-matter, but also in its awarding prizes to works of a highly problematic or critical content, such as Guttuso's *Crucifixion*.[21]

17 Letter from Guttuso to Ennio Morlotti, dated 1943, published in T. Sauvage, *Pittura italiana del dopoguerra*, Milan, 1957, pp. 219-20.

18 Signed editorial, 'Continuità', *Corrente*, 15 December 1939. *Corrente* consisted of a loosely knit group of writers and artists, among them Birolli, Arnaldo Badodi, Bruno Cassinari, Sandro Cherchi, Giuseppe Migneco, Aligi Sassu and Italo Valenti. Lucio Fontana, Giacomo Manzù and Guttuso also participated in its various exhibitions and activities. It evolved from the Fascist youth journal, *Vita Giovanile*, founded in Milan in January 1938. Originally aimed at cultural revisionism through official channels, the bi-monthly publication soon developed an openly critical stance. In October 1938, it was retitled *Corrente di Vita Giovanile*, removing the symbols of the *fasci* and Mussolini's motto from its masthead, and, from February 1939, it was simply entitled *Corrente*. For the most recent studies on the movement, see *Corrente: Il movimento di arte e cultura di opposizione 1930-1945*, Milan, 1985.

19 Within the Ministry of National Education, Bottai organized an Office for Contemporary Art and created the Central Institute of Restoration, where qualified people could work in a specialized field. He also expanded the supporting initiatives of the state to other agents in the art world, such as private galleries and collectors, by sponsoring exhibitions and awards. He sought out channels for diffusing contemporary art beyond the exhibitions organized by the artists' syndicates, and he favoured the establishment of Centres of Action for the Arts in various cities throughout Italy. To ensure patronage of decorative works for public buildings, he instituted the so-called 'two per cent [for art] law'.

20 For an analysis of the magazine and of Bottai's role in the culture of the period, see L. Mangoni, *L'interventismo della cultura: Intellettuali e riviste del fascismo*, Bari, 1974; '*Primato*' *1940-1943: Antologia*, ed. L. Mangoni, Bari, 1977.

21 Mafai and Birolli were among the *Corrente* artists who received awards from the 'Premio Bergamo'. In 1940, the third prize was given to Guttuso for *The Flight from Etna* and, in 1942, he received the Second Prize for *Crucifixion*.

Luciano Caramel

Abstract Art in Italy in the Thirties

The first examples of abstract art in Italy appeared around 1910 and were connected with the chromatic and optical experiments of Symbolism and Divisionism. Some works by Romolo Romani, possibly dating from as early as 1907-8, used pulsating forms and colours to evoke the frequencies of sound waves. Another pioneering artist was Arnaldo Ginna, who, with his brother Bruno Corra, published *Arte dell'avenire* (*The Art of the Future*) in 1910 and advocated a non-figurative art based on correspondences with music and psychological states. Giacomo Balla began to produce his *Compenetrazioni iridescenti* (*Iridescent Compenetrations*; Cat. 8, 9) in 1912; he continued with the series *Velocità astratta* (*Abstract Speed*; Cat. 11, 12) and with the *Complessi plastici* (*Plastic Complexes*; Fig. 3, p. 167), which he made with Fortunato Depero and published in the manifesto *Ricostruzione Futurista dell'Universo* (*Futurist Reconstruction of the Universe*) in 1915. Enrico Prampolini also created abstract works within the Futurist circle, while Alberto Magnelli produced his *Composizioni* (*Compositions*) in 1915, in response to the work of Henri Matisse and other developments in Paris.[1]

Immediately following the war, between 1918 and 1920, the philosopher Julius Evola, who had earlier been influenced by Futurism, painted his series of 'mystical' abstractions, which included Constructivist elements and esoteric symbolism.[2] By the early twenties, reproductions of works and texts by Piet Mondrian, Theo Van Doesburg and Georges Vantongerloo were appearing in the Italian Dada journals *Bleu* and *Noi*. A new phase of abstract art was inaugurated in the 1920s by Balla and Prampolini; it was part of the general climate of the 'return to order' in Italy, even though the two artists maintained an avant-garde stance and an open dialogue with Constructivism, Neo-Plasticism and the Bauhaus. Prampolini was in direct contact with these movements, while Balla followed a more personal and idiosyncratic style which influenced the artists of Second Futurism throughout the decade.[3]

The true period of Italian abstraction, however, began in the late 1930s, in a context that bore no resemblance to that which had surrounded the efforts of the pioneers. The climate had also changed dramatically outside Italy. Gone were the social and artistic conditions that had prompted the radicalism of the avant-garde in the first third of the century, be it the utopias based on spiritual-philosophical premises (Mondrian, Wassily Kandinsky, Kasimir Malevich) or those founded on an industrial-technological model (Vladimir Tatlin, Walter Gropius). With no pressures to reject the past and construct the new, the 'post'-avant-garde freely availed itself of a variety of internationally practised styles.

The foundation of the Parisian *Cercle et Carré* in 1930 (organized for the most part by Michel Seuphor) reflected this changed situation. The group's journal contrasted sharply with the anachronistic rigour of Van Doesburg's single issue of *Art Concret*, published in the same year. Some eighty artists gathered under the mantle of *Cercle et Carré*, but only some of them worked in a truly abstract style; others painted or sculpted in a post-Cubist or Surrealist manner, the latter combining biomorphic abstraction with figurative elements. This all-inclusive approach also characterized the movement *Abstraction-Création* (1932-6), which continued to exist after the dissolution of *Cercle et Carré*. It united heterogeneous styles under the general label of 'non-figurative art', a term which, along with the catchwords 'abstraction' and 'creation', indicated the underlying ambiguity of the movement.

That many Italian artists joined *Abstraction-Création* is significant, for it reveals the degree of freedom permitted by the contradictory cultural policy of the Fascist

1 See R. Barilla, S. Evangelisti and B. Passamani, *Romolo Romani*, Milan, 1982; M. Scaligero and G. Sprovieri, *Arnoldo Ginna: Un pioniere dell'astrattismo*, Rome, 1961; G. Lista, *Balla* (with an English text), Modena, 1982; E. Crispolti, *Ricostruzione futurista dell'universo*, Turin, 1980; F. Menna, *Enrico Prampolini*, Rome, 1967; A. Maisonnier, *Magnelli: L'Œuvre peint*, Paris, 1975.
2 E. Crispolti, 'Giulio Evola', *Notiziario*, 1963.
3 On Second Futurism and abstraction, see Crispolti, *Ricostruzione*, pp. 162-5, 284-7, 612, and the essay by the same author in this catalogue.

regime. Artistic autonomy was, in fact, encouraged both in theory and in practice. Foreign art journals and books (especially those published by the Bauhaus) circulated freely, while many of the abstract artists – among them, Osvaldo Licini, Mauro Reggiani and Luigi Veronesi – travelled frequently outside Italy and were in close contact with other European artists.[4] More to the point, everyone could see the work of Josef Albers, Fernand Léger, Willy Baumeister, Cesare Domela, Jean Arp and Sophie Tauber-Arp at the Galleria del Milione in Milan.[5]

The Galleria del Milione was the focal point for the development of abstract art in Italy during the thirties. The gallery and bookshop was opened in 1930 by the painter Gino Ghiringhelli and his brother Peppino in a building across from the Pinacoteca di Brera (Fig. 1). In November 1934, it held the first exhibition of Italian abstract art, with works by Oreste Bogliardi, Ghiringhelli and Reggiani. On this occasion, the gallery published the 'Dichiarazione degli espositori' ('Declaration of the Exhibitors'), which came to be known as the 'manifesto' of Italian abstraction. In December of that year, it mounted an exhibition of works by Veronesi and Albers, while in 1935 one-man shows were devoted to Lucio Fontana, Atanasio Soldati, Fausto Melotti and Licini. Meanwhile, Felice Casorati and Enrico Paulucci were exhibiting the works of the leading Italian abstractionists in their studio in Turin.[6] The year 1935 was the crucial one for Italian non-figurative art: at the second Quadriennale in Rome, Bogliardi, Ghiringhelli, Reggiani, Licini, Soldati, De Amicis and Magnelli (who was living in Paris) exhibited together for the first time as a 'group'.

Absent from the Quadriennale, however, were a number of artists working in the city of Como, just north of Milan: Mario Radice, Manlio Rho and Carla Badiali, who were later joined by Aldo Galli, and Carla Prini and Cordelia Cattaneo, the wife and sister, respectively, of the architects Alberto Sartoris and Cesare Cattaneo. The Como group took part in the activities of the Galleria del Milione, but derived its distinctive profile from a rapport with contemporary Rationalist architecture. The artists in Como were in direct contact with the leading figures of the Rationalist movement, including Giuseppe Terragni, Pietro Lingeri, Sartoris and Cattaneo. Terragni provided the initial inspiration, leading the artists to consider extra-pictorial issues of space, structure and materials (Fig. 2).[7] They had the opportunity to apply the results of their investigations to actual projects: Radice and Cattaneo, for example, collaborated on the design of the fountain in the Piazzale di Camerlata in Como, exhibiting the plan at the Milan Triennale in 1936, and worked together again in the early 1940s on prototypes for ecclesiastical buildings.[8] Furthermore, Radice executed the abstract decoration for Terragni's Casa del Fascio (the local Fascist administrative building) in Como (Fig. 3). Apart from their quality, these designs are remarkable for being the only example of a successful meeting of the 'new' painting and architecture: the relationship between Rationalism and abstract art was, at best, precarious and, on the whole, the architects preferred the paintings and decorative projects of the *Novecento* artists.[9]

Nonetheless, the Rationalist architects provided an important formal and theoretical precedent for abstract artists, and not only in Como. *Gruppo 7* was founded in 1926 by the seven architects Gino Figini, Guido Frette, Sebastiano Larco, Adalberto Libera, Gino Pollini, Carlo Enrico Rava and Terragni. In the Bauhaus and other contemporary European developments they saw an alternative to the compromising modernism of the *Novecento* architects. 'The new architecture, the real architecture,' they claimed, 'must develop from a strict adherence to logic and rationality ... sincerity, order, logic and, above all, great lucidity are the true characteristics of the new spirit.'[10]

The importance of the architects' example was also recognized by Carlo Belli, the critical champion of the abstract artists of the Galleria del Milione and their chosen spokesman. He later recalled: 'The architecture of my friends Figini, Pollini and Terragni, who ... created so-called "Rational" architecture in Italy, worked a miracle among the other members of the group. Those forms, those new dimensions, created the need for an equivalent in the fine arts.'[11]

Fig. 1 Pietro Lingeri, Galleria del Milione, Milan, 1930. Views of entrance and bookshop

4 In addition to *Cercle et Carré* and *Abstraction-Création, Cahiers d'Art* was also read by the Italian abstractionists. While in Paris and northern Europe, Licini met Kandinsky, Vantongerloo, Franz Kupka, Auguste Herbin and Christian Zervos. Reggiani and Veronesi were acquainted with, respectively, Jean Arp, Kandinsky, Léger and Max Bill, Robert and Sonya Delaunay, Herbin, Moholy-Nagy and Vantongerloo.

5 The first director of the gallery was Edoardo Persico, a writer and critic from Turin who was aligned with the *Gruppo di Sei* and later, as editor of the magazine Casabella, championed the Rationalist architects in opposition to the *Novecento*. On the Galleria del Milione and its central role in the history of abstract art in Italy, see P. Fossati, *L'immagine sospesa: Pittura e scultura astratta in Italia 1934-1940*, Turin, 1971; C. Belli, M. Cernuschi Ghiringhelli, A. Longatti, N. Ponente and G. Marchiori, *Anni creativi al 'Milione' 1932-1939*, Milan, 1980; E. Pontaggia, *Il Milione e l'Astrattismo 1932-1938*, Milan, 1988.

6 The exhibition included works by Bogliardi, Ghiringhelli, Licini, Melotti, Fontana, Reggiani, Soldati, Veronesi, Ezio D'Errico and Cristoforo De Amicis (who participated only briefly in the abstract movement).

7 On Terragni, see A. F. Marciano, *Giuseppe Terragni: L'Opera completa 1925-1943*, Rome, 1987, and A. Cuomo, *Terragni ultimo*, Naples, 1987.

8 On Cattaneo, see R. Fiocchetto, *Cesare Cattaneo 1912-1943: La seconda generazione del razionalismo*, Rome, 1987. The collaboration between Cattaneo and Radice, especially on the ecclesiastical buildings, is discussed in L. Caramel, ed., *L'arte e l'ideale: La tradizione cristiana nell'opera di Cesare Cattaneo e Mario Radice*, Como, 1988.

9 For information on the Como artists and their relationship with the Rationalist architects, see L. Caramel, *Aspetti del primo astrattismo italiano*, Monza, 1969, pp. 21-8; idem, 'Esperienze d'arte non figurativa a Como negli anni 1933-40', *L'Architettura, cronache e storia*, 15, no. 1, May 1969, pp. 32-4; and M. Di Salvo, *Lo spazio armonico*, Como, 1987.

10 Declaration in the periodical *La Rassegna Italiana*, December 1926-May 1927.

11 C. Belli, 'La musa astratta', *Notizie*, nos. 1-2, 1978, p. 1.

12 Rosmini (1797-1855), founder of the *'rosminiani'* congregation, was a priest, philosopher and theologian whose idea of a harmony between philosophy and religion had widespread influence in Italy.

Fig. 2 Giuseppe Terragni, Casa del Fascio,
Como, 1932-6

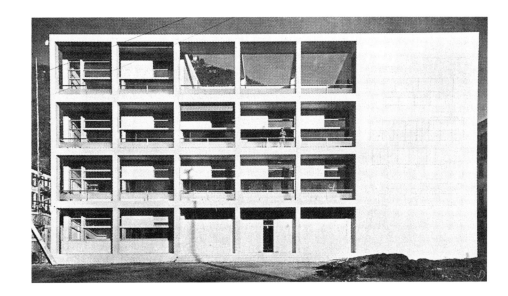

13 C. Belli, *Kn*, Milan, 1935; revised ed., Milan,
1972.

14 *Le nombre d'or* was published in Paris in 1931
with the subtitle *Rites et rythmes pythagoriciens
dans le développement de la civilisation occidentale.*
Ghyka proposed a series of correspondences
between nature and art based on mathematical
formulae, and also argued that the harmony of
classical architecture was based on pythagorean
geometry.

15 O. Bogliardi, G. Ghiringhelli and M. Reggiani,
'Dichiarazione degli espositori', *Il Milione:
Bollettino della Galleria del Milione*, no. 32,
November 1934.

16 F. Melotti, 'Presentazione', *Il Milione: Bolletino
della Galleria del Milione*, no. 40, May 1935.

17 D. Bonardi, 'Una tappa importante della pit-
tura astratta', *La Sera*, 24 November 1934;
reprinted, together with many other texts first
published in *Il Milione*, in Fossati, *L'immagine
sospesa*, pp. 73-5.

Fig. 3 Mario Radice, *Composition*, 1934-6.
Decoration for the Casa del Fascio,
Como

Belli was the author of the treatise *Kn*, which was written in 1930 and published in *Il Milione* (the gallery's monthly bulletin) in 1935. *Kn* has been considered the 'bible' of Italian abstraction, but it is, in fact, a highly personal view and often contradicts the standpoints of certain of the artists. Indeed, Belli and his book are largely responsible for the rather partial interpretations that have coloured the literature on abstract painters and sculptors in Italy in the 1930s. *Kn* is marked by Belli's doc-trinaire stance: he does not demonstrate, he asserts. With an unhesitating radicalism, he delves into the metaphysics of art, his ideas influenced by the Catholic-spiritualist philosophy of Antonio Rosmini.[12] In *Kn* he specifically cites Rosmini (who, like Belli and Melotti, hailed from Rovereto in South Tirol) as a spiritual model: 'Italians must return to Rosmini, to this lucid revealer of God, who knew how to counter the agonizing day-dreams of Kant with the luminous Italian idea of "being", which works against every arbitrary and Romantic fluctuation of the Hegelian "ego".'[13]

Belli's arguments allowed of no compromise with phenomenal reality. For him, art was a completely autonomous reality: 'art is'. Hence the formula 'K' (the basic work of art) to the power of 'n' (its manifestation in various media and styles). Despite Belli's inflexible stance, he was a point of reference for the writings and paintings of the artists around the Galleria del Milione, even though his concepts of modern classicism and Mediterranean values were part of a larger cultural phenome-non. It was not by chance that these artists looked closely at Matila C. Ghyka's *Le nombre d'or* and spoke of order, canons of proportion and equilibrium.[14] The 'Dichiarazione degli espositori' had already stated: 'The real revolutions are the most profound aspirations to order, at whatever cost. They create ideal correspondences at the deepest levels.... Therefore, we believe today in a type of Mediterranean climate made up of order and equilibrium, clear intelligence and serene passion. We are thus favourably disposed to accept the classical.'[15] Similarly, Melotti proclaimed: 'We believe in Greek order. When the last Greek chisel ceased to resound, night settled on the Mediterranean. It was a long night illuminated only by the half-moon (reflected light) of the Renaissance. Now we feel the breeze again on the Mediterra-nean. And we dare to think that it is the dawn of a new era.'[16] In *Kn* Belli, too, affirmed his faith in the 'new classicism' and did not hesitate to suggest that 'the age of Pericles is closest to our precise, pure and crystalline era'.

In his review of the first exhibition of Bogliardi, Ghiringhelli and Reggiani, the critic Dino Bonardi claimed that this 'Mediterranean climate' and 'sympathy for the classical' distinguished their paintings from those of foreign abstract artists. They were characterized by 'an ordered harmony of tonal rhythms, a slight emphasis on content as opposed to form, a peaceful equilibrium which is classical and Mediterra-nean'.[17] Compared with the work of their European counterparts, their abstraction of phenomenal reality revealed, as Belli put it, a 'relentless clarity, a dazzling abso-lute of forms, a geometric spirit which tolerated nothing but purity'. Indeed, as

Fig. 4 Luigi Veronesi, *Composition*, 1938.
Veronesi Collection, Milan

Paolo Fossati has argued, this progressive clarification of form became 'a kind of symbol of the modern – a symbol, it should be stressed, that attempted to preserve that element of the past which persists in the present'.[18] It also often resulted in a kind of reductionism that sacrificed the variety and experimentation characteristic of the avant-garde of the previous generation to neo-Platonic abstraction, to a static and *a priori* purist ideal. The theoretical premise behind this extremism can again be traced to Belli's exaltation of 'absolute immobility', 'absolute purity', 'transcendental immobility' and 'a new order which reflects an all-embracing universality'.

Such ideas, and the art they inspired, were inevitably connected with Fascism. As Belli claimed: 'Fascism is the hallmark of the new age . . . the harmony which made the Greece of Pericles and the Florence of the Medici great must illuminate the age of Fascism with equal intensity.' He also affirmed that Fascism was the 'establishment of morality', a 'form of discipline' that represented 'classicism of the spirit'. These and similar attitudes cannot be attributed to obsequiousness or opportunism, even if they existed throughout the period among artists and critics of various stylistic orientations. People active in the visual arts were drawn into a working relationship with the regime by the practical benefits of exhibitions, prizes and acquisitions, instituted by the cultural bureaucracy in an attempt to guarantee consensus. Nor was it simply a question of superficial collaboration – the situation was far more complicated. Artists both of the *Novecento*, such as Mario Sironi and Arturo Martini, and of opposite aesthetic standpoints – for example, Terragni and the abstract artists – believed, at least initially, that Mussolini would realize their ideal of a new Italy of rationality and order. Even with the abstractionists, therefore, formal order was equated with the political order of Fascism.

It is because of, not in spite of, these ideological equivocations – which, after all, were not exclusive to Italy – that individual artists should not be interpreted according to preconceived theories or in terms of their public relationship with the regime. Rather, the determining factor for all of them was the concrete reality of their art and work, the particular characteristics of which emerge when compared with contemporary European movements as well as with the Italian avant-garde of the previous decade.

The Futurist experience, for example, was particularly relevant for many of the abstract artists of the 1930s, even for those who had never been in direct contact with the movement. Veronesi, for one, continued in the Futurist spirit of open investigation, experimenting with a variety of media – graphics, scenography, photography and cinema, as well as painting – and thereby crossing the boundaries of individual

Fig. 5 Bruno Munari, *Useless Machine*, 1934.
Private collection, Milan

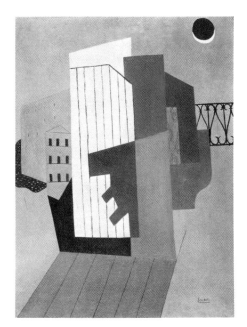

Fig. 6 Atanasio Soldati, *Seascape*, 1933.
Museo Civico d'Arte Contemporanea,
Palazzo Reale, Milan

artistic disciplines (Fig. 4). Fontana, too, demonstrated an unfailing intolerance of pre-existing schemes in that race towards the 'finishing line' which Persico described in 1936 as the very presence of 'life in art', working with the contingent and the relative in a flexible, undogmatic way.[19] In the 1930s, as others retreated into abstract art, Fontana concerned himself with the nature of phenomenal reality in a direct and unsystematic manner, attempting, for example, to reduce volumes to planes even in figurative works (Cat. 120), and employing materials unknown to conventional statuary, such as terracotta, plaster and ceramics (Cat. 123-8).

There were also direct exchanges between Futurism and non-objective art, as witnessed by the work of Prampolini, whose abstract pieces of the 1930s were infused with a dream-like, surrealistic space (Cat. 119). Bruno Munari, who was associated with Second Futurism from 1927, created 'flying' or 'useless' machines, 'abstract' in their use of geometric structures and dynamic equilibrium, and paintings which were conceived of as fields for various aggregations of form (Fig. 5).

These points of contact must be seen in relation to the influence of Metaphysical painting, which was fundamental to all movements between the wars, from the *Novecento* to Second Futurism. Among the abstractionists, Soldati, for instance, infused the compositional grids of late Synthetic Cubism with a sense of metaphysical suspension (Fig. 6), and similar inflections were apparent in the work of Bogliardi, Galli, Badiali and Melotti (Cat. 133, 135).

The extent of the exchanges between abstract artists varies from individual to individual and cannot be subsumed in a general scheme. A survey of influences should begin with an analysis of the concept of pure abstraction itself, of the relationship of the Italian movement to international Constructivism and Neo-Plasticism. Although such rigorous styles of abstraction were widespread in Europe, in Italy they put in an appearance for only a brief period around 1935. Pure geometric compositions were notably absent from the work of many artists, who preferred an unrestricted and liberal use of colours and volumes, emphasizing free invention as opposed to preconceived rational schemes.

Melotti, like Fontana, worked towards abstraction while retaining figurative references and made use of his own interpretation of Metaphysical art. His works from the period of his association with the abstractionists of *Il Milione* show his particular method of constructing forms – a combination of rigorous precision (he was trained as an engineer) and rarified poetry. As he wrote in the catalogue of his exhibition at the Galleria del Milione in 1935: 'Art is the angelic, geometric spirit. It addresses the intellect, not the senses. For this reason, brushwork in painting and modelling in sculpture are of no importance. . . . It is modulation, not modelling, that counts.' In Melotti's works, simple structural elements thus seem to 'modulate' space; but they also suggest an absolutely controlled emotional release and evoke the sensation of music (Fig. 7). It is this musical quality – and Melotti was, in fact, a musician – that raises his art, like that of Fontana, above mere order for order's sake. Order is not predetermined, but is the natural outcome of seizing the moment and the material as concrete realities.

Guided by similar notions, Licini could state in 1935: 'Painting is the art of colours and forms freely conceived . . . an irrational art in which fantasy and imagination – that is to say, poetry – predominate' (Fig. 8) – so much so in Licini's case, that he attempted to demonstrate that geometry could become sentiment (Cat. 131-2).[20] His pictorial universe was a strange space of presence and absence, marked by a constant tension between the elusive and the explicit, the dynamic and the restrained. He captured that precarious, magical balance of centrifugal and centripetal forces and, significantly, gave his works such titles as *Bilico* (*Balance*) and *Ritmo* (*Rhythm*). These abstract paintings represent a progressive purification of his figurative works from the 1910s and 1920s, which had already been permeated by a nervous handling that tended to stretch the image to the point of dissolution. Even in his most cerebral compositions – dating, like the *Archipitture*, from around 1935 – Licini's abstractions were always lyrical, never static. Like the works of Giorgio Morandi, who influenced him, Licini's paintings are characterized by pictorial har-

18 P. Fossati, 'I confratelli astratti degli anni 30',
 Quindici, 13, 1968, p. 28.
19 E. Persico, *Tutte le opere (1923-1935)*, ed.
 G. Veronesi, Milan, 1964, p. 191.
20 O. Licini, 'Lettere aperta al Milione', *Il
 Milione: Bolletino della Galleria del Milione*,
 no. 39, April-May 1935.

monies ordered by the mind, but nonetheless nurtured and enlivened by sentiment. For Licini, reason could not be separated from fantasy or emotion, nor the heart from the mind.

The work of Fontana, Licini and Melotti shows that the various developments during the thirties cannot be reduced to a common denominator, for these artists' individual concerns converged in 1935 only to disperse again later in the decade, their individuality emerging fully in the post-war period. In the years after 1938, the situation became even more complicated as the politics and ideology of Fascism became increasingly restrictive. In this changed climate, artists of varying tendencies and dispositions, including abstractionists, found a point of common ground in the journal *Valori Primordiali*, founded by the philosopher Franco Ciliberti.[21] The first issue was published in Como in February 1938 and included writings by the literary figures Massimo Bontempelli and Salvatore Quasimodo, the collector Riccardo Gualino, the artists Carlo Carrà, Anton Giulio Bragaglia and Prampolini, and the architect Ernesto Rogers, to name but a few. Such breadth and variety was also reflected in the choice of illustrations – the architecture of the Rationalists alongside paintings by Giorgio de Chirico and Morandi, works both by *Novecento* artists and members of the Galleria del Milione circle, the sculpture of Arturo Martini together with pieces by Fontana.[22] The pluralism of *Valori Primordiali* ought not to be compared to that of the late forties and early fifties, which saw the formation of such groups as *Forma* in Rome and *M.A.C.* (*Movimento Arte Concreta*) in Milan. Although their members did not entirely neglect the abstract work of the thirties, the art of the post-war period evolved in a completely different national and international context.

21 Ciliberti (1906-46), philosopher and theologian, received his diploma in 1929 with a thesis on the history of religion. In 1936 in Milan, he founded the *Primordialismo* movement, which included architects, painters, sculptors, poets and musicians.

22 This issue of *Valori Primordiali*, no. 1, February 1938, reproduced works by Sartoris, Lingeri, Terragni, Figini, Pollini, Cattaneo, Carrà, de Chirico, Morandi, Guido Marussig, Achille Funi, Massimo Campigli, Ottone Rosai, Renato Birolli, Ghiringhelli, Licini, Reggiani, Soldati, Radice, Rho, Martini, Marino Marini and Fontana. The introduction stated: 'The aim of *Valori Primordiali* is to present a current vision of Italian spirituality. Convinced of the leading role of Italy, in all its manifestations, we seek in the art and thought of our generation, which includes tradition, the well-spring of all that is truly civilized in the modern world. In addition to exemplary figures, we present a mythical condition which transcends the habitual and intellectual fashions: it is the sum total of the inspirational forces operating in the realm of the spirit.'

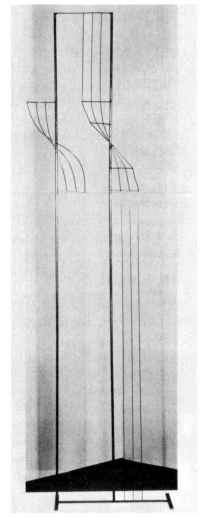

Fig. 7
Fausto Melotti, *Sculpture 17*, 1935.
Museo Civico d'Arte Contemporanea,
Palazzo Reale, Milan

Fig. 8
Osvaldo Licini, *Obelisk*, 1934.
Museo Civico d'Arte Contemporanea,
Palazzo Reale, Milan

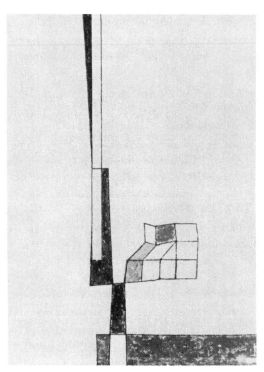

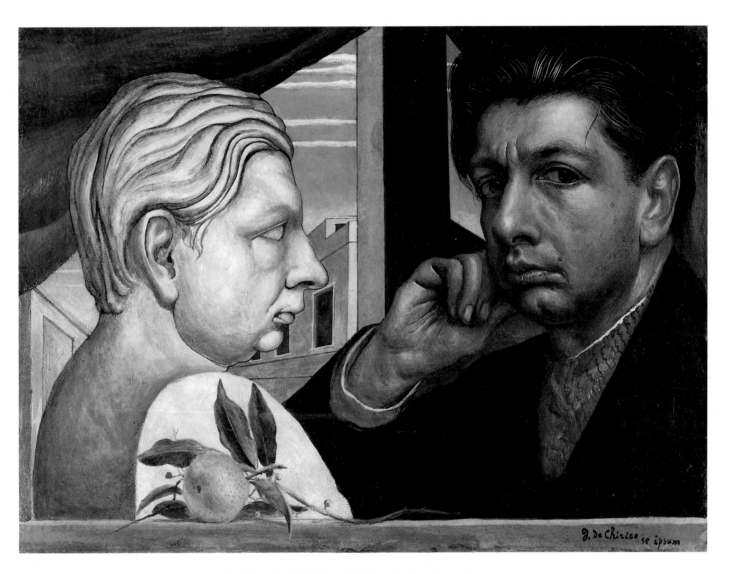

68 Giorgio de Chirico, Self-Portrait (*Autoritratto*) c.1922

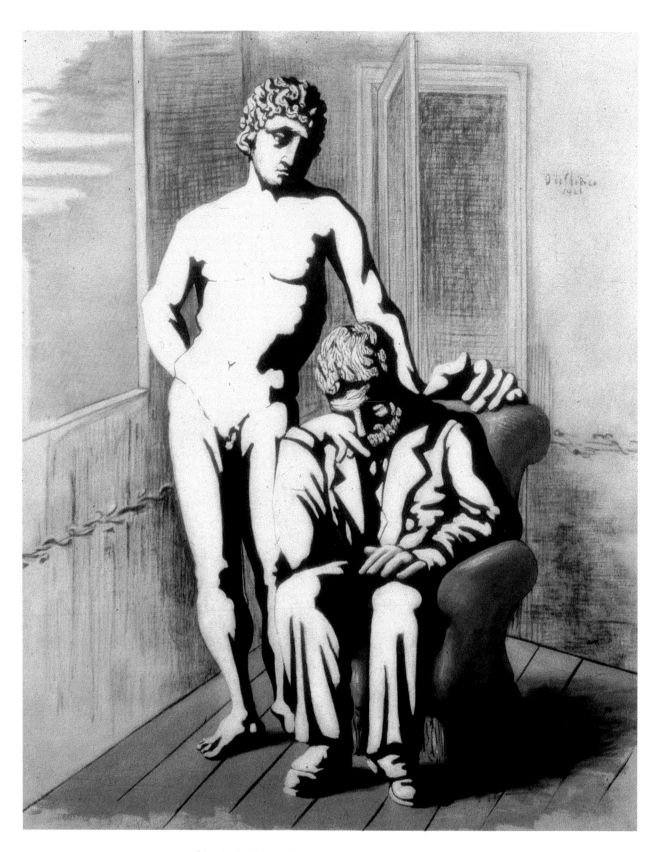

69 Giorgio de Chirico, The Prodigal Son (*Il figliol prodigo*) 1926

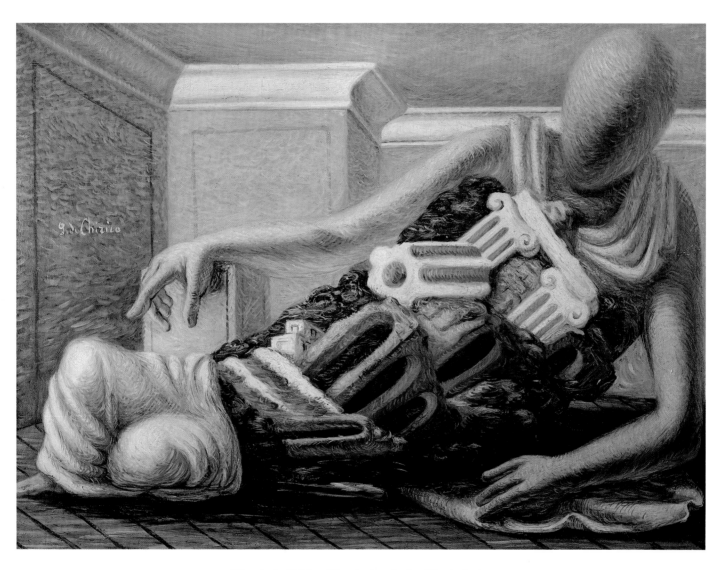

70 Giorgio de Chirico, The Archaeologist (*L'archeologo*) 1927

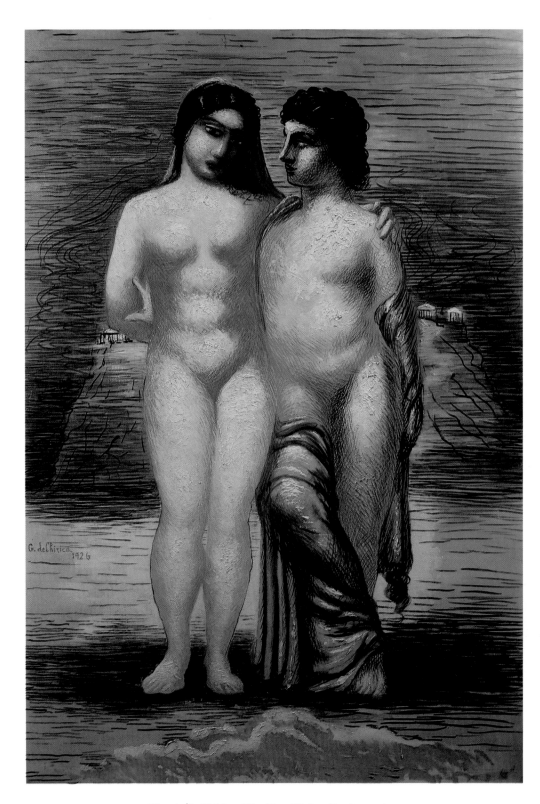

71 Giorgio de Chirico, The Two Nudes (*Les deux nus*) 1926

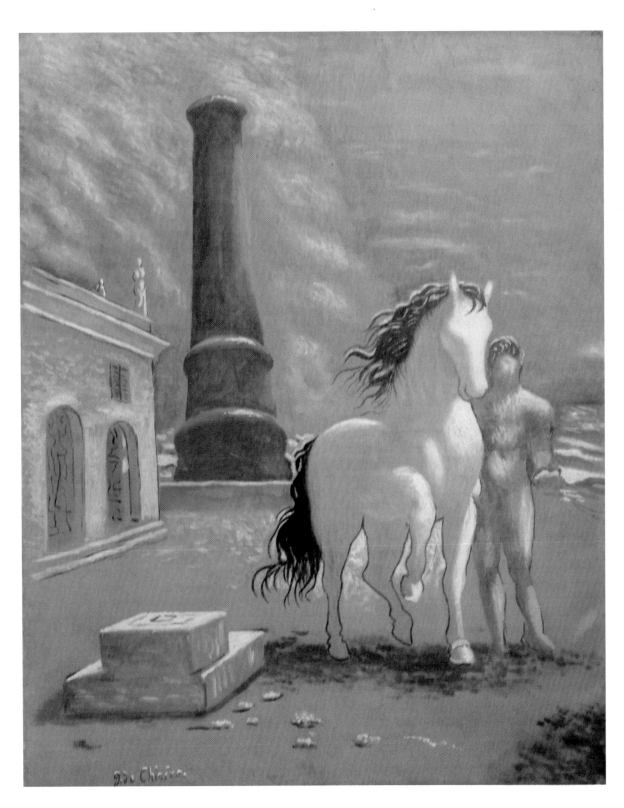

72 Giorgio de Chirico, The Shores of Thessaly (*Les rivages de la Thessalie*) 1926

73 Giorgio de Chirico, The Spirit of Domination (*L'esprit de domination*) 1927

74 Giorgio de Chirico, Furniture in a Valley (*Meubles dans une vallée*) 1927

75 Giorgio de Chirico, Columns and Forest in a Room (*Temple et forêt dans la chambre*) 1928

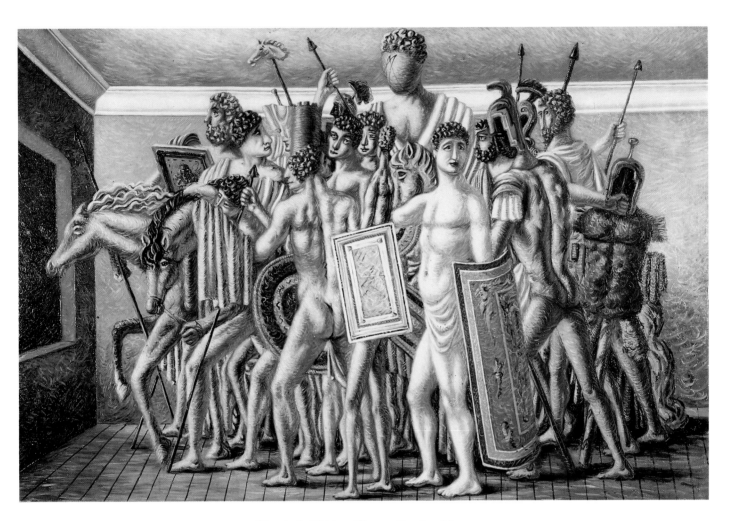

76 Giorgio de Chirico, Victory (*Le triomphe*) 1928-9

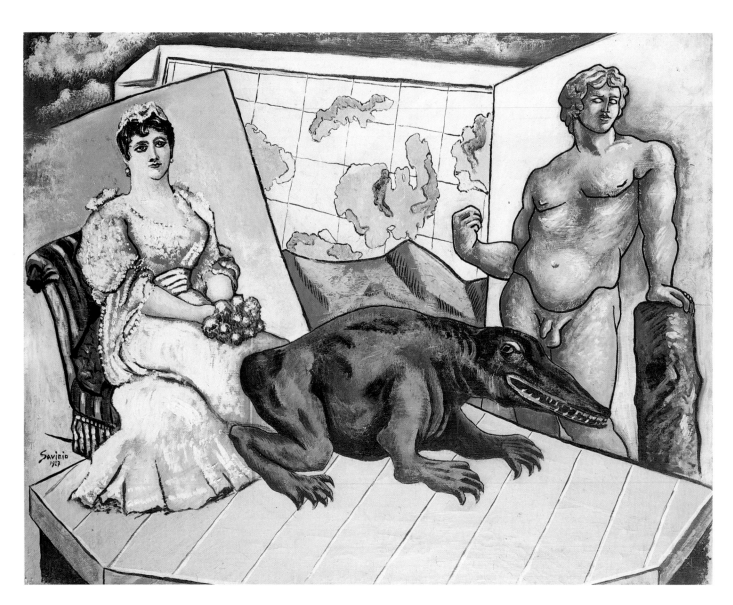

77 Alberto Savinio, Atlas (*Atlante*) 1927

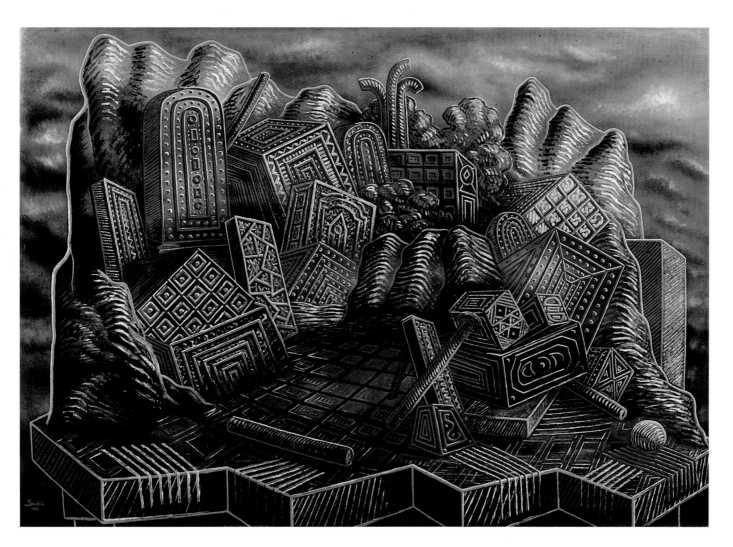

78 Alberto Savinio, The Isle of Charms (*L'île des charmes*) 1928

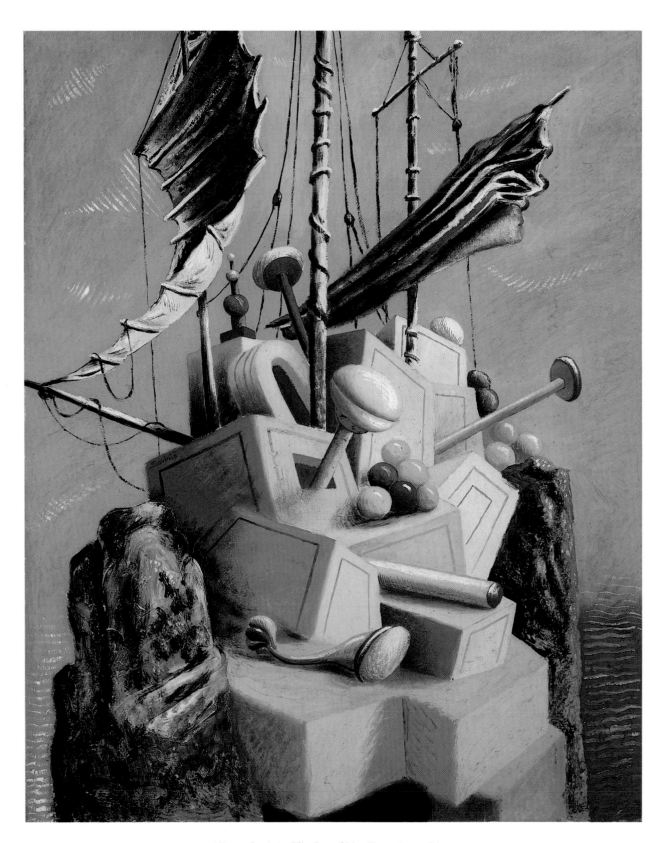

79 Alberto Savinio, The Lost Ship (*Le navire perdu*) 1926

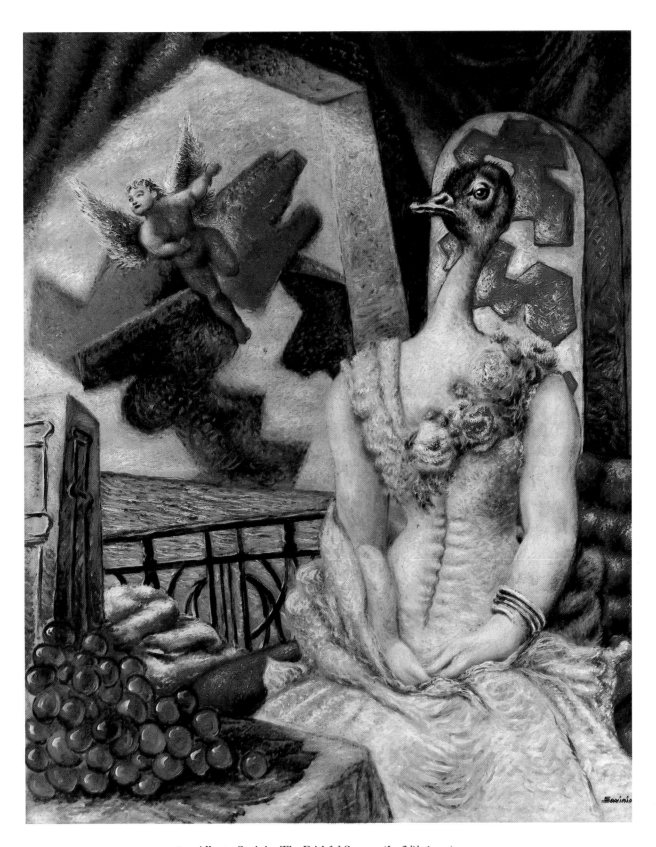

80 Alberto Savinio, The Faithful Spouse (*La fidèle épouse*) 1929

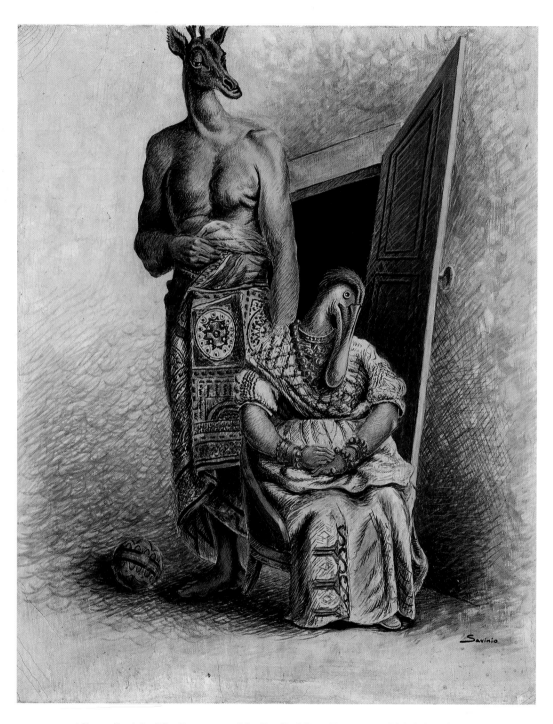

81 Alberto Savinio, The Departure of the Prodigal Son (*La partenza del figliol prodigo*) 1930

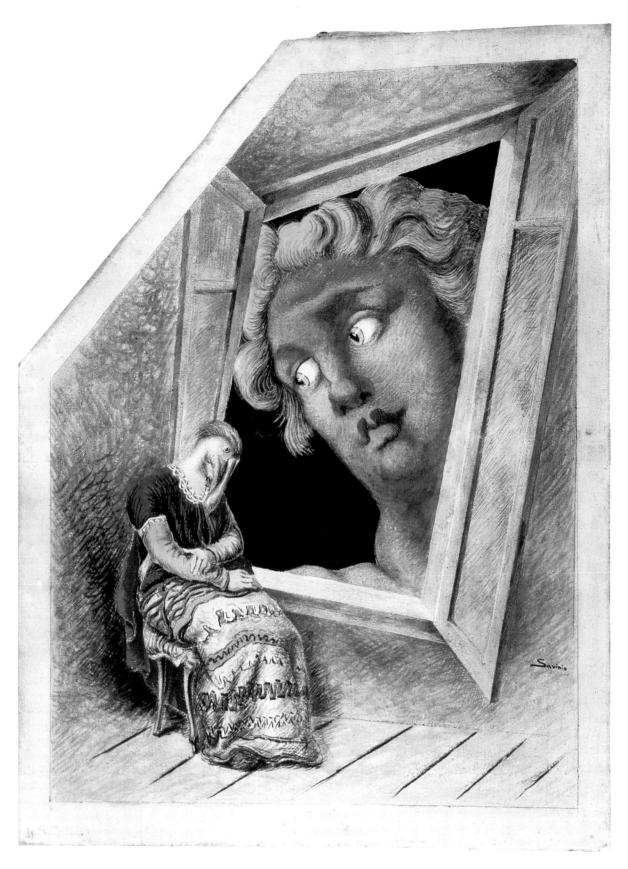

82 Alberto Savinio, Annunciation (*Annunciazione*) 1932

83 Filippo de Pisis, Still-Life with Capricho by Goya (Still-Life with Feather Duster)
(*Natura morta con capriccio di Goya [Natura morta con piumino]*) 1925

84 Filippo de Pisis, Marine Still-Life with Lobster (*Natura morta marina con aragosta*) 1926

85 Filippo de Pisis, Sacred Bread (*Pane sacro*) 1930

86 Filippo de Pisis, Interior with Newspaper and Fruit (*Interno con giornale e frutta*) 1934

87 Giorgio Morandi, Flowers (*Fiori*) 1920

88 Giorgio Morandi, Still-Life (*Natura morta*) 1921

89 Giorgio Morandi, Still-Life (*Natura morta*) 1926

90 Giorgio Morandi, Still-Life (*Natura morta*) 1929

91
Giorgio Morandi,
Still-Life (*Natura morta*)
1929

92
Giorgio Morandi
Landscape (*Paesaggio*)
1928

93 Giorgio Morandi, Landscape (*Paesaggio*) c. 1929

94 Giorgio Morandi, Still-Life (*Natura morta*) 1929-30

95 Carlo Carrà, The House of Love (*La casa dell'amore*) 1922

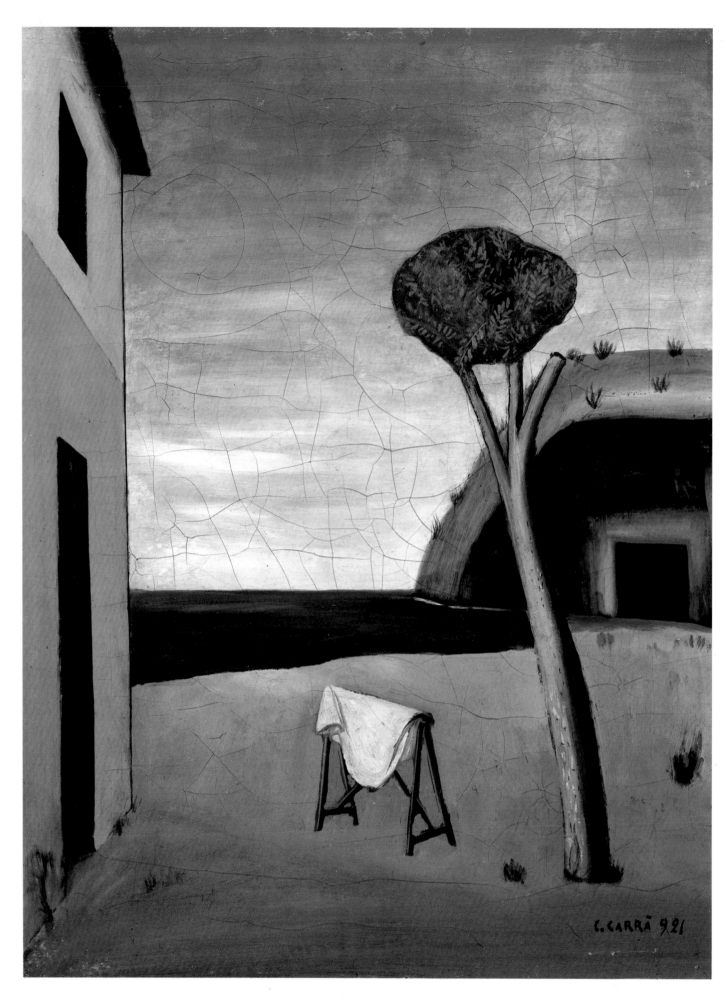

96 Carlo Carrà, The Pine Tree by the Sea (*Il pino sul mare*) 1921

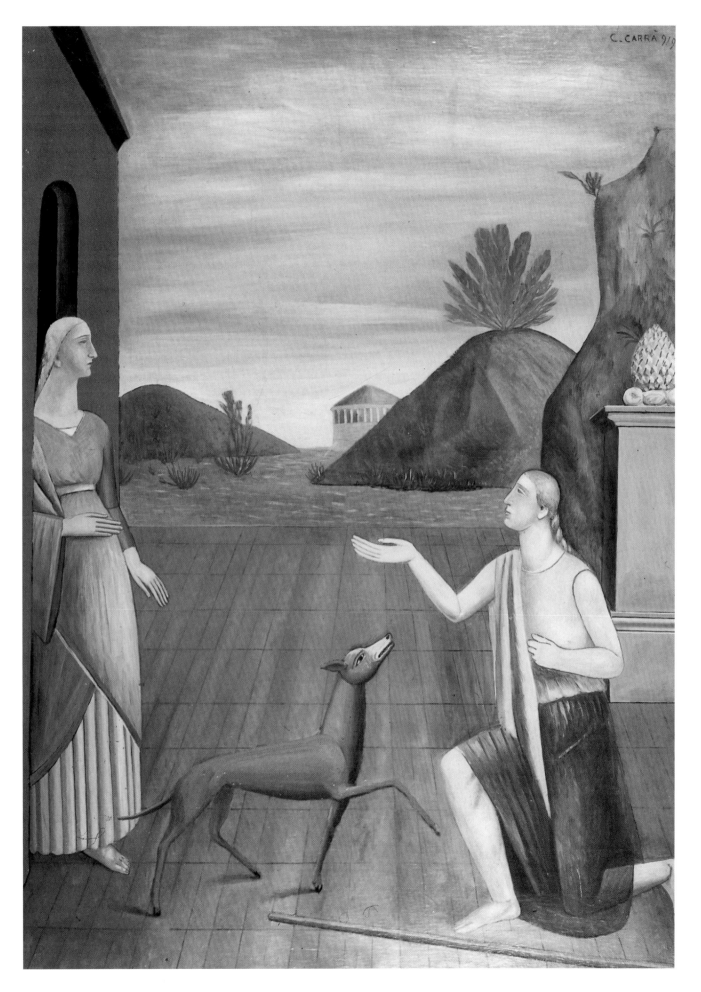

97 Carlo Carrà, Lot's Daughters (*Le figlie di Loth*) 1919

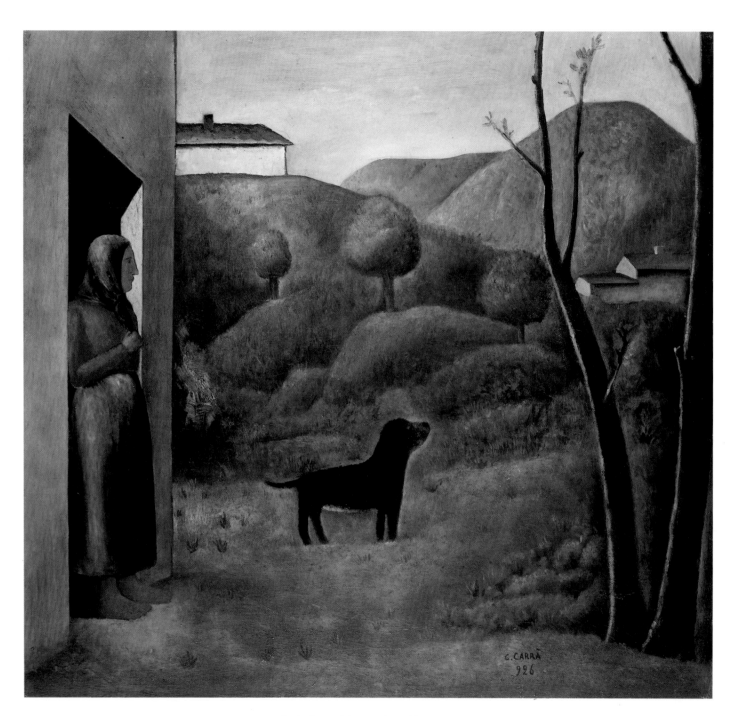

98 Carlo Carrà, Expectation (*L'attesa*) 1926

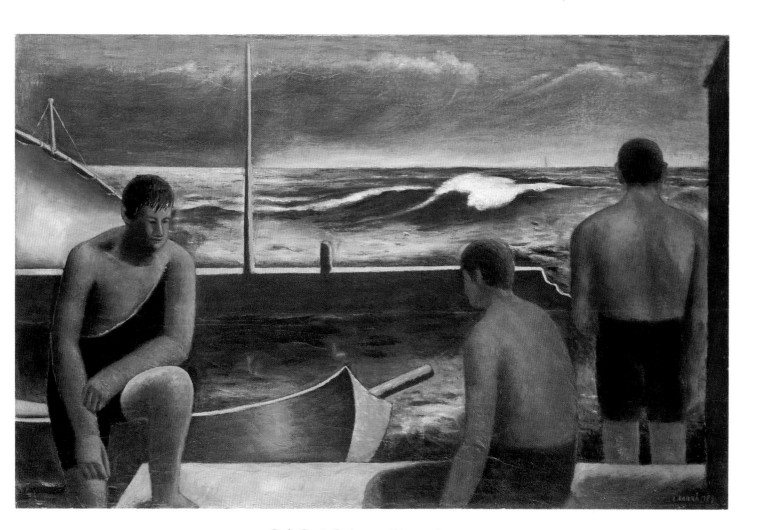

99 Carlo Carrà, Swimmers (*Nuotatori*) 1929

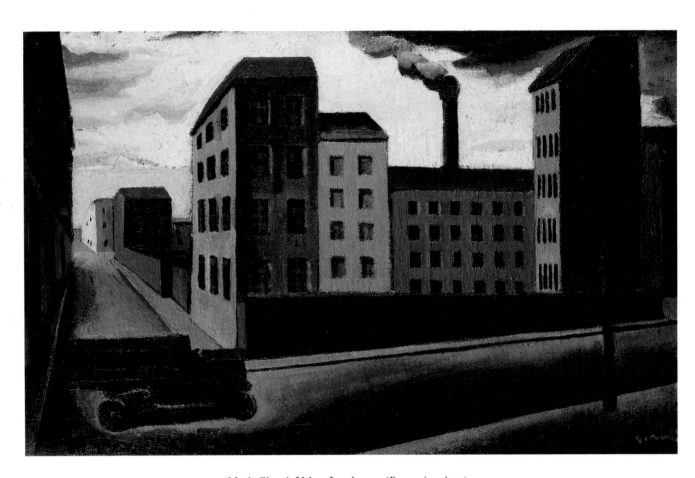

100 Mario Sironi, Urban Landscape (*Paesaggio urbano*) 1921

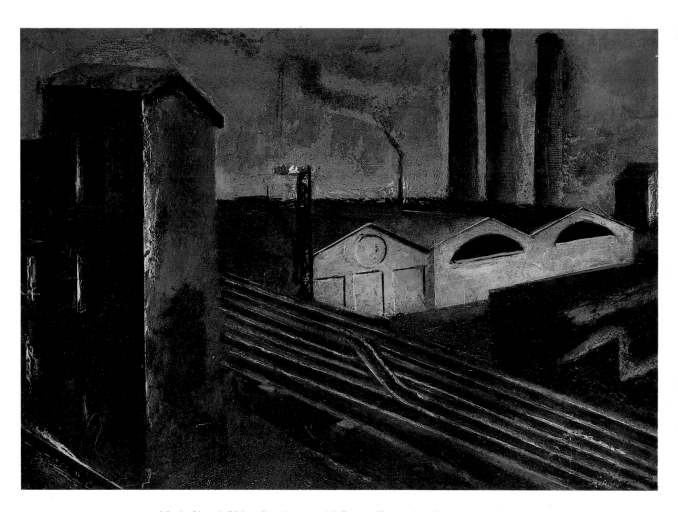

101 Mario Sironi, Urban Landscape with Lorry (*Paesaggio urbano con camion*) 1920-3

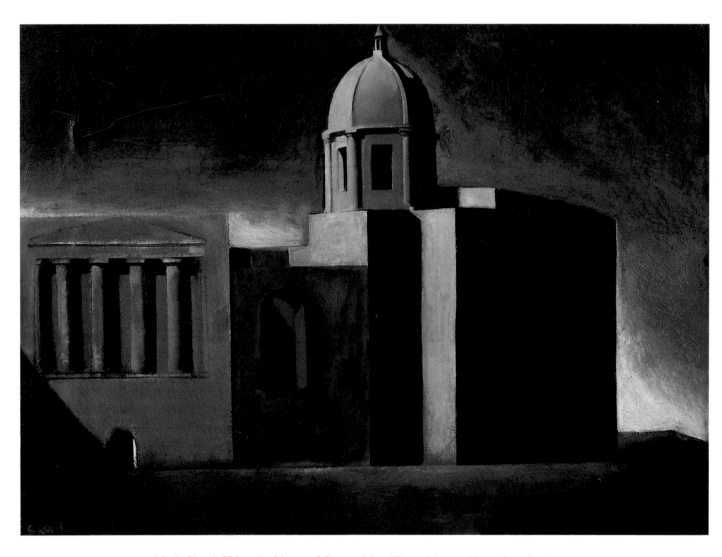

102 Mario Sironi, Urban Architectural Composition (*Composizione architettonica urbana*) 1919-23

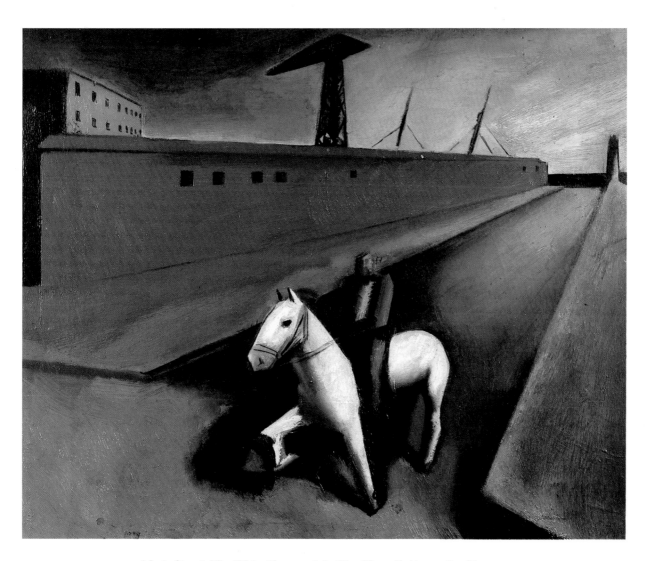

103 Mario Sironi, The White Horse and the Pier (*Il cavallo bianco e il molo*) c. 1920-2

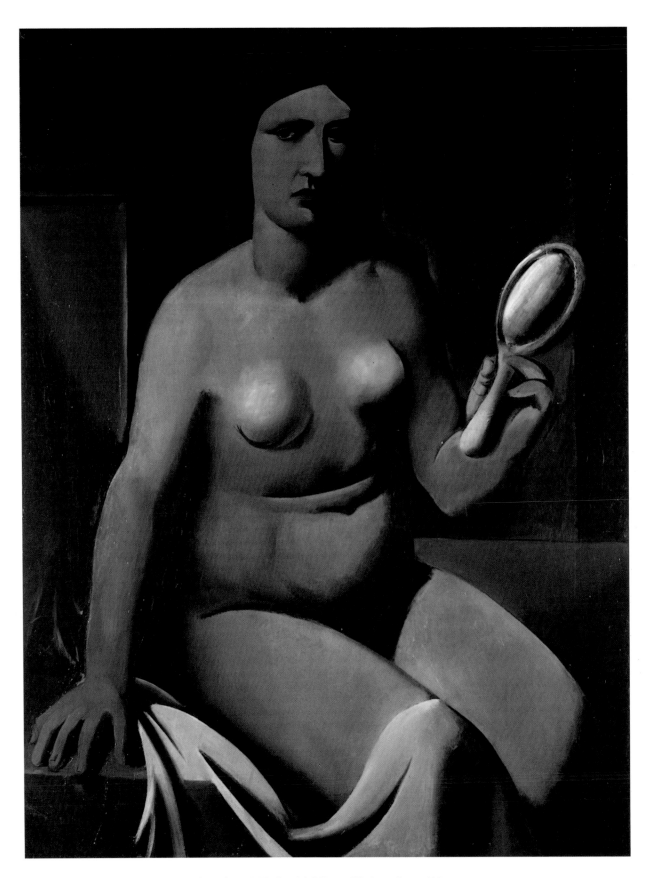

104 Mario Sironi, Nude with Mirror (*Nudo con lo specchio*) 1923-4

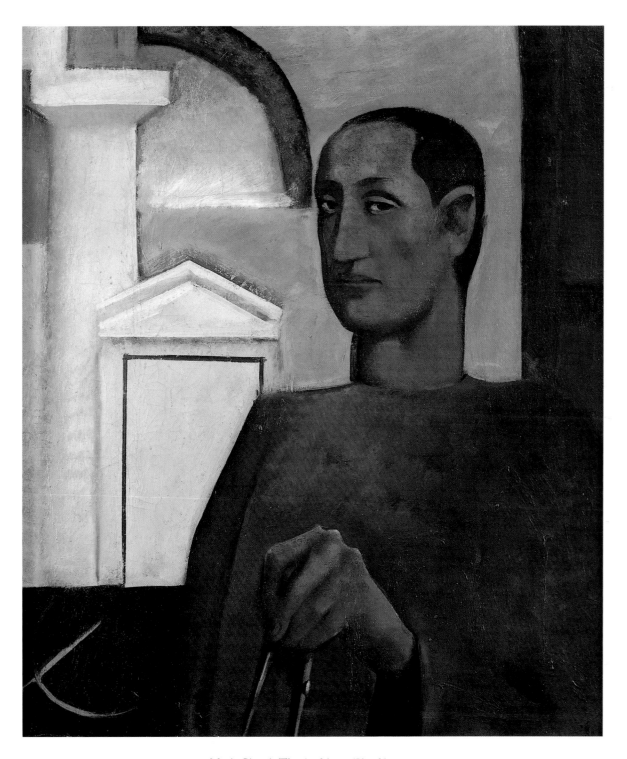

105 Mario Sironi, The Architect (*L'architetto*) 1922

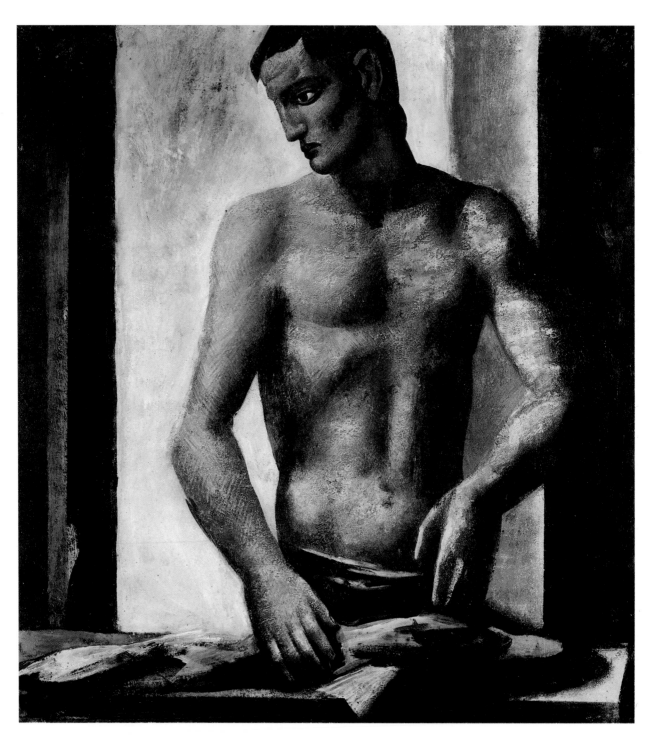

106 Mario Sironi, The Fishmonger (*Il pescivendolo*) 1927

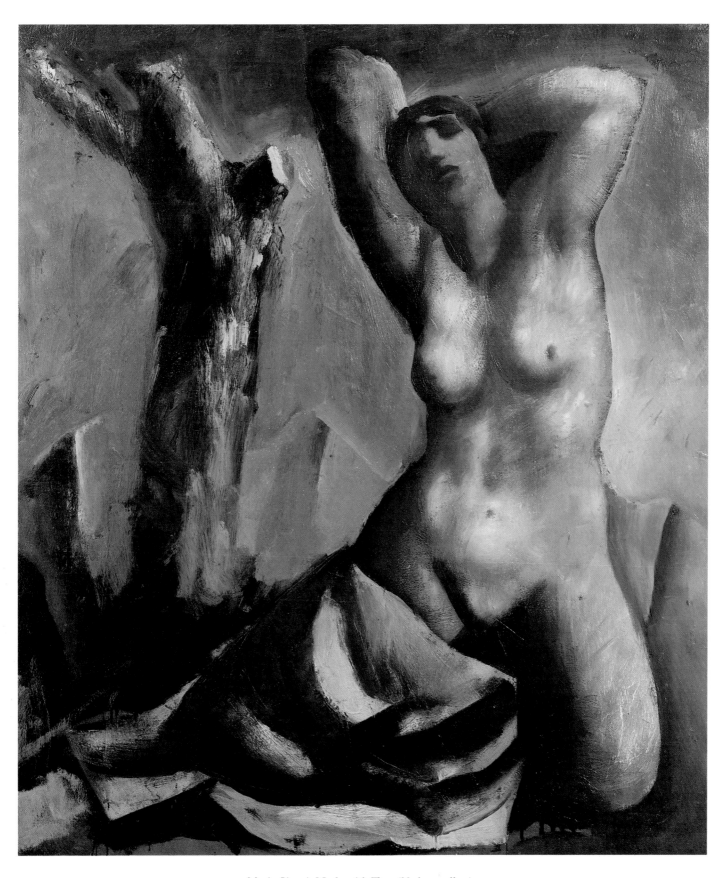

107 Mario Sironi, Nude with Tree (*Nudo con albero*) 1930

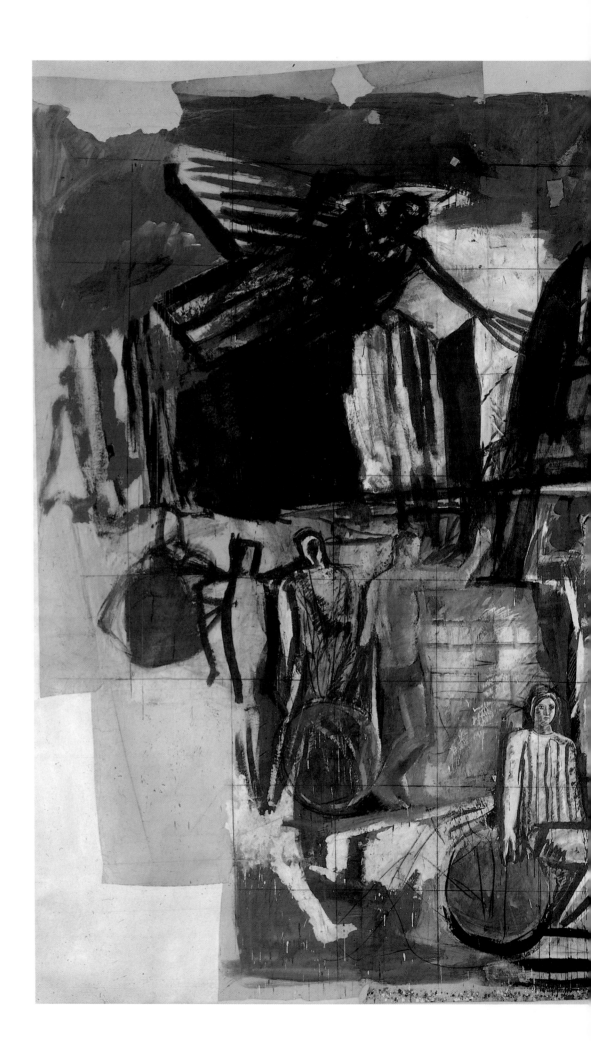

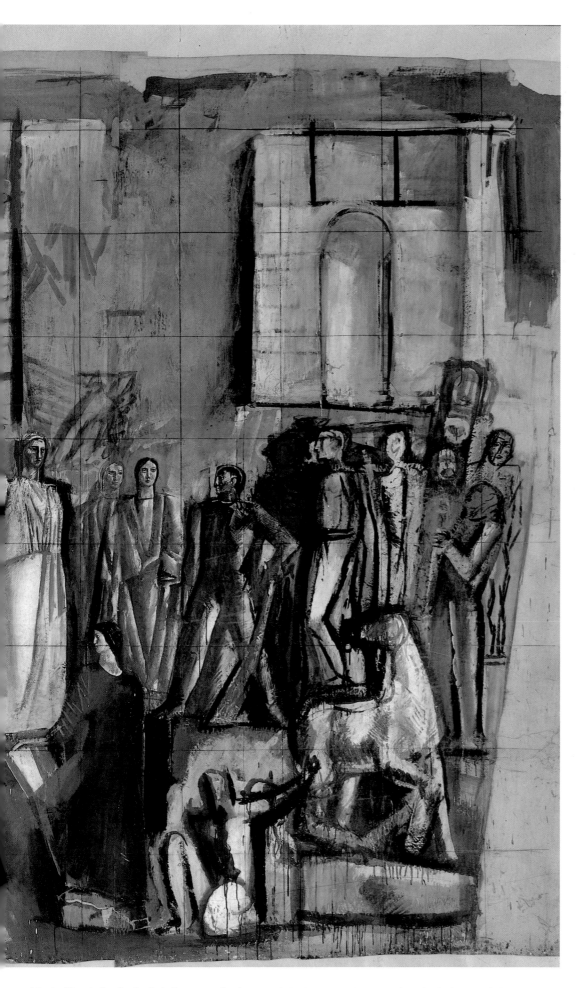

108 Mario Sironi, Study for Italy between the Arts and the Sciences (*Studio per L'Italia fra le Arti e le Scienze*) 1935

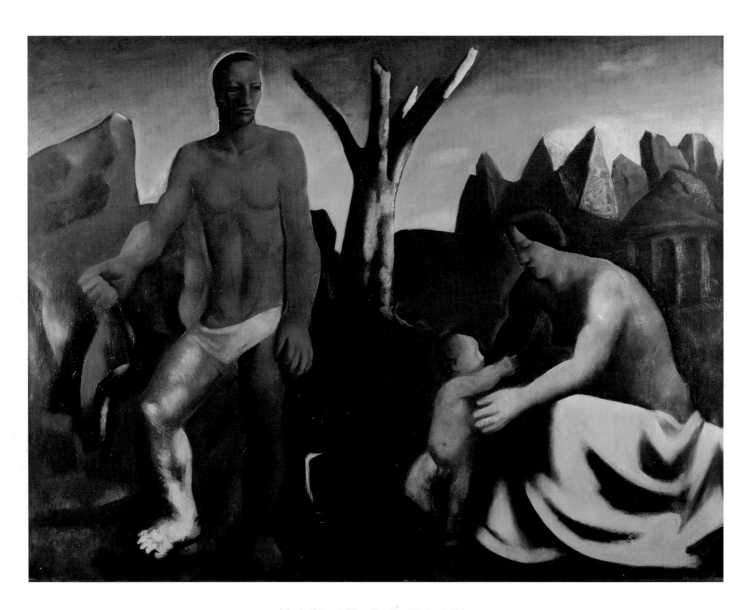

109 Mario Sironi, The Family (*La famiglia*) 1929

110 Arturo Martini, Expectation (*L'attesa* or *La veglia*) 1930-1

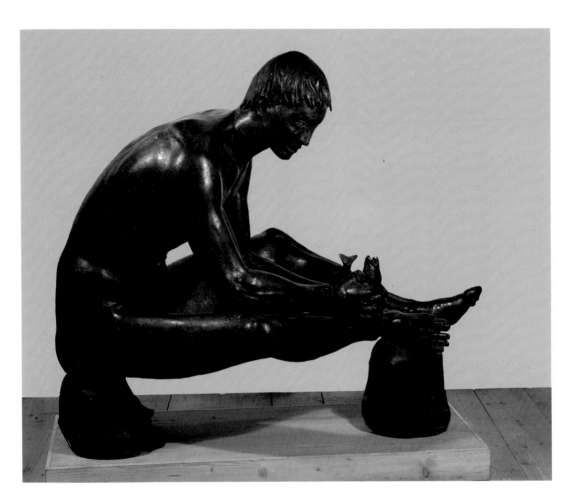

111 Arturo Martini, Tobiolo 1934

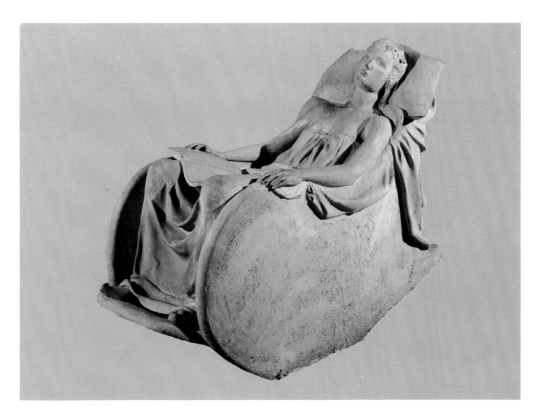

112 Arturo Martini, The Convalescent (*La convalescente*) 1932

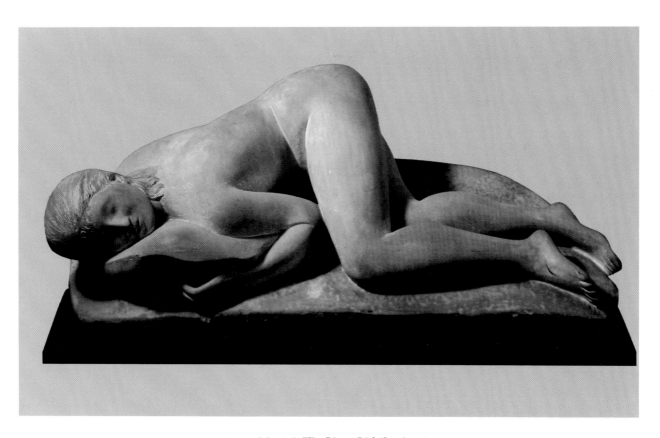

113 Arturo Martini, The Pisan Girl (*La pisana*) 1928

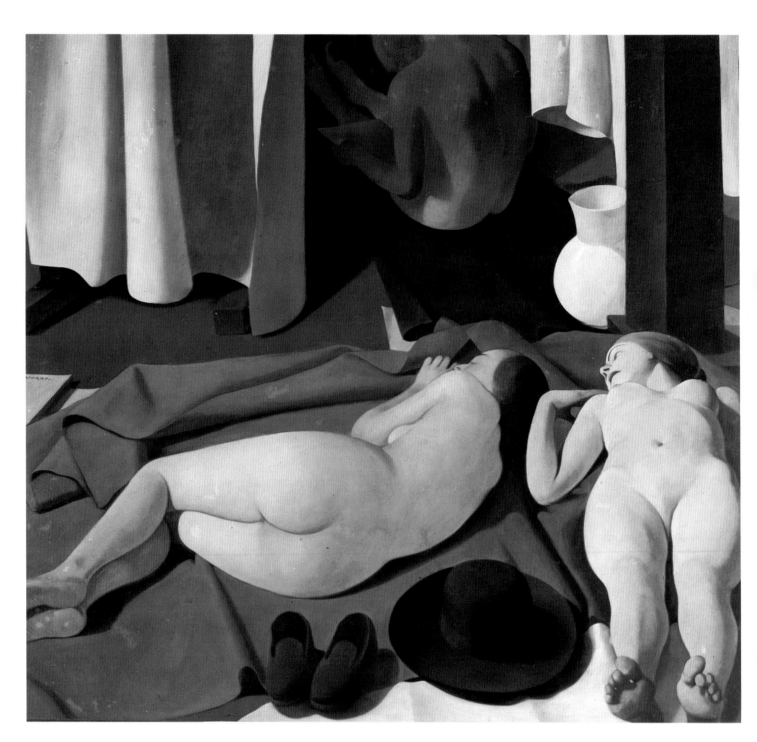

114 Felice Casorati, Midday (*Meriggio*) 1922

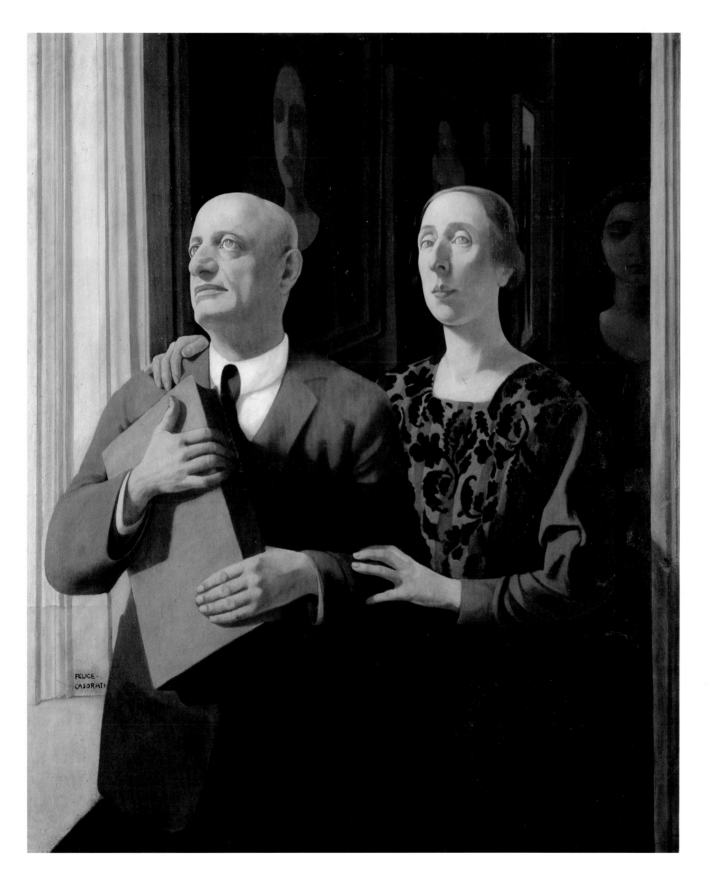

115 Felice Casorati, Double Portrait (with Sister) (*Doppio ritratto [con la sorella]*) 1924

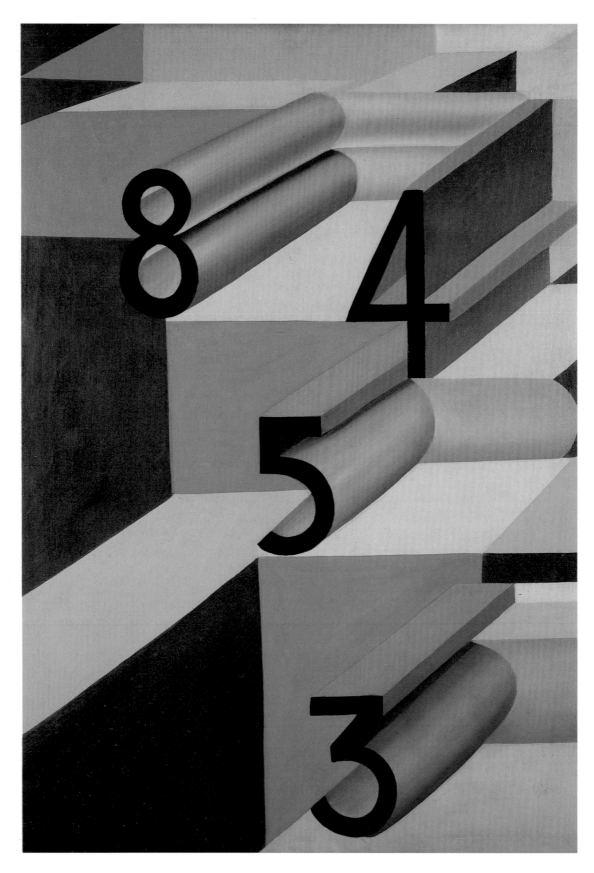

116 Giacomo Balla, Numbers in Love (*Numeri innamorati*) 1920

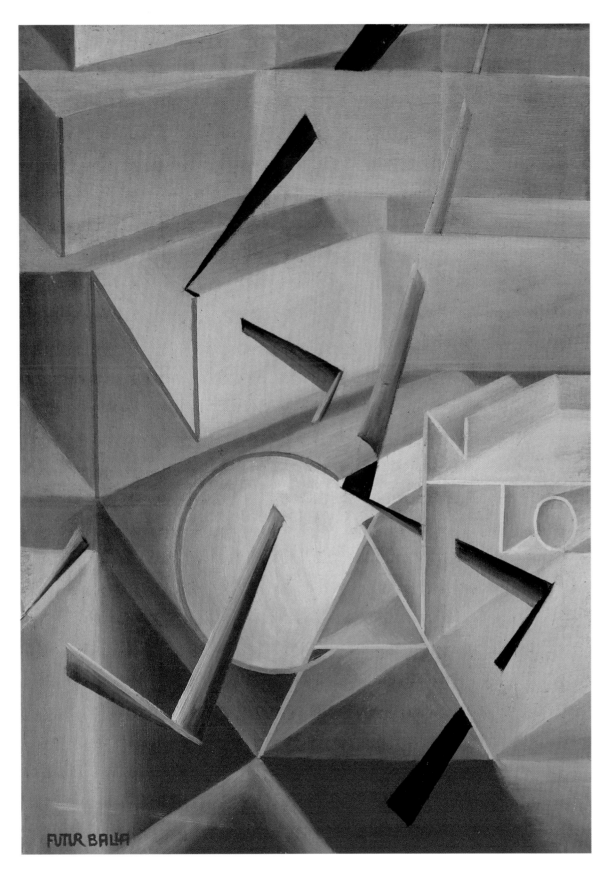

117 Giacomo Balla, The Spell is Broken (*S'è rotto l'incanto*) c. 1920

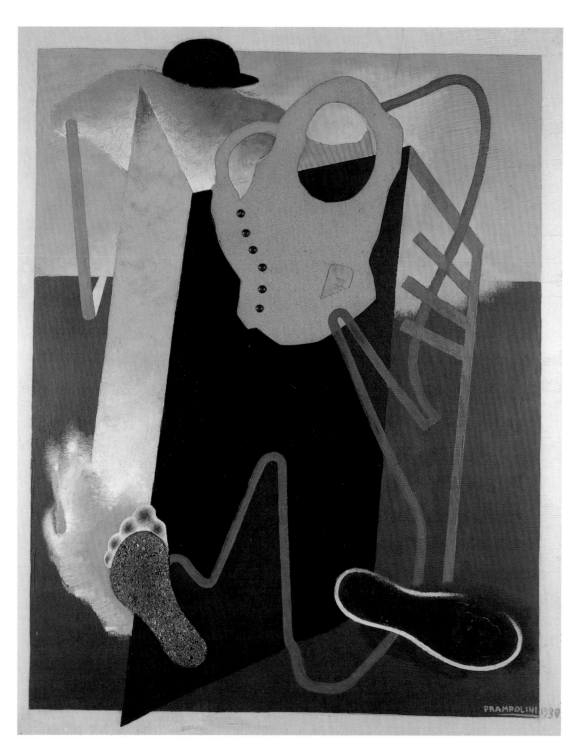

118 Enrico Prampolini, The Everyday Automaton (*L'automa quotidiano*) 1930

119 Enrico Prampolini, Encounter with Matter (*Intervista con la materia*) 1930

120 Lucio Fontana, Seated Girl (*Signorina seduta*) 1934

121
Lucio Fontana
Head of a Girl (*Testa di ragazza*)
1931

122
Lucio Fontana,
Black Figures (*Figure nere*)
1931

123 Lucio Fontana, Scratched Tablet (*Tavoletta graffita*) 1931

124 Lucio Fontana, Abstract Sculpture (*Scultura astratta*) 1934

125 Lucio Fontana, Abstract Sculpture
(*Scultura astratta*) 1960
(replica of 1934 original)

126 Lucio Fontana, Abstract Sculpture (*Scultura astratta*) 1934

127 Lucio Fontana, Abstract Sculpture
(*Scultura astratta*) 1960
(replica of 1934 original)

128 Lucio Fontana, Abstract Sculpture (*Scultura astratta*) 1934

129 Lucio Fontana, Conch and Octopus (*Conchiglia e polpo*) 1938

130 Lucio Fontana, The Horses (*I cavalli*) 1938

131 Osvaldo Licini, Biting (*Addentare*) 1936

132 Osvaldo Licini, Composition with Black and Blue Lines (*Composizione con linee nere e blu*) 1935

133 Fausto Melotti, Sculpture No. 12 (*Scultura n. 12*) 1934

134 Fausto Melotti, Sculpture No. 11 (*Scultura n. 11*) 1934

135 Fausto Melotti, Sculpture No. 16 (*Scultura n. 16*) 1935

136 Fausto Melotti, Sculpture No. 24 (*Scultura n. 24*) 1935

137 Alberto Magnelli, Stones No. 1 (*Pierres No. 1*) 1933

138 Alberto Magnelli, Stones No. 3G (*Pierres No. 3G*) 1933

139 Massimo Campigli, Six Heads (*Sei teste*) 1945

140　Massimo Campigli, Market of the Women and the Amphorae (*Mercato delle donne e delle anfore*)　1929

141 Fausto Pirandello, Interior in the Morning (*Interno di mattino*) 1931

142 Fausto Pirandello, Golden Rain (*Pioggia d'oro*) 1934

143 Scipione, Piazza Navona 1930

144 Scipione, Portrait of Cardinal Decano (*Ritratto del Cardinale Decano*) 1930

145 Scipione, The Octopus (The Molluscs – Pierina Has Arrived in a Big City)
(*La Piovra [I molluschi – Pierina è arrivata in una grande città]*) 1929

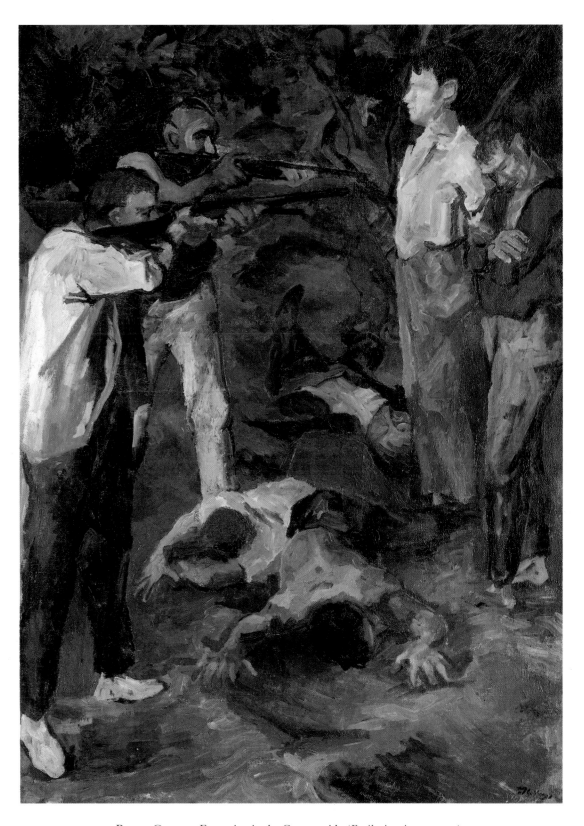

146 Renato Guttuso, Execution in the Countryside (*Fucilazione in campagna*) 1939

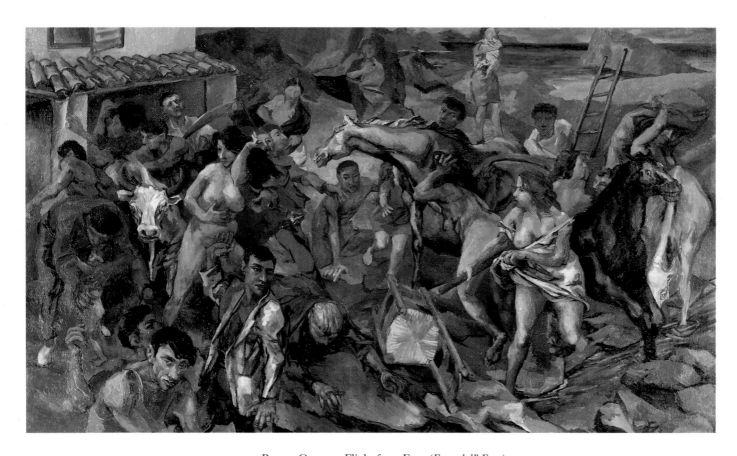

147 Renato Guttuso, Flight from Etna (*Fuga dall' Etna*) 1940

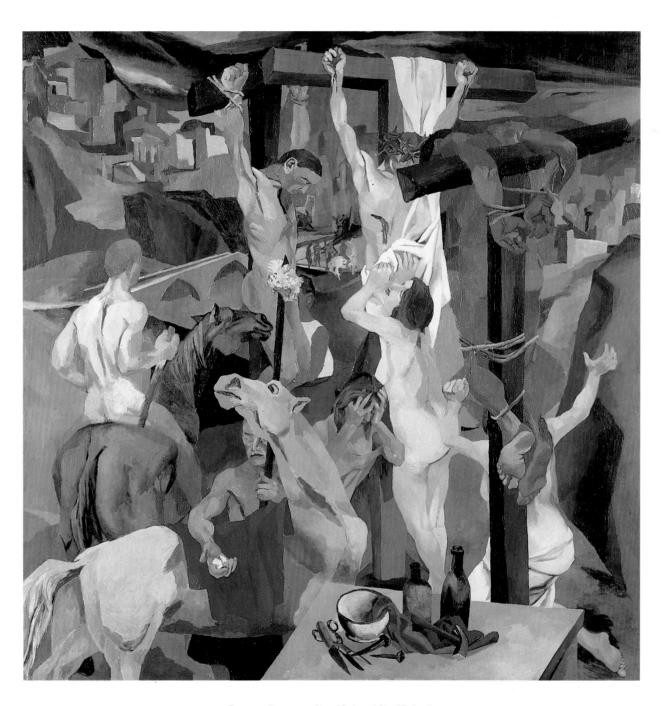

148 Renato Guttuso, Crucifixion (*Crocifissione*) 1941

149 Giacomo Manzù, Christ with Magdalene (*Christo con Maddalena*) 1947-66

150 Giacomo Manzù, Christ with General (*Cristo con generale*) c. 1947

151 Marino Marini, Pomona 1941

152 Marino Marini, Horseman (*Cavaliere*) 1947

1945-1968

Stuart Woolf

History and Culture in the Post-war Era, 1944-1968

The overthrow of Fascism in 1943-5 was not simply a change of government. It contained a political and moral significance that explained the birth and, in the final analysis, the democratic resilience of the Italian republic. The student revolt of 1968, with the cruelty characteristic of all conflicts between generations, dismissed its predecessor's struggles as embalmed in rhetoric, for among the deconsecrating tenets of these young Italians, all born after the war, was the assertion that the anti-Fascist Resistance was of no practical relevance to their analysis of the contradictions of Italian capitalism. The revolt was symbolic of the profound transformation of Italian society in this quarter of a century.

Fascism had not fallen because of anti-Fascist opposition, but because of the internal disintegration of the regime under the pressure of cumulative defeats in the war and of the Allied invasion of Sicily. Yet after the palace coup of 25 July 1943, the Italians had spontaneously organized a partisan movement in northern and central Italy against Benito Mussolini's Republic of Salò and the Nazi forces occupying the country. While the Allied armies fighting their way slowly up the peninsula were responsible for defeating the German divisions (Naples was freed in September 1943, Rome in June and Florence in August 1944), the military Resistance movement, under the political leadership of the Committee of National Liberation for Upper Italy (Comitato di Liberazione Nazionale dell'Alta Italia, CLNAI), effectively sabotaged German communications and liberated Bologna, Genoa, Turin, Milan, Venice and Trieste (Fig. 1).

The Resistance movement constituted the crucial premise in the formation of the new Italy, with both positive and negative repercussions. On the one hand, it ensured the right of Italians to decide on the constitutional form of their state (rather than have it imposed on them, as happened in defeated Germany), a right they asserted in the referendum of 2 June 1946, which replaced the monarchy by a republic. On the other hand, the division of Italy between north and south for so prolonged a period of warfare and, even more, the lingering control of the Allies blunted the cutting edge of the radical proposals of the CLNAI's 'wind from the north'. As a result, the purge of Fascists and collaborators was aborted and the

Fig. 1 Partisans in Milan, April 1945

Fascist-appointed bureaucracy and judiciary remained intact, while the proposals for decentralization of the state were ignored. The liberation government under the partisan leader Ferruccio Parri was cold-shouldered by the Allied military administration, and many of the less laudable practices of pre-Fascist liberal democracy rapidly re-emerged, particularly in the south. The abolition of the monarchy, which had seemed certain in spring 1945, was passed in the referendum fifteen months later with a majority of only two million out of twenty-four million voters.

The Resistance movement had provided a praiseworthy example of the subordination of deep ideological differences among the partisans to the greater need of defeating Nazism and Fascism. However, such unity rapidly disappeared with victory, as political and social differences inevitably resurfaced. In retrospect, three influences prevailed in the politics of this immediate post-war period. From the outset, there was a remarkable domination of the political parties. The six parties of the CLNAI had mobilized the general latent hostility to the war into an effective form of political action, which was essential for the success of the Resistance. During and after the war, the discussions about Italy's future were as notable for their assertion of the role of parties as the sole legitimate expression of democracy as for their ignorance of economics and the mechanics of administration. The adopted system of proportional representation reflected this shared view of the centrality of the parties, as it ensured that voting strength was translated directly into numbers of seats. One consequence was the presence in parliament of at least nine or ten parties, although from the very beginning, in the first post-war elections of 1946, only three attracted substantial electoral support – Christian Democrats, Communists and Socialists.

The second characteristic was the success of the Vatican in washing itself clean of the taint of its support of Fascism and in reaffirming the Church as the strongest pillar of established values in Italy. The Church had already regained its central position within Italian society with the Concordat of 1929. Upon the collapse of Fascism, it set the moral tone and expanded its political role. In the 1946 elections the Christian Democrats (Democrazia Cristiana, DC) emerged as the party of relative majority; its leaders, including Alcide De Gasperi, the prime minister elected after Parri's fall, had been close to the Vatican during the years of Fascist persecution. The Concordat was confirmed in the new constitution, despite its encroachments on the independence of the state, particularly in education and in the juridical imparity between the Catholic church and other denominations. Above all, the Church offered the Christian Democrats a dense network of ideological and organizational support through, on the one hand, its anti-Communism and stress on traditional values, and, on the other, the capillary structure of Italian Catholic Action (Azione Cattolica Italiana) and the hierarchical lines of authority within the dioceses. 'Christ versus Communism', the powerful slogan of the DC in the 1948 elections, was so effective because of the Church's readiness to intervene heavily in Italian politics.

The powerful role of working-class organizations comprises the third novel feature of the Italy that emerged from Fascism. Both the Italian Communist Party (Partito Comunista Italiano, PCI) and the trade unionists, who rapidly founded a single confederation (Confederazione Generale Italiana del Lavoro, CGIL), had attracted and organized massive support in the strikes and military action of the Resistance. Together with the Socialist Party (Partito Socialista Italiano, PSI), they ensured the political presence and participation of the masses in Italian society. In the difficult consolidation of the post-Fascist republic, with only the elitism of pre-Fascist Italy as a reference point, these organizations played an inestimable role in educating the formerly excluded working-class and peasant masses in the values of liberty and democracy.

Such a process of transmission of new values needs to be placed in the context of the spontaneous outburst of cultural and social activities that followed the fall of Fascism. Neo-realism had its roots in the 1930s, and its literary and visual prototypes emerged in the war years – Elio Vittorini's novel *Conversazione in Sicilia* (*Conversation in Sicily*, 1941), Luchino Visconti's film *Ossessione* (1942), and *Crucifixion* (1941; Cat. 148) and other paintings by Renato Guttuso. From 1945 to the early

Fig. 2 Funeral of Palmiro Togliatti, Rome, 1964.
The poster shows Togliatti watched over
by Antonio Gramsci

1950s, Italy's inventive genius reaffirmed itself at an international level in novels, films and paintings by Vasco Pratolini, Cesare Pavese, Beppe Fenoglio, Vittorio De Sica, Roberto Rossellini, Guttuso, Carlo Levi and many others.[1] Neo-realism focused on the discovery of a popular Italy and the everyday lives of the people in their multiform, quintessentially local or regional identities. It expressed the political commitment of artists in a polemic directed at the tradition of an art detached from the daily problems of real life.[2]

The same commitment can be observed on the part of intellectuals on a political level. They were concerned not merely with refuting Fascism but with overcoming the gap between the elites and 'real Italy', a schism that had characterized the Liberal era before the First World War. This attitude was manifested in the total political failure of the enlightened, elitist, highly intellectual Party of Action (Partito d'Azione) at the first electoral test of 1946. With the publication of Antonio Gramsci's *Quaderni del Carcere* (*Prison Notebooks*, 1948-51),[3] theorisation on the role of the intellectual in relation to mass movements added a new dimension to the well-established public debate about the intelligentsia.

Intellectuals in Italy have always enjoyed a higher reputation and greater influence than in English-speaking countries. The aged philosopher Benedetto Croce personified the traditional values of Liberal Idealism which assigned a distinctive and superior function to the intellectual, above the fray of everyday politics. In Gramsci's polemical Marxist alternative to Croce's Idealism, the 'organic intellectuals' played a pivotal role, together with the political parties, in articulating and organizing the subordinate classes, with whose aims and aspirations they identified. For Gramsci, intellectuals constituted a broad sociological category, in contrast to Croce's elite of 'high intellectuals': it cut across traditional class divisions to include all whose function was the transmission of ideas, from university professor to primary-school teacher and priest. Gramsci's highly original reflections were attractive to ever-widening circles of the Italian reading public, partly because they were formulated in the immediately understandable framework of Italy's history and intellectual development, partly because they corresponded to the new active and organizational presence of the masses in Italian society, to whom Crocean liberalism had little to offer. There can be little doubt that the Gramscian concept of 'hegemony', or the winning-over of mass society as the necessary premise of political control, was increasingly influential among intellectuals as a defence against the Christian Democrat offensive. It was also seminal in preparing the change in mentality that was to lead to the explosion of 1968.

Gramsci's ideas were central to the policy of the Communist party under the leadership of Palmiro Togliatti (Fig. 2). Yet the very importance of the intellectuals to the PCI made their relationship a troubled one. Intellectuals such as Vittorini

1 Pratolini's Florentine *Cronache dei Poveri Amanti* was published in 1947, his *Le Ragazze di San Frediano* in 1949; he had already published *Il Quartiere* in 1943. Pavese was responsible with Elio Vittorini for the discovery of American literature in Italy in these years; his work (*Paesi tuoi*, 1941; *Feria d'Agosto*, 1946; *La Luna e i Falò*, 1950) was a rediscovery of the Piedmontese countryside and his childhood there. Fenoglio's *I Ventitrè Giorni della Città di Alba* (1952) turned to the partisan movement in the Langhe. De Sica produced *Ladri di Biciclette* (*Bicycle Thieves*) in 1948, *Miracolo a Milano* (*Miracle at Milan*) in 1951 and *Umberto D.* in 1952. Rossellini's *Roma Città Aperta* was produced in 1945, *Paisà* in 1946 and *Germania Anno Zero* in 1947. Levi's *Cristo si è Fermato a Eboli* (*Christ Stopped at Eboli*) appeared in 1945. Pier Paolo Pasolini's *L'Usignolo della Chiesa Cattolica*, with poems from the years 1943 to 1949, was published in 1958, *Le Ceneri di Gramsci* in 1967.

2 Carlo Salinari, *La Questione del Realismo*, Florence, 1960.

3 The original edition of the *Quaderni del Carcere* was arranged according to the subjects on which Gramsci (1891-1937) reflected during his years of imprisonment: this highlighted the themes of the intellectuals, the party as the 'modern prince' and the 'national-popular' tradition in Italian history. The definitive critical edition was published in four volumes by Giulio Einaudi Editore in 1975.

Fig. 3 Giorgio de Chirico, Advertisement
for Fiat 1400 car, 1950

Fig. 4 Mario Sironi, Advertisement for Fiat
1900 A car, 1954

asserted the importance of the distinction between politics and culture. The heavy-handed intervention of the party in cultural and ideological questions, typical of the Stalinist approach but accentuated by Togliatti's defensive attitude during the years of the Cold War, disregarded the autonomy to which intellectuals were accustomed. With the crisis following the Soviet invasion of Hungary in 1956, many intellectuals left the Communist party, though without abandoning their commitment to a closer relationship between culture and politics.

The political history of post-Fascist Italy has always been heavily conditioned by international developments, to some extent paradoxically, in view of the absence of any aggressive sense of nationalism following the debacle of the war and the loss of colonies. Whatever the initial expectations of Togliatti, the Cold War and its subsequent thaw became the touchstone of internal Italian politics. American political and financial support underlay the secession of Giuseppe Saragat from the PSI and the resulting formation of the Social Democrat Party (Partito Socialdemocratico Italiano, PSDI) in January 1947, De Gasperi's expulsion from the government of Communists and Socialists in May 1947 and the breakaway from the unified confederation, CGIL, of Catholic and Social-Democrat trade unionists in July 1948. Anti-Communism polarized the political and social scene, reinforcing the anti-Fascist solidarity of Pietro Nenni's Socialists with the PCI and creating extremely close ties between political parties and trade unions.

Italy's uncritical alignment with American world policy had profound repercussions on the reconstruction of the economy, both in the degree of capitalist development and in the offensive against working-class organizations during the 1950s. Italian capitalism had rapidly regained strength after the war, expanding production in response to a world demand that was already growing during the period of the Korean War (1950-3). The capitalist groups of the northwest industrial triangle, large and equipped with modern technology, depended on growth in exports, making the economy particularly sensitive to fluctuations in international trade. If the major private manufacturers, symbolized by Fiat, acted as the pacemakers of the economy, the large public sector, inherited from Fascism and grouped in the Istituto per la Ricostruzione Industriale (IRI) and the Ente Nazionale Idrocarburi (ENI, created in 1953), fulfilled a counter-cyclical function in maintaining levels of investment and employment.

Fig. 5 Election banners in Rome, 1963

Throughout the 1950s, with over two million unemployed and the structural distortions of the economy unchanged (a backward south and massive overcrowding in agriculture, artisanal industry and the tertiary sector), the political climate of anti-Communism facilitated Fiat's defeat of working-class agitation in the factories by discriminating against the Communist-dominated CGIL. The creation of the European Economic Community in 1957 accelerated the pace of growth and, after the so-called 'economic miracle' of 1958-63, the triumph of a rampant capitalism, exempt from public control and prone to stock market manipulations, seemed complete. The 1960s witnessed the spectacular emergence of a domestic market based on middle- and working-class demand, in southern as well as northern central Italy: 425,000 cars were registered in 1951, 2,449,000 in 1961, 9,173,000 in 1969 (Figs. 3, 4).[4] Yet as the labour supply began to dry up for the first time in Italian history, and the international economy faltered, the trade unions regained bargaining power. Against this background of alternating growth and crises, the 1960s were marked by labour conflict.

This transformation of the Italian economy took place within the context of an increasingly rigid political system. The Cold War lay at the root of the creation and permanence of what one political analyst has described in a famous phrase as an 'imperfect bi-party system'.[5] Three mass parties had emerged from the first local elections in the spring of 1946 – the Christian Democrats with around forty per cent of the votes, the Communists and Socialists with roughly thirty-five per cent between them. The remaining votes, in polls which regularly attracted around ninety per cent of the voters, were split among small lay parties of the centre and the right, each with between one and seven per cent of the votes. The stability of such voting patterns, combined with the ideological divide of the Cold War, created a system of permanent government by the DC and permanent opposition of the PCI. The small parties of the centre gravitated in and out of coalition with the dominant Christian Democrats in a kaleidoscope of governmental crises of byzantine impenetrability, whose rapid sequence (on average, one every eleven months) masked the underlying stability of the system. The gradual drop in international tension following the Cold War was reflected in Italian politics with a certain time lag, possibly because of the reluctance of many leaders of both the DC and minor lay parties to share power.

The immobility of this political system can be explained, at least in part, by the constantly active role of the parties. Compared to Britain or the United States, where the prevailing mode of political disinterest and apathy is only inconvenienced at elections, post-Fascist Italian society has displayed a high degree of political activism (Fig. 5). Over and above ideological allegiances, this undoubtedly derived from the strong links forged by the parties with the citizens in their areas of support. These links were reflected not only in the massive size of the parties (the PCI had over two million members until 1956, the DC 1.6 million in 1963), but also in the dense web of organizations connected to the various parties – trade unions, cooperatives, Catholic Action, sports clubs and a multitude of other associations. Political polarization led to mutually exclusive Catholic and left-wing sub-cultures, which also served as networks of material assistance. Over the years, in the Catholic Veneto as in the 'red belt' of Emilia and Tuscany, uninterrupted party control of local government and such party affiliated bodies reinforced each other and provided opportunities for economic and social activities. For the Communists in particular, the capacity to articulate the interests of the working class and peasantry through such organizations was an essential part of their defence against governmental and industrial attack. By the 1960s, the growing evidence of corruption surrounding the Christian Democrat monopoly of national power pointed up the contrast with the efficiency of Communist local administration.[6]

At its peak, the Cold War provided the Christian Democrat leaders with an ideological justification for their aim of obtaining an absolute majority and of 'reconquering' Italian society with Catholic values. The political objective was nearly reached in the 1948 elections, when the DC increased its share of votes to forty-eight per cent, but the attempt backfired in the 1953 elections because the government had

4 C. Pinzani, 'L'Italia Repubblicana', in *Storia d'Italia*, vol. 4, part 3, *Dall'Unità a Oggi*, Turin, 1976.

5 Giorgio Galli, *Il Bipartitismo Imperfetto*, Bologna, 1966.

6 Paradoxically, by the 1970s 'red' Bologna under its mayor, the historian Renato Zangheri, was raised by American political scientists to the level of a paradigm of effective and upright local government.

tried to modify the electoral law to its own advantage. The ideological drive led to the imposition of Catholic doctrines throughout all sections of Italian society, from education (obligatory religious instruction in schools) to culture (film censorship) and judicial practice (prohibition of divorce). The very force of this campaign, with political broadcasts by Father Lombardi (known as 'God's microphone'), a wholly conformist radio and, from 1954, television network and highly vocal propaganda to protect Rome from outward signs of immorality, gave Italy the appearance of a clergy-dominated society, comparable in the 1950s only with Spain and Portugal. In retrospect, the DC and its allies were fighting a losing battle against the inevitable secularization of society resulting from economic and social changes.

Such Catholic integralist practices only consolidated the opposition of the great majority of intellectuals. Indeed, Italian culture, so lively in these decades, was notable for the absence of Catholic inspiration. Despite Rossellini's affirmation of his Catholic motivation, for example, his reputation and influence were hardly dependent on his one overtly religious film, *Francesco giullare di Dio* (*The Flowers of St. Francis*, 1950). It is arguable that, by driving all lay intellectuals, including non-Communists, into opposition, the revival of anti-clericalism weakened the government's attempt to isolate the Communists. This acquired particular importance in the late 1950s, when some of the consequences of uninterrupted Christian Democrat rule became clear. The growing evidence of political corruption, the close connections between Italian capitalism, government and bureaucracy, the ever more apparent backwardness of a politically manipulated south, the incapacity of government to cope with the enormous social consequences of rapid economic growth . . . all attracted increasing criticism among intellectuals and leaders of taste in cultural matters, confusing and weakening the efficacy of the anti-Marxist crusade.

The irrevocable transformation of Italian society became dramatically visible in 1960 with mass public demonstrations against the attempt of a DC leader, Fernando Tambroni, to set up a government dependent on neo-Fascist support. With the end of the economic miracle, the scale of the social disequilibria to which it had given rise necessitated urgent state intervention. Nenni's Socialist Party had been gradually detaching itself from the PCI. Socialism was associated with planning in the political language of the early 1960s, and the entry of the PSI into government promised both stronger economic direction and a broadening of the parliamentary base of support. In the event, the painful transition from 'centrist' to 'centre-left' coalitions, finally achieved by the DC leader Aldo Moro in 1963, failed to fulfil the great hopes placed in the Socialist assumption of governmental responsibility. Economic planning achieved only the nationalization of the electricity sector, while the PSI, representing no more than thirteen per cent of the electorate before its left wing seceded, not surprisingly failed to stem the DC's control or even influence its style of government. Perhaps the most visible effects of this new phase of Italian political life were the revelation of wide-scale corruption and the alacrity with which the local PSI cadres took to the fruits of power. The disillusionment caused by the failure of this left-wing alternative to the PCI was a contributory factor in the revolt of 1968.

Yet it would be misleading to explain the wholly unexpected and profound crisis of 1968 simply in terms of disillusionment with the parties in government. If 1968 represents a major watershed in the history of post-war Italy, its fundamental causes must be located in the structural changes within Italian society as well as in the manifest lack of imagination of a political system characterized (even after the opening to the left) by immobility in meeting the new needs.

The rapidity and profundity of the transformation cannot be exaggerated. Migration was no new phenomenon in Italy, and western Europe provided a constant demand for labour in the 1950s. However, with the acceleration of industrial growth, internal migration from south to north assumed hitherto unimagined dimensions. In the decade following 1951, 1.75 million people (ten per cent of the inhabitants) emigrated from the south, with another 2.3 million by 1971. The 'southern question', which had accompanied Italy's history since unification, was suddenly transformed from one of over-population to one of agriculture and villages

Fig. 6 Carlo Levi, Election poster for the Italian Socialist Party, 1953. Museo Risorgimento, Milan

Fig. 7 Student demonstrators on the 25th anniversary of the liberation from Fascism, Milan, 25 April 1970

abandoned to women, children and the old (Fig. 6). Populations exploded in the cities of the north: Turin, Fiat's capital, doubled in size in fifteen years, with 700,000 southern immigrants, and Rome grew from 1.6 million in 1951 to 2.75 million in 1971. Public housing, schools, hospitals, lighting, transport, sewage were provided belatedly, inadequately and often begrudgingly. Northern politicians continued to run local administration and did little to dampen down the traditional hostility and contempt for southerners. Bureaucracy and employment in the public sector increased in size but failed in services. Visconti's *Rocco e i suoi fratelli (Rocco and His Brothers*, 1960) dramatically portrayed the squalor of this novel process of urbanization.

Politically, the PCI opposition was strengthened by such mass immigration in the cities. In the factories, by contrast, the huge increase in unskilled labour and changes in work methods weakened the unions' contact with most workers and understanding of their needs. As in France, the unions were taken by surprise by the workers' demonstrations in 1968, although they identified remarkably quickly with the new demands.

Economic growth and urbanization brought rapidly rising personal incomes and expectations. With better food and piped water, health improved. With the abandonment of agriculture, large family households became ever less common; young couples set up as independent residential units and the birth rate declined. Television (with over four million licence-holders in 1963), motor-scooters and cars increased the urban noise level and spread their messages of modernity. Above all, religious values underwent a crisis as secularization accelerated: between 1956 and 1968, weekly church attendance fell from sixty-nine to forty-eight per cent of all adults; recruitment to the priesthood slumped sharply. As Pope John XXIII (1958-63) began to disengage the Italian Church from heavy intervention in politics, the clerical wing of Christian Democracy lost ground.

The revolt of 1968, in Italy as in France and the United States, began with demonstrations by university students. In the universities, protests and sit-ins directed at the inadequacies of libraries, lecture rooms and teachers had occurred well before the famous 'May Days' in Paris. Thus the immediate explanation for the revolt can be found in the failure of the universities as an institution to anticipate the needs occasioned by the increase in student numbers. Yet the deeper causes are to be found in the cultural changes of the previous years. Italy has always been a culturally open society, eager to absorb the intellectual production of other countries and, if anything, too modest about its own achievements. Except in the natural sciences, the universities had long ceased to act as transmitters of foreign culture. Commercial publishers, especially Einaudi and Feltrinelli, were responsible for offering to the educated (and less educated) the best of Italian and foreign writings in the social and human sciences, literature and the arts. They provided the student leaders of 1968 with remarkable cultural depth. The anti-Fascist, lay credo prevalent among the older generation of intellectuals seemed inadequate in the newly capitalist Italy. The elitism implicit in their insistence on cultural independence was condemned in a reading of Gramsci's model of 'organic intellectuals' that stressed, as a style of life, practical everyday collaboration with politically conscious workers.

1968 was not just a student revolt, nor did its participants contest the universities only (Fig. 7). It spread rapidly and with a high degree of spontaneity to the workers and the middle-class supporters of the left. It challenged the entire 'system' – not just the Christian Democrats but the PCI, not just the capitalists but the unions, not just American imperialism in Vietnam but the Italian state, not just the Church but the family, not just the universities but the central values of Western development since the war. In Italy, as elsewhere, the protest movements of 1968 failed to overthrow the 'system'. Nonetheless, their repercussions were felt long after, among the younger generations perhaps more on the individual and cultural level than on the political level. For 1968 marked a generational change.

Mario De Micheli

Realism and the Post-war Debate

The years immediately following the Second World War were marked by an impassioned and wide-ranging artistic debate, a deeply rooted cultural crisis that did not suddenly emerge after 1945. Its origins dated to the period preceding the outbreak of war and it matured in the heat of the Resistance, a fact that should not be overlooked in reviewing the various aspects the debate presented during the post-war decade.

It is to the credit of a younger generation of intellectuals, artists and critics who reached maturity in the second decade of Fascism to have questioned and ultimately rejected the regime's politics of cultural autarchy. In an effort to break with this chauvinism, they sought a renewed rapport with Europe, in particular with its cultural developments of the previous half-century. They not only rejected classicizing tendencies with rhetorical, nationalistic overtones, but also those modes of representation which were not sufficiently concerned with the destiny of humanity. Hence, the Metaphysical art of Giorgio de Chirico was judged too elusive, and the paradigms of abstraction were considered too aesthetic. The common stylistic ground of these various artists was a generic Expressionism, sometimes vaguely lyrical or dramatic, sometimes imbued with a sense of resolute protest.

These positions, together with an urgent desire to overcome provincialism, were promulgated in the journal *Corrente*, which was published in Milan between January 1938 and May 1940. In its pages many Italians read for the first time names such as Jean-Paul Sartre, Martin Heidegger and Ludwig Klages; Paul Hindemith, Bela Bartok and Arnold Schoenberg; Franz Kafka, James Joyce and Ernest Hemingway – not to mention the poetry of Sergey Esenin, Garcia Lorca and T. S. Eliot, and of the Italians Eugenio Montale and Salvatore Quasimodo. The most lively and progressive forces in various parts of the country came together in *Corrente*. Above all, it served as a vehicle of organization for artists and intellectuals of diverse points of view who were united in their repudiation of the stifling cultural climate of the Fascist regime.[1]

At the beginning of the war, however, a group within *Corrente* felt impelled to draw up a more precise set of tenets with more than aesthetic implications. A document drafted between the closing weeks of 1942 and the first weeks of 1943 is fundamental to an understanding of many of the positions taken up immediately after the war. It was a true manifesto and would have been published as such but for certain arrests carried out by the police. Among the contributors to the statement were the painters Ennio Morlotti, Ernesto Treccani, Emilio Vedova, Bruno Cassinari; the critics Raffaele De Grada and Mario De Micheli; and, from Rome, Renato Guttuso, who had always maintained close links with the *Corrente* group.

Among other things, the manifesto declared: 'We want to discuss the revolutionary function of painting. We don't want painting about painting, as is the conceit of certain recent tendencies, but painting that is like a common bond, a means of finding a common identity. . . . It matters to us that popular images serve as the basis of our pictorial language. . . . We accuse Italian painting of the previous generation of not taking account of life With our painting we are going to hoist flags!'[2]

The manifesto already proclaimed the premises of Realism in an explicit manner, a fact that needs stressing in order to refute critical interpretations that tend to explain Italian Realism as a product of Communist party intervention. But what sort of Realism was contemplated at that time? A text issued in the underground press stated: 'a veristic or naturalistic interpretation of Realism must be avoided if one is not to fall into the same error as Aragon, the error of "Social Realism".'[3]

1 The relative freedom which *Corrente* enjoyed for over two years was due to the family connections of its editor, the young Ernesto Treccani. His father had founded the famous *Encyclopedia Italiana* under the general editorship of the Fascist philosopher Giovanni Gentile, and this guaranteed a certain political cover. After the regime's suppression of the review in May 1940, *Corrente* devoted its energies to publishing books, among them the poetry anthologies *Lirici spagnoli e sudamericani*, edited by Carlo Bo, and *Lirici graci*, translated by Quasimodo (who later received the Nobel Prize for literature), and also *L'Occhio quadrato* by A. Lattuada, an album of photographs that foreshadowed certain aspects of Realism in the cinema. At the same time *Corrente* opened an art gallery which exhibited the works of Aligi Sassu, Renato Birolli, Giuseppe Migneco, Bruno Cassinari and others.

2 The 'manifesto' is quoted in E. Treccani, *Arte per amore*, Milan, 1978, p. 34. It included the statement: 'We recognize ourselves only in love and hate. Picasso in 1937 posed this problem. We look to Picasso as the most authentic example of those who have invested completely in life The images of this painter are a provocation and a flag for thousands of men.'

3 M. De Micheli, 'Realismo e poesia', *Il '45*, no. 1, Milan, February 1946. Among the contributors to this review, of which there were only three numbers, were R. De Grada, De Micheli, A. Gatto, Guttuso, Cassinari, Morlotti, Treccani, E. Vittorini and S. Terra.

The emblematic work of art for this group of artists was Pablo Picasso's *Guernica*, a painting that unequivocally aligned itself with humanity against the abuses of history. Such an example could not, however, be accepted by artists still employing the pictorial language of Van Gogh or an Expressionism interlaced with subtle allusions, as was the case with, for instance, Renato Birolli , for instance, Renato Birolli and Vedova. This difference in orientation signalled the beginning of a profound disagreement that would eventually divide the members of *Corrente* as well as the vast majority of Italian artists after the war.[4]

Meanwhile, the war had been a strong unifying force. Artists, critics and various intellectuals opposed to the Fascist regime made common cause with the Resistance, which was largely driven by, and composed of, members of the Communist party. Partisans fought in the mountains or were active in the cities; many were imprisoned and suffered in concentration camps, and many sacrificed their lives. Such experiences left a profound mark on a great number of artists and their work. Birolli and Guttuso, so divided in their artistic viewpoints, were unwittingly reconciled in their cycles of drawings that documented the crimes committed during the Nazi occupation.[5]

The end of the war ushered in a new epoch. The artistic confrontations and debates began in Rome, which had been liberated on 4 June 1944. Despite doubts and hesitations about the appropriate stylistic means, every artist felt the unquestioning need for a social and political commitment that would address problems with concrete action. This was also the attitude of those who would later choose the path of abstract art. A painter such as Achille Perilli, for example, wrote in October 1945: 'Today, the young artist, free of old prejudices and strengthened by past experiences, wants to get back to reality, to turn again to landscapes and to the figure, and extract both harmony and, above all, sentiment from these new motifs.'[6] In a similar spirit, the *Arte Sociale* group founded a small review, *La Fabbrica*, in August 1946. Here an artist like Piero Dorazio could write frankly popular verse on life in the urban periphery: 'This is how men are living now/Their overalls filthy with grease....'[7]

In Rome in 1947, Perilli and Dorazio, together with the painter Giulio Turcato and the sculptor Pietro Consagra, founded the monthly *Forma I*, which in April of that year published a manifesto of abstract art. Although the choice the *Forma* artists had made was an aesthetic one – a clear rejection of Realism in favour of the pure expressive values of line, form and colour – they still formulated their artistic task in terms of political commitment: 'We declare ourselves to be FORMALISTS and MARXISTS, convinced that the terms Marxism and Formalism are not irreconcilable, especially today when the progressive elements in our society have to maintain a REVOLUTIONARY and AVANT-GARDE position....'[8] Such convictions were held by other groups of non-figurative artists, such as the so-called Classical Abstractionists based in Florence, whose manifesto proclaimed: 'We invite artists to take stock of their position in society and ask themselves for whom are they working, what sort of man does their art speak for, what kind of relationship is he capable of – in short, what are their intuitions? We invite them to leave their studios and descend among the living, among those to whom the future belongs.'[9]

Lively arguments also went on in the north, which had won its freedom later, in April 1945. Elio Vittorini's journal *Il Politecnico* served as a forum for the discussion of the intellectual's role in the construction of post-war society. Vittorini himself advocated a non-conformist culture that was not subject to the demands of any political ideology, an opinion that led to a debate in the press with the leader of the Communist party, Palmiro Togliatti. Other reviews focused more specifically on the problems of art, such as *Il '45*, *Numero* and *Pittura*, whose pages hosted many of the names that had appeared in *Corrente*.[10] The dilemma of Realism was felt more acutely among the Milanese artists. In the 'Manifesto del Realismo', published in *Numero* in March 1946, the signatures of Morlotti and Vedova appeared alongside those of several younger artists. The manifesto was largely theoretical, taking the question of political commitment for granted and skirting the issue of coherent

4 Birolli in his diary at the time wrote against this politically motivated choice of Picasso: 'Polemics for the Picassoists.... But there is no point in eating with one's fingers if there's a spoon handy, nor in turning Picasso into a Marat. Here they're making a great mistake.' R. Birolli, *Taccuini*, Turin, 1960, p. 174.

5 Guttuso, in Rome, drew scenes of the German massacres in the Ardeatine Caves. The drawings were later published as *Gott mit Uns* by La Margherita, Rome, 1944, with a preface by Antonello Trombadori. Birolli, on the other hand, drew the dramatic events of the Nazi occupation in the countryside round Milan. These drawings were published in 1952 under the title *Italia 1944*. On the subject of drawings devoted to the Resistance, see M. De Micheli, *Disegni della Resistenza*, Milan, 1986.

6 A. Perilli, 'Spunti', in *Ariele*, Rome, October 1945.

7 P. Dorazio, 'Ode alla periferia', *La Fabbrica*, no. 1, Rome, August 1946.

8 *Forma I*, Rome, April 1947. The other signatories were Mino Guerrini, Ugo Attardi, Antonio Sanfilippo and Carla Accardi.

9 De Micheli, *Disegni della Resistenza*, p. 10.

10 The life of these reviews was somewhat brief. *Il '45*, which came out in February 1946, folded in May of the same year; *Numero*, born in December 1945, finished in April 1946; *Pittura*, which appeared in December 1946, closed in August 1947. Each one published only three or four numbers. *Il Politecnico* was published in two series, from September 1945 to April 1946 and May 1946 to December 1947.

11 At the head of the manifesto appeared quotations from Cézanne and Picasso. The first announced 'a new era in art'. The second ended with the famous sentence: 'Painting is not made for decorating apartments. It is an offensive and defensive instrument of war against the enemy.'

12 L. Ferrante, *Arte e realtà*, Venice, 1952.

13 *Rinascita*, Rome, October 1948.

implementation. Despite the authoritative tone, the ideas it contained were inherently problematic; it claimed, for example, that 'reality exists objectively', while at the same time arguing that 'in art, reality is not the real, nor is it visible phenomena, but the conscious sensation of becoming one with reality'. Realism, therefore, was not 'Naturalism, Verism or Expressionism, but when one's concrete apprehension of the world determines, shares, coincides and corresponds with the reality of others, when it becomes, in short, a common measure with respect to reality itself'.[11]

The programme of this manifesto, which is better known by the title 'Oltre Guernica' (Beyond Guernica) was quite different from that put forward by the Roman *Forma*. Indeed, the statement from Milan, with its acceptance of figurative modes of expression, revealed the legacy of *Corrente* and the desire to retain the complexity of an experience that had involved so many artists. There were several initiatives to keep together this fundamentally heterogeneous group (which included a stylistic range from Cubo-Expressionism to Naturalism), the most important being the *Fronte Nuovo delle Arti* of 1947, which comprised twelve prominent artists: Birolli, Guttuso, Morlotti, Vedova, Turcato, Antonio Corpora, Nino Franchina, Pericle Fazzini, Giuseppe Santomaso, Armando Pizzinato, Alberto Viani and Leoncillo Leonardi. The *Fronte* was, in turn, a re-organized version of the *Nuova Secessione Italiana*, which had been founded in September 1945 and had included Carlo Levi and Cassinari. Unlike 'Oltre Guernica', which mentioned certain formal and technical criteria, the manifesto of the *Secessione* had proposed only a common ethical platform – namely, a recognition of the artist's moral responsibility – to the exclusion of any particular *a priori* aesthetic that would hinder the future evolution of a style. The manifesto stated: 'Eleven Italian artists intend to converge their apparently contrasting tendencies in a synthesis that will emerge in the future, substituting an aesthetic of forms by a dialectic of forms, in sharp contrast to all the preceding syntheses, which were governed by technical or at least *a priori* decisions. . . . Art is not the conventional face of history, but history itself, which cannot exist without men.'[12]

Fronte Nuovo delle Arti organized its first show in Milan in 1947. The general introduction to the catalogue was written by the critic Giuseppe Marchiori, who revived the themes of the 1945 manifesto and stressed that the *Fronte* was not a conventional group since each artist was responding 'with his own work and his own aesthetic individuality'. Yet it is highly revealing to examine the critical presentations of the various artists and discern the common cultural background, despite the diversity of styles. Lionello Venturi introduced Guttuso, Giulio Carlo Argan wrote about Birolli, Alberto Moravia on Leoncillo, Marchiori on Pizzinato and Vedova, Corrado Maltese on Franchina and Turcato. The pervasive themes of the Resistance – cooperation and unity – still persuaded critics and artists, despite the internal contradictions of the *Fronte*, to maintain the mutual understanding forged in the dark years of Fascism and the war. The *Fronte* was the last manifestation of this solidarity, and received international recognition at the Venice Biennale of 1948.

In the same year, an episode occurred that profoundly altered the tolerant mood and the non-alignment of style with political ideology. Many of the artists mentioned so far were Communists or Communist sympathizers. The Communist party enjoyed a great deal of prestige among intellectuals, and its cultural policy (the only one clearly articulated by an Italian party) was ostensibly opposed to favouring any one artistic tendency. The comment published by the party's official journal, *Rinascita*, on the 'Prima mostra nazionale d'arte contemporanea' held at the Alleanza della Cultura in Bologna that autumn therefore came as a shock. It was scathing about the exhibition (which contained work by many *Fronte* and *Forma* artists) and effectively denied any possibilities for modernist painting and sculpture. 'How can one call this stuff "art" or even "new art",' it asked, 'and how could they ever find in Bologna. . . . so many worthy people willing to use their authority to endorse publicly this exhibition of horrors and imbecilities as an artistic event?'[13]

Although brief and clearly written in haste, the review had weighty consequences, for it was signed 'Roderigo di Castiglia', known to be the pseudonym of

Togliatti himself. Artists reacted immediately, beginning with a letter in the next number of *Rinascita*, signed by a group of Communists that included Guttuso, Mario Mafai, Turcato, Leoncillo and Consagra. Among other things, the letter declared:

> We know well that we must free ourselves from intellectualized positions of art without content, of a solitary and pessimistic art detached from the problems of the world.... But we do not wish to proceed from simplistic *tabulae rasae*, throwing out the grain with the chaff or the baby with the bath water. We want to enrich our recent experiences with the expressive possibilities of an art which should truly become one with the just struggle of the working class.... it would be evading this struggle, or at least limiting it to a marginal exercise, not putting it in focus, to exclude what are historically the most advanced tendencies in contemporary art.[14]

Without question the letter spoke for the majority of artists determined to change the state of Italian art. Beyond this general conviction, however, there was an equally strong movement pressing for novelty of formal invention as against explicitness of content; and it is here that opinions began to diverge. At the exhibition in Bologna a series of debates took place, leading to harsh confrontations that were sometimes marked by intransigence and intolerance. The true end of the *Fronte* can be traced to the bitterness of those debates.

Meanwhile, the political situation was undergoing a profound transformation. In the first half of 1947, the pact which had bound the various anti-Fascist parties together during the Resistance came to an end and the Communists were expelled from Alcide De Gasperi's cabinet and the Christian Democrat coalition government. At the same time, the Cold War was threatening, while on the domestic front agitation by factory workers and peasants began to assume the proportions of a vast popular movement. Against the background of these events aesthetic positions became more extreme. If from 1945 to 1948 artists such as Morlotti, Birolli and Turcato had continued to include figurative elements in, for example, *Donna che si lava* (*Woman Bathing*), *Contadino con pannocchie* (*Peasant with Corncobs*; Fig. 1), both of 1946, and *Comizio* (*Meeting*) of 1948, now the representational component tended to disappear in favour of a more allusive and abstract formalism. By contrast, the Realists' images became increasingly explicit in subject-matter, rapidly expanding their persuasive power. Guttuso and Pizzinato had disassociated themselves from the *Fronte* and had already gathered numerous other artists, including some of the younger generation, to their cause.

The Realist movement was thus fuelled by the contemporary socio-political context, by the artists' active participation in the new democratic life of the country.

Fig. 1 Renato Birolli, *Peasant with Corncobs*, 1946. Museo del Premio Guzzara, Parma

Fig. 2 Renato Guttuso, *Occupation of Uncultivated Land in Sicily*, 1949-50. Gemäldegalerie Neue Meister, Dresden

14 *Rinascita*, December 1948.
15 See the novels of Vasco Pratolini and Pier
 Paolo Pasolini's *Le ceneri di Gramsci*; also, the
 films of Vittorio De Sica and Roberto
 Rossellini.
16 Letter from Guttuso to Morlotti, reprinted in
 M. De Micheli, '*Occupazione della terre incolte* di
 Renato Guttuso', in *Le circostanze dell'arte*,
 Genoa, 1987, pp. 242-3.

The Realists aligned themselves with the Communist party, like many other intellectuals who believed it to be the most effective and innovative force, capable of transforming the history of the nation. This allegiance was quite natural and spontaneous, a logical outcome of a consensus that had been nurtured in the pre-war period and strengthened during the years of armed conflict. It could be argued that the Realists elected the Communist party as their politico-cultural representative, rather than the other way round, even if it is not difficult to understand why Realism, in turn, was favoured by the party.

In all its manifestations Realism was undoubtedly the most forceful movement of the immediate post-war period, attracting followers not only in the fine arts, but also in literature and the cinema.[15] In June 1952, the first number of the journal *Realismo* was published in Milan and became the official organ of the movement. The Realists sought a creative means of overcoming that traditional gulf between art and the masses which had characterized modern Italian culture, sought a language of broad communication that was capable of expressing the values implicit in the country's democratic development, without compromising aesthetic standards. Peasants in the south confiscating uncultivated landed estates to plough and render them productive, factory workers in the north striking for better working conditions . . . these provided unprecedented themes for a politically committed art. As Guttuso had written in 1943:

> I think more and more of painting that can function as a wrenching scream, a manifestation of rage, of love or of justice, on the corners of the streets and in the angles of the city squares, rather than in the sad atmosphere of the museum, where a few specialists go once in a while to find it. Every question comes down to this: the amount of living flesh that can be put into a picture or a book. Art isn't made out of thanks to God or as a means of revelation, etc. God doesn't count; only we ourselves and the amount of blood, intelligence and moral life that is thrown into it.[16]

The seminal work in this genre, and one which the artist considered to be his first politically committed canvas, was Guttuso's *Fuga dall'Etna* (*Flight from Etna*; Cat. 147), completed in 1940. The idea for the painting had come to Guttuso a year earlier, when he had returned to Sicily after military service and subsequently shared a studio with Lucio Fontana and Italo Valenti in Milan. In 1940, the picture was exhibited at the 'Premio Bergamo', where the image of peasants running in confusion, fleeing from the incandescent lava that flowed in currents of red against their shoulders ended up stealing the show. It aroused exceptional interest among the more advanced critics and younger artists, who were seeking a means of combatting conformism and academicism; here, Guttuso's 'Caravaggesque manner' and 'underlying ethnic and popular meanings' were mentioned for the first time.

Fig. 3 Armando Pizzinato, *A Spectre Stalks Europe*, 1948. Collection of the artist, Venice

Fig. 4 Giuseppe Zigaina, *Meeting of Day-Labourers on Cormor Hill*, 1952. Collection of the artist, Cervignano (Friuli)

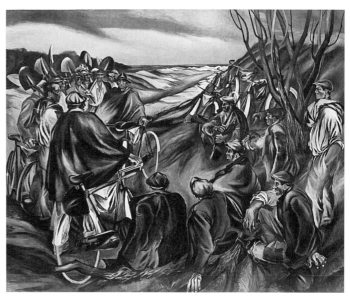

Guttuso was closely bound to his native Sicily, to its landscape, people and history. From an early age he was acquainted with the difficult conditions of the island's workers. In the post-war years, he personally followed events in Sicily; he returned there repeatedly, to the peasants in the countryside, the miners in the province of Caltanisetta, the stevedores in the ports. It was the theme of the peasantry, however, which attracted Guttuso's particular interest between 1945 and 1953. If it is true that the peasant movement in the post-war years resembled a sort of 'Resistance' in the south, it is also true that such movements had existed in Sicily for decades. But after the war, the *'Mezzogiorno* question', which had always been a subject of inquiry and debate among intellectuals, finally took on concrete force with the participation of the workers and peasants themselves, providing the Realists with one of their most passionate and persuasive themes.[17]

The energetic presence of the Realist artists was felt most vividly in the national exhibitions, beginning with the Venice Biennale of 1950. This was the Biennale of Realism. Guttuso showed his enormous canvas *Occupazione delle terre incolte in Sicilia* (*Occupation of Uncultivated Land in Sicily*; Fig. 2), in which he abandoned the Cubist syntax that had previously dominated his work. His paintings at this Biennale inaugurated a smoother, less schematic style, which he continued to refine for the rest of his career.

Another picture which excited particular interest was *Un fantasma percorre l'Europa* (*A Spectre Stalks Europe*; Fig. 3), painted by Pizzinato in 1948 for the centenary of the Communist manifesto. Here workers of the earth and of the machine were placed within an aggressive rhythm of Constructivist and Cubo-Futurist elements, endowing the call to revolution with a dynamic, incisive force. Giuseppe Zigaina (Fig. 4), a Realist of the younger generation, attracted much attention with his image of the occupation of the land, this time in the north. He rendered the day-labourers marching close together, bicycles at their sides, scythes held aloft, in strident reds and greens made more violent by the post-Cubist angularity of the forms. Other Realists included Franco Francese, Renzo Vespignani, Alberto Sughi, Augusto Perez and Fernando Farulli. The Biennale of 1952 devoted a room to Agenore Fabbri, whose polychrome terracotta figures were the colour of lacerated flesh, metaphors of anger and suffering (Fig. 5). At the following Biennale Levi had a one-man exhibition, filled from floor to ceiling with the sad and knowing faces of the peasants of Calabria and Lucania, whom he had first encountered during his confinement in the south in 1935-6 (Fig. 6). As in his literary masterpiece, *Cristo si è fermato a Eboli* (*Christ Stopped at Eboli*, 1945), he documented an unpublished piece of Italian history in a manner free from aestheticism or exoticism. Among the other significant visual manifestos of Italian Realism were Treccani's *Ritorno a Fragalà* (*Return to Fragalà*, 1953) and

17 Ibid., pp. 242, 245.

Fig. 5 Agenore Fabbri, *War Cat*, 1948. Private collection, Milan

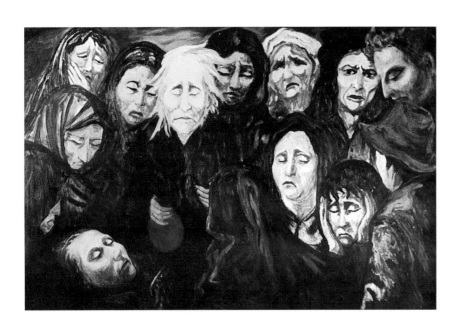

Fig. 6 Carlo Levi, *Mourning for Rocco Scotellaro*, 1954. Fondazione Carlo Levi, Rome

Fig. 7 Giuseppe Migneco, *Lemon-Pickers*, 1951.
Private collection, Turin

18 L. Venturi, *Otto Pittori Italiani*, Rome, 1952,
p. 7.

La terra di Melissa (*The Land of Melissa*, 1955), Guttuso's *Boogie-Woogie* (1953), Zigaina's *La spiaggia* (*The Beach*, 1956) and the series of harsh images of Sicilian peasants by Giuseppe Migneco (Fig. 7).

The Realists were digging themselves into an entrenched position, especially in reaction to growing critical hostility; as a result, they also isolated themselves from international developments in the figurative arts. By 1955, more than one Realist artist had perceived the necessity of modifying what was becoming a rather uncompromising stance. Nonetheless, the movement continued to hold together until the dramatic events in Eastern Europe and the Soviet invasion of Hungary in 1956, which precipitated a crisis within the Italian Communist party. A tangible sign of the times was the closing of the review *Realismo* that year. Without a central point of reference, artists were thrown back on their own resources and independent resolutions of aesthetic issues.

In truth, the post-war climate had ended and, with it, the period of groups and manifestos. From the opposite camp, the *Gruppo degli Otto* had appeared at the Biennale of 1952, gathering the remaining artists from the disbanded *Fronte Nuovo delle Arti* under its auspices: Afro Basaldella, Birolli, Corpora, Morlotti, Mattia Moreni, Santomaso, Turcato and Vedova. Lionello Venturi presented this new coalition of non-figurative painters, underlining the values of autonomy and liberty, perhaps even more than certain abstract artists of the group would have cared to contemplate:

> These painters are not, and do not wish to be considered, 'abstract' painters; nor are they, or do they wish to be considered, 'realistic'. Instead, they propose to break away from the contradictions inherent in these two terms, contradictions which tend, on the one hand, to reduce abstraction to a new mannerism and, on the other, to give priority to political considerations, which can only lead to the disintegration of artistic freedom and spontaneity.[18]

In the following decade, the terms of the debate changed, initiating the styles and concepts of present-day artistic currents. The immediate post-war period can now be judged with greater detachment and historical objectivity, while the polemics and polarization of those years have given way to a pluralism and tolerant acceptance of diverse forms of expression.

Maurizio Calvesi

Informel and Abstraction in Italian Art of the Fifties

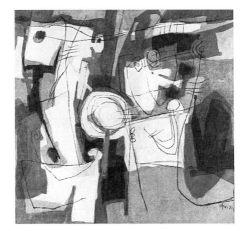

Fig. 1 Afro Basaldella, *Exemplary No. 3: Villa Fleurent*, 1952. Museo d'Arte Moderna, Ca' Pesaro, Venice

In the early sixties, an exhibition entitled 'L'Informale in Italia fino al 1957' (*Art Informel* in Italy until 1957) was organized in the city of Livorno.[1] The exhibition aimed at surveying those trends in Italian art which could be seen as authentic interpretations of *Art Informel*. The year 1957 was chosen as a closing date because afterwards, *Informel* spread throughout Italy, losing its shocking novelty. In the wake of the exhibition, and in part owing to the fact that many paintings had been backdated by some of the artists, the impression arose that *Informel* had already been a widespread phenomenon in the early 1950s, contemporaneous with other developments in pure abstraction.

In fact, the history of *Informel* in Italy unfolded rather differently. Until 1957, geometric, or 'post-Cubist', forms dominated non-figurative art, as exemplified by the so-called *Astratto-Concreto* (Abstract-Concrete) movement, led by the critic Lionello Venturi.[2] This style offered a 'hot' version of abstraction, using naturalistic colours and an atmospheric luminosity that evoked landscapes and narrative situations, memories and emotions of the real world. This was the central stylistic current of the decade; its most characteristic exponents were the painters Afro Basaldella (Fig. 1), Renato Birolli, Antonio Corpora, Filippo Santomaso, Antonio Scordia and Enzo Brunori. Around 1957-8, these artists began to evolve a richer impasto, to render the outlines of their forms more indistinct and to mark and scratch the surfaces of their canvases. Nevertheless, their images preserved the evocative quality of *Astratto-Concreto*, and cannot be confused with *Informel*.

What, then, is the true hallmark of *Informel*? Let me repeat the definition I proposed on the occasion of the exhibition in Livorno. *Informel* is not simply a synonym for 'without form', but signifies 'nonformal'; it implies the negation of form as a category or value that remains distinct from reality, even though it may represent it. It denies the idea of form as something created according to plan.

Instead, *Informel* is dominated by the direct communication of the 'sign', the artist's gesture; it is an instant immersion in reality itself. The gesture is the direct trace of the living presence of the artist; the material does not evolve into form, but remains pure action, a sign of reality in ferment. No longer a screen for an image (be it figurative or abstract), the canvas becomes the scene of an existential encounter between the artist and the world; it is the field of his 'action', from which it derives its new value and importance. Italian *Informel* never presented a uniform appearance, was never dominated by one particular style. Rather, it was marked by a variety of approaches, as a survey of its various protagonists will make clear.

In the early fifties, a few Italian artists could be seen as part of the larger international development towards *Informel*. Michel Tapié's book *Un Art Autre*, published in Paris in 1952, was the first critical text to offer a survey (albeit a very partial one) of the nascent *Informel* movement. He included reproductions of works by the Italians Giuseppe Capogrossi and Gianni Dova, as well as examples by two artists of the older generation, Mario Sironi and Marino Marini. The latter were still tied to the figurative culture of the inter-war years, despite the presence of a rough materiality of paint and a loose gestural quality in their work. They provided an approximate stylistic precedent but, strictly speaking, did not belong to *Informel*.

Genuine Italian *Informel* was initiated by other artists, in particular, Alberto Burri, Lucio Fontana and Emilio Vedova. From the very beginning, the movement exhibited two distinct approaches: one involved the use of the emphatic gesture, in the manner of American Action painting, the other an original investigation into the

1 The exhibition, accompanied by a catalogue edited by M. Calvesi and D. Durbé, was held at the Palazzo Communale in Livorno in March-April 1963. The introductory text by M. Calvesi was reprinted in the author's collected essays, *Le due avanguardie: Dal Futurismo alla Pop Art*, Milan, 1966, pp. 204-42 (further editions, published in Bari, appeared in 1971, 1981 and 1984).

2 See L. Venturi, *Otto pittori italiani: Afro, Birolli, Corpora, Moreni, Morlotti, Santomaso, Turcato, Vedova*, Rome, 1952. This book launched the *Astratto-Concreto* movement, grouping together artists who embodied its aesthetics with others, such as Vedova, Turcato and Moreni, to whom they remained largely foreign.

material of paint that was more typical of European *Informel* proper. (The latter approach was nonetheless different from that of the French artist Jean Fautrier, who focused on thick, turbulent paint.) The originality of Italian *Informel* was also due to the presence of the Futurist tradition. This component (which can be discerned in different forms in the individual artists) is neither immediately recognizable nor marked by explicit quotations from the work of Umberto Boccioni or Giacomo Balla, but is part of an underlying cultural frame of reference.

Vedova was the most typical representative of the 'gestural sign', of Action painting, in Italy. In a series of drawings from the late 1930s, he employed a graphic style of thick, unordered marks, loosely inspired by Tintoretto and Piranesi. Around 1950, his rather static composition of forms developed into a dynamic network of lines, devoid of figurative allusions but nevertheless related to the Futurists' 'lines-of-force' (see Cat. 171). These lines were subsequently divested of all rigidity, becoming impetuous and dramatic marks that registered the action of the painter in his encounter with the canvas.

Vedova's style is distinguished from the Action painting of the American Abstract Expressionists by its dynamic charge, by a sense of drama that reaches beyond the canvas (see Cat. 172). Futurist 'dynamism' thus remained a specific precedent, even if the impulse was so internalized that, when it did break forth, it was with the force of an explosion. Rather than being a celebration of movement, machines or speed, Vedova's dynamism was a vehicle for ideological intervention, a furious will to violate and modify reality. In the early 1960s, Vedova created the *plurimi*, irregularly shaped, painted structures which jutted out into the surrounding space (Fig. 2). In this way, his canvases found a natural outlet for their expansive energy, forcing the viewer to 'enter the painting', as Boccioni had advocated earlier in the century.

By contrast, material itself comprised the artistic revolution initiated by Burri, who gained notoriety in the early fifties for his burlap pieces, the *Sacchi* (*Sacks*; Cat. 165-7). The novelty of his approach had international repercussions, influencing Robert Rauschenberg, who became acquainted with Burri in 1953 and visited his studio.[3] Although the use of found materials in place of painted colour and form had been anticipated in Cubist collages and in the Dada assemblages of Kurt Schwitters, Burri's invention was more radical, involving an unprecedented drama and sensibility. Here again, the Futurists provided an antecedent, in the shape of their 'polymaterialism'. The incorporation of diverse and unconventional materials was first employed by Boccioni, continued by Enrico Prampolini (a less imposing figure than Boccioni, but an extremely influential one; see Cat. 119) and developed by other Futurists to an extent unparalleled by the rest of the European avant-garde.[4]

Burri's *Sacchi*, and his later wood and iron pieces, surpassed all forerunners in expressive manipulation of material. The material itself became the protagonist, with the exposed seams, torn edges and folds of the burlap, the scorch marks of the *Legni* (*Wood pieces*; Cat. 168) and the grooves in the *Ferri* (*Iron pieces*). The painter intervened in the organic process of the material, his gesture becoming itself an act of consummation. This existential image of 'lived time', as if time were arrested in its all-consuming passage, engaged in a dialogue with Burri's rigid idea of space, achieved by his quietly monumental arrangement of the material. In this way, he reinstated a sense of form, not as a self-sufficient entity, but as a moment wrested from flux. With the passing of the years, the devastating novelty of the *Sacchi* has undoubtedly lost its edge, allowing their beauty to emerge more clearly. Yet it is a beauty deriving from the tension inherent in their component parts.

Another aspect of Futurism's legacy can be seen in the work of Fontana: the opening up of a new dimension of space-time and the reflection of cosmic flux (rather than existential philosophy) in art. In 1949, Fontana invented the *buco* (hole) punctured in the canvas, which he followed with the *taglio* (slash) (Cat. 154, 158). These actions offered an original interpretation of the artist's gesture which, instead of resting on the surface of the canvas, now broke through it. Fontana's action was not invested with the almost sadistic harshness characteristic of the wounds that Burri inflicted on his material. Instead, his gesture negated the function of the canvas as a

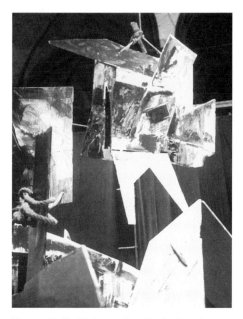

Fig. 2 Emilio Vedova, *Absurd Berlin Diary '64: Plurimo No. 5*, 1964, detail. Collection of the artist

3 Rauschenberg visited Burri's studio when he travelled to Italy in 1953 for his one-man shows in Florence, at the Galleria d'arte contemporanea, and Rome, at the Galleria dell'Obelisco. Burri had had two exhibitions at the same galleries the year before. He also had a one-man show at the Frumkin Gallery, Chicago, in April 1953 and at the Stable Gallery in New York during November of that year, and later showed in the 'Younger European Painters' exhibition at the Guggenheim Museum, New York (December 1953-February 1954).

4 See M. Calvesi, 'Il Futurismo e l'avanguardia europea', *La Biennale*, nos. 36-37, July-December 1959 (reprinted in *Le due avanguardie*, pp. 146-9), and idem, *Dinamismo e Simultaneità nella poetica Futurista*, Milan, 1967, pp. 161-92.

5 G. Balla and F. Depero, *Recostruzione futurista del universo*, March 1915; reprinted in E. Crispolti, *Recostruzione futurista del universo*, Turin, 1980, pp. 27-30.

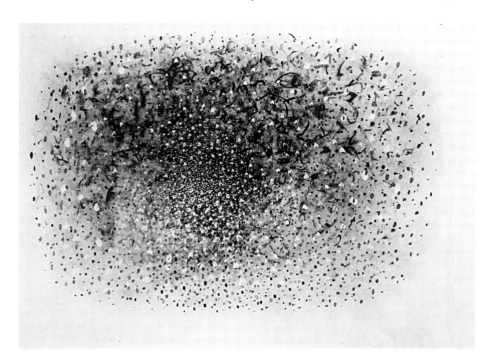

Fig. 4 Ettore Colla, *Pygmalion*, 1951-2. Courtesy
 of Galleria Christian Stein, Turin

screen, transforming it into a 'three-dimensional plane' that registered actions rather as radar registers the frequencies of boundless space. Fontana's holes often form constellations that evoke the sky punctured by stars and are accompanied by fluorescent pockets of sand like the surface of the moon or by pebbles scattered like the tail of a comet.

Rather than representing space as an abstract entity, a void, Fontana's punctures present it as a tangible phenomenon. With the unusual title of *concetti spaziali* (*spatial concepts*), his paintings give rise to a new figuration through the relationships between the canvas and the openings, and the number and rhythm of their groupings. These should not be interpreted, however, as simple relationships of solid-void or light-shadow, but as the result of a new opening in the very foundations of conventional pictorial space. Following these principles, in 1949 Fontana created his first *ambienti spaziali* (*spatial environments*), in which his characteristic slashed and punctured forms glowed suspended in the darkness, engaging the viewer in a new spatial dimension. This foreshadowed his installations of the 1950s, which incorporated neon light (Fig. 3, p. 296).

Fontana's initial forays into *Informel* were associated with the activities of the avant-garde in Milan in the early part of the decade: the *Spazialismo* (spatialism) and *Nucleare* (nuclear) movements. In 1951-2, the protagonists of these groups engaged in precocious experiments with paint either spilled on to the canvas (Dova, Enrico Baj, Sergio Dangelo) or worked up into intertwining spirals and all-over gestures (Roberto Crippa, Cesare Peverelli), arriving, for the most part, at free figuration. In 1953, Emilio Scanavino produced his characteristic spectral images and, a few years later, Arnaldo and Gio Pomodoro became the leading representatives of an abstract tendency in Italian sculpture. Although their organic treatment of material could be connected with *Informel*, their work, especially that of Gio Pomodoro, was rooted in a sense of full-bodied form.

One should also note the canvases of Tancredi Parmeggiani a painter who worked in Venice until his premature death in 1964. By the early 1950s, Tancredi had developed a personal *Informel* idiom characterized by luminously coloured gestures that were sometimes interwoven and sometimes scattered asunder like elements of a fantastic galaxy (Fig. 3).

In Rome, Burri was briefly attached to the *Gruppo Origine* in 1951, along with Mario Ballacco, Ettore Colla and Capogrossi. Of these artists, only the sculptor Colla can be linked with Burri. After a phase of geometric abstraction, Colla turned

to assemblages of discarded materials. His compositions of rusted scrap-metal, transformed into fanciful machinery, recall another Italian tradition – that of Metaphysical art. The strange conglomerations of gears suspended in time seem like a cross between the 'trophies' and mannequins of Giorgio de Chirico and the non-functional machines of Francis Picabia and Marcel Duchamp (Fig. 4). The impotence of the rigid gears stands in paradoxical contrast to the over-size, and normally dynamic, components of wheels, cranks and pistons. The sense of materials consumed by time, evoking a silent and immobile existence, links Colla's work with the aesthetic of *Art Informel* (see Cat. 175).

Pietro Consagra in Rome, Umberto Mastroianni in Turin and Alberto Viani in Venice led the renewal in Italian sculpture in the post-war years. Somewhat later, a new interest in sculpture as a parallel to poetry or music was seen in the work of Fausto Melotti, who had already been a pioneer of abstraction in the 1930s (see Cat. 133-6). Melotti's aerial forms, made of wire, nets and fabrics, were either completely abstract or narratives drawn from the observation of everyday reality and imbued with a delicate and amused astonishment. Melotti's sculptures, too, hark back to Futurism and the 'plastic complexes' created by Balla in 1915 from 'wire, cotton silk . . . metal nets . . . fabrics, metal sheets, coloured tin foils'.[5] Yet in Melotti's work, Futurist dynamism is replaced by harmonious equilibrium. Spontaneity and deliberation, horizontal and vertical, the straight line and the curve, are brought together in dialogue and balance, as Melotti manipulates his docile materials.

The paintings of Capogrossi, who also belonged to the *Gruppo Origine*, are among the most original examples of non-figurative art in post-war Italy. In 1949-50, Capogrossi extended the repertoire of abstract notation by inventing his characteristic 'comb' marks. Dilating, spreading and scattering in space, these activate the perception of phenomenal space beyond the plane of the canvas (Fig. 5).

Forays into abstraction began in Rome as early as 1947, with the founding of the group *Forma*, whose members included Giulio Turcato, Consagra, Achille Perilli, Piero Dorazio, Antonio Sanfilippo and Carla Accardi. Turcato, one of the most important figures in post-war Italian painting, is also one of the most difficult to classify. While connected with the *Astratta-Concreto* movement, he dabbled very briefly in geometric abstraction, but his subsequent work does not fit in comfortably with the definition of *Informel* given above because of a persistent narrative component. The continual variety of his forms has only one unifying characteristic: an extraordinary vital and original use of colour (see Cat. 163). This colouristic quality was already apparent in his early geometric configurations of the late 1940s, which combined Picasso's post-Cubist manner (particularly influential in Italy in the immediate post-war years) with the style of Balla's abstractions of 1915. From Balla, Turcato derived the motif of the triangle that 'penetrates' space (see Cat. 164). In his more mature work, the overall compositional grid disappeared in favour of a free arabesque of lines.

Fig. 6 Piero Dorazio, *Hand of Mercy*, 1963.
Galerie Springer, Berlin

Fig. 7 Toti Scialoja, *Rosa Rosae*, 1958. Collection
of the artist

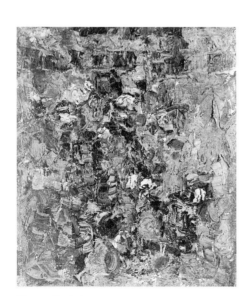

Fig. 8 Ennio Morlotti, *Autumn Countryside*, 1956.
Museo d'Arte Moderna, Ca' Pesaro,
Venice

Turcato evokes a space that is both emotive and metaphoric and alludes to the depth and light of the cosmos. He conjures up other worlds with porous, 'lunar' surfaces of paint, or astral journeys with the traces of his gestures. Other images have the quality of transient and ephemeral atmosphere, created by an intense luminosity of colour. Something of the Futurists' experimental spirit also survives in Turcato's metaphoric interpretation of painting as a limitless field of exploration.

Dorazio began with a rigorous analysis of form, modifying its expressive possibilities until he reached his mature style around 1959. The shapes of his coloured signs are varied, but they are always interwoven in patterns to create vibrations of uniform, luminous frequency (Fig. 6). Dorazio views art as a militant activity and is concerned to understand the conceptual and sensory essence of painting. In the early fifties, he visited the aged Balla in his studio and discovered the latter's Futurist 'iridescent compenetrations'. From these grids of intersecting triangles, rainbow-like in their luminosity, Dorazio inherited a serene sense of colour ordered in textured patterns. At the same time, he was influenced by Max Bill in the use of precise modules to structure his compositions. While Dorazio's colours were always defined by form, they developed a new fluidity in the *Informel* climate of the late 1950s; the interweaving of his subtle, coloured 'signs' found their closest parallel in the work of the American painter Mark Tobey.

Dorazio's relentless inquiry into the intellectual foundations of painting were shared by Achille Perilli, whose work shows a greater interest in narration, even within the abstract idiom, relying on a dialogue between geometric rigour and the gestural automatism of the 'sign'. Carla Accardi's paintings represent an instinctive and emotional response to the world, expressing vitality through animated brush-strokes and brilliant colours (Cat. 177, 178). Her motifs are like living organisms, continually recreated with great inventive freedom, while her colouristic experiments anticipated the Op Art of the 1960s.

In Rome around 1956-7, Gastone Novelli turned to *Informel*, weaving suggestive colours into unstable surfaces, incising the coagulated paint with those lively, enraptured gestures that were to become the dominant motifs of his later paintings.

Toti Scialoja also occupied an important position on the Roman scene. After a trip to New York in 1956, he introduced the technique of dripped paint and, in 1958, began to explore the lyrical quality of the 'imprint', the repeated gesture of impressing damp pieces of paper or fabric on to canvas (Fig. 7). The roots of Scialoja's *Informel* style, however, must also be sought in the pre-war period, when he participated in the Expressionism of the *Scuola Romana* with canvases of spectral images made substantial through thick furrows of colour. Mario Mafai, one of the principal exponents of the *Scuola Romana*, also experimented with *Informel* in the late fifties and early sixties: he translated his images of decaying flowers (dating from the 1930s) into pure abstractions by soaking string in paint and applying it to the canvas.

The sculptor Leoncillo Leonardi experienced a similar passage from the *Scuola Romana* to *Art Informel*. After 1956, the forms of his ceramics became increasingly organic and naturalistic, expressive of the growth of trees or of layers of split rock and aching with a sense of humanity.

This 'naturalistic' current of *Informel* was prevalent in northern Italy, in Turin, Emilia and particularly Milan, where it stood in opposition to the *Spaziale* and *Nucleare* movements. In Milan, the most important exponent of this tendency was Ennio Morlotti, who pushed his images of landscapes and figures to the limits of non-figuration, evoking mud, earth and germination with his dense materiality of paint (Fig. 8). Subsequently, the figurative aspect of this laden and stratified painting re-emerged in a more obvious manner. Similarly, Mattia Moreni in Emilia later turned to figuration, after working during the 1950s in an *Informel* style which was marked by impetuous gestures cut into the dense, radiating paint.

In Bologna earlier in the decade, Vasco Bendini embarked on an individual investigation of *Informel*. He began with a series of tempera paintings in which almost imperceptible traces of a face arise from fluid black gestures with the concentrated automatism of Zen. Bendini's paintings are among the most intense and delicate

expressions of Italian *Informel* and, to a certain degree, their material quality can be compared to that of Fautrier.

The 'naturalism' of Morlotti, Moreni and Bendini, with its identification with the suffering of material and its existential angst, contrasts with the spectacle of nature that shines through with a lyrical emotive colour in the images of the *Astratto-Concreto* artists. Indeed, we are dealing with two antithetical visions of nature. The former is *natura naturans*, a germinating matrix of a magmatic substance that both represents and materially embodies the cycle of generation and transformation. In the work of the *Astratto-Concreto* artists, by contrast, nature is evoked metaphorically through the arabesques of lines and colours. Imagination and memory recreate a universe of forms: dreamy and subaqueous, on the border between consciousness and the unconscious, in the work of Afro; luminous and orchestrated in a musical polyphony in the paintings of Corpora; veiled but vibrant in the canvases of Santomaso, which inevitably recall the liquid transparency of his native Venice.

The body of work created by Italian painters and sculptors during the 1950s was extremely rich and varied. The artists of the post-war period never worked in isolation but engaged in a constant dialogue with international developments. Nevertheless, within each individual style one can discern an indigenous quality, linking the works to the historical and ethnic particulars of the modern Italian tradition.

Germano Celant

From the Open Wound to the Resurrected Body: Lucio Fontana and Piero Manzoni

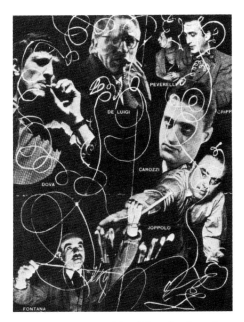

Fig. 1 Six members of *Spazialismo*. Leaflet published by the Galleria del Naviglio, 1949

It is always rather arbitrary to single out certain key years that mark the passage from one period to another in the continual flow of history. Nonetheless, one can discern a particular and decisive cultural moment at the time of the encounter between Lucio Fontana and Piero Manzoni. The place was Milan, and the time, the two-year span between 1956 and 1958. Why these precise dates? In 1956, Giampiero Giani published the first definitive historical account of *Spazialismo* (Spatialism; Fig. 1), and in the same year, the related *Movimento Nucleare* (Nuclear Movement) gained ground through exhibitions in Holland and France.[1] Fontana was the compelling force behind these new tendencies, and Manzoni participated with the youthful enthusiasm of one interested in a radically new visual language. The activities of these years were documented by the new magazine *Il Gesto*, which provided a forum for a lively exchange of ideas on the renewal of art. It published texts by the critics Pierre Restany and Gillo Dorfles and images by Jean Dubuffet and Fontana, as well as ones by such younger writers and artists as Edoardo Sanguineti, Nanni Ballestrini, Sergio Dangelo and Manzoni himself.

In 1957, Yves Klein showed eleven ultramarine-blue monochrome paintings at Guido Le Noci's Apollinaire gallery, and Alberto Burri's great *Neri* (*Blacks*) could be seen at the Galleria del Naviglio, where Fontana exhibited his *concetti spaziali* (*spatial concepts*) in February and November of that year. These three artists provided an example of how to push back accepted boundaries in art, prompting a series of responses in various manifestos, among them, *Per una pittura organica* (*For an Organic Painting*) which was penned and distributed by a group of young artists in their twenties, including Manzoni.[2] Manzoni officially joined the *Movimento Nucleare* and, together with all its international members, signed the *Manifesto Contro lo Stile* (*Manifesto Against Style*) in the autumn of that year.

In 1958, the Apollinaire gallery put on a one-man exhibition of Jean Fautrier while, again at the Naviglio, Fontana showed his most rarified, least material pieces. In the meantime, Manzoni had moved away from figurative images and begun his 'achromes'. Fontana and Manzoni participated in the exhibition 'L'Avanguardia' at the Galleria Montenapoleone, which also included works by Francis Picabia, Antonio Sant'Elia and Enrico Baj. It was held in conjunction with the publication of the third number of *Il Gesto*, which sported a punctured cover by Fontana.

This series of contacts was not proof of a father-son relationship, or even of mutual exchange, between Fontana, who was at the height of his powers, and Manzoni, who was only just emerging as an artist. Indeed, given their close proximity and the wide and rapid dissemination of ideas during these years, it is important to determine what had already been achieved by Fontana and what was being developed independently by Manzoni.

Fontana started with the incisive and intense gestures of the *tavolette graffite* (*scratched tablets*; Cat. 123) of 1931-4. This body of work already announced his disregard for traditional techniques and his predilection for substrata and extensions of infinite space. They convey the impression of liquid surfaces in movement by means of marks that coalesce and dissolve like the disincarnate actions of free-floating figures. Around the same time, Fontana made abstract and figurative sculptures which negated any distinction between solid and void, between a mark carved out of material and a mark etched in space (Cat. 127, 128). Fontana's concern was for the shifting density of matter, which could transform itself from an amorphous mass into a recognizable figure, demonstrating its capacity for metamorphosis (Cat. 122).

Parts of this essay were published in *Piero Manzoni*, New York, 1972.

1 G. Giani, *Spazialismo: Origine e sviluppi di una tendenza artistica*, Milan, 1956. The *Movimento Nucleare* was founded in 1952; its original members included Fontana, Enrico Baj, Roberto Crippa, Gianni Dova and Cesare Peverelli.
2 The manifesto was published in Milan in June 1957 by Guido Biasi, Mario Colucci, Ettore Sordini, Angelo Verga and Manzoni.

Similarly, he focused on the metamorphosis of surfaces and volumes when he strew the body of *Signorina seduta* (*Seated Girl*; Cat. 120) with glittering paint or covered *Ritratto* (*Portrait*) of 1938 with gold mosaic. Obdurate or coagulated materials were thus transformed into light and luminous flesh in a way that testified to the 'passage' to another dimension, prefiguring the cuts and holes in his canvases. The same process of transmutation was found in the ceramic sculptures he produced in 1947, a year after the publication of the *Manifesto Blanco* (*White Manifesto*). In these, intervals of lightness and transparency emerge between the hardened and encrusted forms, the passage of the volumes from solid to void evoking the sensation of passing over a threshold (Cat. 129, 130). This threshold was finally crossed in 1949 with the first *concetti spaziali*, initially executed on paper and then in space (Cat. 153-7).

The extraordinary appearance of the puncture and, later, the slash on the surface of the canvas – like a rapid streak of light – carried the imprint of the artist's gesture to its ultimate consequences (Fig. 2). Whereas in the tablets and ceramic sculptures Fontana had worked against the weight and consistency of mass to render it lighter, he now penetrated the opaque plane of the canvas to make it transparent. He cut through its density and tautness, relieving it of its stasis to impart a sense of ascending movement. He violated it with a gesture of absolute clarity, altering both its physical and symbolic form.

This passage from the concrete to the non-concrete affirmed the impalpable nature of the 'imagination' – the fundamental concept in Fontana's 'abstract' endeavours. The aerial quality of his sculpture had already demonstrated this desire to establish art as a means of passing through matter and space. In 1949, at the Galleria del Naviglio, he designed and built an *Ambiente spaziale* (*Spatial Environment*) in which the play of light – that is, the passage of the immaterial – determined the viewer's experience of the surrounding space as it passed through and dematerialized the architecture of the room. It was almost as if the incorporeal had the power to cut through substances. The sensitized surfaces of the forms suspended in space reacted to the light, creating a luminous dance of reflections that recalled those on the gold surface of the earlier *Portrait*. Now, in the environmental installations, light and darkness actually penetrated and doubled back on each other. Thus one realized that the holes and cuts of the *concetti spaziali* were not a negation, but a 'reversal', of the surface: an opening onto another dimension that was now set free. In the environments the light was 'white'; in the canvases it was 'black', reflecting the change of dimension within the continuity of space (Fig. 3).

Fontana desired to make visible the plane that both joins and separates the opposing fields of light and dark, while producing the greatest luminosity at their point of confrontation. In the *concetti spaziali* this aim was achieved with the energy of a vital gesture. To emphasize the meeting of light and dark, he turned to shiny, varnished canvas, thus accentuating its brilliance and resilience. This gave the painting a very thick 'epidermis' which, once slashed, formed a 'chromatic pulp' around its gaping wound (Fig. 4). The mystery of what 'lies below' the uniform colour of the surface emerges with dramatic force: in *Concetto spaziale – Sole in Piazza San Marco* (*Spatial Concept – Sun in Piazza San Marco*, 1961; Fig. 5) the energy explodes from behind. The precious quality of the 'black light' is underlined by the trace of coloured stones and shining crystals on the surface, which glow with liquid transparency. They grant the surface an appearance of softness, like a fluid body that is penetrated by two kinds of light.

Similarly, in the *Concetto spaziale – Natura* (*Spatial Concept – Nature*, 1959) Fontana polished rough ceramics to produce a smooth and highly reflective surface, giving rise to the luminosity that emanates from the gash in the centre of the form. Once penetrated, the material reveals its many layers, like the inner folds of a sexual organ. Again, the interior bursts forth, and matter is emancipated with a powerful, sensual force.

Fontana turned increasingly towards the exploration of the metaphorical possibilities of material and gesture, reducing the physical presence of his works and exalting the idea behind them. In the *Concetti spaziali – Attese* (*Spatial Concepts –*

Fig. 2 Lucio Fontana. Photograph by Ugo Mulas, 1965

Fig. 3 Lucio Fontana with one of his *Spatial Environments*. Milan Triennale, 1951

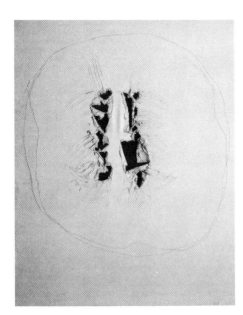

Fig. 4 Lucio Fontana, *Spatial Concept*, 1962. Private collection, Milan

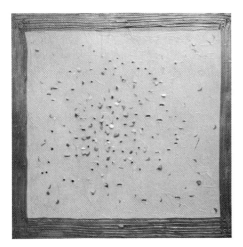

Fig. 5 Lucio Fontana, *Spatial Concept – Sun in Piazza San Marco*, 1961. Private collection, Milan

3 This and all subsequent statements by Manzoni are quoted from P. Manzoni, 'Libera dimensione', *Azimuth*, no. 2, January 1960.

Expectations), dating from the years 1958 to 1968, the surface is toned down, loses its voluptuousness, while the incision is made more precise and probing (Cat. 157, 158). Rendered lighter and more transparent, like a veil, the carnal, swollen surfaces are calmed and dematerialized, cut into slivers by the black light. Executed along the vertical axis, the slashes seem like the darkened auditorium of a theatre, with moments of energy emerging from the depths. The work of art becomes a kind of enclosed spectacle, with hidden images; indeed, Fontana's last works from 1968 were entitled *Teatrini* (*Little Theatres*).

This brief analysis of the spatial energy present in the work of Fontana helps to explain those issues which were central to Italian art at the beginning of the sixties. Foremost among them was the concept of a transparent pictorial language, one related to the gesture, but not to the psychology, of the artist. Art was not the expression of its maker's ego but a celebration of material and its hidden properties. The idea of the wound as an abyss which swallowed up the identity of the artist to allow the true, physical nature of materials to emerge was subjected to various interpretations by artists in Rome and Milan.

In post-war Rome the continued Futurist tradition of tactile, multi-media surfaces took a startling turn in 1948, with Burri's *paesaggi materici* (*material landscapes*). In his *Gobbi* (*Hunchbacks*) and *Sacchi* (*Sacks*; Cat. 165-7) of the early fifties, tar and rags, burlap bags and paint, were combined to form a previously unexplored visual terrain consisting of earthy materials and primitive symbols. This universe of urban refuse was also investigated by Cy Twombly in 1956 and, later, by Jannis Kounellis. Francesco Lo Savio, on the other hand, purged this terrain, making it the basis of a new utopian order (Cat. 186).

In the north, by contrast, materials were used in an aesthetic and reductive manner. The canvas or painting became a 'mental space'. The investigation of monochrome by Manzoni, Enrico Castellani and the young Giulio Paolini gave rise to a kind of 'white mysticism'. This tendency emerged again in 1963, in the purism of Luciano Fabro's early glass and mirror pieces.

The pivotal figure was Manzoni, who maintained an unwavering belief in art as a place of encounter between the mind and the body, thereby influencing Conceptual and Performance art in the 1960s. Looking back over his career, one can see that, from the very beginning, Manzoni's *modus operandi* was to reject the idea of art as a passive entity, as a mere surface for the existential outpourings of the artist – as it was for the artists of *Art Informel* and for certain members of the *Movimento Nucleare*. Instead, art became a space for 'absolute images that have no value as representations, descriptions or expressions, but only as what they are: simply being'.[3]

In 1957, these considerations led Manzoni to invent the 'achrome' (Cat. 179). He started from a *tabula rasa* and, leaving behind his projections and attention to what is real, began to view the canvas as an 'area of liberty' which freed itself from all chromatic and figurative implications and became 'a-chrome', a mere surface, a mute piece of canvas, a basic, elementary sign. The 'achrome' technique eliminated autobiographical elements, did away with the mystique of the artist and accorded the individuality of the canvas an artistic value. The canvas was the purest of entities: it said nothing and explained nothing; it was not an instrument, but a field of limitless possibilities. 'A picture', Manzoni stated, 'has value in that it exists: there's no need to say anything; being is all that matters: two colours in harmony, or two shades of the same colour, already represent a relationship which is extraneous to the meaning of the unique, limitless, absolutely dynamic surface'.

In the 'achromes' Manzoni closed the canvas to any type of action, no longer entering into the picture but making it self-reliant and self-expressing. The problem was how 'to produce a totally white – or rather, totally colourless – surface, removed from all pictorial phenomena . . . a white which is in no sense a polar landscape, an evocative or even merely beautiful material, a sensation or a symbol, or anything else of the kind; a white surface which is a white surface and nothing else (a colourless surface which is a colourless surface); indeed, better still, a surface which is, and nothing else: being'.

In presenting raw canvas coated with kaolin as a work of art (Cat. 180), Manzoni contrived to overcome the aesthetic osmosis between matter and action: he succeeded in separating the two elements, making each of them autonomous. He exalted both the canvas and himself, thus turning the values of the Action painter (canvas, material, the ego, the subject, biological action and body) upside down and inside out, rendering them autonomous and meaningful in themselves.

Unlike Klein, Jasper Johns and Robert Rauschenberg – all of whom also broke with fortuitous relationships between subject and picture in 1957-8 – Manzoni did not see the canvas as a place where the individual is encountered. Rather, both the canvas and the individual became separate, self-sufficient elements which moved autonomously in their own dimensions. For Manzoni, colours were extraneous to the canvas, so it represented neither the absolute nor the everyday, but found and revealed only its own internal value, anonymous and colourless. This value was inherent in the entity 'picture', which could not be combined with the entity 'individual' and could not be broken down further. The 'achrome' was thus a total and continuous space which lasted until it died, and which developed by means of a wide variety of materials – board, felt, bread (Cat. 181), cotton, fibres, rabbit fur, stones, polystyrene – all of which attested to the infinite existence of the entity 'painting' as meaningful in itself.

What interested Manzoni was not so much being inside an object, a canvas, a type of material, but being, seeing that things can exist autonomously. Thus, he did not project himself onto things, but lived out a continuous and parallel relationship of identification with them, extending this concept of ironic distance to the relationship between himself and his body. This might have led him to fall back into the emotive gestures of Abstract Expressionism yet, at each successive stage of his work, he revealed a rationally anarchic, and extremely cold, behavioural and ideological consciousness. This cool rationality enabled Manzoni to isolate events, making them present themselves – for example, a line which does not express anything, but simply is, which stands out as a meaningful event with a precise physical dimension, in metres and centimetres, and a precise place in time, down to the year and the month.

The *linee* (*lines*) date from 1959, and were executed by drawing a line on a roll of white paper with an ink-soaked pad. The lines were always of different length, ranging from 2.85 to 7,200 metres (Cat. 182, 185), and the date was sometimes written on the back of the paper. They were rolled up and placed in black cardboard tubes or in special containers, on which the date of execution and the length were marked; this formed the title. The line of 7,200 metres was made in a paper-mill in Herning, Denmark, on 4 July 1960 between 4 and 6.55 p.m. It was then enclosed in a large cylindrical container with a design of laminated squares on the outside that resembled one of the artist's 'achromes'.

The lines were concrete events, in contrast to the representation of space as an abstract entity. They presented the facts of size and time. Their dimension was not formal but vital: they were documents of a real phenomenon. One of them was called 'infinite'. 'An infinite line can only be drawn if all problems of composition and size are left aside; in total space there is no size', Manzoni stated. He attached the label 'line of infinite length' to the container, producing a line which is conceivable but incapable of execution, which exists only in the mind, as a concept.

Manzoni's conception of art was tautological: everything coincided with itself. His artistic activity coincided with himself; it was a direct communication with his own body. This amounted to the emergence from a state of existential anguish, a change towards affirming one's own primordial physical being, a being (or existence) linked to one's own breath and one's own blood – hence the artist's plan to produce 'phials of Artist's Blood'. His activity and his production were intended merely to fill up the time-span of existence; and for him personally, this coincided with his own body.

In 1960, Manzoni did in fact make and exhibit fingerprints of his thumbs, while in 1961, he produced ninety cans of *Artist's Shit* (30 grammes per can) without artificial preservatives – made in Italy (*Merda d'artista*; Fig. 6)! The excrement was sold at the

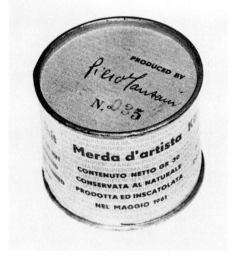

Fig. 6　Piero Manzoni, *Artist's Shit*, 1961. Woog-Institut, Zurich

Fig. 7 Piero Manzoni signing eggs at the
Azimuth gallery, Milan, 21 July 1960

Fig. 7 Piero Manzoni signing eggs at the
Azimuth gallery, Milan, 21 July 1960

same price, per gramme, as gold. This marked a further stage in the exclusive identification of art with the self. The individuality of his body acquired a definite artistic value, which could be expressed in concrete or ritual terms for the public, who were thus able to enter into communion with art. This communion became physical and psychological fact on 21 July 1960 in Milan (Fig. 7) and in 1961 in Copenhagen, when Manzoni invited the public to 'consume' art. A number of eggs were boiled on a table, given the artistic mark of Manzoni's thumbprint and then distributed to the public to eat.

The same notion lay behind the 'magic bases', which also date from 1961 (Cat. 184). These were plinths on which whoever or whatever stood became a work of art and remained so for as long as they stayed there. If each body is a manufacturer of 'traces' (breath [Cat. 183], fingerprints, blood, excrement) which can be works of art, the 'magic base' offered an instrument of total artistic metamorphosis for all bodies. In contrast to the 'predatory' attitude of Rauschenberg and Merce Cunningham, of Klein and Allan Kaprow, who 'appropriated' the body's gestures and actions for aesthetic or artistic ends, Manzoni eliminated this purpose and acted out a 'gesture of love'. Instead of making use of the body, he exalted it and the individual as a living sculpture. He approved these living sculptures by signing their bodies and issuing a certificate of authenticity: 'This is to certify that Mr . . . has been signed by my hand and is thus to be considered from this day on an authentic and genuine work of art. Signed, Piero Manzoni'.

For Manzoni, it is individuality itself which becomes art, in real time and with a concrete material body which does not suffer manipulation in any way. This concept was extended to include the whole world, comprising the separate individualities of all bodies and all objects on the earth, movable and immovable – the largest living sculpture. The means of transforming the world into a work of art was *The Base of the World*, the third of the 'magic bases'. An iron parallelepiped placed in a park on the outskirts of Herning, it bears the upside-down inscription 'Socle du Monde, socle magique n. 3 de Piero Manzoni 1961 – Hommage à Galileo'. Since the base itself is upside down, it holds up the entire world.

After making art of his own body, Manzoni thus performed the miracle of the rebirth of the world: *The Base of the World* transformed everything animal, vegetable and mineral into a work of art. Art becomes a phenomenon in the purest of states; it neither speaks nor explains, but only is. 'There's no need to say anything; being is all that matters', to quote Manzoni again. Together with Fontana, he opened up an unlimited realm of possibilities for art.

Giuliano Briganti

Cultural Provocation: Italian Art of the Early Sixties

The passage from the 1950s to the 1960s marked the beginning of a profound transformation in the cultural fabric of Italian society. It was an important boundary which, like Joseph Conrad's 'line of shadow', fell across the history of the formation of Italy's modern national identity, definitively leaving behind the reality and the myths that nurtured the debates of the post-war period. It is not easy to reduce to formulae the meaning and direction of that renewal which, in a wave of vitality and open-mindedness, swept through the literature, art, social sciences, cinema and theatre of the 1960s. One might characterize it as a series of negations: the negation of the principle of authority, of all dogmatism, of ideological schemes, of political engagement and of traditional expressive means. Or, as some artists did, one might stress the need for formal absoluteness, the exclusion of all elements extraneous to the art in question, the investigation of new themes and respect for the pluralism of positions that aspired to a complete rupture with the past. These were the ideas which brought about the phenomenon of the neo-avant-garde and were at the heart of the cultural revolution that exploded in 1968.

It is true that these ideas in and of themselves were not entirely new, given their close affinity to Dada, to Russian Suprematism, to Piet Mondrian's opposition to the notion of 'artistic fiction', to Marcel Duchamp (who at that time began to be mythicized), or, to draw close to home, to the work of Lucio Fontana (Cat. 159). The context, however, was clearly new, that is, Italian society in a state of rapid transformation, and the objective, to seize reality, was more uncompromising and extreme, conferring an unquestionable originality on the ideas being formulated. But to whatever degree these ideas were new, 'theories', to quote Goethe, 'are grey and the tree of life is green' and the principal characteristic that distinguished the manifestations of the sixties and the force that sustained them (by which I mean not their cause and their anti-ideological ideologies, but their substance, their quality) was above all vitality. It was a vitality that broke through all schematic barriers, quick as mercury, provocative and disenchanted. And, in the case of the neo-avant-garde, this vitality – on the impulse of an inventive inspiration that ignored all limits and all pre-established forms – sometimes sustained the light, fragile, ephemeral apparition of poetry, just as a dancing, fragile ball of celuloid in a shooting range in a fairground is kept aloft for barely a moment in the most precarious equilibrium by a jet of water. The presence of this fleeting, indefinable epiphany of poetic images and ideas (of a poetry expressed in new and elusive forms and merging in unexpected contexts) is indispensable if we are to acknowledge the validity – or better, the value – of sixties radicalism, to establish its artistic nature, irrespective of the intentions which originally lay behind it.

Artistic intentions and qualities are often indissolubly tied to the beginnings of a movement whose nascent state implies a rupture with the past, confirming Henri Focillon's principle that the content of every work of art is its form. This is particularly true of the early sixties, when the intention was to disavow any prefigured plan and was declaredly anti-ideological, 'anti-content'; instead, the artistic task was identified as a sort of short-circuiting of the work itself.

At the threshold of the 1960s, the emerging intention was to impose a radical change on the very notions of art, of the artist, of space and of pictorial gesture, so that the eyes of the new generation of artists were opened to fresh possibilities. To some, these possibilities seemed immediately convincing, even fascinating, and, in the name of a totally non-figurative art (which was neither painting nor sculpture),

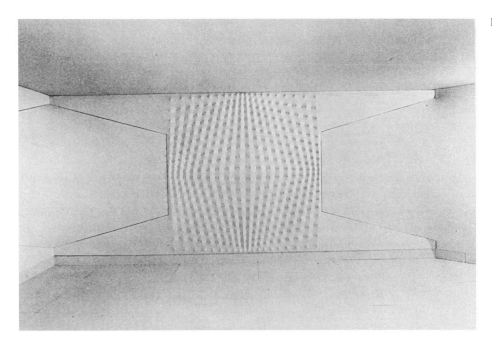

Fig. 1 Enrico Castellani, *White Space*, 1967.
Installation in the exhibition 'Lo spazio
dell'immagine', Palazzo Trinci, Foligno

they turned their backs on the past, on the old and tormented debates of the post-war period, debates which were still kept alive during the fifties and which were now considered destitute of all interest by partisans of both realist and abstract art. A new and provocative current swept away existentialism's clouds of ontological anguish, the romantic and visceral sensibility of *Informel*, and above all the super-ego of commitment that had been nurtured by intellectual anxiety and by a sense of guilt in the years following the fall of Fascism.

The new objective, which was presented as a pure, absolute affirmation of vitality and freedom, did not presuppose *a priori* certainties and did not presume to convey any message. The only *a priori* assumption was that of the artist's creative nature: only the artist could elevate any object to the category of art, and only his action could concretely affirm reality in and of itself. It excluded all objective or subjective transcriptions of reality into pre-established languages, whether abstract or realistic, all recourse to those techniques that have traditionally pertained to painting and sculpture. Art was the will to make art, nothing more. It had no history.

The *Nuova concezione artistica* (New Artistic Conception) announced these objectives in the pages of the Milan magazine *Azimuth*, which was founded by Piero Manzoni and Enrico Castellani.[1] (It lasted for only two issues, the first published in the winter of 1959, the second in January 1960.) Manzoni and Castellani personified two opposing poles of that desire to change the world that animated so many vital forces during those years – a period that was clearly impassioned and full of hope, in Italy and elsewhere, but one that also gave way to rapid disillusionment. Castellani held fast to an almost mystical belief in art as a *tabula rasa*, an idea that he pursued and still pursues with the intransigent austerity of an ancient iconoclast (Fig. 1). Manzoni's ever ingenious, provocative inventions employed ironic ambiguity to push his ideas to the limits of joke and whimsy, making amusement an essential and almost always clever component of his mocking performance. But in reality, this champion of non-engagement was driven by a sense of challenge for most of his brief career.

In 1960 Manzoni wrote:

I cannot understand those painters who, while saying they are open to contemporary problems, continue to place themselves in front of a canvas as if it were a surface to be covered with colours and forms in a more or less habitual and easily appreciated style. They draw, take a few steps back and look with satisfaction at what they have done, cocking their heads, half-closing an eye. They approach the canvas again, add another line, apply another touch. These gymnastics continue until the canvas is completely covered: the painting is finished. A surface of unlimited possibilities has been reduced to a kind of receptacle into which unnatural colours and artificial meanings have been forced. Why not empty this receptacle? Why not liberate the limitless sense of total space, of pure, absolute light? There is only this to express: being and living.[2]

1 The *Nuova concezione artistica* exhibition was held at the Galleria Azimuth in Via Clerici, Milan.
2 P. Manzoni, 'Libera dimensione', *Azimuth*, 2, January 1960.

This search for an absolute reality, for a direct, immediate relationship between the artist and the object of his reality, that is, the work of art, was pushed to the limits of tautology in works such as Manzoni's *Linea, 7,200 m* (*Line, 7,200 m*, 1960; Cat. 185) or *Sculture viventi* (*Living Sculptures*, 1961; Fig. 2) – people bearing the artist's signature on their arms or backs – or his notorious canned excrement, *Merda d'artista* (*Artist's Shit*, 1961; Fig. 6, p. 298). This commitment to provoke, moving beyond any type of representation or pictorial expression, was not entirely new in the history of the avant-garde, from Dada to Neo-Dada and contemporary developments in Pop Art (*Target with Plaster Casts* of 1955 by Jasper Johns and Robert Rauschenberg's *Monogram* of 1959 were illustrated in the first issue of *Azimuth*). But the cultural provocation of the sixties was concerned more with conceptual invention than with the desecration of the object, with how to choose the most appropriate among infinite realities and be anti-representational in a way which produced the mental spark and poetic intuition that characterized the relationship between the artist and the world. As Luciano Fabro has maintained, this world, which one begins to know from *things* themselves, was seen in terms of what *is*, and not according to traditional formal interpretation. It is the idea that is visualized and materialized as presentation of fact – fact that is present, not represented.

This sort of cultural provocation was unthinkable without the contributions of Fontana, who was surely the forerunner of *Nuova concezione artistica*. Fontana did not approach the canvas as a surface ready to receive an image, but rather, in his use of monochrome (absolute monochrome was one of the objectives of those years), he considered the canvas itself as an image. It was the image of a spatial reality with which the artist could interfere only with a gesture that verified its very reality: the gesture of a cut or a hole.

Although Fontana was certainly the forerunner, his was not the only voice in the desert. Alberto Burri was also on the frontier of the *totally new* during the fifties. Burri's *Sacchi* (*Sacks;* Cat. 165-7), which first appeared in 1950, represented a radical transformation of the concept of painting: the passage from representation to object. The burlap sacks, by their material and the stencilled letters announcing their identity, were immediately recognizable for what they were. But Burri added his own signs, forms and colours. The variations in tone and weave of the rough canvas, the compositional zones created by the lines of seams and different tones of burlap, the relationships between fiery reds and intense blacks and the natural colours of the raw jute, reflected a rigorous underlying formal system. In the formal nobility of the *Sacchi*, Burri revealed his latent classicism, his instinctive faith in the ancient and continually renewed Italian sense of scale, what one might even call *divine proportion*. And this is the connecting thread, at first hidden and then increasingly obvious, that binds together all his work, up to the most recent pieces. It is not difficult to imagine Burri with his head tilted and eyes half-closed, lovingly observing his work in progress, adding and taking away, correcting and changing, moving back from and approaching the canvas, in short, engaging in all those gymnastics that Manzoni found useless and ridiculous.

The *Sacchi*, which are the true, disconcerting novelty of the fifties, with their tangible presence of material marked by use and the action of time, are also images charged with a deep suggestiveness, with references to life forces and the history of man. The nature of some of these metaphors may derive from the Umbrian origins of the artist, from that medieval sense of poverty and labour that the mended and rough material evokes. Is not a Burri burlap piece perhaps like the worn, patched cowl of Saint Francis, preserved in a case in Assisi, or like the blackened, torn sacks of the coal-miners who lit their fires in the Apennines?

From 1960 to 1967, that is, until the first exhibition dedicated to *Arte Povera*, projects of cultural provocation made themselves felt throughout Italy, particularly in the urban centres of Milan, Turin and Rome. In January 1960, a few days after the Milan exhibition of *Azimuth*, Francesco Lo Savio had a show entitled 'Spazio luce' (Space Light) at the Galleria Selecta in Rome; his mute surfaces clearly presupposed both Fontana's 'spatial concepts' and a new interest in the non-painting of

Fig. 2 Piero Manzoni, *Living Sculpture*. At the Galleria La Tartaruga, Rome, 22 April 1961

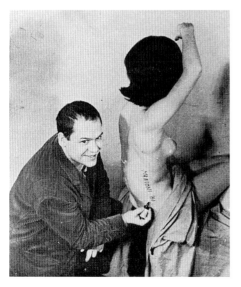

'achromatism'. (In the same year, Udo Kultermann organized the 'Monochrome Malerei' exhibition at the Städtisches Museum in Leverkusen, where Lo Savio's work was shown along with that of Fontana, Manzoni, Castellani and Yves Klein.) In September, Lo Savio exhibited his first *Metalli* (*Metal Pieces*; Cat. 186) at the Galleria La Salita in Rome. Slabs of opaque black metal, modulated by transverse planes, revealed the artist's attempt to achieve the greatest possible freedom in the formal structuring of the object-artwork, defining a space of action within the object itself, and articulated by the reflections of the space-light.

In March 1962, Michelangelo Pistoletto exhibited his *Acciai riflettenti* (*Reflecting Steel Pieces*; Cat. 197-200) at the Galleria La Promotrice, Turin. As he stated in the catalogue, 'When I realized that someone like Pollock, although he attempted to transfer life onto canvas through action, did not succeed in taking possession of the work, which continued to escape him, remaining autonomous, and that the presence of the human figure in the painting of Bacon did not succeed in rendering a pathological vision of reality, I understood that the moment had arrived to make the laws of objective reality enter the painting'.[3] A year later, Pistoletto applied images of human figures to mirrors, redefining the notion and spatial dimension of collage and engaging the viewer in a literal penetration of the field of the painting-object.

The year 1960 saw the debut of Mario Schifano, in the '5 Pittori Romani 60' exhibition at the Galleria La Salita, although his mature work dates from 1963 onwards. Despite the almost monochromatic, large canvases of his early years, Schifano was strongly attracted to the latest developments in America. Works of American Pop Art were exhibited at the United States Consulate in Venice during the Venice Biennale of 1964 and came as a revelation to many Italian artists. Schifano's sensibility was close to that of such artists as Johns and Jim Dine, and he instinctively embraced a pictorial quality that was completely alien to his contemporaries' non-figurative concerns (*Mare* [*Sea*], 1963; Cat. 196).

In October 1964, Giulio Paolini had his first one-man show, also at the Galleria La Salita, where he presented monochrome wooden panels resting against or hanging from the walls, mimicking an exhibition in the course of preparation and analysing, with panels instead of canvases, the fundamental relationships behind the concept of an exhibition. Perhaps the artist of greatest conceptual originality among the young protagonists who emerged during the sixties, Paolini throughout his career has found his bearings within the labyrinth of relationships that can be discovered

3 M. Pistoletto, quoted in G. Celant, ed., *Identité Italienne*, Paris, 1981, p. 81.

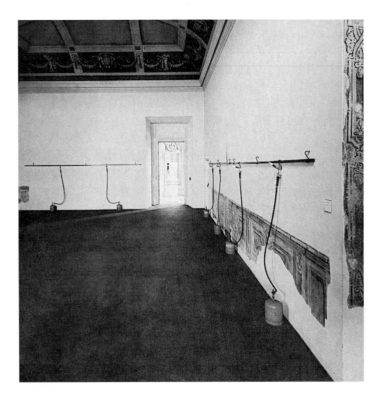

Fig. 3 Jannis Kounellis, *Untitled*, 1969-84. Castello di Rivoli, Turin

between one object and another, between an object and its significance, between object and viewer, between object and time. And he does so with a lucidity and rationality that borders on folly ('folly' in the sense of an unpredictable and fantastic amplification of the rational), and with an abstinence from all references to the senses, save that of sight.

The temperament of Jannis Kounellis is substantially different. He, too, must be considered one of the most complex and poetically talented artists of the non-figurative neo-avant-garde – an artist in continual growth and one who contributed some of the most significant works of the sixties and the following decade. His first one-man show was held in 1960 at the La Tartaruga gallery in Rome, where he exhibited his *Alfabeti* (*Alphabets;* Cat. 213), a series of black letters and numbers stencilled on a white background. By the mid-sixties, Kounellis was feeling the need to move beyond the rigorous conceptual neutrality of language that was fundamental, for example, to the logical demonstrations of Paolini, and he tried to turn away from all manifestations of conceptual transcendence. He attempted to prove that the images presented by an artist are no different from any other form of life: containers of earth, cacti, live horses lined up along the walls of the gallery like works on show (Cat. 215). They have an identity, an identity that conveys an idea. This was clearly only a passage in Kounellis's history of polemical statements of his lack of interest in lifeless images, that is, his interest in life. It was an assertive passage towards a greater sense of individual identity which then led him towards images that reflect the most noble qualities in the history of Western art, conveyed through the tangible, concrete life of objects and materials bearing the imprint of primitive human work – in other words, that sense of form that not even the counter-culture movement succeeded in destroying. At the same time, he has incorporated in his work such archetypal elements as fire, used as a linguistic term, as an active presence and as a 'trace' in the form of smoke or charred material (Fig. 3). But he reconciles fire with his innate aspiration to classical rhythms: a sharp flame, emerging from the ear of an overturned classical head, or an imprint of fire blackening the wall in a series of lines high up in a room, like the rhythm of columns surrounding a temple.

The personality most representative of the extraordinary artistic vitality of the sixties is, however, without doubt Pino Pascali. His development was as brief as it was vital – less than ten years, as if his overwhelming life force were inextricably linked to the brevity of his life. From his first Neo-Dada experiments in 1959 to his 1964 *Quadri oggetto* (*Object Squares*) – *Biancavela* (*White Veil*), *Labbra rosse* (*Red Lips;* Fig. 4), *Muro di pietra* (*Stone Wall*), to name only the most well-known – he freed

himself from any particular model. He then produced the *Armi* (*Cannons*, 1965; Cat. 188) and the *Finte sculture* (*False Sculptures*, 1966): animals made of white canvas stretched over wooden ribs, which are equally false animals and false sculptures. And there were *Mare* (*Sea*, 1966), consisting of waves of canvas with a lightning bolt of black wood, the *Elementi della natura* (*Elements of Nature*, 1967-8), made of water, earth and straw, and finally, in 1968, the *Ricostruzione della natura* (*Reconstruction of Nature*), works which could be defined as his desires. His path of development was like the crashing of an ocean wave; it was violent and acerbic, charged with fantasy, with mythical and profound meanings, with references to the earth.

The search for the essential, for the *primal*, the urge to strip things of all super-structure, to remove them from the authority of history and arrive at what can be understood as the mythical core – this is the continually recurring theme of Pascali's work. His investigations sometimes followed the path of rediscovered childhood and infantile passions, relived with aggressive purity. At other times, he pursued the primitive, the prehistoric, to re-find in the essence of things the spatial and temporal ideas of the first agricultural peoples. Clearly for Pascali, as for children, names lie within things, are things themselves, and it is no accident that he quoted the psychologist Jean Piaget in this connection. This complete identification between things and names, which is experienced in a primitive world and recaptured in childhood, is the key to a work such as *Mare*, Pascali's sea of canvas and wood. What are canals, if not water and form? – precisely regular, elongated containers of water, as in *Canali d'irrigazione* (*Irrigation Canals*, 1967; Fig. 5). Yet there comes a moment when reality is revealed differently: names are not concrete things, but simply abstract players in a game of association. Pascali investigated this further in the realm of childhood, as in *Bruchi da setola* (*Bristle Caterpillars*), consisting of a series of brushes and mapping out a territory of encounter between imagination, word and thing. The pursuit of his goals was indeed a demonstration of 'continually giving birth to himself', of immediately settling himself in the future, as Cesare Brandi has written.[4]

That great tumult of ideas and emotions, that youthful surge of energy, joy and courage, those lucid theorizings, those archetypal references, that sense of the ephemeral – all those forces that from 1959 acted to ignite the creativity of a group of artists were seized on, adopted and promoted by the art critic Germano Celant, who was the first to recognize the common motivations and dynamic force behind the artists' work. He organized the first group exhibition dedicated to the provocative work of the sixties at the Galleria La Bertesca in Genoa in 1967. It included work by Kounellis, Paolini, Pascali and Alighiero Boetti, and was brought together under the name *Arte Povera* (a reference to the 'poor theatre' hypothesized by Jerzy Grotowsky) to indicate a linguistic process that 'consists of removing, eliminating, reducing to the minimum, impoverishing signs, reducing them to their archetypes'. In 1968, a broader *Arte Povera* exhibition was organized by Celant in Bologna at the Galleria de' Foscherari, with the work of Giovanni Anselmo, Pascali, Gilberto Zorio, Emilio Prini, Mario Merz, Pistoletto, Paolini, Kounellis, Fabro and Mario Ceroli. The exhibition became an occasion for extensive debate, engaging critics and artists of the most varied tendencies, among them Celant, Renato Barilli, Maurizio Calvesi, Fran-cesco Arcangeli, Umbro Apollonio, Renato Guttuso and Achille Bonito Oliva.

The tone of the various essays published by Celant after the first *Arte Povera* exhibition was undoubtedly consonant with the tense situation prevailing in Italian political and intellectual circles during those years, as witnessed by his 1967 article 'Arte Povera: Notes for a Guerrilla War'.[5] The various artistic manifestations of *Arte Povera* projected the utopias that inspired the cultural revolution of the 1968 student demonstrations with the slogan of 'power to the imagination': the return to a natural state; Pier Paolo Pasolini's nostalgic vision of a productive system based on the direct relationship between man and the object of his work, between man and nature; and the idea of a new semiology based on the language of action. Above all, they called for the necessity for art to free itself from the system of production and the power of capitalism. In 1967-8, there arose around *Arte Povera* the ideological myth of a new

4 C. Brandi, introduction to V. Rubiu, *Pascali*, Rome, 1976.

5 G. Celant, 'Arte Povera: Appunti per una guer-riglia', *Flash Art*, 5, November-December 1967.

6 G. C. Argan, in a paper read at the twelfth Con-gresso Internazionale d'artisti, critici, e specia-listi d'arte, Verrucchio, September 1963. The content of Argan's discourse and the subsequent press debate are discussed in Celant, ed., *Identité Italienne*, pp. 107-10.

autonomy of art, freed, through conscious force of will, not only from every pre-established norm, but also from the structure of power and the market place; it was the myth of an art that annihilates itself, identifying with the very process of life.

It is worth considering that annihilation as a form of sublimation, implying a positive, optimistic sign, of that order of ideas which, in its negative, pessimistic implication, led Giulio Carlo Argan in 1963 to revive Hegel's idea of the 'death of art'.[6] Argan posed the problem of the abolition of the creative autonomy of art in favour of a transformation of art itself into a sort of technique of the imagination that would place its products at the service of collectivity, replacing the images created by industry or the mass media. Art, in other words, as the highest private expression, the expression of the individual, no longer had reason to exist in the modern world. This was a common belief in the sixties.

There is no doubt that the sensibility of many artists associated with *Art Povera* showed notable affinities with the utopias of 1968. But the vitality, the fantasy, the subtlety, the freedom, that had ignited the flame of cultural provocation in the early sixties were transmitted to many of the protagonists who emerged with the movement, like Boetti, Mario and Marisa Merz and Zorio. Inevitably, the intellectual and poetic energy soon slowed down, and the tumult of ideas and feelings that had animated an entire decade ebbed away. But the matrix of *Arte Povera*, the impulse that it had conveyed, gave birth to new linguistic variants, new forms of cultural extension, new paradoxical provocations. The fact remains that Italian art in the 1960s, with its provocative tendency towards extremes, showed that, despite the radical ruptures with the past, art and poetry are inalienable private and individual expressions of the human soul.

153 Lucio Fontana, Spatial Concept (*Concetto spaziale*) 1952

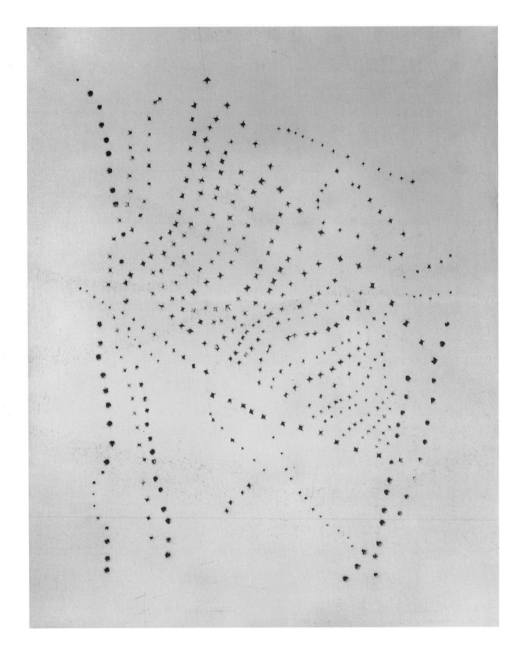

154 Lucio Fontana, Spatial Concept (*Concetto spaziale*) 1951

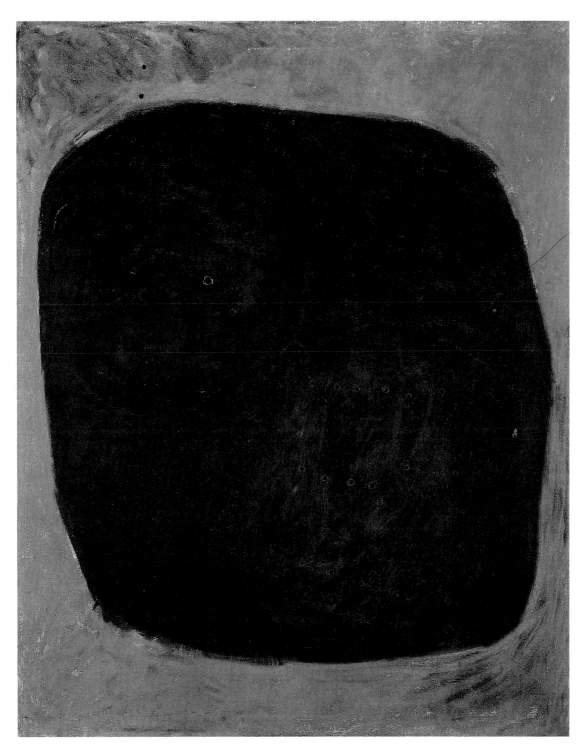

155 Lucio Fontana, Spatial Concept (*Concetto spaziale*) 1957

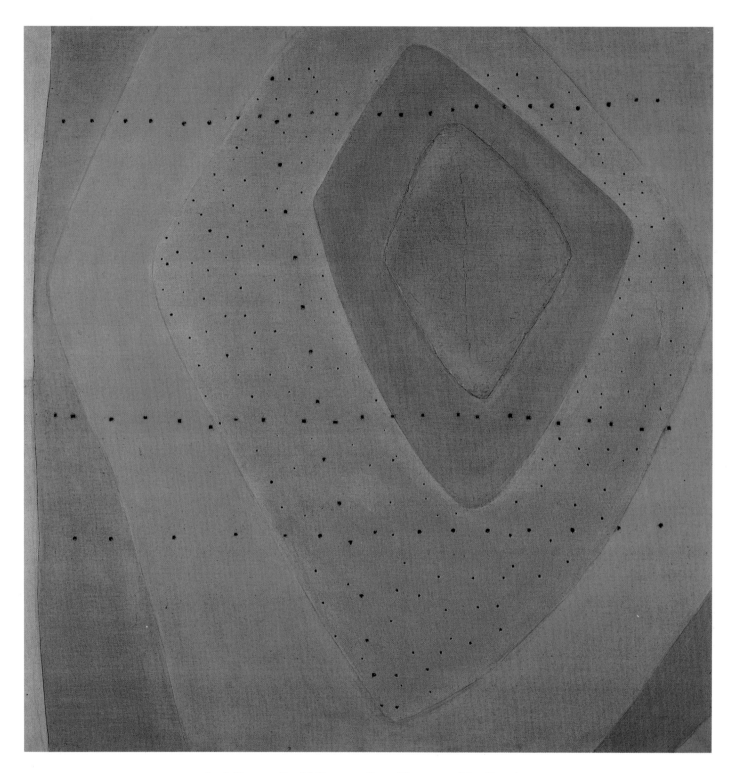

156 Lucio Fontana, Spatial Concept – Form (*Concetto spaziale – Forma*) 1958

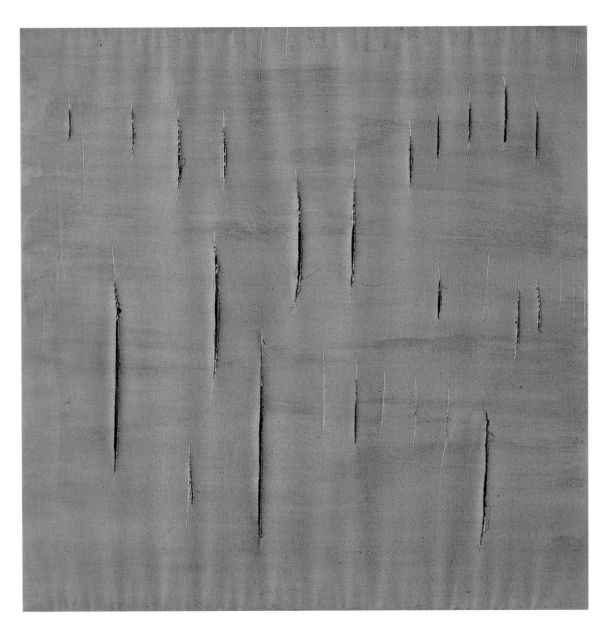

157 Lucio Fontana, Spatial Concept (*Concetto spaziale*) 1958

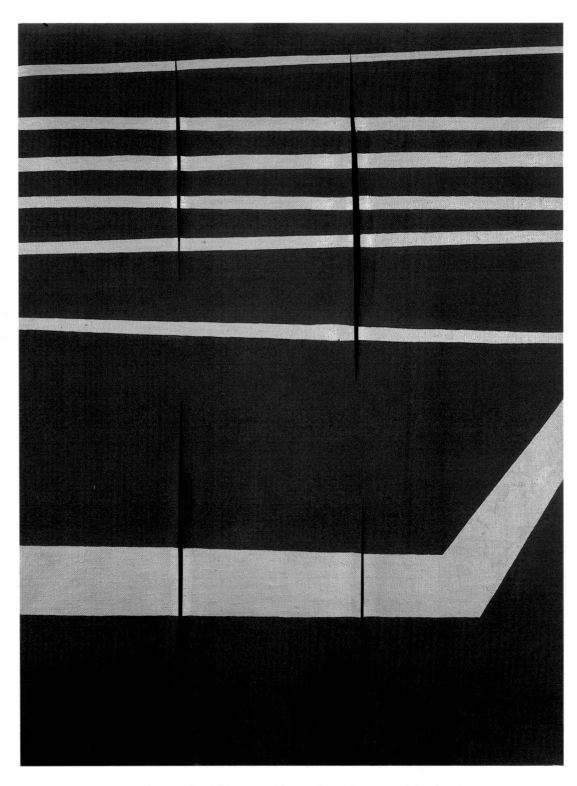

158 Lucio Fontana, Spatial Concept – Expectations (*Concetto spaziale – Attese*) 1959

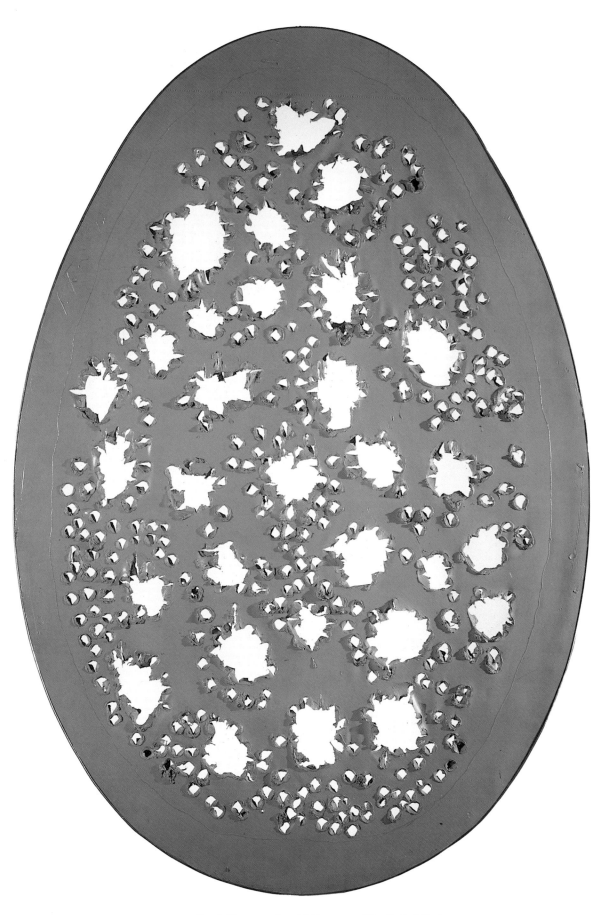

159 Lucio Fontana, Spatial Concept – The End of God
(*Concetto spaziale – La fine di Dio*) 1963

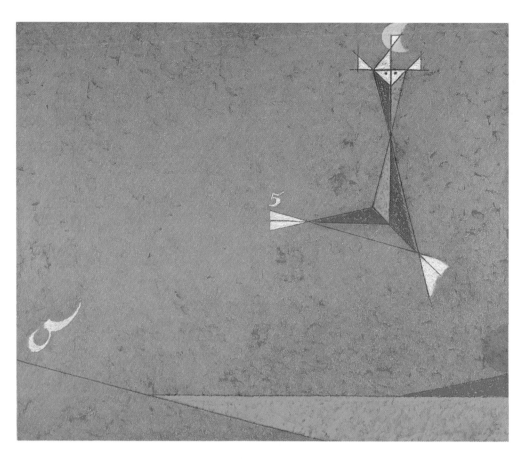

160 Osvaldo Licini, Angel of San Domingo (*Angelo di San Domingo*) 1957

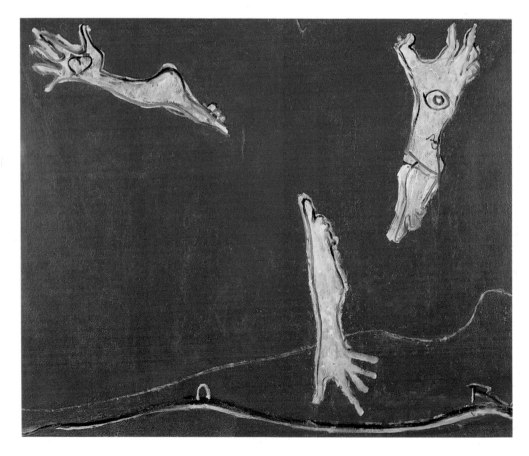

161 Osvaldo Licini, Amalassunta No. 2 1952

162 Osvaldo Licini, Rebel Angel on Yellow Background (*Angelo ribelle su fondo giallo*) 1950-2

163 Giulio Turcato, Desert of the Tartars (*Deserto dei Tartari*) 1957

164 Giulio Turcato, Political Gathering (*Comizio*) 1950

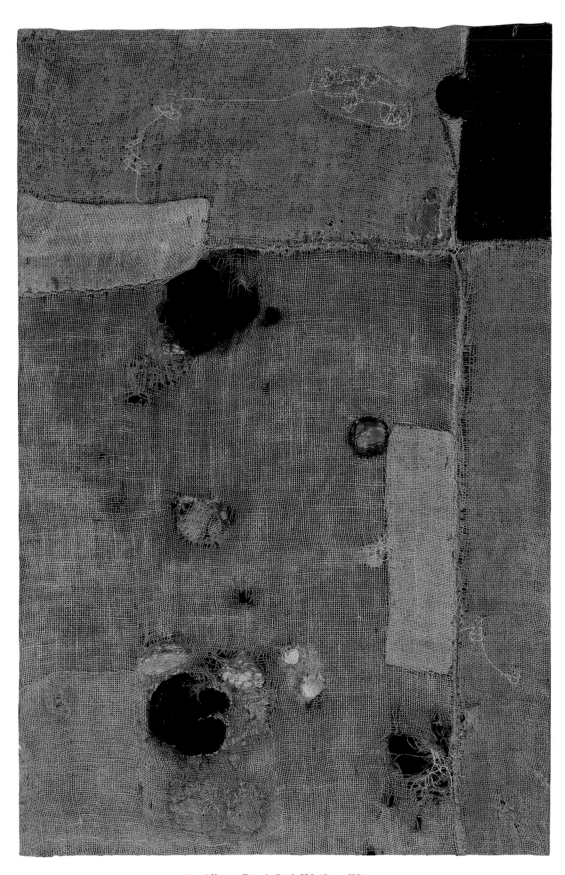

165 Alberto Burri, Sack IV (*Sacco IV*) 1954

166 Alberto Burri, Sack (*Sacco*) 1952

167 Alberto Burri, Large Sack (*Grande sacco*) 1954

168 Alberto Burri, Large Wood Piece G59 (*Grande legno G59*) 1959

169　Alberto Burri, Large White Plastic Piece B3 (*Grande bianco plastica B3*)　1966

170 Alberto Burri, Red Plastic Piece (*Rosso plastica*) 1964

171 Emilio Vedova, Concentration Camp (*Campo di concentramento*) 1950

172　Emilio Vedova, Absurd Berlin Diary '64 – Plurimo No. 5 (*Absurdes Berliner Tagebuch `64 – Plurimo Nr. 5*)　1964

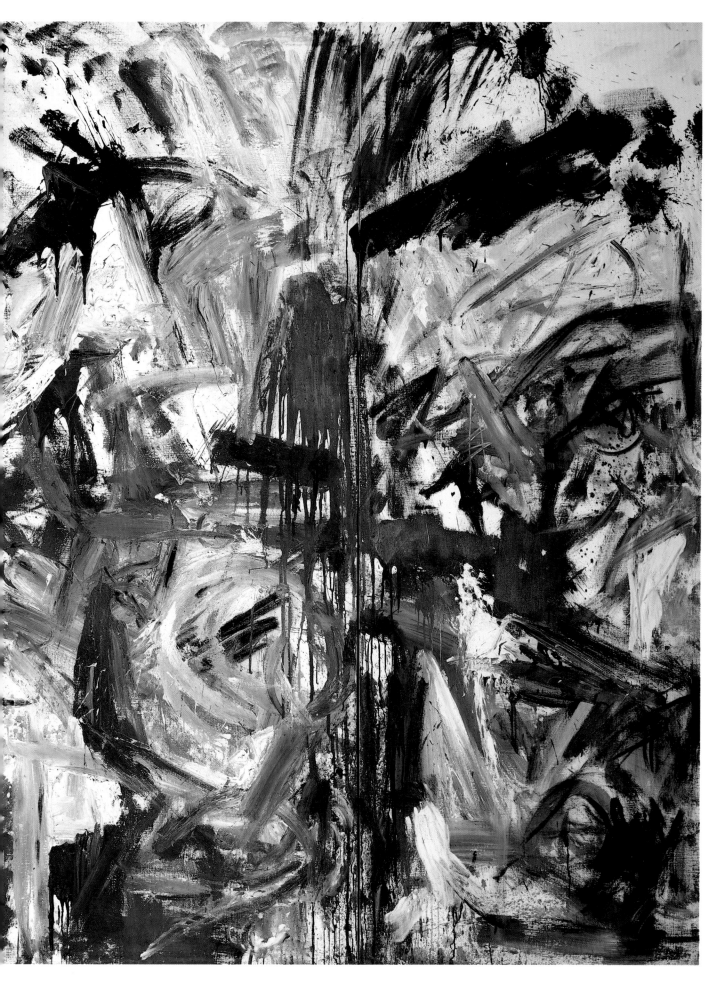

173 Emilio Vedova, Conflicting Situations I (*Scontro di situazioni I*) 1959

174 Ettore Colla, Transparent Column
(*Colonna trasparente*) 1967

175 Ettore Colla, Ritual (*Rituale*) 1962

176 Ettore Colla, Dogmatics (*Dogmatica*) 1963

177　Carla Accardi, Matter with Greys (*Materico con grigi*)　1954

178 Carla Accardi, Labyrinth with Sections (*Labirinto con settori*) 1957

179 Piero Manzoni, Achrome 1958

180 Piero Manzoni, Achrome 1958

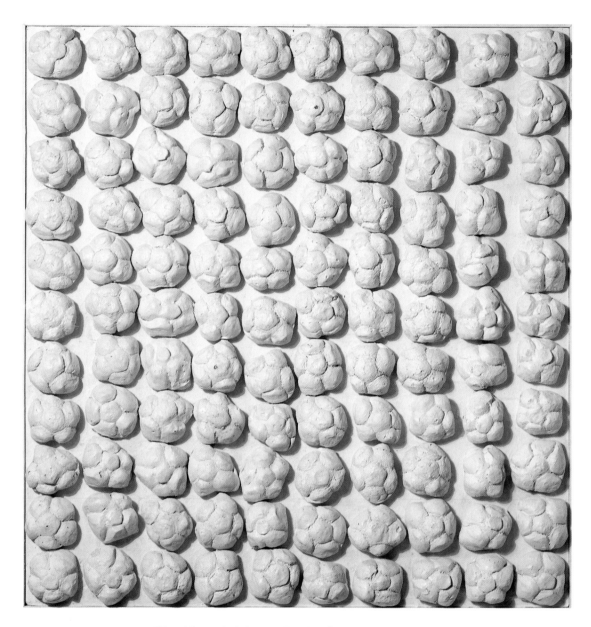

181 Piero Manzoni, Achrome (Bread Rolls) (*Achrome [Panini]*) 1961-2

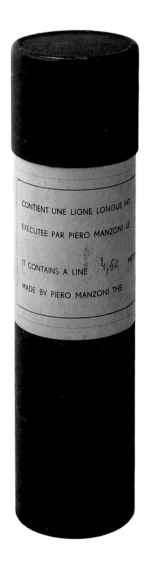

183 Piero Manzoni, Artist's Breath (*Fiato d'artista*) 1960

182
Piero Manzoni,
Line, 4.5 m (*Linea, 4.5 m*)
1959

184 Piero Manzoni, Magic Base (*Base magica*) 1961

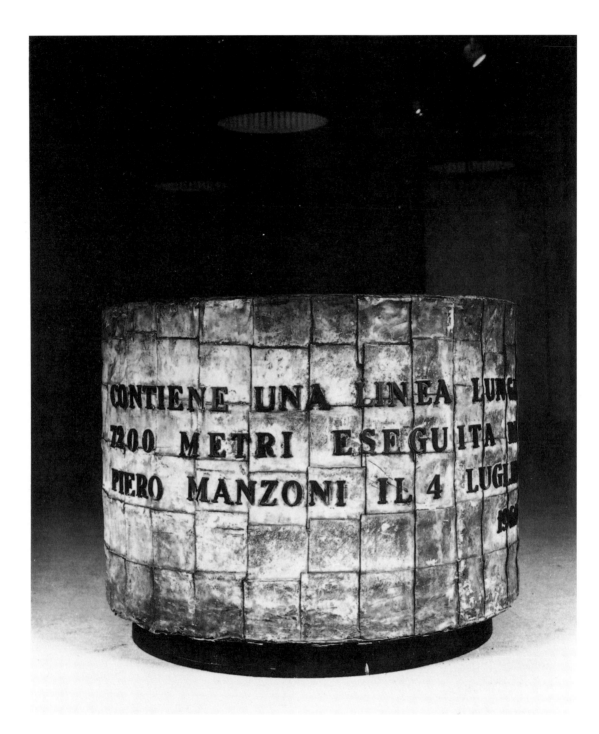

185　Piero Manzoni, Line, 7,200 m (*Linea, 7,200 m*)　1960

186 Francesco Lo Savio, Black Uniform Opaque Metal – Horizontal Surface Articulation
(*Metallo nero opaco uniforme – articolazione di superfice orizzontale*) 1960

187 Pino Pascali, Beheading of the Rhinoceros (*Decapitazione del rinoceronte*) 1966

188 Pino Pascali, Self-propelled Cannon (*Cannone semovente*) 1965

189 Pino Pascali, Colosseum (*Colosseo*) 1964

190 Pino Pascali, Stone, Stone (*Pietra, pietra*) 1964

191 Domenico Gnoli, Restaurant Tables (*Tavole di ristorante*) 1966

192 Domenico Gnoli, Shirt Collar 1 5 ½ (*Giro di collo 15 ½*) 1966

193 Mimmo Rotella, The Assault (*L'assalto*) 1963

194 Mimmo Rotella, Marilyn 1962

195 Mario Schifano, Modern Times (*Tempo moderno*) 1962

196 Mario Schifano, Sea (*Mare*) 1963

197 Michelangelo Pistoletto, Person Seen from the Back (*Persona di schiena*) 1962

198 Michelangelo Pistoletto, Vietnam 1965

199 Michelangelo Pistoletto, Marzia with Child (*Marzia con la bambina*) 1962-4

200 Michelangelo Pistoletto, Bottle (*Bottiglia*) 1962-4

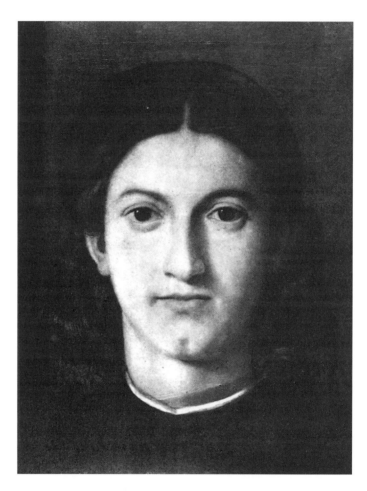

201 Giulio Paolini, Young Man Looking at Lorenzo Lotto
(*Giovane che guarda Lorenzo Lotto*) 1967

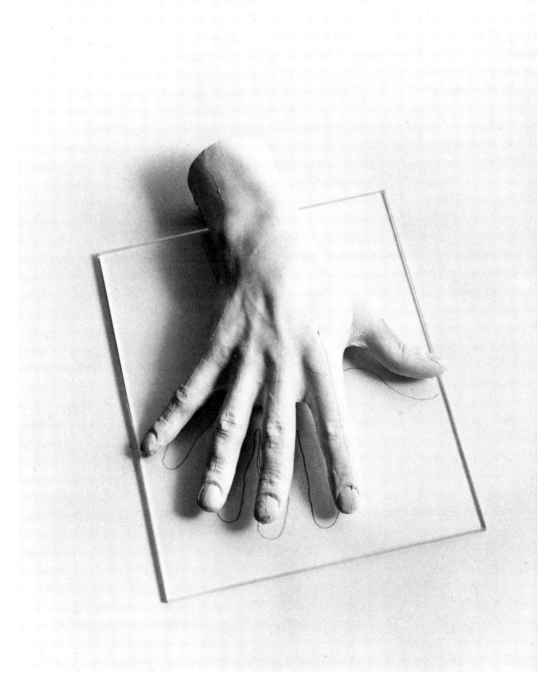

202 Giulio Paolini, Proteus I, II, III (*Proteo I, II, III*). Detail 1971

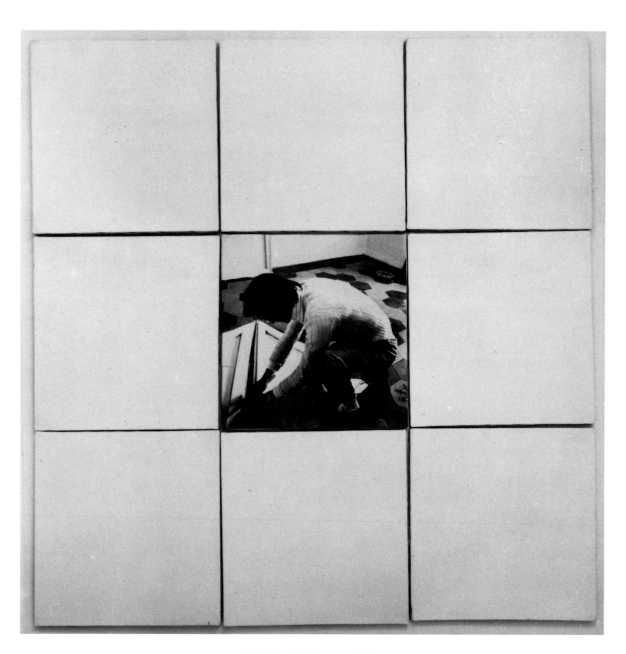

203 Giulio Paolini, Frame (*Cadre*) 1971

1968-1988

Alberto Asor Rosa

Contemporary Italy

The years 1968-9 marked an important, perhaps decisive, stage in the history of contemporary Italy. It was a time of student demonstrations and general strikes that resulted in a profound upheaval of old political balances and cultural relationships.

The intellectual life of the preceding period in Italy had been dominated by a left-wing culture, often Marxist in orientation, an offshoot of currents of thought associated with Walter Benjamin, Georg Lukács and the Frankfurt School, and Jean-Paul Sartre. In the literary sphere, authors like Vladimir Mayakovsky and Bertolt Brecht were particularly well received, and there were notable innovations in the fields of theatre and linguistics. There was a great deal of talk about both the 'literature *of* the revolution' and the 'literature *for* the revolution'. For most intellectuals, concepts of art and literature were inseparable from those of 'engagement', political struggle and 'militancy'.[1]

On a more strictly literary plane, the so-called neo-avant-garde (or *Gruppo '63*, after the year in which the first group meeting of the movement took place) was important during the sixties. Participants included such writers as Alberto Abbasino, Edoardo Sanguineti, Antonio Porta, Elio Pagliarani, the young essayist Umberto Eco and the art and literary critic Renato Barilli. Given what later came to pass, it is important to bear in mind the significance of this movement in the history of modern Italy. Modern Italian culture has always been distinguished by the predominance of ideological factors over linguistic ones, but in the sixties, for the first time, language prevailed over ideology. It was no accident that the forerunners of the neo-avant-garde, who fiercely opposed 'easy' writers for the masses, like Alberto Moravia, Carlo Cassola and Giorgio Bassani, included Elio Vittorini and his magazine *Il Politecnico* (1945-7). Although primarily devoted to anti-Fascist and progressive politics, this publication experimented a great deal with language and design (a sense of modernization and formal renewal, for example, was achieved by the graphic designer Albe Steiner, who drew on the examples of *De Stijl* and the Bauhaus).[2] It was equally no accident that, in the neo-avant-garde, a significant osmosis took place between literature and the other arts – for example, in music, where the most significant presence was probably Luciano Berio, and in painting, where there was a markedly fertile relationship between Sanguineti and Enrico Baj.

Moreover, during the sixties there was an intensification of, and increase in, the cultural exchange between Italy and the rest of Europe. There had already been hints of this on an ideological or political level; now there were indications that scholars in such fields as semiology, anthropology and sociology were tending to take up increasingly autonomous and original positions. The so-called 'human sciences' began to prevail over what until then had been considered a sort of 'national ideology', that is, historicism, which at times was Idealist (Benedetto Croce and Giovanni Gentile) and at other times Marxist (Antonio Gramsci). Thus, much of the previous philosophical culture was Hegelian in origin, passing through Italian Idealism, on the one hand, and through Marx, on the other. Around 1968-9, however, Italian culture ceased being Hegelian and became essentially structuralist, phenomenological, sociological and semiological. This was the entry into 'modern' Italian culture.

In addition to being a decisive watershed 1968-9 was also an interval, a meeting-point of unresolved confrontations, a period of remorse and, for some, a dismal dream. For reasons of clarity, the subsequent historical phase has been divided here into two periods.

1 For a broader discussion of this period, see A. Asor Rosa, 'Lo stato democratico e i partiti politici', in *Letteratura italiana*, ed. A. Asor Rosa, Turin, 1982, especially pp. 620-43.

2 For further information on Elio Vittorini and *Il Politecnico*, see M. Zancan, *Il progetto 'Politecnico': Cronace e struttura di una rivista*, Venice, 1984.

The first began in 1968-9 and ended in 1979. It was a period of broad and deep social and economic upheavals and of extreme industrial and institutional crises. It was also the period when the two largest political parties in the country, the Christian Democrats and the Communists, attempted an alliance, which failed. The explosion of bitter, widespread terrorism characterized the entire decade, a phase brought to an end by the kidnapping and assassination of the Christian Democrat leader, Aldo Moro, by the Red Brigades in 1979.[3]

However, during the same period, Italy demonstrated its level of civil and political maturity in the two referendums on abortion and divorce. The country also reacted with solidarity to the anti-institutional terrorist attacks from both the left and the right (the latter intertwined with ambiguous and ever-present threats from military circles and Masonic organizations to overthrow the government). Furthermore, a strong, militant feminist movement took root and grew during the seventies, which not only affected even the most inveterate aspects of Italian life, but also made contributions to culture and cultural history (including a rediscovery of an underground and often censored female tradition within Italian history of the past centuries).[4]

The second period, which began around 1980 and has continued to the present, is distinguished first of all by a strengthening of the capitalist sector. The large employers, led by Fiat, have reorganized their managerial structures and reduced the power of the unions in the factories. These politico-economic factors deserve pride of place in our discussion, and not just for chronological reasons; indeed, they have had an important effect on aspects of national culture, which will be examined later. At the same time, there has been a rearrangement of the political scene according to the so-called 'pentapartito' (five-party) formula of government (Christian Democrats, Socialists, Social Democrats, Republicans and Liberals), with the pointed exclusion of the Communists. The economy has flourished, with strong repercussions in both home and international markets. Apparently, Italy has once again become a country of 'large-scale development', its gross national product surpassing those of nations which possess older manufacturing and industrial traditions, like France and Great Britain.

Cultural developments have been slow to react to the changed situation, even when the right conditions seemed to be present, and have frequently fallen victim to the onslaught of the last twenty years.

First of all, any sort of position that directly embraced the concept or practice of 'engagement' has emerged much the worse for wear. The political perspective, both Italian and European, has narrowed. The relationship between literary and artistic creation and the social role of the intellectual, which once was accepted almost as a moral imperative, has been decidedly weakened. In one way, this has worked to minimize considerably (and positively) the eloquent, even rhetorical, style of many traditional Italian intellectuals (for example, the Settembrini brothers, with whom Thomas Mann liked to identify, when he was not identifying with Gabriele D'Annunzio, and whom the great German writer defined, in a wonderfully graphic expression, as the 'spaghetti-makers of the spirit'). In another way, however, it has slackened the ethical tension, the sense of responsibility, the Weberian 'Beruf' that was supposed to lie behind every intellectual activity.

Consequently, all collective solidarity, all alignments of movements, all intellectual and artistic associations, have been weakened to the point of dissolution. *Gruppo '63* was the last testament to a collective intellectual endeavour, and looks like remaining the only one for some time to come. In Italy today, there is not a single place for debate or a single movement-linked magazine that warrants mention.[5]

In Italian culture, the 'post-modern' is thus presented beneath the banner of individuals and their activities. It seems to me no accident that against this background, the only cultural enterprises that stand out are those entrusted to distinct personalities, to the 'knights errant' who move about without equerries in a feudal universe, which is what the extreme phase of 'Italian modernization' runs the risk of resembling.

3 For a concise view of the positions of intellectuals on terrorism, see the small volume *Coraggio e viltà degli intellettuali*, ed. D. Porzio, Milan, 1977, which brings together numerous contributions from those years.

4 See M. Zancan, 'La donna', in *Letteratura italiana*, vol. 5: *Le questioni*, Turin, 1986, pp. 765-827. Naturally, it would be impossible to cite the large number of publications and works inspired by the women's movement that have appeared during the past decade. Briefly, it can be stated that, while feminism has played an extremely important role in the intellectual world, it has encountered more obstacles in the political and social spheres. Among the most recent texts to appear is *Svelamento, Sibilla Aloramo: Un biografia intellettuale*, ed. A. R. Buttafuoco and M. Zancan, Milan, 1988, a collection of the proceedings of a conference held in Milan in January 1988.

5 An overall picture of the transformations ten years ago (a picture that is at times debatable) can be drawn from the anthology *Dal '68 a oggi: Come siamo e come eravamo*, Bari, 1979.

My thesis is that the true, great cultural revolution of the eighties in Italy has been realized, not by the intellectual 'class', but by the workings of big capital and its figure-heads. In comparison to what has been achieved with the willing mediation of the mass media, the arguments of the surviving intellectuals seem more like small talk. There is a new set of power relationships: the big company is unassailable and its workers cannot be unionized effectively. There is a new system of values: efficiency, speed, economy, merit (often polemically opposed to the world of state organizations, including schools and universities, where waste, incompetence and interminable delays prevail) and, above all, *success*. There is a new Olympus of heroes, glorified with an insistence that once characterized the bureaucrat-dictators of the East. These people are followed and studied in every detail of their public and private lives, and held up for the masses as an example of intelligence, astuteness, power, decisiveness: Agnelli, De Benedetti, Gardini, Romiti, Berlusconi, Benetton, and all the rest.

This is the true mass culture in Italy today. There has been a radical modification of the co-ordinates and dynamics of forming consensus; anthropology, taken in its most factual and immediate sense, creates a premium on ideology and philosophy (not to mention literature).

This secularization of Italian culture during the last decade, its desanctification and loss of ideology, is the result of very real changes in ways of feeling and of being Italian, and are by no means the invention of narrow groups of intellectuals. I think that the most interesting cultural experiences belong to those who have taken note of this (whatever their view of it) and who have registered the structural changes in cultural discourse with a certain Italian flair (and, at times, cleverness). For the first time in many decades – perhaps since the beginning of the century, the so-called 'Giolittian age' – culture is facing the sudden collapse of all previous 'myths', due to a wide-ranging material process. Intellectuals, scholars and artists have been pushed to the edges of this process, for 'modernization' in Italy now constitutes more a process of modification of the economic and productive structures, of conditions and styles of life, than a true aggregation of new cultural factors.

In the philosophical field, the contributions of Gianni Vattimo and others, which have led to the so-called *'pensiero debole'*, are especially interesting. Following in the footsteps of Nietzsche and, above all, Heidegger, rather than Hegel, they acknowledge the irremediable end of 'strong systems' and restore to philosophy the task of guiding man through the vicissitudes of everyday life and the pressing concerns of the technological universe, more as a submissive counsellor than as a guide to absolute certainties.

The Venetian Massimo Cacciari has moved along another path, in search of 'fundamentals'. In such works as *Krisis* (1976), *Dallo Steinhof* (1980) and *Icone della legge* (1985), he passed through the enormous territory of nineteenth- and twentieth-century European philosophical and literary culture (from Novalis and Schelling to Nietzsche, from Kafka to Heidegger), to map out that 'no man's land' which is now the universe of contemporary thought. In this exploration, he has pushed towards a current of mystico-religious thought which has its origins, on the one hand, in the Talmud and in Hebrew heretical writings and, on the other, in the modern followers of St Paul and St Augustine.

Although political commentaries and literary criticism have not been lacking in vitality, I will focus here on literature, which best reveals the difficulties and bitter tensions of our time.[6]

Among young writers, where the names of Franco Cordelli and Daniele Del Giudice stand out (different in temperament, but both strong personalities), one senses that the continuity of process that has run through the development of contemporary Italian literature has been irrevocably broken. Their work often appears somewhat contrived. Stylistically and linguistically, their writing on the Italian reality oscillates between a sort of violent, shrill expressionism (Aldo Busi), in the manner of a Pasolini gone parodic and grotesque, and an all too miserly, stilted minimalism (Mario Fortunato). Antonio Tabucchi represents the rather exceptional

6 An interesting choice of texts can be found in the book *Il piacere della letteratura: Prosa italiana dagli anni '70 a oggi*, ed. A. Guglielmi, Milan, 1981. The volume is significant because it expands the concept of 'literary prose' to include journalism and documentary texts, a confusion of genres which persists today.

case of an elegant and refined writer who advances a discourse that is all his own, without paying much heed to the enticements of the market place (it is no accident that he counts the Portuguese writer Fernando Pessoa among his mentors).

Collectively, the current literary scene is less than thrilling and seems to strain to find authentic originality (despite the appreciable success that some writers have found abroad). Yet Italy can count at least two of the most prodigious and prestigious stars to appear on the international horizon in the last decade, Umberto Eco and Italo Calvino; so beyond facile schematism, a certain vitality evidently does survive, drinking at the strangest and most varied of fountains.

In 1980, Eco, an eminent scholar of semiotics (a field in which he has written unusually interesting essays), published the novel *Il nome della rosa* (*The Name of the Rose*), which met with extraordinary success (translations into twenty-one languages, six or seven million copies sold in the course of a few years). In 1988, this was followed by a second novel, *Il pendolo di Foucault* (*The Pendulum of Foucault*). In these works Eco has displayed a remarkable capacity to create a 'narrative machine' that is extremely efficient and an equally remarkable capacity to present the material in a multitude of expressive, linguistic, ideological and cultural sub-systems. As a result, his books become 'multiple objects', capable of satisfying different expectations of the public simultaneously. The use of the computer in the elaboration and writing of *The Pendulum of Foucault* has brought this system to the point of perfection. Eco's 'literature' is effectively literature of the technological, post-modern era: synthetic (even if not completely non-ideological) and extremely functional.

Calvino is very different. He was a traditional man of letters, a humanist and an extremely refined stylist, who spent his entire life delving into the possibilities (and also the limitations) of his chosen expressive means of literature. He, too, pursued a combinatory literature – for example, in his truly extraordinary book *Le citte invisibili* (*Invisible Cities*, 1972) – but, in his final years, he came to question the very feasibility of writing literature, of 'narrating', in a time like our own. Thus, in *Se una notte d'inverno un viaggiatore* (*If on a Winter's Night a Traveller*, 1979), he wrote a novel that is not a novel; made up of many novels, it is, in fact, a fable, elegant, amusing, yet also dramatic, about the difficulties, not only of writing, but also of reading, today. And in *Palomar* (*Mr Palomar*, 1983), he returned to a reflection on that difficult and disturbing problem of interweaving life, individual existence, cosmic existence and writing, which takes on the symbolic value of a more general question about the utility and function of cultural activity itself.

On the other hand, in *Lezioni americane* (*American Lessons*), written for a lecture series at an American university, and published posthumously in 1988, Calvino makes a claim for the irreplaceable role of literature in raising human consciousness, even in the face of the next millennium. It should be borne in mind, however, that he often made such eloquent and moving pronouncements when on the edge of an intellectual crisis, and the fact that these pieces were written so close to his death makes them seem more like a pathos-filled testament than a confident message for the future.

In conclusion, I would say that, at this particular moment, Italian culture is typical of a country where many assurances have been given but no true certainties have emerged. The facade is more gaudy and ostentatious than the interior, which remains rather modest. And this holds true for individuals as well as for the system as a whole. We suffer from an exaggerated reputation that we ourselves have to seek to place in perspective if we are to know whether or not we really deserve it.

Caroline Tisdall

'Materia': The Context of *Arte Povera*

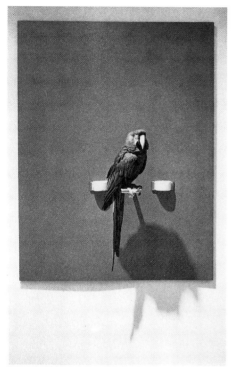

Fig. 1 Jannis Kounellis, *Untitled*, 1967. Detail of installation at the Galleria L'Attico, Rome, November 1967

Fig. 2 Pier Paolo Calzolari, *A Dulcet Flute for Me to Play*, 1968. Collection of the artist

'Intuitions, inventions of instruments, explorations and revelations, challenging functions, systems, fixing and inventing points, organizing signs, oxygenating the perceptive faculties, indicating other images that accompany the image' Let us give the first word on *Arte Povera* to Gilberto Zorio, the artist whose alphabetical destiny it is to be last in any catalogue. His list of artistic concerns evokes something of the enigmatic tone that has dominated Italian art for the past twenty years or so. It dates from 1980, the same year as his work entitled *Per purificare le parole* (*To Purify Words*; Cat. 208), an ominous title for a construction of leather and buckskin, copper pipe, iron pipe and alcohol which is slung through space in a state of tension. The receptive viewer may be intrigued by the association of 'words' with these materials, but a search for definite meaning will be frustrated: a mood, a poetic or threatening atmosphere may emerge, but never a precise answer.

That, at least, has been my experience of *Arte Povera*. The most evocative works that have been grouped under this curious label stretch back through the memory in a strange combination of enigmatic titles and endearingly odd materials, which sometimes achieve a magical effect. One thinks of Jannis Kounellis's live parrot perched in front of a painted canvas (1967; Fig. 1), his colours defeating anything in the artist's palette. In the same year, Giulio Paolini offered another paradox in the making of art and its materials: a photograph of a painting by Lorenzo Lotto entitled *Giovane che guarda Lorenzo Lotto* (*Young Man Looking at Lorenzo Lotto*; Cat. 201), though in fact at that moment he was looking at me, the spectator looking at a photograph centuries later.

Such experiences had to do with art and its substance. Other images which stayed in the mind perhaps had more to do with life. In 1968, Luciano Fabro produced a huge, suspended, upside-down Italy, which was hung from its toe so the familiar boot was reversed. An allusion to the events of May? A comment on how things might change in Italy if the poverty-stricken south were in the north, and vice-versa? From that year, too, dates a memory of a quite different kind: Pier Paolo Calzolari's flute, frozen white in a frozen plate of metal, and under it, in frozen Roman lettering, a magic message: *Un flauto dolce per farmi suonare* (*A Dulcet Flute for Me to Play*; Fig. 2).

Then in 1971, Alighiero Boetti presented the outcome of his wanderings through the world, far from art and far from Europe, in the form of a map of the world embroidered in Afghanistan, in which the proportions of the Western world became as unimportant as the exact location of Kabul might be to us. There follows a sour memory of Gino De Dominicis exhibiting (or exploiting) a Mongoloid boy at the Venice Biennale in 1972, all in the name of a 'quest for immortality'; it succeeded in provoking a scandal, for what that was worth. Many images come to mind of Mario Merz's igloos in all kinds of permutations and materials, from the menace of jagged glass to softer hints of anthropology in leather (Cat. 221). And there was Marisa Merz knitting copper wire, little patches put together with the patience of Penelope, while Mario wandered from art capital to art capital with his installations. Later, at the Whitechapel Art Gallery in London, one recalls the sight, sound and smell of a whole array of Calor gas bottles alight and blazing in the *mélange* of colour and fire that Kounellis is so skilled at creating.

Mostly, though, one remembers *Arte Povera* as a series of fragments: fragments of plaster casts as used by Michelangelo Pistoletto, Paolini and Kounellis, fragments of meaning and fragments of words combined with fragments of material.

What, then, held all these pieces together? With hindsight, it was certainly the Italian response to a general spirit of the times, a genuine *Zeitgeist* that led many artists to explore territories beyond the traditional concerns and materials of art. It had elements of art as life and art of the everyday, as well as a questioning of what art is or could be; this and an element of theatricality is shared with the Fluxus movement in the United States and West Germany, though even in the performances of the early days of *Arte Povera* there was never the intense will towards a shared and multi-disciplinary 'total art work' that distinguished Fluxus. The artists had a common desire for a heightened degree of sensuality in art, and the need to expand the mental and physical boundaries of art. In the context of international developments, it was the antithesis of the Minimal Art which had swept through Europe from the lofts of New York in the mid-sixties. The 'poor' of *Arte Povera* did not mean spare.

In fact, in a country where the critic holds an astounding – even perturbing – amount of power, *Arte Povera* meant more or less what the critic most associated with it wanted it to mean. Germano Celant in Genoa was the main force behind it, coining the term *Arte Povera* as early as 1967. Achille Bonito Oliva in Rome and Tommaso Trini in Milan rivalled him in their promotion of the *'povera'* artists through the Italian gallery system. Writing of the phenomenon in 1985, Celant said that it emerged

> from a combination and dovetailing of contrasting entities, such as the embrace between embroidery and electronics, the fusion of tracings and fires, the vertigo of igloos and fruits, the focus on sculptural mirror fragments, the flight of stones on the blue horizon, the melting of ice and crazy colour, the physical determination of the rainbow, the snail-like creeping of metal on walls and in empty space, the mimesis of a sculpture sea, the crossing of giants, the transfiguration of acids into colours, and the figures of a forest made of imprints and bronze epidermises.[1]

As this spectrum of images suggests, *Arte Povera* was never a movement or a group as such. In the early years, the artists represented in Italy as *'povera'* were grouped together in foreign exhibitions with representatives of all the other labels that were gaining currency at the time: Body Art, Process Art, Conceptual Art. Their works were included under a series of titles that make amusing reading now: 'Situations and Crypostructures' (Amsterdam, 1969), 'When Attitudes Become Form' (Berne, 1969), 'Hidden Structures' (Essen, 1969), 'Processes of Visualized Thought' (Lucerne, 1970), 'Between Man and Matter' (Tokyo, 1970) and 'The Vitality of the Negative' (Rome, 1970).

The cultural context for *Arte Povera*, however, is not to be found within the international art world. Whether by intention or instinct, the artists included here have consistently created works that are quintessentially Italian. They do not draw on the glamour of Andy Warhol, the passion and global strategy of Joseph Beuys, the linguistic irony of Marcel Broodthaers, the ideological issues investigated by Hans Haacke or the violence of Wolf Vostell. The terms most often used to describe their approach are 'nomadism' or 'vagabondage' – the right to shift from material to material, avoiding the trap of continuity and consistency into which many artists fall. Thus Merz will move from igloo to wall painting, or Kounellis from wall drawing to tableau. The representatives of *Arte Povera* have kept something of the aspiration of the Renaissance artist by including in their work hints of history, nature of an urban type, science of a practical kind, poetry and plenty of archaeology. Above all, they are Italian in their ability to present images which, however 'ordinary', are handled with uncanny 'style'.

Fig. 3 Giulio Paolini, *Mimesis*, 1975. Collection of the artist

Essentially Italian is the serene way in which these artists explore the history of art. Paolini evoked Lorenzo Lotto in 1967 and, going back still further, raided the plaster casts of antiquity. Paolini's Venus (*Mimesi* [*Mimesis*], 1975; Fig. 3) confronts or contemplates her twin, both of them muffled in the dead material of plaster, so far from the sensual pleasure afforded by marble. A winged Hermes flies upside down across the museum ceiling (*Melancholia ermetica* [*Hermetic Melancholy*], 1983), while other figures, sawn in half, seem to pass through the museum walls (*Intervallo* [*Interval*], 1985). Paolini knows that no Italian artist can avoid the presence of the past, for it is there in the most material form in almost every city. A living museum

1 G. Celant, *The Knot: Arte Povera*, Turin, 1985. Unless otherwise stated, all quotations are taken from this source.

2 C. Carrà, 'Il quadrante dello spirito', *Valori Plastici*, no. 1, 15 November 1918.

3 G. de Chirico, 'Statues, Meubles et Généraux', *Bulletin de l'Effort Moderne*, October 1927; reprinted in *Il meccanismo del pensiero*, ed. M. Fagiolo dell'Arco, Turin, 1985, pp. 277-8.

of antiquity, a collage of art history from ancient Rome through the Renaissance and the Baroque to modern times, confronts every Italian daily, from earliest childhood onwards.

It would be strange indeed if the influence of this legacy, so carefully preserved in each city's *centro storico* (historic centre), did not filter through into the artist's contemplation of the making of art. Pistoletto's *Venere degli stracci* (*Venus of the Rags*, 1967; Fig. 4) reflects this in a literal way, as do Kounellis's fragments of a past that stretches even further back, to the ancient culture of his native Greece. This is merged with his uneasy contemplation of the modern world: 'What disorder, the fragment of the eye in the statue of Athena on the stairway leading to the garden – the banner, the battle, the rifle, the iron bridge, the river, the shots, the pain, the loss, the road, the defeat, the head over the window near the corner, the hand of the bronze horseman at the entrance, the illegible scripts of an epigraph, the iron, the sewing machine, the cane, the trumpet, the umbrella, the socks, the shoes, the coloured drinking glasses, the broken panes . . .' (1982).

This fusion of images drawn from the physical presence of the past with the artist's uneasy sensibility has been a recurrent phenomenon in the Italian art of this century. When Carlo Carrà was recovering from the turmoil of Futurism and entering his Metaphysical phase with Giorgio de Chirico, his musings in the magazine *Valori Plastici* were remarkably similar:

> On the same plane, but further back, rises the archaic statue of my childhood (anonymous and timid lover, or angel without wings?). In his hand a tennis racket and ball like his rubber sister on the wall in front of me.
> Still further back, and to the right, can be glimpsed the funeral cippus that perhaps bears an inscription in Latin, which to us Italians sounds as sweet as Provençal to a Frenchman.
> At the same distance, and parallel, immobile and spectral, is the enormous overthrown copper fish, resting on two primitive iron bars. (Could it have escaped from a museum?)
> The shadows fall piercing and black on the grey floor. This is the drama of the apparitions.[2]

Some years later, de Chirico, writing in the essay 'Statues, Furniture and Generals', described the effect of antique figures that inhabit his Metaphysical paintings:

> And yet a statue is not destined always to stand in a place enclosed by well-defined lines We have long been accustomed to seeing statues in museums To discover newer and more mysterious aspects we must have access to new combinations. For example: a statue in a room, whether it be alone or in the company of living people, could give us a new emotion if it were made in such a way that its feet rested on the floor and not on a base. The same impression could be produced by a statue sitting in a *real* armchair or leaning against a *real* window.[3]

When Metaphysical painters like de Chirico and his brother Alberto Savinio placed statues from the Italian past or biscuits from the shop window displays of Ferrara in their paintings, they did so with a feeling for material presence that is at odds with the dry scumble of their brushwork. The objects are *there*, prefiguring the literal and physical incorporation of strangely juxtaposed imagery in the material world of *Arte Povera*.

As Kounellis said in 1984, 'It's very difficult indeed to make a painting without a sense of history'. *Arte Povera* was born in the hiatus that followed the post-war industrial boom in Italy. A mania for mass production swept the country in a way that recalled the Futurists' ecstatic espousal of the modern in the period before the First World War. Indeed, Celant's proclamation of 1968 reads remarkably like a Futurist manifesto: 'The artists believed that the crisis and discontent of civilization were caused by their ties with the past and an indifference to the desires and precariousness of life. In their new approaches, artists broke out of the suffocating bear-hug of money and immersed themselves in the present.'

Perhaps the artist perceives 'the present' rather differently. For a Futurist, the rupture with the past was total, insofar as that is possible. For Kounellis or Pistoletto, the art of the past and perception of the present are not necessarily contradictory. Pistoletto pays homage to the excitement of Futurist vision in his description of modern perceptual experience: 'From the window of a racing train we see the hedge passing at a dizzying speed, the houses further on are the "minus objects", a soft verification. Then the slower hills in the distance and far away the mountains!'

Fig. 4 Michelangelo Pistoletto, *Venus of the Rags*, 1967. Di Bennardo Collection, Naples

Kounellis admires Boccioni as a figure of force and inspiration in Italian art, rather than as a direct sculptural or pictorial influence. The allure of Boccioni's title *Materia* (*Matter*, 1912; Cat. 25), and his desire to break down the barriers between a piece of sculpture and the world surrounding it, are still a precious legacy:

> Boccioni? Right from the start, from the very first paintings, this man's will to renew could be seen. He was the man of dialogue, of openings.... He had a grand design for renewal.... He was visionary, that's why he went beyond results.... Today, at a time when the search for identity is reduced to a small design, Boccioni's stature increases. This is why I say he is the moral master for me. He, more than any other, represents the attempt to renew, to vie with history. Without reducing. [1984]

For the older Italian artists, there was also the terrible, and very material, memory of the war. Pino Pascali, who died in 1968, was twelve when the war broke out and the menacing images of his *Contraerea* (*Anti-Aircraft Artillery*) of 1965 evoke those memories. Pistoletto paid homage to the previous generation of artists who lived through the horror and had the courage to create:

> Born in 1933, I live in the heart of this century, in this gigantic century.... At ten years of age I find myself in the middle of the 'World War', the last 'Great War', terribly great, great as terror. The mountains are mountains of death, the factories are factories of death, the chimneys smoke bodies, the chimneys smoke cannons. Oceanic rows of boys dressed in black on their way, rows of the wretched in tatters, the hungry and the dying coming back.
> My problem is therefore great.
> What is God: Great problem.
> What is Art: An equally great problem.
> Fontana's holes, Burri's sacks.
> Burri made his sacks in the concentration camp during the war.
> Bravo Burri.
> My problem is so great that I look at myself in the mirror and search within myself, in my image, for the answer, the solution, in my own image. And I work on the mirror. [1962]

Lucio Fontana and Alberto Burri were of fundamental importance as the immediate precursors of *Arte Povera*, as were Piero Manzoni and Emilio Vedova. In their different ways they widened the scope of art to an extent that was not acknowledged outside Italy until much later. They were concerned with the materials of art as direct conveyors of experience, rather than as indirect filters of reality. The penetration of the surface of Fontana's canvases is a real gesture in space (Cat. 158). Vedova took fragments of everyday life in his *Absurdes Berliner Tagebuch* (*Absurd Berlin Diary*) of 1964 – collages of charcoal, paint, graffiti, burnt and cut wood – and slung them suspended through space and on the floor, 'because, they say, painting should be experience in depth, so it follows that it should be trodden underfoot as well ...' (Cat. 172).

Manzoni represents a turning point in art, an absolute that was hard to follow. More than any other artist he drew the most extreme consequences from the artist's role as a producer of goods. His *Fiato d'artista* (*Artist's Breath*, 1960; Cat. 183) and *Merda d'artista* (*Artist's Shit*, 1961; Fig. 6, p. 298) share similar intentions, though the latter has of course attracted more scandalized attention in a society still traumatized by an anal taboo. Everything the artist produces is art. In an age of mass production and chemical miracles this product, like any other, can be packaged, tinned and sold in series.

Celant has argued that Manzoni, like Pier Paolo Pasolini in the cinema and literature of the same period, represented the 'ghettoized' side of society, the outcast, rejected and despised sectors, the minorities and the underprivileged. Certainly, both presented a challenge to the artificial politeness and sterility of bourgeois culture at the very moment when the economic boom was making itself felt in the newly opulent northern urban centres of Italy. Both of them achieved that rarest of syntheses in art, the transformation of raw, rough material into spiritual energy. Manzoni's legacy included the example of his lively rapport with the international art world, which he achieved with the magazine *Azimuth* (1959-60).

By 1966, an unease had become tangible in Italy that pre-dated the turmoil of 1968. Tension and conflict were already apparent in the art works of Kounellis and Pistoletto. Kounellis later said: 'In 1962-3, we were already 68ers and in '68 we were already established politicians.' Pistoletto's *Rosa bruciata* (*Burnt Rose*, 1966; Fig. 5)

Fig. 5 Michelangelo Pistoletto, *Burnt Rose* (*Minus Objects*), 1965. A.C.P., Turin

displays the bitter poetry of disillusion, perhaps with a system of art that succeeded in neutralizing the artist's challenge to norms of perception and therefore behaviour. As Pistoletto wrote in 1967: 'The ambiguity of art is simply a matter of putting two things in relation to each other so as to be able to observe the representation of their conflict. It's what the Romans were doing when they put the lions and the Christians in the arena to enjoy the spectacle.'

In Italy everything is ideology. Discussions in 1968 were endless. With hindsight, it is remarkable how much faith and hope was invested in the power of material objects – art works – to effect a change of attitude, but that is the driving force of art and one should resist the cynicism that belittles it. Direct reflections of the events of May were everywhere to be found except in the art world. True, Mario Merz produced a comical neon seat entitled *Sit-in*, and Fabro's Italy was turned on its heel, but tangible reflections were less apparent than discussions and moves to open art to a wider audience. Bigger exhibitions, and more of them, were the result, backed by the local authorities, for whom a stake in contemporary culture is more important than local councils in Britain could ever imagine.

Political tension in Italy is ever present, and it continued through the waves of extremist bombings and terrorism of the seventies. To a certain extent it is possible to see an element of retreat creeping into the work of these years, in keeping with the rest of the art world. Was it the familiar process of mellowing with age that led Pistoletto back to huge chunks of sculpted material called *Capelli azzurri* (*Blue Hair*, 1982) and to write in the same year: 'We are now living through the great bourgeois reversion Ideology is also finished. Thus a void, a great void. I now feel a serene space where an affirmative art can be placed. The physical body of the autonomy of art in the sacredness of the form'?

The other side of the coin was a strong belief in the liberating effect of the creative act, in personal expression as a political statement and the pursuit of pleasure as a social gesture. The context of *Arte Povera* was and is, after all, the gorgeous *palazzi* and high-ceilinged white spaces of the art world, not the turmoil of the streets. The language through which these artists' work is promoted in Italy, as in France, is of an obscurantism that defies the most determined intellectual, let alone a wider public.

Above all, this is an art of the rich urban centres of the fifth most prosperous country in the world. It is far removed from the side of Italy that is 'poor'. South of Rome there are courageous galleries in Naples, Bari and Pescara which carry the message of the avant-garde, but they too are worlds apart from the real poverty of the south. This is the poverty of a displaced peasantry, fifteen million of whom have moved north in search of work since the war. There is no charm to be found in the roughness of this poverty, no appeal for the artist in the harshness of the materials that surround peasant life, and no bourgeois solace.

This harshness is acknowledged in *Arte Povera*, sometimes by default. When Pascali brought *1 mc di terra, 2 mc di terra* (*1 Cubic Metre and 2 Cubic Metres of Earth*) into a gallery in 1967, it was exotic material from another world. When Mario Merz presents his igloos and the image of the wandering nomad, he is reminding us of a lost past and unity. In Merz's work, nature and architecture are equivalent. His great contribution has been to introduce the magic of the laws that govern the proliferation of natural growth, and to play this off with poetic irony against the harsh proliferation of human artefacts (Fig. 6). To compare the effect of the Fibonacci numbers escalating in nature through the scales of a lizard or the seed growth of a sunflower head is a joy. To see the scale increase to gigantic proportions when the same numerical sequence is applied to a basic man-made object like a table is threatening. Merz's works have an apparent simplicity that leaves room to breathe and dream, a touch of incongruity in the tidiness of an artificial world.

When Anselmo placed fresh vegetables between the two granite blocks of *Struttura che mangia* (*Structure That Eats*, 1968; Fig. 7), it was to observe the passage of time that would cause the smaller of those two blocks to fall to the ground: a process of decay causing a moment of energy, a movement of material. Energy is what concerns Anselmo, energy in relation to the human being's perception of the world.

Fig. 6 Mario Merz, *Progression of Fibonacci on a Stair*, 1971. Pistoletto Collection, Turin

'I, the world, things, life – we are points of energy, and it is not as necessary to crystallize these points as to keep them open and alive', was how he described the motivation behind his magnets and compasses in 1969. 'No beginning, no end. Just points of the compass.'

Penone is perhaps the artist who comes closest to fulfilling Celant's claim that the artists of *Arte Povera* reunited culture and nature in the way expounded by the anthropoligist Claude Lévi-Strauss – that is, the sense of nature as an integral part of culture, as the basic module for human conceptual structures. Penone writes romantically of nature: 'If the earth is mother . . . forming the earth is a sensuous act . . .' His work has an anthropomorphic tendency (see Cat. 211). Human beings grow in or out of trees, or plants grow out of bodies. Reading further in Penone's text of 1984, it becomes clear that he too is not talking about nature as such, but art as nature:

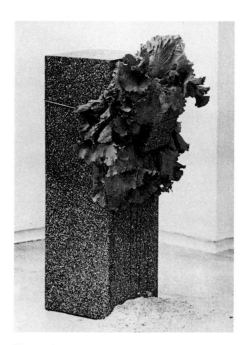

> We admire:
> The landscape of the patina of bronze.
> The plant life fossilized by the bronze.
> The colour of rain, of wind, of sun, of cold,
> of heat, of frost
> The germinal energy expressed by plants.
> The vertical motion of plants.
> The gesture of sculpture as a synthesis of the landscape.

The artists of the *Arte Povera* generation have survived the latest challenge. They have carried their materials of ice and earth, brushwood and stone, out into the space of the gallery floor and back to the walls, undefeated by the younger generation's return to painting in the 1980s. Their faith in the virtue of art remains intact, it seems, and with it, perhaps, their faith in human endeavour, as expressed by Fabro a quarter of a century ago: 'Sharpen the instruments of the mind and, by means of them, extend the new instruments, the potency of the hand, extend the body into all things of the world as obedient limbs, imitating nature in order to transform the world according to human ideas.'

Fig. 7 Giovanni Anselmo, *Untitled* (*Structure That Eats*), 1968. Ileana Sonnabend Collection, New York

Norman Rosenthal

C.C.C.P.: Back to the Future

Art is continually searching for new ways of seeing and describing our world. In the years around 1980, when for more than a decade such new ways had mostly taken the form of conceptual sculpture, for the most part realized in black and white, the possibility of colour began to reassert itself. It was described at the time as a 'return to painting'. Critics, constantly on the look-out for new phenomena, described the new movement in Italy as a *transavanguardia* – implying perhaps that the days of the avant-garde were over, that the progress of twentieth-century art, in which one movement followed another, had passed. In fact, by 1980 art in a certain sense could scarcely have become 'poorer' or more 'minimal' in the manner in which it sought to describe the world and come to terms with its history. In some quarters it was felt that the new painting was a sell-out of the hard-won, and hitherto rigorously applied, principles of artistic modernism, and it is particularly interesting that it was young Italian artists who largely led the way in reviving figurative painting. Even at that time, it seemed to some critics that this was part of a new decadence, the beginning of the *fin de siècle* of the twentieth century.

Almost a decade later, it is already possible to perceive the so-called *transavanguardia* as part of the continuing discourse that has characterized twentieth-century art. More deliberately than most movements in art, it has drawn on the past, both in form and in content, and by stimulating a new and heightened awareness of what is possible, it has opened up new prospects for art and especially for painting. Thus, ten years ago, at a moment when it seemed as though the well-spring of art was running dry, it gushed forth again with new possibilities that triumphantly assimilated the tragic history of Europe and the richness of its past culture. A modern artist could look again and reflect upon Giorgione and Titian, could paint landscapes and portraits, and could, above all, give new life to myths drawn from an endless diversity of source material. Classical mythology, history, Eastern literature, dreams, all were set down in a new language of paint which had little to do with the Cézannesque inheritance but was deliberately and often aggressively eclectic.

Of course, figurative painting as an art form had never died. In England there was Francis Bacon, in America Philip Guston, in Germany Georg Baselitz, to name only three, and above all there was the late work of Picasso, who had gone on relentlessly through the sixties and seventies, even if largely ignored and despised by much 'respectable criticism'. It was therefore all the more remarkable that it was through the attention given to a number of young Italian painters, all born after 1945, that critics began to reconsider this kind of painting. Their work was first seen at an exhibition that took place north of the Alps, in Basle and later in Amsterdam and Essen, in which seven young Italian painters – Sandro Chia, Francesco Clemente, Enzo Cucchi and Mimmo Paladino, along with Nicola De Maria, Luigi Ontani and Ernesto Tatafiori – came to the fore, although most of them had been active in Italy for several years. Their subject-matter, ranging from the classical to the scatological, seemed unimaginably eclectic and appeared to offer rich possibilities for a continued life of art, which shortly before had seemed to be talking itself into a self-reverential corner. In fact, most of the artists had been exhibiting in Rome and Milan since the beginning of the seventies. Their early painting was often quite tentative, even minimal. Consider, for instance, the earliest frescos and paintings of Clemente, which, though of great poetic beauty for those who were prepared to look at them at the time, seemed almost Zen-like, so minimal were they in their sparing use of imagery. The early works of Chia incorporated objects, sometimes

toys, or, in the case of *Volto Scandaloso* (*Scandalous Face*, 1981; Cat. 225), a painted basket that acted as a kind of surrealistic head or mask enacting a scene of rape in a composition that recalls both Titian and Max Ernst.

Paintings such as these, however, for all their inherent violence, contained a new lyricism, a romantic nostalgia, a sense of humour that diminished the risk of portentousness. They celebrated youth, but not in the sense of a new pop culture, such as had dominated the figurative art of the sixties; rather, their art drew inspiration from literature and philosophy. With increasing success, their work became rapidly grander in scale and ambition. These ever larger and more exuberant or tragic canvases soon found their way into exhibitions, collections and museums on both sides of the Atlantic, winning more rapid acceptance than the work of any previous twentieth-century Italian artists, including even the Futurists or Giorgio de Chirico in their most productive years. Suddenly, the eyes of the art world were turned towards Italy, prompting a complete revaluation of the Italian achievement of this century, of which this book and the exhibition it accompanies are a part.

Italian art of the twentieth century was, indeed, worthy of re-investigation. A controversy sprang up around the work of de Chirico in his post-Metaphysical period, which hitherto had been judged by most critics, particularly in America, as being of little worth. His ambiguous later works might sail close to the edge of kitsch but their ironic classicism suddenly took on a new relevance. A major exhibition of de Chirico at the Museum of Modern Art in New York, and later at the Tate Gallery, restricted the master, with some token exceptions, to his work prior to 1919. A revised version of the same exhibition was shown in Munich and Paris and contained many works of the twenties and thirties, including the *Bagni misteriosi* (*Mysterious Baths*, 1934–5; Fig. 7, p. 76), regarded by orthodox Surrealists as well as orthodox interpreters of modern art as being well beyond the pale. The belated recognition accorded these paintings and even such later images as *Il ritorno di Ulisse* (*The Return of Ulysses*, 1968; Fig. 1) has not a little to do with the controversial reception given to the artists of the *transavanguardia* in Italy. Their work, therefore, went hand in hand with a reappraisal of the whole concept of the modern movement, and in the long and furious debate which has ensued, the quality of the work has sometimes been disregarded. For if the *transavanguardia* opened up a polemic about the history of painting that surely did lead to a fundamental revision and, above all, an opening up of critical perceptions, those against such revisions tended to overlook the real achievement of certain individuals, who were able to add an important chapter to the recent history of art.

Fig. 1 Giorgio de Chirico, *The Return of Ulysses*, 1968. Isa de Chirico Collection, Rome

Chia, the oldest of the group and in some ways its ideological leader, proposes a new sense of heroism in art, which has been demonstrated by an increasingly prolific outpouring of paintings like *Zattera temeraria* (*The Audacious Raft*, 1982; Cat. 226). His is an approach that embraces the whole history of art and culture in an almost epic manner. Chia expressed his thoughts on the purpose of painting in an open letter written in 1983 to the director of the Stedelijk Museum in Amsterdam, Edy de Wilde, who had openly warned the young artist against too great ambition and too large a production. Chia replied that he found himself

in my studio as if in the stomach of a whale. My paintings and my sculptures appear in this place like the undigested residues of a former repast and I recall the phrase with which Goethe opens his introduction to the magazine *Propyläen*: 'The youth who begins to feel the attraction of nature and art believes that a serious effort alone will enable him to penetrate their inner sanctuary: but the man discovers after lengthy wanderings up and down that he is still in the forecourt.'[1]

But if self-doubt were ever present for the artist, it lived side by side with a heroic confidence and technical bravura unknown amongst the artists of the seventies, who had indeed tended to self-doubt. However, one has only to think of such artists as Kandinsky or those of the Russian avant-garde – not to mention the bombastic confidence of the Futurists themselves – or to recall the melancholy heroics of Mario Sironi, in order to realize that this 'new' posture was not without precedent, although in its very excessiveness the concern with the self (in a Dionysian or perhaps a Nietzschean sense) was something very new.

1 *Sandro Chia*, Amsterdam, Stedelijk Museum, 1983, n. p.

Fig. 2 Sandro Chia, *Speed Boy*, 1981.
 Private collection

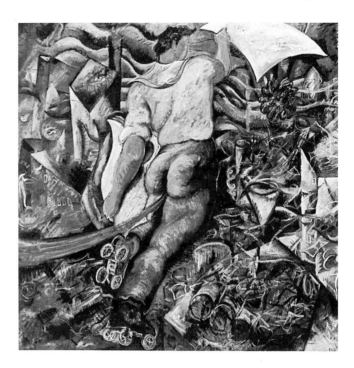

Chia went on in his letter to de Wilde:

> I could write about art only from the interior, from the cave, from the stomach of the whale. In this
> place, surrounded by my paintings and my sculptures, I am like a lion-tamer amongst his beasts and I
> feel close to the heroes of my childhood, close to Michelangelo, Titian and Tintoretto. I'll make these
> sculptures and these paintings dance on only one leg to my music and for my pleasure. I have the
> absolute power of life and death over them, I can make these strange creatures beautiful or ugly. I can
> destroy them, I can change their subject, their colour and their form.

His art became increasingly that of a virtuoso, the imagery almost always having the
artist at the centre, sometimes appearing as a child (the child as father to the man) or
as a youth without fear or inhibition storming through the world with the force of a
god, regardless of the havoc he might leave behind him. It is a world of dreams, of
the solitary individual, the hunter, the soldier, the fisherman, the courageous boy
scout. *Tutto va bene* (*Everything is going well*) and *Speed Boy* (Fig. 2) are titles of
paintings of 1981 and yet for all the exuberance and heroics there is in Chia's
painting a strong sense of melancholy, no more poetically expressed than in *The
Audacious Raft*. The artist-hero himself is asleep on a raft steered by two giants
floating down a river, perhaps towards poetic immortality, perhaps towards obliv-
ion. The art of Chia, for all its bombast, is not without self-awareness; that is the
hallmark of the true artist, who, whatever his position, minimal or expansive, takes
on the world, invents a cosmos that at once exists within a tradition and is entirely *sui
generis*.

 If Chia invents the artist as an all-conquering hero, Paladino has been concerned
primarily with the problem of silence. *Rosso silenzioso* (*Silent Red*, 1980; Fig. 3) is the
title of a huge painting exhibited in 1981 in 'A New Spirit in Painting' at the Royal
Academy. Resembling a huge red curtain, surmounted by a small, mask-like head, it
seems to invite the audience to share in a secret drama of cultural memory, as yet
unrevealed. Paladino's work is very precisely located in the region from which the
artist comes and where he continues to live and work, namely, the southern Italian
city of Benevento. It is a region where the layers of cultural activity reach back to
antiquity and to more ancient mysteries. As for so many Italian artists of this
century, from de Chirico onwards, the painter's personal vision of the world thus
interacts with a whole collective memory. For Paladino,

> art is like a castle with many unfamiliar rooms filled with pictures, sculptures, mosaics, frescos, which
> you discover with amazement in the course of time. The way Conceptual Art goes through this castle is
> very clearly defined. Mine is not, but mine runs parallel. I can choose. The old questions about image
> and representation have, in my opinion, been swept aside by abstract art I can simultaneously take
> up a relationship in my pictures to Matisse and Malevich without there being a relationship between

Fig. 3 Mimmo Paladino, *Silent Red*, 1980.
Bruno Bischofberger Collection,
Kuesnacht, Zurich

them. I believe at such an important point in the crisis, the artist, like the tightrope dancer, goes in various directions, not because he is skilful but because he is unable to choose only one.[2]

Paladino's eclecticism is characteristic of the *transavanguardia* generation. For him, art evokes secrets silently and functions in a ritualistic way; the artist alone officiates and we are merely privileged observers. His paintings and sculpture, and his remarkable drawings, are full of the imagery of rituals; priests and witch doctors engage in precisely those subterranean dramas that exist in dreams and myths and which in a post-Freudian age cannot be satisfactorily explained. His works are not in any sense programmatic. The ceremonial banquets which are a recurring theme in his work have a quality that evokes the notion of death. They are literally '*natura morta*'; they take one to a new reality in another world. The figures are masked but the artist has little wish to divulge their meaning:

> the figures in my paintings, the animals, the masks, the theme of death – I do not want to explain or analyse them. They are the roots out of which the picture develops, but not its content. That is an entirely different area which also cannot be researched with the methods of art criticism. These things are not decisive in the dispute between art and the world. De Chirico never spoke philosophically or psychoanalytically about his work. He always said, 'I use colour, the place, the painting of the Cinquecento, the light, the surface'. This is how I wish to hear painters talk about their work, not because I believe art is a technical problem but because the artist always plays his game of hiding what might be evident.[3]

Paladino uses luminous, rich, primary colours, his deep red, his yellow which invariably possesses the quality of alchemist's gold, his deep blues and blacks which evoke the mysteries of the night. His figures stare hypnotically at the viewer and the artist loses himself in a web of memory that seems to cover the whole history of art – African cave painting, Gothic sculpture, the great fourteenth-century frescos of Florence, the Roman mysteries as described in Pompeian wall paintings, Byzantine mosaics – all are evoked in an eclectic but personal vision that is also cognizant of the art of this century – Picasso, de Chirico, Joseph Beuys are never far away. However, Paladino is not overwhelmed by this past and in his 'red silence' he contrives to open doors that had seemed to be closed.

Cucchi, like Paladino, is a highly gifted draughtsman. Indeed, the idea of '*disegno*', so central to the tradition of Italian art, is the vehicle for an endless stream of ideas, only some of which find their way into painting and sculpture. If, for Paladino, the drawing is a way of discovering silence, for Cucchi, it functions as a transmitter of images, both of explosion and implosion, which once again relate to those basic problems of time and history that are the prime concerns of the artist. Just as Paladino evokes the south of Italy, Cucchi's work refers very specifically to his own

2 *Mimmo Paladino*, Munich, Städtische Galerie im Lenbachhaus, 1985, pp. 43-4.
3 Ibid.

locality in the Italian Marches around Ancona, the great Adriatic port of central Italy and a city of strong Romanesque tradition: Ancona provides the key to an understanding of the dark landscapes of Cucchi. It is not for nothing that the artists whom Cucchi professes most to admire are Masaccio, Caravaggio and El Greco, all three themselves artists of darkness, artists who in their own time were felt to be outsiders, on the fringe rather than in the centre of their society. Italy for Cucchi does not offer, as it did for Sironi, a vision of a great classical past, but rather of an empire burnt to the ground, where even the phoenix of creative life seems to be charred. Cucchi's landscapes convey a sense of the repeated barbaric invasions of Italy that, too, are a central aspect of her creative heritage. The Metaphysical device – the mannequin head – no longer stands upright in front of a classical facade as in de Chirico; rather, it lies on the ground, its head half-buried, whilst all around lie ruins that add to the strata of historical events. The accumulated debris of civilization seems to wait for still further invasions.

In the painting *Quadro al buio sul mare* (*Picture in the Dark by the Sea*, 1980; Cat. 227), an immensely long and powerful red ship floats on top of a deep, black sea, while even below the seabed there seems to be an extensive red lake in which a man swims helplessly. Cucchi, like his colleagues, prefers not to explain his subject-matter, but the sense of a desperate spirit, struggling against absurd odds in order to survive, is clear enough. It is a psychological fantasy but one grounded in a historical evocation of time and place, Metaphysical in its use of allegory, Futurist in its perception of time. It is a painting at once as abstract as a Barnett Newman, figurative and surreal, consciously avoiding style, perhaps: a monumental conjunction of opposites apparently designed to confound the viewer. In *Quadro tonto* (*Stupid Picture*, 1982; Cat. 228), a sleeping head that in itself seems to contain all the wisdom of the world lies on top of the narrow grain-siloes, an architectural feature that recurs again and again in the artist's work, acting as an image of regression.

In the early eighties, Cucchi became more expressionistic in style and adopted a manner that seemed deliberately to look towards the north. He is an Italian who turns to Van Gogh, Baselitz and Anselm Kiefer, but then de Chirico learned much from Arnold Böcklin, as Umberto Boccioni did from Van Gogh. Cucchi's painting is situated in a European tradition and is quite unlike anything produced during the preceding thirty years, when American art had been dominant. As much as any of

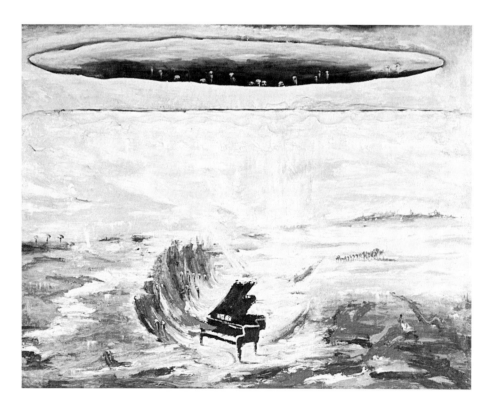

Fig. 4 Enzo Cucchi, *Vitebsk-Harar*, 1984.
Marx Collection, Berlin

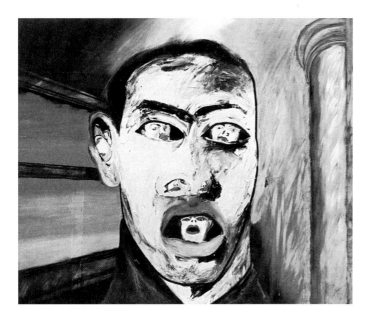

the leading members of the *transavanguardia*, Cucchi has quite consciously asserted the independence of European culture. Painting in his home town in the Marches, he is a leading exponent of an art whose epicentre is in central Italy, but whose conception of Europe extends from Vitebsk, the city of Malevich, in the north to Harar, the city in Africa in which Rimbaud met his tragic end (Fig. 4). Above all, Cucchi's work evokes a dark expressionism that has reasserted itself in Italian art of this century – for instance, in the work of Boccioni, Sironi, Scipione and Vedova – but which goes back to Tintoretto and earlier.

Paladino and Cucchi have resolutely continued to live and work in Italy in their own home towns and Chia has divided his time between Italy and New York. Clemente, however, has made himself an exile from Italy and has worked for the last ten years in New York, spending extensive periods in Madras in India. Such self-imposed exile is no new phenomenon and Clemente is only one of many artists who, like Amedeo Modigliani, have preferred the creative environment of the self-declared cultural world capital of its time. It is perhaps a certain perception of the parochialism of the Italian art world, with its many warring politico-critical factions, that may at one level have induced Clemente to divide his life between the art metropolis of our time, on the one hand, and the esoteric world of Madras, far away from the concerns of the European art world, on the other hand. There is a creative schizophrenia that characterizes Clemente's work, which might be described in all its aspects as constituting a single, kaleidoscopic, multi-layered self-portrait. Indeed, there is a further paradox in that New York, for all the social contact it provides, is perhaps indicative of a fundamental loneliness in the artist, whilst the books, the sculpture and the 'tantric' paintings that Clemente has produced in India seem to be born of a collaboration with local artist-craftsmen of a kind that seems lost in the Western cultural world.

Clemente is a great master of the watercolour and its analogous medium, the fresco – analagous because both media allow for no error and both need to be executed at great speed, analagous because the pellucid colours of both media give to the artist's work a characteristic nimbus. However, the driving force behind his work is above all psychological, an almost erotic drive towards self-exploration and self-exposure that is virtually without precedent among artists of this century, who, in spite of such exceptions as Egon Schiele, have set out to hide rather than reveal the basic motivation behind their creativity. Neither de Chirico nor Picasso, nor even Bacon, all masters of the self-portrait, explores under the skin with such psychologi-cal force and honesty (Fig. 5). Clemente revels in exploring every human orifice, an exploration whose depths are shown to be the source of all creativity.

In 1986, Clemente published and illustrated a text in English by Alberto Savinio, *The Departure of the Argonaut*. Savinio, the brother of de Chirico, whose creative genius combined Proustian nostalgia with surrealist fantasy, is only now being discovered in America and Britain for the master that he is. The text is a fantastical war-time diary, written in 1918, and shows the author, himself a restless wanderer, describing the creative urge in a way that could refer to Clemente's remarkable oeuvre. 'Where one doesn't consider aroused senses as a mere effervescence of the erotic itch (and that would only be a position of a thorough beast), they constitute the internal flowering of every major seed of intelligence, comprehension, fore- and hindsight. Creation, that is to say, the creation of ancient forgotten values (second-hand values), arises through the stimulation of the senses: a tremendous force whose manipulation exacts a consummate experience'.[4]

Clemente's frescos, shown here, are masterpieces of a moribund technique that is quintessentially Italian. They reveal an artist who has absorbed both East and West, who has a precise sense both of this world and the other, of the self and the community, who shows himself both anguished and at peace. In *Priapea* (1980; Cat. 229), his body is fragmented and dismembered, floating in a Baroque heaven and borne aloft by angelic putti – a dream in which reality and fantasy are mingled. In his most recent fresco, *Fraternità* (*Brotherhood*, 1988; Cat. 231), the artist confronts us with a wall that blocks our path but which also demands to be penetrated. On the other side is surely either hell or heaven. We are presented both with reality and an abstraction.

All too often in this century figurative painting and drawing have been pronounced dead. These younger Italian artists have reasserted figurative painting in a fundamental way and have demonstrated that it can never become a marginal activity, any more than can descriptive writing. It is a very special achievement of these four artists to have reasserted the Italian tradition in the 1980s and to have demonstrated that, by absorbing the past, both recent and distant, it is possible to transform the present.

4 A. Savinio, *The Departure of the Argonaut*, New York, 1986, n. p.

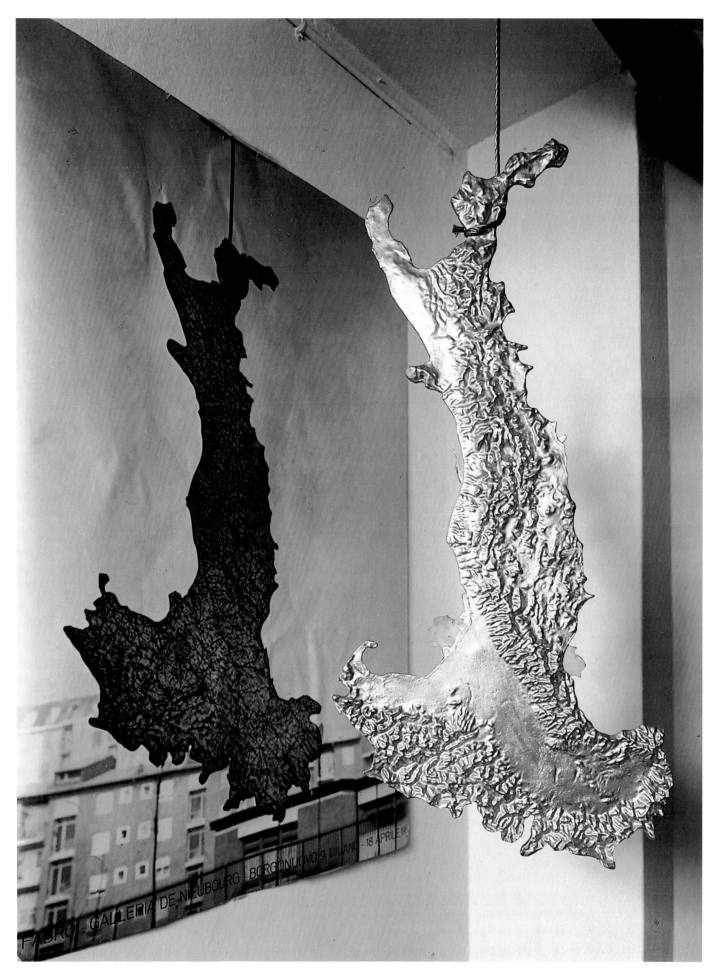

204 Luciano Fabro, Golden Italy (*Italia d'oro*) 1971

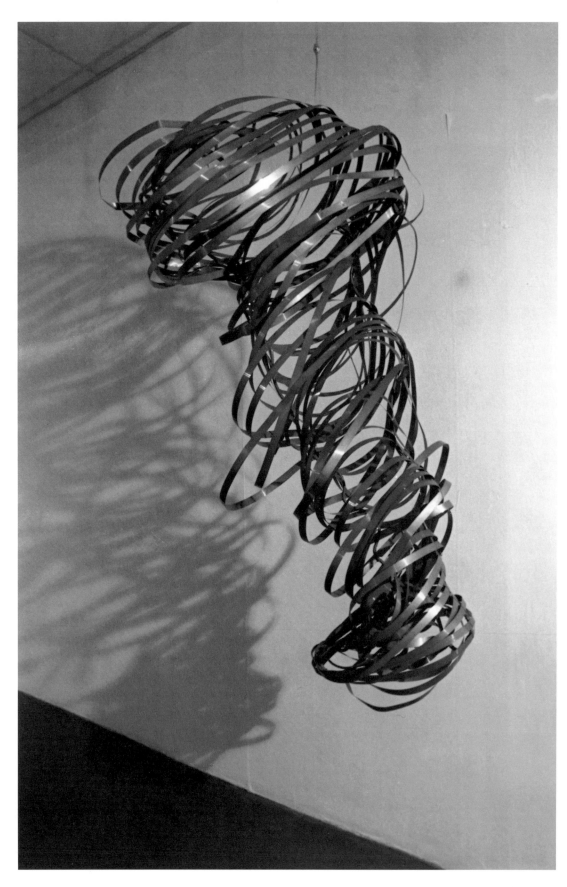

205 Luciano Fabro, Fetish Italy (*Italia feticcio*) 1981

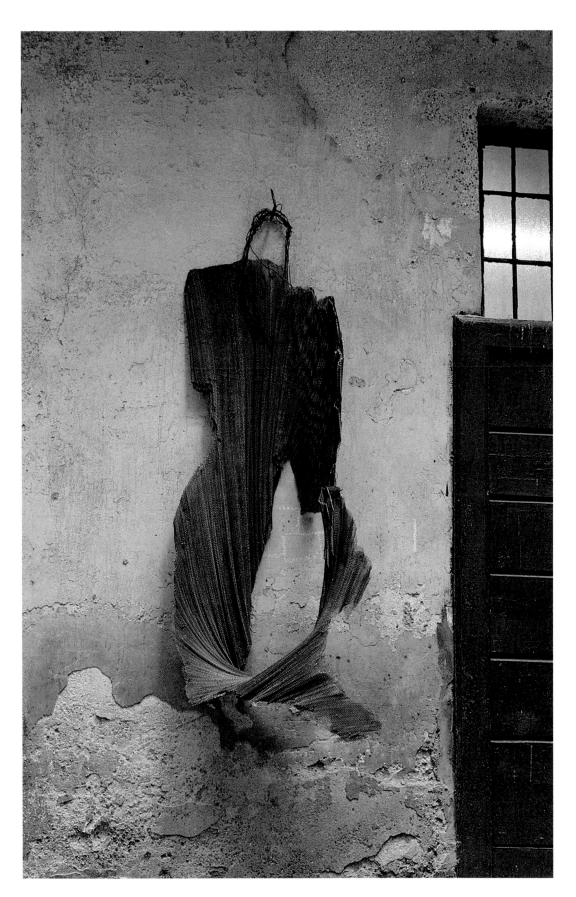

206 Luciano Fabro, Italy of War (*L'Italia da guerra*) 1981

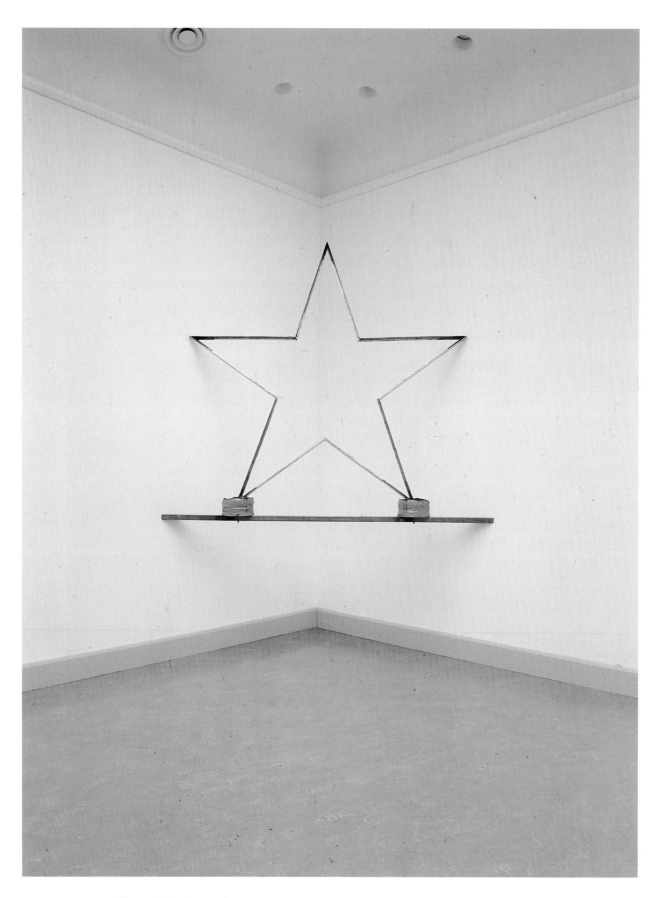

207 Gilberto Zorio, Bronze Star with Acids and Parchment (*Stella di bronzo con acidi e pergamena*) 1978

208 Gilberto Zorio, To Purify Words (*Per purificare le parole*) 1980

209 Giovanni Anselmo, Direction (*Direzione*) 1967-9

210 Giovanni Anselmo, Towards Overseas (*Verso oltremare*) 1984

211 Giuseppe Penone, Breath I (*Il soffio I*) 1978

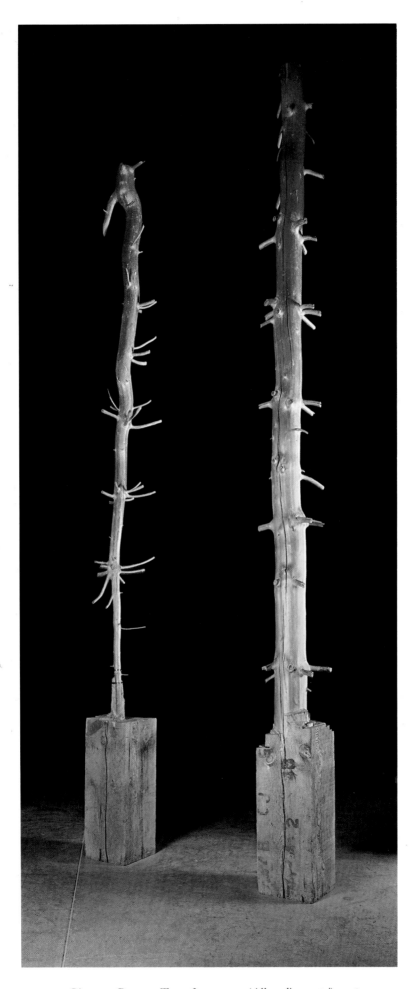

212 Giuseppe Penone, Tree of 12 metres (*Albero di 12 metri*) 1980-2

213 Jannis Kounellis, Alphabet (*Alfabeto*) 1959

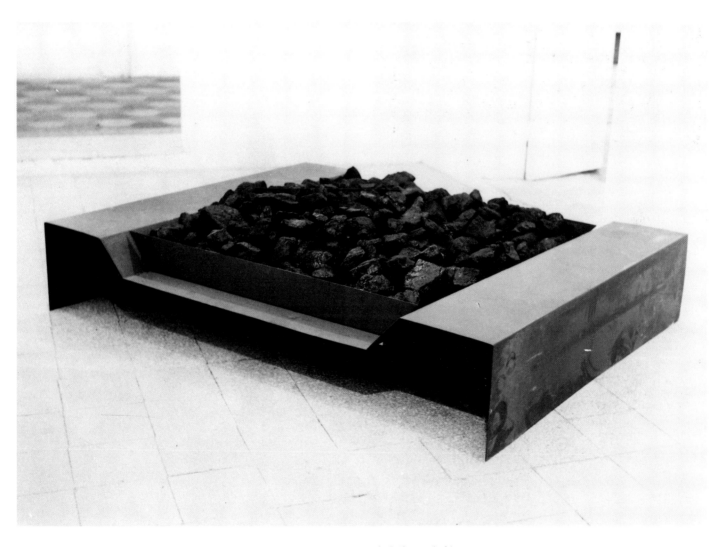

214 Jannis Kounellis, Untitled (*Senza titolo*) 1967

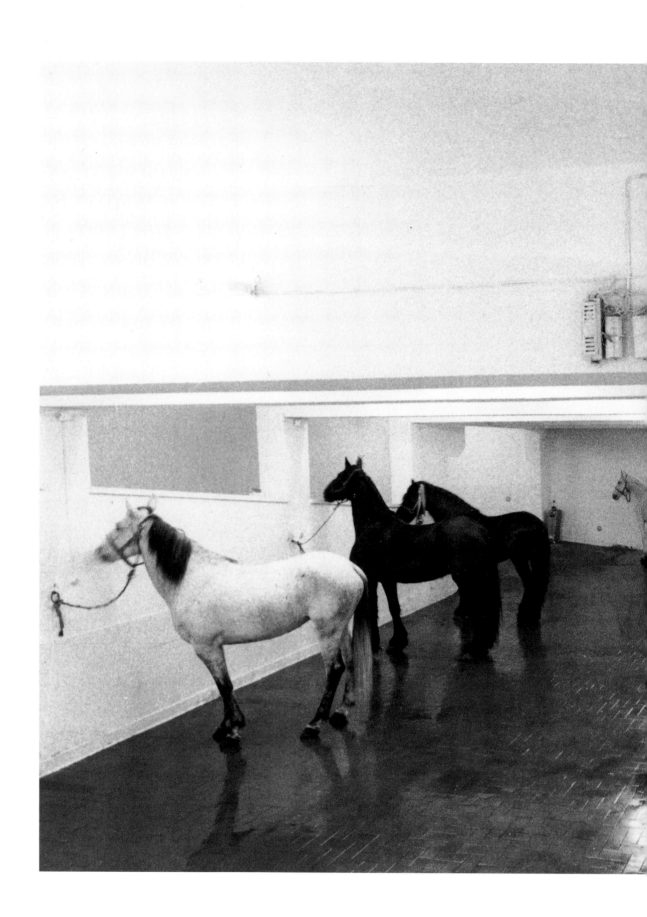

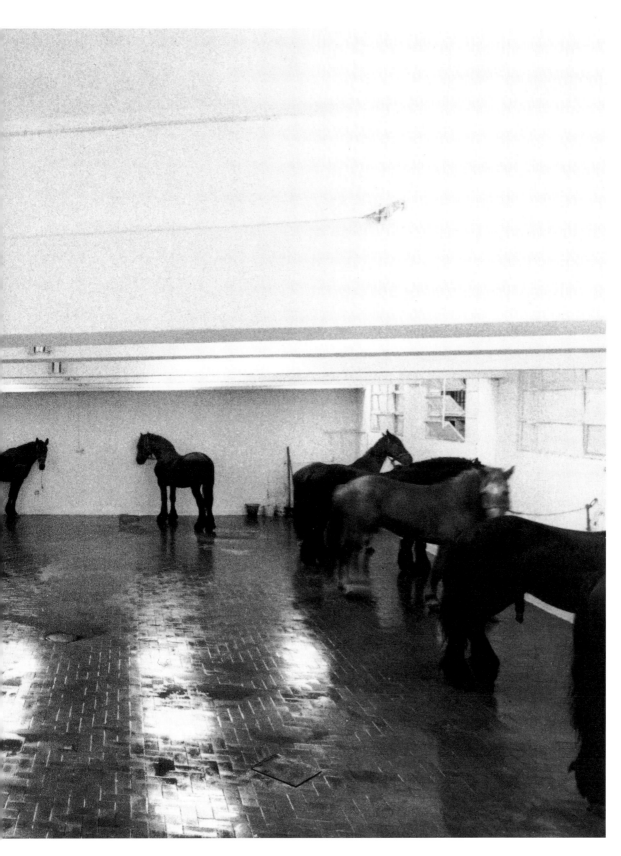

215 Jannis Kounellis, Horses (*Cavalli*) 1969

216 Jannis Kounellis, Untitled (*Senza titolo*) 1988

217 Mario Merz, Unreal City (*Città irreale*) 1968

218 Mario Merz, Raincoat (*Impermeabile*) 1967

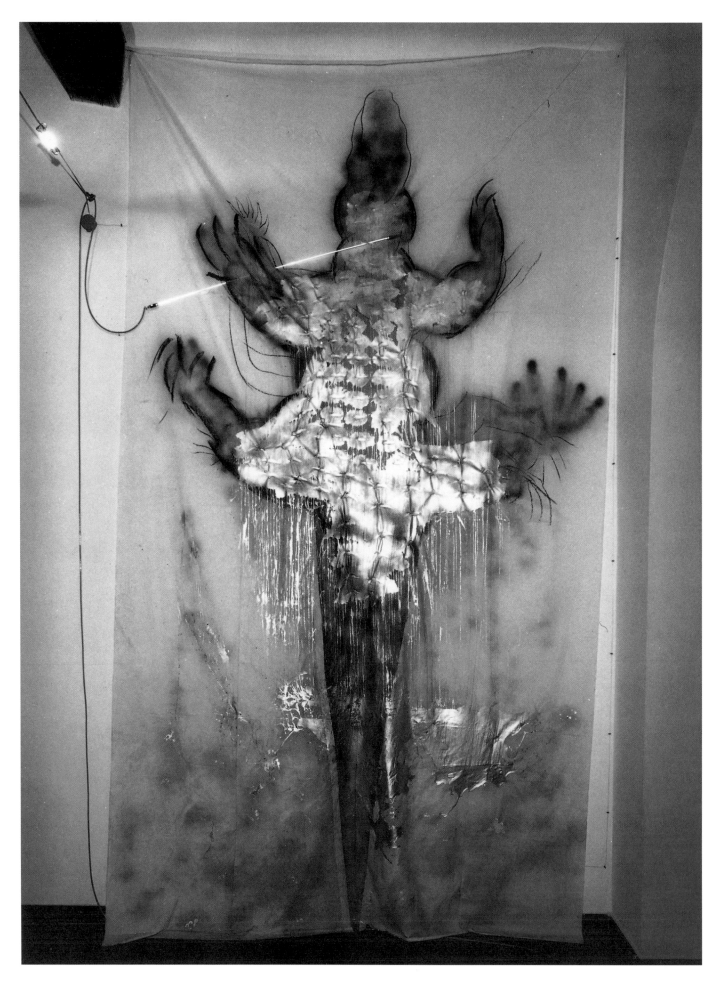

219 Mario Merz, Silver Crocodile (*Coccodrillo d'argento*) 1980

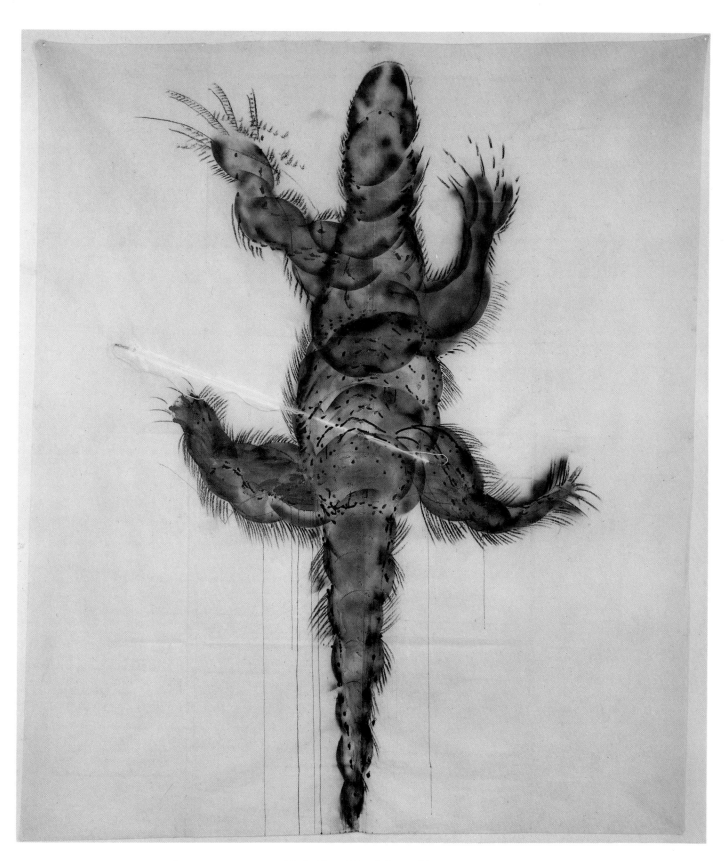

220 Mario Merz, Lizard (*Lucertola*) 1978

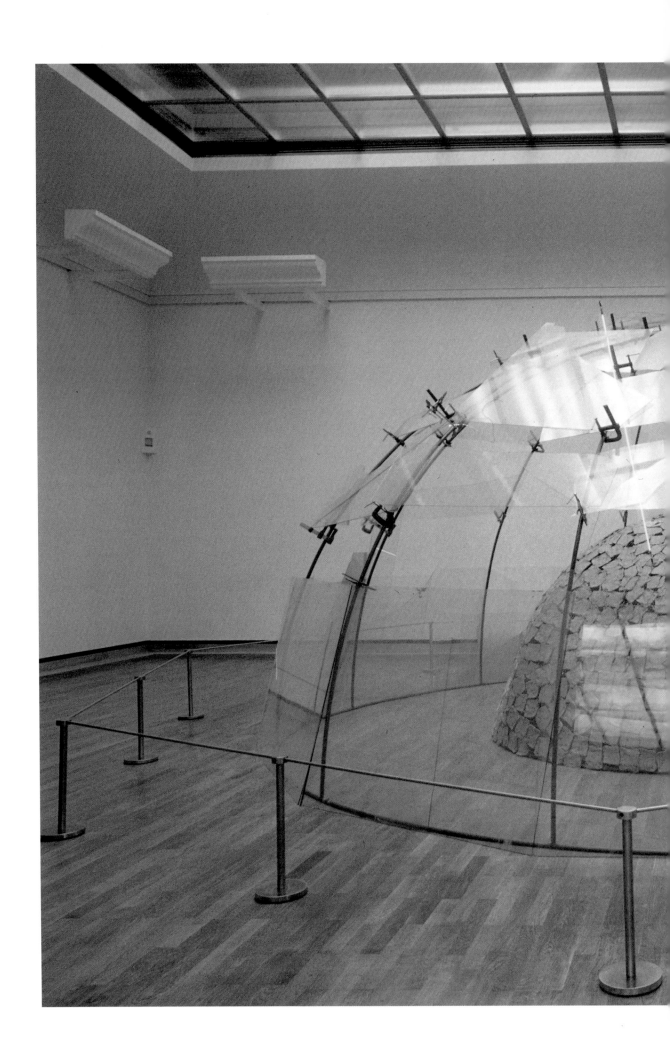

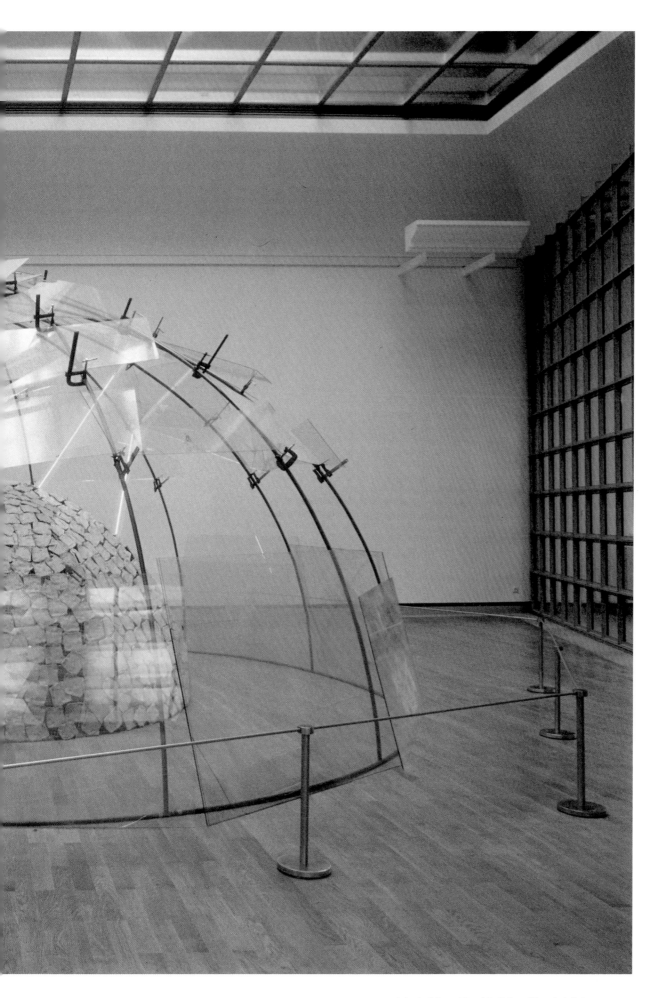

221 Mario Merz, Double Igloo (*Doppio igloo*) 1968-81

222
Gino De Dominicis,
Urvasi and Ghilgamesh
(*Urvasi e Ghilgamesh*)
1980

223 Gino De Dominicis, Untitled (*Senza titolo*) 1987

224 Gino De Dominicis, Titled (*Con titolo*) 1985

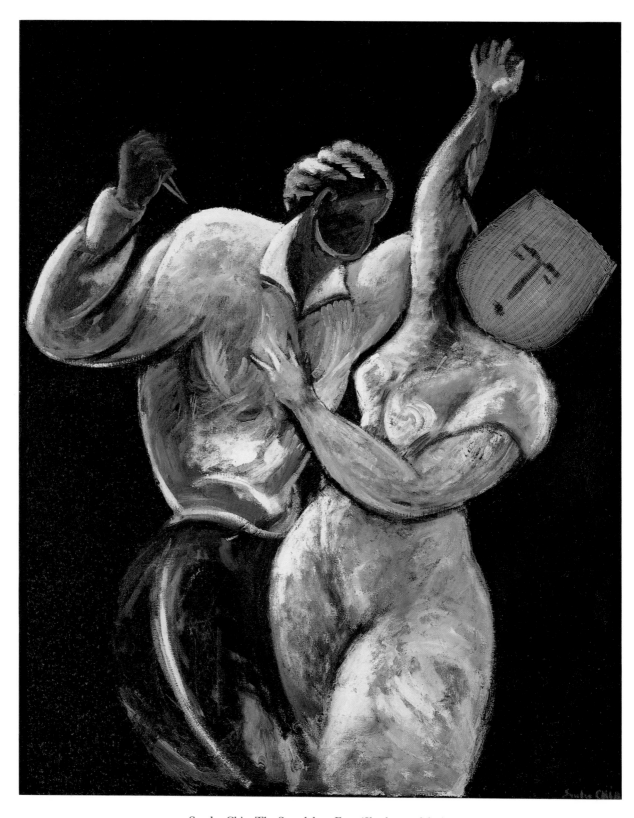

225 Sandro Chia, The Scandalous Face (*Il volto scandaloso*) 1981

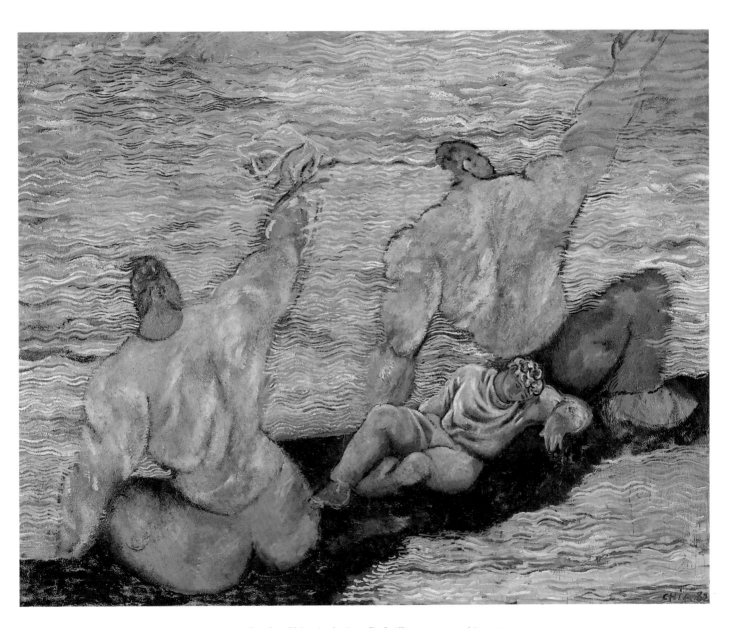

226 Sandro Chia, Audacious Raft (*Zattera temeraria*) 1982

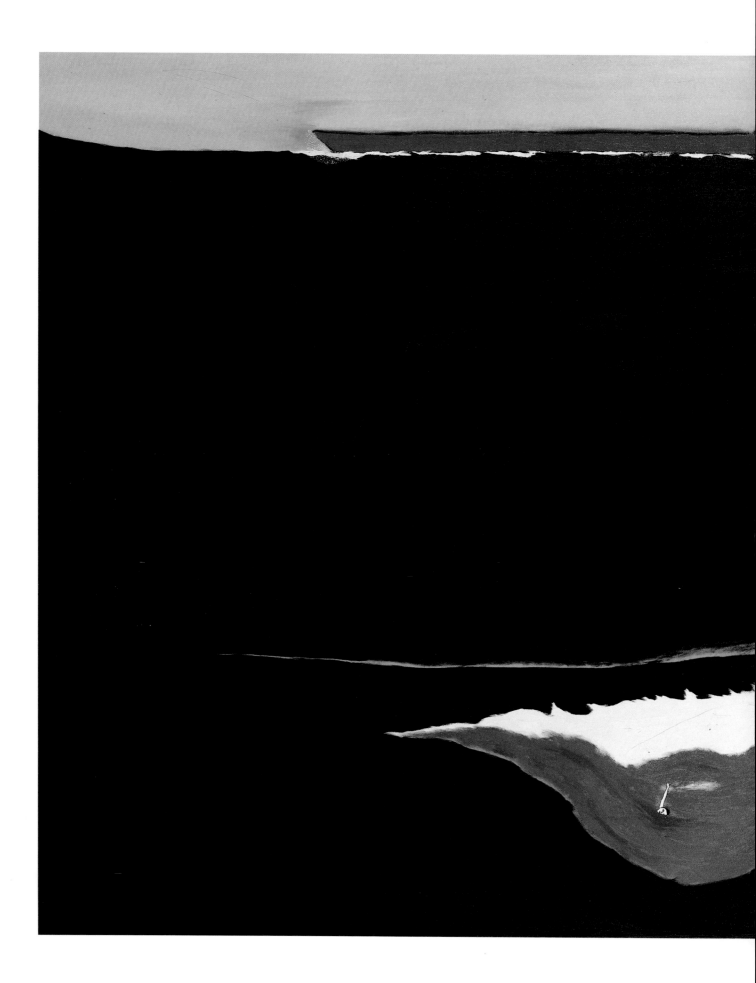

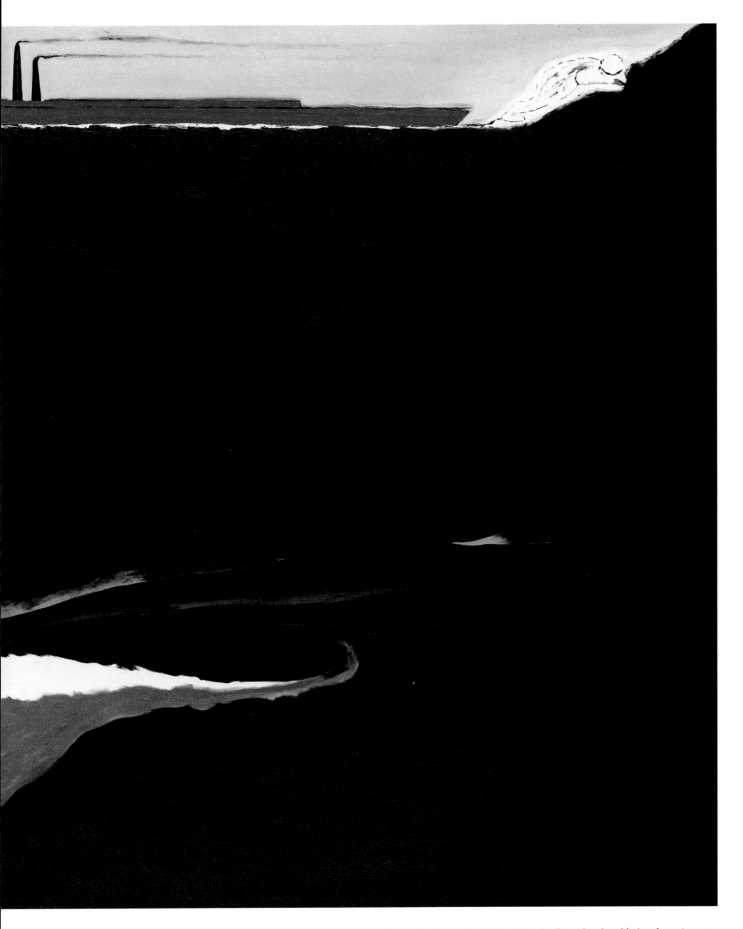

227 Enzo Cucchi, Picture in the Dark by the Sea (*Quadro al buio sul mare*) 1980

228　Enzo Cucchi, Stupid Picture (*Quadro tonto*)　1982

229　Francesco Clemente, *Priapea*　1980

230 Francesco Clemente, Roots (*Radici*) 1982

231 Francesco Clemente, Brotherhood (*Fraternità*) 1988

232 Mimmo Paladino, Untitled (*Senza titolo*) 1982

233 Mimmo Paladino, Baal 1986

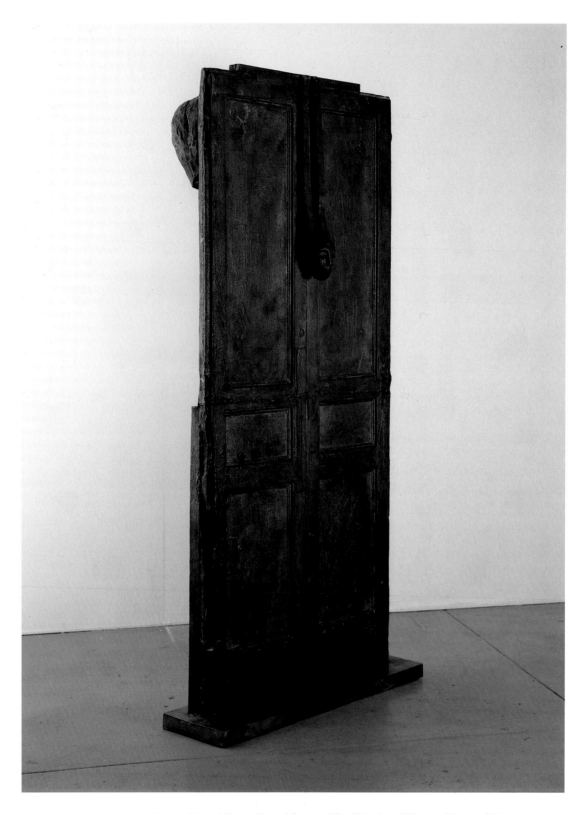

234 Mimmo Paladino, Round Earth, Frugal Repast: The Wayfarer Waits in Distant Cities
(Alla rotonda terra al magro pasto il viandante attende in città lontane) 1986

List of Works

Carlo Carrà
28 *Leaving the Theatre (Uscita dal teatro)* 1909
Oil on canvas, 69 x 91 cm
Collection Mr and Mrs Eric Estorick

Carlo Carrà
29 *Swimmers (Nuotatrici)* 1910-12
Oil on canvas, 105.3 x 155.6 cm
The Carnegie Museum of Art, Pittsburgh (Gift of G. David Thompson, 1955)

Carlo Carrà
30 *What the Tram Told Me (Ciò che mi ha detto il tram)* 1910-11
Oil on canvas, 52 x 67 cm
Städelsches Kunstinstitut, Frankfurt am Main (on loan from private collection)

Carlo Carrà
31 *Portrait of Marinetti (Ritratto di Marinetti)* 1910-11
Oil on canvas, 97 x 81 cm
Private collection

Luigi Russolo
32 *Plastic Synthesis of a Woman's Movements (Sintesi plastica dei movimenti di una donna)* 1912
Oil on canvas, 85 x 65 cm
Musée de Peinture et de Sculpture de Grenoble

Luigi Russolo
33 *Music (Musica)* 1911
Oil on canvas, 225 x 140 cm
Collection Mr and Mrs Eric Estorick

Gino Severini
34 *The Boulevard (Le boulevard)* 1911
Oil on canvas, 63.5 x 91.5 cm
Collection Mr and Mrs Eric Estorick

Gino Severini
35 *Self-Portrait (Autoritratto)* 1912-13
Oil on canvas, 55 x 46 cm
Private collection, Switzerland

Gino Severini
36 *The Blue Dancer (La danseuse en bleu)* 1912
Oil and sequins on canvas, 61 x 46 cm
Mattioli Collection, Milan

Gino Severini
37 *Cannon in Action (Canon en action)* 1915
Oil on canvas, 50 x 60 cm
Städelsches Kunstinstitut, Frankfurt am Main (on loan from private collection)

Gino Severini
38 *Plastic Synthesis of the Idea 'War' (Synthèse plastique de l'idée 'Guerre')* 1915
Oil on canvas, 60 x 50 cm
Bayerische Staatsgemäldesammlungen, Staatsgalerie moderner Kunst, Munich

Fortunato Depero
39 *Idol Dancer (Ballerina idolo)* 1917
Oil on canvas, 75 x 71.3 cm
Museo Provinciale d'Arte, Trento

Giorgio de Chirico
40 *Self-Portrait (Autoritratto)* 1913
Oil on canvas, 87.3 x 69.8 cm
The Metropolitan Museum of Art, New York (Gift in memory of Carl Van Vechten and Fania Marinoff, 1970)

Giorgio de Chirico
41 *Study (Etude)* 1912
Oil on canvas, 90.5 x 72.5 cm
Private collection

Giorgio de Chirico
42 *Melancholy (Melanconia)* 1912
Oil on canvas, 78.8 x 63.5 cm
Collection Mr and Mrs Eric Estorick

Giorgio de Chirico
43 *The Tower (La tour)* c. 1913
Oil on canvas, 115.5 x 45 cm
Kunsthaus, Zurich (Vereinigung Zürcher Kunstfreunde)

Giorgio de Chirico
44 *Ariadne's Afternoon (L'après-midi d'Ariane)* 1913
Oil on canvas, 135 x 65 cm
Private collection

Giorgio de Chirico
45 *The Enigma of Fatality (L'énigme de la fatalité)* 1914
Oil on canvas, 138 x 95.5 cm
Kunstmuseum, Basle (Emanuel Hoffmann Foundation)

Giorgio de Chirico
46 *Self-Portrait (Autoritratto)* 1913
Oil on canvas, 81.2 x 54 cm
The Alex Hillman Family Foundation

Giorgio de Chirico
47 *Turin 1888 (Torino 1888)* 1914-15
Oil on canvas, 60 x 46 cm
Private collection, Switzerland

Giorgio de Chirico
48 *Metaphysical Interior with Large Factory (Interno metafisico con grande officina)* 1916-17
Oil on canvas, 96.3 x 73.8 cm
Staatsgalerie, Stuttgart

Giorgio de Chirico
49 *The Jewish Angel (L'angelo ebreo)* 1916
Oil on canvas, 67.3 x 43.8 cm
The Jacques and Natasha Gelman Collection

Giorgio de Chirico
50 *The Dream of Tobias (Le rêve de Tobie)* 1917
Oil on canvas, 59 x 48 cm
Private collection

Giorgio de Chirico
51 *The Revolt of the Sage (La révolte du sage)* 1916
Oil on canvas, 67.3 x 59 cm
Collection Mr and Mrs Eric Estorick

Carlo Carrà
52 *Penelope* 1917
Oil on canvas, 94.5 x 54.5 cm
Private collection

Carlo Carrà
53 *The Enchanted Room (La camera incantata)* 1917
Oil on canvas, 68 x 52 cm
Pinacoteca di Brera, Milan (Gift of Emilio and Maria Jesi)

Carlo Carrà
54 *The Drunken Gentleman (Il gentiluomo ubriaco)* 1916
Oil on canvas, 60 x 45 cm
Private collection

Giorgio Morandi
55 *Still-Life (Natura morta)* 1918
Oil on canvas, 54 x 38 cm
Fondazione Magnani Rocca, Corte di Mamiano, Parma

Giorgio Morandi
56 *Still-Life (Natura morta)* 1919
Oil on canvas, 53.5 x 57.5 cm
Private collection, Milan

Giorgio Morandi
57 *Still-Life (Natura morta)* 1919
Oil on canvas, 60 x 59 cm
Pinacoteca di Brera, Milan (Gift of Emilio and Maria Jesi)

Amedeo Modigliani
58 *Portrait of Juan Gris (Portrait de Juan Gris)* 1915
Oil on canvas, 55.5 x 38 cm
The Metropolitan Museum of Art, New York (Bequest of Miss Adelaide Milton de Groot, 1967)

Amedeo Modigliani
59 *Study for the Portrait of Frank Burty-Haviland (Etude pour le portrait de Frank Burty-Haviland)* 1914
Oil on canvas, 61 x 50 cm
Los Angeles County Museum of Art (Mr and Mrs William Preston Harrison)

Amedeo Modigliani
60 *The Cellist (Le violoncelliste)* 1909
Oil on canvas, 130 x 81 cm
Private collection

Amedeo Modigliani
61 *Portrait of Jean Cocteau*
 (Portrait de Jean Cocteau) 1916
 Oil on canvas, 100 x 81 cm
 Henry & Rose Pearlman
 Foundation Inc.

Amedeo Modigliani
62 *Seated Nude (Nu assis)* 1916
 Oil on canvas, 92.4 x 59.8 cm
 Courtauld Institute Galleries, London
 (Courtauld Collection)

Amedeo Modigliani
63 *Nude with Clasped Hands (Nu aux mains*
 jointes) 1917
 Oil on canvas, 65 x 100 cm
 Private collection

Amedeo Modigliani
64 *Portrait of Jeanne Hébuterne*
 (Portrait de Jeanne Hébuterne) 1919
 Oil on canvas, 91.5 x 73 cm
 The Metropolitan Museum of Art,
 New York (Gift of Mr and Mrs Nate
 B. Spingold, 1956)

Amedeo Modigliani
65 *Portrait of Thora Klinckowstrom*
 (Portrait de Thora Klinckowstrom) 1919
 Oil on canvas, 99.7 x 64.8 cm
 Private collection

Amedeo Modigliani
66 *Head (Tête)* 1912
 Stone, height 50 cm,
 base 19 x 19 cm
 Private collection

Amedeo Modigliani
67 *Head (Tête)* 1911-13
 Limestone, 63.5 x 15.2 x 21 cm
 Solomon R. Guggenheim Museum,
 New York

Giorgio de Chirico
68 *Self-Portrait (Autoritratto)* c. 1922
 Oil on canvas, 38.4 x 51.1 cm
 The Toledo Museum of Art
 (Gift of Edward Drummond Libbey)

Giorgio de Chirico
69 *The Prodigal Son (Il figliol prodigo)* 1926
 Oil on canvas, 100 x 80 cm
 Private collection

Giorgio de Chirico
70 *The Archaeologist (L'archeologo)* 1927
 Oil on canvas, 96 x 128 cm
 Private collection, USA

Giorgio de Chirico
71 *The Two Nudes (Les deux nus)* 1926
 Oil on canvas, 130 x 89.5 cm
 Museum Ludwig, Cologne

Giorgio de Chirico
72 *The Shores of Thessaly (Les rivages de la*
 Thessalie) 1926
 Oil on canvas, 93 x 73 cm
 Collection Augusto Vallunga

Giorgio de Chirico
73 *The Spirit of Domination*
 (L'esprit de domination) 1927
 Oil on canvas, 89 x 116 cm
 Private collection

Giorgio de Chirico
74 *Furniture in a Valley (Meubles dans une*
 vallée) 1927
 Oil on canvas, 100 x 135 cm
 Galleria dello Scudo, Verona

Giorgio de Chirico
75 *Columns and Forest in a Room (Temple et*
 forêt dans la chambre) 1928
 Oil on canvas, 130 x 97 cm
 Private collection

Giorgio de Chirico
76 *Victory (Le triomphe)* 1928-9
 Oil on canvas, 160 x 240 cm
 Private collection, Milan

Alberto Savinio
77 *Atlas (Atlante)* 1927
 Oil on canvas, 71 x 91 cm
 Private collection

Alberto Savinio
78 *The Isle of Charms (L'île des charmes)* 1928
 Oil on canvas, 114 x 162 cm
 Regole d'Ampezzo, Pinacoteca Mario
 Rimoldi, Cortina d'Ampezzo

Alberto Savinio
79 *The Lost Ship (Le navire perdu)* 1926
 Oil on canvas, 82 x 66 cm
 Private collection, Turin

Alberto Savinio
80 *The Faithful Spouse (La fidèle épouse)* 1929
 Oil on canvas, 81 x 65 cm
 Galleria dello Scudo, Verona

Alberto Savinio
81 *The Departure of the Prodigal Son*
 (La partenza del figliol prodigo) 1930
 Oil on canvas, 81 x 64.5 cm
 Giuliano Gori, Fattoria di Celle

Alberto Savinio
82 *Annunciation (Annunciazione)* 1932
 Oil on canvas, 99 x 75 cm
 Civico Museo d'Arte Contemporanea,
 Palazzo Reale, Milan
 (Boschi Collection)

Filippo de Pisis
83 *Still-Life with Capricho by Goya*
 (Still-Life with Feather Duster)
 (Natura morta con capriccio di Goya
 [Natura morta con piumino]) 1925
 Oil on canvas, 68.5 x 86.5 cm
 Private collection

Filippo de Pisis
84 *Marine Still-Life with Lobster (Natura*
 morta marina con aragosta) 1926
 Oil on canvas, 56 x 88 cm
 Galleria dell'Oca, Rome

Filippo de Pisis
85 *Sacred Bread (Pane sacro)* 1930
 Oil on canvas, 100 x 65 cm
 Private collection

Filippo de Pisis
86 *Interior with Newspaper and Fruit*
 (Interno con giornale e frutta) 1934
 Oil on canvas, 50 x 65 cm
 Private collection

Giorgio Morandi
87 *Flowers (Fiori)* 1920
 Oil on canvas, 46 x 39 cm
 Private collection

Giorgio Morandi
88 *Still-Life (Natura morta)* 1921
 Oil on canvas, 44.7 x 52.8 cm
 Museum Ludwig, Cologne

Giorgio Morandi
89 *Still-Life (Natura morta)* 1926
 Oil on canvas, 60 x 60 cm
 Comune di Firenze, Raccolta d'Arte
 Contemporanea Alberto Della
 Ragione, Florence

Giorgio Morandi
90 *Still-Life (Natura morta)* 1929
 Oil on canvas, 55 x 58 cm
 Pinacoteca di Brera, Milan
 (Gift of Emilio and Maria Jesi)

Giorgio Morandi
91 *Still-Life (Natura morta)* 1929
 Oil on canvas, 51 x 47 cm
 Private collection

Giorgio Morandi
92 *Landscape (Paesaggio)* 1928
 Oil on canvas, 46 x 40 cm
 Private collection

Giorgio Morandi
93 *Landscape (Paesaggio)* c. 1929
 Oil on canvas, 41 x 49.5 cm
 Private collection, Rome

Giorgio Morandi
94 *Still-Life (Natura morta)* 1929-30
 Oil on canvas, 42 x 50.5 cm
 Private collection

Carlo Carrà
95 *The House of Love (La casa dell'amore)* 1922
Oil on canvas, 90 x 70 cm
Pinacoteca di Brera, Milan
(Gift of Emilio and Maria Jesi)

Carlo Carrà
96 *The Pine Tree by the Sea (Il pino sul mare)* 1921
Oil on canvas, 68 x 52.5 cm
Private collection

Carlo Carrà
97 *Lot's Daughters (Le figlie di Loth)* 1919
Oil on canvas, 110 x 80 cm
Private collection, Switzerland

* Carlo Carrà
98 *Expectation (L'attesa)* 1926
Oil on canvas, 95 x 100 cm
Private collection

Carlo Carrà
99 *Swimmers (Nuotatori)* 1929
Oil on canvas, 88 x 138 cm
Private collection, Milan

Mario Sironi
100 *Urban Landscape (Paesaggio urbano)* 1921
Oil on canvas, 50 x 68 cm
Pinacoteca di Brera, Milan
(Gift of Emilio and Maria Jesi)

Mario Sironi
101 *Urban Landscape with Lorry (Paesaggio urbano con camion)* 1920-3
Oil on canvas, 50 x 80 cm
Private collection

Mario Sironi
102 *Urban Architectural Composition (Composizione architettonica urbana)* 1919-23
Oil on canvas, 60 x 80 cm
Galleria dello Scudo, Verona

Mario Sironi
103 *The White Horse and the Pier (Il cavallo bianco e il molo)* c. 1920-22
Oil on canvas, 44 x 56 cm
Private collection, Rome

Mario Sironi
104 *Nude with Mirror (Nudo con lo specchio)* 1923-4
Oil on canvas, 96.2 x 72.5 cm
Private collection

Mario Sironi
105 *The Architect (L'architetto)* 1922
Oil on canvas, 70 x 60 cm
Private collection

Mario Sironi
106 *The Fishmonger (Il pescivendolo)* 1927
Oil on canvas, 48 x 44.5 cm
Private collection

Mario Sironi
107 *Nude with Tree (Nudo con albero)* 1930
Oil on canvas, 80 x 60 cm
Private collection, Monza

Mario Sironi
108 *Study for Italy between the Arts and the Sciences (Studio per L'Italia fra le Arti e le Scienze)* 1935
Tempera on paper on canvas, 370 x 475 cm
Private collection

Mario Sironi
109 *The Family (La famiglia)* 1929
Oil on canvas, 167 x 210 cm
Private collection

Arturo Martini
110 *Expectation (L'attesa* or *La veglia)* 1930-1
Terracotta and wood, 215 x 160 x 70 cm
Private collection

Arturo Martini
111 *Tobiolo* 1934
Bronze, 122 x 144 x 80 cm
Private collection

* Arturo Martini
112 *The Convalescent (La convalescente)* 1932
Terracotta, 100 x 110 x 49 cm
Galleria d'Arte Moderna, Genoa-Nervi

Arturo Martini
113 *The Pisan Girl (La pisana)* 1928
Patinated terracotta, 37 x 122 x 64 cm
Comune di Firenze, Raccolta d'Arte Contemporanea Alberto Della Ragione, Florence

Felice Casorati
114 *Midday (Meriggio)* 1922
Oil on panel, 120 x 130 cm
Civico Museo Revoltella, Galleria d'Arte Moderna, Trieste

Felice Casorati
115 *Double Portrait (with Sister) (Doppio ritratto [con la sorella])* 1924
Varnished tempera on panel, 122 x 91 cm
Private collection

Giacomo Balla
116 *Numbers in Love (Numeri innamorati)* 1920
Oil on panel, 77 x 56 cm
Private collection, Switzerland

Giacomo Balla
117 *The Spell is Broken (S'è rotto l'incanto)* c. 1920
Oil on canvas, 40 x 30 cm
Private collection

Enrico Prampolini
118 *The Everyday Automaton (L'automa quotidiano)* 1930
Mixed media on canvas, 100 x 80 cm
Galleria Nazionale d'Arte Moderna, Rome

Enrico Prampolini
119 *Encounter with Matter (Intervista con la materia)* 1930
Mixed media on canvas, 98 x 78.5 cm
Museo Civico di Torino, Turin

Lucio Fontana
120 *Seated Girl (Signorina seduta)* 1934
Bronze painted gold and black, 84 x 103 x 83 cm
Civico Museo d'Arte Contemporaneo, Palazzo Reale, Milan

Lucio Fontana
121 *Head of a Girl (Testa di ragazza)* 1931
Painted terracotta, 38 x 32 x 15.5 cm
Teresita Fontana

Lucio Fontana
122 *Black Figures (Figure nere)* 1931
Painted terracotta, 41 x 30 x 12.5 cm
Teresita Fontana

Lucio Fontana
123 *Scratched Tablet (Tavoletta graffita)* 1931
Painted cement, 23 x 29 cm
Private collection, Turin

Lucio Fontana
124 *Abstract Sculpture (Scultura astratta)* 1934
Plaster, 29 x 32 cm
Collection Beatrice Monti della Corte, Milan

Lucio Fontana
125 *Abstract Sculpture (Scultura astratta)* 1960 (replica of 1934 original)
Painted plaster, 41 x 23 x 1.8 cm
Collection Giorgio Marconi

Lucio Fontana
126 *Abstract Sculpture (Scultura astratta)* 1934
Painted plaster, 28 x 18 x 1 cm
Teresita Fontana

Lucio Fontana
127 *Abstract Sculpture (Scultura astratta)* 1960 (replica of 1934 original)
57 x 54 x 2 cm
Carla Panicali, Rome

Lucio Fontana
128 *Abstract Sculpture (Scultura astratta)*
1934
Iron, 62.5 x 50 x 7 cm
Museo Civico di Torino, Turin

Lucio Fontana
129 *Conch and Octopus (Conchiglia e polpo)* 1938
Clay, fired and glazed,
13 x 45 x 23.5 cm
Galleria Narciso, Turin

Lucio Fontana
130 *The Horses (I cavalli)* 1938
Clay, fired and glazed, 38 x 47 x 62 cm
Wilhelm-Lehmbruck-Museum,
Duisburg

Osvaldo Licini
131 *Biting (Addentare)* 1936
Oil on canvas, 65.5 x 88.5 cm
Private collection

Osvaldo Licini
132 *Composition with Black and Blue Lines (Composizione con linee nere e blu)* 1935
Oil on canvas, 17.5 x 82 cm
Private collection

Fausto Melotti
133 *Sculpture No. 12 (Scultura n. 12)* 1933
Plaster, 55 x 55 x 15 cm
Melotti Collection

Fausto Melotti
134 *Sculpture No. 11 (Scultura n. 11)* 1933
Plaster, 80 x 70 x 14.5 cm
Melotti Collection

Fausto Melotti
135 *Sculpture No. 16 (Scultura n. 16)* 1935
Plaster, 90 x 90 cm
Melotti Collection

Fausto Melotti
136 *Sculpture No. 24 (Scultura n. 24)* 1935
Plaster, 90 x 90 cm
Melotti Collection

Alberto Magnelli
137 *Stones No. 1 (Pierres No. 1)* 1933
Oil on canvas, 116 x 89 cm
Private collection

Alberto Magnelli
138 *Stones No. 3G (Pierres No. 3G)* 1933
Tempera on paper, 125 x 86 cm
Private collection

Massimo Campigli
139 *Six Heads (Sei teste)* 1945
Oil on canvas, 53.3 x 47 cm
Collection Mr and Mrs Eric Estorick

Massimo Campigli
140 *Market of the Women and the Amphorae (Mercato delle donne e delle anfore)* 1929
Oil on canvas, 220 x 160 cm
Assitalia SPA

Fausto Pirandello
141 *Interior in the Morning (Interno di mattino)* 1931
Oil on canvas, 175 x 150 cm
Musée National d'Art Moderne,
Centre Georges Pompidou, Paris

Fausto Pirandello
142 *Golden Rain (Pioggia d'oro)* 1934
Oil on panel, 100 x 130 cm
Private collection

Scipione
143 *Piazza Navona* 1930
Oil on canvas, 78.5 x 80.5 cm
Galleria Nazionale d'Arte Moderna,
Rome

Scipione
144 *Portrait of Cardinal Decano (Ritratto del Cardinale Decano)* 1930
Oil on canvas, 133.7 x 117.3 cm
Galleria Comunale d'Arte Moderna,
Rome

Scipione
145 *The Octopus (The Molluscs – Pierina Has Arrived in a Big City) (La Piovra [I molluschi – Pierina e arrivata in una grande città])* 1929
Oil on panel, 60 x 71 cm
Cassa di Risparmio della Provincia
di Macerata, Macerata

Renato Guttuso
146 *Execution in the Countryside (Fucilazione in campagna)* 1939
Oil on canvas, 100 x 75 cm
Galleria Nazionale d'Arte Moderna,
Rome

Renato Guttuso
147 *Flight from Etna (Fuga dall'Etna)* 1940
Oil on canvas, 147.5 x 256.3 cm
Galleria Nazionale d'Arte Moderna,
Rome

Renato Guttuso
148 *Crucifixion (Crocifissione)* 1941
Oil on canvas, 200 x 200 cm
Galleria Nazionale d'Arte Moderna,
Rome

Giacomo Manzù
149 *Christ with Magdalene (Cristo con Maddalena)* 1947-66
Bronze, 73.5 x 54.5 cm
Galleria Nazionale d'Arte Moderna,
Rome

Giacomo Manzù
150 *Christ with General (Cristo con generale)* c. 1947
Bronze, 71 x 51 cm
Galleria Nazionale d'Arte Moderna,
Rome

Marino Marini
151 *Pomona* 1941
Bronze, 156 x 58.5 x 54.5 cm
Musées Royaux des Beaux-Arts
de Belgique / Koninklijke Musea voor
Schone Kunsten van Belgie, Brussels

Marino Marini
152 *Horseman (Cavaliere)* 1947
Bronze, 163.8 x 154.9 x 67.3 cm
The Trustees of the Tate Gallery,
London

* Lucio Fontana
153 *Spatial Concept (Concetto spaziale)* 1952
Painted iron, diameter 300 cm
Museo Civico di Torino, Turin

Lucio Fontana
154 *Spatial Concept (Concetto spaziale)* 1951
Oil on canvas, 81 x 65 cm
C. Benporat Collection, Milan

Lucio Fontana
155 *Spatial Concept (Concetto spaziale)* 1957
Pastel on canvas, 125 x 101 cm
Teresita Fontana

Lucio Fontana
156 *Spatial Concept – Form (Concetto spaziale – Forma)* 1958
Aniline and collage on canvas,
149 x 150 cm
Teresita Fontana

Lucio Fontana
157 *Spatial Concept (Concetto spaziale)* 1958
Aniline on paper on canvas,
100 x 100 cm
Teresita Fontana

Lucio Fontana
158 *Spatial Concept – Expectations (Concetto spaziale – Attese)* 1959
Water-based paint and oil on canvas,
167 x 127 cm
Musée d'Art Moderne de la Ville de
Paris, Paris

Lucio Fontana
159 *Spatial Concept – The End of God (Concetto spaziale – La fine di Dio)* 1963
Oil on canvas, 175 x 121 cm
Private collection

Osvaldo Licini
160 *Angel of San Domingo (Angelo di San Domingo)* 1957
Oil on insulating material,
60.2 x 72.8 cm
Giuliano Gori, Fattoria di Celle

Osvaldo Licini
161 *Amalassunta No. 2* 1952
Oil on canvas, 80 x 100 cm
Galleria Nazionale d'Arte Moderna,
Rome

Osvaldo Licini
162 *Rebel Angel on Yellow Background*
(Angelo ribelle su fondo giallo) 1950-2
Oil on panel, 92.5 x 114.5 cm
Civico Museo d'Arte Contemporanea,
Palazzo Reale, Milan

Giulio Turcato
163 *Desert of the Tartars (Deserto dei*
Tartari) 1957
Oil on canvas, 160 x 220 cm
Paolo Sprovieri Collection, Rome

Giulio Turcato
164 *Political Gathering (Comizio)* 1950
Oil on canvas, 145 x 200 cm
Galleria Anna D'Ascanio, Rome

Alberto Burri
165 *Sack IV (Sacco IV)* 1954
Sacking, cotton, glue, silk and paint on
black cotton, 114 x 76 cm
Collection Anthony Denney

Alberto Burri
166 *Sack (Sacco)* 1952
Sacking, cloth and acrylic on canvas,
97.5 x 87.5 cm
Fondazione Palazzo Albizzini
(Burri Collection), Città di Castello

Alberto Burri
167 *Large Sack (Grande sacco)* 1954
Sacking and canvas, 150 x 250 cm
Private collection, Milan

Alberto Burri
168 *Large Wood Piece G59*
(Grande legno G59) 1959
Wood and acrylic on canvas,
200 x 185 cm
Galleria Nazionale d'Arte Moderna,
Rome

Alberto Burri
169 *Large White Plastic Piece B3*
(Grande bianco plastica B3) 1966
Plastic, acrylic and glue on
cellotex, 150 x 250 cm
Collection of the artist

Alberto Burri
170 *Red Plastic Piece (Rosso plastica)* 1964
Plastic and acrylic, 133 x 118 cm
Fondazione Palazzo Albizzini
(Burri Collection), Città di Castello

Emilio Vedova
171 *Concentration Camp*
(Campo di concentramento) 1950
Oil on canvas, 128 x 124 cm
Antonietta and Giovanni Demarco

Emilio Vedova
172 *Absurd Berlin Diary '64 – Plurimo No. 5*
(Absurdes Berliner Tagebuch '64 – Plurimo
Nr. 5) 1964
Oil, tempera, charcoal, collage and
decollage on wooden panels, metal
hinges, cords, 284 x 260 x 80 cm
Collection of the artist

Emilio Vedova
173 *Conflicting Situations I*
(Scontro di situazioni I) 1959
Oil on canvas, 275 x 445 cm
Galerie Neuendorf, Frankfurt am Main

Ettore Colla
174 *Transparent Column (Colonna*
trasparente) 1967
Scrap metal, height 320 cm,
diameter of base 35 cm
Galleria L'Isola, Rome

Ettore Colla
175 *Ritual (Rituale)* 1962
Scrap metal, height 300 cm,
base 1 x 50 x 40 cm
Galleria L'Isola, Rome

Ettore Colla
176 *Dogmatics (Dogmatica)* 1963
Scrap metal, height 247 cm,
diameter of base 40 cm
Galleria L'Isola, Rome

Carla Accardi
177 *Matter with Greys (Materico con grigi)*
1954
Oil and cementite on canvas,
128 x 158 cm
Rosangela Cochrane Collection, Turin

Carla Accardi
178 *Labyrinth with Sections (Labirinto con*
settori) 1957
Tempera and enamel paint on canvas,
133 x 204 cm
Luciano Pistoi Collection

Piero Manzoni
179 *Achrome* 1958
Gesso and kaolin on canvas, 76 x 97 cm
Collection Gianni Malabarba

Piero Manzoni
180 *Achrome* 1958
Kaolin on canvas, 130 x 162.5 cm
Museo Civico di Torino, Turin

Piero Manzoni
181 *Achrome (Bread Rolls) (Achrome [Panini])*
1961-2
Bread rolls glued on wood and
varnished, 90 x 85 cm
Collection Gianni Malabarba

Piero Manzoni
182 *Line, 4.5 m (Linea, 4.5 m)* 1959
Ink on paper in cardboard container,
height 22 cm, diameter 6 cm
Attilio Codognato Collection, Venice

Piero Manzoni
183 *Artist's Breath (Fiato d'artista)* 1960
Rubber balloon on wooden base,
2 x 18 x 18 cm
Attilio Codognato Collection, Venice

Piero Manzoni
184 *Magic Base (Base magica)* 1961
Wood and felt, height 60 cm,
base 81 x 80 cm
Attilio Codognato Collection, Venice

Piero Manzoni
185 *Line, 7,200 m (Linea, 7,200 m)* 1960
Ink on paper in zinc and lead container,
height 66 cm, diameter 96 cm
Kunstmuseum, Herning

Francesco Lo Savio
186 *Black Uniform Opaque Metal – Horizontal*
Surface Articulation (Metallo nero opaco
uniforme – articolazione di superfice
orizzontale) 1960
Sheet metal, varnished black,
95 x 200 x 20 cm
Galleria La Salita, Rome

* Pino Pascali
187 *Beheading of the Rhinoceros (Decapitazione*
del rinoceronte) 1966
Oil on canvas over wooden framework,
100.3 x 330.2 x 90.2 cm
Private collection

Pino Pascali
188 *Self-propelled Cannon*
(Cannone Semovente) 1965
Wood, scrap metal and rubber,
150 x 130 x 450 cm
Collection Franz Paludetto, Turin

Pino Pascali
189 *Colosseum (Colosseo)* 1964
Enamel paint on absorbent cloth on
canvas over wooden framework,
170 x 220 cm
Private collection, Venice

Pino Pascali
190 *Stone, Stone (Pietra, pietra)* 1964
Enamel paint on canvas, 200 x 300 cm
Private collection, Venice

Domenico Gnoli
191 *Restaurant Tables (Tavole di ristorante)*
1966
Oil and sand on canvas, 150 x 160 cm
Marie-Anne and Jan Krugier
Collection, Geneva

Domenico Gnoli
192 *Shirt Collar 15½ (Giro di collo 15½)*
1966
Oil and sand on canvas, 120 x 160 cm
Courtesy of Jan Krugier Gallery,
New York

Mimmo Rotella
193 *The Assault (L'assalto)* 1963
Collage on canvas, 151 x 136 cm
Staatsgalerie, Stuttgart

Mimmo Rotella
194 *Marilyn* 1962
Decollage, 125 x 95 cm
Maria Cohen, Turin

Mario Schifano
195 *Modern Times (Tempo moderno)* 1962
Enamel paint on paper on canvas,
180 x 160 cm
Collection Giorgio Marconi

Mario Schifano
196 *Sea (Mare)* 1963
Enamel paint on canvas, 200 x 200 cm
Collection Giorgio Marconi

Michelangelo Pistoletto
197 *Person Seen from the Back (Persona di
schiena)* 1962
Painted tissue paper on polished
stainless steel, 200 x 120 cm
Collection of the artist, Turin

Michelangelo Pistoletto
198 *Vietnam* 1965
Graphite pencil, oil and transparent
paper on polished stainless steel,
220 x 120 x 2.2 cm
The Menil Collection, Houston

Michelangelo Pistoletto
199 *Marzia with Child (Marzia con la
bambina)* 1962-4
Painted tissue paper on polished
stainless steel, 200 x 120 cm
Courtesy The Sonnabend Collection,
New York

Michelangelo Pistoletto
200 *Bottle (Bottiglia)* 1962-4
Photo silk-screen print on polished
stainless steel, 230 x 120 cm
Courtesy The Sonnabend Collection,
New York

Giulio Paolini
201 *Young Man Looking at Lorenzo Lotto
(Giovane che guarda Lorenzo Lotto)* 1967
Photo silk-screen print on canvas,
30 x 24 cm
Collection of the artist

Giulio Paolini
202 *Proteus I, II, III (Proteo I, II, III)* 1971
Plaster and plexiglass,
bases 10 x 30 x 30 cm, 20 x 30 x 30 cm,
10 x 25 x 30 cm
Collection Paul Maenz, Cologne

Giulio Paolini
203 *Frame (Cadre)* 1971
Canvas and photo silk-screen print
on canvas, 125 x 135 cm (9 canvases,
each 40 x 40 cm)
Private collection

Luciano Fabro
204 *Golden Italy (Italia d'oro)* 1971
Gilded bronze, 100 x 80 cm
Courtesy Galleria Christian Stein,
Milan und Turin

Luciano Fabro
205 *Fetish Italy (Italia feticcio)* 1981
Copper, 170 x 100 cm
Ch. Szwajcer

Luciano Fabro
206 *Italy of War (L'Italia da guerra)* 1981
Iron wire mesh, 150 x 100 cm
Collection of the artist

Gilberto Zorio
207 *Bronze Star with Acids and Parchment
(Stella di bronzo con acidi e pergamena)*
1978
Bronze framework, terracotta, acids
and steel, 220 x 230 x 30 cm
Jean Bernier Gallery, Athens

Gilberto Zorio
208 *To Purify Words (Per purificare le
parole)* 1980
Steel, glass and leather,
180 x 220 x 420 cm
Jean Bernier Gallery, Athens

Giovanni Anselmo
209 *Direction (Direzione)* 1967-9
Granite, magnet and glass,
50 x 80 x 15 cm
Musée National d'Art Moderne,
Centre Georges Pompidou, Paris

Giovanni Anselmo
210 *Towards Overseas (Verso oltremare)* 1984
Granite, steel cable and paint,
320 x 136 x 3 cm
Courtesy Galleria Christian Stein,
Milan and Turin

Giuseppe Penone
211 *Breath I (Il soffio I)* 1978
Terracotta, height 160 cm,
diameter 100 cm
Courtesy Galerie Rudolf Zwirner,
Cologne

Giuseppe Penone
212 *Tree of 12 metres (Albero di 12 metri)*
1980-2
Wood, two sections,
each approx. 6 m., bases 45 x 45 cm
Collection of the artist

Jannis Kounellis
213 *Alphabet (Alfabeto)* 1959
Oil on canvas, 200 x 200 cm
Collection Ingvild Stöcker, Munich

Jannis Kounellis
214 *Untitled (Senza titolo)* 1967
Steel and coal, 28 x 155 x 125 cm
Collection of the artist

* Jannis Kounellis
215 *Horses (Cavalli)* 1969
Installation at Galleria L'Attico, Rome

Jannis Kounellis
216 *Untitled (Senza titolo)* 1988
Steel, iron, jute, coal and paper,
400 x 650 x 60 cm
Courtesy Galleria Christian Stein,
Milan and Turin

* Mario Merz
217 *Unreal City (Città irreale)* 1968
Iron, wire mesh, wax and neon light
tube, 200 x 164 x 28 cm
Stedelijk Museum, Amsterdam

* Mario Merz
218 *Raincoat (Impermeabile)* 1967
Cloth, wax and neon light tube,
125 x 170 x 40 cm
Courtesy Galleria Christian Stein,
Milan and Turin

Mario Merz
219 *Silver Crocodile (Coccodrillo
d'argento)* 1980
Canvas and neon light tube,
420 x 200 cm
Egidio Marzona

Mario Merz
220 *Lizard (Lucertola)* 1978
Canvas and neon light tube,
280.7 x 233.7 x 10.2 cm
Anthony d'Offay Gallery, London

Mario Merz
221 *Double Igloo (Doppio igloo)* 1968-81
Steel, glass and earth, height 274 cm,
diameter 547 cm
Staatsgalerie, Stuttgart

Gino De Dominicis
222 *Urvasi and Ghilgamesh
(Urvasi e Ghilgamesh)* 1980
Pen and pencil on paper, 19.7 x 15 cm
Giorgio Franchetti, Rome

Gino De Dominicis
223 *Untitled (Senza titolo)* 1987
Tempera and pencil on panel,
240 x 240 cm
Lia Rumma, Naples

* Gino De Dominicis
224 *Titled (Con titolo)* 1985
Tempera and clay on wood,
250 x 160 cm
Collection of the artist

Sandro Chia
225 *The Scandalous Face
(Il volto scandaloso)* 1981
Mixed media on canvas, 162.5 x 130 cm
Kunsthalle, Bielefeld

Sandro Chia
226 *Audacious Raft (Zattera temeraria)* 1982
Oil on canvas, 300 x 371 cm
Marx Collection, Berlin

Enzo Cucchi
227 *Picture in the Dark by the Sea (Quadro al
buio sul mare)* 1980
Oil on canvas, 206 x 357 cm
Galerie Bruno Bischofberger, Zurich

Enzo Cucchi
228 *Stupid Picture (Quadro tonto)* 1982
Oil on canvas, 280 x 360 cm
Marx Collection, Berlin

Francesco Clemente
229 *Priapea* 1980
Fresco, 200 x 320 cm
Marx Collection, Berlin

Francesco Clemente
230 *Roots (Radici)* 1982
Fresco, 200 x 300 cm
Collection Lilott and Erik Berganus

Francesco Clemente
231 *Brotherhood (Fraternità)* 1988
Fresco, three panels, each 300 x 200 cm
Courtesy Sperone Westwater Gallery,
New York

Mimmo Paladino
232 *Untitled (Senza titolo)* 1982
Oil on canvas, 200 x 300 cm
Staatliche Museen Preussischer
Kulturbesitz, Nationalgalerie, Berlin

Mimmo Paladino
233 *Baal* 1986
Mixed media on canvas with wooden
frame, diameter 260.4 cm
Courtesy Sperone Westwater Gallery,
New York

Mimmo Paladino
234 *Round Earth, Frugal Repast: The Way-
farer Waits in Distant Cities (Alla rotonda
terra al magro pasto il viandante attende in
città lontane)* 1986
Bronze, 217.2 x 105.4 x 47.6 cm
Courtesy Sperone Westwater Gallery,
New York

*The following works in the exhibition
are not illustrated in the plate section:*

Lucio Fontana
*Venetian Nocturne (Notturno di
Venezia)* 1965
Aluminium on wood, glass, neon light
tubes and light bulbs, 215 x 105 x 30 cm
Galerie Fahnemann, Berlin →

Gino De Dominicis
Untitled (Senza titolo) 1988
Gilded plaster, 270 x 230 x 50 cm
Collection of the artist
(not illustrated)

Luciano Fabro
Palladio 1972
Photo silk-screen prints on paper,
4 sheets, each 280 x 220 cm
Collection of the artist

Luciano Fabro
Italy of the Puppets (Italia dei pupi) 1975
Brass, 200 x 100 cm
Private collection

Lucio Fontana
*Venetian Nocturne (Notturno di
Venezia)* 1965
Aluminium on wood, glass, neon light
tubes and light bulbs, 215 x 105 x 30 cm
Galerie Fahnemann, Berlin

Francesco Lo Savio
Black Uniform Opaque Metal – Ellipsoid
with Flat Middle Horizontal Section
(Metallo nero opaco uniforme – elissoidale
con parte centrale piana orizzontale) 1961
Sheet metal, varnished black,
76 x 200 x 16.5 cm
Galleria La Salita, Rome

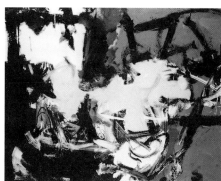

Giulio Paolini
Untitled (Senza titolo) 1962
Canvas, Masonite and wood,
two sections, each
60 x 40 cm
Collection of the artist

Giulio Paolini
Two plus Two (Due più due) 1965
Plywood, 200 x 160 cm
Collection Z. Mis

Giuseppe Penone
Breath III (Il Soffio III) 1978
Terracotta, height 152 cm,
diameter 85 cm
Private collection

Emilio Vedova
Cycle 62 B.B. 6 (Ciclo 62 B.B. 6) 1962
Oil on canvas, 145.5 x 185.5 cm
Collection of the artist

Emilio Vedova
Cycle 62-63 B. 3 (Ciclo 62-63 B. 3)
1962-3
Oil on canvas, 145.5 x 185 cm
Collection of the artist

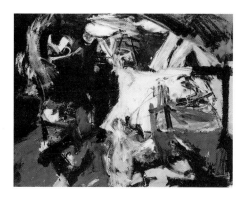

Biographies of the Artists

Compiled by *Julia Blaut* (J. B.), *Emily Braun* (E. B.), *Ester Coen* (E. C.), *Simonetta Fraquelli* (S. F.), *Matthew Gale* (M. G.), *Margherita Giacometti Brais* (M. G. B.), *Pepe Karmel* (P. K.) *and Joan Pachner* (J. P.)

Carla Accardi

was born in 1924 in Trapani (Sicily). She graduated from the local liceo classico in 1943 and subsequently attended courses at the Accademia di Belle Arti in Palermo and in Florence. Dissatisfied with her academic training, she spent much of her time in museums studying the Old Masters, in particular, Fra Angelico. In 1946, she settled in Rome and befriended Antonio Sanfilippo (whom she married in 1949), Turcato, Pietro Consagra and Ugo Attardi. Together they went to Paris, where Accardi first encountered the European avant-garde. With Piero Dorazio, Mino Guerrini and Achille Perilli, they established the group *Forma* in 1947. The eight signatories of the manifesto (dated 15 March 1947) proclaimed themselves both 'Formalists and Marxists' and split from the artists of the *Fronte Nuovo delle Arti*, who aimed at expressing their social consciousness through figurative art.

Turcato presented Accardi's first solo exhibition at the Libreria Age d'Or in Rome in 1950. The following year, she exhibited at the Libreria Salto in Milan, the meeting place of the artists of the group *M.A.C.* (*Movimento per l'Arte Concreta*). At that time, her work was primarily influenced by Cubism and the static compositions of Magnelli, whom she met in Paris in 1951. While in the French capital, she also became acquainted with Hans Hartung and kept up to date with the latest developments in *Art Informel*. Accardi's work already contained a dynamism and energetic zest which, although based on abstract pictorial elements, was reminiscent of Futurism. Following a period of crisis in 1953, during which she hardly painted at all, Accardi re-emerged in 1954 with a new, mature style of black-and-white compositions with a labyrinthine complex of lines and sharp tonal contrasts. Rising from her subconscious, the spontaneity of her gestures expressed a variety of emotions and existential confrontations with the world. Accardi first exhibited these works

in a solo exhibition at the Galleria San Marco in Rome in 1955. That year, she received international recognition when Michel Tapié invited her to participate with Burri, Fontana, Giuseppe Capogrossi and Yves Klein in the exhibition 'Individualità d'oggi', held at the Galleria Spazio in Rome, and with Sam Francis, Jean Paul Riopelle, Georges Mathieu and Serge Poliakoff in 'Individualité d'aujourd'hui', shown at the Galerie Rive Droite in Paris.

By the late fifties, Accardi had begun to incorporate shades of grey and then elements of colour into her painting; areas that gave the impression of 'infinite' space were introduced in between the interwoven patterning. Accardi's use of an automatic script on a monochrome ground has been likened to the work of Mark Tobey, which she saw on the occasion of his one-man show at the Venice Biennale of 1958. In 1961, she joined the group *Continuità* and, in accordance with its tenets, introduced greater order and deliberation into her work as a reaction against *Informel*. She also began to use strident colours which heightened the optical vibrations of the small, arabesque brushstrokes.

Accardi pushed her compositions to the edge of the canvas in order to capture the phenomenological experience of shifting, expanding space. It was therefore a natural progression when, in the mid-sixties, she began to construct paintings in actual space with fragile 'tents' made of transparent plastic. Her coloured forms now seemed to float and flutter in mid-air, as the fragile structures reacted to the slightest movement in the surroundings. The motif of the tent and its 'nomadic connotation', as well as Accardi's experiments with environmental installations, were to influence the artists of the *Arte Povera* generation. She had individual exhibitions at the Venice Biennale in 1964 and 1988. She was included in the 'Arte Ambiente' section of the 1976 Biennale and in the exhibition 'Avanguardia e Transavanguardia' at the Mura Aureliane in Rome in 1982. Accardi lives and works in Rome. S. F.

Milan, Padiglione d'Arte Contemporanea, *Carla Accardi*, 1983
Madrid, Istituto Italiano di Cultura, *Carla Accardi*, 1985
Bruno Corà, 'Carla Accardi', *Flash Art*, no. 125, March 1985, pp. 14-17

Giovanni Anselmo

was born on 5 August 1934 in Borgofranco d'Ivrea (Piedmont). From 1959 to 1964, he painted in oils, but found that the medium was too limited for the ideas and emotions he wanted to express. He turned to Conceptual Art after a revelatory experience in August 1965. Standing high on the slopes of Mount Stromboli, Anselmo watched the sun rise below him and realized that his shadow was being cast, not onto the ground, but upwards into the atmosphere. He took this as a signal to redirect

his artistic activity: if the shadow normally cast downwards by a body signified the particulars of time and place, then the shadow cast into the void indicated the possibility of an art concerned with the timeless and amorphous qualities of the universe.

Between 1966 and 1971, Anselmo embodied his ideas in individual works or installations pertaining to elementary phenomenological experiences, such as stasis, elasticity, equilibrium and the pull of gravity. *Direction* (1967-8) featured a compass set into a triangular block of granite, conjoining obdurate matter with the ephemeral fields of magnetic energy. By placing an eighty-kilogramme granite slab high on a wall in an untitled work of 1969, Anselmo lessened the gravitational pull of the earth to a small but measurable degree, drawing attention to the invisible and unfathomable workings of natural forces through concrete objects. In other installations of the period, organic materials were wedged between a slab of stone tied to a support; unless they were replaced before shrinking and disintegrating, the slab would fall. Like the work of Robert Morris or Richard Serra, Anselmo's demonstrations revealed the forces of gravity through organic processes of decay or through the precarious 'balance' of sculptural forms. He has been associated with *Arte Povera* since his inclusion in the group's second exhibition, at the Galleria De' Foscherari in Bologna in 1968.

In 1969, Anselmo began to employ language both as a symbolic means and as an object in its own right. In the series of drawings and the artist's book entitled *Details of the Infinite*, the image of the word 'infinite' was enlarged so that the bodies and edges of, and the intervals between, the letters were visible only as shadow or light, evoking a

sense of a limitless expanse. Similarly, in the 1972 artist's book *Leggere* (To Read) the word *'leggere'* shrinks to microscopic size, disappears, re-emerges and swells to fill the last, black page of the book. The 'huge' proves to be as imperceptible as the 'minute'. A number of other works dating from the seventies play with the dimensions of words as they land on a solid surface or on the viewer's body from the light of a slide projector.

In the 1980s, Anselmo has returned to the iconography of the granite slabs, introducing a theatrical dimension in the series *The Greys Jettison Out to Sea*. These consist of hyper-realist, life-size renderings of an open hand gesturing across the space of a room towards a group of blocks seemingly 'in flight' along the wall. Whether resting on the floor or tied precariously to the wall, Anselmo's granite slabs represent the immobile wrested, in continual tension, from a state of flux. His theme of juxtaposing matter and the void continues the Metaphysical concerns of de Chirico in the contemporary idiom of Process and Conceptual Art. Anselmo lives and works in Turin. P. K.

Giovanni Anselmo, *Leggere*, Turin, 1972
Giovanni Anselmo, ed. Jean-Christophe Ammann, Lucerne, Kunstmuseum, 1973
Giovanni Anselmo, ed. Jean-Christophe Ammann, Giovanni Anselmo and M. Suter, Basle, Kunsthalle, 1979

Giacomo Balla

was born in Turin on 18 July 1871. His father, an industrial chemist, was a keen amateur photographer. Essentially self-taught, Balla briefly attended drawing classes in 1891 at the Accademia Albertina in Turin, where he met Pilade Bertieri who introduced him to Pellizza da Volpedo. In 1895, he moved to Rome, befriending the educationalist Alessandro Marcucci, the brother of his future wife, Elisa. His Socialist leanings were encouraged by Marcucci, Duilio Cambellotti, Giovanni Prini and Giovanni Cena, who ran the Scuola dell'agro romana. In September 1900, Balla went to Paris to see the 'Exposition Universelle'; he remained there several months working for the illustrator Sergio Macchiati. On his return, he became an important propagator of Divisionist techniques: Severini, Boccioni and Sironi were among his pupils. His paintings, which were inspired by contemporary Positivist ideas, combined humanitarian themes with a scientific interest in the effects of both natural and artificial light. The subject of work occurred frequently in his art, acquiring reverential overtones in paintings such as the triptych *The Worker's Day*.

Balla signed the *Manifesto of Futurist Painters* and *Futurist Painting, Technical Manifesto* in 1910. Despite his embracing of modern themes, he continued to work in a Divisionist-inspired style, as in *Street Lamp* (1909), until 1912. The latter canvas was listed in the catalogue of the 1912 Futurist exhibition at the Galerie Bernheim Jeune in Paris, but Balla, in fact, did not participate. From the beginning, his interests in science, the chronophotography of Etienne Jules Marey and the photodynamism of Anton Giulio Bragaglia led him to pursue a style and idea of Futurism very different from that of Boccioni. His mature Futurist works of 1912, such as *Girl Running on a Balcony* and *Rhythm of a Violinist*, demonstrated his new line of research in the breaking down of movement into successive stages. That year he had travelled to

Düsseldorf to paint murals for the Löwenstein house. There he began his pioneering abstract works, *Iridescent Compenetrations*, which reduced the effects of light and velocity to the hermetic purity of geometric patterns.

His first *Abstract Speeds*, of fast-moving cars and swallows in flight, appeared at the end of 1913. By 1914 he was participating as both an actor and set designer in the theatrical spectacles of Francesco Cangiullo, and began to compose his *parole-in-libertà* (words-in-freedom). In 1915, he and Depero published the manifesto *Futurist Reconstruction of the Universe*, which sought to apply the Futurist aesthetic to fashion, furnishings and every aspect of modern life. Together they produced a series of completely non-figurative constructions, or 'plastic complexes', made of cardboard, tin, silk and other everyday materials. Between 1914 and 1915, Balla produced *Interventionist Demonstrations*, which reflected the Futurists' enthusiasm for military patriotism and Italy's entry into the war. During the war years, his studio became a meeting place for young artists. In 1917, he designed stage sets for Sergej Diaghilev's ballet *Fireworks* with music by Igor Stravinsky. He became increasingly involved with the decorative arts and in 1920 opened his house in Via Nicolò Porpora to display what was effectively the first entirely coloured environment. In 1921-2 he designed the decoration for the Bal Tic Tac, a Futurist-style dance hall, and in 1925, with Depero and Prampolini, he participated in the 'Exposition des Arts Décoratifs' in Paris. There, impressed by the Russian pavilion by Rodchenko and El Lissitsky and by the pavilion of *L'Esprit Nouveau* by Le Corbusier, he subsequently produced Constructivist-influenced works such as *Numbers in Love* (1920), which were also close to the mechanical images of Ivo Pannaggi and Vinicio Paladini.

He was briefly associated with Filippo Marinetti's Second Futurism, signing the *Manifesto of Aeropainting* in 1929 and participating in the 'Prima Mostra di Aeropittura dei Futuristi' in Rome in 1931. Nonetheless, his style was already orientated towards a naturalistic figuration, as was evident in his one-man show at the Società degli Amatori e Cultori in 1929-30. By the late thirties, he had dissociated himself from Futurism, 'in the conviction that pure art is to be found in absolute realism, without which one falls into decorative ornamental forms'. Despite a brief period in the

fifties, when his works were praised by the younger generation of abstract painters (the *Gruppo Origine* held an exhibition of his paintings in 1951), Balla's style remained figurative until his death in Rome on 1 March 1958. S. F.

Giacomo Balla, ed. Enrico Crispolti and M. L. Drudi Gambillo, Turin, Museo Civico, 1963
Giovanni Lista, *Giacomo Balla*, Modena, 1982
Balla, The Futurist, ed. Maurizio Fagiolo dell'Arco, Oxford, Museum of Modern Art, 1987

Umberto Boccioni

was born on 19 October 1882 in Reggio Calabria. His father was a government employee who was frequently transferred to other towns; the family moved to Forlì, then Genoa, Padua and Catania, where Boccioni completed his studies. From 1899, he lived in Rome and began to attend the Scuola Libera del Nudo. There he met Severini, and together they studied Divisionist techniques in Balla's studio. From 1903 to 1906, he participated in the annual exhibition of the Società degli Amatori e Cultori; in 1905, he also showed at the impromptu Salon des Refusés organized by a group of young artists dissatisfied with the conservatism of the official juries. Tired of the provincial atmosphere in Rome, Boccioni left for Paris in the spring of 1906; he was fascinated by the modernity of the city. That summer he travelled to Russia, returning to Italy at the end of the year; after brief stays in Padua and Venice, he finally settled in Milan in August 1907.

Once in the Lombard capital, he was attracted to the style and theories of Gaetano Previati, whose luminous canvases and Idealist subjects provided an alternative to Balla's more realistic, Positivist-inspired painting. Between 1907 and 1909, Boccioni employed various techniques influenced by Divisionism and Symbolism. His stylistic experiments, personal doubts and ambitions were recorded in a detailed diary which he kept from January 1907 to August 1908, and which is

an important source for studies of the artist. Sometime between late 1909 and early 1910, he met Filippo Marinetti, and it was only after joining the Futurist movement that he started to evolve a truly modern style of pictorial expression.

In the course of 1910, he progressed from the modified Divisionism of *The City Rises* to the *States of Mind*, in which he fractured the contours of form in an effort to evoke abstract sensations of emotion and memory. He signed the *Manifesto of Futurist Painters* in February 1910 with Balla, Russolo, Severini and Carrà. Denying the concept of a space-time continuum, he sought to create a 'synthesis of what one remembers and what one sees'. The realization of his ideas on simultaneity and dynamism, already expressed in the *Futurist Painting, Technical Manifesto* in April 1910, was confirmed by his study of Cubism during a visit to Paris in November 1911. In his subsequent paintings – for example, *The Street Enters the House* and *Simultaneous Visions* – Boccioni abolished the traditional way of looking at things, uniting interior and exterior, the actual and the recollected, in a single image. To this end, he developed his characteristic 'lines of force', which traced the trajectories of an object's movement in space.

From 1912 (the year of the first Futurist exhibition in Paris, at the Galerie Bernheim-Jeune), Boccioni applied his concept of 'plastic dynamism' to sculpture as well. His *Technical Manifesto of Futurist Sculpture*, published in April of that year, advocated the use of different media, such as wood, paper, glass and metal, in one and the same work, and he began to incorporate fragments of objects into his plaster forms: 'Sculpture must make objects come to life by rendering their prolongation into space perceivable, systematic and three-dimensional: no one can still doubt that one object leaves off where another begins and that there is nothing that surrounds our own body – bottle, automobile, house, tree, street – that does not cut through it and slice it into cross-sections with an arabesque of curves and straight lines.'

After the publication of his book *Pittura scultura futuriste* (1914), which summarized his activities and theories to date, Boccioni experienced a period of profound crisis at the time of his active involvement in politics. From the end of 1914, he began to rethink his radical approach, and returned to the use of light effects in the modelling of solid form, as witnessed by *Portrait of Maestro Ferruccio Busoni* of 1916.

He participated in interventionist demonstrations in favour of Italy's entry into the First World War in the autumn of 1914. In July 1915, he enlisted in the Lombard Volunteer Cyclist Battalion, and served at the front with Marinetti, Russolo, Antonio Sant'Elia and Sironi. The battalion was disbanded in December 1915, and in the following July he was assigned to the field artillery in the army and sent to Verona. Boccioni died on 17 August 1916 after falling from a horse. E. C.

Guido Ballo, *Boccioni*, Milan, 1964; 2nd ed., 1982
Maurizio Calvesi and Ester Coen, *Boccioni: L'Opera Completa*, Milan, 1983
Boccioni, ed. Ester Coen, New York, Metropolitan Museum of Art, 1988

Alberto Burri

was born on 12 March 1915 in Città di Castello, Umbria. In 1940, he graduated in medicine from Perugia university, and served in the Italian army as a doctor until 1943, when his unit was captured by the British in Tunisia. He began to paint while in a prisoner-of-war camp in Hereford, Texas. After his return to Italy in 1946, he continued to pursue his interest in art and went to live in Rome with his mother's cousin, the musician Annibale Bucchi. He held his first one-man show, of expressionist landscapes and still-lifes, at the La Margherita gallery in 1947.

The following year, after experimenting with pictographs inspired by Joan Miró and Paul Klee, he began his first abstractions in a series of 'material' pieces. From his earliest efforts, Burri demonstrated a fascination with the physical properties of both artists' and industrial paints, creating images of refined elegance from a poverty of means. The *Blacks* were composed by varying the consistency of paint, creating contrasts of glossy and matt surfaces, rhythms of random cracks and textural variations of encrusted pigment. In the *Moulds* additives in the pigment resulted in the 'flowering' of paint like bacterial growth. He also introduced the concept of the monochrome as early as 1951 with the series of pitch-black *Tars*. The characteristics of the traditional canvas and stretcher were exploited in the three-dimensional *Hunchbacks*, begun between 1950 and 1952, into which he inserted wooden supports to bend the painting into sculptural relief. At the same time, he achieved a radical reinvention of collage with the *Sacks*, made of patched and darned burlap bags mounted on stretcher frames. These often bore the stencilled letters of the sacks' trademarks. Although they found their ultimate historical precedent in Kurt Schwitters's *Merz-pictures*, Burri's compositions dismissed the irony of Dada in favour of grand scale and tragic mood, and always subordinated the qualities of the scabrous and the random to the rigour of the underlying compositional structure.

Burri founded the *Gruppo Origine* in 1951 with Colla, Mario Ballocco and Giuseppe Capogrossi. The manifesto emphasized the literal qualities of painting and renounced spatial illusion and descriptive colour, but Burri's canvases were inevitably interpreted as images of landscape, biological processes and 'living flesh' and as metaphors of carnage and decay. Burri was championed by the critic J. J. Sweeney, who included him in the 'Young European Painters' exhibition at the Guggenheim Museum in New York, and wrote the

first monograph on the artist, published by the Galleria dell'Obelisco in 1955. Burri began to exhibit abroad extensively in 1953 and his shows at the Frumkin Gallery in Chicago and the Stable Gallery in New York helped to make him the best-known Italian artist of the post-war period in America. Robert Rauschenberg visited his studio twice in 1953 and subsequently produced his first *Combine* paintings.

The theme of metamorphosis led Burri to burn, melt and char materials in the *Combustions* and *Iron Pieces* of the late fifties and in the *Wood Pieces* and *Plastics* of the early sixties. Since 1975, in the *Cellotex* series (industrial particle board composed of sawdust and glue), he has further investigated the dramatic forms and acrid colours of synthetic materials.

Burri's combination of formal composition and random process bridged the generations of *Informel* and *Arte Povera*. His work, along with that of Fontana, was the most original and radical of the 1950s in Italy, and provided the inspiration for a style of pure abstraction, independent of the gestural immediacy of European *Informel*. He has had numerous exhibitions in Italy and abroad, and was the subject of a major retrospective in Milan in 1985; his most recent works were exhibited at the 1988 Venice Biennale. Burri lives and works in Città di Castello and Los Angeles. S. F.

Cesare Brandi, *Alberto Burri*, Rome, 1963
Maurizio Calvesi, *Alberto Burri*, Milan, 1971
Burri, ed. Carlo Pirovano, Milan, Pinacoteca di Brera, 1985

Massimo Campigli

was born on 4 July 1895 in Florence. His family moved to Milan in 1909. He wrote for the journal *Letteratura* and frequented avant-garde circles, meeting Boccioni and Carrà. In July 1914, the Futurist periodical *Lacerba* published his *Newspaper+Street: Words-in-Freedom*. During the First World War, Campigli was captured and imprisoned in Hungary (1916-18). At the end of the war, he moved to Paris, where he served as a correspondent for the Milanese newspaper *Corriere della Sera*.

Although he had made drawings during the war, it was only on his arrival in the French capital that he began to paint. His early figurative works applied a geometric order to the human figure, reflecting the influence of Pablo Picasso and Fer-

nand Léger, and the Purism of *L'Esprit Nouveau*. He was also profoundly affected by the Egyptian art that he studied at the Louvre. In 1923, he had his first one-man show, at the Galleria Bragaglia in Rome. Over the next five years, his figures developed a monumental bearing, often with stylized poses and limbs interlocked in a sculptural solidity. His emphasis on order and tradition, the aura of serenity and timelessness, were in line with the post-war mood of reconstruction and the programme of the *Novecento* artists, with whom he exhibited regularly, both in Milan (1926 and 1929) and abroad (1927-31). From 1926, Campigli also associated with the *Italiani di Parigi*, along with de Chirico, de Pisis, Renato Paresce, Savinio, Severini and Mario Tozzi.

In 1928 (the year of his debut at the Venice Biennale), Campigli was deeply moved by his visit to the Etruscan collections at the Museo di Villa Giulia in Rome. He broke with the rigourous massiveness of his previous work in favour of a scumbled surface and archaizing, schematic forms. While travelling in Romania with his wife, Magdalena Radulescu, he began a new series of scenes of women engaged in domestic and agricultural activities. The figures were distributed in asymmetrical, hieratic compositions and hovered on a roughly textured ground, inspired by ancient frescos.

These works received critical acclaim during their exhibition at the Jeanne Bucher gallery in Paris in 1929 and the Galleria del Milione, Milan, in 1931. There followed a series of one-man shows during the 1930s in New York, Paris and Milan, which established his international reputation. In 1933, Campigli moved back to Milan, where he adapted his style to large-scale projects. In that year, he signed Sironi's *Manifesto of Mural Painting* and painted the fresco *Mothers, Workers and Peasants* (destroyed) for the fifth Milan Triennale. He received other commissions during the decade: *The Constructors* for the League of Nations, Geneva, 1937; *Thou Shalt Not Kill* for the Palazzo di Giustizia, Milan, 1938; and an enormous fresco (300 metres square) for the atrium designed by Gio Ponti in the Palazzo del Liviano, Padua, 1939-40.

Divorced in 1939, Campigli married the sculptress Giudetta Scalini. They spent the war years in Milan and Venice, and later divided their time between Rome, Paris and St Tropez. A one-man exhibition at the Venice Biennale of 1948 presented his new compositions of women housed in complex architectural structures, in series such as the *Theatres*. In the 1960s, his figures were reduced to coloured signs in the nearly abstract group of canvases, the *Shields*. Campigli was honoured with a retrospective at the Palazzo Reale in Milan in 1967. He died in St Tropez in 1971. M.G.

Franco Russoli, *Massimo Campigli*, Milan, 1965
Giancarlo Serafini, ed., *Omaggio a Campigli*, Rome, 1969
Giorgio Ruggeri, *Lo Specchio di Giuditta: La Favola senza fine di Massimo Campigli*, Bologna, 1981

Carlo Carrà

was born in Quargnento (Piedmont) on 11 February 1881. During the first third of the new century, Carrà's work reflected key artistic developments from Futurism and Metaphysical painting to the *Novecento* and the mural movement of the 1930s. At the age of twelve he was apprenticed to local decorators and continued to earn a living as a stucco-worker and painter of house murals after moving to Milan in 1895. He travelled to Paris in 1899-1900 to decorate pavilions for the Exposition Universelle, and subsequently lived for six months in London where, among exiled Italian anarchists, he immersed himself in the writings of Karl Marx and Mikhail Bakunin. In 1904-5, he trained at the Scuola serale d'arte applicata in Milan. He enrolled at the Accademia di Brera in 1906 and studied under Cesare Tallone with Aroldo Bonzagni and Romolo Romani. In 1908, while organizing exhibitions for La Famiglia Artistica, he met Boccioni and Russolo. Together with Severini and Balla, they signed Filippo Marinetti's *Manifesto of Futurist Painters* in 1910.

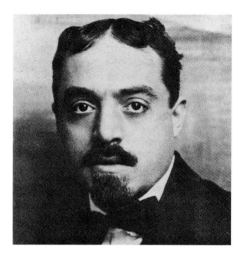

In the same year, Carrà began *Funeral of the Anarchist Galli*, the treatment of its political theme inspired by the Divisionist technique of Giuseppe Pellizza da Volpedo. After a trip to Paris in 1911, Carrà reworked the canvas in order to assimilate Cubism's fragmentation of form. The final version was shown in the Futurist exhibition at the Galerie Bernheim-Jeune in February 1912. His increasing rivalry with Boccioni and differences with Marinetti led Carrà to distance himself from the Milan group and collaborate with Ardengo Soffici and Giovanni Papini on the Florentine Futurist periodical *Lacerba* (1913-15). He travelled to Paris again in 1914, and was about to enter into a contract with the gallery owner Daniel Henry Kahnweiler when the First World War broke out. In 1915, he supported the campaign for intervention with his *Guerrapittura*, a book of 'words-in-freedom' which was also intended as a riposte to Boccioni's *Pittura scultura futuriste* (1914).

During the war years, Carrà developed a consciously naive, or '*anti-grazioso*', style inspired by the plastic solidity of Tuscan Trecento painters and Henri Rousseau. He expressed his ideas on the tactile values of painting in the articles 'Parlata su Giotto' and 'Paolo Uccello Costruttore', published in *La Voce* in 1916. Sent to Ferrara on military service in 1917, he met de Chirico and Savinio and together they comprised the 'school' of Metaphysical painting. Carrà's interiors of 1917-19 displayed the disquieting iconography characteristic of Metaphysical painting, but the mood of his images differed markedly from the pervasive irony and nihilism of de Chirico's work. Carrà concentrated on rendering the solidity and emphatic three-dimensionality of objects, reaffirming his faith in an underlying order. In articles such as 'Il rinovimento della pittura italiana', published in Mario Broglio's Roman journal *Valori Plastici*, he championed a return to traditional and indigenous

pictorial values. In 1921, he became the art critic of the Milan newspaper *L'Ambrosiano*, an influential position which he held for seventeen years.

Carrà's stylistic uncertainty was not resolved until 1921, with the canvas *Pine Tree by the Sea*. Wilhelm Worringer devoted an important essay to the painting in the Zurich periodical *Wissen und Leben* in 1925, arguing that Carrà had achieved a new, harmonious balance between artist and subject. The picture was one of a series of canvases which belonged to the Magic Realist style of the *Novecento*, with whom Carrà exhibited. From 1926, he spent his summers at Forte dei Marmi on the Tuscan coast, where he painted seascapes, in atmospheric brushwork and with a uniform surface, which were inspired by his re-appraisal of nineteenth-century Lombard Naturalism. This style informed his painting for the rest of his career, together with the notion that 'all figurative values of form and colour are subordinate to an underlying architectural order'. In 1933, Carrà signed Sironi's *Manifesto of Mural Painting* and executed frescos for the Milan Triennale (1933, destroyed) and the Palazzo di Giustizia (1938). In 1941, he was appointed professor of painting at the Accademia di Brera.

In the post-war years, Carrà gradually modified his landscapes and seascapes of Forte dei Marmi with scumbled surfaces, looser brushwork and increased luminosity. In 1962, four years before his death, a comprehensive exhibition of his work was organized at the Palazzo Reale, Milan. M.G.

Massimo Carrà, *Carlo Carrà: Tutta l'opera pittorica*, 3 vols, Milan, 1967-8
Carlo Carrà, *Tutti gli scritti*, ed. Massimo Carrà, Milan, 1978
Carlo Carrà, Milan, Palazzo Reale, 1987

Felice Casorati

was born in Novara on 4 December 1883. His father, a career officer and amateur painter, came from a family known for its mathematicians and scientists. Casorati spent his childhood in Milan, Reggio Emilia, Sassari and finally Padua, where he devoted himself to musical studies with such intensity that he suffered from nervous exhaustion at the age of eighteen. During a period of rest in the Euganean hills of Praglia he began to paint, producing his first known work, *Paduan Farmhouses*, in 1902.

In 1906, he graduated in law from the university of Padua, but decided to follow a career as an artist. *Portrait of a Lady*, an elegant image of his sister Elvira, was accepted by the jury of the 1907 Biennale. While living in Naples from 1908 to 1911, he studied the work of Pieter Brueghel the Elder in the collection of the Museo Nazionale. He showed at the 1909 and the 1910 Biennale and was particularly impressed by the installation of Gustav Klimt in the latter exhibition. The decorative, symbolic style of the Viennese Secession became the formative influence on Casorati's early work. In 1911-15, he lived in Verona, and in 1914 co-founded the journal *La Via Lattea*, to which he contributed illustrations that recalled the Art Nouveau manner of Jan Toorop and Aubrey Beardsley. During the remainder of the decade he was in close contact with the artists of Ca' Pesaro (Martini, Gino Rossi, Pio Semeghini), whose European orientation brought him into contact with recent artistic developments in Paris and Munich.

Casorati was conscripted in 1915. After the death of his father in 1917, he moved with his family to Turin, and soon became a central figure in the city's intellectual circles. He befriended the composer Alfredo Casella and the political activist Piero Gobetti, whose group *Rivoluzione Liberale* he joined in 1922. His close association with the anti-Fascist Gobetti led to Casorati's arrest for a few days in 1923, but after this he avoided open conflict with the regime. In his mature works of the post-war period, such as *Portrait of Silvia Cenni* (1922) and *Midday* (1922), decorative detail was replaced by a meditation on essential form, influenced by the mathematical spatial constructions of Quattrocento painting and, in particular, the still atmosphere of Piero della Francesca's work. In 1924, Casorati had a one-man exhibition at the Biennale, accompanied by an influential catalogue essay by Lionello Venturi. The crystalline purity and enigmatic tone of Casorati's compositions helped to define the style of Magic Realism, which he shared with the early *Novecento* group. Although he participated in the *Novecento* exhibitions of 1926 and 1929, he maintained a profile distinct from Margherita Sarfatti's movement.

During the twenties Casorati assumed a leading role in Italian cultural life. In 1923, he established the Scuola casoratiana for young artists in his studio on the Via Mazzini. Among his pupils were Francesco Menzio, Carlo Levi, Gigi Chessa and Jessie Boswell, who later formed part of the *Gruppo di Sei*. In 1930, he married Daphne Maugham, who had frequented his school since 1926; their son Francesco also became a painter. In 1925, he co-founded the Società Belle Arti Antonio Fontanesi, which organized exhibitions of nineteenth-century and contemporary Italian and foreign artists. His interest in interior design was encouraged by his friendship with the industrialist and collector Riccardo Gualino. In 1925, he worked with Alberto Sartoris on the Piccolo Teatro attached to the Gualino house. For the third 'Biennale d'Arti Decorative di Monza', he and Sartoris collaborated on the 'commercial street' for the Piedmont pavilion, and he designed the atrium of the 'Mostra dell'Architettura' at the Milan Triennale of 1933. In 1935, the studio of Casorati and Enrico Paulucci hosted the 'Prima mostra collettiva d'arte astratta italiana', which included works by Licini, Melotti and Fontana.

In 1938, Casorati won the Prize for Painting at the Venice Biennale. He also received awards at exhibitions in Paris, Pittsburgh and San Francisco in the late thirties. He was particularly active in stage and costume design – for the Teatro dell'Opera in Rome, La Scala in Milan and the Maggio Musicale in Florence – an activity which continued into the post-war period. In 1952, he had a one-man show at the Biennale and, with Ottone Rosai, was awarded the Premio Speciale della Presidenza. He died on 1 March 1963. M. G. B.

Felice Casorati, Ferrara, Palazzo dei Diamanti, 1981
Felice Casorati 1883-1963, Turin, Accademia Albertina di
 Belle Arti, 1985
M. M. Lamberti and Paolo Fossati, *La Naturalezza
 Cosciente*, Bologna, 1986

Sandro Chia

was born on 20 April 1946 in Florence, and grew up in the working-class neighbourhood of San Frediano. His future vocation was influenced by the paintings he saw on regular visits to the Galleria degli Uffizi and Florentine churches. At the Istituto d'Arte in Florence (1962-7) he mastered the rudiments of figure drawing and painting technique, and studied etching under Rodolfo Margheri. A Picasso exhibition that he saw in Paris in 1966 was also influential on his early development. In 1967-9, he studied at the Accademia di Belle Arti in Florence, then spent a year travelling through Europe, Turkey and India, before settling in Rome in 1970.

During the early and mid-seventies, Chia experimented with conceptual, process and performance art, influenced by the *Arte Povera* movement, and his installations often incorporated his own poetry and prose. His first solo exhibition, entitled 'L'Ombra e il suo doppio' (The Shadow and its Double), was held at the Galleria La Salita in Rome, 1971, and he published the first of his numerous books, *Bibliographie*, the following year. By 1977, he was gradually returning to a figurative style, which fully emerged in his 1979 exhibition at the Gian Enzo Sperone gallery in Rome. Entitled 'I Pattinatori' (The Skaters), it consisted of drawings and paintings of animated figures floating on a densely worked, expressionist ground. Following his inclusion in group exhibitions of the new figuration at the Basle Kunsthalle and Venice Biennale in 1980, and the Royal Academy in 1981, he became associated with the *Transavanguardia*, with Clemente, Cucchi, Nicola De Maria and Paladino. In 1981, he also had his first solo exhibition in New York, at the Sperone Westwater Fischer Gallery, and he subsequently established a residence there while maintaining studios in Rome and Ronciglione.

In the early 1980s, Chia painted mythological scenes, such as *The Waterbearer* and *Idleness of Sisyphus*, with expansive, muscular figures, recalling the nudes of Michelangelo and Savinio. His protagonists are often shown floating, overcoming their physical weightlessness and transcending the banality of everyday existence. Underlying his work is the idea of the role of the artist as magician who uncovers the world with a combination of ironic distance and innocent wonder. Similarly, Chia's appropriation of other artists' famous compositions is a running commentary on the mannerism of style.

The energy of Chia's vivacious brushwork is also translated into the intricate cross-hatching and stippling techniques of his etchings, drypoints and aquatints. A retrospective exhibition of his prints was held at the Mezzanine Gallery in the Metropolitan Mueum of Art, New York, in 1984. He began to cast bronze sculpture in 1979. In keeping with the playful exuberance of his work, he has designed several figurative fountains: the reclining, water-spouting *Putto* for a park in Fessenbach, West Germany, and a collaboration with Cucchi, *Sculpture Gone, Sculpture Reversed*, exhibited in the 'Zeitgeist' exhibition, Berlin, 1982. In 1986, his exhibition at the Kunsthalle, Bielefeld, contained writings and works related to the bronze *Passion for Art*, which had been commissioned the previous year by the city for a public square. In 1985, he completed *Europe and the Sea* for the Tuileries gardens, Paris.

In 1985-6, Chia was chiefly occupied with a large-scale commission to paint the interior of the Palio bar in New York. His four-part narrative of the Siennese horse-race, with its riotous colour and rampant art historical quotations, served as a summation of his first mature style. Since 1987, his painting has been dominated by increasingly complex surface patterns and spatial ambiguities, inspired by Italian Futurist painting, and often accompanied by his poetry and *trompe l'œil* collage elements.

Chia's work has been shown widely in Europe, the United States and Japan. His one-man exhibitions include those at the Stedelijk Museum, Amsterdam, 1983; the Kestner-Gesellschaft, Hanover, and the Staatliche Kunsthalle, Berlin, 1983-4; and the Musée d'Art Moderne, Paris, 1984. From September 1980 until August 1981, he worked in Mönchengladbach, West Germany, on a scholarship he received from the city. He taught painting at the School of Visual Arts in New York in 1984-5. Most recently, his work was featured at the 1988 Venice Biennale and in a one-man exhibition at the 1988 Spoleto Festival. Chia currently lives and works in New York City; Rhinebeck, New York; and Montalcino, Tuscany. J. B.

Sandro Chia, Hanover, Kestner-Gesellschaft, 1983
Sandro Chia Prints 1973-1984, New York, The Mezzanine
 Gallery, Metropolitan Museum of Art, 1984
Sandro Chia, ed. Bruno Mantura, Spoleto, Ex-Chiesa di
 San Nicolo, 1988

Francesco Clemente

was born in Naples on 23 March 1952 into a titled family; his father was a judge. He spent his childhood in Naples, where he studied Latin and Greek as well as modern literature and philosophy. Making yearly trips with his parents to countries throughout the Continent from 1954 to 1969, Clemente was exposed at an early age to diverse

cultures and artistic traditions. He began painting at the age of eight, and published his first poems in 1964. In 1970, he moved to Rome, where he studied architecture for a short time at the university and associated with artists, poets, film-makers and actors. Among the influences on his early work were Cy Twombly and Alighiero Boetti. He began to create conceptual works in photography and had his first solo exhibition in 1971, at the Galleria Valle Giulia in Rome. Two years later, he journeyed to India, where he has spent extended periods since 1975. Between 1971 and 1978, he produced a large number of drawings that combined abstract and figurative forms; these images, or 'ideograms', formed the basis of the visual vocabulary he developed in his later work. Since 1978, he has kept a studio in Madras, and has studied the work of local artists as well as eastern languages and religions. In 1979, he began to be associated with the neo-Expressionists Chia, Cucchi and Paladino, who were identified as the *Transavanguardia* by Achille Bonito Oliva in an article in *Flash Art* in October of that year. He first travelled to New York in 1980, and established a studio there in 1983.

Despite his lack of formal training, Clemente is accomplished in a variety of media, including watercolour, pastel, monotype, various printing techniques, sculpture and, since 1980, oil on canvas. During his frequent travels he has schooled himself in indigenous techniques, producing woodcuts in Japan and frescos in Italy. His imagery draws on diverse sources in western and oriental art as well as on the popular culture of film and television. Clemente's works are largely autobiographical; his own image, often fragmented or blended with plant, animal and female forms, is a recurrent motif. In a dream-like atmosphere, and using himself as protagonist, Clemente investigates the human condition, considering man's fundamental drives and experiences from birth to death. His sexually explicit imagery depicts the human body, with its orifices and scatological functions, as the mediator between the inner world of the psyche and the outer cosmos. He frequently works in cycles, such as *The Fourteen Stations*, exhibited at the Whitechapel Art Gallery in 1983. Although this series was inspired by the Stations of the Cross, its Christian significance was largely subsumed by a psychological investigation of the self. While Clemente has remained committed to representational imagery, his recent paintings, done in Monte Argentario during the summers of 1986 and 1987, have become increasingly simplified and abstract.

Clemente enjoys working on an intimate scale and has created numerous artists' books. In 1973, he published the first of these, *Pierre Menard*, a collection of photographs of architecture inspired by the Jorge Luis Borges story of the same name. *Francesco Clemente Pinxit* (1981) contained a group of miniatures painted in collaboration with Indian artists from Madras. His published illustrations include watercolours for Allen Ginzberg's poem *White Shroud* of 1983 and lithographs for Savinio's 1918 epic, *The Departure of the Argonaut*, which were exhibited at the Museum of Modern Art, New York, in 1986. His interest in collaboration as a means of understanding other methods and artistic ideologies led him to execute a series of canvases with Andy Warhol and Jean-Michel Basquiat in 1984.

Since 1980, Clemente has had solo exhibitions throughout Europe and the United States, including the University Art Museum, Berkeley, 1981; the Kestner-Gesellschaft, Hanover, and the Nationalgalerie, Berlin, 1984; the Ringling Museum of Art, Sarasota, Florida, 1985; the Art Institute of Chicago and the Fundacion Caja de Pensiones, Madrid, 1987; and the Kunstmuseum, Basle, 1987. He currently divides his time between Rome, Madras and New York. J. B.

Rainer Crone, *Francesco Clemente: Pastelle 1973-1983*, Munich, 1984
Michael Auping, *Francesco Clemente*, Sarasota, The Ringling Museum of Art, 1985
The Fourteen Stations, London, Whitechapel Art Gallery, 1983

Ettore Colla

was born in Parma on 13 April 1896. His studies at the local Accademia di Belle Arti (1913-22) were interrupted by military service in the First World War, during which he was decorated.

In 1923, Colla went to Paris, where he worked in the studios of Charles Despiau, Henri Laurens and Constantin Brancusi; he also befriended Antoine Bourdelle and Aristide Maillol. At the end of the year, he travelled to Belgium, where he met Victor Rousseau, and in 1924, he assisted the sculptor Wilhelm Lehmbruck in Munich. During the next year, he worked as a coal-miner in Belgium, a photographer in Paris and an elephant trainer's assistant in Vienna.

Colla settled in Rome in 1926 and resumed his career as a sculptor; he was initially engaged on the completion of the monument to Vittorio Emanuele II. The influences on his early independent works ranged from the refined style of fifteenth-century Florentine sculpture (*Bust of a Young Girl*, 1927) to the more agitated manner of Bourdelle (*Victory*, c. 1930).

In the 1930s, Colla established his reputation as a figurative sculptor. He contributed to the Venice Biennale in 1930 and 1932. In 1933, he was awarded the Savoia Brabante Prize in Rome for *Struck*, a highly stylized figure of a soldier in the classical pose of Andromeda with a gas mask hanging limply from his wrists. By 1935, he had begun to receive official commissions, including a large bas-relief for the Palazzo dell'Agricultura at the 'Esposizione Universale Roma (E. U. R. '42)'. In the late thirties, he exhibited small plaster, polychrome works which reflected the influence of Martini's archaizing sculptures. Other works from this period reflect contemporary developments in Paris, with which Colla was familiar through such magazines as *Minotaure*. From 1936, he lived in

Naples and returned to Rome in 1939 to teach sculpture at the Liceo Artistico.

Colla abandoned figurative sculpture during the Second World War; in this period of artistic crisis, 1942-6, he turned to painting and collage. In 1948-9, at about the time he met Alberto Burri and the writer Emilio Villa, Colla began to create paintings in a classic style of geometric abstraction. He was a founding member of the *Gruppo Origine* in 1951. That year, he also constructed abstract reliefs in painted wood and created his first free-standing metal sculpture, *Dynamic Equilibrium*; the piece was destroyed in 1960 when Colla decided to use part of it in another work, *Caryatid*.

In 1955, he made *The King*, his first assemblage from discarded industrial objects – Colla did not always use the individual elements of his *objets trouvés* in their 'natural' state; instead, he shaped them to fit into an overall geometric scheme. His compositions were often carefully planned by the use of such proportional systems as the Golden Section, and his method was slow, as befitted a modern-day classicist. His pieces are therefore often more rigorously geometric than comparable works in welded metal by his predecessors Julio Gonzalez and Pablo Picasso or his American contemporary David Smith. Colla frequently named his sculptures after mythological characters (*Pygmalion*, 1955), characteristically combining classical subjects with a modern style.

Colla's assemblages were exhibited at the Rome Quadriennale in 1955 as a result of influence exerted by his friend the painter Mario Mafai, but his sculptures were rejected for inclusion in the Venice Biennale the following year. His first one-man exhibition was in 1957, at the Galleria La Tartaruga in Rome. Two years later, he had his first museum show in London at the Institute of Contemporary Art. Colla's work was included in the important *Art of Assemblage* exhibition at the Museum of Modern Art, New York, in 1961. In 1962, he showed three large works in 'Sculture nella città' at the Festival of Two Worlds in Spoleto; it was there that he met David Smith.

In the 1960s, Colla refined his compositions, reducing the number of elements in each work, and negative space became a more prominent feature. *The Juggler* (1963), for example, is an open-work sphere that sits directly on the ground, without a base. Other sculptures suggest non-functional machines (*Sun Workshop No. I*, 1964) and cosmic spheres. In addition to various smaller works, Colla once again created low-relief compositions in metal. His second career as a sculptor earned him

an international reputation, enabling him to carry out works on a monumental scale. The 32-foot-high *Grand Spirale*, originally executed for the Spoleto festival in 1962, is now placed outside the Gallerie Nazionale d'Arte Moderna, Rome. Many of Colla's late works, such as *Solar Column* (1967), are architectonic and recall the influences of his early years in Paris, particularly Brancusi's *Endless Column*. Colla died in Rome in 1968. M. G./J. P.

Lawrence Alloway, *Ettore Colla: Iron Sculpture*, Rome, 1960
Lo Spazio dell'imagine, ed. Palma Bucarelli, Foligno, Palazzo Trinci, 1967
Giorgio de Marchis and Sandro Pinto, *Colla: Catalogo Completo delle Opere*, Rome, 1972

Enzo Cucchi

was born on 14 November 1949 in Morro d'Alba (the Marches), the son of poor farmers. Expelled from school at the age of fifteen, he subsequently earned a living as a black marketeer, a land surveyor and, briefly, as an assistant to a restorer in Florence. While occasionally attending the Accademia di Belle Arti in Macerata, he visited the studios of artists and artisans and, reading widely, began to draw and to write poetry and song lyrics. At eighteen, he won first prize in an amateur art competition in Ancona with the painting *Battle between Gods and Heroes*, which prefigured the mythological subjects of his mature work. Cucchi experimented with Conceptual Art, and had his first one-man exhibition in 1977, at the Luigi De Ambrogi gallery in Milan. By the late seventies, he had returned to painting on canvas and, since his inclusion in the exhibition 'Aperto '80' at the 1980 Venice Biennale, has been associated with the neo-Expressionists Chia, Clemente and Paladino.

Although he maintains a studio in Rome, Cucchi has seldom spent extended periods away from the Marches, where he was born; since 1975, he has lived in Ancona on the Adriatic coast. The pagan and Christian heritage, the sea and dramatic cliffs, and the ancient, medieval and modern architecture of the city figure prominently in his apocalyptic scenes. His recurrent motifs of wild and domestic animals, skulls, severed heads and embryonic figures, maritime subjects and hill-top towns are endowed with a timeless and archetypal significance. Pier Paolo Pasolini was an important early influence on Cucchi, as witnessed by the artist's emphasis on the regional and on a constantly renewed contact with primitive traditions. On the other hand, the ritualistic dialogue with nature and the idea of the artist as a shaman reveal his acknowledged admiration for Joseph Beuys.

Cucchi has often affixed found objects to his canvases: prior to 1980, he used pieces of coloured ceramics and, subsequently, wood and iron. His pictures depict, or incorporate actual references to, the elements of earth, water and fire, such as soil and charred wood. These evoke the primeval and rejuvenating forces of nature, the cycles of death and destruction, rebirth and resurrection. Surfaces are densely worked with impasto and dripped paint, accentuating the drama of his themes by strong chiaroscuro, abrupt changes in scale and the contrast of acrid and earth-coloured pigments. Cucchi's paintings have been combined with free-standing objects in installations or conceived in thematic groups, such as the *Vitebsk/Harar* series (the title refers to his artistic heroes, Kasimir Malevich and Arthur Rimbaud) exhibited at the Mary Boone and Sperone Westwater galleries, New York, in 1984.

Cucchi's distinctive iconography, local in inspiration and universal in resonance, is rendered with greater formal simplicity in charcoal, crayon and pastel. His small graphic works have served as pendants to his paintings, and he has illustrated his own prose in a number of artist's books, the first of which, *Il veleno è stato sollevato e trasportato*, was published in the mid-seventies. In 1980-2, Cucchi produced a series of extremely large drawings in charcoal with collage elements; these were the subject of a one-man exhibition, 'Enzo Cucchi Zeichnungen', shown at the Kunsthaus, Zurich, and the Groninger Museum, Groningen, in 1982. That year, he collaborated with Chia on the fountain *Sculpture Gone, Sculpture Reversed*, which was included in the 'Zeitgeist' exhibition in Berlin. Commissions for outdoor sculptures have included a piece for Merian Park in Basle (1984) and for his one-man exhibition at the Louisiana Museum of Modern Art, Humlebaek, in 1985. His outdoor works are in bronze, while his most recent, indoor pieces (1987) consist of attenuated figures carved from wood.

Cucchi's work has been shown internationally since 1980, including exhibitions at the Stedelijk Museum, Amsterdam, 1983-4; the Fundación Caja de Pensiones, Madrid, 1985-6; the Guggenheim Museum, New York, and the Centre Pompidou, Paris, 1986; the Kunsthalle, Bielefeld, 1987; and the Städtische Galerie im Lenbachhaus, Munich, 1987-8. J. B.

Enzo Cucchi, ed. Diane Waldman, New York, The Solomon R. Guggenheim Museum, 1986
Enzo Cucchi: Guida al Disegno, Bielefeld, Kunsthalle, and Munich, Staatsgalerie Moderner Kunst, 1987
Enzo Cucchi: Testa, ed. Helmut Friedel, Munich, Städtische Galerie im Lenbachhaus, 1987 (English translations included)

Giorgio de Chirico

was born on 10 July 1888 in Volos, Greece, of Italian parents; his father, Evaristo de Chirico, was an engineer engaged in designing the railway in Thessaly. The family moved frequently between Volos and Athens, which gave rise to the themes of travel and evocative contrasts between ancient and modern Greece that inspired de Chirico's later work. Giorgio and his brother Andrea (who assumed the pseudonym Alberto Savinio in 1912) received a thorough education in classical history, languages and Greek mythology. Following their father's death in 1905, the brothers' careers were guided by their ambitious mother, Gemma Cervetto. From 1903 to 1905, de Chirico studied painting at the polytechnic in Athens under the Munich-trained George Jacobides. He continued his studies at the Accademia di Belle Arti in Florence (1905-6) and at the Akademie der Bildenden Künste in Munich (1906-10), where he was influenced by the German Symbolists Max Klinger, Hans Thoma and, above all, Arnold Böcklin. In February 1910, Savinio went to Paris, while de Chirico returned to Milan and then Florence. During a protracted illness he studied the writing of Arthur Schopenhauer and Friedrich Nietzsche and made his first paintings free of Böcklin's influence. He and his mother followed Savinio to Paris in July 1911, stopping in Turin, the city which had seen the onset of Nietzsche's madness.

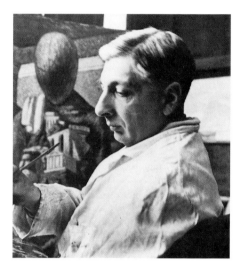

At the Salon d'Automne of 1912, de Chirico first exhibited his melancholic images of city squares, populated by solitary monuments and enclosed by dark arcades. Disrupting the canons of traditional perspective and illusionistic modelling, he created disconcerting spaces and jarring juxtapositions of objects that evoked a disquieting, metaphysical reality. Towards the end of 1914, he introduced the iconography of the mannequin, influenced by the collaborative poetry and theatre of Savinio and Guillaume Apollinaire.

When Italy entered the First World War in 1915, the brothers were posted to Ferrara, where they met the poets Corrado Govoni and Filippo de Pisis and, in 1917, the painter Carrà. During their stay in the military hospital at the Villa del Seminario, Carrà was strongly influenced by de Chirico and they collaborated on the development of Metaphysical painting. De Chirico depicted a series of claustrophobic interiors filled with idiosyncratic objects – biscuits, maps and canvas stretchers – while the mannequins were endowed with a new monumentality and set against the Ferrara cityscape, as in *The Great Metaphysician* (1917).

After the war, he articulated his theory of Metaphysical painting and Classicism in numerous essays, distinguishing his art from that of Carrà. Many of these appeared in Mario Broglio's Roman periodical *Valori Plastici* (1918-22), which also expounded a programme for a new Italian classicism. His first one-man show, held at the Galleria Bragaglia in 1919, provoked negative criticism from Roberto Longhi in his sarcastic review *Il dio ortopedico*. Over the next five years de Chirico reverted to mythological narratives, influenced by Böcklin and Renaissance masters. His technical virtuosity, already demonstrated in the Ferrara

period, was emphasized in his self-portraits and in his article 'Il ritorno al mestiere', published in *Valori Plastici* in 1919.

In 1924, de Chirico returned to Paris, attracted by the admiration for his work expressed by André Breton and the Surrealists, but a gulf soon emerged between his artistic intentions and their Freudian interpretation of his paintings. Breton's championing of 'early' de Chirico, to the exclusion of his later painting, has remained influential on critical assessments. Nonetheless, it was this second Paris period that established de Chirico's reputation. In the mid-twenties, he married the Russian actress Raissa Gurievich Kroll, who subsequently studied archaeology at the Sorbonne under Charles Picard. During the twenties de Chirico reconsidered the theme of the mannequin, now composed of fantastic architectural elements and enveloped in atmospheric brushwork. He developed the new series *Horses on the Beach* and *Gladiators*, battling figures in closed interiors. The latter culminated in the Room of the Gladiators painted for Léonce Rosenberg's house in 1928-9. In 1929, he published his novel *Hebdomeros*, a masterpiece of Surrealist literature. In 1931, he met Isabella Pakszwer Far, who became his second wife.

In the thirties, de Chirico divided his time between Paris and Italy; in 1933, he painted the mural *The Culture of Our Time* (destroyed) for the Milan Triennale and designed sets and costumes for the theatre, including those for performances of Bellini's *I puritani* given at the first Maggio Musicale Fiorentino. In 1934, he completed a series of lithographs for Jean Cocteau's *Mythologie*, which gave rise to the series of *Mysterious Baths*. After a successful stay in the United States from 1935 to 1937, he settled in Rome in 1944. Beginning in the late thirties, his works seemed to reflect a more conservative taste and he began to repeat many of his successful metaphysical subjects. Over the following two decades he continued his investigations into the craft of painting, mixing his own glossy emulsions which facilitated the luscious brushwork of his 'Baroque' still-lifes and self-portraits in costume. During the same period he aroused controversy by making copies and variants of his earlier masterpieces, thereby emphasizing the primacy of the idea over its various realizations. The situation was complicated by his own backdating of the canvases and by the presence of actual forgeries in some of his post-war retrospectives. De Chirico died on 20 November 1978, having united the themes and styles of his entire oeuvre during the last decade of his life in the so-called Neo-Metaphysical period. M. G.

Giorgio de Chirico, ed. James Thrall Soby, New York, Museum of Modern Art, 1966
Paolo Baldacci and Maurizio Fagiolo dell'Arco, *De Chirico: Parigi 1924-29*, Milan, 1982
Giorgio de Chirico, *Il Meccanismo del Pensiero: Critica, Polemica, Autobiografia 1911-1943*, ed. Maurizio Fagiolo dell'Arco, Turin, 1985

Gino De Dominicis

was born in 1947 in Ancona (the Marches). At the age of seventeen, he mounted his own first one-man show, at the D.D. gallery in Ancona. In 1964 he settled in Rome. Since 1966, he has focused on the age-old themes of death and immortality, involving mythological as well as autobiographical references. His conceptual and performance pieces draw attention to invisible natural forces in a futile

attempt to stop their advance. This desire to elude the relative and the contingent, and the obsession with stasis and immobility, connect De Dominicis with the modern Italian tradition of Metaphysical art. Like de Chirico, De Dominicis focuses on the strange familiarity of things: 'A glass, a man, a hen . . . are not really a glass, a man, a hen, but only verifications of the possibility of existence. . . . To truly exist, things would have to exist eternally, immortally. Only then would they be not only verifications of certain possibilities, but truly things.'

De Dominicis first expressed his preoccupation with life and death in the text *Lettera sull'Immortalità del corpo* (*Letter on the Immortality of the Body*), written between 1966 and 1969. To announce his first one-man exhibition, at the Galleria L'Attico, Rome, in 1969, De Dominicis printed posters of his own obituary. Taking the dematerialization of the object to its literal consequences, he exhibited a series of 'invisible objects' – among them, *Invisible Cube and Cylinder* and *Invisible Pyramid*, which consisted of outlines drawn on the floor. In the same year, he first referred to the Sumerian myth of Urvasi (the goddess of beauty) and Ghilgamesh (the Mesopotamian king) in a photographic work, and has since elaborated on the theme, depicting the two figures in various forms. De Dominicis identifies with the quest of Ghilgamesh who, as two-thirds god and one-third man, attempted (unsuccessfully) to halt the ageing of his human body, whereas Urvasi already possessed immortal beauty.

In 1970, at the Galleria L'Attico, he incarnated the twelve signs of the zodiac in their actual attributes, including a live bull (Taurus), a lion in a cage (Leo) and a young girl (Virgo). In the piece *Mozzarella in carrozza* at the same gallery later that year, De Dominicis set a piece of mozzarella in the back seat of an old-fashioned carriage, giving concrete form to the name of an Italian dish.

In 1977, he performed a 'vanishing act', making a person disappear during a public performance. Two years later, at the Mario Pieroni gallery in Rome, he presented his first *Invisible Statues*, which were comprised of slippers on a pedestal, a straw hat suspended from the ceiling and nothing in between. For an exhibition at the Pio Monti gallery in Rome which began on 14 January 1977, and on the same date the following year, he installed the identical piece in order to demonstrate its imperviousness to age and 'refusal to die'.

His concern with invisibility as a means of avoiding the passage of time is also reflected in the strategy of his self-presentation. De Dominicis has generally avoided the press and the publication of monographs and catalogues, and has been reluctant to reveal details of his life, participating only erratically in international group exhibitions.

His personal notoriety was assured, however, in 1972, when he showed *La seconda possibilità di immortalità* (*l'universo è immobile*) (*The second possibility for immortality [the universe is immobile]*) at the Venice Biennale. This work evoked paradoxical situations of stasis through one of his invisible cubes, a rubber ball with a label describing its previous movement and a rock with a notice of its imminent 'spontaneous movement'. The installation also included a pair of twins and a Mongoloid young man. The inclusion of the latter caused a public scandal and resulted in the exhibit being closed to the public. It was later defended by the poet Eugenio Montale when he received the Nobel prize in 1975. According to the critic Germano Celant, De Dominicis's piece revealed to the public those 'ways of thinking for which culture has little framework'. E. B.

Italo Tomassoni, 'Il Caso Gino De Dominicis', *Flash Art*, no. 144, June 1988, pp. 38-41
Germano Celant, 'Art to the Power N', *Artforum*, December 1986, pp. 100-6

Fortunato Depero

was born on 30 March 1892 in Fondo (South Tirol), which was Austrian territory until 1918. He studied at the Scuola Reale Elisabettiana in Rovereto, where he was one of an outstanding group of students that included Luciano Baldessari, Tullio Garbari and Melotti, and later applied unsuccessfully to the Akademie der Bildenden Künste in Vienna. In 1913, he published *Spezzature-Impressioni – Segni e Ritmi*, a volume of Symbolist poetry and drawings influenced by Alfred Kubin and Alberto Martini. While in Rome from December 1913 to May 1914, Depero came into contact with the Futurist movement, meeting Balla, Filippo Marinetti and Francesco Cangiullo. He participated in the latter's performance *Piedigrotta* and exhibited in the 'Prima Esposizione Libera Futurista' at the Galleria Sprovieri. He returned to Rome later in the year when Austria declared war on Serbia. He worked in close collaboration with Balla and together they published the *Futurist Reconstruction of the Universe* in March 1915. The manifesto proposed the invention of an abstract Futurist style to represent psychological states and sensory impressions. It was illustrated with photographs of their 'plastic complexes' – non-figurative and kinetic constructions made of ephemeral materials.

After taking part in interventionist demonstrations, Depero volunteered for military service, but was discharged as unfit. In April 1916, he exhibited two hundred works in his first Roman one-man show at Corso Umberto 20, and in the same year composed his first 'onomalinguistics', or noise poetry and lyrics. In the autumn, he met Mikhail Larionov, Léonide Massine and Sergej Diaghilev, and was commissioned to design sets and costumes for Igor Stravinsky's *The Song of the Nightingale*; although the project was never realized, it marked the beginning of his involvement in the theatre. During the same period he collaborated with the Swiss writer Gilbert Clavel on the choreography of *Balli Plastici* for puppets, performed at the Teatro dei Piccoli in Rome in 1918.

Depero continued his Futurist activities in the post-war period with painting and scenography, chiefly inspired by the theme of mechanization, as well as with interior design and phonetic poetry.

By 1919, he had developed his characteristic style, depicting flora, fauna and human beings in a fantastic mechanical world, with the spatial incongruities and atemporal mood of Metaphysical painting. In 1919, he founded the Casa d'Arte Futurista in Rovereto, where he and his wife Rosetta produced tapestries, furniture, posters and other items of applied art. He furnished the Cabaret del Diavolo in Rome (1920-2) and produced the mechanized ballet *Anhicam del 3000*, with music by Franco Casavola, for the Nuovo Teatro Futurista in 1924. In 1925-6, he spent eighteen months in Paris, exhibiting with Balla and Prampolini at the 'Exposition Internationale des Arts Décoratifs et Industriels Modernes'. For the 'Seconda Biennale Internazionale d'Arte Decorativa' in Monza (1927), he designed the critically acclaimed book pavilion in the form of monumental letters, a style which he called typographical or advertising architecture. The pavilion also included his distinctive 'bolted book' *Depero Futurista* of *parole-in-libertà* and typographic designs. From 1928 to 1930, he lived in New York, where he designed magazine covers (notably for *Vanity Fair*) and murals and decoration for the Zucca, and Enrico and Paglieri restaurants. His imagery was influenced by the frenetic rhythm of the city, its skyscrapers and jazz music.

Depero signed the *Manifesto of Futurist Aeropainting* in 1929, although he maintained his independent style of 'scenographic' painting throughout the thirties. After many years of magazine design and commercial advertising, including his well-known campaign for Campari, he wrote the *Manifesto of Advertising Art* in 1932. The following year he published five issues of the Futurist journal *Dinamo Futurista*. In 1934, he issued a volume of poems, *Liriche radiofoniche*, to be broadcast on the radio and exhibited in the 'Prima Mostra di Plastica Murale' in Genoa.

After the Second World War, Depero continued with commissions for large-scale decoration and, apart from a short trip to the United States in 1948-9, remained in Rovereto. In 1950, he published the *Manifesto of Nuclear Painting*. The Museo Depero in Rovereto was opened a year before his death on 29 November 1960. M. G.

Bruno Passamani, ed., *Depero e la scena da 'Colori' alla scena mobile 1916-1930*, Turin, 1970
Fortunato Depero, ed. Bruno Passamani, Rovereto, Musei Civici, Galleria Museo Depero, 1981
Depero Futurista + New York, ed. Maurizio Scudiero and David Lieber, Rovereto, Musei Civici, Galleria Museo Depero, 1986

Filippo de Pisis

was born Luigi Filippi Tibertelli on 11 May 1896 in Ferrara; he later adopted his family's ancestral surname of de Pisis. During his adolescence, he wrote poetry and studied painting with numerous instructors (notably Odoardo Domenichini). He surrounded himself with rare and curious objects and old books, and accumulated a collection of butterflies and wild flowers which he donated to the university of Padua in 1915.

Suffering from a nervous disorder, de Pisis was placed under observation at the Venice psychiatric hospital in 1915 and exempted from war service. He subsequently divided his time between Ferrara and the university of Bologna, where he studied literature and philosophy from 1916 to 1919. He met Morandi, wrote articles for Giuseppe Raimondi's *La Raccolta* and Bino Binazzi's *La Brigata*, and was introduced to Futurist activities by the Ferrara poet Corrado Govoni. In 1915, de Chirico and Savinio arrived in Ferrara as military conscripts. Together with de Pisis and Carrà, who joined them in 1917, they formed the nucleus of the Metaphysical 'school'. De Pisis wrote collections of lyrical prose and poetry – *Canti della Croara* and *Emporium* (1916) and *La città dalle 100 Meraviglie* (1920) – which were influenced by the de Chirico brothers' nostalgic and melancholic mood.

It was only upon moving to Rome in 1919 that he turned to painting. He frequented the circle of *Valori Plastici* and befriended the painter Armando Spadini. In these surroundings he began to evolve his characteristic style of still-life – an evocative juxtaposition of heterogeneous objects united by a loose, sensuous facture and replete with the *Stimmung* of Metaphysical painting. The literary element, be it the motif of a book, fragments of poetry or visual references to the work of earlier artists, remained a central component of his work. He searched for the secret, dramatic aspect of things, maintaining that 'the lyrical and internal value of a still-life takes precedence over its pictorial or constructive quality'.

De Pisis's delight in the beauty of the painterly style – '*La bonne peinture*' – was promoted by his move to Paris in 1925. He lived in the French capital for fourteen years. His admiration for Eugène Delacroix, Edouard Manet and Camille Corot as well as for Henri Matisse and the Fauves was reflected in an increasingly gestural application of paint and in brilliant colour accents. In addition to still-lifes, he painted cityscapes, homoerotic nudes and images of hermaphrodites. His

most distinctive works of the twenties were the *Marine Still-Lifes*, dream-like images of incongruous objects placed on the beach in a jarring spatial relationship with the seascape beyond.

De Chirico presented de Pisis's first one-man exhibition in Paris at the Galerie au Sacre du Printemps in 1926; the first monograph on him was written by the French critic Waldemar George two years later. De Pisis continued to exhibit in Italy – for example, with the *Novecento* in Milan in 1926 and 1929 – and contributed articles to *L'Italia Letteraria*, *L'Orto* and *Rivista di Ferrara*. He was part of the loose association known as the *Italiani di Parigi*, which included de Chirico, Savinio, Campigli, Mario Tozzi and Renato Paresce; they were presented by Waldemar George in the exhibition 'Appels d'Italie' at the Venice Biennale of 1930. In 1931, de Pisis provided watercolour illustrations for the book *Questa è Parigi* by the Italian writer Giovanni Comisso, a close friend. He also painted with a fellow ex-patriot, Mario Cavaglieri, who lived in south-west France. In the 1930s, he visited England on three occasions, becoming friends with Vanessa Bell and Duncan Grant.

De Pisis returned to Milan upon the outbreak of the Second World War and, in 1944, settled in Venice, where he was inspired by the painting of Francesco Guardi and other eighteenth-century Venetian masters. As on his sojourns in London, de Pisis responded to particulars of light and climate, dissolving city monuments in a loose, calligraphic brushwork and luminous gradations of tone.

The last decade of his life was marked by failing health caused by a disease of the nervous system. His work was prominently featured at the Venice Biennale in 1948 and 1954. He died in Milan in 1956. M. G.

Giuseppe Raimondi, *Filippo de Pisis*, Florence, 1952
Filippo de Pisis, ed. Giuseppe Marchiori and Scudo Zanotto, Ferrara, Palazzo dei Diamanti, 1973
De Pisis: Gli Anni di Parigi, 1925-1939, ed. Giuliano Briganti, Verona, Galleria dello Scudo, 1987

Luciano Fabro

was born on 20 November 1936 in Turin. In 1958, he moved to Milan, where he was influenced by the '*tabula rasa*' achieved by Fontana, Manzoni and Yves Klein in their monochrome paintings. They advocated a radically new approach to pictorial space, what Fabro termed the 'space which matter imposes'. From this insight he drew his own conclusion: 'once we have realized that matter imposes a spatial law, we can see various conditions of matter which enter into pacts and agreements with one another. And the artist is always the person who is at hand to enable things to go to the right place – not to assign a place to them, because they already have their place.'

Fabro's works are devoted to the premise that the role of the artist is not to create a fictional or illusory reality, but to act upon and highlight the nature of reality as it already exists. To this end, he seeks to divest the viewer of preconceived ideas of form or taste. Art is liberated from aesthetic categories and becomes simply an 'occasion for experiences'.

Fabro began with a series of works designed to provide objective evidence of space. Between 1963 and 1966, he delineated a given environment with partly reflecting glass panels in the shape of circles or rectangles which, like Marcel Duchamp's *Large*

Glass, were not so much seen as seen through. At the same time, the mirror surface of certain areas allowed the viewer to perceive the entire circum-ambient space, as in Pistoletto's contemporary reflecting pieces. The art work was fully realized only when the viewer perceived the various occurrences of reflection, refraction, transparency and distortion. These glass panels, and a group of small metal tubes that also plotted or circumscribed space, were included in Fabro's first one-man show, at the Galleria Vismara, Milan, in 1965. His reduction of art to a set of phenomenological experiences aligned him with the *Arte Povera* movement, with which he has been associated since its inception in 1967. His work is also related to the larger, international phenomenon of Post-Minimalism and to the 'anti-form' installations of Eva Hesse and Robert Morris.

In 1968, Fabro returned to representational objects in a series of works that combined deliberately vulgar materials with fetishistic images. The series *Feet* (1968-72) consisted of long, tubular torsos of pleated shantung silk suspended from the ceiling, from which emerged shod feet of Murano glass, bronze or marble. The works gave expression to the artist's interest in the symbolism of hung or draped cloth. The sexual connotations of forms of fabric was made explicit in a group of close-up photographs of women's creased and pleated skirts, published in 1972. In *The Deceased* Fabro depicted himself as a medieval *gisant*, his body covered with a sheet, his head alternatively covered or exposed. From a set of photographs he reproduced the headless version in marble, in the style of realistic nineteenth-century tomb sculpture.

Fabro's best-known works, the *Italy* series, were begun in 1968. The country's distinctive 'boot' silhouette is rendered in glass, lead, fur, gold or other sensuous materials as a running commentary on Italy's rich cultural traditions and its post-war capitalist boom. Throughout the seventies and eighties, Fabro has continued to discover new formal and iconographic possibilities within his given set of materials. The *Clothes-Hangers* installation of 1976 presented panels of coloured cloth undulating across the walls and topped by laurel leaves in an allusion to Apollo's rape of Daphne. In other works, from the glass masks of *Iconography* (1975) to the perspectival cage of *Paolo Uccello 1450-1985* (1985), Fabro uses 'poor materials' and a fundamental language of forms to suggest, not a *tabula rasa*, but the rich palimpsest of European cultural history. P. K.

Luciano Fabro, Essen, Museum Folkwang, and Rotterdam, Museum Boymans-van Beuningen, 1981
Jole De Sanna, *Luciano Fabro*, Ravenna, 1983
Luciano Fabro: Works 1963-1986, Edinburgh, Fruitmarket Gallery, Archives of Contemporary Art, 1987

Lucio Fontana

was born the son of a Milanese sculptor, Luigi Fontana, on 19 February 1899 in Rosario di Santa Fe, Argentina. In 1905, his family moved to Milan. Fontana studied surveying at the Carlo Cattaneo technical college, 1914-15; he received his diploma in 1918 after serving in the army in 1917 and sustaining injuries at the Front. He followed his father to Argentina in 1922 and opened his own sculpture atelier in 1924. Returning to Milan, he continued his training at the Accademia di Brera, 1928-30, where he worked under the *Novecento* sculptor, Adolfo Wildt.

He held his first one-man show in 1931, at the Galleria del Milione in Milan; among the works exhibited was *Black Figure* (1930; now lost). The reductive forms of this figurative sculpture, partly influenced by Martini, demonstrated a new line of research in his work and his growing interest in the European avant-garde. In 1931, he produced his first *Tavolette graffite* (*Scratched Tablets*), of coloured cement, incised with a gestural abstraction akin to the graphic automatism of the Surrealists and anticipating his work of the fifties. He was close to the abstract artists associated with the Galleria del Milione, and signed the manifesto of the 'Prima mostra collettiva d'arte astratta italiana' held in the studio of Casorati and Enrico Paulucci in Turin in 1935. Several of Fontana's abstract sculptures of this period were lost or destroyed and later reconstructed by the artist in the 1950s. Although he supported the Paris movement *Abstraction-Création* in 1935, he continued to work concurrently in abstract and figurative styles throughout the decade. Among the few public art commissions he received under the Fascist regime was an allegorical bas-relief in marble for the Palazzo della Giustizia in Milan in 1937. He also participated in the exhibitions of *Corrente* without sharing the group's official anti-*Novecento* stance.

Fontana's experiments with ceramics also date from the 1930s. He began at the studio of Tullio d'Albisola (Giuseppe Mazzotti) in Liguria and worked in the Sèvres factory in Paris in 1937. His ceramic sculptures, which were partly influenced by the work of Medardo Rosso and Boccioni, were notable for their gestural freedom and plastic expressiveness. He was mentioned by Marinetti in the 1936 *Futurist Manifesto of Ceramics and Aeroceramics*.

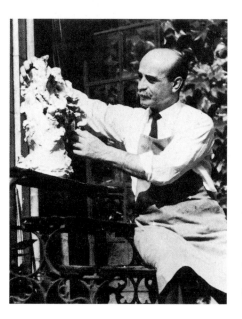

Fontana sailed for Argentina in 1940 and during the war years he continued to work in a figurative style. In 1946, he founded the Altamira academy in Buenos Aires with Jorge Romero Brest and Jorge Larco. This soon became a centre for young artists and intellectuals, and prompted the publication of the *White Manifesto*. Although it was not actually signed by Fontana, it contained ideas that formed the basis of his theory of 'Spatialism'. These were elaborated on in a series of five manifestos written between 1947 and 1952. After his final return to Milan in 1947, investigations into the metaphysical and material properties of space became the sole focus of his work. In 1949, he made his first punctuated canvases, *Buchi* (*Holes*), which were succeeded by the *Tagli* (*Slashes*) of 1959. He carried out parallel experiments in his *Nature* cycle of terracotta and metal sculpture. *Stones* (1952-3), laden with pigment and coloured glass, underlined his continual interest in the physicality of materials along with the evocation of the infinity of space. He also engaged in large-scale installations, beginning with his *Spatial Environment*, a continuous arabesque of neon light, at the Galleria del Naviglio in Milan in 1949. These were significant precursors of neon art of the sixties. Pursuing his interest in environmental design, Fontana collaborated with the rationalist architect Luciano Baldessari in the decoration of several exhibition pavilions in the early 1950s.

During the 1960s, he produced *The Death of God* (1963), a series of oval, monochrome canvases pierced with a mass of holes and sprinkled with sequins, which simultaneously evoke divinity and the void; *Little Theatres* (1964), with abstract, perforated forms in a stage setting, and *Ellipses* (1967), elliptical pieces of lacquered wood punctuated with holes at regular intervals. In 1966, Fontana received the International Grand Prize for Painting at the Venice Biennale. He died on 7 September 1968, shortly after moving to Comabbio near Varese. S. F.

Lucio Fontana, New York, Solomon Guggenheim Museum, 1978
E. Crispolti, *Lucio Fontana*, catalogue raisonné, 2 vols, Milan, 1986
Lucio Fontana, ed. Bernard Blistène, Paris, Musée national d'art moderne, Centre Pompidou, 1987

Domenico Gnoli

was born in Rome on 3 May 1933. His father, Umberto Gnoli, was an art historian and his mother, Annie de Garron, a painter and ceramicist. The poet Giulio Orsini was his paternal grandfather. His family encouraged his artistic interests, although he received no formal training apart from private lessons in drawing and engraving from Carlo Alberto Petrucci.

Gnoli had his first one-man show in 1950, at the Galleria La Cassapanca in Rome, where he exhibited a series of drawings entitled *My Knights*. He frequented the studios of Fabrizio Clerici and the Russian-born stage designer Eugene Berman. His devoted study of the northern masters, particularly Pieter Brueghel the Elder, influenced the bird's-eye views, crowded compositions and human grotesques found in his illustrations of contemporary life and travel scenes.

In 1952, he briefly enrolled in courses in scenography at the Accademia di Belle Arti in Rome, but was soon involved with commissions for stage

and costume design, which included *The Merchant of Venice* presented by the Cesco Baseggio company at the Zurich Festival in 1953. In 1954, he travelled to Paris, where he befriended Leonor Fini and Friedrich Hundertwasser. While in London in 1955, he met Michael Benthall, director of the Old Vic Theatre, and designed sets and costumes for *As You Like It.* Despite the critical success of the project, Gnoli decided to leave the theatre and, dividing his time between London, Paris, Rome and New York, concentrated on painting and illustration.

His early canvases, such as *Tower in the Room* (1956) and *Cathedral* (1958), still bore the structure and space of stage design, and were influenced by the obsessive detail of Hundertwasser and the whimsical mood of Paul Klee. In his show at the Bianchini Gallery in New York in 1960, he exhibited paintings of household objects, such as *The Iron Bed* and *Linen Baskets*, executed in a dense impasto of tempera and sand and exuding an atmosphere reminiscent of Metaphysical painting.

In the sixties, Gnoli continued his prodigious activity as an illustrator of literary texts and travel vignettes for such magazines as *Fortune, Holiday* and *Horizon.* In 1962, the Hazlitt Gallery, London, exhibited Gnoli's his watercolours and drawings for his book *Orestes or the Art of Smiling.* In the same year, he met the painter Yannick Vu in Paris; he married her in 1965. He exhibited regularly at the Society of Illustrators in New York and was awarded prizes for his work in *Show Magazine* and *Sports Illustrated.* In 1966, he received a gold medal as America's Illustrator of the Year. He returned frequently to Rome, where he visited Balthus and Mario Schifano.

His painting reached maturity with details of commonplace objects presented in frontal compositions that filled the entire space of the canvas, and culminated in a series of huge canvases exhibited at the Sidney Janis Gallery in New York in December 1969. Works such as *Hair Part, Lady's Shoe* and *Button* combined the ironic banality of American Pop Art with the tense lucidity of Magic Realism, while eschewing all narrative or symbolic elements. As Gnoli stated in the catalogue of the Premio Marzotto of 1966: 'At a time like this, when iconoclastic anti-painting wants to sever all connections with the past, I want to join my work to that 'non-elegant' tradition born in Italy in the Quattrocento and recently filtered through the Metaphysical school. It seems that the experience of those who wanted to interpret, deform, decompose and recreate has come to an end, and reality is presented undaunted and intact. The common object, isolated from its usual context, appears as the

most disquieting testimony to our solitude, without further recourse to ideologies and certitudes.'

Gnoli died of cancer on 17 April 1970. His first retrospective was held at the Krugier Gallery in Geneva that year, followed by museum exhibitions in Germany, Belgium, France, Holland and, most recently, at the Galleria Nazionale d'Arte Moderna in Rome in 1987. M. G. B.

Domenico Gnoli, 1933-1970: Gemälde, Skulpturen, Zeichnungen, Druckgrafik, Bremen, Kunsthalle, 1981
Domenico Gnoli, Milan, Padiglione d'Arte Contemporanea, 1985
Domenico Gnoli, Rome, Galleria Nazionale d'Arte Moderna, 1987

Renato Guttuso

was born in Bagheria, near Palermo (Sicily), on 2 January 1912. Through his father, a land surveyor of Socialist leanings, the young Guttuso saw much of the Sicilian countryside and peasant population that would later inspire his subject-matter. He was encouraged to paint by his father, and frequented the studios of the Post-Impressionist Domenico Quattrociocchi and the Futurist Pippo Rizzo. In 1929, he participated in the 'Seconda Mostra del Sindacato Siciliano'. He enrolled in law school in Palermo in 1930, but abandoned his studies after his success at the first Quadriennale of Rome the following year. He exhibited with a group of Sicilian painters at the Milanese Galleria del Milione in 1932 and 1934. In the early thirties, he befriended the artists of the *Scuola Romana*: Corrado Cagli, Mario Mafai, Alberto Ziveri, Mirko Basaldella and Pericle Fazzini. In 1933, he contributed an enthusiastic article on Picasso for the Palermo newspaper *L'Ora*; the Spanish artist remained the chief stylistic and moral influence throughout his career.

While on military service in Milan in 1935, Guttuso met the painters Renato Birolli, Aligi Sassu, Fontana and Italo Valenti, who were later associated with the *Corrente* movement. In 1937, he settled in Rome, where he met his future wife, Mimise Dotti, and had his first one-man exhibition at the Galleria della Cometa the following year. In 1940, he joined *Corrente* and the clandestine Communist party. Guttuso became the most vocal spokesman of a younger generation of artists who had grown increasingly disillusioned with politics and the cultural policies of the regime in the years

before the Second World War, voicing his opinions on creative freedom and the moral imperative of realism in various articles in *Primato, Il Selvaggio, Le Arti* and *Meridiano di Roma.* He realized these ideals in a series of large-scale canvases, beginning with *Execution in the Country* (1938-9) dedicated to Federico Garcia Lorca, *Flight from Etna* (1940) and *Crucifixion* of 1941. The latter's crude imagery and implicit criticism of the Fascist regime provoked strong reactions from both the Church and the government. Nonetheless, Guttuso also enjoyed official recognition: both *Flight* and *Crucifixion* were awarded prizes at, respectively, the second and fourth Premio Bergamo, the state exhibition sponsored by the minister Giuseppe Bottai. These visual manifestos were inspired by Picasso's *Guernica,* although Guttuso transformed the latter's Cubist syntax into a more realistic narrative.

Fleeing Rome for political reasons in 1943, Guttuso took refuge in Quarto, Genoa, in the home of his patron and friend, Alberto della Ragione. He returned in 1944 to join the Resistance. He participated in the exhibition 'L'arte contro la barbarie', sponsored by the Communist paper *L'Unità,* where he exhibited his drawings of the atrocities of war; these were subsequently published in the album *Gott mit Uns* of 1945. In 1947, he was among the founders of the *Fronte Nuovo delle Arti,* with Renato Birolli, Giuseppe Santomaso, Melotti, Turcato and Vedova. He participated in the group's exhibition at the Galleria Spiga in Milan, but shortly thereafter left the *Fronte* because of ideological differences between its figurative and abstract artists. In various articles in *Vie Nuove, L'Unità* and *Rinascita* he championed a descriptive realism which he considered to be inherently popular and accessible to the masses. Although he noted affinities with Russian Social Realism, he maintained that his artistic ideology sprang from deeply felt convictions and was not imposed by any prevailing political system. He continued to produce large-scale narratives of contemporary events, often with allegorical overtones, politically charged images of the Sicilian peasantry and autobiographical scenes.

Among the best known of Italian artists abroad in the post-war years, Guttuso has been the subject of numerous exhibitions, including a retrospective at the Pushkin Museum in Moscow and the Hermitage in Leningrad. In 1966-8, he taught painting at the Accademia di Belle Arti in Rome, and served as visiting professor at the Hochschule für Bildende Kunst, Hamburg, in 1968. He was made Senator of the Republic in 1976. He died in Rome on 18 January 1987. M. G. B.

Enrico Crispolti, *Renato Guttuso: Catalogo generale dei dipinti,* 3 vols, Milan, 1983, 1984, 1985
Renato Guttuso dagli esordi al 'Gott Mit Uns', 1922-44, Bagheria, Galleria d'Arte Moderna e Contemporanea, Villa Cattolica, 1987

Jannis Kounellis

was born on 21 March 1936 in Pireaus, Greece. In 1956, he emigrated to Italy and has lived in Rome ever since, seldom returning to his native country. As a student in Rome at the Accademia di Belle Arti, he was particularly influenced by the work of the Russian Constructivist Kasimir Malevich, as well as by the contemporary Italians Fontana, Burri and Manzoni. Around 1958, in reaction

against the painterly gesture of European *Informel*, Kounellis stencilled black letters, numbers and symbols on unprimed canvas. These *Alphabets* comprised his first one-man exhibition, in 1960 at the Galleria La Tartaruga in Rome. He subsequently incorporated found objects into his work and turned to performance art, sometimes accompanying his painting with music and song, or using his painted canvas as a costume.

Between 1965 and 1967, he ceased to create and developed a personal philosophy that was to inform all his later work. According to Kounellis, art is a binding force, or what he terms 'measure', a means of reintegrating man into society in a world that is increasingly fragmented by civil strife and divorced from nature. Considering painting to be an anachronistic medium, he began to make installations of raw materials and primal structures, such as bed-frames, doors and shelves, to reveal the symbolic associations that emerge and endure in the world, despite its apparent disorder.

Since 1967, he has been associated with the *Arte Povera* movement. In that year, he first used burlap sacks, either hung on the walls or heaped in a cart, alluding to their ancient function as a means of measure and trade, as well as to the contemporary work of Burri. Since the late sixties, he has made increasingly complex installations, combining various fundamental materials of the earth and alchemy, of commerce and construction – wool, wax, gold, lead, wood, burlap, coal and fire – and imbuing his work with multiple formal and symbolic associations. Many of these works are organized around the relationship between the opposing principles of 'structure' and 'sensibility'. The former refers to rigid inorganic materials such as metals (represented by bed-frames since 1969) and the latter to organic matter, such as plants, birds, horses, even people, which serve to integrate real life into art.

In 1967, during the period of social and political unrest, Kounellis introduced fire (in the form of blow-torches) as a symbol of change, be it destruction, purification or enlightenment. Other installations were marked by the vestige of a flame gone out – smoke, soot or a charred surface – as a trace of the vitality of a past civilization or, in the more immediate context of the late sixties, as a comment on waning political activism. His belief that spiritual vision in modern society is blurred or completely blinded accounts for the motifs of

blocked doorways, blindfolded figures or statues, and windows with lead panes, as well as for his abstract, opaque black square paintings, which are also a homage to Kasimir Malevich.

During the seventies, Kounellis reflected on the concept of history as a remnant or vestige in our collective memory. The motif of 'shelves', used in his work since 1969, was intended as a metaphor of history, as the place where objects accumulate over time and are reassembled in a new totality. He has since incorporated revered artistic icons from the past as symbols of a lost unity, including references to the gold grounds of Byzantine painting, and, since 1975, fragments of plaster casts of classical sculpture.

Despite the consistent evolution of his personal 'anti-iconography', Kounellis has continually rebelled against what he calls 'the inertia of style' by challenging the traditional notion of the art object or even the art exhibition. For his first retrospective in the United States in 1986, he extended his installations beyond the walls of the Museum of Contemporary Art in Chicago into four abandoned industrial buildings in different areas of the city. Since 1977, he has had solo exhibitions throughout Europe, including those at the Boymans-van Beuningen Museum, Rotterdam, and the Kunstmuseum, Lucerne (1977); the Folkwang Museum, Essen (1979); ARC, Musée d'Art Moderne de la Ville de Paris (1980); a travelling retrospective at the Van Abbemuseum, Eindhoven, La Caixa, Madrid, and the Whitechapel Art Gallery, London (1981); and the Städtische Galerie im Lenbachhaus, Munich (1985). J. B.

Kounellis, Paris, ARC, Musée d'Art Moderne de la Ville de Paris, 1980
Jannis Kounellis, ed. Helmut Friedel, Munich, Städtische Galerie im Lenbachhaus, 1985
Jannis Kounellis, Chicago, Museum of Contemporary Art, 1986

Osvaldo Licini

was born on 22 March 1894, the son of a commercial artist; his mother was French. He spent his youth between his isolated home town of Monte Vidon Corrado (the Marches) and Paris, where his family lived from 1902. From an early age Licini was particularly interested in French art and literature. He attended the Accademia di Belle Arti in

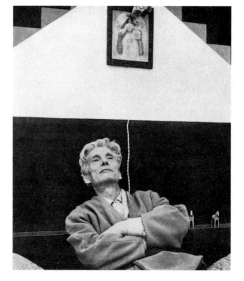

Bologna between 1908 and 1913 with Morandi. In 1914, he took part in a notorious Futurist evening at the Hotel Baglioni in Bologna and later that year moved to Florence, where he studied at the Accademia di Belle Arti until volunteering for the army in 1916. Following a serious leg injury in 1917, he went to convalesce in Paris, which remained his principal residence until 1926. In the year of his arrival, he attended the performance of *Parade*, met Jean Cocteau, Blaise Cendrars, Pablo Picasso and Chaim Soutine, and befriended Modigliani. His interest in French Symbolist poetry (Charles Baudelaire, Stéphane Mallarmé, Paul Verlaine, Arthur Rimbaud, Lautréamont) increased during these years, and he exhibited regularly in the Salon d'Automne and the Salon des Indépendants. On his return to Italy, he participated in 'Il Novecento Italiano' of 1926 and 1929, and in several of the group's exhibitions abroad. In an autographed note of 1929 he divided his artistic development into three stages: 'Fantastic Primitivism', 1913-15; 'War Episodes' (nearly all destroyed), 1915-20; and 'Realism', 1920-9. The latter referred to his Post-Impressionist landscapes and still-lifes which were indebted to Paul Cézanne and Henri Matisse.

Following a trip to Paris and Sweden in 1930-1, he rejected his figurative style and painted his first abstract works. From 1934, he was associated with the Galleria del Milione in Milan and with the *Abstraction-Création* group in Paris. In 1935, he had his first one-man show at the Galleria del Milione and participated in the 'Prima mostra collettiva d'arte astratta italiana' held in the studio of Casorati and Enrico Paulucci in Turin. In Paris later that year, he met Wassily Kandinsky, Georges Vantongerloo, Frantisek Kupka, Auguste Herbin and Magnelli. Despite his open association with these artists and movements, he did not conform to a completely non-objective style or aesthetic ideology. Instead, he turned to abstraction 'in a reaction against the excessive naturalism and materialism of the twentieth century. Painting is the art of colours and signs: signs express force, will and the idea, while colour expresses magic.' Licini's poetic approach to the image had affinities with the work of Paul Klee and Joan Miró. In 1938, he signed Marinetti's manifesto, *Evolution of Italian Art*, protesting against the anti-Semitic, anti-modernist campaign of the racial laws. He also supported the manifesto of the *Gruppo Primordiale Futurista* in 1941. During the war years he refused to exhibit.

After the war, Licini became the first Communist mayor of Monte Vidon Corrado, where he remained until the end of his life, working in semi-seclusion. Abandoning the abstraction of the thirties, he filled his canvases with fields of intense colour and a personalized mythology of imaginative figures (Rebels, Angels, Lovers, Flying Dutchmen) rendered with a graphic freedom akin to the psychic automatism of the Surrealists. These works were first exhibited at the 1948 Venice Biennale. He won the International Grand Prize for Painting at the Biennale a decade later, a few months before his death on 11 October 1958.
S. F.

Giuseppe Marchiori, *I Cieli Segreti di Osvaldo Licini*, Venice, 1968
Gino Baratta, Franco Bartoli and Zeno Birolli, eds, *Errante, Erotico, Eretico (Gli scritti letterari e tutte le lettere)*, Milan, 1974
Licini, Venice, Galleria della Fondazione Bevilacqua La Masa, 1988

Francesco Lo Savio

was born on 28 January 1935 in Rome. In 1955, he received his diploma from the Accademia di Belle Arti in Rome, after which he began to study architecture. He never practised as an architect, although he did work briefly as an industrial designer in 1958. Lo Savio's earliest paintings, done in 1959-60, immediately placed him in the forefront of the European avant-garde. Developing with extraordinary rapidity, he created a series of works anticipating American Minimalism – *Painteds, Filters, Metal Pieces, Total Articulations* – and then committed suicide in Marseille in 1963, at the age of twenty-eight.

Lo Savio's first paintings, a series of monochrome canvases, attracted attention in 1959 and he had his first one-man exhibition the following year at the La Selecta gallery in Rome. In March 1960, he was included in the 'Monochrome Malerei' exhibition organized by Udo Kultermann at the Städtisches Museum Morsbroich, Leverkusen, and, in the same year, was one of the '5 Pittori Roma '60' shown at the Galleria La Salita, along with Franco Angeli, Tano Festa, Schifano and Giuseppe Uncini. The speckled and atmospheric surfaces of his monochromes seemed to derive from Fontana's 'spatial concepts', although Lo Savio soon developed a completely different line of investigation into the effect of ambient light on the painting-object. In his book *Spazio-Luce* (1962) Lo Savio described his work as the 'development of a pure spatial conception, in which light is the unique element defining structure'.

Lo Savio's earliest pictures evoked space solely by means of paint, using monochrome as a metaphor of infinity, but he soon began to layer coloured filters over the canvas background. These filters absorbed light in varying degrees and, as Lo Savio wrote, 'set up real contact with the surrounding space'. The interest in space as an active field of energy, rather than as colour *per se*, distinguished Lo Savio from such contemporaries as Yves Klein, and foreshadowed the environmental art of the Americans Robert Irwin and James Turrell. The *Filters* were succeeded by a series of metal works composed of intersecting, matt-black panels which engaged the viewer in the perception of an intense activity of reflected ambient light. As Lo Savio himself put it, 'Only with the metal pieces did the activity of the work truly confront the fact of three-dimensional space'. Although he based these works on precepts of perceptual psychology, Lo Savio also considered light as a mystical portent of cosmic energies.

In January 1961, Lo Savio exhibited again in Leverkusen, as part of an exhibition that also included Ad Reinhardt. Meanwhile, he had become associated with the 'Gruppo O', and that June he organized an exhibition of new European tendencies at the Galleria La Salita in Rome. This show, sometimes referred to as 'Gruppo O+O', featured Klein, Günther Uecker, Heinz Mack and Otto Piene. Mack and Piene were the editors of *Zero*, the journal of 'Gruppo O', and Lo Savio participated in their 'Zero 3' exhibition. He was also included in 'Nul' at the Stedelijk Museum, Amsterdam (1962), and, posthumously, in the 1964 'Gruppo O' exhibition at the Institute of Contemporary Art of the University of Pennsylvania.

By 1962, Lo Savio had arrived at what he called *Total Articulations*. These consisted of white cubes with two open ends through which a curved black plane could be seen bisecting the interior space. The cube, Lo Savio wrote, represented 'a space of activity integrated into the object itself . . . limiting the interference of the external surroundings'. On the border between painting and sculpture, these works strikingly anticipated the Minimal constructions of Donald Judd and Sol LeWitt. Lo Savio also produced several pieces resembling architectural models, complex structures composed of intersecting spherical sections.

Despite his premature death, Lo Savio's work continued to be shown in numerous exhibitions throughout the 1960s and 1970s, including the first Documenta in Kassel (1968). P. K.

Francesco Lo Savio, *Spazio-luce: Evoluzione di un'idea, volumo primo*, Rome, 1962
Francesco Lo Savio, Milan, Padiglione d'Arte Contemporanea, 1979
Francesco Lo Savio: Raum-Licht, Bielefeld, Kunsthalle, 1986

Alberto Magnelli

was born on 1 July 1888 in Florence, and began to paint at the age of fifteen. Although his career unfolded largely in France, Magnelli retains a key position in modern Italian art as an early exponent of pure abstraction. By 1911-12, he had become close to the Futurist group around *La Voce* and *Lacerba*, but the main influences on his art were the painters of the early Quattrocento, especially Piero della Francesca and Paolo Uccello, from whom he inherited a lifelong preference for strongly architectonic composition. Arriving in Paris in the spring of 1914, he soon befriended Pablo Picasso, Guillaume Apollinaire and their avant-garde circle. The geometry of Magnelli's 1914 still-lifes and landscapes suggested Cubist influence, but the dark, unbroken outlines and areas of unmodulated colour were particularly indebted to Henri Matisse, with whom he had also become acquainted. The outbreak of the First World War found Magnelli in Italy; there, he painted a series of totally abstract works, but returned to a figurative style in 1916.

In 1918, Magnelli again veered towards abstraction in the series *Lyrical Explosions*. In the course of the 1920s, these dynamic compositions gave way to static scenes of the Tuscan countryside which were influenced by the still atmosphere of Metaphysical painting; in retrospect, this decade seems the least progressive period of his career. Around 1930, he underwent a crisis which caused him to stop painting, but inspiration returned following a visit to the marble quarries of Carrara in the summer of 1931. For Magnelli, the huge blocks of stone were reminiscent of Michelangelo's *Slaves* and led to a realization of his own sense of imprisonment within the provincial artistic atmosphere of Tuscany; he left for Paris in October 1931.

There he began the series *Stones:* massive, jagged forms of illusionistically modelled volumes floating in an undefined space, similar to Fernand Léger's contemporary paintings of isolated objects. In the early thirties, Magnelli supported the *Abstraction-Création* group and was in close contact with Prampolini. He continued to exhibit in Italy, showing the *Stones* at the 1935 Quadriennale in Rome.

In the second half of the thirties, he began a second period of abstraction with completely non-figurative compositions purged of the surrealistic overtones of the previous works. In 1937, he was included in the exhibition 'Origines et Developpement de l'Art International Indépendant' at the Jeu de Paume, Paris, and had a one-man show at the Boyer Galleries in New York. He and his wife spent the war years in Provence, where they formed a close friendship with Jean Arp and Sophie Tauber-Arp and, later, with Sonia Delaunay. Lack of canvas and other artists' supplies led Magnelli to begin a new kind of 'stone' painting, consisting of gouaches executed on slate slabs resembling school blackboards. He returned to Paris in 1944, where he participated in several important exhibitions of abstract art, including 'Art Concret', organized by the Galerie Rene Drouin in 1945. A large one-man show presented by the same gallery two years later finally established Magnelli's reputation. In his work of the fifties the forms became locked in a stricter compositional grid, accentuated by rhythmic linear elements. While Magnelli's treatment of space and colour derived from Synthetic Cubism, his angular, non-biomorphic forms anticipated the 'hard-edged' abstraction of the sixties. He continued to work in this style for the rest of his career.

Italy accorded Magnelli due recognition with a retrospective at the 1950 Venice Biennale. From 1959, he lived in Meudon-Bellevue, and received a series of prizes and exhibitions throughout the 1950s and 1960s. In 1963, his seventy-fifth birthday was celebrated by major exhibitions at the Zurich Kunsthaus and the Palazzo Strozzi in Florence. At his death in 1971, he left significant bequests to the Palazzo Pitti, Florence, and the Musée d'Art Moderne, Paris. M. G./P. K.

Alberto Magnelli: Œuvres de 1914 à 1968, Paris, Centre National d'Art Contemporain, 1970
Anne Maisonnier, *Alberto Magnelli: L'œuvre peint, catalogue raisonné*, Paris, 1975
Magnelli: Exposition du Centenaire, ed. Daniel Abadie, Avignon, Palais des Papes, 1988

Piero Manzoni

was born into an aristocratic family in Soncino near Milan in 1933. He studied briefly at the Accademia di Brera. After painting traditional landscapes during the early fifties, Manzoni experimented with new materials, such as oil, wax, enamel, gesso and glue. His first mature works were influenced by the Expressionism of the *Informel* artists Burri, Fontana and Jean Fautrier. By the beginning of 1956, he had begun to produce images by dipping such objects as keys, scissors, pliers and pincers in paint and impressing them on the canvas. These were followed by paintings built up with oil and tar. On 9 December 1956, Manzoni published the manifesto *Towards the Discovery of a Zone of Images* in collaboration with Camillo Corvi-Mora, Ettore Sordini and Giuseppe Zecca. Manzoni claimed that the 'work of art has its origin in an unconscious impulse that springs from a collective substratum of universal values common to all men, from which all men draw their gestures'.

In the spring of 1957, he participated in a group show organized by Fontana at the Galleria Pater in Milan, and in June he joined the *Gruppo Nucleare*, which distributed his manifesto *Towards an Organic Painting*. In the autumn, he signed the *Manifesto against Style* which confirmed his support of the *Gruppo Nucleare Internazionale*. In response to the work of Fontana, Burri and Yves Klein (whose blue monochromes he had seen in the latter's first Italian exhibition, in January 1956), he invented the 'achrome', a painting built up of rough gesso that was then scratched or marked. The subsequent series of colourless *achromes* included canvases coated with kaolin (1958), felt, cotton and polystyrene (1960), wool and rabbit fur (1961), bread rolls and stones (1962).

In January 1958, he had an exhibition with Enrico Baj and Fontana at the Galleria Bergamo but, by the beginning of 1959, he had left the *Gruppo Nucleare* and was working more independently. He met Agostino Bonalumi, Vincenzo Agnetti and Enrico Castellani and published the review *Azimuth* with the latter. Developing an increasingly conceptual approach, Manzoni produced his first *Lines* in 1959. These were made by drawing a line with an ink-soaked pad on a roll of white paper. The various lengths of paper were rolled and each placed in a container which specified its length and date of execution. The longest line produced was that of Herning Park, Denmark (1960);

it measured 7,200 metres. Henk Peeters introduced him to the Zero group during a visit to The Hague. In April 1959, Manzoni was in Rome to launch his book in gesso entitled *Piero Manzoni Parla*. On his return to Milan he created forty-five *Bodies of Air*, instantly inflatable sculptures which he continued to make until 1961. Those containing his own breath were known as *Artist's Breath*.

He opened the Azimuth gallery with Castellani in December 1959; in July of the following year, he organized an exhibition entitled 'Consumazione dell'arte attraverso la sua divorazione' (Consuming Art by Devouring It), during which he handed out hard-boiled eggs signed with his thumb print and invited the public to eat them. Like much of Manzoni's work, the eggs parodied the mass-produced items of our consumer society and, in a Neo-Dada vein, satirized the reverence afforded to fine art and the artist. Late in 1960, he signed the manifesto *Against Nothing* with Castellani, Heinz Mack and Otto Piene. The following year, he produced his first *Magic Base* for living sculptures: while standing on the base, anyone would become a work of art. At the Galleria La Tartaruga, Rome, he signed his first living sculptures and issued them with certificates of authenticity. He also produced ninety cans of *Artist's Shit* which he considered to be the ultimate statement on the unity of art and life. In 1961, he also went to Paris to see the *Nouveau Réalisme* exhibition '40° au-dessous de Dada', where he met and befriended Arman, Jean Tinguely and Klein.

In Manzoni's words, 'being is all that counts'. He thus held that art comprised everything in the world, whether animal, vegetable or mineral. He glorified this notion in *Base of the World* (1961), an upside down 'magic base', dedicated to Galileo, which held up the entire world. A precocious exponent of Conceptual Art, Manzoni was a tireless promoter of exhibitions and manifestos and an important link between the Italian and other European avant-gardes. He died in 1963, leaving an artistic legacy that was an inspiration to the younger generation, especially to the artists of *Arte Povera*. S. F.

Piero Manzoni, ed. Germano Celant, Rome, Galleria Nazionale d'Arte Moderna, 1971
Germano Celant, *Piero Manzoni*, New York, 1972
Piero Manzoni, London, The Tate Gallery, 1974

Giacomo Manzù

was born on 22 December 1908 in Bergamo (Lombardy), the son of a cobbler. From the age of eleven he was apprenticed to various artisans, including a carpenter and a woodcarver, and later took modelling classes at the Fantoni school. During military service in Verona (1927), he occasionally studied at the Accademia Cicognini. After a brief trip to Paris in 1929, Manzù settled in Milan, where the architect Giovanni Muzio commissioned him to decorate the chapel of the Università Cattolica (1931-2). In 1932, he participated in a group show at the Galleria del Milione, and the first monograph on his work was published by Giovanni Scheiwiller. Despite these initial successes, Manzù retreated to Selvino near Bergamo, where his use Egyptian and Minoan sources was replaced by the example of Rosso. He exhibited a series of portrait busts at the Milan Triennale of 1933, which brought him considerable recognition. With the painter Aligi Sassu (with whom he shared a studio) he travelled to Paris in 1936 and

visited the Rodin museum. In the following year, he had his first major exhibition, along with Sassu, at the Galleria della Cometa in Rome.

Manzù took part in his generation's revolt against Fascism, beginning with his participation in the activities of the Milan *Corrente* group, with whom he exhibited in 1939. That year, he began the series of bas-reliefs entitled *The Crucifixions* (1939-46), which, with a classicizing style and pathos recalling Donatello, used the iconography of the Crucifixion to symbolize resistance to the brutalities of the regime. The works were denounced by both the Church and State at their exhibition at the Galleria Barbaroux in Milan in 1942. At the same time, Manzù continued to gain official recognition: he was appointed professor of sculpture at the Accademia di Brera in 1940, and his nude of Francesca Blanc won the Grand Prize for Sculpture at the Rome Quadriennale of 1942. He spent the war in Clussone, north of Bergamo.

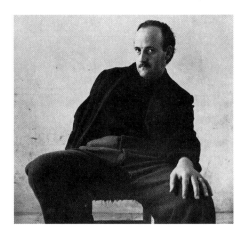

In 1946, Manzù made numerous studies for a portrait of Signora Lampugnani, which culminated in the important life-size work, *Lady in a Dressing Gown*. At the Biennale of 1948 he was awarded the Gold Prize for his series *Cardinals*, which he had begun in 1937. He taught at the Brera until 1954, and then at the Salzburg summer academy from 1954 to 1960. There he met Inge Schabel, who became his life-long companion; she and her sister, Sonja, became the regular models for his work. While in Salzburg, he executed the bronze *Doors of Love* in bas-relief for the Cathedral. These were followed by the *Doors of Death* for St Peter's in Rome (1958-64). Upon completion of this commission, Manzù moved to Ardea, outside Rome, where he worked on a third set of doors, *Peace and War*, for the church of St Laurenz in Rotterdam (1965-8). After devoting nearly a decade to work in bas-relief, he returned to the figure in the round and more intimate themes, such as the series *Dance Steps*, *Skaters* and *Lovers*. He has also designed sets and costumes, notably for Igor Stravinsky's *Oedipus Rex* (1965), Richard Wagner's *Tristan und Isolde* (1971) and Giuseppe Verdi's *Macbeth* (1985).

Manzù has received numerous accolades from art institutions, including the title of Honorary Academician from the Royal Academy of Arts in London. In 1979, he donated his collection to the Italian state. Manzù lives and works in Ardea.
 M. G.

Carlo Ludivico Ragghianti, *Giacomo Manzù: Scultore*, Milan, 1957
John Rewald, *Giacomo Manzù*, London, 1967
Manzù, ed. Livia Velani, Edinburgh, Scottish National Gallery of Modern Art, 1987

Marino Marini

was born in Pistoia on 27 February 1901. His father and grandfather were bankers; his sister Egle became a poet, with whom he would later collaborate on several illustrated books. Between 1919 and 1926, he attended the Accademia di Belle Arti, Florence, studying painting under Galileo Chini and later sculpture under Domenico Trentacoste. In 1929, he moved to Milan and succeeded Martini as teacher at the school of art, Villa Reale, Monza, a position he held until 1940. He travelled widely in Europe, making frequent sojourns in Paris in the early thirties. There he met de Pisis, Aristide Maillol, Pablo Picasso, Julio Gonzalez, Jacques Lipchitz, Georges Braque and Henri Laurens. In 1929, he produced his first significant sculpture, *The People*, a double portrait in terracotta, inspired by the Etruscan sarcophagi of Cerveteri and Tarquinia. Marini was attracted to the realism of Etruscan sculpture, with its unclassical proportions and rough surface textures. His stylistic approach was encouraged by his contacts with Martini, the leader of the *maniera etrusca*, which reached a height of popularity in the 1930s, under the influence of recent archaeological excavations.

Marini participated in the 1929 exhibition 'Il Novecento Italiano' in Milan, followed by the group's other shows in major European cities. In 1935, he won the Grand Prize for Sculpture at the Rome Quadriennale. During the 1930s, he produced several works in the classical mode, among them *Rider* (1936), *Gentleman on a Horse* (1937) and *Pilgrim* (1939). The archetypal sculptural themes of the horse and rider, the *Pomona* series of the female nude and the portrait recur throughout Marini's career, revealing his stylistic development in subtle changes of rhythm, proportion and line.

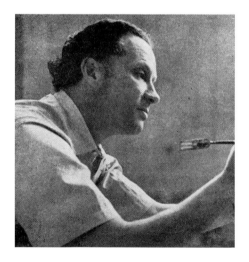

In 1938, he married Mercedes (Marina) Pedrazzini, and two years later he started teaching sculpture at the Accademia di Brera, Milan. In 1941, he began a series or portraits of artists and personalities of the twentieth century. After his house was bombed in 1942, he moved to Tenero-Locarno, Switzerland; from there he made frequent trips to Basle and Zurich, where he met Otto Baenninger, Germaine Richier, Fritz Wotruba and Alberto Giacometti. In 1946, he returned to Milan.

The war had a profound impact on Marini, affecting the serenity and classical structure of his works. In 1943, he produced *The Miracle*, *The Archangel* and *The Hanged Man*, whose linear tension and rough surface treatment expressed anguish and dismay at a world deprived of certainty. His new perception of human tragedy was also reflected in the changed symbolism of his equestrian series, *The Miracles*: the dramatic posture of the rider, captured or being thrown from his rearing horse, negated the harmonious form and equilibrium belonging to the humanistic tradition and Marini's earlier work.

In 1950, he exhibited at the Curt Valentin Gallery in New York, where he received great public acclaim. In the United States he met Jean Arp, Max Beckmann, Lyonel Feininger, Alexander Calder and Igor Stravinsky, and sculpted the latter's portrait that same year. In 1952, he was awarded the Grand Prize for Sculpture at the Venice Biennale and, two years later, the International Grand Prize at the Accademia dei Lincei, Rome. In 1953, he purchased a house in Forte dei Marmi, Tuscany, where he established his studio and spent his summers until the end of his life.

In 1956, Marini began the series *Warriors*, in which horse and rider appear wounded, broken and mutilated, as if survivors on the tragic battlefield of life. Constructed with a powerful interplay of angular, hard, hollow shapes, the compositions reflected the influence of Cubism and, specifically, Marini's study of Picasso's *Guernica*. The series *Screams*, begun in 1962, furthered the dramatic implications of the *Warriors*. In the same years, Marini resumed painting with renewed vigour; in 1975, an important exhibition of his early pictures was held at the Castello Sforzesco, Milan. In 1976, the Munich Staatsgalerie moderner Kunst opened a permanent display of his works, later enlarged by a donation from his wife. In 1979, the artist was present at the opening of the Centro Documentazione Marino Marini in the Palazzo Pubblico, Pistoia. Marini died in Viareggio on 6 August 1980. In 1984, the Galleria d'Arte Moderna, Milan, dedicated to him the Museo Marino Marini. M. G. B.

E. Trier, *Marino Marini*, New York, 1961
Herbert Read, Patrick Waldberg and G. di San Lazzaro, *Marino Marini: Complete Works*, New York, 1970
Marino Marini: Sculture, Pitture, Disegni dal 1914 al 1977, Venice, Palazzo Grassi, 1983

Arturo Martini

was born in Treviso (Veneto) on 11 August 1889. He left school in his early adolescence and worked as an apprentice, first with a goldsmith and then in a ceramics factory, where he learned the fundamentals of modelling and glazing terracotta. In 1906, he entered the studio of the sculptor Antonio Carlini. Upon moving to Venice in 1908, he studied with Urbano Nono and met the Burano group of Neo-Impressionist painters led by Gino Rossi. Back in Treviso, he worked at the ceramics factory of Gregorio Gregorj. With Gregorj's financial assistance he studied in Munich, where he attended the lectures on sculpture given by Adolf von Hildebrand. His early work, exhibited regularly at Ca' Pesaro, was influenced by the Munich Secession and Medardo Rosso. In 1912, Martini travelled with Gino Rossi to Paris, where he exhibited etchings in the Salon d'Automne. He worked again with Gregorj in Treviso and exhibited at the second Roman Secession of 1914. While in Rome he met Boccioni, the Russian sculptor Mitrofan Ruscavsc'nicov and the Yugoslavian Ivan Mestrovich. Conscripted in 1916, he was sent to an arms factory in Vado Ligure, where he acquired

his knowledge of casting techniques. There he met Brigida Pessano, whom he married in 1920.

After the war, Martini went to Milan, attended the salons of Margherita Sarfatti and enjoyed the brief patronage of the industrialist Pietro Preda. In 1920, his first one-man show, presented by Carrà, was held at the Gli Ipogei gallery in Milan. On this occasion Martini gave a lecture on sculpture and the inviolability of plastic form, which attracted the attention of the critic Mario Broglio. He joined Broglio's *Valori Plastici* in 1921, and was the only sculptor to be included in the group's exhibition in Berlin that year. His works of this period, such as *Bust of a Young Girl* and *The Poet Chekhov*, showed a new linear purity and formal simplicity inspired by the masters of the early Quattrocento.

Despite the commission for a war memorial in Vado Ligure in 1923, Martini spent much of the 1920s in economic difficulty. From 1924 to 1929, he was obliged to work with the American sculptor Maurice Sterne on the conception and realization of the latter's *Monument to the Pioneers of America*, commissioned by the city of Worcester, Massachusetts. He participated in both versions of 'Il Novecento Italiano', exhibiting *Leda* in 1926 and *The Prodigal Son* in 1929. Although Martini's approach to tradition embodied the ideals of Sarfatti's *Novecento* movement, he preferred vernacular styles and subject-matter, depicting popular myths or capturing the informal moment in the suspended atmosphere of Magic Realism. The leader of the Etruscan revival of the 1930s, he used rough or indurate materials such as the local stones of Vicenza and Finale and porous tufa to new expressive ends. In 1931-2, he employed specially equipped ovens at the Ilva Refrattari factory to realize a series of monumental terracotta sculptures – among them, *The Dream* and *Expectation* – of unprecedented scale and technical virtuosity. He won the Grand Prize for Sculpture at the first Quadriennale in Rome in 1931.

Between 1934 and 1942, he was involved in several commissions for the Fascist regime, including *Victory of the Air* (1934) for Angiolo Mazzoni's post office in Naples and *Athena* (1935) for the new university of Rome designed by Marcello Piacentini. He worked in marble for the first time in the bas-relief *Corporate Justice* (1937) for Piacentini's Palazzo della Giustizia and in *The Sforzas* (1938-9) for the Ospedale Maggiore, both in Milan. During this period he began to paint and held the first exhibition of his canvases in 1940 at the Barbaroux gallery in Milan. In Carrara in 1941, he produced the marble *Woman Swimming Underwater*, which

attracted considerable interest at the Venice Biennale the following year. In 1942, he sculpted *Titus Livius* for Padua university and began to teach at the Venice Accademia di Belle Arti. As a result of an artistic crisis he wrote *La Scultura lingua morta (The Dead Language of Sculpture)*, which proclaimed the death of monumental statuary. In 1946, he completed *Palinurus or The Partisan Masaccio*, inspired by the Virgilian myth of the young helmsman who, while gazing at the stars, fell into the sea. Although it was commissioned in honour of a young hero of the Resistance, Martini considered the work to be autobiographical. He died a year later on 22 March 1947. M. G. B.

Arturo Martini, *Scultura lingua morta*, Venice, 1945
Arturo Martini, Milan, Palazzo Reale, 1985
Arturo Martini, ed. Fabio Benzi, Rome, Galleria Arco Farnese, 1986

Fausto Melotti

was born on 8 June 1901 in Rovereto (South Tirol). In 1916, his family moved to Florence, where he finished his secondary school education. He began studying physics and mathematics at Pisa university in 1918, but eventually graduated in electronic engineering from Milan polytechnic college in 1924. During these years he was also a devoted student of music. After his military service, he pursued his interest in sculpture and enrolled at the Accademia di Brera in Milan, where he attended the courses of Adolfo Wildt. There he met Fontana, who became a lifelong friend.

In 1932, he took up a teaching post at the Scuola Artigianale del Mobile at Cantù near Milan. With Fontana, Licini and others he supported the *Abstraction-Création* movement in Paris and signed the manifesto of the 'Prima mostra collettiva d'arte astratta italiana', held in the studio of Casorati and Enrico Paulucci in Turin in 1935. These artists aimed to bring the art and architecture of Italy into a direct dialogue with the European avant-garde, as a counter to the nationalistic cultural policies of the Fascist regime. Carlo Belli, the theorist and supporter of the group, was Melotti's cousin. Melotti was also associated with the Galleria del Milione in Milan, where he held his first one-man show of abstract sculptures in 1935. Devoid of representational elements, these gesso or metal constructions were ordered primarily by the proportions of the Golden Section and the formal geometries of musical counterpoint. Following the critical failure of the exhibition, Melotti worked as a ceramist and only produced sculptures on commission. In contrast to his investigations into abstraction, these were for the most part figurative pieces, such as the series of allegorical bas-reliefs in marble for the portals of Marcello Piacentini's Palazzo della Giustizia in Milan, 1937-9. Between 1941 and 1943, he lived in Rome; there he worked on monumental figure groups for inclusion in the 'Esposizione Universale Roma (E. U. R. '42)', which was aborted because of the war.

A volume of his poems entitled *Il triste Minotauro* was published by Scheiwiller in 1944. Melotti's poetry, like his sculpture, was governed by rhythmic intervals and numerical harmonies analogous to musical composition. In the post-war years, he produced the *Small Theatres*: multicoloured terracotta constructions, subdivided by walls and floors like a house or stage. During the fifties he won several awards for his ceramics, including the Gold Medal of Prague and that of Munich.

Throughout, Melotti's work continued to be inspired by musical counterpoint. In contrast to his pre-war geometric abstractions, his works of the sixties were made of delicate wire mesh and cloth, which vibrated and introduced a kinetic element. These sculptures were not exhibited until his one-man show at the Galleria Toninelli, Milan, in 1967. He soon gained the critical success that had eluded him earlier in his career. In 1973, he received the Premio Rembrandt from the Goethe Foundation in Basle, and in the following year published a collection of his writings and poems, *Linee*, whose title complemented the fine wire forms of his contemporary works. This was followed by a second volume in 1976. In the same year, he won the Feltrinelli award for sculpture. Melotti died in Milan on 22 June 1986. S. F.

Melotti, ed. Zeno Birolli, Turin, Galleria Civica d'Arte Moderna, 1972
Fausto Melotti, Parma, Centro Studi e Archivio della Comunicazione, Università di Parma, 1976
Melotti: L'Acrobata invisibile, Milan, Padiglione d'Arte Contemporanea, 1987

Mario Merz

was born on 1 January 1925 in Milan; his father was an engineer and inventor. Since his early childhood, he has lived in Turin. A member of the anti-Fascist group *Giustizia e Libertà*, he was imprisoned in 1945 for his activities as a partisan. After the war, Merz visited Rome and Paris and befriended artists and writers in Turin, particularly Mattia Moreni, Ennio Morlotti and Luigi Spazzapan. In 1949, his drawings were published in the Communist newspaper *L'Unità*. He received his first one-man exhibition at the Galleria La Bussola in Turin in 1954, and during the fifties painted in a European *Informel* style.

In the mid-sixties, Merz began to experiment with process and conceptual art that challenged the isolation and stasis of the art object and viewer. He incorporated neon into sculptural installations of commonplace objects, such as bottles, umbrellas and raincoats, dematerializing their substance and

transcending their everyday function with a new metaphysical significance. In 1968, he made his first igloos: hemispherical structures constructed with a metal framework, covered with clay, wax, slate, broken glass or branches, and often surmounted with political slogans or literary references in neon lettering. The igloo became Merz's leitmotiv, a metaphoric form for the transitory and the organic, underlying his view of art as a continuous process of changing and becoming. In 1968, he and his wife, the artist Marisa Merz, became associated with the *Arte Povera* movement, which advocated the fleeting and the variable as a protest against the standardization and efficiency of modern technological culture.

Since 1969, Merz has ordered his installations according to the Fibonacci formula of mathematical progression, whereby each number is equal to the sum of the two terms which proceed it (1, 1, 2, 3, 5, 8, 13), expressing the idea of proliferation and growth in a spatial and temporal structure. Fibonacci proportions account for the rate of growth in leaves, reptiles' skins and shells, organic materials which Merz has often incorporated into his installations and iconography, in a metaphoric unity of biological and creative processes. The series has also been used to define space and the logic of architectural design. In the 1971 Guggenheim International Exhibition, Merz distributed neon numbers in proportionately increasing intervals in harmony with the evolving spiral of the building's architectural form, and similarly articulated the tapered incline of the spire of the Mole Antonelliana in Turin in 1984.

In 1970, Merz introduced the table as his other central motif. Like the form of the igloo, the table refers to fundamental structures which have evolved from patterns in human behaviour and sociability. The table became the stage for a series of happenings in which participants were seated in numerical patterns and rhythms according to the Fibonacci formula, as in *It is as possible to have a space with tables for 88 people as it is possible to have a space with tables for no one*, performed at the John Weber Gallery, New York, in 1973. By the mid-1970s, Merz was combining igloos, tables, neon, organic and found materials in increasingly complex installations that demonstrated the constant interaction between the natural and the cultural, between stability and flux. Since 1979, he has returned to painting, using mixed media on unstretched and unprimed canvas, allowing the paint to be absorbed into the surface and again stressing chance and process. His subjects are primarily vegetal forms and exotic, archetypal wild beasts, such as the tiger and crocodile.

Merz's exhibitions include those at the Walker Art Center, Minneapolis, 1972; the Kunsthalle, Basle, and the Kunstmuseum, Lucerne, 1975; the Whitechapel Art Gallery, London, 1980; the Albright-Knox Art Gallery, Buffalo, New York, 1984; the Kunsthaus, Zurich, 1985; and the Louisiana Museum of Modern Art, Humlebaek, and the Institute of Contemporary Arts, Nagoya, 1988. Merz has also published poetry and prose, as well as exhibition catalogues to accompany his installations. J. B.

Mario Merz, ed. Germano Celant, San Marino, Palazzo Congressi ed Esposizioni, 1983
Mario Merz, Buffalo, Albright-Knox Art Gallery, 1984
Mario Merz, Zurich, Kunsthaus, 1985

Amedeo Modigliani

was born in Livorno on 12 July 1884 into a Jewish merchant family that had recently lost its wealth in a business failure. His brother Emanuele became a well-known Socialist deputy in the Italian parliament. Modigliani suffered from pleurisy and left school in 1898 after contracting typhoid. From 1899 to 1900, he trained in the studio of Guglielmo Micheli along with Oscar Ghiglia, Gino Romiti and Llewelyn Lloyd. After another attack of pleurisy, he spent the winter of 1901 with his mother in the south of Italy, and visited galleries in Naples and Rome. In Florence on the journey home, he studied the works of the Trecento masters Duccio, Simone Martini and Tino di Camaino, whose sinuous lines and elongated forms influenced his later style. In 1902, he attended the Scuola Libera del Nudo at the Accademia di Belle Arti in Florence and studied with the *Macchiaioli* master Giovanni Fattori. Later in the year, he left for the Istituto di Belle Arti in Venice, where he met Guido Cadorin, Guido Marussig and Boccioni. His contact with French painting at the Venice Biennales of 1903 and 1905, in particular the work of Eugène Carrière, Henri Toulouse-Lautrec and the Impressionists, prompted his decision to leave for Paris at the beginning of 1906.

Modigliani settled in Montmartre, where he joined the avant-garde circle of Severini, André Derain, Pablo Picasso, Max Jacob and André Salmon. He enrolled at the Académie Colarossi, but his work of the period, such as *Violincellist*, was mainly inspired by Paul Cézanne, whose works he had studied at the Salon d'Automne. In 1907, he met his first patron, Dr Paul Alexandre, who encouraged him to exhibit in the Salon des Indépendents the following year. In 1909, he moved to Montparnasse and befriended Constantin Brancusi, his neighbour on Rue Cité Falguière. He spent the summer in Livorno, where he was visited by Brancusi, and began to devote his energies to sculpture. Despite his close friendship with Severini, he declined the invitation to sign the Futurist manifesto in 1910. His primary interest in portraiture was reflected in the subjects of his stone carvings; twenty-three out of twenty-five known sculptures depict his characteristic elongated heads, influenced by African and Oceanic art and the Italian primitives. He envisaged the sculptures as a group and exhibited seven together under the title *Têtes, ensemble décoratif* at the Salon d'Automne of 1912. He also embarked on a series of caryatids, *Colonnes de tendresse*, for which one carved version

and numerous preparatory sketches exist. As a result of weakening health, physical hardship and the shortage of stone during the war, he ceased sculpting around 1914/15.

Modigliani's painting reached maturity in the portraits of his friends in Montparnasse – Jean Cocteau, Chaim Soutine, Jacques Lipchitz, Max Jacob and Moise Kisling. In 1914, he was introduced to the dealer Paul Guillaume, who purchased several of his works over the following years, but Modigliani's economic situation remained precarious and his dependence on alcohol and drugs was increasingly debilitating. He began a romantic liaison with the English poet and journalist Beatrice Hastings (whom he depicted in numerous paintings and drawings), which lasted until 1916. In that year, he exhibited with Picasso and Henri Matisse at the Lyre et Palette and met the Polish poet Leopold Zborowski, who became his dealer in wartime Paris. During this period he painted his series of reclining nudes with a remarkably sensuous line and colour. They caused a scandal at his first one-man show, organized by Zborowski in 1917 at the Galerie Berthe Weill, but despite the uproar, no pictures were sold.

Modigliani's later portraits were dominated by Jeanne Hébuterne, a nineteen-year-old student at the Académie Colarossi whom he met in April 1917 and married that autumn. With her pregnancy and his worsening tubercular condition, Zborowski and Hébuterne's family arranged funds to send them to Nice. Their child Jeanne was born on 29 November 1918. They returned to Paris in May 1919. After being taken into hospital for nephritis, Modigliani died on 24 January 1920; two days later, Hébuterne committed suicide. Their daughter was raised by the artist's sister. After his death, the prices of Modigliani's paintings began to soar, encouraged by his posthumous reputation as a reckless bohemian and self-destructive genius. He subsequently became known in Italy through his retrospectives at the Venice Biennales of 1922 and 1930. M. G.

Ambroglio Ceroni and Françoise Cachin, *Tout l'œuvre peint de Modigliani*, Paris, 1972
Amedeo Modigliani 1884-1920, Paris, Musée d'art moderne de la Ville de Paris, 1981
Modigliani, dipinti e designi: Incontri italiani 1900-1920, ed. Osvaldo Patani, Verona, Galleria dello Scudo, 1984

Giorgio Morandi

was born in Bologna on 20 July 1890, the eldest of five children. At the age of sixteen he went to work in his father's commercial office but by 1907 he had enrolled at the Accademia di Belle Arti in Bologna, where he befriended Licini and received his diploma in 1913. He studied the Renaissance painters Giotto, Uccello, Masaccio and Piero della Francesca, as well as Paul Cézanne and the *Macchiaioli*. In 1914, he came into contact with the Futurists and, following his participation in a group exhibition held at the Hotel Baglioni in Bologna, he was invited to show at the Galleria Sprovieri in Rome. Nonetheless, his interest in the movement was moderate and barely perceptible stylistically; in 1914, he was chosen to represent Bologna in the 'Seconda Esposizione Internazionale della Secessione' in Rome which specifically excluded Futurist works. In the autumn of that year, he was appointed instructor of drawing for the elementary schools of the municipality of Bologna, a post he held until 1929. When Italy entered the First World War in 1915, Morandi enlisted with the grenadiers but, following a physical breakdown, he was soon discharged and exempted from further service.

During the war years he became familiar with Cubism and particularly admired the painting of Henri Rousseau for its direct perception of reality and emphatically tactile forms. Between 1918 and 1919, he produced a small number of still-lifes with enigmatic objects juxtaposed in jarring perspectives; these were influenced by the Metaphysical paintings of de Chirico and Carrà which he had seen reproduced in *La Raccolta*, a small but influential review founded by Giuseppe Raimondi in 1918. *La Raccolta* reflected the new conservative tone of Italian art criticism in reaction to the war, and was also the first review to support Morandi's work. By the end of 1919, he had abandoned the unsettling atmosphere of his Metaphysical compositions and concentrated on the formal essence of things, imbuing his still-life objects with palpable mass and volume. He was a leading exponent of Mario Broglio's *Valori Plastici* and participated in the group's exhibition which travelled to Berlin, Dresden, Hanover and Munich in 1921. In the catalogue essay for the 'Fiorentina Primaverile' in 1922 de Chirico defined Morandi's work as 'the metaphysics of everyday objects'.

Although he participated in the *Novecento* exhibitions of 1926 and 1929, he did not subscribe to the

canons of monumentality and the nationalism promoted by the Milanese critic Margherita Sarfatti. He was associated with the grass roots movement *Strapaese*, whose journals, *Il Selvaggio* (edited by Mino Maccari) and *L'Italiano* (edited by Leo Longanesi), endorsed the more regional and rustic aspects of Italian cultural traditions. Maccari and Longanesi interpreted the purity and simplicity of Morandi's painting as quintessentially Italian and created the myth of the artist as an isolated figure divorced from the mainstream of modern art. His drawings and etchings were reproduced in *Il Selvaggio* (the journal had prompted a local renaissance in printmaking) and he showed with the *Strapaese* artists at the 'Seconda Esposizione dell'Incisione Moderna' in Florence in 1927. In the late twenties, he worked mainly in aquatint. From 1930 until 1956, he held the chair for printmaking at the Accademia di Belle Arti in Bologna.

By the thirties, his still-lifes had become more abstracted, as objects lost their individual characteristics in a unifying veil of colour and atmosphere. He continued to restrict his subjects to still-lifes and landscapes, introducing livelier colour accents in the latter half of the decade. His critical reputation was secured when the art historian Roberto Longhi included him in a lecture on the masters of Bolognese painting (published as *Momenti della pittura bolognese* in 1935).

The perception of Morandi as a reclusive artist and a modern Chardin increased in the post-war years. He spent most of his life in his native town, and did not visit Paris until 1956. Recent scholarship, however, has shown that he was anything but an isolated figure in Italy, and was well informed about, and often directly involved with, the cultural and political debates of his time. Among the most recognized and widely collected of Italian artists, he had numerous international exhibitions before his death in Bologna on 18 June 1964. S. F.

Lamberto Vitali, *Morandi catalogo generale*, 2 vols, Milan, 1977
Giorgio Morandi: 20th Century Modern, ed. Joan Lukach, Des Moines, Des Moines Art Center, 1982
Morandi e il suo tempo, Milan, 1985

Mimmo Paladino

was born Domenico Paladino on 18 December 1948 in Paduli, near the city of Benevento, and spent his childhood in Naples. Through his uncle, a painter, he developed an early interest in art and attended the Liceo artisco di Benevento from 1964 to 1968. In the early seventies, he devoted himself almost exclusively to drawing, introducing the mythological subjects which were to dominate his later work. His first one-man exhibition, of photographs, took place at the Nuovi Strumenti gallery, Brescia, in 1976. The following year, he executed a large-size pastel on a wall of the Lucio Amelio gallery in Naples. This expansion of his concepts of drawing and scale induced him to work in oil on canvas. In the seminal painting, *Silently I Retire to Paint* (1977), he employed a figurative style which resurfaced in his mature work. Between 1978 and 1980, Paladino created monochromatic paintings in primary colours, affixing geometric elements and found objects, such as twigs and masks, to the canvas. These works marked a transition from the conceptual precepts of *Arte Povera* to the artist's subsequent concern with traditional painting and representation. From 1977, he maintained a studio

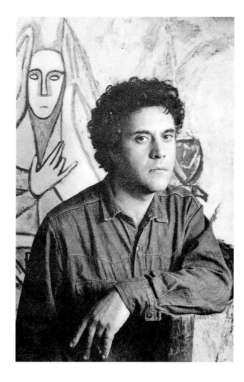

in Milan. In the exhibition 'Aperto '80' at the Venice Biennale the art critic Achille Bonito Oliva grouped Paladino with the *Transavanguardia*, along with Chia, Clemente, Cucchi and Nicola De Maria.

Paladino's work draws on diverse archaeological and stylistic sources, including Egyptian, Etruscan, Graeco-Roman, early Christian and Romanesque art, which reflects the complex cultural history of his native region. His enigmatic allegories depict a somnambulent realm where the dead and living coexist and participate in unspecified rituals; skulls, skeletons and spirits commingle with animals and human figures, often dismembered or with flayed skin and mask-like faces. Tondos and triptychs are common in his work, and he has also employed such ancient techniques as mosaic and encaustic in reference to traditional religious art. In 1983, he began to attach sculptural forms, usually carved or battered wood, to the surface of his canvases, adding to the fetishistic quality of the painted object. In addition to Catholic and pagan rituals, Paladino's images evoke a primitive animism, encouraged by the art he saw during several trips to Brazil between 1982 and 1985.

A prolific draughtsman, Paladino has also emerged as a master printmaker since 1980, experimenting with a variety of techniques, including etching, aquatint, woodcut and linocut, which enhance the spectral quality of his archetypal figures. Since 1984, he has printed with the Giorgio Upiglio atelier in Milan. His prints are frequently conceived in series, as in the drypoint *Caves of Naples* (1983) and the linocuts based on James Joyce's *Ulysses* (1984).

Beginning with the monumental *Hortus Conclusus* of 1982, Paladino has recreated his archaic personages in bronzes with coloured patinas. He has also carved in wood and, in 1985, he made a series of totemic objects in limestone: the truncated figures bear musical instruments, masks or animals as attributes and are rendered in a style reminiscent of the archaism of Martini. In his large-scale wall installation *It Won't Have a Title* (1985) he combined figurative elements in bronze, such as horses, heads and speers, with monochromatic minimalist panels, blurring the distinction be-

tween painting and sculpture in a dialogue between traditional and minimal modes of representation.

Paladino has had exhibitions regularly throughout Europe since 1976, and in the United States since 1980. Important one-man shows include those at the Badischer Kunstverein, Karlsruhe, 1980; the Kunstmuseum, Basle, 1981; the Kunstnernes Hus, Oslo, 1985; the Städtische Galerie im Lenbachhaus, Munich, 1985; and the Virginia Museum of Fine Arts, Richmond, 1986. He currently lives and works in Paduli and Milan. J. B.

Mimmo Paladino: Zeichnungen 1976-1981, Basle, Kunstmuseum, 1981
Mimmo Paladino: Arbeiten von 1977 bis 1985, Munich, Städtische Galerie im Lenbachhaus, 1985 (English translation included)
Mimmo Paladino: Bilder und Zeichnungen 1981-1982, Wuppertal, Von der Heydt Museum, and Erlangen, Städtische Galerie, 1982

Giulio Paolini

was born on 5 November 1940 in Genoa. He was trained as a graphic designer. His art has evolved in response to the enquiry 'how do we see what is represented and how do we represent what we see?' Although his name has been associated with *Arte Povera* since the group's inception, his reputation had already been established earlier in the decade. His investigations of linguistic systems and his repetition of a module as a compositional principle have much in common with the work of Art & Language, Sol LeWitt and other exponents of Conceptual Art.

His first documented work, *Geometric Design* (1960), consisted of a small canvas divided by a horizontal, a vertical and two diagonal lines – in other words, the structural grid that permits the transfer of correct proportions when reproducing a picture. Paolini left this preliminary scaffold as the finished image, thereby highlighting one aspect of the painting process, much as a linguist would analyse the syntax of a sentence. This minimal composition then served as a basic module. In the multi-part composition *A Painting* (1970) it was reproduced photographically on fourteen identical canvases, each of which was marked on the reverse with a fictitious title and signature, thus confounding the distinctions between simulacrum and unique creation, authenticity and appropriation. Many projects of the early sixties were concerned with the system of linear perspective in an attempt to expose the structures of our perception. Paolini also extended his field of enquiry to include the institutionalization of art: in his first one-man show, at the Galleria La Salita, Rome, in 1964, he distributed a series of blank panels around the room in various stages of installation in an effort to analyse 'the fundamental relationships involved in the conception of an exhibition'.

The complex mental dialogue between maker, subject and viewer was scrutinized in *A Young Man Looking at Lorenzo Lotto* (1967), shown in the first *Arte Povera* exhibition, at the Galleria La Bertesca, Genoa, in September 1967. He reproduced Lotto's painting of 1505 as a black-and-white photograph of the canvas; the title reverses the relationship between artist and subject, placing the viewer in the position of the former, and also refers back to the moment when Paolini confronted Lotto's picture with his camera.

Paolini favours reproductive media, such as photography and plaster casts, since they call into question the meaning of 'fine art', originality and reproduction. In 1975, he began the series entitled *Mimesis*, in which pairs of plaster copies of famous classical busts or statues – for example, Praxitiles's *Hermes* – are placed facing each other in a mirror image. Their silent dialogue creates a metaphorical and physical cleft that refers to both the span of history and the distance from the hand of the original artist.

Following developments in the history of art, his investigations have moved from the single vanishing point perspective of the Quattrocento to the spatial complexities of the Baroque. This was encouraged by his work in the theatre (costume and set design), in particular, by his collaboration with Carlo Quartucci in Turin. Paolini has also published images in philosophical and critical tracts, such as *IDEM* (1975), with a text by Italo Calvino, and *L'Arte e lo spazio* (1983), in which four photographs by him accompanied a text by Martin Heidegger. Since the early 1980s, his installations have become both physically more elaborate, through the inclusion of architectural elements and video, and more multi-layered in meaning.

Perhaps the most rigorous exponent of Conceptual Art in Italy, Paolini emphasizes that his interest lies in the art object *per se*, rather than in social or political issues. Paolini lives and works in Turin. J. P.

Germano Celant, *Giulio Paolini*, New York, 1972
Giulio Paolini, ed. Harold Szeemann and David Elliott, Oxford, Museum of Modern Art, and Amsterdam, Stedelijk Museum, 1980
Giulio Paolini, Stuttgart, Staatsgalerie, 1986

Pino Pascali

was born on 19 October 1935 in Bari. His father, a police officer, was transferred to Albania in 1940-1, but the family returned to Bari after the Second World War. Pascali attended the local Liceo Scientifico and then transferred to the Liceo Artistico in Naples, which he left in 1955. That year, he moved to Rome, where he studied scenography with Toti Scialoja at the Accademia di Belle Arti and received his diploma in 1959. To support himself, he worked as a graphic designer for advertising firms and on sets for television.

His work with the mass media and his experience with scenography proved particularly important for the forms of his sculpture and the staging of his installations. He initially experimented with paintings and sculptures in diverse media, such as plastic and polyester treated with acid and papier mâché. Few of his works executed before 1964 survive; he had refused to exhibit them and they were largely destroyed after his death in 1968 by his father, in accordance with his wishes.

While Pascali's career has been associated with the *Arte Povera* movement, his reputation was already established in Italy by the early sixties. He achieved his first mature style in a series of lacquered canvas reliefs, their forms inspired by Burri's *Hunchbacks*, but with explicit Pop imagery of isolated anatomical parts, akin to the paintings of Tom Wesselman. These were exhibited in his first one-man show, at the Galleria Tartaruga in Rome in 1965. *Red Lips: Homage to Billie Holiday* specifically refers to the eroticism of American jazz music, while the curvaceous black ground and protruding, oversize red lips assume the value of both an ironic and a provocative sexual totem. In the subsequent series, *Cannons* (exhibited at the Sperone gallery in Turin in 1966), Pascali constructed simulacra out of found objects – shovels, carburettors, water pipes – aestheticizing and trivializing instruments of war, and mocking their threatening posture with their functional impotence.

Between 1966 and 1968, Pascali turned to more lyrical images of nature, while continuing to develop his overriding interest in blatant artificiality as a means of evoking rather than describing an object. Among his most innovative works were the 'decapitated' animals, including a giraffe, hippo-

potamus and dolphin, which treated the potentially grisly subject of mutilation with evocative and sensual forms. These 'fake sculptures', as Pascali subtitled the series, were made by stretching canvas over a wooden framework their fragmented and transparent forms recall the sculptures of Constantin Brancusi and Jean Arp. In 1966, Pascali made his first environmental sculpture, entitled *Sea* – a mass of stylized waves on the floor of the Galleria L'Attico in Rome.

Pascali's jarring play with scale and artificial materials recalls the sculpture of Claes Oldenburg, but his work treads a finer line between dream and

nightmare. In 1967-8, Pascali extended his Pop imagery and Neo-Dada irreverence to the microscopic world of nature, creating oversized insects (spiders and silkworms) that looked like props out of a science fiction film, made out of bristles and shiny acrylic materials at once attractive and repulsive. At the same time, he began to place organic materials such as water or earth in regularly shaped containers, comparable to the activities of the Americans Robert Smithson and Robert Morris. One such work, *1 Cubic Metre and 2 Cubic Metres of Earth* (1967), was included in the first *Arte Povera* exhibition at the Galleria La Bertesca in Genoa.

Pascali gained increasing recognition and was awarded an exhibition room at the Venice Biennale of 1968, which closed three days after the opening as a result of student protests. His career was cut short when he died in Rome on 11 September 1968 of injuries sustained in a motorcycle accident. In 1969, a retrospective of his work was held at the Galleria Nazionale d'Arte Moderna in Rome. He has influenced a number of younger artists, including Cucchi, who especially admired the early, experimental paintings. His sculptures are frequently included in group exhibitions in Europe, but are less well known in America.

 J. P.

Pino Pascali, ed. Palma Bucarelli, Rome, Galleria Nazionale d'Arte Moderna, 1969
Vittorio Rubio, *Pino Pascali*, Rome, 1976
Pino Pascali (1935-1968), ed. Fabrizio d'Amico and Simonetta Lux, Milan, Padiglione d'Arte Contemporanea, 1987

Giuseppe Penone

was born on 3 April 1947 in Garessio Ponte (Piedmont). From 1966 to 1968, he studied at the Accademia di Belle Arti in Turin with Anselmo and Pistoletto and, in 1968, had his first one-man exhibition, at the Deposito d'Arte Presente in Turin. Penone's art has been inspired by his close contact with the forests of his native Garessio in the Alps. It consists of a constant modification of the natural environment through the projection of his spiritual and physical self onto the landscape. He reveals the 'intrinsic reality of nature' by disrupting the processes of growth or the disposition of organic form. Such visions of a harmonic rapport between man and nature can be viewed as part of his generation's counter-culture movement; he has been associated with *Arte Povera* since 1969, while specific projects relate to international currents in Land and Process Art.

Since the late sixties, the tree has been the main object of his inquiry into natural processes. Penone views it as a model for sculpture and a symbol of generative energy, with its vertical form, forking branches, wood grain and rings of growth that mark the passage of time. He stated that the tree, 'devoid of any emotional, formal or cultural significance, appears to me really as it is: a vital element in continuous expansion, proliferation and accretion. I used it as a natural "force" which was countered by, and reacted to, another force – my own.' In *The Tree Will Continue to Grow Except at this Point* (1968) he placed a cast-iron impression of his fist around the trunk of a sapling; in time, the tree grew over and around the human obstruction, embodying the 'fixed' gesture of the artist's hand. In the series *To Repeat the Forest* (1969-80) he sculpted a trunk and the stubs of branches from wooden

planks, returning the material to its original form. Ultimately, time is the main subject of his art, time charted through natural growth and documented by photography, which has become the fundamental medium of his art.

In the seventies, he used his own body as the sole source of his imagery, leaving his imprint on nature as part of a 'transfusion of energies'. In *Potatoes* (1977) and *Absolute Black from Africa* (1978-9) he placed casts of his ears, lips and nose over vegetables which then grew into the moulds, taking on the shapes of his features. In 1978, he began his most distinctive series, inspired by the idea of wind as an elemental sculptural force as it blows through the dense thickets of the forest, swaying branches and scattering leaves. The *Breaths* – terracotta vessels in the shape of ancient amphorae – derived from the conflation of two creation myths: the gods shaping man from clay, by hand or on the potter's wheel, and the breath of the gods that gave life to the inanimate human form. Penone blew on a pile of leaves and the concavity of their displacement – the 'shape' of his breath – determined the form of the vessel. He also imprinted his body onto the surface of wet clay, extending the idea of fingerprints left by ancient potters on their pieces and binding the 'flesh' of the form and the maker.

In the eighties, Penone has increasingly focused on the metamorphosis of human and vegetal forms; sculptures of vegetables or plants cast in bronze often bear the imprint of his hand or face. He has also executed a large corpus of drawings, among it, the *Forkings*, which consist of almost abstract, often erotic details of rippling bark and the issuing of branches from the trunk.

Penone has been the subject of numerous exhibitions, including those at the Kunstmuseum, Lucerne (1977); the Staatliche Kunsthalle, Baden-Baden, and the Museum Folkwang, Essen (1978); the Stedelijk Museum, Amsterdam (1980); the Städtisches Museum Abteiberg, Mönchengladbach (1982); and the National Gallery of Canada, Ottawa (1983). Since 1970, he has taught at the Liceo Artistico in Turin. Penone lives and works in Turin. J. P.

Giuseppe Penone, ed. Jean-Christophe Ammann, Lucerne, Kunsthalle, 1977
Giuseppe Penone, Baden-Baden, Staatliche Kunsthalle, 1978
Giuseppe Penone, ed. Jessica Bradley, Ottawa, National Gallery of Canada, 1983

Fausto Pirandello

was born on 17 June 1889 in Rome, the son of the playwright Luigi Pirandello. His studies in the classics were interrupted by military service in 1917. After the war, he began to train in the studio of the sculptor Sigismondo Lipinsky. By 1920, he had turned to painting, influenced initially by the Impressionist Naturalism of Armando Spadini, and then by Felice Carena, under whom he studied together with Giuseppe Capogrossi and Emanuelle Cavalli. He exhibited for the first time at the third Biennale di Roma in 1925 and participated in the Venice Biennale the following year.

Pirandello moved to Paris at the end of 1927. He was drawn at first to the post-Cubist still-lifes of Georges Braque, but the intimate realism and atmospheric brushwork of Jules Pascin proved to be the more enduring influence. While in the French capital, he was in contact with de Chirico, Savinio, de Pisis, Campigli, Mario Tozzi and Renato Paresce, who frequently exhibited together as the *Italiani di Parigi*. One-man exhibitions in Paris and Berlin were followed by Pirandello's first in Italy, immediately upon his return in 1931, at P. M. Bardi's Galleria di Roma. At that time, he associated with Antonietta Raphaël, Mario Mafai and Scipione who, as the so-called *Scuola di via Cavour*, were developing a style of painterly realism with elements of poetic fantasy, independent of the prevailing Naturalist and neo-classical currents. He was also close to the group of painters known as the '*tonalisti*': Capogrossi, Cavalli and especially Roberto Melli, who wrote an important article on Pirandello in *Quadrivio* in 1934.

Despite his affiliations with these 'alternative' tendencies of the 1930s, Pirandello maintained a distinct profile and developed a wholly individual style of Expressionist Realism, rendering commonplace subjects in densely painted, scabrous canvases. He captured the awkward moments of social and physical intimacy, depicting them as part of the given conditions of work and leisure among the lower classes and peasantry: cramped interiors in *The Stairway* (1934), the duress of physical labour in *Drought* (1938) and mounds of human flesh in *Crowded Beach* (1939). The forms of his still-lifes and figures are arrested in a sedimentary structure built up with layers of encrusted pigment and are infused with the dreamy mood of Metaphysical painting. Pirandello's emphasis on the little man, on the concrete and unabashedly

human, was far from the celebratory rhetoric of the Fascist regime; he nonetheless enjoyed success in the second decade of Fascism. He participated in the Venice Biennale and Rome Quadriennale and was awarded prizes at the latter in 1935 and 1939. In 1939, he was one of several Roman artists, including Guttuso, who exhibited with the *Corrente* group in Milan.

After the Second World War, Pirandello became a close friend of the critic Lionello Venturi, who wrote a monograph on the artist in 1958. His dense brushwork and Expressionist handling, like that of Giovanni Stradone and others of the so-called *Scuola Romana*, was a point of departure for a younger generation of abstract painters in the postwar years. He was awarded numerous prizes, among them the Premio Marzotto of 1953. Pirandello died on 29 November 1975 in Rome. E. B.

Fausto Pirandello, ed. Bruno Mantura, Rome, Galleria Nazionale d'Arte Moderna, 1977
Guido Giuffrè, *Fausto Pirandello*, Rome, 1984
Fausto Pirandello: Opere su carta 1921-1975, ed. G. Appella and F. D'Amico, Rome, Palazzo Venezia, 1986

Michelangelo Pistoletto

was born in Biella (Piedmont) on 23 June 1933. The following year, Pistoletto's family moved to Turin, where his father, who had been deaf since the age of eight, set up shop as a restorer and fresco painter. His mother was also a painter. 'In our family the eye was always privileged,' he later remarked. Pistoletto worked with his father as a restorer from 1947 to 1958, mastering a range of historical styles and techniques, and for several years also did advertising work.

In 1947, the first year of his apprenticeship, Pistoletto began the series of self-portraits that was to dominate his oeuvre until 1962. In his early pictures, Pistoletto's face swelled to fill the entire canvas. In 1958, he changed course radically after seeing an exhibition of Francis Bacon's paintings at the newly opened Galleria Galatea in Turin. Under the impression of Bacon's work, Pistoletto began to focus on life-size figures and the problem of filling the canvas around them. To free himself from the English painter's overwhelming influence, he tried to defuse the emotional charge of the image, suppressing all movement and expression. These were the works exhibited in Pistoletto's first one-man show, held at the Galleria Galatea in 1960.

By then, he had reduced his backgrounds to blank areas of metallic gold or silver, or varnished black. Noticing his own reflection in the shiny black background of a 1961 painting, Pistoletto realized that the canvas itself would suffice as a mirror in which to observe himself. He began his famous series of mirror paintings in 1962. In these works, first exhibited at the Galleria Galatea in 1963, realistic figures, painted in brownish, monochrome tones on tissue-paper, were cut out and attached to polished, mirror-like steel plates. The mirror surface having taken over the task of self-depiction, Pistoletto's own image began to vanish from his pictures and was replaced by a series of anonymous figures, men and women sitting or standing in attitudes of quiet concentration. The figures, facing away from the picture plane, seemed to be on the point of noticing the real people who had wandered into their fictional space. The mirror paintings thus created an Alice-in-Wonderland world where representation and reality were inextricably linked. In 1964, Pistoletto

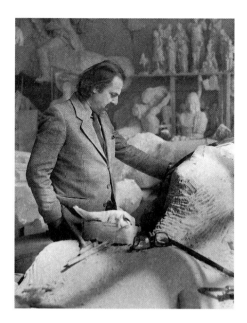

began to use photographs silk-screened onto tissue-paper to provide the staffage of his pictures. In the same year, an exhibition of the mirror paintings at the Galerie Sonnabend in Paris established his international reputation.

Despite his figurative style, Pistoletto was profoundly influenced by the Abstract Expressionists. *Painter* (1958) was based on a photograph by Hans Namuth showing Jackson Pollock at work. As 'events' captured on canvas, Pollock's paintings had provided inspiration for the new art form of the Happening. Pistoletto's mirror paintings were like permanent Happenings, a part of their content dictated by the actions of viewers and passers-by. 'The figure that I place on the surfaces of the mirror paintings [is] a fixed sign, an image "snapped" at a certain moment in time,' Pistoletto later explained. 'But in my mirror paintings the image coexists with every present moment . . . the current time of the future is already included in the continuous mobility of the images, in the constantly renewed present of the reflection.'

Since 1964, Pistoletto has explored a wide variety of media and styles. In a series of 1960s installations which he called 'minus objects' he tried to escape from the implicit egoism of the mirror works. Brightly coloured rags provided the motif and material for works such as *Venus of the Rags* (1967) and *Orchestra of Rags* (1968), in which the rags supported panes of glass under which kettles on hot-plates whistled and steamed, sending up clouds of mist that condensed beneath the glass. For Germano Celant, 'the rags represent the confusion and multivalence of marginalized people . . . perverts, convicts, racial minorities, women and prisoners'. In 1967, Pistoletto began a series of collaborative performance pieces such as *Zoo*, presented at the exhibition 'Arte Povera e Azione Povera' in Amalfi in 1968.

Pistoletto's career took a surprising turn in 1980, when he began a series of sculptures of over-sized heads and torsos carved from polyurethane or marble. The hacked surfaces of these figures recall the work of Alberto Giacometti, which Pistoletto had admired at the Galleria Galatea in the 1950s. Yet Pistoletto's iconography is highly idiosyncratic. The complex motif of the reflecting well (*Figure Looking into a Well*, 1983) suggests that, for Pistoletto, the mirror is not a neutral, philosophical symbol, but a personal image coloured by fears of death and imprisonment. P. K.

Michelangelo Pistoletto, ed. Germano Celant, Genoa, Galleria la Bertesca, 1966
Michelangelo Pistoletto, ed. Germano Celant, Florence, Forte di Belvedere, 1984
Germano Celant and Alana Heiss, *Michelangelo Pistoletto: Division and Multiplication of the Mirror*, New York and Milan, 1988

Enrico Prampolini

was born in Modena on 20 April 1894. In 1912, he enrolled at the Accademia di Belle Arti in Rome, where he studied under Duilio Cambellotti. The following year, he was expelled for having issued the manifesto *Let's Bomb the Academies*, and immediately joined the Futurist circle, frequenting Balla's studio. In 1914, he took part in the 'Prima Esposizione Libera Futurista' at the Galleria Sprovieri. During the war years he painted in a style close to Synthetic Cubism with an interest in correspondences between music, movement and abstract form. In 1915, he published the manifestos *Absolute Constructions of Motion-Noise* and *Futurist Scenography and Choreography, Technical Manifesto*. The following year, he met Tristan Tzara and Hans Arp, and participated in Zurich Dada. With Bino Samminiatelli, he established the Futurist periodical *Noi*, which was initially a vehicle for Dada and later supported the Purism of *L'Esprit Nouveau*. In 1918, he and Mario Recchi founded the Casa d'Arte Italiana in Rome to promote awareness of the international avant-garde, a project supported by Louis Aragon, Fernand Léger, Kurt Schwitters and others.

Prampolini was a tireless cultural organizer and proselytizer for Italian Futurism both at home and abroad. In the early twenties, he exhibited with the *Novembergruppe*, designed stage sets in Prague and kept in contact with the Bauhaus, De Stijl and the Section d'Or. He attended the International Congress of Progressive Artists in Düsseldorf in 1922 with Hans Richter, El Lissitsky and Theo Van Doesburg, and published the *Manifesto of Mechanical Art* with Ivo Pannaggi and Vinicio Paladini in *Noi* in May 1923. Between 1925 and 1937, he was based in Paris. He won the Grand Prix d'Art Théâtrale at the 'Exposition Internationale

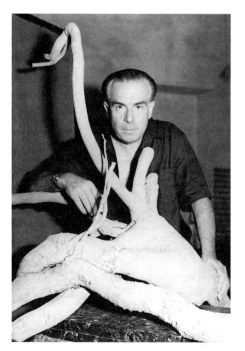

des Arts Décoratifs et Industriels Modernes' (1925) for his Magnetic Theatre, which used the play of light effects instead of actors. He exhibited with *Cercle et Carré* in 1930 and supported the *Abstraction-Création* group from 1931 to 1935.

Continuing his leading role in Futurist activities, he exhibited regularly in Italy at the Venice Biennale and Milan Triennale, and co-ordinated the Paris performance by Luciano Folgore's Teatro Pantomima Futurista (1927). He signed the *Manifesto of Futurist Aeropainting* in 1929, and became the leading exponent of 'cosmic idealism', with a style combining biomorphic and non-objective forms. In the thirties, he was noted for his exhibition installations, including rooms for the 'Mostra della rivoluzione fascista' (1932). He founded the periodical *Stile Futurista* with Fillìa (Luigi Colombo) in 1934 and exhibited in the 'Prima Mostra della Plastica Murale' in Genoa. While in Rome during the war years, he returned to the figure, painting a series of mourning women in a Cubo-Expressionist style influenced by Pablo Picasso; he wrote a small book on Picasso's sculpture in 1943.

In 1944, Prampolini published *Arte Polimaterica*, expounding his ideas on the use of diverse and unconventional materials. He co-founded the Rome Art Club in the following year to promote an active dialogue with international trends. In the post-war period, he developed a style of lyrical abstraction, exhibited on several occasions with Licini, Magnelli and Atanasio Soldati, and, in 1948, joined the *Movimento Arte Concreta* (MAC) led by the critic Gillo Dorfles. In 1955, he served as vice-president of the UNESCO Plastic Arts Committee and was appointed professor of scenography at the Accademia di Brera in Milan. He died in Rome on 17 June 1956. M. G.

Enrico Prampolini, ed. Palma Bucarelli, Rome, Galleria Nazionale d'Arte Moderna, 1961
Filiberto Menna, *Enrico Prampolini*, Rome, 1967
Continuità dell'avanguardia in Italia: Enrico Prampolini (1894-1956), Modena, Galleria Civica d'Arte Moderna, 1978

Medardo Rosso

was born in Turin on 21 June 1858, the son of a railway station-master; the family moved to Milan when he was twelve. He served in the army from 1879 to 1881, and in 1882 entered the Accademia di Brera, Milan, to study anatomy and sculpture. He was expelled a year later when he rebelled against the traditional method of drawing from casts and turned to live models. His sculpture was first exhibited in 1883, at the 'Esposizione Internazionale di Belle Arti' in Rome.

Rosso's early work was influenced by the painters Tranquillo Cremona and Daniele Ranzoni and the sculptor Giuseppe Grandi, a member of the *Scapigliatura* movement who used exaggerated chiaroscuro modelling to soften the forms of his Realist subjects. In works such as *Lovers under the Street Light* (1882) the contours of the figures were dissolved, merging with the ambient light and atmosphere. In order to achieve his emphatically pictorial and tactile effects Rosso experimented with the unusual and fragile medium of wax over plaster. Its malleability permitted a subtle modulation of the surfaces and an unpredictable interplay of light and shadow, challenging the inviolability of sculptural form and evoking the fleeting sensations of visual experience.

Rosso's style evolved significantly after his first visit to Paris in 1884, where he worked in the studio of the Naturalist sculptor Jules Dalou and met Auguste Rodin. He returned to Milan at the end of the year, just before his mother died. In 1885, he married Giuditta Pozzi, who bore him a son. *Mother and Child* of that year may reflect these developments in his private life; the composition also recalls the diffuse atmosphere of contemporary paintings by Eugène Carrière. In this period, his poor financial situation forced him to accept portrait commissions for funerary monuments. He continued to exhibit his work in Paris, at the Salon des Champs Elysées (1885) and at the Salon des Indépendents (1886).

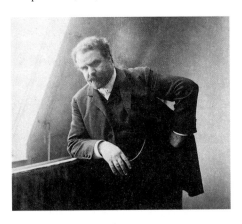

Rosso left his wife in 1889 and returned to Paris, where he participated in the Exposition Universelle of that year. He remained in the French capital for the next eight years. His work attracted the attention of Henry Rouart, a banker and prominent collector, who commissioned Rosso to do his portrait in 1890. In 1893, he exhibited in the foyer of the Bodinière, an experimental theatre frequented by artists and intellectuals. It was probably on this occasion that Rodin gave Rosso a bronze torso and took *Petite Rieuse* (*Little Laughing Girl*, 1890) in exchange. In January 1894, Rodin visited Rosso's studio and admired his work, but the professional association between the two artists ended abruptly when the plaster cast of Rodin's *Balzac* was shown at the Societé Nationale des Beaux-Arts in 1898: Rosso was convinced that Rodin had taken the inspiration for the sculpture from his own work.

In the 1890s, Rosso increasingly abstracted form in an attempt to express the psychological unity of the human figure and its environment. His portrait of the famous nightclub singer Yvette Guilbert (1894) was rendered as if seen from a distance, anticipating Alberto Giacometti's elongated forms of the 1940s. In 1896, he exhibited in London with the Pre-Raphaelites, and the South Kensington Museum purchased two of his portrait busts. Towards the end of the decade, Rosso created few new works; his private and professional lives had become unstable, undoubtedly as a result of the public clash with Rodin. His work was rejected by the Italian commissioners for the Exposition Universelle of 1900, but his friend the dealer Alberto Grubicy succeeded in placing five of Rosso's works in an installation together with paintings by Giovanni Segantini. On this occasion he met Etha Fles, one of the Dutch commissioners, who became his patron and included him as the only sculptor in an exhibition of Impressionism in Holland in 1901. He fell ill on his way to exhibit at the Vienna Secession and, after a slow convalescence, returned to Paris in 1903.

In 1906, he had a one-man show at the Cremetti Gallery in London, and was subsequently commissioned to execute the portrait of the young Alfred William Mond, the *Ecce Puer* (1906). Although Rosso lived another twenty-two years, after *Ecce Puer* he produced only replicas of his previous sculpture which were intended mainly for the art market and museums. He reworked his original conceptions in various media and experimented with different modelling and casting techniques.

In Paris he met the critic Ardengo Soffici, who began writing about Rosso in 1903 and brought his work to the attention of the Italian public in 1909 with the book *Il Caso Medardo Rosso*. Rosso's work was praised by the Futurists, in particular by Boccioni in the 1912 *Technical Manifesto of Futurist Sculpture*. Boccioni's concepts of simultaneity and 'dynamic sensation' were inspired by Rosso's *De l'Impressionisme en sculpture*, published in 1902. Despite the Futurists' solicitations, Rosso remained indifferent to their movement.

During the First World War, Rosso divided his time between Paris and Milan, where he was in contact with Modigliani, Carrà and Soffici. In the 1920s, Margherita Sarfatti championed his work and included him in the first *Novecento* exhibition in 1926. He died in Milan on 31 March 1928.

M. G. B.

Medardo Rosso, ed. M. Scolari Barr, New York, Museum of Modern Art, 1963
Medardo Rosso, Milan, Palazzo della Permanente, 1979
Jole De Sanna, *Medardo Rosso e la Creazione dello Spazio Moderno*, Milan, 1985

Mimmo Rotella

was born Domenico Rotella on 7 October 1918 in Catanzaro (Calabria). He attended the Naples Accademia di Belle Arti but left in 1941 when a position at the Ministry of Post and Telecommunications made it possible for him to go to Rome. After a period of military service, he returned to Naples in 1944 to complete his studies at the Accademia, before moving back to Rome the following year. From 1945 to 1951, he explored a variety of styles; towards the end of this period, he had his first one-man show at the Chiurazzi gallery in Rome. In 1951, a Fulbright grant enabled him to visit the United States, where he studied at the University of Kansas City, Missouri. In 1952, he exhibited at the Rockhill Nelson Gallery in Kansas City and gave recitals of his phonetic poetry there and at Harvard University in Boston.

On his return to Italy, Rotella suffered a year-long crisis during which he stopped painting. At this time, he became fascinated by the 'carpet of peeling posters' on the walls of the Piazza del Popolo in Rome, where his studio was located. 'I was very impressed by these [posters], especially as I thought that painting as such was finished and that one needed to discover something new, alive, up-to-date. And so in the evenings I began to tear down the posters. I literally stripped them from the walls, and took them along to my studio.'

In this way Rotella invented the *décollage*, so called because he tore strips of paper from the layered posters (which he glued to canvas supports) instead of affixing pieces of paper as in conventional collage. Rotella worked from both the front and rear of the posters; the latter approach eliminated lettering and imagery, leaving only the col-

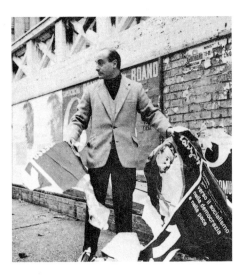

our of the paper and the red stucco of the walls from which the posters had been removed.

It is difficult to assess the significance of Rotella's American sojourn in the invention of *décollage*; in particular, it is not known whether he saw Walker Evans's photographs of road signs or his *Torn Movie Poster* (1930). In 1951-2, Aaron Siskind was also making 'abstract' photographs of torn posters and peeling paint. The compositions of Rotella's *décollages* are very close to those of paintings by Willem de Kooning from the late 1940s; the latter's gestural brushstroke finds an equivalent in the violent laceration of strips of paper, although critics have interpreted Rotella's work as an ironic rejection of Abstract Expressionism, with its supposed stress on emotional commitment and self-expression. In addition, the fragments of words in Rotella's *décollages* are reminiscent of the random lettering in many works by de Kooning and Franz Kline, but can also be seen as an extension of his experiments with phonetic poetry.

After 1958, Rotella gradually abandoned purely 'abstract' compositions in favour of *décollages* which preserved some coherent sense of an underlying image. Rather than treating the layered posters as inert material from which to shape his compositions, he began to see them as important statements in their own right, as significant fragments of reality to be inflected but not obscured. This tendency culminated in the explicit subject-matter of the *Cinecittà* (*Cinema City*) series, images of Italian filmstars which were first exhibited in 1962.

Independently of Rotella, three Parisian artists – Raymond Hains, Jacques Mahé de la Villeglé and François Dufrêne – had also been exploring posters as an artistic medium. However, their work was not publicized until 1958, by the French critic Pierre Restany who, in 1960, was instrumental in forming the *Nouveaux Réalistes* group. Its original members included Arman, Yves Klein, Martial Raysse, Daniel Spoerri, Jean Tinguely and the three French poster artists. Rotella showed with the *Nouveaux Réalistes* for the first time in the exhibition '40° au-dessus de Dada', held at Restany's Galerie J., Paris, in May 1961. In 1964, he left Rome to settle in the French capital.

By then, Rotella had abandoned the *décollage* method in favour of what he called *reportages*, works created by projecting photographs from newspapers, printers' proofs and other sources onto sensitized canvas. Rotella dubbed this activity 'mechanical art', 'mec art' for short. In 1966, he began making paintings blown up from Polaroid portraits of fellow artists. He published his autobiography, *Autorotella*, in 1972, and in 1975 a re-

cording of his poetry, *Phonetic Poems, 1949-75*, was issued. In the 1980s, Rotella has returned to the medium of paint on canvas and to the subject of Italian film. M.G./P.K.

Pierre Restany, *Rotella: Dal Décollage alla Nuova Immagine*, Milan, 1963
Domenico Rotella, *Autorotella: Autobiografica di un'artista*, Milan, 1972
Rotella: Décollages 1954-1964, Milan, 1986

Luigi Russolo

was born in Portogruaro (Veneto) on 7 May 1885. He studied music with his father, the local cathedral organist and director of the Scuola Cantorum at Latisana; his two older brothers studied at the Milan conservatory. In 1901, Russolo joined the family in Milan, where he decided to take up painting. His only formal training came as an assistant to the restorer Crivelli, working on the Castello Sforzesco and Leonardo da Vinci's *Last Supper*. In 1909, he exhibited a group of etchings at the Famiglia Artistica, where he met Boccioni and Carrà. The following year, he signed the *Manifesto of Futurist Painters* and the *Futurist Painting Technical Manifesto*. His early paintings were influenced by the style of Gaetano Previati and the Symbolist theme of synaesthesia. Works such as *Perfume* (1909-10) aimed at conveying non-visual sensations through undulating line and Divisionist brushwork. With *Music* (1911-12), he developed a more dynamic style, possibly influenced by Cubism or the chronophotography of Etienne-Jules Marey. In the years preceding the First World War, he participated in all of the Futurist soirées and exhibitions, but it remains unclear whether he actually accompanied the group to Paris in the autumn of 1911.

Russolo's interest in music led to the publication of his manifesto *The Art of Noises* in March 1913 (expanded in book form in 1916). Although it was dedicated to the Futurist composer Balilla Pratella, it was more radical than the latter's *Futurist Music Technical Manifesto* (1911), for it proposed the incorporation of incidental noise into musical composition. Also in 1913, Russolo and the painter Ugo Piatti invented the *intonarumori* (noise-intoners), machines that emitted different types of noises (gurgles, hisses, explosions, buzzes), with the capacity to regulate tone and pitch. The *intonarumori* were enthusiastically received by Igor Stravinsky, Sergej Prokofiev, Sergej Diaghilev and the pianist Kpzy during a private demonstration in Milan in 1915. Russolo's 'noise spirals' were greeted by public amazement and hostility, however, when *The Awakening of a Great City* and *Meeting of Motor-Cars and Aeroplanes* were performed in Modena and Milan (1913) and London (1914). He also devised an influential notational system for his intoners, which was published as 'Grafia enarmonica per gli intonarumori Futuristi' in *Lacerba* in 1914. Russolo volunteered for the war and was seriously wounded in December 1917. After eighteen months' convalescence, he resumed activity, assisting Fedele Azari to modify the engine noises of his aeroplane for Le Théâtre Aerien Futuriste.

While in Paris in June 1921, Russolo and Piatti gave three concerts at the Théâtre des Champs Elysées, featuring music by Russolo's brother Antonio and twenty-eight *intonarumori*. The performances were highly praised by Piet Mondrian in the magazine *De Stijl*. In reaction against the Fascist

regime, Russolo spent long periods in Paris between 1927 and 1932. There he invented and patented a series of instruments, including the 'harmonic bow'. He participated in the Futurist Pantomime Theatre at the Théâtre de la Madeleine in 1927 with the *rumorarmonio* or *russolofono*, which created the effects of the *intonarumori* through a keyboard. Plans to produce the instrument commercially were discussed with the Fox Movietone company, but never materialized, although Russolo used it on various movie projects and three short Futurist films by Filippo Marinetti.

Russolo gave his last concert, presented by Edgard Varèse, in 1929 at a Futurist exhibition in the Galerie 23 in Paris. He briefly resumed painting in a Realist style (the works from this period are now lost). In 1931, he moved to Tarragona in Spain, where he studied occult philosophy. He returned to Italy in 1933, settling in Cerro di Laveno on Lake Maggiore. His philosophical reflections, *Al di là della materia*, were published in 1938. During the last five years of his life he began to paint again, in a style which he termed 'classic-modern'. He had his first one-man exhibitions in Como in 1945 and in Milan the following year. He died at Cerro di Laveno on 4 February 1947. M.G.

Maria Zanovello Russolo, Ugo Nebbia and Paolo Buzzi, *Russolo: l'uomo, l'artista*, Milan, 1958
Gianfranco Maffina, *L'Opera grafica di Luigi Russolo*, Varese, 1977
Gianfranco Maffina, *Luigi Russolo e l'Arte dei Rumori*, Turin, 1978

Alberto Savinio

was born Andrea de Chirico on 25 August 1891 in Athens. He adopted his pseudonym in 1912 to distinguish himself from his brother, the painter Giorgio de Chirico. The brothers identified with the heavenly twins, Castor and Polydeukes (the Dioscuri), and remained extremely close well into their forties, sharing the invention and elaboration of Metaphysical art.

Savinio studied music at the Athens conservatory, graduating with honours at the age of twelve. His prodigious talent determined the family's relocation after the death of their father in 1905. By 1906, Savinio was studying under Max Reger in Munich; and at the age of seventeen he composed his first opera, *Carmela*, which was praised by

Pietro Mascagni. Early in 1910, Savinio moved from Munich to Paris, which afforded a rich musical and literary life. He met Pablo Picasso, Francis Picabia, André Breton and Blaise Cendrars and developed a close friendship with Guillaume Apollinaire. He performed his first concert in May 1914, at the offices of Apollinaire's journal *Les soirées de Paris*. Savinio's music, which he later defined as 'metaphysical', created a dramatic sense of the real through unexpected juxtapositions of sounds and voices, rather than evoking states of mind in the form of impressionistic nuance. In the July issue of *Les soirées de Paris* he published *Les Chants de la mi-mort*, accompanied by the musical score and a description of the staging and costumes. He defined 'half death' as a state of heightened perception between dream and reality. Although the sets and costumes were never realized, the faceless, robotic figures directly inspired the mannequins of de Chirico, which first appeared in his paintings of 1915.

With Italy's intervention in the First World War in 1915, Savinio was posted to Ferrara with his brother and then sent to Salonika in the summer of 1917 to work as a translator on the Balkan front. He developed his metaphysical style in literature in the novel *Hermaphrodito*, which was begun in Paris, published serially in *La Voce* from 1916 and issued in its entirety in 1918. After the war, he contributed to the Roman periodical *Valori Plastici* (1918-22). His series of articles defined Metaphysical painting as the intuition of the exterior world through the intellect rather than the senses, based on the revelation of the essential through the devices of 'spectrality' and 'irony'.

In the early twenties, he wrote dramas for Luigi Pirandello's Compagnia del Teatro dell'arte and met the actress Maria Morino, whom he married in 1926. Later that year, they moved to Paris, joining de Chirico, who had returned to the French capital in the autumn of 1924. There Savinio began to paint, a talent only hinted at in a few earlier drawings for the stage and some undated collages. His first one-man show was presented by Jean Cocteau at the Galerie Jacques Bernheim in 1927. His fantastic images were based on the theme of travel, metamorphosis and childhood memories fused with the archetypes of Greek mythology. His first endeavours consisted of family portraits based on photographs and combined with bizarre depictions of classical statuary. In 1928, he began the series *Playthings in the Forest*, in which brilliantly coloured objects floating in the landscape served as a metaphor for the casual and the absurd, inspired by the Nietzschean image of the world as the plaything of the gods. In the following year, he painted

large-scale versions of *Monument to the Playthings* for the house of the dealer Léonce Rosenberg, which also contained works by de Chirico, Severini and Picabia. In 1929-30, monstrous figures with the heads of beasts and birds, influenced by Otto Weininger's theory of the analogies between human and animal psychology, began to invade his images of complacent bourgeois interiors. He exhibited for the first time in Italy at the 1930 Venice Biennale as part of the group *Italiani di Parigi*, which was presented by the critic Waldemar George.

Savinio returned to Italy in 1933, where his painting was, for the most part, neglected by the critics. In 1936, he painted a mural for the Palazzo Istituto Nazionale delle Assicurazioni (INA) in Turin in collaboration with Domenico Valinotti. He founded the short-lived periodical *Colonna* (1933-4), and continued to write semi-autobiographical novels, such as *Capitano Ulise* (1934), *Dico a te, Clio* (1939) and *Infanzia di Nivasio Dolcemare* (1941). In 1940, he distinguished Metaphysical painting from French Surrealism in an important article in *Prospettive*. In the same year, he had a one-man show at the Galleria del Milione, Milan.

After the war, Savinio dedicated his energies to the theatre, where he realized to the full his talents as composer, author, producer and designer. In 1946, he composed the ballet *La vita dell'uomo*, which was first performed at the Teatro Eliseo in Rome in 1948 and at La Scala, Milan, in 1951. He was involved in several projects for La Scala, including Igor Stravinsky's *Firebird* and Jacques Offenbach's *Tales of Hoffmann*. He designed sets and costumes for Gioacchino Rossini's *Armida*, produced by the Maggio Musicale Fiorentino in 1952. He died on 5 May of that year. A retrospective of his work was organized in 1967 by the Galleria Nazionale d'Arte Moderna in Rome. M.G.

Alberto Savinio, Milan, Palazzo Reale, 1976
Alberto Savinio, Rome, Palazzo delle Esposizioni, 1978
Con Savinio: Mostra bio-biblio-grafica di Alberto Savinio, ed. Cristina Nuzzi, Fiesole, Palazzina Mangani, 1981

Mario Schifano

was born in Homs, Libya, in 1934. He emerged as a major figure on the Roman art scene when he participated in the 1960 exhibition '5 Pittori Roma '60' at the Galleria La Salita, a show which also included Lo Savio, Franco Angeli, Tano Festa and Giuseppe Uncini.

Despite his talent for luscious brushwork, Schifano has rebelled throughout his career against the notion of painting as a purely aesthetic enterprise. His paintings from 1959 to 1961 employed only one or two colours, which he applied to wrapping paper glued onto canvas. Jasper Johns's influence was apparent in the use of isolated numbers or letters as motifs, but Schifano's handling of paint was more akin to Robert Rauschenberg's. A painting from 1960 consists of the word 'no' painted with drips in large block letters, like a graffito. Contemporary critics remarked on Schifano's 'industrial colours' and on the resemblance of his paintings to street signs and traffic lights. For Maurizio Calvesi his canvases evoked 'waiting and abstention'; they depicted a 'nothing containing a project for everything'. Arturo Carlo Quintavalle saw Schifano's early work as a kind of substitute Marxism, a research into ideology and language which presented a viable alternative to Guttuso's realistic illustration of social themes.

Schifano had his first one-man show in 1961, at the La Tartaruga gallery, Rome, which also exhibited the work of such artists as Cy Twombly, Kounellis and Rotella. International recognition came in 1962 with his inclusion in the exhibition 'The New Realists' at Sidney Janis in New York.

At about this time, Schifano began using more complex motifs, often borrowed from advertising, such as the Coca-Cola or Esso logos. (It was probably no accident that these signs provided omnipresent visible evidence of American economic domination.) He also became fascinated by the Futurist problem of depicting motion in painting. Many works of this period include the motif of a walking man, with movement indicated by multiple torsos and legs, as in *When I remember Giacomo Balla and the Villa Borghese* (1964).

Not content to be a purveyor of lusciously painted Pop images, Schifano pursued his interest in movement by turning to the cinema. His 1968 film *Satellite* reveals the world as a continuous flux of images crossing the walls of his studio. Schifano's ambitions for a more revolutionary cinema fell victim to fund-raising difficulties, but a group of 1970 paintings addressed the power of television and other mass media. The images were set in a black frame, like a video screen, and had the low definition and rounded corners of pictures on a cathode ray tube; hues were garish and exaggerated, as if the colour knob had been turned up too far, but the handling remained seductively painterly.

Disillusioned about the possibility of making socially effective art, Schifano temporarily abandoned painting and went to join a commune in Asia. In the 1970s and 1980s, his work has increasingly focused on art and artists as subject-matter, utilizing photographs of historical 'icons' such as de Chirico, Henri Matisse, Leonardo da Vinci, Paul Cézanne and the Futurist group. This tendency can be traced back to his painting *Futurism Revisited* (1966), in which the title is written over the famous photograph of the Futurists taken on the occassion of their 1912 exhibition in Paris. P.K.

Vittorio Rubiu, 'Mario Schifano: Dada?', *Metro*, 7, 1962, pp. 88-9
Mario Schifano: L'Uomo e l'arte, Milan, Centro d'Arte Contemporanea e Primitiva, 1972
Mario Schifano, 1960-1970, Milan, Studio Marconi, 1974

Scipione

was born Gino Bonichi on 25 February 1904 in Macerata (the Marches); he took his pseudonym in 1927 in homage to the ancient hero Scipio Africanus. In 1909, his family moved to Rome. Although he was athletic in his youth, in 1919 he contracted pleurisy, which later developed into tuberculosis. He chose not to follow his father's military profession and began to teach himself to paint. Mario Mafai, whom he befriended in 1924, convinced him to enrol in the Scuola Libera del Nudo at the Accademia di Belle Arti. After their expulsion from the Accademia the following year, they made a short-lived attempt to sell posters and figurines under the acronym 'Bomaf', and continued their education by reading art history and contemporary art journals at the fine art library at the Palazzo Venezia. In 1925, Mafai began to live with the Lithuanian-born artist Antonietta Raphaël and in 1927 they moved to a studio in the Via Cavour; Scipione and the sculptor Renato Marino Mazzacurati were frequent visitors. Together they formed a close artistic association, and were dubbed the *Scuola di via Cavour* by the critic Roberto Longhi in 1929.

Raphaël, who had studied in London and Paris and painted in a manner reminiscent of Marc Chagall and Chaim Soutine, encouraged Scipione to abandon the early, naive style of his *Leda and the Swan* (1928) in favour of a lyrical expressionism. His style matured around 1929, when he spent the summer in Collepardo, south of Rome, and painted landscapes and still-lifes of a dream-like intimacy, such as *The Ace of Spades* and *The Octopus*. During this period, he also began to write poetry in a style of nascent Surrealism. His images took on a decidedly hallucinatory edge after he saw the paintings of El Greco and Goya in an exhibition in Rome in 1930. *Cardinal Decano* and *Piazza Navona* depicted a world at once decadent and wondrous, rendered with a sensuous facture and glowing, bituminous hues. His vision of Rome as a city of the baroque and the sublime found its parallel in the poetry of his close friend, Giuseppe Ungaretti.

He shared his first exhibition with Mafai at P.M. Bardi's Galleria di Roma in 1930; despite his idiosyncratic style, he received favourable attention from the local Roman critics. Among his early supporters was Cipriano Efisio Oppo, head of the Fascist Syndicate of Artists: through his efforts, Scipione received a showing at the first Quadriennale of Rome in 1931. He also enjoyed much success as an illustrator and satirist. In 1929, he had

contributed the first of his drawings for the cultural journal *L'Italia Letteraria*, under the editorship of Enrico Falqui; by the following year, his literary vignettes and parodies of the national artistic scene were regularly featured. He grew close to a circle of Roman writers that included Libero de Libero and Leonardo Sinisgalli, and through the efforts of Falqui, he illustrated book covers for editions of Eugenio Montale, Bruno Barilli and Vincenzo Cardarelli. In 1931, he worked with Mazzacurati on the planning of a new literary and artistic journal, *Fronte*, which ceased publication, however, after two issues.

In the spring of that year, he went for the first of several treatments at the sanatorium in Arco in the province of Trento. Although he returned to Rome and continued to paint, his production declined with his failing health. He took part in his last exhibition, '22 Artistes italiens modernes', at the Galerie Georges Bernheim in Paris in March 1932. He died at Arco on 9 November 1933. Four days later, *L'Italia Letteraria* devoted a special issue to his memory. Exhibitions of his work were organized by Oppo for the 1935 Quadriennale in Rome, and in 1941 at the Brera in Milan. Scheiwiller published the first edition of his poetry, *Le civette gridano*, in 1938, which was followed by the collection *Carte Segrete*, issued by Einaudi in 1943. After his retrospectives at the Venice Biennale of 1948 and the Galleria Nazionale d'Arte Moderna in Rome in 1954, Scipione's post-war reputation reached legendary proportions. Despite his relatively small production, he became a symbol of heroic individuality in the context of the Fascist period. E. B.

Omaggio a Scipione, ed. Palma Bucarelli, Rome, Galleria Nazionale d'Arte Moderna, 1954
Scipione 1904-1933, Macerata, Palazzo Ricci, 1985
Scuola Romana, ed. Maurizio Fagiolo dell'Arco, Milan, Palazzo Reale, 1987

Gino Severini

was born in Cortona on 7 April 1883. In 1899, he moved to Rome, where he worked as a bookkeeper. Financial support from a prelate in Cortona allowed him to attend design school and the Scuola Libera del Nudo. In 1901, he met Boccioni and in the following years they were taught Neo-Impressionist techniques by Balla. Severini was attracted to Socialism through the circle of Duilio Cambellotti and Giovanni Cena and read Karl Marx, Mikhail Bakunin, Arthur Schopenhauer and Friedrich Nietzsche. His early work consisted of portraits and landscapes painted in a Symbolist-infused Divisionism. Rejected by the annual salon of the Società Amatori e Cultori in 1904, he and Boccioni organized a 'Mostra dei Rifutati' at the Teatro Nazionale the following year.

In November 1906, Severini moved to Paris, where he befriended Modigliani and Susanne Valadon and was soon introduced to avant-garde circles. He met Félix Fénéon of the Galerie Bernheim Jeune, who organized a Futurist exhibition in February 1912. Severini's city scenes were initially painted in broad Pointillist brushwork that was indebted to Paul Signac, but by 1910 he had absorbed the influence of Analytical Cubism. In the same year, he signed the *Manifesto of Futurist Painters* and the *Futurist Painting Technical Manifesto*. He kept his colleagues informed of developments in Paris, primarily through his correspondence with Boccioni, and organized their trip to the French

capital in the autumn of 1911. Severini shared the Futurist interest in modern technology in his series of paintings of the Paris metro (*The North-South Train*, 1912), but his interpretation of movement through the fracturing of form found its most consistent expression in the frenzied dancers of the Parisian *café concerts* (*The Pan-Pan at the Monico*, 1911-12; *Dancer at Bal Tabarin*, 1912). By the end of 1913, his interest in 'plastic analogies of dynamism' led him to depict the rhythms of dance as a luminous field of energy, rendered with abstract volumetric forms and a modified Pointillist brushwork. In 1913, he had his first one-man show at the Marlborough Gallery in London, which travelled to Der Sturm gallery in Berlin. In the same year, he married Jeanne Fort, daughter of the Symbolist poet Paul Fort.

Illness prevented Severini from participating in the First World War, but he created some of Futurism's most dynamic icons of military activity, notably *The Armoured Train* (1915). Working closely with Juan Gris and Pablo Picasso during the war years, he painted still-lifes in the style of Synthetic Cubism; these were based on the golden section and square root proportions and influenced by the writings of Fénéon and Charles Henry. Like Picasso, Severini worked simultaneously in figurative and abstract styles, beginning with *Motherhood* (1916), one of the most precocious examples of the return to order precipitated by the war. He began to publish his theories on a new classicism in *Mercure de France*. He exhibited at Léonce Rosenberg's Galerie L'Effort moderne for the first time in 1919 and contributed to the journals *Valori Plastici*, *De Stijl* and *L'Esprit Nouveau*. His treatise *Du cubisme au classicisme*, published in 1921, expounded a return to figuration based on precise laws of geometry and proportion, a style which he termed 'réalisme classicisant'.

These ideas were realized in his cycle of *Commedia dell'Arte* frescos (1921-2), commissioned by Sir George Sitwell for his house at Montegufoni near Florence. In 1923, Severini befriended the philosopher Jacques Maritain, who encouraged his return to Catholicism, imparting a new religiosity to his theories of geometric order. He began a series of murals and mosaics in Switzerland for the churches of Semsales (1924-6), La Roche (1927-8) and St Pierre (1931-2) in the canton of Fribourg and for Notre Dame du Valentin in Lausanne (1933-5). He participated in the *Novecento* exhibitions of 1926 and 1929. In the late twenties, he

began to be associated with the *Italiani di Parigi*, led by the painter and critic Mario Tozzi and including de Chirico, Savinio, Campigli and de Pisis; he presented the group at the Venice Biennale of 1932. His mosaic *The Arts* is the only surviving commission for the ill-fated Milan Triennale of 1933. After returning to Italy in 1935, he won the prize for painting at the second Quadriennale in Rome. He received commissions for other large-scale projects, including frescos for the university of Padua (1933) and mosaics for the Palazzo di Giustizia, Milan (1937-8), and the central post office in Alessandria (1936-8).

Severini returned to Paris in 1946 and published his autobiography, *Tutta la vita di un pittore*, the following year. He was involved in further large-scale decorative projects, notably the murals for the Palazzo dei Congressi in Rome (1953). He continued to work in both abstract and his earlier, Futurist styles until his death on 26 February 1966. M. G.

Gino Severini, ed. Renato Barilli, Florence, Palazzo Pitti, 1983
Gino Severini: Prima e dopo l'opera, ed. Maurizio Fagiolo dell'Arco, Cortona, Palazzo Casali, 1983
Daniela Fonti, *Gino Severini: Catalogo Ragionato*, Milan, 1988

Mario Sironi

was born on 12 May 1885 in Sassari (Sardinia); his maternal grandfather, Ignazio Villa, was a noted architect and inventor. His father, an engineer, moved the family back to Rome in 1906. After graduating from the technical college, he enrolled in the faculty of engineering at the university of Rome in 1902, only to abandon his studies after a long neurasthenic illness. The following year, he began at the Scuola Libera del Nudo, where he befriended Balla, Boccioni and Severini. In the summer of 1908, he shared a flat in Paris with Boccioni, who would remain his closest friend and artistic mentor. He travelled to Frankfurt in 1910 at the invitation of the sculptor Otto Tannenbaum. The music of Richard Wagner and the philosophy of Arthur Schopenhauer and Friedrich Nietzsche were formative influences. He spent long periods of his youth in seclusion and destroyed much of his early, Divisionist work.

Sironi moved to Milan late in 1914 or early 1915. He briefly experimented with Futurist painting, but adhered to the movement for ideological rather than stylistic reasons. In the First World War, he served at the Front with Filippo Marinetti, Antonio Sant'Elia and Boccioni, and signed the manifesto *Italian Pride* in October 1915. After his discharge from the army, he made hundreds of drawings of silent city streets and manikins, transforming the irony and iconography of Metaphysical painting with a modern urgency and alienation. These drawings developed in the immediate post-war years into the *Urban Landscapes*. In 1922, Sironi was one of the founding members of *Sette pittori del Novecento*. His series of portraits, *The Architect* and *The Pupil*, exhibited at the Biennale of 1924, are among the most significant examples of the group's Magic Realist style.

By the late twenties, Sironi considered easel painting to be an anachronism of bourgeois individualism in an age of mass culture and politics, and turned his attention to propaganda work and didactic murals. He was the most prominent caricaturist for Mussolini's official press, *Il Popolo*

d'Italia, contributing political commentary and literary vignettes to the daily newspaper and its satellite publications from 1921 until the fall of the regime in 1943. He also served as art critic for *Il Popolo d'Italia* (1927-33) and *La Rivista illustrata del Popolo d'Italia* (1934-9). With Giovanni Muzio he designed the Italian press pavilions at the international exhibitions in Cologne (1928) and Barcelona (1929). In Cologne he was deeply impressed by El Lissitsky's installation for the Soviet pavilion. His skill as a propagandist culminated in his rooms for the monumental 'Mostra della rivoluzione fascista' of 1932. During these years he was also active as a stage designer, his work including the sets for Gaetano Donizetti's *Lucrezia Borgia* in the first Maggio Musicale Fiorentino of 1933.

Sironi's monumental style was decidedly anti-naturalistic, inspired by Roman mosaics and Romanesque relief sculpture, which he considered to be inherently popular and Italian traditions, in contrast to the Augustan Classicism favoured by the regime in these years. In the early thirties, he was engaged in a bitter polemic in the press with party minister Roberto Farinacci, who denounced his art as degenerate and foreign-influenced. Sironi had the opportunity to realize his ideal of mural painting when he commissioned some thirty artists to decorate the Palazzo dell'Arte for the fifth Triennale of Milan. The results generated a heated controversy over the appropriate style for a Fascist art, and the works, including Sironi's fresco *Days and Labours*, were destroyed. He subsequently published the *Manifesto of Mural Painting*, also signed by Carrà, Achille Funi and Massimo Campigli. Sironi continued to receive commissions throughout the decade, including a monumental stained glass window, *Work*, for the Palazzo dell'Industria, Rome, 1931-2; the fresco *Italy between the Arts and the Sciences* for the university of Rome, 1935 (significantly altered by restoration); the mosaic *Justice between Law and Force*, Palazzo di Giustizia, Milan, 1937; and the marble and porphyry bas-reliefs *The People of Italy*, Palazzo dei Giornali, Milan, 1939-41. He also designed the exterior decoration for Giuseppe Terragni's unexecuted projects for the Palazzo Littorio, 1934 and 1937, and the Danteum, 1938.

Sironi supported the Republic of Salò in 1943. After the war, he turned his attention again to easel painting and produced a large body of late work. He continued to design for the opera, including Wagner's *Tristan und Isolde* for La Scala in

1946 and Giuseppe Verdi's *Don Carlos* for the twelfth Maggio Musicale Fiorentino in 1951. In 1956, he was elected member of the Accademia di San Luca. Sironi died on 13 August 1961. The Venice Biennale mounted a retrospective of his work the following year. E. B.

Mario Sironi, *Scritti editi e inediti*, ed. Ettore Camesasca, Milan, 1980
Mario Sironi 1885-1961, ed. Claudia Gian Ferrari, Milan, Palazzo Reale, 1985
Mario Sironi, ed. Jürgen Harten, Düsseldorf, Kunsthalle, 1988

Giulio Turcato

was born in Mantua on 16 March 1912. In 1925, his family moved to Venice, where he attended the Liceo artistico and the Scuola Libera del Nudo. His first landscapes and still-lifes date from 1926. Between 1934 and 1935, he did his military service at the school for officers in Palermo and, in 1937, he went to Milan to work for the *Novecento* architect Giovanni Muzio. He was in contact with the artists of *Corrente* but never officially joined the group. After a brief visit to Rome in 1942, he returned to Venice and taught drawing at the Avviamento Professionale school in Portogruaro. In spring 1943, he was in the capital again for a group exhibition with Toti Scialoja, Vedova and others at the Galleria Lo Zodiaco. That autumn, he settled in Rome and began collaborating with the Resistance movement.

After the war, Turcato played an active role in reaffirming cultural ties between Italy and other European countries, and was among the founding members of the Art Club of Rome in 1945. In 1946, he joined the *Nuova Secessione Artistica*, subsequently known as the *Fronte Nuovo delle Arti*. On 15 March 1948, he signed the manifesto of *Forma* and aligned himself with those intellectuals who proclaimed themselves 'formalists and Marxists', underlining their intention to adopt new forms of artistic expression. In his article 'Crisi della Pittura', published in the first issue of *Forma* in April 1947, Turcato argued against the Realist style supported by certain factions of the Communist party ('the misunderstanding has arisen from the belief that a visual language dictated by the contents of the past can be continually modernized') and he stressed the importance of the modernist tradition represented by Paul Cézanne, Henri Matisse and

the Cubists. He participated in the first group exhibition of *Forma* at the Art Club late in 1947, and was included in a room devoted to the *Fronte* at the Venice Biennale of 1948. After the schism between the group's abstract and realist artists, he exhibited in a controversial show organized by the Alleanza di Cultura of Bologna, which provoked the Communist party leader, Palmiro Togliatti, to publish a polemic against new tendencies in art in *Rinascita* in October 1948. Against the background of these events, Turcato painted non-geometric abstract *Compositions* indebted to Pablo Picasso, Futurism (especially the work of Balla) and Magnelli. His series *Ruins of Warsaw* and *Ruins of War* were inspired by his trip with the Italian delegation to the Warsaw Peace Congress in 1948. From 1948 to the mid-fifties, Turcato continued to emphasize the political commitment of his art, while maintaining his autonomy as an artist: in the series *Revolts*, *Political Gatherings*, *Factories* and *Mines* colour was inlaid in a schematic grid depicting symbolic elements, such as red flags in *Comizio* (1950).

He travelled to Paris for a few months on a study grant during 1950. After returning to Italy, he joined Lionello Venturi's *Gruppo degli Otto Pittori Italiani* with Afro, Renato Birolli, Vedova, Ennio Morlotti, Giuseppe Santomaso, Mattia Moreni and Antonio Corpora. He participated in the group's 1952 exhibition which travelled to Munich, Hanover, Hamburg and Berlin and was also shown at the Venice Biennale. Gradually he was attracted to the more expressive gestural painting of *Art Autre*, promoted by the critic Michel Tapié. This, combined with his interest in Zen philosophy and Oriental art (reinforced by a trip to China in 1956), led Turcato to adopt a looser, more atmospheric ground and free compositions of a gestural and suggestive calligraphy. He won the National Prize for his one-man show at the Venice Biennale in 1958.

From 1960 to 1962, he was associated with the group *Continuità* (whose original members included Carla Accardi, Pietro Consagra, Dorazio, Gastone Novelli and Achille Perilli), which advocated a greater structural rigour in reaction against *Informel*. He was influenced further in this direction after seeing the works of Mark Rothko, Clyfford Still and Barnett Newman during a visit to America in 1963. In the mid-sixties, he intensified his investigation of colour by using hues which he termed 'beyond the solar spectrum'.

Turcato has had numerous one-man shows in Italy and abroad, including a major retrospective at the Galleria Nazionale d'Arte Moderna in 1987. He lives and works in Rome. S. F.

Giorgio De Marchis, *Turcato*, Milan, 1971
Giulio Turcato, Munich, Villa Stuck, 1985
Giulio Turcato, ed. Augusta Monferini, Rome, Galleria Nazionale d'Arte Moderna, 1987

Emilio Vedova

was born in Venice on 9 August 1919. The son of an artisan, he was the third of seven children. He attended evening classes at the Scuola dei Carmini for a brief period but was essentially self-taught. He spent much of his youth doing odd jobs to earn a living and to allow him to draw and paint, making numerous sketches of architectural ruins and copies after the Venetian masters, especially Tintoretto. From early on, the main theme in his work was the plight of man in a world of aggressive

confrontation and social injustice. He spent 1939 to 1940 in Florence, where his interest in the poor led him to spend much of his time observing life in the streets and also brought him into contact with anti-Fascist groups. His first one-man show was in the Botteghe d'Arte in Venice in 1940. In 1942, he exhibited in the 'Premio Bergamo' with two Realist-Expressionist works and he participated in the Milanese *Corrente* exhibition in 1943. Later that year, he joined the Resistance in Rome and collaborated in clandestine activities in Via Margutta with Mario Mafai, Turcato and Guttuso.

At the end of the war, Vedova returned to Venice, while his *Partisan Drawings* were exhibited in various cities throughout Italy. He signed the manifesto *Beyond Guernica* in Milan in May 1946. In the same year, he participated in the *Nuova Secessione Artistica*, later known as the *Fronte Nuovo delle Arti*. A vehement opponent of Neo-Realism, he was one of the protagonists of the break between the abstract and figurative painters of the *Fronte* in 1946. Between the end of 1946 and the beginning of 1947, he painted a series of works known as *Black Geometries*, in which he adopted a style of geometric abstraction inspired by Futurism and Picasso. The political content of many of these was explicit in his choice of titles: *Explosion, Battle, Europe, Concentration Camp*. In 1950, he participated in the twenty-fifth Venice Biennale and exhibited abroad for the first time in New York in 1951. By the early fifties, he had developed his mature gestural style, using strident colours, especially black, and broad decisive brushstrokes. In 1952, he joined the *Gruppo degli Otto* championed by the critic Lionello Venturi. His series *Cycle of Protest* and *Cycle of Nature* date from 1953 and were exhibited at the Biennale of 1954. In 1955, he participated in the Documenta in Kassel and began the *Protest Cycle for Brazil*. These series were among the most significant examples of *Informel* art in Italy and like much of Vedova's oeuvre the expressive gesture of the artist's actions conveyed both pictorial and social radicalism. In 1960-1, he

produced the set designs and costumes for Luigi Nono's opera *Intolleranza '60*. The same year, he began a new line of pictorial research which led to the *Plurimi*: painted constructions with movable component parts that engage in an aggressive dialogue with the surrounding space. He developed these in the *Absurdes Berliner Tagebuch '64* during his residence in Berlin (1963-5) at the Arno Brecher studio. From 1965 to 1969, he taught at the Sommerakademie für Bildende Kunst in Salzburg.

Since the late fifties, Vedova has had numerous exhibitions in Italy and abroad, and has won several prizes both for his painting and graphic works, including the Grand Prize for Painting at the thirtieth Venice Biennale in 1960. He was an active participant in the 1968 student movement; he joined demonstrations and taught a series of 'alternative' courses at the Accademia di Belle Arti in Venice. For the last two decades, Vedova has lived and worked in Venice. S. F.

Giuseppe Marchiori, *Emilio Vedova*, Venice, 1952
Filiberto Menna, *Vedova*, Milan, 1982
Emilio Vedova, ed. Germano Celant, Venice, Museo Correr, 1984

Gilberto Zorio

was born on 21 September 1944 in Andorno Micca (Piedmont). He studied painting at the Accademia di Belle Arti, Turin, from 1963 to 1970. Zorio's projects reveal the constant transformation of natural energies, be it in elementary chemical reactions or in symbolic forms of alchemy and metamorphosis. He has been associated with *Arte Povera* since his inclusion in the group's second exhibition, at the Galleria De' Foscherari, Bologna, in 1968.

In his first one-man show at the Galleria Sperone in Turin in 1967, Zorio presented the seminal piece *Pink-Blue-Pink*, which consisted of a container made of fibre cement filled with cobalt chloride that continually changed colour according to the level of humidity in the room. For Zorio, the art object is never completed, but 'continues to live by itself, while I place myself in the role of the spectator, both of its reactions and the reactions of the viewers. It is in this sense that I employ the idea of process in my work.'

Flux, instability and the unforeseeable also underlay his interest in language, as is revealed by a series of sculptures and performances produced between 1968 and 1971. In *To Purify Words* (1969) the participant spoke into a vessel; his words passed through alcohol and stimulated the flashing of floodlights at the other end. Other installations

used neon or phosphorescent wax forms as a means of generating and absorbing energy in constant dialogue with the variables of the environment or with the viewer's actions.

From these physical embodiments of chemical change Zorio evolved a symbology of elemental forces; since 1972, his work has become identified with the forms of the star, suggestive of the non-material energy of the cosmos, and the javelin, a metaphor of the physical energy of man. Despite the beauty and symmetry of these forms, Zorio emphasizes their potential for violence as explosions or weapons. He has also employed neon or beams of light either within metal frameworks or alone, as in *Laser Star* (1975), an installation in which the viewer interrupted a beam of light projected near floor level.

In 1984, Zorio introduced a third symbolic form, that of the canoe; the elegant curve of its bow often traverses the space between floor and ceiling in his installations, mediating between the earthbound javelins and the celestial stars. His most recent works, comprised of air-compressors, pumps and pipes which act on water or blow hidden whistles and harmonicas, resemble intricate machines. Zorio lives and works in Milan. J. P.

Gilberto Zorio, ed. Jean-Christophe Ammann, Amsterdam, Stedelijk Museum, 1979
Gilberto Zorio, ed. Catherine David et al., Paris, Centre Georges Pompidou, Musée national d'art moderne, 1986
Gilberto Zorio, ed. Nahama Guralnik, Tel Aviv, Tel Aviv Museum, 1987

Selected Bibliography

See 'Biographies of the Artists' (pp. 425-51)
for literature on individual artists

General Surveys and Reference Books

Alloway, Lawrence, *The Venice Biennale 1895-1968*, New York, 1968.

Anzani, Giovanni, and Luciano Caramel, *Scultura in lombardia, 1900-1950*, Milan, 1981.

Apollonio, Umbro, *Pittura italiana moderna*, Venice, 1950.

Arcangeli, Francesco, *Dal romanticismo all'informale*, 2 vols, Turin, 1977.

Argan, Giulio Carlo, *Salvezza e caduta nell'arte moderna*, Milan, 1964.

Asor Rosa, Alberto, *Storia d'Italia*, vol. 4/2: *La Cultura*, Turin, 1975.

Baldini, Umberto, *Pittori toscani del novecento*, Florence, 1978.

Ballo, Guido, *Pittori italiani dal futurismo a oggi*, Rome, 1956. Translated as *Modern Italian Painting from Futurism to the Present Day*, trans. Barbara Wall, New York, 1958.

Ballo, Guido, *Le linea dell'arte italiana dal simbolismo alle opere moltiplicate*, 2 vols, Rome, 1964.

Barilli, Renato, *La scultura del novecento*, Milan, 1968.

Calvesi, Maurizio, *Le due avanguardie: Dal futurismo alla Pop Art*, Bari, 1984.

Caramel, Luciano, and Carlo Pirovano, *Musei e Gallerie di Milano: Galleria d'Arte Moderna, Padiglione d'Arte Contemporanea, Raccolta Grassi*, Milan, 1973.

Caramel, Luciano, and Carlo Pirovano, *Musei e Gallerie di Milano: Galleria d'Arte Moderna, Opere del Novecento*, Milan, 1974.

Caramel, Luciano, Carlo Pirovano and Maria Teresa Fiorio, *Musei e Gallerie di Milano: Galleria d'Arte Moderna, Collezione Boschi*, 2 vols, Milan, 1980.

Carrieri, Raffaele, *Pittura e scultura d'avanguardia in Italia (1890-1955)*, Milan, 1955. Translated as *Avant-garde Painting and Sculpture in Italy (1890-1955)*, Milan, 1955.

Del Guercio, Antonio, *La pittura del Novecento*, Turin, 1980.

Geneva, Musée Rath, *Du futurisme au spatialisme* (exhibition catalogue, 7 October 1977-15 January 1978).

Mallè, Luigi, *I dipinti della Galleria d'Arte Moderna*, Turin, 1968.

Maltese, Corrado, *Materialismo e critica d'arte*, Rome, 1956.

Maltese, Corrado, *Storia dell'arte in Italia, 1785-1943*, Turin, 1960.

Marchiori, Giuseppe, *Pittura moderna italiana*, Trieste, 1946.

Marchiori, Giuseppe, *Scultura italiana moderna*, Venice, 1953.

Marchiori, Giuseppe, *Arte e artisti d'avanguardia in Italia 1910-1950*, Milan, 1960.

Milan, Museo Poldi Pezzoli, *Milano 70/70: Un secolo d'arte, 1° dall'Unità al 1914* (exhibition catalogue, 21 May-30 June 1970).

Milan, Museo Poldi Pezzoli, *Milano 70/70: Un secolo d'arte, 2° dal 1915 al 1945* (exhibition catalogue, 28 April-10 June 1971).

Milan, Palazzo della Permanente, *La Permanente 1886-1986: Un secolo d'arte a Milano* (exhibition catalogue, 9 June-14 September 1986).

Milan, Palazzo Reale, *Arte italiana del XX secolo da collezioni americane* (exhibition catalogue, 30 April-26 June 1960).

Munich, Haus der Kunst, *Mythos Italien – Wintermärchen Deutschland* (exhibition catalogue, ed. Carla Schulz-Hoffmann, 24 March-29 May 1988).

New York, The Museum of Modern Art, *Twentieth Century Italian Art* (exhibition catalogue, ed. James Thrall Soby and Alfred Barr Jr, 1949).

Pansera, A., *Storia e cronaca della Triennale*, Milan, 1978.

Patani, Osvaldo, *La storia del disegno italiano 1900-1974*, Turin, 1974.

Pica, Agnoldomenico, *Storia della Triennale 1918-1957*, Milan, 1957.

Rome, Galleria Nazionale d'Arte Moderna, *Cento opere d'arte italiana dal futurismo ad oggi* (exhibition catalogue, text by Giorgio de Marchis, 1968).

Rome, Galleria Nazionale d'Arte Moderna, *Pittura e scultura del XX secolo nelle collezioni della Galleria Nazionale d'Arte Moderna* (museum catalogue, 1969).

Rome, Galleria Nazionale d'Arte Moderna, *Collezioni del XX secolo: Il primo Novecento* (museum catalogue, 1987).

Trieste, Stazione marittima, *Arte nel Friuli-Venezia Giulia 1900-1950* (exhibition catalogue, text by Decio Gioseffi, Sergio Molesi and Marco Pozzetto, December 1981-February 1982).

Turin, Galleria Civica d'Arte Moderna, *Capolavori d'arte moderna delle raccolte private* (exhibition catalogue, 1959).

Turin, Galleria Civica d'Arte Moderna, *Arte Moderna a Torino: 200 opere d'arte acquisite per la Galleria Civica d'Arte Moderna* (exhibition catalogue, ed. Rosanna Maggio Serra, 16 November 1986-4 January 1987).

'Un demi-siècle d'art italien', *Cahiers d'art*, no. 1, 1950, pp. 3-272.

Verona, Galleria d'Arte Moderna e Contemporanea, Palazzo Forti, *Le Scuole Romane: Sviluppi e continuità 1927-1988* (exhibition catalogue, 9 April-15 June 1988).

1900-1919

Andreoli de Villers, J. P., *Futurism and the Arts: A Bibliography*, Toronto, 1975.

Apollonio, Umbro (ed.), *Futurist Manifestos*, London, 1973.

Ballo, Guido, *Preistoria del futurismo*, Milan, 1960.

Barocchi, Paola, *Testimonianze e polemiche figurative in Italia dal Divisionismo al Novecento*, Messina and Florence, 1974.

Bellonzi, Fortunato, *Architettura, pittura, scultura dal neoclassicismo al Liberty*, Rome, 1978.

Bellonzi, Fortunato, *Il Divisionismo nella pittura italiana*, Milan, 1967.

Bohn, Willard, 'Apollinaire and de Chirico: The Making of the Mannequins', *Comparative Literature*, 27, no. 2, 1975, pp. 153-65.

Calvesi, Maurizio, *Il futurismo*, L'arte moderna, 5, Milan, 1967.

Calvesi, Maurizio, *La metafisica schiarita*, Milan, 1982.

Calvesi, Maurizio, *Boccioni prefuturista*, Milan, 1983.

Carpi, Umberto, *L'estrema avanguardia del Novecento*, Rome, 1985.

Carrà, Massimo, Ewald Rathke and Patrick Waldberg, *Metafisica*, Milan, 1968.

Carrieri, Raffaele, *Il futurismo*, Milan, 1961.

Caruso, Luciano (ed.), *Manifesti, proclami, interventi e documenti teorici del Futurismo, 1909-44*, 4 vols, Florence, 1980.

Crispolti, Enrico, *Il mito della macchina e altri temi del Futurismo*, Trapani, 1969.

Crispolti, Enrico, *Storia e critica del Futurismo*, Rome, 1986.

Damigella, Anna Maria, 'Idealismo e socialismo nella cultura figurativa romana del primo '900: Duilio Cambellotti', *Cronache di Archeologia e di Storia dell'Arte*, 8, 1969, pp. 119-73.

Damigella, Anna Maria, *La pittura simbolista in Italia 1885-1900*, Turin, 1981.

De Maria, Luciano (ed.), *Marinetti e il Futurismo*, Milan, 1973.

Drudi, Maria Gambillo, and Teresa Fiori, *Archivi del Futurismo*, 2 vols, Rome, 1958, 1962.

Falqui, Enrico, *Bibliografia e iconografia del Futurismo*, Florence, 1959.

Fauchereau, Serge, Antonio Porta and Claudia Salaris (eds), 'Futurismo Futurismi', special issue of *Alfabeta (La Quinzaine littéraire)*, 8, no. 84, May 1986.

Ferrara, Palazzo Massari, *La Metafisica: Museo Documentario* (museum catalogue, text by Maurizio Calvesi, Giovanna Dalla Chiesa and Ester Coen, 1981).

Fiori, Teresa, and Fortunato Bellonzi (eds), *Archivi del Divisionismo*, 2 vols, Rome, 1968.

Florence, Palazzo Medici-Riccardi, *Futurismo a Firenze: 1910-1920* (exhibition catalogue, 18 February-8 April 1984).

Fossati, Paolo, *La realtà attrezzata: Scena e spettacolo dei futuristi*, Turin, 1977.

Fossati, Paolo, *La 'Pittura Metafisica'*, Turin, 1988.

Gentile, Emilio, *La Voce e l'età giolittiana*, Milan, 1972.

Godoli, Enzo, *Guida all'architettura moderna: Il Futurismo*, Bari, 1983.

Gorizia, Palazzo Attems, *Frontiere d'avanguardia: Gli anni del futurismo nella Venezia Giulia* (exhibition catalogue, 1985).

Kirby, Michael, and Victoria Nes Kirby, *Futurist Performance*, New York, 1986.

Lista, Giovanni, *Futurisme*, Lausanne, 1973.
Lista, Giovanni, *Arte e politica: Il futurismo di sinistra in Italia*, Milan, 1980.
London, Royal Academy of Arts, *Post Impressionism* (exhibition catalogue, ed. John House and Mary Anne Stevens, 1979-80).

Marinetti, Filippo T., *Teoria e invenzione futurista*, ed. Luciano De Maria, Milan, 1968.
Marinetti, Filippo T., *Taccuini 1915/1921*, ed. Alberto Bertoni, Bologna, 1987.
Martin, Marianne, *Futurist Art and Theory*, Oxford, 1968.
Martin, Marianne, 'Reflections on de Chirico and Arte Metafisica', *Art Bulletin*, 60, June 1978, pp. 342-53.
Milan, Palazzo della Permanente, *Mostra della Scapigliatura* (exhibition catalogue, May-June 1966)
Milan, Palazzo della Permanente, *Mostra del Divisionismo italiano* (exhibition March-April 1970).
Milan, Palazzo della Permanente, *Mostra del Liberty italiano* (exhibition catalogue, 1972).
Milan, Palazzo Reale, *Boccioni e il suo tempo* (exhibition catalogue, text by Guido Ballo, Luciano De Maria and Franco Russoli, December 1973-February 1974).
Milan, Palazzo Reale, *Boccioni a Milano* (exhibition catalogue, ed. Guido Ballo, December 1982-March 1983).
Modena, Galleria Civica, *I futuristi e la fotografia: Creazione fotografica e immagine quotidiana* (exhibition catalogue, text by Giovanni Lista, 7 December 1985-26 January 1986).

New Haven, Yale University Art Gallery, *The Futurist Imagination: Word and Image in Italian Futurist Painting, Drawing, Collage and Free-Word Painting* (exhibition catalogue, ed. Anne Coffin Hanson, 13 April-26 June 1983).
New York, The Museum of Modern Art, *Futurism* (exhibition catalogue, text by Joshua C. Taylor, 31 May-5 September 1961).
New York, Solomon R. Guggenheim Museum, *Futurism: A Modern Focus* (exhibition catalogue, 1973).

Pagani, Severino, *La pittura lombarda della Scapigliatura*, Milan, 1955.
Perloff, Majorie, *The Futurist Moment*, Chicago, 1986.
Philadelphia, Philadelphia Museum of Art, *Futurism and the International Avant-garde* (exhibition catalogue, text by Anne d'Harnoncourt and Germano Celant, 26 October 1980-4 January 1981).
Previati, Gaetano, *I principi scientifici del Divisionismo (La tecnica della pittura)*, Turin, 1906.

Quinsac, Annie-Paule, *La peinture divisionniste italienne (1880-1895): Origines et premiers développements*, Paris, 1972.
Quinsac, Annie-Paule (ed.), *Segantini: Trent'anni di vita artistica europea nei carteggi inediti di Segantini e dei suoi mecenati*, Lecco, 1985.

Ragghianti, Carlo Ludovico, *Bologna Cruciale 1914*, Bologna, 1982.

Rome, Galleria Nazionale d'Arte Moderna, *Aspetti dell'arte a Roma, 1870-1914* (exhibition catalogue, text by Dario Durbé, Paola Frandini, Gianna Piantoni and Anna Maria Damigella, 1972).
Rome, Galleria Nazionale d'Arte Moderna, *Roma 1911* (exhibition catalogue, ed. Gianna Piantoni, 4 June-15 July 1980).
Rome, Palazzo Barberini, *Il futurismo* (exhibition catalogue, ed. Giorgio Castelfranco and Jacopo Recupero, 1959).
Rome, Palazzo Venezia, *Secessione romana 1913-1916* (exhibition catalogue, text by Rossana Bossaglia, Maria Quesada and Pasqualini Spadini, 4-28 June 1987).

Salaris, Claudia, *Storia del Futurismo*, Rome, 1985.
Salaris, Claudia, *Bibliografia del Futurismo 1909-1944*, Rome, 1988.

Tallarico, Luigi, *Per una ideologia del futurismo*, Rome, 1977.
Tisdall, Caroline, and Angelo Bozzolla, *Futurism*, London, 1977.
Toni, Anna Caterina, *Futuristi nelle Marche*, Rome, 1982.
Turin, Mole Antonelliana, *Ricostruzione futurista dell'universo* (exhibition catalogue, ed. Enrico Crispolti, June-October 1980).
26 Esposizioni futuriste 1912-1918 (reprints of Futurist exhibition catalogues), ed. Piero Pacini, Florence, 1978.

Venice, Palazzo Grassi, *La pittura metafisica* (exhibition catalogue, text by Giuliano Briganti and Ester Coën, 1979).
Venice, Palazzo Grassi, *Futurismo & Futurismi* (exhibition catalogue, 1986).
Venice, Sala Napoleonica, *Primi espositori di Ca' Pesaro 1908-1919* (exhibition catalogue, ed. Guido Perocco, 28 August-19 October 1958).
Venice, Sala Napoleonica and Museo Correr, *Venezia: Gli anni di Ca' Pesaro 1908-1920* (exhibition catalogue, 19 December-28 February 1987).
Verdone, Mario, *Cinema e letteratura del futurismo*, Rome, 1968.
Verona, Galleria dello Scudo, *Modigliani: Dipinti e disegni – Incontri italiani 1900-1920* (exhibition catalogue, ed. Osvaldo Patani, 25 November 1984-31 January 1985).

1919-1945

Acqui Terme, Palazzo Liceo Saracco, *I Sei di Torino 1929-1931* (exhibition catalogue, ed. Renzo Guasco, 1986).
Ancona, Galleria Civica d'Arte Moderna, *Pompei e il recupero del classico* (exhibition catalogue, ed. Marilena Pasquali, June-September 1980).
Armellini, Guido, 'Fascismo e pittura italiana', *Paragone*, no. 271, 1972, pp. 50-68; no. 273, 1972, pp. 36-51; no. 285, 1973, pp. 34-68.
Armellini, Guido, *Le immagini del fascismo nelle arti figurative*, Milan, 1980.

Ballo, Guido, 'La Galleria del Milione e il primo astrattismo italiano', *Domus*, no. 424, March 1965, pp. 49-54.
Barbaroux, V.E., and Giampiero Giani, *Arte italiana contemporanea*, Milan, 1940.
Belli, Carlo, *Kn*, Milan, 1935; revised edn, Milan, 1972.
Belli, Carlo, *Lettera sulla nascità dell'astrattismo in Italia*, Milan, 1978.

Bellonzi, Fortunato, *Pittura italiana del Novecento*, Milan, 1963.
Bernardi, Marziano, *Riccardo Gualino e la cultura torinese*, Turin, 1970.
Bertonati Emilio, 'Neue Sachlichkeit in Italien', in *Neue Sachlichkeit und Realismus* (exhibition catalogue, Vienna, Museum des XX. Jahrhunderts, 1977), pp. 181-4.
Birolli, Zeno, Enrico Crispolti and Berthold Hinz, *Arte e fascismo in Italia e in Germania*, Milan, 1974.
Bologna, Galleria d'Arte Moderna, *Metafisica del Quotidiano* (exhibiton catalogue, ed. Franco Solmi, 1978).
Bologna, Galleria d'Arte Moderna, *La metafisica: gli anni Venti*, 2 vols (exhibiton catalogue, ed. Renato Barilli and Franco Solmi, May-August 1980).
Bontempelli, Massimo, *L'avventura novecentista*, Florence, 1938.
Bossaglia, Rossana, *Il 'Novecento italiano': Storia, documenti, iconografia*, Milan, 1979.
Bovero, Anna (ed.), *Archivi dei sei pittori di Torino*, Rome, 1965.
Braun, Emily, 'The Scuola Romana: Fact or Fiction?', *Art in America*, 76, no. 3, March 1988, pp. 128-37.

Cammet, John, *Antonio Gramsci and the Origins of Italian Communism*, Palo Alto (California), 1967.
Cannistraro, Philip, *La fabbrica del consenso*, Bari, 1975.
Cannistraro, Philip (ed.), *Historical Dictionary of Fascist Italy*, Westport (Conn.), 1982.
Carrà, Carlo, *Artisti moderni*, Florence, 1943.
Carrà, Carlo, *Il rinnovamento delle arti in Italia*, Milan, 1945.
Carrà, Massimo, *Tra le due guerre: Il rapporto di cultura e realtà*, L'arte moderna, 9, Milan, 1967.
Carrà, Massimo, *Gli anni del ritorno all'ordine*, Milan, 1978.
Carrà, Massimo, Patrick Waldberg and Ewald Rathke, *Metafisica*, Milan, 1968.
Caruso, Luciano, and Stelio Martini (eds), *Futurismo e Novecentismo*, Livorno, 1985.
Castelfranco, Giorgio, and Marco Valsecchi, *Pittura e scultura italiana dal 1910 al 1930*, Rome, 1956.
Costantini, Vincenzo, *Pittura italiana contemporanea*, Milan, 1934.
Crispolti, Enrico, 'Appunti sul problema del secondo futurismo nella cultura italiana fra le due guerre', *Notizie*, 2, no. 8, April 1958, pp. 34-51.
Crispolti, Enrico, *Il secondo futurismo: 5 pittori + 1 scultore*, Turin, 1962.

Danesi, Silvia, and Luciano Patetta (eds), *Il razionalismo e l'architettura in Italia durante il fascismo*, Venice, 1976.
De Felice, Renzo, *Mussolini il rivoluzionario 1883-1920*, Turin, 1965.
De Felice, Renzo, *Mussolini il fascista, I: La conquista del potere*, Turin, 1966.
De Felice, Renzo, *Mussolini il fascista, II: L'organizzazione dello Stato fascista*, Turin, 1968.
De Felice, Renzo, *Interpretations of Fascism*, trans. B. Huff Everett, Cambridge, 1969; 2nd edn, Cambridge, 1977.
De Felice, Renzo, *Mussolini il duce*, vol. I, Turin, 1974.
De Grada, Raffaele, *Il movimento di Corrente*, Milan, 1952.
De Grand, Alexander, *Bottai e la cultura fascista*, Bari, 1978.
De Grand, Alexander, *Italian Fascism: Its Origins and Development*, Lincoln (Nebraska), 1982.

De Grazia, Vittoria, *The Culture of Consent: Mass Organization of Leisure in Fascist Italy*, New York, 1981.

De Libero, Libero, *Roma 1935*, Rome, 1981.

Della Porta, A. F., *Inchiesta sul novecentismo*, Milan, 1936.

De Micheli, Mario, *Consenso, fronda, opposizione: Intellettuali nel ventennio fascista*, Milan, 1977.

De Micheli, Mario, *La scultura del Novecento*, Turin, 1981.

De Seta, Cesare, *La cultura architettonica in Italia tra le due guerre*, Bari, 1972.

Doordan, Dennis, *Architecture and Politics in Fascist Italy: Il Movimento Italiano per L'Architettura Razionale, 1928-1932*, Ann Arbor, 1983.

Ellwood, David, *L'Alleato Nemico*, Milan, 1977.

Fagiolo dell'Arco, Maurizio, *Scuola Romana: Pittura e scultura a Roma dal 1919 al 1943*, Rome, 1986.

Falkenhausen, Susanne von, *Der Zweite Futurismus und die Kunstpolitik des Faschismus in Italien von 1922-1943*, Frankfurt am Main, 1979.

Florence, Galleria d'Arte Moderna di Palazzo Pitti, *Le collezioni del Novecento 1915-1945: Presentazione antologica* (exhibition catalogue, text by Ettore Spalletti, 30 December 1986-30 June 1987).

Florence, Palazzo Strozzi, *Arte Moderna in Italia 1915-1935* (exhibition catalogue, text by Carlo Ludovico Ragghianti, 26 February-28 May 1967).

Folin, Alberto, *Il ritratto dell'italiano: Cultura, arte, istituzioni in Italia negli anni trenta e quaranta*, Venice, 1983.

Fossati, Paolo, *L'immagine sospesa: Pittura e scultura astratta in Italia*, Turin, 1971.

Fossati, Paolo, *'Valori Plastici' 1918-1922*, Turin, 1981.

Fossati, Paolo, 'Pittura e scultura fra le due guerre', in *Storia dell'arte italiana*, pt 2, vol. 3: *Il Novecento*, Turin, 1982, pp. 175-259.

Genoa, Centro dei Liguri, *Genova, il Novecento* (exhibition catalogue, ed. Giuseppe Marcenaro, 1986).

Gentile, Emilio, *Le origini dell'ideologia fascista, 1918-1925*, Bari, 1975.

Gentile, Emilio, 'La Politica di Marinetti', *Storia Contemporanea*, 7, no. 3, September 1976, pp. 415-38.

Ghirardo, Diane, 'Italian Architects and Fascist Politics: An Evaluation of the Rationalists' Role in Regime Building', *Journal of the Society of Architectural Historians*, 39, no. 2, May 1980, pp. 109-27.

Ghirardo, Diane, 'Politics of a Masterpiece: The *Vicenda* of the Decoration of the Facade of the Casa del fascio, Como 1936-39', *Art Bulletin*, 62, no. 3, September 1980, pp. 466-78.

Giani, Giampiero, *Il Novecento*, Milan, 1942.

Gualino, Riccardo, *Frammenti di vita e pagine inedite*, Rome, 1966.

Guerri, Giordano Bruno, *Giuseppe Bottai: Un fascista critico*, Milan, 1976.

Isenghi, Mario, *Il mito della grande guerra*, Bari, 1970.

Isenghi, Mario, *Intellettuali militanti, intellettuali funzionari: Appunti sulla cultura fascista*, Turin, 1979.

Lazagna, C., 'La Concezione delle arti figurative nella politica culturale del fascismo', *Il movimento di liberazione in Italia*, 4, 8, 9, October-December 1967, pp. 3-27.

London, Tate Gallery, *Modern Italian Art from the Estorick Collection* (exhibition catalogue, 1956).

Luti, Giorgio, *La letteratura nel ventennio fascista*, Florence, 1972.

Lyttelton, Adrian, *The Seizure of Power: Fascism in Italy, 1919-1929*, London, 1973.

Mafai, Mario, *Diario 1926-1965*, ed. Giuseppe Appella, Rome, 1984.

Mangoni, Luisa, *L'interventismo della cultura*, Bari, 1974.

Mangoni, Luisa, (ed.), *Primato 1940-43*, Bari, 1977.

Masiero, Franco, '"Strapaese" e "Stracittà"', *Problemi*, no. 44, 1975, pp. 260-90.

Milan, Comune di Milano, *Gli anni Trenta: Arte e cultura in Italia* (exhibition catalogue, 27 January-30 April 1982).

Milan, Galleria d'Arte Moderna, Padiglione d'Arte Contemporanea, *Miti del '900: Letteratura – Arte* (exhibition catalogue, ed. Zeno Birolli, 1979).

Milan, Galleria Philippe Daverio, *Fillia e l'avanguardia futurista negli anni del fascismo* (exhibition catalogue, text by Silvia Evangelisti and Paolo Baldacci, 1986).

Milan, Palazzo della Permanente, *I^a Mostra del Novecento italiano* (exhibition catalogue, preface by Margherita Sarfatti, February-March 1926).

Milan, Palazzo della Permanente, *II^a Mostra del Novecento italiano* (exhibition catalogue, preface by Margherita Sarfatti, March-April 1929).

Milan, Palazzo della Permanente, *Il Novecento italiano (1923/1933)* (exhibition catalogue, 12 January-27 March 1983).

Milan, Palazzo Reale, *Corrente: Il movimento di arte e cultura di opposizione* (exhibition catalogue, ed. Mario De Micheli, 25 January-28 April 1985).

Milan, Palazzo Reale, *Scuola Romana: Artisti tra le due guerre* (exhibition catalogue, text by Maurizio Fagiolo dell'Arco and Valerio Rivosecchi, 13 April-19 June 1988).

Modena, Galleria Civica, *Rome 1934* (exhibition catalogue, text by Giuseppe Appella and Fabrizio D'Amico, 1986).

Monza, Villa Reale, *Aspetti del primo astrattismo italiano* (exhibition catalogue, ed. Luciano Caramel, 1969).

Papa, Emilio, *Storia di due manifesti*, Milan, 1958.

Paris, Centre Georges Pompidou, *Les réalismes 1919-1939* (exhibition catalogue, December 1980-April 1981).

Patetta, Luciano, *L'architettura in Italia, 1919-1943: Le polemiche*, Milan, 1972.

Perfetti, Francesco, 'Arte e fascismo tra "Novecento" e "Novecento italiano"', *Storia Contemporanea*, 1, no. 2, April 1981, pp. 315-34.

Persico, Edoardo, *Tutte le opere, 1922-1935*, ed. Giulia Veronesi, Milan, 1964.

Persico, Edoardo, *Oltre l'architettura: Scritti scelti e lettere*, ed. Riccardo Mariani, Milan, 1977.

Personè, Luigi, *Pittori Toscani del Novecento*, Florence, 1952.

Pistoia, Officine San Giorgio, *Artisti e cultura visiva del Novecento* (exhibition catalogue, June-August 1980).

Pittura d'oggi (Felice Casorati, Renato Birolli, Mino Maccari, Domenico Purificato, Virgilio Guidi, Massimo Campigli, Mario Mafai), Florence, 1954.

Pontaggia, Elena, *Il Milione e l'astrattismo 1932-1938*, Milan, 1988.

Pratesi, Maurizio, 'Scultura italiana verso gli anni Trenta e contemporanea rivalutazione dell'arte etrusca', *Bollettino d'Arte*, 28, November-December 1984, pp. 91-106.

Prato, Palazzo Novellucci, *Anni Creativi al 'Milione' 1932-1939* (exhibition catalogue, 1980).

Radice, Mario, *Memorie del primo astrattismo italiano degli anni '30 e '40*, Lugano, 1979.

Ragghianti, Carlo Ludovico, *'Il Selvaggio' di Mino Maccari*, Venice, 1959.

Ragghianti, Carlo Ludovico, and Marco Valsecchi, *La raccolta Della Ragione*, Florence, 1969.

Roh, Franz, *Nach-Expressionismus, Magischer Realismus: Probleme der neuesten europäischen Malerei*, Leipzig, 1925.

Rome, Galleria Arco Farnese, *Gli artisti di Villa Strohl-Fern: Tra Simbolismo e Novecento* (exhibition catalogue, ed. Lucia Stefanelli Torossi, 28 April-10 June 1989).

Rome, Galleria 'La Barcaccia', *La scuola romana* (exhibition catalogue, text by Romeo Lucchese, 1964).

Rome, Palazzo delle Esposizioni, *Mostra della Rivoluzione Fascista* (exhibition catalogue, 1932-3).

Rome, VIII Quadriennale di Roma, *La scuola romana dal 1930 al 1945* (exhibition catalogue, text by Giorgio Castelfranco and Dario Durbé, 1960).

Sarfatti, Margherita, *Segno, colori, luce*, Bologna, 1925.

Sarfatti, Margherita, *Storia della pittura moderna*, Rome, 1930.

Scheiwiller, Giovanni, *Art italien moderne*, Paris, 1930.

Shapiro, Ellen, *Building Under Mussolini*, Ann Arbor, 1986.

Silva, Umberto, *Ideologia e arte del fascismo*, Milan, 1975.

Talvacchia, Bette L., 'Politics Considered as a Category of Culture: The Anti-Fascist *Corrente* Group', *Art History*, 8, no. 2, September 1985, pp. 336-55.

Tempesti, Fernando, *Arte dell'Italia fascista*, Milan, 1976.

Torino 1920-1936: Società e cultura tra sviluppo industriale e capitalismo, Turin, 1976.

Turin, Galleria Civica d'Arte Moderna, *Materiali: Arte italiana 1920-1940 nelle collezioni della Galleria civica d'arte moderna di Torino* (exhibition catalogue, text by Luciano Caramel, Paolo Fossati and Rosanna Maggio Serra, September-December 1981).

Turin, Galleria Civica d'Arte Moderna, *I Sei di Torino 1929-1932* (exhibition catalogue, 1965).

Turin, Galleria Civica d'Arte Moderna, *Piero Gobetti e il suo tempo* (exhibition catalogue, 1976).

Turin, Galleria d'Arte Moderna, *Torino tra le due guerre* (exhibition catalogue, 1978).

Valori Plastici, 1918-1921, reprint, Rome and Milan, 1969.

Venturi, Lionello, *Pretesti di critica*, Milan, 1929.

Verona, Galleria dello Scudo, *Realismo Magico* (exhibition catalogue, ed. Maurizio Fagiolo dell'Arco, 27 November 1988-29 January 1989).

Zagarrio, Vito, 'Il fascismo e la politica delle arti', *Studi Storici*, 17, no. 2, April-June 1976, pp. 234-56.

Zangrandi, Renato, *Il lungo viaggio attraverso il fascismo*, Milan, 1962.

1945-1968

Allum, Percy, *Italy: Republic without Government?*, New York, 1973.

Apollonio, Umbro, and Marco Valsecchi, *Panorama dell'arte italiana*, Turin, 1950.

Apollonio, Umbro, and Marco Valsecchi, *Panorama dell'arte italiana*, Turin, 1951.

Arezzo, Galleria Comunale d'Arte Contemporanea, *Mitologia del nostro tempo* (exhibition catalogue, ed. Luigi Carluccio, 1965).

Argan, Giulio Carlo, *Arte Concreta*, Milan, 1949.

Barilli, Renato, *Dall'oggetto al comportamento: La ricerca artistica dal '60 al '70*, Rome, 1971.

Barilli, Renato, *Informale, oggetto, comportamento*, Milan, 1979.

Barilli, Renato, *L'arte in Italia nel secondo dopoguerra*, Bologna, 1979.

Bologna, Galleria Comunale d'Arte Moderna, *L'informale in Italia* (exhibition catalogue, ed. Renato Barilli and Franco Solmi, June-September 1983).

Boston, Institute of Contemporary Art, *Young Italians* (exhibition catalogue, introduction by Alan Solomon, 23 January-23 March 1968).

Bucarelli, Palma, *Scultori italiani contemporanei*, Milan, 1967.

Calvesi, Maurizio, *Nove casi della giovane pittura*, Rome, 1959.

Cavellini, A., *Arte Astratta*, Milan, 1959.

Clark, Martin, *Modern Italy 1871-1982*, London, 1984.

Crispolti, Enrico, 'Appunti per una storia del nonfigurativo in Italia', *Ulisse*, 6, no. 33, 1959, pp. 29-45.

De Fusco, Renato, *Storia dell'arte contemporanea*, Bari, 1983.

De Grada, Raffaele, *Pittura e scultura degli anni '60*, Milan, 1967.

De Marchis, Giorgio, 'L'arte in Italia dopo la seconda guerra mondiale', in *Storia dell'arte italiana*, pt 2, vol. 3: *Il Novecento*, Turin, 1982, pp. 553-652.

De Micheli, Mario, *Scultura italiana del dopoguerra*, Milan, 1958.

De Micheli, Mario, *Arte contro, 1945-1970: Dal realismo alla contestazione*, Milan, 1970.

Dorazio, Piero, *La fantasia dell'arte nella vita moderna*, Rome, 1955.

Dorfles, Gillo, *Ultime tendenze nell'arte d'oggi*, Milan, 1961; 2nd edn, Milan, 1973.

Fagiolo dell'Arco, Maurizio, *Rapporto 60: Le arti oggi in Italia*, Rome, 1966.

Farneti, Paolo (ed.), *Il Sistema Politico Italiano*, Bologna, 1973.

Ferrara, Casa Romei, *Rinnovamento dell'arte in Italia 1930-45* (exhibition catalogue, 1960).

Foligno, Palazzo Trinci, *Lo spazio dell'immagine* (exhibition catalogue, text by Maurizio Calvesi and Alberto Boatto, 2 July-1 October 1967).

Gallarate, Civica Galleria d'Arte Moderna, *M.A.C.: Movimento Arte Concreta*, vol. 1: 1948-1952, vol. 2: 1953-1958 (exhibition catalogue, text by Luciano Caramel, April-June 1984).

Galli, Giorgio, and Alfonso Prandi, *Patterns of Political Participation in Italy*, New Haven, 1970.

Gatt-Rutter, John, *Writers and Politics in Modern Italy*, London, 1978.

Ghiringhelli, Gino, *Pittura moderna italiana* (text in English and Italian), Turin, 1949.

Giani, Giampiero, *Spazialismo: Origini e sviluppi di una tendenza artistica*, Milan, 1956.

Guttuso, Renato, 'Del realismo, del presente e d'altro', *Paragone*, 8, no. 85, January 1957, pp. 63-74.

Kogan, Norman, *A Political History of Post-War Italy*, London, 1966.

Lange, Peter, and Sidney Tarrow (eds), *Italy in Transition*, London, 1980.

La Palombara, Joseph, *Interest Groups in Italian Politics*, Princeton, 1964.

Leprohon, Pierre, *The Italian Cinema*, London, 1972.

Liverpool, Walker Art Gallery, *New Italian Art 1953-71* (exhibition catalogue, text by Giovanni Carandente, 22 July-11 September 1971).

Livorno, Palazzo Comunale, *L'Informale in Italia fino al 1957* (exhibition catalogue, text by Dario Durbé and Maurizio Calvesi, March-April 1963).

Lucerne, Kunstmuseum, *Informale in Italia* (exhibition catalogue, 1987).

Milan, Galleria della Spiga, *Prima Mostra del 'Fronte Nuovo delle Arti'* (exhibition catalogue, 1947).

Milan, Padiglione d'Arte Contemporanea, *Otto pittori italiani 1952-1954* (exhibition catalogue, text by Luisa Somaini, 1986).

Milan, Palazzo della Permanente, *Giovani artisti italiani* (exhibition catalogue, 20 April-16 May 1958).

Milan, Palazzo Reale, *Pittura a Milano dal 1945 al 1964* (exhibition catalogue, June-July 1964).

Milan, Palazzo Reale, *Aspetti dell'informale* (exhibition catalogue, May-June 1971).

Modesti, Renzo, *Pittura italiana contemporanea*, Milan, 1964.

New York, The Jewish Museum, *Recent Italian Painting and Sculpture* (exhibition catalogue, text by Guido Ballo and Kynaston McShine, 24 May-2 September 1968).

Parma, Università di Parma, Centro Studi e Archivio della comunicazione, Salone delle Scuderie in Pilotta, *L'opera dipinta 1960-1980* (exhibition catalogue, 3 March-26 March 1982).

Pinzani, Carlo, 'L'Italia Repubblicana', in *Storia d'Italia*, vol. 4/3, Turin, 1976, pp. 2484-734.

Posner, Michael, and Stuart Woolf, *Italian Public Enterprise*, London, 1967.

Prandi, Alfonso, *Chiesa e Politica: La Gerarchia e l'Impegno Politico dei Cattolici Italiani*, Bologna, 1968.

Quazza, Guido, *Resistenza e Storia d'Italia*, Milan, 1976.

Restany, Pierre, *Lyrisme et abstraction*, Milan, 1960.

Restany, Pierre, *Les nouveaux réalistes*, Paris, 1968.

Rome, Galleria Arco D'Aliberti, *Forma I* (exhibition catalogue, text by Maurizio Fagiolo dell'Arco, 1966).

Rome, Galleria La Salita, *Mostra di gruppo: Angeli, Festa, Lo Savio, Schifano, Uncini* (exhibition catalogue, text by Pierre Restany, 1959).

Rome, Galleria Nazionale d'Arte Moderna, *Aspetti dell'arte italiana contemporanea* (exhibition catalogue, ed. Giorgio de Marchis, 1966).

Rome, Galleria Nazionale d'Arte Moderna, *Arte astratta in Italia* (exhibition catalogue, 2 April-11 May 1980).

Rome, X Quadriennale, *La ricerca estetica dal 1960 al 1970* (exhibition catalogue, March 1973).

Rome, Palazzo delle Esposizioni, *Vitalità del negativo nell'arte italiana 1960/70* (exhibition catalogue, ed. Achille Bonito Oliva, November 1970-January 1971).

Sauvage, Tristan, *Pittura italiana del dopoguerra (1945-1957)*, Milan, 1957.

Sauvage, Tristan, *Arte Nucleare*, Paris, 1962.

St. Louis, City Art Museum of St. Louis, *Contemporary Italian Art* (exhibition catalogue, 13 October-14 November 1955).

Tomassoni, Italo, *Arte dopo il 1945: Italia*, Bologna, 1971.

Turin, Accademia Albertina, *Arte a Torino 1946/1953* (exhibition catalogue, 1983).

Valsecchi, Marco, *I pittori dopo il Novecento*, Milan, 1969.

Venice, Biennale Internazionale d'Arte di Venezia, *Il fronte nuovo delle arti* (exhibition catalogue, text by Giuseppe Marchiori, 1948).

Venice, Biennale Internazionale d'Arte di Venezia, *Dall'opera al comportamento* (exhibition catalogue, text by Francesco Arcangeli, 1972).

Venice, Chiesa di San Samuele, *Artisti italiani contemporanei 1950-1983* (exhibition catalogue, ed. Achille Bonito Oliva, 1983).

Venturi Lionello, *Otto pittori italiani: Afro, Birolli, Corpora, Moreni, Marlotti, Santomaso, Turcato, Vedova*, Rome, 1952.

Woolf, Stuart (ed.), *The Rebirth of Italy, 1943-1950*, London, 1972.

Zariski, Raphael, *Italy: The Politics of Uneven Development*, Hinsdale, 1972.

1968-1988

Barilli, Renato, *Tra presenza e assenza: Due ipotesi per l'età postmoderna*, Milan, 1974; 2nd edn, 1981.

Barilli, Renato, *L'arte in Italia nel secondo dopoguerra*, Bologna, 1979.

Belfast, The Arts Council of Northern Ireland Gallery, *New Italian Art* (exhibition catalogue, text by Germano Celant, 1973).

Berlin, Internationale Kunstausstellung, *Zeitgeist* (exhibition catalogue, ed. Christos M. Joachimides and Norman Rosenthal, 1982).

Berne, Kunsthalle, *When Attitudes Become Form* (exhibition catalogue, ed. Harald Szeemann, March 1969).

Berne, Kunsthalle, *Fabro, Kounellis, Merz, Paolini* (exhibition catalogue, February 1980).

Bielefeld, Kunsthalle, *Sandro Chia, Francesco Clemente, Enzo Cucchi* (exhibition catalogue, text by Heiner Bastian and Wolfgang Max Faust, 13 February-17 April 1983).

Bologna, Galleria De' Foscherari, *Arte povera* (exhibition catalogue, text by Germano Celant, February 1968).

Bonito Oliva, Achille, *Europe-America: The Different Avant-gardes*, Milan, 1976.

Bonito Oliva, Achille, 'Process, Concept and Behaviour in Italian Art', *Studio International*, 191, no. 979, January-February 1976, pp. 3-10.

Bonito Oliva, Achille, 'The Italian Trans-avant-garde', *Flash Art*, 92-93, October-November 1979, pp. 17-20.

Bonito Oliva, Achille, *La Transavanguardia italiana*, Milan, 1980. Translated as *The Italian Trans-avantgarde*, Milan, 1980.

Bonito Oliva, Achille, *Il sogno dell'arte tra avanguardia e transavanguardia*, Milan, 1981.

Calvesi, Maurizio, *Teatro delle Mostre*, Rome, 1968.

Celant, Germano, 'Arte povera: Appunti per una guerriglia' *Flash Art*, no. 5, November–December 1967, p. 3.

Celant, Germano, *Arte povera*, Milan, 1969.

Celant, Germano, *Arte povera: Conceptual, actual or impossible art?*, London, 1969.

Celant, Germano, *Pre-cronistoria, 1966-69*, Florence, 1976.

Celant, Germano, *The Knot: Arte Povera*, Turin, 1985.

Clarke, John R., 'Up Against the Wall: Trans-avanguardia', *Arts Magazine*, 57, December 1988, pp. 70-81.

Foligno, Palazzo Trinci, *Il tempo dell'immagine* (exhibition catalogue, text by Maurizio Calvesi and Italo Tomassoni, 1983).

Genazzano, Castello Colonna, *Le stanze* (exhibition catalogue, text by Achille Bonito Oliva, 30 November 1919-29 February 1980).

Genoa, Galleria La Bertesca, *Arte povera* (exhibition catalogue, ed. Germano Celant, October 1967).

London, Institute of Contemporary Arts and Hayward Gallery, *Arte Italiana 1960-1982* (exhibition catalogue, October 1982-January 1983).

London, Royal Academy of Arts, *A New Spirit in Painting* (exhibition catalogue, text by Christos M. Joachimides, Norman Rosenthal and Nicholas Serota, January-March 1981).

Martin, H., 'From Milan and Turin', *Art International*, 15, December 1971, pp. 74-7.

Martin, H., 'The Italian Scene, Dynamic and Highly Charged', *Art News*, 80, no. 3, March 1981, pp. 70-7.

Milan, Palazzo della Permanente, *Luoghi del silenzio imparziale: Labirinto contemporaneo* (exhibition catalogue, ed. Achille Bonito Oliva, June-August 1981).

Milan, Palazzo della Permanente, *Il segno della pittura e della scultura* (exhibition catalogue, 20 September-23 October 1983).

Milan, Palazzo Reale, *Scultori italiani contemporanei* (exhibition catalogue, March-April 1971).

Milan, Palazzo Reale, *L'ultima avanguardia* (exhibition catalogue, text by Lea Vergine, 4 November 1983-27 February 1984).

Milan, Rotonda di via Besana, *Giovani pittori scultori italiani* (exhibition catalogue, 29 October-12 December 1982).

Modena, Sala di cultura, *Arte e critica '70* (exhibition catalogue, 1970).

Munich, Städtische Galerie im Lenbachhaus, *Der Traum des Orpheus: Mythologie in der italienischen Gegenwartskunst 1964-1984* (exhibition catalogue, ed. Helmut Friedel, 1984).

Mussa, Italo, *La pittura colta*, Rome, 1983.

New York, Solomon R. Guggenheim Museum, *Guggenheim International Exhibition 1971* (exhibition catalogue, text by Edward Fry and Diane Waldman, 1971).

New York, Solomon R. Guggenheim Museum, *Italian Art Now: An American Perspective – 1982 Exxon International Exhibition* (exhibition catalogue, ed. Diane Waldman, 2 April-20 June 1982).

Paris, Centre Georges Pompidou, *Identité Italienne: L'art en Italie depuis 1959* (exhibition catalogue, ed. Germano Celant, 25 June-7 September 1981).

Philadelphia, Museum of the Philadelphia Civic Center, *Italy Two: Art around '70* (exhibition catalogue, November 1973).

Ratcliff, Carter, 'On Iconography and Some Italians', *Art in America*, 70, September 1982, pp. 152-9.

Rome, Galleria L'Attico, *Fuoco, immagine, acqua, terra* (exhibition catalogue, ed. Alberto Boatto and Maurizio Calvesi, March 1967).

Rome, Palazzo delle Esposizioni, *Linee della ricerca artistica in Italia 1960-1980* (exhibition catalogue, text by Maurizio Calvesi, February 1981).

Spoleto, Chiesa di San Nicolò, *L'Attico 1957-1987* (exhibition catalogue, 1987).

Toronto, Art Gallery of Ontario, *The European Iceberg: Creativity in Germany and Italy Today* (exhibition catalogue, ed. Germano Celant, 8 February-7 April 1985).

Trini, Tommaso, 'The Sixties in Italy', *Studio International*, 184, no. 949, November 1972, pp. 165-70.

Turin, Galleria Civica d'Arte Moderna, *Conceptual Art, Arte povera, Land Art* (exhibition catalogue, ed. Germano Celant, June 1970).

Turin, Galleria Civica d'Arte Moderna, *Arte in Italia 1960-1977* (exhibition catalogue, ed. Renato Barilli, Antonio Del Guercio and Filiberto Menna, May 1977).

Venice, Biennale Internazionale d'Arte di Venezia, *Anacronismo, ipermanierismo* (exhibition catalogue, text by Maurizio Calvesi and Italo Tomassoni, 1984).

Washington, Hirshhorn Museum, *A New Romanticism: Sixteen Artists from Italy* (exhibition catalogue, ed. Howard N. Fox, text by Brandon Strehlke, 3 October 1985-5 January 1986).

Lenders to the Exhibition

Assitalia SPA Cat. 140
Athens, Jean Bernier Gallery Cat. 207, 208

Basle, Kunstmuseum (Emanuel Hoffmann
 Foundation) Cat. 45
C. Benporat Collection, Milan Cat. 154
Collection Lilott and Erik Berganus Cat. 230
Berlin, Galerie Fahnemann Lucio Fontana,
 Venetian Nocturnes (p. 422)
Berlin, Staatliche Museen Preussischer Kultur-
 besitz, Nationalgalerie Cat. 232
Bielefeld, Kunsthalle Cat. 225
Brussels, Musées Royaux des Beaux-Arts de Bel-
 gique/Koninklijke Musea voor Schone Kunsten
 van Belgie Cat. 151
Alberto Burri Cat. 169

Città di Castello, Fondazione Palazzo Albizzini
 (Burri Collection) Cat. 166, 170
Collection Rosangela Cochrane, Turin Cat. 177
Attilio Codognato Collection, Venice Cat. 182,
 183, 184
Maria Cohen, Turin Cat. 194
Cologne, Galerie Rudolf Zwirner Cat. 211
Cologne, Museum Ludwig Cat. 4, 71, 88
Cortina d'Ampezzo, Regole d'Ampezzo,
 Pinacoteca Mario Rimoldi Cat. 78
Gino De Dominicis Gino De Dominicis, *Untitled*
 (p. 422)
Antonietta and Giovanni Demarco Cat. 171
Collection Anthony Denney Cat. 165
Duisburg, Wilhelm-Lehmbruck-Museum
 Cat. 130

Collection Mr and Mrs Eric Estorick Cat. 1, 6,
 17, 28, 33, 34, 42, 51, 139

Luciano Fabro Cat. 206; Luciano Fabro, *Palladio*
 (p. 422)
Comune di Firenze, Raccolta d'Arte Contem-
 poranea Alberto Della Ragione Cat. 89, 113
Teresita Fontana Cat. 121, 122, 126, 155, 156,
 157
Giorgio Franchetti, Rome Cat. 222
Frankfurt am Main, Galerie Neuendorf Cat. 173
Frankfurt am Main, Städelsches Kunstinstitut (on
 loan from private collection) Cat. 30, 37

The Jacques and Natasha Gelman Collection
 Cat. 49
Giuliano Gori, Fattoria di Celle Cat. 81, 160
Grenoble, Musée de Peinture et de Sculpture de
 Grenoble Cat. 32

Herning, Kunstmuseum Cat. 185
The Alex Hillman Family Foundation Cat. 46
Houston, The Menil Collection Cat. 198

Jannis Kounellis Cat. 214
Marie-Anne and Jan Krugier Collection,
 Geneva Cat. 191

London, Courtauld Institute Galleries (Courtauld
 Collection) Cat. 62
London, Anthony d'Offay Gallery Cat. 220
London, The Trustees of the Tate Gallery
 Cat. 11, 27, 152
Los Angeles, Los Angeles County Museum of Art
 Cat. 59

Macerata, Cassa di Risparmio della Provincia di
 Macerata Cat. 145
Collection Paul Maenz, Cologne Cat. 202
Collection Gianni Malabarba Cat. 179, 181
Collection Giorgio Marconi Cat. 125, 195, 196
Marx Collection, Berlin Cat. 226, 228, 229
Egidio Marzona Cat. 219
Mattioli Collection, Milan Cat. 13, 24, 25, 36
Melotti Collection Cat. 133, 134, 135, 136
Milan, Banca Commerciale Italiana Cat. 14
Milan, Civica Galleria d'Arte Moderna
 (Grassi Collection) Cat. 7
Milan, Civico Museo d'Arte Contemporanea,
 Palazzo Reale Cat. 19, 20, 21, 120, 162
Milan, Civico Museo d'Arte Contemporanea
 (Boschi Collection) Cat. 82
Milan and Turin, Galleria Christian Stein
 Cat. 204, 210, 216, 218
Milan, Pinacoteca di Brera (Gift of Emilio and
 Maria Jesi) Cat. 16, 53, 57, 90, 95, 100
Collection Z. Mis Giulio Paolini, *Two plus Two*
 (p. 423)
Collection Beatrice Monti della Corte,
 Milan Cat. 124
Munich, Bayerische Staatsgemäldesammlungen,
 Staatsgalerie moderner Kunst Cat. 38

New York, Courtesy of Jan Krugier Gallery
 Cat. 192
New York, Solomon R. Guggenheim Museum
 Cat. 67
New York, Courtesy The Sonnabend Collection
 Cat. 199, 200
New York, Courtesy Sperone Westwater Gallery
 Cat. 231, 233, 234
New York, The Metropolitan Museum of Art
 Cat. 40, 58, 64

New York, The Museum of Modern Art
 Cat. 5, 18
Collection Franz Paludetto, Turin Cat. 188
Carla Panicali, Rome Cat. 127
Giulio Paolini Cat. 201; Giulio Paolini, *Untitled*
 (p. 423)
Paris, Musée d'Art Moderne de la Ville de
 Paris Cat. 158
Paris, Musée National d'Art Moderne, Centre
 Georges Pompidou Cat. 141, 209
Parma, Fondazione Magnani Rocca, Corte di
 Mamiano Cat. 55
Henry & Rose Pearlman Foundation Inc. Cat. 61
Giuseppe Penone Cat. 212
Luciano Pistoi Collection Cat. 178
Michelangelo Pistoletto Cat. 197
Pittsburgh, The Carnegie Museum of Art Cat. 29

Rome, Galleria Anna D'Ascanio Cat. 164
Rome, Galleria Communale d'Arte Moderna
 Cat. 144
Rome, Galleria dell'Oca Cat. 84
Rome, Galleria L'Isola Cat. 174, 175, 176
Rome, Galleria La Salita Cat. 186; Francesco Lo
 Savio, *Black Uniform Opaque Metal* (p. 423)
Rome, Galleria Nazionale d'Arte Moderna
 Cat. 118, 143, 146, 147, 148, 149, 150, 161, 168
Lia Rumma, Naples Cat. 223

Paolo Sprovieri, Rome Cat. 163
Collection Ingvild Stöcker, Munich Cat. 213
Stuttgart, Staatsgalerie Cat. 48, 193
Ch. Szwajcer Cat. 205

Toledo, The Toledo Museum of Art Cat. 68
Trento, Museo Provinciale d'Arte Cat. 39
Trieste, Civico Museo Revoltella, Galleria d'Arte
 Moderna Cat. 114
Turin, Galleria Narciso Cat. 129
Turin, Museo Civico di Torino Cat. 119, 128,
 180

Collection Augusto Vallunga Cat. 72
Emilio Vedova Cat. 172; Emilio Vedova, *Cycle 62
 B.B. 6* and *Cycle 62-63 B. 3* (p. 423)
Verona, Galleria dello Scudo Cat. 74, 80, 102

Zurich, Galerie Bruno Bischofberger Cat. 227
Zurich, Kunsthaus (Vereinigung Zürcher Kunst-
 freunde) Cat. 26, 43

Also many owners who prefer to remain
 anonymous

Photographic Acknowledgments

The exhibition organizers would like to thank the following for making photographs available:

Catalogue Illustrations

Claudio Abate, Rome Cat. 216
Franco Abbondanza, Milan Cat. 133, 134
Carla Accardi Cat. 177, 178
Agfachrome Studio-Service Cat. 3, 88
Salvatore Ala Gallery, New York Cat. 187
Aurelio Amendola, Pistoia Cat. 81
Jörg P. Anders Cat. 232
Archivio Fabbri, Milan Cat. 12
Arte Fotografica, Milan Cat. 14
Artshot, Houston Cat. 68
P. Bressano, Turin Cat. 199
Mimmo Capone, Rome Cat. 224
Luca Carrà, Milan Cat. 13, 16, 19, 20, 21, 25, 36, 52, 53, 54, 56, 57, 90, 95, 96, 101, 155, 156, 157
Giorgio Colombo, Milan Cat. 172
Prudence Cuming Associates Ltd, London Cat. 1, 2, 121, 122, 123, 124, 125, 126, 127
Dallas Museum of Art Cat. 165
W. Drayer, Zurich Cat. 43
Gabinetto Fotografico Nazionale, Rome Cat. 55
Galleria Gian Ferrari, Milan Cat. 142
Galleria Philippe Daverio, Milan Cat. 73, 110, 111
Galleria Christian Stein, Milan Cat. 201, 202, 203, 204, 206
David Heald Cat. 67
Paul Hester, Houston Cat. 200
Photocolor Hinz, Allschwil-Basel Cat. 45
Jannis Kounellis Cat. 213, 215, 216
J. Littkemann, Berlin Cat. 226, 229
The Metropolitan Museum of Art, New York Cat. 22, 49, 58, 61
Herbert Michel, Fehraltorf Cat. 17, 34, 42, 191, 192
Murgia, Turin Cat. 188

Massimo Napoli, Rome Cat. 142
Anthony d'Offay Gallery, London Cat. 220
Parvum Photo, Milan Cat. 98, 162
Tommaso Pellegrini, Milan Cat. 115
P. Pellion, Turin Cat. 197, 198
Michelangelo Pistoletto Cat. 198, 199
Ditta Quattrone Mario, Florence Cat. 89, 113
Gordon H. Roberton (A. C. Cooper Ltd), London Cat. 50
F. Rosenstiel, Cologne Cat. 173
Lia Rumma, Naples Cat. 223
Foto Saporetti, Milan Cat. 7, 82, 83, 120, 179, 181
Paolo Mussat Sartor, Turin Cat. 209, 210, 219
Oscar Savio, Rome Cat. 144
Giuseppe Schiavinotto, Rome Cat. 75, 118, 143, 146, 147, 148, 149, 150, 161, 164, 168
Gian Sinigaglia, Milan Cat. 101
Mark Smith, Venice Cat. 182, 183, 184
Foto Studio 3 di Michele Rubicondo, Milan Cat. 104, 109
Dorothy Zeidman, New York Cat. 234

All other photographs were provided by the owners of the works of art reproduced

Text Illustrations

Archivio Nunes Vais, Rome p. 26
Giancarlo Baghetti, Milan p. 286
Bayerische Staatsgemäldesammlungen, Munich p. 79
Fotopress, Turin p. 423 (Paolini, *Untitled*)
J. Littkemann, Berlin p. 422 (Fontana, *Venetian Nocturnes*)

Robert E. Mates, New York p. 66
John Mills, Liverpool p. 70
The Museum of Modern Art, New York p. 66
Paolo Pellion di Persano, Turin p. 422 (Fabro, *Palladio*)
Foto Pozzar, Trieste p. 285
Andrea Sironi p. 175
Foto Soprintendenza Speciale alla Galleria Nazionale d'Arte Moderna e Contemporanea, Rome pp. 181-185, 291/2
Courtesy Christian Stein, Turin p. 422 (Fabro, *Italy of the Puppets*)

Photographs of the Artists

Umberto Boccioni: Electa Editrice, Milan
Carlo Carrà: Luca Carrà, Milan
Sandro Chia: Amendola, Pistoia, Courtesy Fischer Fine Arts, London
Luciano Fabro: Nanda Lanfranco, Genoa
Renato Guttoso: Giuseppe Schiavinotto, Rome
Jannis Kounellis: Maria Mulas, Milan
Fausto Melotti: Ugo Mulas, Milan
Giorgio Morandi: Luca Carrà, Milan
Michelangelo Pistoletto: Nanda Lanfranco, Genoa
Enrico Prampolini: Massimo Prampolini, Rome
Medardo Rosso: Museo Medardo Rosso, Barzio
Alberto Savinio: Angelica Savinio, Rome
Mario Schifano: Studio Marconi, Milan

All uncredited illustrations are taken from the publishers' and authors' archives

Index of Names

Numbers in italics refer to pages with illustrations